Nature's Nation
American Art and
Environment

Princeton University Art Museum

Distributed by Yale University Press, New Haven and London

With contributions by
Miranda Belarde-Lewis
Teddy Cruz
Rachael Z. DeLue
Mark Dion
Fonna Forman
Laura Turner Igoe
Robin Kelsey
Anne McClintock
Timothy Morton
Rob Nixon
Jeffrey Richmond-Moll
Kimia Shahi
Jaune Quick-to-See Smith

Nature's Nation
American Art and Environment

Karl Kusserow and Alan C. Braddock

Colonization and Empire

Industrialization and Conservation

Contents

Ecology and Environmentalism

Foreword

Art history traces its antecedents to Roman antiquity and the writings of Pliny the Elder, but its true roots lie centuries later during the Renaissance, when a return to classical study engendered a renewed focus on humanistic pursuits. Giorgio Vasari's *Lives of the Artists*, first published in 1550, established the biographical focus that characterized the field until Enlightenment scholars such as Johann Winckelmann urged a shift from artist to art, enabling a parallel move from attention on a work's creator to its beholder. During the nineteenth century and into the early twentieth, the discipline came into its own as figures such as Heinrich Wölfflin and Erwin Panofsky expanded the field (Panofsky for many years from a perch at the Institute for Advanced Study here in Princeton) through the analysis of style, iconography, and cultural context more broadly. Later, Marxist, feminist, and a variety of postmodern approaches informed by critical theory further enriched the study of visual culture, questioning received paradigms and considering the vantage points of diverse consumers of objects and images.

This increasing range of perspectives, coupled with the awareness that current global environmental challenges provoke in looking to both past and future, has given rise to a new interdisciplinary area of research: the environmental humanities. Efforts have coalesced in the last decade around the fields of anthropology, philosophy, history, literature, and now art history, as scholars, curators, and museums seek to enlarge upon the traditional anthropocentrism of the humanities and embrace a more nuanced consideration of nature, ecological systems, and changing human understanding of them. *Nature's Nation: American Art and Environment* marks a dramatic intervention into this ongoing trajectory; as the first sentence of this book's introduction makes clear, the project "rethinks the history of American art in light of ecology and environmental history." What this might mean—not just for American art but for art history in general—is compellingly explored in the pages that follow and on the walls of the sweeping exhibition they accompany. Encompassing paintings, sculptures, prints, drawings, photographs, videos, and works of decorative art ranging from the colonial period to the present—from Chippendale furniture to the

art of Early Republican natural science, Hudson River School landscape painting to Indigenous carved ivory, Dust Bowl regionalism to modernist abstraction and post-war environmental activism—*Nature's Nation* unites art historical interpretation with environmental history, scientific analysis, and the dynamic field of ecocriticism. The result is a once-in-a-generation scholarly undertaking that reimagines the subjects and contexts of creation, as well as the materials and techniques, of American art through an inclusive, holistic approach grounded in contemporary perspectives and concerns.

This project results from an extraordinary, long-term collaboration between Karl Kusserow, the Princeton University Art Museum's John Wilmerding Curator of American Art, and Alan Braddock, Ralph H. Wark Associate Professor of Art History and American Studies at William & Mary. Extending over seven years, including three semesters that brought Alan to Princeton to teach and conduct research with Karl, this undertaking, like the subject it concerns, has been a uniquely wide-ranging and interdisciplinary affair, involving not just colleagues at the Museum but a broad range of artists, faculty, and graduate and undergraduate students from Princeton and beyond. I want particularly to name here the exceptional and enduring partnership offered by the Princeton Environmental Institute; it is my belief that the resulting exhibition and publication lay claim to the unique possibilities of collaboration that exist at a place that includes this Art Museum, a landmark American Studies Program, and the Environmental Institute. Fundamentally, however, it is Karl and Alan's new vision of American art history that is unveiled here, and we salute with admiration the intelligence, aspiration, and industry that enabled its realization. Their work, to cite the glowing peer review of their book-length contributions to the catalogue, "develops an exciting, utterly compelling and persuasive argument for breaking from traditional art history approaches, providing a strikingly original interpretation of American art history that moves the discipline in new directions by bringing art and history to bear on some of the most urgent problems of our time." In light of such an expansive ambition—one I was pleased to promote and encourage from the onset—it seems

appropriate that *Nature's Nation* is being shared with two particularly vital institutions whose commitment to present art broadly in its full social and cultural context makes the pairings especially auspicious. Following its presentation at Princeton, the exhibition first travels to the Peabody Essex Museum, highly regarded for the range and sophistication of its programming, where Dan L. Monroe, Rose-Marie and Eijk van Otterloo Director and CEO, embraced the project from the start, offering encouragement and advice from the curators' first visit and remaining interested in the exhibition's evolution. Equally fitting, the tour concludes at one of the nation's most remarkable new institutions, Crystal Bridges Museum of American Art, where Rod Bigelow, Executive Director & Chief Diversity and Inclusion Officer—whose title suggests the museum's deep commitment to accessibility—also offered enthusiasm and support for this similarly inclusive undertaking.

The scale and scope of *Nature's Nation* entailed the generosity of an unusually large number of lenders—individuals and institutions alike—who agreed to part with cherished works for an extended period. While each is identified elsewhere, I thank all of them here for their collegial cooperation, upon which we have gratefully relied. The ambitious "nature" of *Nature's Nation*—it is, in fact, one of the most ambitious exhibitions we have ever undertaken—also carried with it substantial costs, and it is a distinct pleasure to acknowledge the crucial, and exceptional, largesse of its many donors. Remarkably generous leadership support came from Shelly Malkin, Class of 1986, and Tony Malkin; and from Annette Merle-Smith. The Henry Luce Foundation; the Princeton Environmental Institute; and the Barr Ferree Foundation Fund for Publications, Department of Art and Archaeology, Princeton University, provided similarly welcome and significant philanthropy. Very generous support was also made available from the Humanities Council, the Dean for Research Innovation Fund, and the Humanities Council's David A. Gardner '69 Magic Grant, Princeton University; and the National Endowment for the Arts. Further greatly appreciated assistance was provided by Susan and John Diekman, Class of 1965; Gail and Peter Ochs, Class of 1965; the PSEG Foundation; the Kathleen C. Sherrerd Program Fund for American Art; Stacey Roth Goergen, Class of 1990, and Robert B. Goergen; the High Meadows Foundation Sustainability Fund; the New Jersey State Council on the Arts, a partner agency of the National Endowment for the Arts; the Program in American Studies, Princeton University; and the Partners and Friends of the Princeton University Art Museum.

It may be that a project such as this—innovative, informed, interdisciplinary—is most suitably undertaken by an academic art museum, where the commitment to scholarly inquiry and pioneering knowledge production accords with institutional priorities and converges with the intellectual wherewithal to realize them. If this is the case, it might be said that Princeton and its Museum are ideally suited to the task: small enough to encourage the productive pollination of ideas across boundaries, blessed with enabling resources, and eager to engage substantial issues. To the extent that *Nature's Nation: American Art and Environment* succeeds, it owes a large measure of its achievement to the fertile ground that nurtured it.

To conclude by returning to the discipline of art history and the humanities generally, it has been said that these are lately in crisis, the victims, supposedly, of an increasingly matter-of-fact, technocratic society. Yet at a time of enormous challenges globally, truly they have never been more relevant, for they provide the means to envision and comprehend the human forces driving these challenges, even as endeavors such as *Nature's Nation* and the environmental humanities move beyond them to reveal our dependence upon and wonderfully rich imbrication with the world we call home.

James Christen Steward
Nancy A. Nasher–David J. Haemisegger, Class of 1976, Director

Preface and Acknowledgments

Public awareness of environmental issues has never been greater, nor has the need for imagining more sustainable and ethical habits of human action and thought, including environmentally informed ways of understanding our cultural history. By critically illuminating the environmental contexts of aesthetic objects past and present, curators and art historians have an extraordinary opportunity to expand the parameters of the discipline while fostering a broader shift in ecological consciousness. As public institutions, museums can play an especially valuable role in addressing these crucial and timely concerns.

Nature's Nation: American Art and Environment engages this opportunity by telling a new environmental history of American art, tracing evolving ideas about the environment—and the human place within it—in North American art from colonial encounters between Indigenous animism and European natural theology to the emergence of modern ecological ethics and activism. Using the interpretive insights of interdisciplinary scholarship in ecocriticism, *Nature's Nation* shows that works of art in all media and genres, produced by a diverse array of makers, have something to teach us about environmental history and perception by virtue of their materials, techniques, subjects, and contexts of creation.

While cultural traditions throughout the world have contributed to such understandings, the peculiar pace and combination of forces in American history—including the Native-European collision, slavery, settler colonialism, immigration, industrialization, and mass consumerism, together with catalytic figures in the emergence of modern ecological thought from George Perkins Marsh to John Muir, Aldo Leopold, and Rachel Carson—make the region an especially appropriate crucible for this ecocritical reexamination of artistic practices and paradigms. At the same time, our project critically engages the idea of "nature's nation" in its title, adapted from a classic 1967 book by the American studies scholar Perry Miller, and challenges the exceptionalism inherent in the term in light of Indigenous, African American, and other cultural perspectives.

We hope Nature's Nation will provide viewers and readers a compelling opportunity to reimagine the history of American art in environmental terms. Although scholars have made great strides in examining the nation's artistic production in relation to social and cultural conditions, they have yet to consider issues of ecology or environmental history in a focused and sustained way. By using eco-criticism to rethink landscape painting along with other genres and media, *Nature's Nation* aspires to expand the purview of American art history on multiple registers. We hope it may enrich the field, opening it up to new considerations of historical context, materiality, method, and meaning, while enhancing the relevance of American art to a wide audience.

. . .

Perhaps appropriately, *Nature's Nation* began where the US nation began, in Philadelphia, if not quite so long ago. In 2011 Karl Kusserow attended a conference that Alan Braddock had organized titled "Grid + Flow"—exploring "emerging interdisciplinary currents in environmental history and ecocriticism"—and suggested collaborating on an exhibition examining American art along similar lines. The title of the symposium in a sense characterizes the resulting extended partnership, which sustained moments of conceptual and logistical gridlock as well as periods of highly satisfying productivity, of flow. What endured throughout, even grew, is our respect and appreciation not just for each other's work but for the principle that underlies it—that art and how we interpret it can matter in ways that extend well beyond the thing itself. And so our first, hearty thanks are to each other—to Karl for asking, to Alan for agreeing, and from one to the other for seeing the project through.

The keynote speaker at "Grid + Flow" was Timothy Morton, some of whose brilliant work we are pleased to include in this book. The link here seems apt, as it is Morton's "ecological thought" (to borrow the title of one of his books) that "everything is connected." Indeed, this is the great abiding truth of ecology, upon the recognition of which we believe our future depends. An initiative of this scope and duration is no different—truly it is an ecology of its own—entailing a great many connections and dependencies, which we are now glad to acknowledge, in approximate order of their connection to the undertaking.

James Steward championed *Nature's Nation* from the moment the idea was broached, offering advice, encouragement, and not least patience over its lengthy gestation, even as he supported its increasing scope and ambition. Bart Thurber provided similar moral as well as practical support and guidance as the project encountered headwinds of schedule and complexity. We are enormously grateful to them both.

In the fall of 2014, Alan came to Princeton to work with Karl toward the realization of the project, a visit enabled by Carol Rigolot of the University's Humanities Council, which through Kathleen Crown has continued its support. A colloquium at the end of the semester brought together faculty from across campus to productively consider *Nature's Nation*'s aims and trajectory, and included Bruno Carvalho, Bill Gleason, Stan Katz, Jenny Price, Sarah Rivett, Marni Sandweiss, Peter Singer, Bill Stowe (Wesleyan), and David Wilcove. While here, Alan taught with Karl the first of three eventual courses revolving around the project, and we thank the students in each for their interest and many astute insights. Indeed, students have abetted *Nature's Nation* directly in a variety of capacities, notably Jeff Richmond-Moll '10 and graduate students Miri Kim and Kimia Shahi. The work of another rising scholar, Laura Turner Igoe, enhanced the initiative immeasurably when, during a postdoctoral appointment in 2014–15 supported by the Dean for Research Innovation Fund, she explored "Creative Matter: Materials Science, Environmental History, and the Sustainability of Art" with advice and assistance from Norman Muller and George Scherer, the result of which is her substantial essay in this volume. Laura joins us in thanking Pablo Debenedetti and Karla Ewalt for making this groundbreaking work possible.

In 2016–17 Alan returned to Princeton as the Currie C. and Thomas A. Barron Visiting Professor in the Environment and the Humanities. Hosted by the Department of Art & Archaeology, his tenure here was enabled by the Princeton Environmental Institute, a key collaborator in multiple ways. It has been one of the great pleasures of this undertaking to engage with faculty and administration there, in particular Kathy Hackett as well as Francois Morel and Mike Celia, to each of whom we offer special thanks.

The exceptional number and diversity of lenders to the exhibition amply reflects the extensive scope of this initiative. Among the many artists, archives, collectors, foundations, galleries, and museums who made crucial loans—each identified later alongside pages listing the book's essayists, in appropriate recognition of their similarly constitutive roles—we would particularly like to thank for their assistance: Nancy Anderson, Bruce Barnes, Erik Bauer, Mark Bowden, Cynthia Brenwall, PJ Brownlee, Tim Burgard, Frank Burgel, Sarah Cash, Ken Cobb, John Coffey, Lori Cohen, Alicia Colen, Sean Corcoran, Teddy Cruz, Anna D'Ambrosio, Paul D'Ambrosio, Christie Davis, Stephanie Delamaire, Elizabeth Diller, Fay Dutler, Emily Feazel, Steve Ferguson, Eva Fognell, Walton Ford, Fonna Forman, Ilene Fort, Kathy Foster, Pam Franks, Laura Fry, Mark Gould, Helen Harrison, Dakin Hart, Margi Hofer, Doug Holland, Barbara Jones, Frauke Josenhans, Matt Kirsch, Frank Kolodny, Betsy Kornhauser, Karen Kramer, Jonathan Kuhn, Sarah Landry, Mark Letzer, Bonnie Campbell Lilienfeld, Maya Lin, Cannupa Hanska Luger, John Lukavic, Shelly and Tony Malkin, Anna Marley, Lissa McClure, Jessica McDonald, Conor McMahon, Virginia Mecklenburg, Harris Mehos, Alan Michelson, Richard Misrach, Mark Mitchell, Erin Monroe, Michael Mouron, Lewis Norton, Andrew Rose, Nancy Rosoff, Brandon Ruud, Amy Scott, Gregg Seibert, Scott Shields, Allison Slaby, Timothy Standring, Gabriel Swift, Eugenie Tsai, Eric White, Catherine Whitney, Bill Wierzbowski, and Sylvia Yount. Marshaling all of *Nature's Nation*'s extraordinary loans and bringing them safely to Princeton was the herculean task of Liz Aldred and especially Carol Rossi, accomplished with expert skill, organization, energy, and equanimity. We are grateful to Carol as well for ensuring the exhibition's indemnification by the Federal Council on the Arts and the Humanities, for which we thank the professionals at the National Endowment for the Arts, and Susan Menconi and Andrew Schoelkopf.

We are especially pleased that *Nature's Nation* will travel to such vibrant and esteemed institutions as the Peabody Essex Museum and Crystal Bridges Museum of American Art. In Salem, we thank Austen Barron Bailly,

Priscilla Danforth, Lynda Hartigan, Karen Kramer, and Dan Monroe, and in Bentonville, Mindy Besaw, Rod Bigelow, Margi Conrads, and Robin Groesbeck for their enthusiasm, assistance, and valued advice. Indeed, at an early meeting in Salem, the suggestion was persuasively made to enhance the representation of Indigenous art on the exhibition checklist. While we had initially been cautious about exhibiting material admittedly outside our realm of expertise—and considering as well that the project's primary focus was always on evolving Euro-American constructions of nature, for good or ill—the wisdom of aspiring to greater inclusivity rightly prevailed. In doing so we recognize the difficulty of transcending one's own positionality, yet we have tried to be conscious of it in our work, and to include the voices of others with perhaps different perspectives. Further, we recognize that history's elisions are not only of race but also of gender and class. As a result of such real historical imbalances, works by women artists appear mainly later in *Nature's Nation*, and folk and outsider art more infrequently still. Ultimately, we offer this project in good faith, and toward that end express thanks for conversations and guidance from those more expert in the arts of Indigenous peoples, including Rachel Allen, Karen Kramer, and Dan Monroe at the Peabody Essex, as well as Amy Chan, Donald Ellis, Chris Green, Jess Horton, India Rael Young, and, for discussions about their work and art, Miranda Belardé-Lewis, Raven Chacon, Cristóbal Martínez, J. R. Norwood, Jaune Quick-to-See Smith, and Kade L. Twist.

It has been an enriching privilege to collaborate with this book's thirteen essay contributors, who in addition to Miranda Belardé-Lewis and Jaune Quick-to-See Smith include Teddy Cruz, Rachael DeLue, Mark Dion, Fonna Forman, Laura Turner Igoe, Robin Kelsey, Anne McClintock, Tim Morton, Rob Nixon, Jeff Richmond-Moll, and Kimia Shahi. Our thanks go to each of them for their compelling, insightful work and good humor in bringing it to fruition. The expert editing, elegant design, and complex production of the volume constitutes its own very substantial contribution, all of which was managed with superlative intelligence, taste, and diligence—as well as exceptional patience—by Anna Brouwer. After valuable and appreciated peer review, Michelle Piranio, assisted by Kathleen McLean, provided dedicated and outstanding editing of the many texts, later ably proofread by Dianne Woo and indexed by Kathleen Friello. The greatly improved result was incorporated into a characteristically sensitive, stylish, and sophisticated design by Daphne Geismar, alongside more than three hundred images painstakingly gathered by Sarah Brown, Dan Cohen, and Jeff Richmond-Moll, Danny Frank and his colleagues at Meridian Printing brought the book into physical being with the consummate artistry for which they are justly renowned. None of this would have been possible without an unprecedented level of support from the Barr Ferree Foundation Fund for Publications, whose jurors Leonard Barkan, Brigid Doherty, Aly Kassam-Remtulla, and Andy Watsky we most sincerely thank.

The exhibition's smart materialization at Princeton results from the skill and devotion of Mike Jacobs, who worked tirelessly to optimally fashion viewers' experience of the show's many diverse objects, working at unusual scale to produce a thoroughly compelling design. In doing so he was assisted by Louise Barrett as well as Barb Barnett and Clay Vogel. Todd Baldwin and Chris Gorzelnik provided expert installation oversight, along with preparators Mark Harris, Pat Holden, Alan Lavery, Rory Mahon, and Justin Webb. As part of the exhibition's presentation, an innovative website, ''Making an Ecocritical Exhibition: Behind the Scenes of *Nature's Nation*,'' was prepared in order to assess and represent the project itself in environmental terms. We thank the members of Alan's 2017 class on the subject for early research—Effie Angus '18, Kira Keating '18, Mikaylah Ladue '20, Natalie Plonk '18, and Katie Pratt-Thompson '18—and Museum colleagues Cathryn Goodwin, Julie Dweck, and Dan Brennan, along with Janice Sung '17, Katie Pratt-Thompson, and graduate students Kimia Shahi and especially Lucy Partman for assistance in imagining and realizing the site, artfully designed by Sean Walsh. Enabling support was furnished by a grant from the High Meadows Foundation Sustainability Fund, administered by Princeton's Office of Sustainability through Shana Weber and Lisa Nicolaison.

Caroline Harris, Julie Dweck, and Veronica White offered much-appreciated advice on matters of interpretation informed by enterprising audience research, and facilitated the project's optimal engagement with faculty and students. Curatorial colleagues, especially Mitra Abbaspour, Calvin Brown, Kate Bussard, John Elderfield,

Laura Giles, Bryan Just, and Betsy Rosasco, volunteered valued expertise and assistance. Indeed, most Museum staff contributed in some way. In addition to those already mentioned, we thank in particular Emile Askey, Aric Davala, Julia Davila, Bart Devolder, Jeff Evans, Erin Firestone, Laura Hahn, Alexia Hughes, Stephanie Laudien, Matt Marnett, Annabelle Priestly, Landon Viney, and Curtis Scott, a particular *Nature's Nation* advocate.

The exhibition's presentation at Princeton is accompanied by an impressive array of programming, capably coordinated by Cara Bramson. We thank Ashley Dawson, Naomi Klein, Cristobal Martinez, Bill McKibben, Rob Nixon, Amilcare Porporato, Alexis Rockman, Kade L. Twist, David Wilcove, and India Rael Young for their participation, and the Princeton Environmental Institute for cosponsoring several of the events. A related symposium and eventual volume of essays—"Picture Ecology: Art and Ecocriticism in Planetary Perspective"—organized by Karl, will bring an international group of scholars together to consider ecocritical approaches to the visual culture of a wide range of places and periods. He thanks Alan, Maura Coughlin, Rachael DeLue, TJ Demos, Finis Dunaway, Stephen Eisenman, De-Nin Lee, Gregory Levine, Anne McClintock, James Nisbet, Andrew Patrizio, Sugata Ray, Fazal Sheikh, Greg Thomas, and Monica Dominguez Torres for their contributions.

Individuals beyond the Museum offered support of various kinds, and we acknowledge gratefully the assistance on many fronts of Elizabeth Allan, Michael Altman, Subhankar Banerjee, Eric Baumgartner, Tricia Loughlin Bloom, Heather Cammarata-Seale, Katherine Drake, Matthew Eckelman, Blair Effron, Linda Ferber, Mia Fineman, Theaster Gates, Alex Geisinger, Kate Kamp, Michael Koortbojian, Josh Lane, Ethan Lasser, Jim Leach, Susan Lehre, Bruce Lundberg, Jessie MacLeod, Jason McCoy, John McPhee, Ken Myers, Sarah Nunberg, Lauren Rich, Cheryl Robledo, Scott Schweigert, Larry Shar, Stephanie Simmons, Chris Slaby, Sarah Sutton, Mia Valley, Andrew Walker, Holly Welles, Rebecca West, Barbara White, and John Wilmerding.

As the extent of the foregoing may suggest, all of this was not free. *Nature's Nation* has been a singularly costly initiative, yet quite happily the Museum has been blessed by the equally singular generosity of its many supporters. In addition to the campus partners already recognized,

Shelly Belfer Malkin and Tony Malkin '86 contributed an enormously vitalizing and enabling gift, one matched with equal munificence by longtime friend Annette Merle-Smith. Terry Carbone at the Henry Luce Foundation facilitated substantial support from that source, which has done so much to advance the study of American art. The National Endowment for the Arts was especially generous, as seems particularly befitting the project at hand. And Ralph Izzo at PSEG encouraged support from that company's foundation. Back in Princeton's orbit, we thank Susie and John Diekman '65, Gail and Peter Ochs '65, Anne Sherrerd★'87 via the fund established in memory of her mother, Kathleen C. Sherrerd, and Stacey Roth Goergen '90 and Robert Goergen for deeply appreciated assistance. Nancy Stout and Courtney Lacy at the Museum facilitated this prodigious fundraising, and Karen Ohland, Mike Brew, and Ellen Quinn managed the effective dispersal of its results.

As noted at the outset of these acknowledgments, *Nature's Nation* has engendered a wealth of connections, rewarding in many ways. We close by recognizing our greatest and dearest ties, to our respective families and spouses, Nicola and Karen. If this project has in some way had the aim of fostering a better world for its magnificently diverse inhabitants, it is with them in mind especially that we make the effort.

Karl Kusserow and Alan C. Braddock

Alan C. Braddock and Karl Kusserow

Introduction

Nature's Nation: American Art and Environment rethinks the history of American art in light of ecology and environmental history. Exploring more than three centuries of creative work in North America, this book adopts a broad historical perspective to examine how artists have reflected and shaped environmental understanding while contributing to the emergence of modern ecological consciousness. Despite the US exceptionalism suggested in the title *Nature's Nation*—taken from an important early study of American literature by the intellectual historian Perry Miller—we invoke the phrase ironically to argue that ecology and environmental history underscore the intrinsic transnationalism of American art, even as the term suggests the historic linkage in the country's discourse and self-conception between ideas about nature and nation. Miller's study concerned earlier Americans' association of nature with notions of promise and virtue, and thus the fate of the nation with the state of its nature. That both "nature" and "nation" derive from the Latin *nasci*, to be born, helps explain why Euro-American settler colonialism and US cultural identity were long entwined with, and construed in terms of, the "natural." Ecological conditions and artistic ideas, however, cross national borders, and those of the United States are no exception. Approaching art history with this in mind is our way of responding to the Anthropocene, Earth's new geological epoch, which scientists have identified by its unprecedented human environmental impact on a global scale since the Industrial Revolution. The fingerprints of our species—and especially people in the United States—are visible all over the world, a fact that increasingly raises questions about the meaning of familiar concepts such as nature and nation. The pervasiveness of human impact makes the planet look more and more like a built environment or an artwork of sorts.[1]

Some scholars contest the term "Anthropocene" for its apparent universalism and anthropocentrism, but we prefer it to various alternatives that have lately been suggested ("Capitalocene," "Plantationocene," "Chthulucene"). Instead, we agree with other scholars who critically embrace the Anthropocene concept for its expansive implications. For example, the historian Dipesh Chakrabarty acknowledges the dilemma of reconciling its universalism with a need to retain "what is of obvious value in our postcolonial suspicion of the universal," but he also observes that "the crisis of climate change calls for thinking simultaneously on both registers." Following Chakrabarty, the writer Amitav Ghosh asserts that "the Anthropocene presents a challenge not only to the arts and humanities, but also to our commonsense understandings and beyond that to contemporary culture in general." For these scholars and for us, the Anthropocene entails something intractably "general" and universal, whether we like it or not, without necessarily eliding historical complexity. In our view, the concept productively refracts and reframes the history of art. Indeed, what art historians have called "modernity" becomes subsumed in this more far-reaching periodization, wherein diverse human and nonhuman environmental histories demand to be understood in planetary terms as inextricable from one another. By focusing here on North America, our book shines a critical light on the art and environmental history of a region, including a heterogeneous nation that—because of the particular circumstances of its explosive growth—has done more to create the Anthropocene than any other, notably by leading the world in per capita greenhouse gas

emissions contributing to global warming over much of the past two centuries. This fact starkly reframes older, triumphant beliefs in American exceptionalism, but it also inspires a growing body of extraordinarily creative work dedicated to positive change, ecological awareness, and the power of art to imagine a more just and sustainable future. The present study celebrates such art and traces its history, while at the same time looking anew at creative material not ostensibly about such things, uncovering in it important environmental and ecological beliefs and attitudes.[2]

Even as *Nature's Nation* examines the ecological trans-nationalism of American art, the book also explores consider-able diversity and dynamism within national borders. Such a project inevitably discloses the intertwined politics of art and ecology by underscoring the ethical importance of envi-ronmental justice as a key factor in creative imagination and historical interpretation. Since ecological conditions and concerns are not experienced or perceived identically by all stakeholders, art history provides a valuable lens for under-standing a range of environmental perspectives.

Engaging ecology and environmental history can inform art historical interpretation of works past and present. *Nature's Nation* contends that art has always embodied ecological con-ditions, both materially and conceptually, whether its makers recognized this or not, for their works cannot help but bear traces of some connection with the earth, its ecosystems, and its many inhabitants human and nonhuman. Featuring exam-ples by diverse artists in a range of media, this book provides a new general interpretation of American art history informed by environmental history, scientific materials analysis, and ecocriticism. Like the exhibition that accompanies it, *Nature's Nation* proposes an ecocritical history of American art.[3]

Ecology and Ecocriticism

What is ecocriticism? Before answering this question, we should briefly consider the meaning of "ecology," a word that first appeared in 1866 as *Oecologie* in the book *Generelle Morphologie der Organismen* (*General Morphology of Organisms*) by the Prussian naturalist Ernst Haeckel (1834–1919), a fol-lower of Charles Darwin (1809–1882) and a promoter of his theory of evolution. Here is the relevant passage in Haeckel's book, translated from the original German:

By ecology we mean the body of knowledge concerning the economy of nature—the investigation of the total rela-tions of the animal to both its inorganic and its organic environment; including above all its friendly and inimical relations with those animals and plants with which it comes directly or indirectly into contact—in a word, ecology is the study of all those complex interrelations referred to by Darwin as the conditions of the struggle for existence.[4]

Reading this foundational statement, which still accurately describes the concept in its broadest sense, we notice the proximity of "ecology" and "economy" as cognates sharing the same Greek etymological root, *oikos*, meaning home, household, or family. Also important here is the idea of heterogeneous vital entities interconnected in an environ-ment characterized by conflict or symbiosis (or both) across species and matter.[5]

The timing and historical context of Haeckel's coinage are significant in understanding its meaning. Ecology emerged in alliance with Darwin's theory of evolution through natural selection, which posed serious challenges

to establish European classical ideas about divine order, stasis, and destiny in nature. Earlier scientists such as Carolus Linnaeus (Carl von Linné) (1707–1778) and Alexander von Humboldt (1769–1859) had done much to reimagine Earth's biotic history in broadly systematic and holistic terms, but they did not invent ecology. Darwin, Haeckel, and their followers in evolutionary biology introduced into Western thought a modern understanding of unpredictable mutation and discontinuity, which flew in the face of fundamental ancient beliefs still held by Linnaeus and Humboldt concerning the inevitability of progress, plenitude, harmony, stasis, and balance. For ecologists—as for Darwin—nothing is ordained or guaranteed except change. As a modern concept, ecology emerged in Europe amid unprecedented industrial growth, environmental transformation, and imperial expansion. This does not mean it necessarily embodies industrialism or imperialism, but these modern conditions facilitated and demanded its invention in a world of increasingly ''complex interrelations'' and anthropogenic change.[6] Although ''ecology'' did not enter everyday language in the English-speaking world until the twentieth century, its conceptual foundations have a long prehistory on both sides of the Atlantic Ocean. For example, as we will see in the next section, the ecological principle of interconnection and linkage has distant roots in the ancient metaphor of the Great Chain of Being. But whereas the Great Chain of Being presupposed an unchanging hierarchy in nature— usually with a Eurocentric, anthropocentric bias—modern ecology has vigorously challenged such parochialism. After all, Indigenous peoples, including those in North America, have long understood the complexity of human relationships to the environment from their own cultural frameworks. What makes ecology modern and effective is a respectful combination of global and local knowledge, both historical and recent, with sensitive awareness about the ethical insights and epistemologies of diverse communities. Accordingly, *Nature's Nation* pays attention to the environmental implications of Native American and other non-Eurocentric creative works while also tracing the emergence and artistic construction of ecology as a international idea, one that has increasingly questioned classical beliefs associated with Europe's colonial expansion into the ''New World'' and elsewhere. As one of the most expansive countries the planet has ever known, the United States provides a particularly illuminating context for understanding the entanglement

of art and environmental history during the centuries before and since the advent of ecology precisely because of its global, transnational impact and complex composition as a nation.[7]

Ecocriticism as a mode of cultural inquiry developed from literary studies and environmental history during the early 1990s. Now it encompasses the study of ecological significance in artistic practices of all kinds, including music, film, architecture, visual art, and more. Emphasizing interconnectedness and environmental justice in interpretation, ecocriticism explores the imbrication of all beings, artifacts, ideas, and matter—including humans and their creative works—within a dynamic mesh of agents, materials, and histories. In art history, ecocriticism considers artifacts of every category as embodying environmental conditions, beliefs, attitudes, and assumptions of one sort or another. There is no single formula for ecocritical interpretation, since the specific approach to understanding a given object will depend on its particular form and context. As a general principle, though, ecocritical inquiry looks beyond conventional humanistic frameworks by exploring neglected but pertinent evidence from environmental history and ecological thought. Instead of focusing narrowly on landscape imagery, which has tended to idealize terrestrial nature as pristinely nonhuman and nonurban, ecocritical art history considers *any* creative genre and environmental context to be potentially worthy of study, regardless of medium, style, period, or location. Such inquiry also investigates the ecological implications of art materials by asking questions like these: What are the materials and where did they come from? Under what conditions were they extracted and processed, and by whom? Are they toxic or benign? Galvanized by mounting concern about contemporary environmental problems, ecocriticism nevertheless does not limit its purview to the present. It also examines the environmental significance of past works—even those created well before the term ''ecology'' appeared—by attending to historically specific evidence.[8] This book focuses on American art viewed broadly over three centuries, but ecocritics have also examined African and Native American literature, Chinese and Latin American film, Shakespeare, urban history, medieval European landscape imagery, and many other topics. Consistent with the ecological principle of interconnectedness, ecocritical interpretation regards human beings and their works as part of a larger biotic community to which we have an ethical

FIGURE 1: Thomas Moran (American, born England, 1837–1926), *The Grand Canyon of the Yellowstone*, 1872. Oil on canvas mounted on aluminum, 213 × 266.3 cm. Smithsonian American Art Museum, Washington, DC. Lent by the Department of the Interior Museum (L.1968.84.1)

obligation to live as fairly and sustainably as possible. This is the case whether or not artists, writers, or other figures of study identify as environmentalists. In other words, ecocriticism does not study only explicitly "green" artists and works; instead, it insists that all have some sort of ecological meaning, for better or worse. Ecocritical art history builds on scholarship of the past few decades that has broadened the discipline in important ways by acknowledging greater human diversity. In light of the Anthropocene, the time has come to further enrich and diversify the field by making it less strictly humanistic and more ecological. *Nature's Nation* offers one contribution to what we hope will be a larger ecocritical intervention in art history.[9]

Doing Ecocritical Art History

As a way of demonstrating ecocritical art history in practice while introducing some of the key themes addressed in this book, we offer a few preliminary observations about selected works spanning various media, genres, and historical contexts. In each case, ecocritical considerations enlarge the parameters of interpretation beyond those typically used in art history.

An appropriate place to start is with a monumental oil painting of 1872 by Thomas Moran (1837–1926) that marked a watershed in American wilderness conservation. *The Grand Canyon of the Yellowstone* (fig. 1) is the most ambitious of

many works that Moran and other artists produced to cele-brate the dedication of Yellowstone as the first US national park, through an act of Congress signed into law by President Ulysses S. Grant on March 1, 1872. The "Act of Dedication" stipulated:

That the tract of land in the Territories of Montana and Wyoming . . . is hereby reserved and withdrawn from settle-ment, occupancy, or sale under the laws of the United States, and dedicated and set apart as a public park or pleasuring-ground for the benefit and enjoyment of the people; and all persons who shall locate or settle upon or occupy the same, or any part thereof, except as hereinafter provided, shall be considered trespassers and removed therefrom.10

Now occupying almost 3,500 square miles in northwestern Wyoming and parts of Montana and Idaho, Yellowstone National Park came into being after an important 1871 federal survey of the region led by the geologist Ferdinand Hayden—one of several government-sponsored expeditions to map western areas, locate mineral deposits, and assess

future railroad routes following the American Civil War of 1861–65. Yellowstone's creation as a park resulted from military conquest, industry, commerce, and government-sponsored science.11

Art also played a role among those expansive impulses. At the recommendation of Jay Cooke, a financier and railroad tycoon anticipating future profits from tourism at Yellowstone, Moran had been invited to accompany the Hayden survey, along with the photographer William Henry Jackson (1843–1942) and the watercolorist Henry Wood Elliott (1846–1930). As an unofficial survey artist, Moran helped make a visual record of the geysers, waterways, can-yons, and other remarkable geological features studied by the expedition scientists, but he had more creative freedom than his peers. Back in Washington after the survey concluded, Hayden used sketches by Moran and Elliott together with Jackson's photographs to compile a government report and lobby Congress in favor of establishing a park. Some of Moran's sketches also appeared in articles promoting Yellowstone as a "Wonderland" in Scribner's Monthly, a nation-ally circulated magazine for which he worked as chief

FIGURE 2: L. Prang & Co. (after Thomas Moran), *The Grand Cañon, Yellowstone*, 1875. Chromolithograph, 24.8 × 35.6 cm. Buffalo Bill Center of the West, Cody, Wyoming. Gift of Clara S. Peck (18.71.8)

illustrator. At his Newark, New Jersey, studio after returning from the West, Moran embarked on *The Grand Canyon of the Yellowstone* with the goal of producing a dramatic artistic summa of the site based on his sketches, recollections, and imagination. Moran did not complete his masterpiece until after the official establishment of the park in 1872, at which time Congress purchased the painting for the enormous sum of $10,000. *The Grand Canyon of the Yellowstone* therefore functioned retrospectively, celebrating and commemorating the park's creation as a fait accompli.[12]

More important, the picture helped institutionalize an aesthetic way of viewing Yellowstone—and national parks in general—that endures today. Moran's painting rendered the park as an exalted place of sublime natural beauty, at once alluring and seemingly beyond reach or comprehension, like a divine work of art created by the hand of God. Such a view drew inspiration from European aesthetic conventions of Romanticism, which infused nature with spiritual and nationalistic meaning. Ideas about the sublime had gained currency in eighteenth-century European philosophy and art theory, notably in the writings of Edmund Burke and Uvedale Price, cultivating a sense of awe about impressive nonhuman phenomena—storms, mountains, and canyons—as proof of God's power and providence. Possessing and pic-turing such places became a matter of national pride and religious belief in the United States during the nineteenth century, when American politicians, settlers, industrialists, tourists, conservationists, and artists aligned their interests to "set apart" Yellowstone as a park.[13]

An English immigrant, Moran knew Romantic artistic conventions well and adapted them to tout the magnif-icence of Yellowstone as an iconic site for his adopted nation. Accordingly, his painting focuses on the most dra-matic geological feature of the region: the Lower Falls of the Yellowstone River, where water cascades three hundred feet downward into the Grand Canyon of the Yellowstone, a smaller chasm than the Grand Canyon of the Colorado River in Arizona to the south but still spectacular. Surround-ing this great cataract—twice the height of Niagara Falls—we see stunning canyon walls aflame with bright yellow, rich ochre, and deep russet colors, recalling earlier works by the British Romantic painter Joseph Mallord William Turner (1775–1851) and vividly amplifying the look of iron oxida-tion and thermal effects associated with volcanic activity and water erosion over millennia. In another Turneresque

gesture, water vapor rises above the waterfall and the turquoise-blue Yellowstone River below, echoing spumes from geysers visible in the distant background. From an ecocritical perspective, Moran's cosmopolitan, transnational artistic styling here reveals how this sublime vision of American wilderness participated in a larger process of European cultural, economic, and environmental colonization. This process accelerated rapidly with help from the latest industrial techniques of mechanical reproduction. In the US Centennial year of 1876, a selection of Moran's Yellowstone pictures were published as color illustrations in a book by Hayden titled *The Yellowstone National Park, and the Mountain Regions of Portions of Idaho, Nevada, Colorado, and Utah*, dissem-inated in a deluxe edition by the Boston chromolithographic firm of Louis Prang and Company (fig. 2)—one of many commercial ventures featuring the artist's western landscapes.[14]

In *The Grand Canyon of the Yellowstone*, we see two tiny human figures standing before the sublime spectacle on an overlook in the shadowy foreground (fig. 3). Their small scale with respect to this grand setting emphasizes the Romantic sublimity of the scene, but they also disclose an important political dimension at the nexus of art, ecology, and nationalism concerning Yellowstone. Despite their size, these figures are in many ways the key to the image and its ideological point. Moran accordingly positions them promi-nently, silhouetted against the much lighter background and at the intersection of compositional vectors formed verti-cally by the waterfall and its vaporous plume and diagonally by the stark contrasts between light and dark that converge

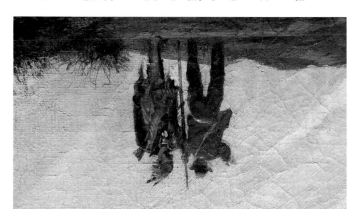

FIGURE 3: Thomas Moran, Detail of *The Grand Canyon of the Yellowstone*, 1872.

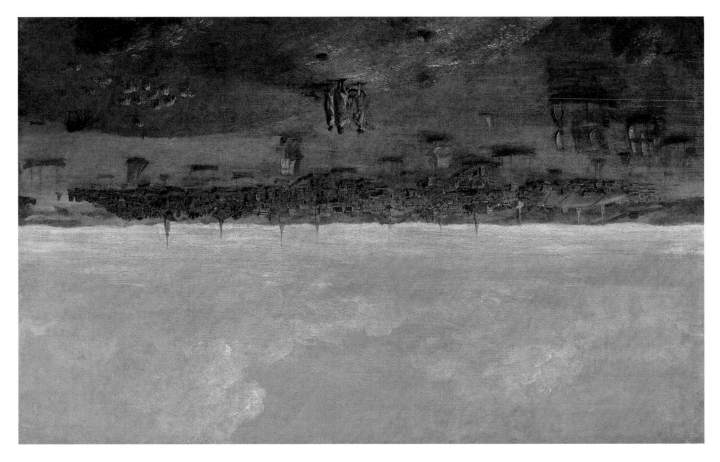

FIGURE 4: John Smibert (American, born Scotland, 1688–1751), *View of Boston*, 1738. Oil on canvas, 76.2 × 127 cm. Courtesy Childs Gallery, Boston

on the pair from each side. At left we see a man wearing a hat, a saddlebag, and other attire of a Euro-American explorer. Letters written by Moran at the time indicate that this figure represents Hayden, leader of the 1871 Yellowstone expedition. Here the explorer appears looking out at the can-yon, gesturing as if to allude to the beauty and/or geological significance of the scene. Yet he does so not with pointed fin-ger but rather with outstretched hand—more laying claim to the landscape than indicating any particularity within it. At his right we see an unidentified Native American man wear-ing a feathered headdress, a bone necklace, a bandolier bag, and leather leggings. He holds a spear and stands with his back to the very scene admired by his white counterpart. In a brilliantly telling detail, Moran renders the two figures pivot-ing around the central axis of the spear, which reads each seems to

hold, implying their clockwise movement around it, with the Euro-American moving toward and into the scene, and the Native American away from it. This emblematic racial juxta-position of figures conveys an important didactic message concerning the political ecology of difference at Yellowstone and in early American wilderness conservation generally. Put simply, Moran's vignette asserts Euro-American possession, knowledge, and aesthetic appreciation of this national park landscape in contrast to Native American dispossession and ignorance. A personification of nature as uncultivated wilder-ness, the Indigenous figure forms part of the scenery yet is rendered as a stranger in his own land. Only a few years before, in an official government report describing another magnificent park setting, at Yosemite in California, the emi-nent American landscape architect Frederick Law Olmsted

had observed, "The power of scenery to affect men is, in a large way, proportionate to the degree of their civilization and to the degree in which their taste has been cultivated"—an aesthetic capacity he and many other white people considered inaccessible to Native American "savages." The latter denigrating term, from the French *sauvage* and the Latin *silvaticus*, was rooted in centuries-old European conceptions of forest wildness and animality.[15]

The expressive pairing of Euro- and Native Americans in fact has a long history in American landscape painting, beginning with its earliest surviving example. In 1738 John Smibert (1688–1751) completed a large *View of Boston* (fig. 4), showing the burgeoning city from Noddle's Island (later swallowed up by Logan International Airport). The painting depicts a formally attired Euro-American man standing with a Native American man and woman, and in front of a seated female colonist, all together comprising two couples. As in Moran's painting, the Euro-American man gestures with outstretched arm, although in this case his back is to the scene behind him—perhaps to express that he is of the city, whereas the Native Americans regard it from their remove across the water. There is an irony in Smibert's choice of island vantage point, since following King Philip's War (1675–78) colonists had forced large numbers of local Native Americans, mostly Nipmucs, onto ships in the Charles River and transported them for incarceration on small islands in Boston Harbor adjacent to Noddle's Island, where half of them died of starvation and exposure. To this day, Native Americans return annually to nearby Deer Island to commemorate the suffering of their ancestors. Smibert's grouping betrays none of this; indeed, unlike the opposing pair in Moran's view, the Native Americans in *View of Boston* are seen as if in some sort of partnership with the figure of the Euro-American protagonist—or, perhaps, as if he were pointing out the land they had once inhabited.[16]

A century and a half later, in 1876, as the United States celebrated its centennial, and a few years after Yellowstone was granted official "protection" from its original occupants, Moran's lithograph showing the same vista as his huge painting of 1872 bears no trace of Indigenous presence (see fig. 2). Native Americans have already exited the stage, and in the place of the single representative from the earlier painting, three Euro-Americans occupy the rocky promontory above the canyon. One peers over the edge, actively exploring now, rather than tending to the transfer. Already Moran had made the transition to portraying Yellowstone exclusively as sublime natural spectacle, in the process conveniently erasing its previous inhabitants.

Moran's *Grand Canyon of the Yellowstone* provided a pictorial analogy of Olmsted's bigoted assertion by envisioning a legal and cultural changing of the guard, radically simplifying a violent process of pacification (a richly ironic term) and relocation occurring across the West during the 1870s. At Yellowstone, the US military fought and forcibly removed the Nez Perce, Bannock, Mountain Shoshone, and other tribes who had lived in or used the area for millennia. Among their many historical activities at Yellowstone, Indigenous people quarried obsidian with which they meticulously fashioned various objects, including spearheads for hunting and long-distance trade, ancient examples of which have been found as far away as Ohio. Yellowstone remained contested for years after the establishment of the national park, a fact embodied in the federal government's construction of a heavily fortified army headquarters there at Mammoth Hot Springs in 1879. The structure occupied a hill providing the "best defensive point against Indians," according to an early report by the military superintendent of the park, where civilian oversight did not begin until 1886.[17]

Although the most violent battles at Yellowstone would occur in the late 1870s and early 1880s, they were part of an ongoing series of conflicts between American soldiers and Native peoples in the West going back decades. Some of the same US military leaders who had used scorched-earth tactics against the Confederacy to ensure Union victory in the Civil War—including Generals William Tecumseh Sherman, Nelson A. Miles, and Philip Sheridan—played key roles in this later conflict with Native Americans. Well before the US military conquest of Yellowstone, though, Indigenous communities there and elsewhere in the West were already reeling from epidemics of European smallpox and the rapid decimation of bison herds at the hands of market hunters during the nineteenth century. Yellowstone became one of the last refuges for Nez Perce, Bannock, and Shoshone peoples as well as shattered buffalo herds that historically had inhabited the Plains. US soldiers and conservationists fought to protect Yellowstone as a tourist destination and buffalo sanctuary, but they evicted Native Americans. By 1886 a tourist guidebook titled *Through the Yellowstone on Horseback* by George Wingate, a Civil War veteran and founder of the National Rifle Association, declared, "The Indian difficulty

has been cured, the Indians have been forced back on their distant reservations, and the traveler in the park will see or hear no more of them than if he was in the Adirondacks or White Mountains." Artistically celebrating this project of dispossession and pacification at Yellowstone, Moran actively imagined the founding act of federal wilderness conservation as a peaceful transition of power and property. His monumental painting sanctified the park as a corollary of Manifest Destiny.[18]

If the interaction between Moran's small figures asserts the visual logic of American imperialism by endorsing the expropriation of territory, from other perspectives, the land was never humans' to give away. In various ways, many Indigenous peoples have understood themselves as belonging to, rather than owning, their environmental surroundings. Euro-American surveying, mapping, and possessing land as real estate—practices on which Moran's picture was predicated—were alien to Plains communities. The historical relationship of Native Americans to the physical world is better expressed in the more fluid and dynamic concept of "bounded space." During the late twentieth century, the Jicarilla Apache/Hispanic philosopher Viola Faye Cordova (1937–2002) developed this concept to describe an area of habitation determined by tradition, agreement, and intimate knowledge of environmental features such as topography and directionality, where reciprocal obligations of stewardship and spirituality prevail.[19]

Indigenous art has played an important role in constructing and modeling such environmental knowledge. The Great Plains ecosystem near Yellowstone receives substantial attention later in this book, so here let us consider a creative example from another region. An extraordinary Chilkat robe woven by a Tlingit artist on the Pacific Northwest Coast before 1832, the oldest known surviving work of its kind, expresses the aforementioned sense of community and reciprocity in both substance and design (see fig. 134). Created entirely out of local natural materials, its characteristic form-lines (continuous, flowing outlines) depict at once an individual and a pod of killer whales—the one literally constituting the other—whose spiritual energy the wearer engaged as a clan descendent, thus indicating a close connection between individual and group as well as between human and non-human life. The garment was created for a potlatch, a custom involving prodigious gift giving as a means of maintaining balance between the two moieties, or halves, of Tlingit society. Whereas Moran's painting memorializes a conspicuous act of

environmental conservation as a feat of national acquisition ostensibly negotiated by individual representatives of opposing human groups, the Chilkat robe functioned quite differently. By embodying animist concepts about the interrelationship of humans and other beings in a shared environment, it asserts deeply held principles of behavior and belief rooted in moral covenants with the nonhuman world.[20]

For Anglo-Americans, *The Grand Canyon of the Yellowstone* helped institutionalize a certain way of viewing the park as a national wilderness in aesthetic terms of sublimity borrowed from Romanticism. This cultural perspective has had significant impact in framing American environmental thought and perception. Moran's basic desire to celebrate and protect environmental beauty seems admirable, but when sites/sights such as Yellowstone National Park are viewed as epitomizing nature in its truest sense, other places begin to look second-rate, inauthentic, or even ugly. As the historian William Cronon has argued, this culturally circumscribed view is also potentially destructive because it encourages neglect of other, less dramatic environments, including those of great ecological importance such as swamps, grasslands, oceans, tundra, and atmospheres. Nature cannot and should not be limited to the relatively narrow range of places depicted in Romantic landscape painting or institutionalized in national parks. In terms of scope and ethical responsibility, ecology has no geographic or spatial limits.[21]

Privileging spectacular nonurban locales such as Yellowstone as representing a mythic, essential nature also distracts attention from cities and other settled environments, effectively stigmatizing them as "unnatural" because they are densely populated and visibly transformed by human activity. Ecologists now recognize that cities are in many ways the most efficient, environmentally sound places for people to inhabit, despite daunting problems facing urban communities. Furthermore, Romantic idealism often overlooks or downplays the history of human habitation at Yellowstone and other supposedly pristine sites, where Native American people had for many years participated as active ecosystem agents by engaging in hunting, fishing, foraging, farming, harvesting timber, and controlled burning of forests. At the same time, another pitfall of Romanticism is its tendency to idealize and reify the ecological wisdom of Native American peoples of diverse communities, whose histories of environmental stewardship have been anything but monolithic.[22]

Perhaps the most insidious aspect of Romantic thinking is the way in which it has fostered an unspoken norm and unacknowledged assumption that "wilderness" naturally belongs to, or is best understood by, educated white people. "Civilization"—a distinguishing trait of Anglo-Americans according to Olmsted, Moran, and many of their contemporaries—ostensibly enabled them to admire places like Yellowstone as aesthetically beautiful therapeutic retreats from urban life. With its stark binary logic of Euro-American land acquisition versus Native dispossession, Moran's *Grand Canyon of the Yellowstone* symbolically institutionalized an association between national parks and whiteness, effectively leaving no room for people of other groups. Many early visual representations of the parks, whether in art or promotional imagery, tended to reinforce this unspoken racial norm, a fact that has fostered a sense of exclusivity and environmental discrimination over the years. Only recently, in fact, has the National Park Service taken proactive steps to diversify the appeal of the parks by reaching out to African Americans, Asian Americans, and other groups. Of course, the history of Native American dispossession complicates such initiatives, particularly when Indigenous peoples assert claims to park lands as sacred places.[23]

Such considerations underscore the importance and interest of a series of Yellowstone paintings executed by the African American artist Grafton Tyler Brown (1841–1918) during the 1880s and 1890s, including *View of the Lower Falls, Grand Canyon of the Yellowstone* (fig. 5). Born in Harrisburg, Pennsylvania, the son of a freedman and abolitionist, Brown learned lithography as a printmaker's apprentice in Philadelphia at the age of fourteen before moving to San Francisco sometime in the 1860s. There, in the midst of gold fever and the rise of early conservationism in the American West, he worked as a lithographer for a printing company while taking up painting. Setting up in Portland, Oregon, during the late 1880s and early 1890s, he painted landscapes based on his travels to Yosemite and Yellowstone National Park. Brown's *View of the Lower Falls, Grand Canyon of the Yellowstone* presents an unusual vertical perspective on the scene made famous by Moran, amplifying the height of the falls and producing a more intimate—rather than panoramic—view. Perhaps reflecting the artist's knowledge as a sometime surveyor and a lithographer familiar with working on stone, Brown's painting conveys an awareness of the variegated textures of the Yellowstone

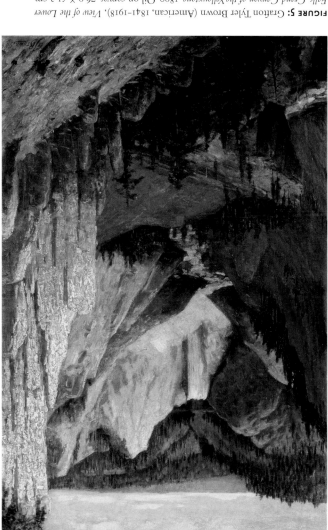

FIGURE 5: Grafton Tyler Brown (American, 1841–1918), *View of the Lower Falls, Grand Canyon of the Yellowstone,* 1890. Oil on canvas, 76.9 × 51.2 cm. Smithsonian American Art Museum, Washington, DC. Museum purchase through the Luisita L. and Franz H. Denghausen Endowment and the Smithsonian Institution Collections Acquisition Program (1994.56)

cliff faces, which appear brightly illuminated at right by the setting sun.[24]

While Brown depicted the site with a somewhat different stylistic approach from that of Moran, both artists operated within a Romantic framework fundamentally shaped by the wilderness ideal. Through his presence at Yellowstone and artistic representation of the park, Brown subtly but powerfully challenged racist stereotypes about who could attain and express "civilization" through art. At the same time, his and Moran's shared commitment to the aesthetics of untouched wilderness fostered an elusive desire for a pristine environment devoid of human presence, as if people were somehow fundamentally external to and "set apart" from the natural world. As noted by the archaeologist William Denevan, this "pristine myth" about wilderness elides the historical presence of Indigenous peoples in the Americas, not just in places like Yellowstone. Ecocritical art history can acknowledge the remarkable achievement of Brown as an early assertion of environmental justice while also forcefully challenging Romantic idealism and the pristine myth. For, if the Anthropocene has taught us anything, it is that human beings are a part of nature—not apart from it—no matter how much we might imagine otherwise. Ecology attends to human diversity and trans-species vitality in spectacular and unspectacular places alike. Ecocriticism therefore demands consideration of the ways in which art represents, overlooks, idealizes, or distorts the planetary mesh and history of life in every place and scale.[25]

With this historical sense of environmental complexity in mind, ecocritical interpretation of Moran's and Brown's Yellowstone pictures must also interrogate more than human events, politics, and existence. How do such works envision nonhuman phenomena? By highlighting the canyon walls and waterfall, they focus our attention on aspects of geology, mineralogy, and hydrology that preoccupied Hayden and other scientists, but not only them. Long ago the bright yellow rock prompted the Hidatsa to call the area *Mi tsi a-da-zi*, or Rock Yellow River (translated by early French trappers as *Roche Jaune*), resulting from volcanic activity, water erosion, and mineral oxidation going back more than six hundred thousand years. Basically, what we see at Yellowstone's Grand Canyon—and dramatized in art—is hardened lava, or rhyolite, containing iron and other metallic ores that have been rusting for millennia.[26]

In contrast to the incremental, deep-time dynamism of those geological processes, Moran's *The Grand Canyon of the Yellowstone* also reveals signs of shorter-term vitality in the form of nonhuman animals: a large bird, probably a bald eagle (*Haliaeetus leucocephalus*), the US national emblem, soaring high over the canyon at center right; a black bear (*Ursus americanus*) lurking in the trees at far left; a dead white-tailed or mule deer (*Odocoileus virginianus* or *Odocoileus hemionus*) lying in the foreground at left, apparently shot by one of the expedition hunters for food; and, in the vicinity of the deer, three domesticated horses (*Equus caballus*) along with two men presumably part of Hayden's expedition. This symbolic selection and composition of animals known to inhabit Yellowstone—with *Homo sapiens* at the focal center—embodies Moran's humanist perspective concerning natural hierarchy, exemplifying the lingering influence of ancient ideas about a Great Chain of Being emanating from God and reflected in a descending order of earthly life forms.[27]

Moran's picture, like Brown's, also acknowledges and orchestrates characteristic forms of botanical life in this region of the park. For example, framing Moran's picture at left and right, and scattered throughout and around the rim of the canyon, we see a number of trees, including many lodgepole pines (*Pinus contorta*), the most common tree of the Yellowstone region. These trees also populate the foreground and background of Brown's *View of the Lower Falls*. Unlike Moran's expansive horizontal composition, however, Brown's smaller close-up view seems more realistic and direct. Comparing these paintings ecocritically, then, we recognize that both painters represented certain environmental truths about this "wilderness," but Moran approached the scene with artistic grandiosity recalling the Romanticism of the Hudson River School of American landscape painting at its most nationalistic moments (see figs. 58, 93, 94).[28]

In *The Grand Canyon of the Yellowstone*, then, we detect the convergence of aesthetic conventions with real historical impulses of Manifest Destiny and commercial development, insofar as art served as an invitation to view, visit, and possess newly acquired US territory. In the case of Yellowstone National Park, the possession belonged to "the people," US citizens who obeyed the law by agreeing not to settle, occupy, or trespass on park land, except as tourists. Since 1872 the regulation of this legal arrangement by the US military and later by the National Park Service has been challenged repeatedly by poachers, squatters, and other designated undesirables. In offering a spectacular enticement

to enter the park and possess it visually, Moran's monumental illusion established the dominant aesthetic terms for tourist consumption of Yellowstone's resources consistent with federal regulations. His many commercial reproductions and variants of the painting attempted to corner the market for such imagery while also cultivating desire for souvenirs and other material forms of ownership. Later versions of *The Grand Canyon of the Yellowstone*, including those painted by Moran shortly after his second and last visit to the park in 1892, eliminated all references to human and nonhuman animals (fig. 6). Coinciding with an exhibition of Moran's work at the 1893 World's Columbian Exposition in Chicago, the artist doubled down on his commitment to Romantic sublimity, a stylistic tradition then largely eclipsed in the art world by Impressionism but still viable as a vehicle for purveying the pristine myth in popular culture. There was

in any case need by then to portray the Euro-American heroes of exploration, imperialism, and settler colonialism. The frontier was declared closed in 1890, the year Brown completed his painting, and in Chicago in 1893, while Moran's big picture hung at the Exposition, Frederick Jackson Turner presented his famous "Frontier Thesis" at a meeting of the American Historical Association held in conjunction with the fair. Arguing that "the existence of an area of free land, its continuous recession, and the advance of American settlement westward explain American development," Turner situated the very exceptionalism Americans imagined in the experience of untrammeled nature. Moreover, he worried they might not retain "that coarseness and strength combined with acuteness and inquisitiveness ... that dominant individualism" in the face of its demise. All the more reason, then, for Moran to depict it empty.[29]

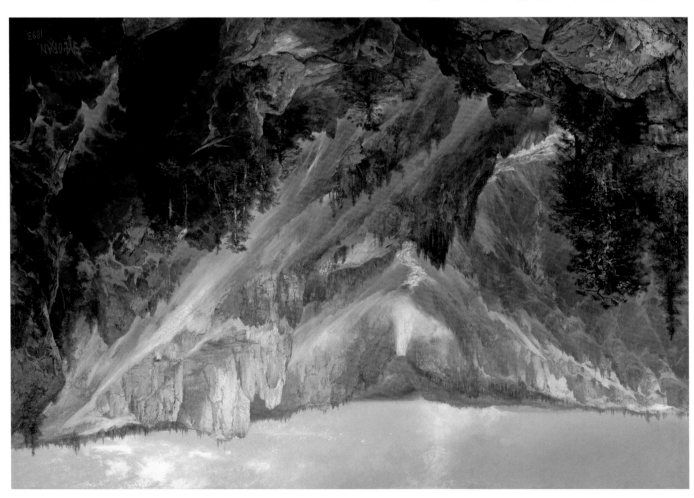

FIGURE 6: Thomas Moran, *Lower Falls, Yellowstone Park*, 1893. Oil on canvas, 100.6 × 150.5 cm. Gilcrease Museum, Tulsa, Oklahoma. Gift of the Thomas Gilcrease Foundation (0126.2344)

Except he didn't always. The same sketching trip that enabled his solitary vision of one Yellowstone canyon also yielded another, almost equally spectacular image, although in this case the imprint of development is featured and celebrated, not elided. In *The Golden Gate, Yellowstone National Park* (fig. 7), Moran shows the site in the northwestern section of the park where, beginning in 1883, a long wooden trestle was constructed along the canyon's western wall to accommodate tourist traffic. Built by the US Army Corps of Engineers, it necessitated the removal of more than fourteen thousand cubic yards of solid rock, accomplished with explosives. Thus, whereas it had been deemed prudent to remove the Native human inhabitants from the park in order to ensure the sequestration of nature as a place of ideal purity, at the same time it was also felt appropriate to blast away tons of rock—forever altering that same nature—so that other humans could more conveniently experience it. Paintings like this one strike a minor chord in Moran's otherwise unsullied representation of the park, but they suggest the strange calculus often at work in matters of environmental justice and politics.[30]

Of course, nineteenth-century pictures of Yellowstone also invite us to consider ecological issues pertaining to the park in more recent years. As noted already, the Anthropocene prompts reevaluation of long trajectories of human activity. Industrial modernity unleashed forces that have had unanticipated effects, both cultural and ecological. For example, the National Park Service acknowledges growing evidence of climate change at Yellowstone as a vector already altering seasonal temperatures, annual snow accumulation, water flows, plant and animal growth, and more. Indian removal brought an end to Indigenous peoples' historical efforts of managing forests and wildlife through periodic burning, resulting now in dense growth that has exacerbated wildfires. Human and other biotic traffic through the park over decades since 1872 has introduced numerous exotic species that have transformed the Yellowstone ecosystem in other ways. Wildlife regulation and management during the park's history has entailed protection of species such as bison and eagles as well as shifting policies toward others, notably wolves, which were deliberately exterminated by rangers in the early twentieth century only to be reintroduced later. Though not represented in Moran's or Brown's pictures, these manifold ongoing changes further debunk the pristine myth about Yellowstone and other parks. Owing to its gargantuan scale, Moran's *The Grand Canyon of the Yellowstone* remains particularly prominent as an artistic expression of appreciation for the beauty and value of a complex ecosystem, one that certainly deserves our respect and protection. At the same time, ecocriticism demands that we look askance today at idealistic interpretations that read Moran's work simply as a neutral document of Yellowstone's timeless purity. Given the scale of ecological challenges moving forward—and their entanglement with issues of visuality, materiality, and creativity—we foresee ecocritical art history playing an increasingly important role in scholarship and public discourse.[31]

Contemporary Artistic Perspectives

Recent creative work offers valuable ecocritical insight about historical art, issues, and contexts. For example, let us briefly compare *The Grand Canyon of the Yellowstone* with *The Browning of America*, a mixed-media assemblage produced by Jaune Quick-to-See Smith (Salish member, Confederated Salish and Kootenai Nation) (fig. 8). Although Smith (born 1940) does not refer specifically to Moran's picture in her work, she does address pertinent questions about nature and nation. Whereas Moran had celebrated a site once inhabited

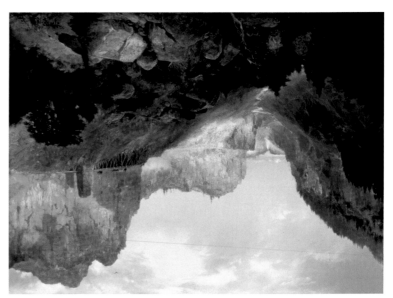

FIGURE 7: Thomas Moran, *The Golden Gate, Yellowstone National Park*, 1893. Oil on canvas, 92.1 × 127.6 cm. Buffalo Bill Center of the West, Cody, Wyoming. Museum purchase (4.75).

by Native Americans and now "set apart" for tourists, Smith gives us a map of the United States that reasserts Indigenous presence through pictograms and brownish red stains extending through and beyond emphatic national borders. A buffalo pictogram occupies parts of Nebraska and Wyoming not far from Yellowstone, a reminder of the bison's historic predominance as a keystone species on the Plains. In contrast to Moran's painterly paean to Yellowstone National Park as a shrine to American nationalism and conservation, Smith's heterogeneous blend of symbols and collaged news-paper clippings offers a decolonial counterdiscourse, ques-tioning the presumptive whiteness of America by reclaiming alternative histories and geographies. Appropriating and politicizing the famously recondite map imagery by Jasper Johns (born 1930) from the 1960s, Smith calls attention to

FIGURE 8: Jaune Quick-to-See Smith (Salish member, Confederated Salish and Kootenai Nation, born 1940), *The Browning of America*, 2000. Oil and mixed media on canvas, 91.4 × 121.9 cm. Crocker Art Museum, Sacramento. Purchase with contributions from Gail and John Enns and the George and Bea Gibson Fund (2007.23)

recent US Census predictions of a demographic shift that will displace white Americans as an ethnic majority by the middle of the twenty-first century. Newspaper clippings partially concealed beneath layers of paint refer wryly to "Invaders from the East" with the names of ancient Northern European tribes, including "Vikings," "Picts," "Gauls," "Visigoths," "Angles," and "Saxons." This Anglo-Saxon reference highlights a deep historical irony, since xenophobic descendants of these very "barbarian" invaders now express fear about the "browning of America" amid rebounding Native populations and foreign immigration.

The disparate ends of *The Grand Canyon of the Yellowstone* and *The Browning of America* are evident in the form each work takes, with the putative veracity of Moran's realistic style ideologically asserting the "truth" of his evacuated image, and the more abstract and conceptual nature of Smith's collage imagining an alternate reality for Native Americans, even as it describes broader demographic realities. But the layers of Smith's artistic palimpsest go even deeper. In its stained facture and connotations in both title and tonality of polluted brown fields, *The Browning of America* also forcefully conjures the specter of environmental pollution associated with fossil fuels, in the form of not only greenhouse gas emissions but also tainted water—a topic of urgent concern lately in the American Midwest as a result of the Dakota Access Pipeline project opposed by Native American activists known as Water Protectors. Elsewhere, predominantly African American cities such as Flint, Michigan, battle to restore the integrity of public water supplies in the face of lead poisoning and poor civic management decisions resulting from negligence and environmental racism. Smith's use of the word "browning" therefore functions with richly prescient ambiguity, for it carries both a positive allusion to demographic diversity and a negative reference to ecological damage. As a Salish artist from the Flathead Reservation in Montana, Smith knows well the brutal history of Indian removal and industrial pollution affecting sacred tribal lands in the West, but she also affirms the resilient power of diversity, both human and nonhuman.[32]

Another way that contemporary artists contribute to ecocritical thinking is by reinterpreting the canon of art history in order to reveal its enduring power to foster mythic beliefs about nature. Valerie Hegarty (born 1967), in her installation *Fallen Bierstadt* (fig. 9), deconstructs a painting by Albert Bierstadt (1830–1902) of *Bridal Veil Falls, Yosemite* (fig. 10), showing an iconic site in California that became the first state park in 1864 and later gained national park status in 1890. By decomposing Bierstadt's work, Hegarty conceptually reframes his seamless and transcendent Romantic vision, violently transforming it into a burned, perforated, and unstable object. She calls her technique "reverse archeology," for it involves "excavating from America's past" to create "a material memory." *Fallen Bierstadt* is not meant as an act of violence against Yosemite per se but rather enacts a deliberate unraveling of landscape

FIGURE 9: Valerie Hegarty (American, born 1967), *Fallen Bierstadt*, 2007. Foamcore, paint, paper, glue, gel medium, canvas, wire, wood, 177.8 × 127 × 42.5 cm. Brooklyn Museum, Gift of Campari, USA (2008.9a-b)

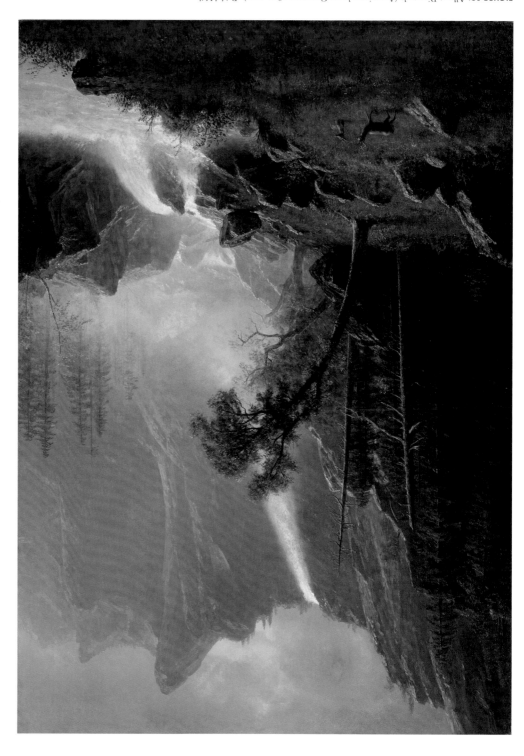

FIGURE 10: Albert Bierstadt (American, born Germany, 1830–1902), *Bridal Veil Falls, Yosemite*, ca. 1871–73. Oil on canvas, 91.8 × 67 cm. North Carolina Museum of Art, Raleigh. Purchased with funds from the North Carolina State Art Society (Robert F. Phifer Bequest) and various donors, by exchange (87.9)

FIGURE 12: Robert Walter Weir, *Embarkation of the Pilgrims*, 1843. Oil on canvas, 365.8 × 548.6 cm. United States Capitol, Washington, DC. Architect of the Capitol.

of the situation for others, Meigs was still able to record in his diary the safe return of his sons from their apparently enjoyable outing, and to characterize it as "a delicious day."[36] Even so, thinking ecocritically, perhaps Weir's picture does in some way bear the trace of the worrisome environmental event that brought it into being in the first place. His most famous painting, completed a decade later, is the *Embarkation of the Pilgrims*, permanently installed in the Rotunda of the US Capitol (fig. 12). Its subject is the departure of the *Speedwell* from Delf's Haven, Holland, for England, where its passengers boarded the *Mayflower* and sailed to America in search of religious freedom. The enormous canvas shows the Pilgrims on the deck of the ship, praying for divine protection during their voyage, a theme expressed compositionally by the overarching sail sheltering them—on which Weir has actually inscribed, in the upper left corner, "God with us." Looking back to the earlier *Greenwich Boat Club*, it becomes clear that his prominent incorporation there of another sheltering sail serves a meaningful role as well, similarly

shielding the depicted party from threat, in this case the miasma of disease from across the bay. As the example of Weir's painting illustrates, ecocritical analysis can lead us to consider how environmental factors of all kinds both produce and condition art in distinctive ways, leading to enhanced understanding of the works themselves and the circumstances surrounding their production.[37]

Creative Matter

Ecocritical art history extends beyond questions of representation to consider the environmental implications of materials—the stuff of art. An extended discussion of this topic can be found elsewhere in this volume, so we will here only briefly remark upon two works produced in very different materials and historical contexts as a way of highlighting the expansive potential of such investigations. First, an eighteenth-century luxury high chest of drawers made in Philadelphia of imported mahogany and

other materials invites interpretation on multiple registers (see fig. 104). Traditional scholarship on this type of object has generally used connoisseurship and formal analysis to assess quality and identify date, location, and sometimes individual maker. Or, through socioeconomic analysis, scholars have examined such works as expressing elite patronage, cosmopolitan taste, and the rise of mercantile discourse about private property, for example with attention to how furniture of this sort served to compartmentalize and secure possessions behind locked doors.[38]

New scholarship in environmental history has dramatically enriched our understanding of mahogany. We now know that luxury furniture made of this wood is the culmination of not only certain aesthetic traditions and artisan practices but also far-flung networks of shipping, enslaved labor, and the harvesting of endangered mahogany trees in the Caribbean—all of which were key to its production and availability for transformation into durable and aesthetically pleasing household furnishings. Such issues open up a wider range of historical concerns regarding transnational economic activity, deforestation, and environmental justice, since the market for mahogany led to the depletion of tropical forests, alteration of ecosystems, and aggressive expansion of slavery—both for harvesting the trees and on the sugar plantations they were felled in part to accommodate. To the extent luxury mahogany furniture became a cultural sign of elite class status among well-to-do patrons in cities such as Philadelphia, Boston, New York, and Charleston, it also served as an important pictorial motif in portraits by John Singleton Copley, Charles Willson Peale, and other artists who helped to fashion identities by carefully posing sitters with studio props made of this material. Thus, artworks, furniture, and their consumers became enmeshed in an international ecosystem of aesthetics, slavery, and deforestation. Even so, close materials analysis fosters an appreciation of the irrepressible vitality of wood itself, the character of which shines through the varnish and rigorous Georgian styling of the chest. Viewed in this way, the material assumes a sort of agency of its own, one ironically reinscribed by its changing value, use, and perception, as abundant harvesting diminished its environmental viability. Similarly, while we can delight in the beauty of this and other finely crafted pieces, we must acknowledge how they also reveal, in the words of Charles Dickens, "through all [their] polish, the wretched hue of the slaves."[39]

Intrigue of 1954 (see fig. 124), a masterpiece of Post-Painterly Abstraction by Morris Louis (1912–1962), could not be more different from the eighteenth-century mahogany chest, but ecocritical inquiry likewise reveals its imbrication in a complex web of material-environmental relations. Beautifully exemplifying the artist's technique of canvas staining (inspired by the work of Helen Frankenthaler and Jackson Pollock), *Intrigue* belongs to Louis's breakthrough Veils series of the mid-1950s. Using acrylic Magna paint thinned with turpentine, the artist created such works by pouring the liquid pigment directly onto the horizontal canvas and then manipulating its flow, steering the ensuing stain to create bright "veils" of color (the term also carries cultural associations of femininity and orientalist exoticism). In such a process, artistic materials took on a life of their own, operating as an animated dye moving via osmosis and merging with the canvas, guided by Louis as facilitator or collaborator. Louis left us with not only a beautiful picture but also an index of vital materiality that expresses something more than human agency alone.[40]

Sadly, Louis's regular exposure to toxic turpentine fumes likely played a role in bringing about his premature death from lung cancer at age forty-nine on September 7, 1962—two weeks before the release of Rachel Carson's *Silent Spring*, a book that drew worldwide attention to dangerous industrial chemicals. Today the National Institute for Occupational Safety and Health (NIOSH) of the Centers for Disease Control and Prevention classifies turpentine as "Immediately Dangerous to Life," citing scientific studies going back to 1915. During Louis's truncated lifetime and afterward, the health effects of turpentine were not widely known or acknowledged, at least not in the art world. In 1965 the art critic Michael Fried commemorated the painter by writing that he "died of lung cancer" but "lived for painting." Louis's death is one of several instances of artist mortality associated with industrial art materials in the modern era. As discussed elsewhere in this book, his painting also relied on industrial turpentine production and consumption that had devastating impacts on forests and impoverished human laborers in the southeastern United States. Thus *Intrigue* begins to look not so different from the eighteenth-century Philadelphia high chest after all, for both of these beautiful objects used materials and processes entailing significant ecological costs. Rather than condemning or ignoring such works, we highlight them as tangible evidence of the need

for more capacious ecocritical analysis. Growing concerns about the toxicity of art materials prompted the College Art Association to issue "Recommendations on the Safe Use of Materials and Equipment" in the organization's revised *Standards and Guidelines* of 2011. Louis's *Intrigue* demonstrates how even art eschewing representation and narrative can tell important material stories that go beyond formalist rhetoric about color, flatness, and stylistic progress.[41]

As a way of concluding this preamble on ecocritical interpretation, we highlight two recent works embodying the transnationalism of recent "American" art, a theme that runs throughout the book but gains momentum and force during the twentieth and twenty-first centuries. One of the works in question is a 2002 photograph by Subhankar Banerjee (born 1967) titled *Caribou Migration I* from the artist's *Oil and the Caribou* series (fig. 13). An icon of environmental activism, Banerjee's picture celebrates the life and ecological complexity of a place remote from the experience of most people: the Arctic National Wildlife Refuge (ANWR) in northern Alaska. A distant view taken from an airplane, it shows a herd of pregnant caribou migrating across the frozen Coleen River toward their calving site on the refuge's coastal plain. The photograph joins a long tradition of art represent-ing and celebrating federally protected land, going back to Moran's *The Grand Canyon of the Yellowstone.* Not unlike that earlier picture, Banerjee's *Caribou Migration I* depicts a highly contested site in anodyne aesthetic terms. We see no conflict, but we know that ANWR has been a recurring locus of partisan political debate in the US Congress over oil drilling. Whereas most Congressional Republicans and oil industry lobbyists have strongly advocated extraction, Democrats have generally opposed this. Aesthetic perceptions of ANWR largely divide along similar lines. As Banerjee was preparing a major exhibition of his work at the Smithsonian Institution in 2003, he became caught up in these petro-politics when California Democrat Barbara Boxer displayed one of his photographs in the Senate as proof against Republican claims that ANWR was nothing but a "flat, white nothingness" that might as well be drilled. Banerjee soon learned that the Smithsonian—obviously bending to political pressure—had

suddenly decided to downsize his exhibition, demoting it to a small basement gallery and deleting explanatory labels describing ANWR's complex vitality and ecological vulnerability. Environmental politics became part of the culture wars in the nation's capital.[42]

The ruckus over this government censorship galvanized Banerjee's commitment to environmental activism and justice by using his talents as a photographer and writer to raise even greater public awareness about the Arctic's trans-species com-munity, one that includes Indigenous peoples, nonhuman animals, and plants—all of which now face cataclysmic change from global warming and the continuing threat of industrial oil extraction. The beauty and visual power of his work can get lost in the cacophony of politics, a potential problem whenever environmental interpretation strays far from the art in question. Thus ecocritical art history must attend not only to environmental history and political context but also to aesthetic dimensions, for these do no more than simply convey a didactic message like a bumper sticker. In its distant aerial perspective, compositional cropping, and ambiguous inter-mingling of realism with abstraction, *Caribou Migration I* defa-miliarizes, or estranges, our perceptions of art as well as our expectations about the Arctic in several ways. At first glance, the image can be very difficult to read or understand without the title or an explanatory caption. Its seemingly abstract pattern of black dots and bluish-white colors initially seems alluringly enigmatic. Are these ants crawling through shaving foam or cotton candy? This suspension of clarity and knowl-edge is central to the work's artistic success, for it keeps some-thing in reserve by resisting rapid didactic exhaustion. Later, when we discover that we are looking at a herd of migrating caribou extending far beyond the photograph's cropped bor-ders, our preliminary sense of aesthetic wonder intertwines with ecological insight, awakening ethical responsibility and recognition of deeper meaning.[43]

Banerjee's cropping of the image, in particular, invites the viewer to think about how far the herd extends beyond the frame and how near we humans actually are—as con-sumers of oil—to this not-so-remote place teeming with life (including many species of birds that migrate here from

FIGURE 13: Subhankar Banerjee (Indian, active in United States, born 1967), *Caribou Migration I*, 2002, from the *Oil and the Caribou* series. Chromogenic print from a digital file, 18.9 × 137.2 cm. Collection Lannan Foundation

FIGURE 14: Postcommodity (founded 2007), *Repellent Fence/Valla Repelente*, 2015. Land Art installation and community engagement (earth, cinder block, paracord, PVC spheres, helium). Installation view, US/Mexico border, Douglas, Arizona/Agua Prieta, Sonora. Courtesy Postcommodity

distant continents to nest). As a result, this picture by an Indian American immigrant compels the viewer to think self-critically about location, duration, and interrelation across spaces and species—not with pity or condescension but rather with the recognition that these caribou are neighbors in a way, fellow planetary inhabitants deserving respect. Moreover, the question of what constitutes "American" here seems to fade in importance in the face of global warming, global capitalism, and global environmental consciousness.

Attenuation of national borders and boundaries provided an explicit theme in a Land Art installation and community engagement project titled *Repellent Fence/Valla Repelente*, created in 2015 by the interdisciplinary arts collective Postcommodity (founded 2007) (fig. 14). The artists—Raven Chacon, Cristóbal Martínez, and Kade L. Twist—describe this work as "a social collaborative project among individuals, communities, institutional organizations, publics, and sovereigns that culminate[s] with the establishment of a

large-scale temporary monument." *Repellent Fence* consisted of twenty-six helium-filled balloons floated at regular intervals one hundred feet above the ground along a two-mile line perpendicular to and crossing the United States/Mexico border near Douglas, Arizona, and Agua Prieta, Sonora. Each balloon replicated an ineffective bird-repellent product on an enlarged scale (ten feet in diameter), but the artists explain that they used imagery long associated with Indigenous spiritual power in the Americas. With thirteen balloons situated in each country, the installation poetically highlighted the artifice and environmental arbitrariness of the geopolitical borders of the modern nation-state. According to Postcommodity, the purpose "is to bi-directionally reach across the U.S./Mexico border as a suture that stitches the peoples of the Americas together—symbolically demonstrating the interconnectedness of the Western Hemisphere by recognizing the land, indigenous peoples, history, relationships, movement and communication." The artists view their work as fostering dialogues about systems beyond national boundaries amid the ongoing global migration crisis with the intention of forming "local and external capacities for the recovery of transborder knowledges that have been arrested through binary discourses." Postcommodity thereby hopes "to identify and support indigenous and border community interests, desires, concerns, and goals for creating a more safe, healthy, and culturally appropriate borderlands environment for its citizens."[44]

As that artistic statement makes clear, ecological concerns about land, interconnectedness, and the borderlands environment cannot be disentangled from other issues, in this case migration, communication, and culture. Postcommodity's statement proceeds to highlight other related problems having to do with trade, economics, and border militarization. *Repellent Fence* exemplifies the global perspective on political ecology informing a growing number of works by contemporary artists today, but it also punctuates the historical assertion at the beginning of this essay as a guiding idea for the book: the Anthropocene increasingly demands an approach to art history that looks carefully at regional environmental conditions while also considering transborder flows over long periods of time. There has never been a specially anointed "nature's nation." By reassessing American art in relation to ecology and environmental history, this book puts that phrase in quotes and seeks to move beyond the exceptionalism it implies.

Outline of This Book

Nature's Nation is arranged in three broad epochs: Colonization and Empire, Industrialization and Conservation, and Ecology and Environmentalism—eras marked by increasing artistic awareness of environmental change, human agency as a factor within it, and the emergence of modern ecological consciousness.

Colonization and Empire addresses art embodying profound epistemological transformation in visions of natural order, as the classical-Christian tradition of immutable hierarchy and plenitude—represented in the idea of nature as a Great Chain of Being—gave way to an incipient comprehension of environmental dynamism, complexity, and discontinuity. This revolutionary epoch in politics, industry, and markets was marked by imperial expansion and violent conflict, cross-cultural encounters, the discovery of extinction, resource scarcity, pollution, and other modern revelations to which diverse works of art bear witness.

Industrialization and Conservation explores aesthetic articulations of the advancing pace—and growing recognition—of the human role in environmental transformation and its pervasive political, economic, social, and cultural implications. In 1864 the US diplomat, linguist, and early conservationist George Perkins Marsh (1801–1882) forcefully expressed in his treatise *Man and Nature* "the importance of human life as a transforming power" in a global context. Marsh further stressed the value of "the restoration of disturbed harmonies" in nature, giving voice to a nascent conservation aesthetic. Tensions between progress and preservation were an environmental expression of nineteenth-century America's great animating nature-culture dialectic. The art discussed in this section, like the techniques and materials of the artists themselves, complicate notions of "progress" that once defined modernity.[45]

The third and final epoch, Ecology and Environmentalism, considers art since the early twentieth century addressing the human place in nature as an issue of increasingly urgent ethical and aesthetic concern on a planetary scale. During this period, artists inventively addressed new creative challenges posed by ecological disasters of unprecedented scope, from the Dust Bowl to world war and global warming. In the process, art itself became ever more expansive in its techniques, media, and range of vision.

missionary entourage to serve as faculty at the seminary college Berkeley hoped to establish in Bermuda. See John Hallam, "The Eighteenth-Century American Townscape and the Face of Colonialism," *Smithsonian Studies in American Art* 4, nos. 3–4 (Summer–Autumn 1990): 155–57. For Native Americans' island incarceration, see "Native Americans and the Boston Harbor Islands," Boston Harbor Islands website, National Park Service, updated February 26, 2015, https://www.nps.gov/boha/learn/historyculture/native-americans-and-the-boston-harbor-islands.htm.

17 Park Superintendent P. H. Conger, quoted in Mark David Spence, *Dispossessing the Wilderness: Indian Removal and the Making of the National Parks* (New York: Oxford University Press, 1999), 57. On the dissemination of Yellowstone obsidian, see Bradley T. Lepper, Craig E. Skinner, and Christopher M. Stevenson, "Analysis of an Obsidian Biface Fragment from a Hopewell Occupation Associated with the Fort Hill (33HI1) Hilltop Enclosure in Southern Ohio," *Archaeology of Eastern North America* 26 (1998): 33–39.

18 George W. Wingate, *Through the Yellowstone on Horseback* (New York: Judd, 1886), 36, quoted in Spence, *Dispossessing the Wilderness*, 55. On buffalo at Yellowstone and the impact of smallpox, see Andrew C. Isenberg, *The Destruction of the Bison: An Environmental History, 1750–1920* (New York: Cambridge University Press, 2001), 25–26, 28, 39, 53–62, 93, 113–20, 143, 164–67, 179–82, 185–92, 195.

19 On bounded space, see Kathleen Dean Moore et al., eds., *How It Is: The Native American Philosophy of V. F. Cordova* (Tucson: University of Arizona Press, 2007), 186–200. For more on European and Native environmental perceptions, see Michael Dean Mackintosh, "Ink and Paper, Clamshells and Leather: Power, Environmental Perception, and Materiality in the Lenape-European Encounter at Philadelphia," in *A Greene Country Towne: Philadelphia's Ecology in the Cultural Imagination*, ed. Alan C. Braddock and Laura Turner Igoe (University Park: Pennsylvania State University Press, 2016), 19–33. Also see David Rich Lewis, "American Indian Environmental Relations," in Sackman, *American Environmental History*, 191–213; Michael E. Harkin and David Rich Lewis, eds., *Native Americans and the Environment: Perspectives on the Ecological Indian* (Lincoln: University of Nebraska Press, 2007); and Joy Porter, *Native American Environmentalism: Land, Spirit, and the Idea of Wilderness* (Lincoln: University of Nebraska Press, 2014).

20 Despite the obvious complexities involved in using the European word "art" to describe Indigenous artifacts, we prefer it to the anthropological terminology of "material culture." On this nomenclature problem, see Carolyn Dean, "The Trouble with (the Term) Art," *Art Journal* 65, no. 2 (Summer 2006): 24–32. For one of the many Native American references to "art," see "Infinity of Nations: Art and History in the Collections of the National Museum of the American Indian," National Museum of the American Indian, Washington, DC, http://nmai.si.edu/exhibitions/infinityofnations/. See also "A:shiwi Map Art," A:shiwi A:wan Museum and Heritage Center, Zuni Pueblo, http://ashiwi-museum.org/collaborations/ashiwi-map-art/. On the ecological beliefs and practices of the Indigenous peoples of the Northwest Coast, see Harkin and Lewis, *Native Americans and the Environment*, chaps. 9 and 10. Also see Fritz Detwiler, "Moral Foundations of Tlingit Cosmology," in *The Handbook of Contemporary Animism*, ed. Graham Harvey (London: Acumen, 2013), 167–80.

21 William Cronon, "The Trouble with Wilderness; or, Getting Back to the Wrong Nature," in *Uncommon Ground: Rethinking the Human Place in Nature*, ed. William Cronon (New York: Norton, 1995), 69–90. Also see Raymond Williams, "Ideas of Nature," in *Problems in Materialism and Culture: Selected Essays* (London: Verso, 1980), 67–85, which anticipates aspects of Cronon's argument and usefully summarizes evolving Euro-American attitudes toward nature.

22 Cronon, "Trouble with Wilderness," 81, and William Cronon, "Introduction: The Search for Nature," in *Uncommon Ground*, 23–56; Witold Rybczynski, "The Green Case for Cities," *The Atlantic* (October 2009), http://www.theatlantic.com/magazine/archive/2009/10/the-green-case-for-cities/307661/. On the historical presence of Native Americans and problems of Romantic idealism, see Peter Nabokov and Lawrence Loendorf, *Restoring a Presence: American Indians and Yellowstone National Park* (Norman: University of Oklahoma Press, 2004); Shepard Krech, *The Ecological Indian: Myth and History* (New York: Norton, 2000); and Harkin and Lewis, *Native Americans and the Environment*.

23 On the visual construction of nature in terms of whiteness, see chap. 2, "Landscape Photography and the White Gaze," in Martin A. Berger, *Sight Unseen: Whiteness and American Visual Culture* (Berkeley: University of California Press, 2005), 42–79; also see Martin A. Berger, "Overexposed: Whiteness and the Landscape Photography of Carleton Watkins," *Oxford Art Journal* 26, no. 1 (2003): 3–23. Also see Carolyn Finney, *Black Faces, White Spaces: Reimagining the Relationship of African Americans to the Great Outdoors* (Chapel Hill: University of North Carolina Press, 2014); James Edward Mills, *The Adventure Gap: Changing the Face of the Outdoors* (Seattle: Mountaineers Books, 2014); and Alysa Landry, "Native History: Yellowstone National Park Created on Sacred Land," *Indian Country Today*, March 1, 2017, https://indiancountrymedianetwork.com/history/events/native-history-yellowstone-national-park-created-on-sacred-land/. For discussion of recent debates about nomenclature at Yellowstone, including efforts by people of the Northern Arapaho, Eastern Shoshone, Northern Cheyenne, and twenty-five other Indigenous tribes to replace Euro-American site names in the park, see Angus M. Thuermer Jr., "Tribes meet Wyoming resistance to Yellowstone name changes," *WyoFile: People, Places & Policy*, May 15, 2018, https://www.wyofile.com/tribes-meet-wyoming-resistance-to-yellowstone-name-changes/?utm_source=twitter&utm_medium=social&utm_campaign=SocialWarfare.

24 Robert J. Chandler, *San Francisco Lithographer: African American Artist Grafton Tyler Brown* (Norman: Charles M. Russell Center, Oklahoma University, 2014); Lizzetta LeFalle-Collins, "Grafton Tyler Brown: Selling the Promise of the West," *International Review of African American Art* 12, no. 1 (1995): 26–44.

25 William M. Denevan, "The Pristine Myth: The Landscape of the Americas in 1492," in *American Environmental History*, ed. Louis S. Warren (Malden, MA: Blackwell, 2003), 5–26; also see Robin Kelsey, "Landscape as Not Belonging," in *Landscape Theory*, ed. Rachael Ziady DeLue and James Elkins (New York: Routledge, 2008), 203–12.

26 Aubrey L. Haines, *Yellowstone Place Names: Mirrors of History* (Niwot: University Press of Colorado, 1996), i, 4. On Yellowstone geology, see "Grand Canyon of the Yellowstone," Yellowstone National Park website, National Park Service, updated September 1, 2017, https://www.nps .gov/yell/learn/nature/grand-canyon.htm; and Robert B. Smith and Lee J. Siegel, *Windows into the Earth: The Geologic Story of Yellowstone and Grand Teton National Parks* (New York: Oxford University Press, 2000).

27 Arthur O. Lovejoy, *The Great Chain of Being: A Study of the History of an Idea* (Cambridge, MA: Harvard University Press, 1936).

28 "Forests," Yellowstone National Park website, National Park Service, updated August 21, 2017, https://www.nps.gov/yell/learn/nature/forests .htm.

29 Karl Jacoby, *Crimes against Nature: Squatters, Poachers, Thieves, and the Hidden History of American Conservation* (Berkeley: University of California Press, 2014); Alan C. Braddock, "Poaching Pictures: Yellowstone, Buffalo, and the Art of Wildlife Conservation," *American Art* 23, no. 3 (Fall 2009): 36–59; Turner's address, "The Significance of the Frontier in American History," was reprinted in the *Annual Report of the American Historical Association for the Year 1893* (Washington, DC: Government Printing Office, 1894), 197–228, quoted 199, 226–27.

30 On the extensive history of road construction in Yellowstone, see "The History of the Construction of the Road System in Yellowstone National Park, 1872–1966," Yellowstone Historic Resource Study, National Park Service, updated December 1, 2005, http://www.nps.gov /parkhistory/online/books/yell/roads/hrst.htm.

31 Paul Schullery, *Searching for Yellowstone: Ecology and Wonder in the Last Wilderness* (Helena: Montana Historical Society Press, 2004); Douglas W. Smith and Gary Ferguson, *Decade of the Wolf: Returning the Wild to Yellowstone*, rev. and updated ed. (Lanham, MD: Lyons Press, 2012).

32 "U.S. Census Bureau Projections Show a Slower Growing, Older, More Diverse Nation a Half Century from Now," U.S. Census Bureau Newsroom Archive, December 12, 2012, https://www.census.gov /newsroom/releases/archives/population/cb12-243.html. On Water Protector opposition to the Dakota Access Pipeline, see #NoDAPL Archive: Standing Rock Water Protectors, http://www.nodaplarchive .com/. Anna Clark, *The Poisoned City: Flint's Water and the American Urban Tragedy* (New York: Metropolitan Books, 2018).

33 Quotations from Valerie Hegarty's website, http://valeriehegarty .com/news.html.

34 For information on the painting's sisters and circumstances of production, see Susan G. Larkin, "'A Delicious Day': Robert Weir's Greenwich Boat Club," *American Art Journal* 33, nos. 1–2 (2002): 21–33.

35 Pintard and Durand's assistant quoted in John Noble Wilford, "How Epidemics Helped Shape the Modern Metropolis," *New York Times*, April 15, 2008, review of *Plague in Gotham! Cholera in Nineteenth-Century New York*, an exhibition at the New-York Historical Society. Also see Charles E. Rosenberg, "The Cholera Epidemic of 1832 in New York City," *Bulletin of the History of Medicine* 33, no. 1 (1959): 37–49; and Rosenberg, *The Cholera Years: The United States in 1832, 1849, and 1866* (Chicago: University of Chicago Press, 1987), excerpted in Warren, *American Environmental History*, 142–55.

36 Meigs quoted in Larkin, "'Delicious Day,'" 27.

37 See "Embarkation of the Pilgrims," Architect of the Capitol website, updated April 29, 2016, https://www.aoc.gov/art/historic-rotunda -paintings/embarkation-pilgrims.

38 On the development of drawers in eighteenth-century high chests for purposes of organization and safekeeping, see Angela L. Miller, Janet C. Berlo, Bryan J. Wolf, and Jennifer L. Roberts, *American Encounters: Art, History, and Cultural Identity* (Upper Saddle River, NJ: Prentice Hall, 2008), 117.

39 Jennifer L. Anderson, *Mahogany: The Costs of Luxury in Early America* (Cambridge, MA: Harvard University Press, 2012), 55–58, 63; Dickens quoted 296.

40 Diane Upright, *Morris Louis: The Complete Paintings; a Catalogue Raisonné* (New York: Abrams, 1985). On vital materiality, see Jane Bennett, *Vibrant Matter: A Political Ecology of Things* (Durham: Duke University Press, 2010); and on materiality and art history, see Veerle Thielemans, "Beyond Visuality: Review on Materiality and Affect," *Perspective 2* (2015), http://journals.openedition.org/perspective/5993.

41 Lon B. Tuck, "Artist Morris Louis Dies of Cancer, Rated Among Best of U.S. Painters," *Washington Post*, September 8, 1962. Rachel Carson, *Silent Spring* (Boston: Houghton Mifflin, 1962). For the NIOSH classification of turpentine, see NIOSH Publications and Products, http:// www.cdc.gov/niosh/idlh/8006642.html. "Blue Veil by Michael Fried," *Morris Louis, Acquisitions (Fogg Art Museum)*, no. 1965 (1965): 177–81; quotation on 177. The College Art Association Standards and Guidelines of 2011 can be found at http://www.collegeart.org/guidelines/practices.

42 Finis Dunaway, "Reframing the Last Frontier: Subhankar Banerjee and the Visual Politics of the Arctic National Wildlife Refuge," in Braddock and Irmscher, *Keener Perception*, 254–74.

43 On defamiliarization, see Braddock and Irmscher, "Introduction," in *Keener Perception*, 9. On Banerjee, see Ashley Dawson, "Documenting Accumulation by Dispossession," in *Critical Landscapes: Art, Space, Politics*, ed. Emily Eliza Scott and Kirsten Swenson (Oakland: University of California Press, 2015), 162–63; and T. J. Demos, *Decolonizing Nature: Contemporary Art and the Politics of Ecology* (Berlin: Sternberg Press, 2016), 83–99.

44 Postcommodity, *Repellent Fence* (2015), artists' statement, http:// postcommodity.com/Repellent_Fence_English.html.

45 George Perkins Marsh, *Man and Nature; or, Physical Geography as Modified by Human Action*, ed. David Lowenthal (1864; repr. Seattle: University of Washington Press, 1965), 3.

Colonization and Empire

Alan C. Braddock

The Order of Things

One of the enduring legacies of European classical antiquity is the idea of order in nature. According to a tradition going back to the ancient Greek philosophers Plato (ca. 428–348/347 BCE) and Aristotle (384–322 BCE), the natural world exists as a coherent, harmonious place of perfection, plenitude, permanence, and design—in its underlying structure if not on the surface. From this classical perspective, nature offers a timeless, unchanging proof of divine creation and ideal purpose, which human beings can detect and delineate in science and art. For two millennia, through the history of Christianity and into the modern era, classically inspired European thinkers and their Western followers represented the natural order of things in hierarchical, anthropocentric terms by placing human beings above all other forms of terrestrial existence. Though not quite divine, humans in this scheme were thought to be created in the image of God and therefore held dominion over the earth, including all knowledge about it. Anthropocentrism likewise governed prevailing Western classical theories of art, which privileged human action and history as the most elevated subject matter. The Western humanistic vision also tended to present Europeans themselves as leaders of world history and progress. Accordingly, during the heyday of European colonization and empire, Western monarchs asserted their "highness" as natural and incontestable, claiming global authority by divine right while supplying artists with important themes modeled on ancient imperial rulers (fig. 15). This epistemology migrated to colonial America, retaining currency and influence until the revolutionary period of the late eighteenth century. Although European culture has never really stopped shaping American life and art, the upheavals of modernity began to challenge classical assumptions about the order of things, not only in politics but also in science and art. "Ecology" did not yet exist, but its conceptual foundations were taking shape. As a modern mode of thought premised on understanding flux and interdependence instead of divine order and static hierarchy in nature, ecology came into being with the help of artists who could recognize and visualize change.[1]

The Great Chain of Being

Since antiquity, European thinkers and artists had imagined the natural order of things in metaphorical terms, often referring to a ladder-like scale or a great unbroken chain that linked different types of being in a hierarchical array. As described by the intellectual historian Arthur Lovejoy, this ancient idea of a "Great Chain of Being" essentially served as a ranking system that began with God in Heaven and descended in graduated steps or rungs through His earthly creation—humankind, animals, plants, and minerals—and finally to Hell. Building on the writings of Plato and Aristotle, for example, the fifth-century Roman writer Macrobius (390–430 CE) referred to a "golden chain," which ... bade hang down from heaven to earth." According to Macrobius, beneath "the Supreme God," from whom arises "Mind" and "Soul," "all things follow in continuous succession, degenerating in sequence to the very bottom of the series ... a connection of parts ... down to the last dregs of things, mutually linked together and without a break." The clear implication of this statement was that a rupture, change, or development of any sort in the chain was impossible, for it would reveal God's fallibility in constructing the universe as a place of stasis, ranked order, and complete harmony. Versions

beginning and the end of which all the gods of the [other] nations are demons, and there is no God besides me." A clear sense of hierarchy prevails even in Heaven, where various divine subsidiaries—the Virgin Mary and two tiers of angels—radiate from the central masculine figure of God. In the earthly world beneath, human beings appear first, followed by birds (whose flight puts them close to Heaven), then assorted fish (an ancient symbol of Christian souls), mammals (including a mythical unicorn and dragon), and plants, all rendered with specificity.

Reflecting Fray Diego's cosmopolitan knowledge, Native Americans stand with Turks and other human subjects of the Christian empire while analogous diversity appears in the nonhuman arrays below (an American llama and African camel face each other, for example, among the quadrupeds). Meanwhile, falling angel figures pictured at right denote the descent of Lucifer, God's favorite until cast out of Heaven, condemned to Hell, and renamed Satan for his rebelliousness. Having resisted God's authority, Lucifer fell from grace to a level beneath the lowest earthly link in the Great Chain of Being, an exemplary missionary warning to anyone who might question the established hierarchy. Even so, all remain linked by the chain, occupying allotted places in the order of things. Produced three centuries before the naturalist Ernst Haeckel coined the term "ecology," this Renaissance vision of linked variety was rigidly moral, with human beings occupying the pinnacle of nature's diversity. It is precisely the static, hierarchical, and theological arrangement of the Great Chain of Being that separates Fray Diego's Christian imperial worldview from the dynamic sense of intercon-nectedness in modern ecological thought, which regards no entity as enjoying a divinely ordained priority or privilege.[4]

The Great Chain of Being also affirmed and naturalized the earthly power of European popes, kings, and aristocrats by divine right. Accordingly, Fray Diego complemented his illustration of that concept with others in *Rhetorica Christiana* showing the "Hierarchia Ecclesiastica" (Ecclesiastical Hierarchy) and "Hierarchia Temporalis" (Temporal Hierarchy), topped by the Pope and the Holy Roman Emperor, respectively. Mirroring the latter, a similar earthly political logic upheld other European colonial regimes during the period, as demonstrated in this statement by Sir Walter Raleigh (1554–1618), a prominent Elizabethan poet and explorer who proudly served the English monarchy in North America:

For that infinite wisdome of GOD, which hath distinguished his Angells by degrees: which hath given greater and lesse light and beauty, to Heavenly bodies: which hath made differences betwene beasts and birds: created the Eagle and the Flye, the Cedar and the Shrub: and among stones, given the fairest tincture to the Ruby, and the quickest light to the Diamond: hath also ordained Kings, Dukes or Leaders of the people, Magistrates, Judges, and other degrees among men.[5]

With so much earthly authority at stake, it's no wonder the Great Chain of Being enjoyed such long duration as a "natural" ordering principle in European science, politics, and culture. More than a century after Raleigh, the English poet Alexander Pope (1688–1744) famously affirmed his Christian faith in God's creation, declaring in *An Essay on Man* (1734), "Vast Chain of Being! which from God began, /.... Where, one step broken, the great Scale's began, /.... Where, one step broken, the great Scale's destroy'd: /.... Order is Heav'n's first Law; and, this confest, / Some are, and must be, greater than the rest." Pope's unbending conviction about divine order and hierarchy in nature expressed the anxious intransigence of a European epistemology intent upon maintaining the status quo and extending its power to the Americas.[6]

Needless to say, while some Indigenous people such as Fray Diego embraced the European new order, others resisted the colonial conquest of North and South America. Indeed, millions of Native Americans lost their lives in this invasion or faced upheaval from various forms of violence and disease—an inescapable fact of monstrous proportions that no history book or exhibition can adequately represent. According to the archaeologist William Denevan, who has estimated a pre-Columbian Indigenous population in the Americas of between forty-three and sixty-five million, approximately 90 percent died as a result of the European invasion, constituting "probably the greatest demographic disaster ever." A few works of art registered the destructive impacts of European colonialism in startling ways that sometimes reveal the interconnectedness of cultural and environmental conditions.[7]

For example, illustrations produced by anonymous Aztec artists for a book titled *General History of the Things of New Spain* (1540–85), known as the Florentine Codex, depict the horrific effects of smallpox, one of many European diseases for which Indigenous Americans had no immunity (fig. 17). The environmental historian Alfred Crosby has described the

"ecological imperialism" of such imported diseases as part of the "Columbian exchange," or transatlantic traffic of biotic vectors that have dramatically changed both America and Europe since the colonial era. Executed in a figurative style adapted from European art, these pictures provide a cultural analogue to the biotic exchange they represent. They show infected Native people reclining on beds, their bodies covered with the characteristic rash of pimples, or macules, indicating the deadliest form of smallpox. According to the science historian Charles Mann, smallpox and other European diseases—including influenza, hepatitis, measles, encephalitis, viral pneumonia, tuberculosis, diphtheria, cholera, typhus, scarlet fever, and bacterial meningitis—may have killed more than three-quarters of the Indigenous population of North and South America during the sixteenth and seventeenth centuries following the arrival of Columbus in 1492. This massive mortality, which many regard as a form of genocide, contributed to later European and American misinterpretation of the New World as a pristine, uninhabited "wilderness." Amid the traumatic transformations of European colonialism—both social and environmental—the cultural adaptations of Fray Diego and the Aztec artists of the Florentine Codex asserted an extraordinary resilience and will to survive. In negotiating and bearing witness to world-altering forces of change in their communities, they created hybrid new art forms and identities that were neither "European" nor "American" in any pure or strict sense.8

As Indigenous Americans faced catastrophic change, Europeans held firm to the Great Chain of Being as an unwavering cosmic principle and ordering system. One of the most influential European systematic thinkers about nature in the eighteenth century was Carl von Linné (1707–1778), a Swedish botanist and taxonomist known internationally by his Latinized honorific name, Carolus Linnaeus. The writings of Linnaeus were published in many editions and translated into multiple languages, including English, disseminating his ideas across Europe and America. In one treatise of 1748, for example, he observed that "the closer we get to know the creatures around us, the clearer is the understanding we obtain of the chain of nature, and its harmony and system, according to which all things appear to have been created."9 In another text of 1749, Linnaeus invoked the chain metaphor to describe nature as having an "economy" designed by God:

FIGURE 17: Anonymous Aztec artist, *Illustration of smallpox victims*, in Bernardino de Sahagún, *General History of the Things of New Spain* [*The Florentine Codex*], vol. 3, ms Med. Palat. 220, f. 460v (12 books bound in 3 vols., 1540–85). Biblioteca Medicea Laurenziana, Florence

> By the Oeconomy of Nature, we understand the all-wise disposition of the Creator in relation to natural things, by which they are fitted to produce general ends, and reciprocal uses.... Whoever duly turns his attention to the things on this our terraqueous globe, must necessarily confess, that they are so connected, so chained together, that they all aim at the same end, and to this end a vast number of intermediate ends are subservient.10

Combining theology with economics, Linnaeus interpreted nature as an interconnected system of reciprocal means and ends, "chained together," foreshadowing aspects of modern ecological thought while retaining a classical belief in stasis, harmony, and divine creation.11

Linnaeus's most widely known work, *Systema naturae* (1735; translated into English as *A General System of Nature*, 1806), included human beings among the animals but still affirmed the ancient hierarchy of the Great Chain of Being. This famous taxonomical study participated in the broader European Enlightenment project of producing systematic and ostensibly universal knowledge, a global impulse at once empirical and imperial, famously exemplified in the *Encyclopédie, ou Dictionnaire raisonné des sciences, des arts et des métiers* (*Encyclopedia, or Systematic Dictionary of the Sciences, Arts, and Crafts*), published by Denis Diderot and

Jean Le Rond d'Alembert between 1751 and 1772. Focusing on the world's known life forms, Linnaeus's *Systema naturae* divided earthly phenomena into three broad "Kingdoms"— mineral, vegetable, and animal—distinguished from each other by increasing degrees of vitality and sentience, with "Man" at the apex of earthly creation. In one table (fig. 18), Linnaeus parsed the animal kingdom into six classes (quadrupeds, birds, amphibians, fish, insects, and worms) subdivided by order, genus, and species identified with binomial nomenclature, as in *Homo Europaeus*, or European Man. At the upper left corner of the table, "Homo" (Man) takes precedence within the order "Anthropomorpha," or primates, located atop the quadruped class. In a further subdivision of the species, "Homo Europaeus" heads the list, followed by "Homo Americanus" (Native American Man), "Homo Asiaticus" (Asian Man), and "Homo Africanus" (African

Man). This taxonomy subtly institutionalized Eurocentric geographical hierarchy as if it were natural law, prefiguring many later assertions of white racial superiority in science and other domains.[12]

Peale's Museum and "the grand scale of Nature"

American art of the eighteenth and early nineteenth centuries remained firmly indebted to European classical ideas about order, harmony, plenitude, and hierarchy in nature, including the Great Chain of Being. By far the grandest expression of this classical tradition appears in Charles Willson Peale's *The Artist in His Museum*, a monumental self-portrait of 1822 by the foremost artist and naturalist in Philadelphia (fig. 19). Summarizing a long interdisciplinary career, the painting represents Peale (1741–1827) in his early eighties raising

FIGURE 18: Carl von Linné (Carolus Linnaeus) (Swedish, 1707–1778), *Systema naturae* (*A General System of Nature, through the Three Grand Kingdoms of Animals, Vegetables, and Minerals*), first edition (Leiden: 1735). Missouri Botanical Garden, Saint Louis. Peter H. Raven Library

FIGURE 19: Charles Willson Peale (American, 1741–1827), *The Artist in His Museum*, 1822. Oil on canvas, 263.5 × 202.9 cm. Pennsylvania Academy of the Fine Arts, Philadelphia. Gift of Mrs. Sarah Harrison (The Joseph Harrison, Jr. Collection) (1878.1.2)

a curtain and proudly inviting the viewer to enter the museum he had founded there in the 1780s. Developed from humble beginnings as a home picture gallery, the museum became an important public institution of art and natural science at the center of American civic life. To accommodate its growing collections, Peale moved the museum in 1802 to the second floor of the Pennsylvania State House, now known as Independence Hall. At this famous location, where American revolutionary representatives had publicly announced the Declaration of Independence (1776) and adopted the US Constitution (1787), Peale's Museum, as it was known, acquired national importance.[13]

Admission tickets to Peale's Museum proclaimed the institution was dedicated to "Wonderfull works of NATURE! and Curious works of ART," recalling the European aristocratic tradition of the *Wunderkammer,* or private curiosity cabinet. Peale updated that tradition, however, by introducing a more inclusive, democratic American emphasis on public access and informative entertainment. Though small by European standards, the museum was the first and largest of its kind in the United States, containing more than ten thousand specimens of fauna and flora as well as portraits of illustrious American patriots and scientists, all open for viewing to anyone paying the twenty-five-cent admission fee. Peale complemented what he called the "rational amuse-ment" of exhibits with lectures on "useful knowledge" about agriculture, commerce, and manufactures. Some of these lectures had an ecological flavor, even though the term "ecology" would not be invented until decades later. For example, introducing one lecture series, he argued, "The farmer ought to know that snakes feed on field mice and moles, which would otherwise destroy whole fields of corn," and, "The mechanic ought to possess an accurate knowledge of many of the qualities of those materials with which his art is connected."[14]

Scholars have written a great deal about Peale, his large artistic family, the museum, and *The Artist in His Museum,* one of the masterpieces of American painting. The key point here for our purposes concerns Peale's commitment to representing stable, harmonious order and hierarchy in nature despite the tumult of recent political revolutions in America (1775–83), France (1789–99), and Saint-Domingue (Haiti) (1791–1804), which had challenged the *ancien régime* of European aristocratic privilege by divine right. If Britain's King George III once appeared infallible as an

imperial leader ordained by God and nature (see fig. 15), the American Revolution called into question aspects of the established order of things. A rich source of visual inspiration, this challenge to the divine right of kings found particularly vivid expression in a genre of pictures representing the British monarch upended in various ways, including being allegorically thrown from "The Horse America" (fig. 20) and iconoclastically torn from his pedestal.[15]

While some loyalist observers criticized the American War of Independence as an "unnatural rebellion," revolutionary patriots regarded it as the logical expression of nature itself. For example, as Thomas Paine wrote in *Common Sense* (1776), defending the revolution,

It is repugnant to reason, to the universal order of things to all examples from former ages, to suppose, that this continent can longer remain subject to any external power.... In no instance hath nature made the satellite larger than its primary planet; and as England and America, with respect to each other, reverses the common order of nature, it is evident they belong to different systems: England to Europe, America to itself.[16]

FIGURE 20: Published by Wm. White. *The Horse America, Throwing His Master,* 1779. Etching, 20.3 × 30.4 cm. Library of Congress, Washington, DC. Prints & Photographs Division

Obviously, the "order of nature" was politically contested and depended on the eye of the beholder. Combining art and scientific display, Peale's Museum arranged a harmonious republican "world in miniature" where visitors could learn about their place in a new American vision of nature. The revolution may have rattled the European Great Chain of Being, but it did not dispense entirely with order or hierarchy.[17]

In fact Peale organized his museum exhibits according to Linnaean principles of taxonomy, demonstrating the international currency of *Systema naturae* and the resilience of European classical epistemology even in postrevolutionary America. In a 1792 broadside titled "My Design in Forming This Museum," Peale articulated his decision "to follow the order in which that great man, Linnaeus, has given, in his classing the objects of natural history." Accordingly, he explained, "In the animal kingdom, man is placed in the first class and first order, called *primates*." He then proceeded to describe each subsequent class of "brutes" in descending Linnaean order (quadrupeds, birds, fish, etc.) while noting "the power of art" to preserve specimens of all kinds in portraiture or taxidermy. Some admiring visitors to Peale's Museum understood its Linnaean premises. One perceived how the exhibits were "arranged with the greatest order and judgment, agreeably to the mode prescribed by Linnaeus," while another mentioned the avian display, observing, "The first order, rapacious birds, begins in the upper row, at the east end of the room, and extends nearly to the centre." In an undated manuscript titled "Walk with a Friend in the Philadelphia Museum," Peale invoked Linnaean ideas about the Great Chain of Being: "on a closer view we find the perfection of the works of Creation … each species being fitted to fill their various stations allotted them in the grand scale of Nature, and the more we inspect into her ways, the more we shall have abundant cause to lift up our hearts and minds in love and admiration to the great first cause!" Peale's references to "perfection," "Creation," and "the grand scale of Nature" recall not only Linnaeus but the longer classical tradition going back to Plato and Aristotle.[18]

Visual confirmation of Peale's debts to Linnaean taxonomy and classical epistemology in general appears most vividly in the left background of *The Artist in His Museum* (see fig. 19). Depicted there we see orderly ranks of framed display cases, each containing a three-dimensional habitat diorama with stuffed specimens of birds and an environmentally appropriate landscape backdrop. As the cultural historian Roger B. Stein has observed, "The regularity of the perspectival system on the left frames the cases of birds, visibly arranged in their Linnaean classes, thus pulling together the several senses of the term *classical*." That is, Peale's painted grid of display cases merged the geometric lines of one-point perspective—a Renaissance artistic technique for organizing spatial representation—with Linnaean taxonomy and the Great Chain of Being, producing a manifold expression of classical ideals about order. Broadly speaking, Peale's systematic museum mirrored the rational logic of Linnaeus's taxonomic table (see fig. 18) and the classical urban grid plan of Philadelphia itself, devised by William Penn and drawn by his surveyor Thomas Holme in 1683 on the model of ancient Roman cities. All of these systematic schemes participated in a long-standing European classical tradition of ordering knowledge and space to produce a stable, harmonious vision of the cosmos.[19]

Atop Peale's painted bird display in *The Artist in His Museum* appears the American bald eagle—a powerful and aggressive raptor—standing above songbirds, ducks, geese, and other species perceived as weaker or more docile. This patriotic arrangement followed the Linnaean classification of birds ("Aves"), headed by the order of raptors ("Accipitres"), the family of hawks ("Falco"), and the genus of eagle ("Aquila") in *Systema naturae*. At Peale's feet in the left foreground of the picture we see a dead American turkey, painted from a specimen acquired by Peale's son Titian Ramsay (1799–1855) during a western expedition led by US Army explorer and engineer Stephen H. Long (1784–1864). The lifeless bird rests on a box of tools, awaiting taxidermy preservation.[20]

Presiding over all of these birds and other nonhuman animals, at the top of the room, are rows of human portraits painted by Peale. Framed in gold and hung in the highest part of the museum gallery in a quasi-celestial space near the ceiling, these portraits affirmed the priority of human beings as god-like agents of reason and knowledge on Earth, reiterating the classical humanist hierarchy formulated in antiquity. In an American twist on that hierarchy, a portrait of George Washington (1732–1799), commander of the Continental Army and the first US president, appears directly above the American bald eagle. The Washington portrait resembles the real version of this picture that Peale painted for his museum, one of many that he made of the

president (fig. 21). Such an emblematic juxtaposition of American icons, human and avian, confirms the nationalistic significance of Peale's Museum and reveals an inescapable political impulse informing his classical vision of natural order. Once again we see the power of art to *naturalize* human social relations, revealing "nature" to be subject to interpretation in some degree, not the incontestable bedrock of truth or reality. As American icons, Washington and the eagle lacked divinity, but Peale and his contemporaries certainly revered them above others in the democratic order of things.[21]

The juxtaposition of eagle and turkey also conjured mythic political debates over the design of the "arms," or Great Seal, of the United States (fig. 22), specifically concerning which bird functioned as a more appropriate national symbol. After serving on the congressional committee deliberating about the seal's design, Benjamin Franklin (1706–1790) wrote a famous letter to his daughter criticizing the selection of the eagle. His criticism was part of a broader complaint about the Society of the Cincinnati, an elite society of Revolutionary War veterans whose hereditary, quasi-aristocratic membership policy he considered un-American. Knowing the eagle was one of their symbols, Franklin observed:

> For my own part I wish the Bald Eagle had not been chosen as the Representative of our Country. He is a Bird of bad moral Character. He does not get his Living honestly. You may have seen him perch'd on some dead Tree near the River, where, too lazy to fish for himself, he watches the Labour of the Fishing Hawk; and when that diligent Bird has at length taken a Fish, and is bearing it to his Nest for

FIGURE 21: Charles Willson Peale, *George Washington*, 1787. Oil on canvas, 61 × 48.6 cm. Pennsylvania Academy of the Fine Arts, Philadelphia. Bequest of Mrs. Sarah Harrison (The Joseph Harrison, Jr. Collection) (1912.14.3)

FIGURE 22: James Trenchard (American, 1747–?), based on a design by Charles Thomson (American, born Ireland, 1729–1824), *Arms of the United States*. Engraving. Published in *Columbian Magazine*, September 1786

the Support of his Mate and young Ones, the Bald Eagle pursues him and takes it from him. With all this Injustice, he is never in good Case but like those among Men who live by Sharping and Robbing he is generally poor and often very lousy. Besides he is a rank Coward.[22]

Objecting further that "Eagles have been found in all Countries," Franklin probably knew about the golden eagle, a species associated with European empires going back to ancient Rome, when centurions carried standards emblazoned with them. According to Franklin's political ornithology, "the Turkey is in Comparison a much more respectable bird, and withal a true original Native of America…a Bird of Courage [that] would not hesitate to attack a Grenadier of the British Guards who should presume to invade his Farm Yard with a red Coat on." By the time Peale painted *The Artist in His Museum* in 1822, Franklin's moral objection to the eagle had become part of American folklore, since his private letter was published in 1817 and widely reprinted in newspapers. Peale's prominent representation of both the bald eagle and the turkey negotiated these politics of national ornithology with adroit evenhandedness.[23]

If earlier European epistemology had presupposed the divine right of kings, the American order of things would instead be an empire of democracy, albeit one still hierarchical in its social implications. *The Artist in His Museum* acknowledges a degree of diversity in Peale's institutional audience by including a female visitor in the background and showing chandeliers for evening hours, which enabled working-class people to visit. Though not pictured in *The Artist in His Museum*, a variety of ethnographic artifacts collected from non-Western human communities around the world were also displayed at the institution. A wax figure of explorer Meriwether Lewis, for example, wore Native American clothing of the Shoshone tribe. Peale hired an African American man, Moses Williams—in fact his former slave—to operate a popular concession for making silhouette portraits, using a device called a physiognotrace to produce souvenir profile pictures of museum visitors (fig. 23). Despite such gestures toward diversity, Peale, like Aristotle and Linnaeus before him, remained the chief arbiter of order and knowledge. Peale's visual prominence at the center of *The Artist in His Museum*, his forehead brightly illuminated as an emblem of "enlightenment," embodied the hegemonic privileges

FIGURE 23: Moses Williams (American, ca. 1775–ca. 1825), *Hannah Moore Peale (1755–1821)*, after 1802. Hollow-cut silhouette on wove paper, 12.4 × 9.8 cm. Philadelphia Museum of Art. Gift of the McNeil Americana Collection (2009-18-42 [168])

enjoyed by men like him in early national America. As the historian David Brigham has observed, "Peale addressed his audience with a rhetoric of inclusiveness that, ironically, promoted social boundaries. . . . The overall message was that humanity should live in harmony, but that hierarchical relationships are natural." Even in the American context of Peale's democratic public museum, the Great Chain of Being's political ecology upheld the prerogative of economically advantaged white men as if it were the law of nature.[24]

Extinction and the End of the Chain

Peale's harmonious classical vision of order and hierarchy faced a looming threat, however, from the greatest attraction in his museum: a reconstructed fossil skeleton of an extinct mastodon. We can see this remarkable specimen lurking mysteriously in the shadows behind Peale's palette and paintbrushes on the right side of *The Artist in His Museum*, partially obscured by the curtain. In 1801 Peale learned about the

FIGURE 24: Charles Willson Peale, *Exhumation of the Mastodon*, ca. 1806–8. Oil on canvas, 124.5 × 156.2 cm. Maryland Historical Society, Baltimore City Life Museum Collection; Museum Department (MA5911)

discovery of large bones in a watery marl pit on a farm in Orange County, New York, near the town of Newburgh, about sixty miles up the Hudson River from Manhattan. Sensing an opportunity to add a dramatic new display to his museum, Peale traveled to upstate New York and negotiated a deal with the farmer for the bones and any additional discoveries on the site. With funding from the American Philosophical Society and equipment from the US Army, Peale constructed an elaborate mill-wheel device with buckets to remove water mechanically from the pit. He also hired twenty-five local laborers to power the device and conduct excavations in hopes of acquiring more bones to produce a complete mastodon skeleton. Working over the summer and early autumn of 1801, this team succeeded in unearthing all but the creature's underjaw and parts of its skull. Together with other Philadelphia scientists and members of his own family, Peale then assembled the skeleton, using papier-mâché to re-create the lost bone fragments. Just before Christmas in 1801, he held a private viewing of the reconstructed fossil specimen for members of the American Philosophical Society. Soon the mastodon would become the star of the museum, occupying a special "Mammoth Room" to which visitors paid a premium admission fee of fifty cents. This popular spectacle drew large crowds and netted Peale a sizable profit, but the special ticket price—comparable to buying a novel or a mid-priced theater seat—put the mastodon exhibit out of reach for many skilled and unskilled workers like those whose labor had made it possible.[25]

Peale commemorated the process of unearthing his prize specimen in *Exhumation of the Mastodon* (fig. 24). The picture dramatizes the discovery as a modern scientific enterprise set in a stormy landscape symbolizing the human struggle to control and understand nature. Here the ranking system of the Great Chain of Being has become a two-tiered industrial hierarchy: barebacked workers conduct physical labor in the muddy pit below, excavating bones and filling buckets of water attached to a mechanical chain, while Peale and other members of his managerial class command the scene from above. In a self-portrait at right, Peale wears a spotless white shirt and down toward the workers while members of his large family stand nearby, signaling their powers of reason and intellect by holding a large scientific drawing of mastodon bones.[26]

Peale enthusiastically promoted his exhibit of the mastodon, advertising it as the "ANTIQUE WONDER" and the

"LARGEST of Terrestrial Beings!" This sort of marketing obviously expressed personal pride and commercial opportunism, but it also conveyed a serious nationalistic message about American natural history at a time of international controversy. An influential European treatise by the foremost eighteenth-century French scientist, Georges-Louis Leclerc, Comte de Buffon (1707–1788), had claimed the American environment was so inhospitable as to cause physical, moral, and intellectual degeneracy among its inhabitants, human and nonhuman alike. Such an argument, if true, might mean that the United States as a new nation was destined to fail, so Peale and other Americans set out to gather evidence to refute it.[27]

Leading this American scientific rejoinder to Buffon was Thomas Jefferson (1743–1826), the great American revolutionary and third president of the United States, who avidly collected specimens of natural history for his Monticello home (fig. 25) when not engaged in his many other nation-building pursuits. Jefferson was particularly interested in "mammoth" specimens that could clearly disprove the Frenchman's theory of American environmental degeneracy. In this climate of naturalistic nationalism, a veritable

FIGURE 25: Upper jawbone of mastodon, excavated 1807. 45.7 × 41.9 × 29.2 cm. Thomas Jefferson Foundation, Charlottesville, Virginia

mania for exploration, exhumation, and display of mastodon bones gripped Peale and his contemporaries. For Jefferson, though, fossil specimens were not enough. He wanted to repudiate Buffon's theory by demonstrating the existence of *living* mastodons and other comparably large creatures that he believed were still roaming the American wilderness. To this end, Jefferson instructed Meriwether Lewis and the Corps of Discovery expedition (1804–6) to pay particular attention to "the animals of the country generally, & especially those not known in the US. / the remains & accounts of any which may be deemed rare or extinct."[28]

Jefferson's uncertain language—"may be deemed rare or extinct"—points to another international scientific controversy, one of far greater significance than that concerning Buffon's inaccurate theory of American environmental degeneracy. This more momentous controversy had to do with species extinction, an issue of crucial importance in the history of ecological knowledge and thought. Amid the frenzy of exploration for mastodon bones and other fossil specimens of natural history circa 1800, most Europeans and Americans, including Jefferson and Peale, doubted that an entire species could become extinct, for this idea contradicted the Great Chain of Being and the entire classical order of things.[29]

Consistent with this enduring classical tradition, Jefferson wrote in *Notes on the State of Virginia* (1785), "Such is the oeconomy of nature, that no instance can be produced of her having permitted any one race of her animals to become extinct; or her having formed any link in her great work so weak as to be broken." Jefferson maintained this belief tenaciously, reasserting it in a 1799 memoir by saying, "For if one link in nature's chain might be lost, another and another might be lost, till this whole system of things should evanish by piece-meal." Not unlike Copernicus's heliocentric model of Earth's solar system, Charles Darwin's theory of evolution, or today's science on global warming, species extinction provoked disbelief and denial among many because it undermined centuries of entrenched classical faith in a stable, harmonious natural order designed by God in perfect plenitude for the eternal dominion of humankind.[30]

The pivotal modern figure responsible for proving the reality of extinction was a French scientist named Georges Cuvier (1769–1832). An expert in comparative anatomy, Cuvier studied fossil skeletons in relation to living species with similar bone structures. Through careful analysis of specimens from around the world, he was able to determine when a fossil differed decisively from all of its living relatives, verifying the extinction of a species. Cuvier's findings appeared in a series of influential French publications during the first years of the nineteenth century, forever altering Western epistemology and history by introducing unequivocal evidence of such discontinuity as a fact of nature. It was even Cuvier who, in an 1806 article, gave the name "mastodon"—or "breast tooth"—to the American creature exhumed and assembled by Charles Wilson Peale, noting how the unique shape of its grinders distinguished the animal from an elephant.[31]

Before Cuvier's publication, Peale and his fellow Americans had referred to the mastodon generically as the "Mammoth" or "Great American Incognitum" (meaning "Unknown"). For example, when Peale's son Rembrandt (1778–1860) took a second mastodon skeleton assembled by his father on a tour of Europe in 1803, he wrote an accompanying booklet titled *Historical Disquisition on the Mammoth, or Great American Incognitum*. But whereas Charles Wilson Peale adhered, like Jefferson, to classical faith in the Great Chain of Being, Rembrandt reflected the emerging modern science of Cuvier by proclaiming, "the bones exist—the animals do not!" News from France traveled quickly to America. Only a few years later, fellow Philadelphian Benjamin Smith Barton (1766–1815) echoed Rembrandt in affirming Cuvier's discovery, writing in *A Discourse on Some of the Principal Desiderata in Natural History* (1807):

I speak of these animals as *extinct*. In doing this, I adopt the language of the first naturalists of the age. No naturalist, no philosopher; no one tolerably acquainted with the history of nature's works and operations, will subscribe to the puerile opinion, that Nature does not permit any of her species of animals, or of vegetables, to perish. . . . THERE IS NO SUCH THING AS A CHAIN OF NATURE.[32]

Within just a few decades at the end of the eighteenth century and the beginning of the nineteenth, revolutions in politics and science had revealed not only "self-evident" truths and "common sense" about the rights of mankind but also discomforting facts concerning species extinction and the instability of order and hierarchy of nature. The order and hierarchy of

FIGURE 26: Charles Willson Peale and Titian Ramsay Peale (1799–1855), *The Long Room, Interior of Front Room in Peale's Museum*, 1822. Watercolor over graphite on paper, 35.6 × 52.7 cm. Detroit Institute of Arts, Founders Society Purchase, Director's Discretionary Fund (57.261)

things no longer seemed to be set in stone. For his part, Charles Willson Peale looked back retrospectively on these developments in *The Artist in His Museum* with a certain ambiguity, just as he had treated the eagle/turkey controversy with deliberate evenhandedness. Environmental historian Mark Barrow has observed that "Peale remained firmly committed to the idea of the chain of being and therefore reluctant to accept the idea of extinction," but in *The Artist in His Museum* he hedged his bets. While unwilling to abandon the ancient paradigm of divine order that had served as an article of faith in Western epistemology for two thousand years, Peale did not want to appear old-fashioned in the face of new science, so he cautiously— and even alluringly—shrouded the mastodon in shadows. A contemporary watercolor sketch, executed by Peale with the help of his son Titian Ramsay, provides a more straightforward documentary view of the museum interior (fig. 26). In its frank depiction of specimens arranged according to Linnaean taxonomies, the watercolor discloses the imaginative dimension of *The Artist in His Museum*, wherein the mastodon appears as a mysterious "unknown."

inserted fictively as a speculative disruption in the otherwise orderly array.[33]

Challenging the Hierarchy of Genres in Art

If Peale and his son Rembrandt diverged in their willingness to embrace the new science of extinction, the generation gap between Charles and another son, Raphaelle (1774–1825), demonstrates the implications of an unraveling classical epistemology in art. Two very different pictures by father and son respectively, *George Washington at the Battle of Princeton* (1783–84) and *Still Life with Steak* (1816–17), reveal an emerging breakdown or schism in the traditional hierarchy of artistic genres, whereby categories of painting were ranked according to degrees of human significance and moral gravity. Let us first consider Charles Willson Peale's *George Washington at the Battle of Princeton* (fig. 27), a large portrait produced with the monumentality and drama of history painting, a genre defined by the representation of exemplary human subjects performing actions of lasting social consequence. In keeping with those conventions, Peale depicted the commander of the

FIGURE 27: Charles Willson Peale, *George Washington at the Battle of Princeton*, 1783–84. Oil on canvas, 237 × 145 cm. Princeton University, commissioned by the Trustees (PP222)

Continental Army leading American revolutionary forces to a crucial military victory at Princeton during the Revolutionary War. Washington, founder and future president of a nation, stands before an American flag in a confident pose that fore-shadows that of Peale himself before the curtain in *The Artist in His Museum*. Meanwhile, General Hugh Mercer, Washington's friend and associate, lies dying at right in the arms of Dr. Benjamin Rush as another soldier looks on. Among the grandest portraits of the first US national icon, Peale's picture of Washington was commissioned by the Trustees of the College of New Jersey (later Princeton University) to commemorate these heroic and historic events at Princeton. There the artist himself had served as an officer in a Philadelphia militia, part of an American force that ejected the British from their stronghold at Nassau Hall, then the college's sole architectural landmark and the portrait's intended destination, visible in the left background of the picture behind the raging battle. Adding to the portrait's rich historical significance, it replaced an earlier picture of King George II that once occupied the same frame—until blasted away by an American cannonball during the battle.[34]

History painting, sometimes called the "grand style," was considered the most elevated genre for its seriousness and technical complexity, conferring high intellectual status on its successful practitioners. Classical theories of art and literature, like those in natural history, dictated the primacy of human beings as the central thematic focus and criterion for judging aesthetic achievement. Here again, Aristotle provided a key theoretical model. His *Poetics* had called for writers and artists to create "representations of life," declaring, "Since living persons are the objects of representation, these must necessarily be either good men or inferior." Moreover, Aristotle believed that "the more serious poets represented fine doings and the doings of fine men" in order to reveal morally instructive "general truths" about human history and character. Follow-ing these theoretical principles, Europeans came to regard history painting, like epic poetry, to be more meaningful than other artistic genres (landscapes, animal pictures, still lifes), which were deemed deficient in moral complexity and depth because they lacked human subject matter. Aristotle's aesthetic criteria were revived by Renaissance humanists such as Leon Battista Alberti and Leonardo da Vinci and then institutionalized in European art academies.[35]

One particularly clear statement about the hierarchy of genres was made by the seventeenth-century French art theorist and historian André Félibien (1619–1695) in a publi-cation for the French Royal Academy under King Louis XIV:

He who produces perfect landscapes is above another who only produces fruit, flowers or seashells. He who paints living animals is more estimable than those who only repre-sent dead things without movement, and as man is the most perfect work of God on the earth, it is also certain that he who becomes an imitator of God in representing human figures, is much more excellent than all the others ... a painter who only does portraits still does not have the highest perfection of his art, and cannot expect the honor due to the most skilled. For that he must pass from repre-senting a single figure to several together; history and myth must be depicted; great events must be represented as by historians, or like the poets, subjects that will please, and climbing still higher, he must have the skill to cover under the veil of myth the virtues of great men in allegories, and the mysteries they reveal.[36]

Félibien did not mention the Great Chain of Being explicitly here, but his statement took its Aristotelian humanistic assumptions and hierarchical logic for granted. His theory of artistic genres reveals the enduring influence of classical crite-ria based on varying degrees of vitality, intellect, and proxim-ity to God. As the cultural historian Mark Ledbury has noted, the "upward progression" of Félibien's statement "justifies the elevation of history painting on religious and philosophical premises which clearly delineate Man from the rest of nature." In this important respect, the classical traditions in art and natural science were mutually reinforcing. The Great Chain of Being and the hierarchy of genres presupposed the same ancient, humanistic belief in a scale of nature. Charles Willson Peale literalized this classical belief in the *Staircase Group* (1795), depicting his eldest son, Raphaelle, climbing a stairway with palette and maulstick in hand. The Philadelphia Museum of Art now displays the *Staircase Group* as it once appeared in Peale's Museum, with a real wooden stair at the base, creating an illusion of continuity between the viewer's space and the painting. As the art historian David Steinberg observes, "Proffering a near-irresistible invitation to ascend virtually, the sequence from step to canvas to picture space implied the transformation that could take place in one's experience of the painting when moving from a low-ranked engagement with illusionism to a high-ranked reading of

FIGURE 28: Benjamin West (American, 1738–1820). *The Death of General Wolfe,* 1770. Oil on canvas, 152.6 × 214.5 cm. National Gallery of Canada, Ottawa. Gift of the 2nd Duke of Westminster to the Canadian War Memorials, 1918; Transfer from the Canadian War Memorials (1921800?)

allegory." The *Staircase Group* expressed Peale's hopeful belief that his son would rise above the low illusionism of still-life painting into the more exalted realm of history.[37]

As we have already seen, however, by the end of the eighteenth century such classical ideas faced important modern challenges and revisions. In a period marked by political revolution and the discovery of extinction, calling into question the Great Chain of Being, artists increasingly tested and modified the old hierarchy of genres. This process of artistic

renegotiation was already well under way by 1770, when the expatriate American painter Benjamin West (1738–1820) produced *The Death of General Wolfe* in London for exhibition at the Royal Academy (fig. 28). West's picture broke with classical conventions by using the familiar elements of history painting—multifigure composition, didactic emotional expressions, and allusions to antiquity—in representing a *recent* event as one of profound importance. Before this time, history painting had focused on events of the

Greco-Roman or biblical past, with figures dressed in togas and other ancient garments. Instead, West's painting drama-tized the demise of an eminent British officer, General James Wolfe, at the Battle of Quebec in 1759, a decisive military engagement of the Seven Years' War between Great Britain and France that determined which European superpower would govern Canada. By showing Wolfe expiring poi-gnantly at the pivotal moment of British victory, posed in a manner recalling earlier pictures of Christian martyrdom yet wearing contemporary military attire, West deftly updated the genre of history painting and conferred moral signifi-cance on a heroic *modern* subject. In this respect, the picture provided an important model for many later artists, includ-ing Charles Willson Peale, who had studied with West in London from 1767 until 1769.[38]

Exhibited publicly at the Royal Academy in 1771, *The Death of General Wolfe* caused consternation among aesthetic traditionalists, who felt that the general and his officers at least should have appeared wearing classical clothing. Royal Academy president Joshua Reynolds objected that "the clas-sic costume of antiquity" was preferable to "the modern garb of war," but West responded by arguing that "the same truth that guides the pen of the historian should govern the pencil of the artist. I consider myself as undertaking to tell this great event to the eye of the world; but, if instead of the facts of the transaction, I represent classical fictions, how shall I be understood by posterity!" Ironically, West's painting intro-duced certain modern fictions by including a number of fig-ures who were not even present at the depicted event. Nevertheless, *The Death of General Wolfe* caused a popular sensation, prompting King George III to appoint West as the official court artist. Even Reynolds had to admit that "this picture will not only become one of the most popular, but occasion a revolution in the art."[39]

Reynolds's apparent flexibility regarding the classical hierarchy of genres also found voice in his well-known series of lectures at the academy, compiled and published as the *Discourses* (1769–90). Compared with Félibien, Reynolds interpreted artistic hierarchy with noticeably greater latitude and liberality. The British painter still used the classical lan-guage of "rank," "mental" activity, and "heroic action," but he was open to the possibility that *any* subject matter—human or nonhuman—"may be raised into dignity... in the hands of a painter of genius." What mattered to Reynolds was the power of art to "convey sentiment" and "produce

emotion" in elevating the chosen subject. These new criteria encompassed sensory, psychological dimensions of human nature that defined modern "aesthetics" (from the Greek *Aisthetikē*, or referring to sense perception).[40]

Raphaelle Peale's *Still Life with Steak* (see fig. 128) belongs to the modern aesthetic world of Reynolds, not the arch-classical paradigm of Félibien, for it asserted the "dignity" and emotional power of inanimate objects—here raw meat, a cabbage, some carrots, and a beet—instead of treating them with imperious condescension. Raphaelle's modest work conforms to the ancient genre of still life, sometimes called "deception" or *trompe l'oeil* (French for "trick the eye"), a category traditionally viewed as the lowliest of all because of its illusionistic representation of ordinary, nonhuman subject matter. As such, Raphaelle's picture occupied the opposite end of the artistic hierarchy and scale of nature so grandly envisioned in his father's *George Washington at the Battle of Princeton*. Whereas Charles remained wedded to the classical pursuit of reason and elevated rank, Raphaelle embraced emerging Romanticism. Accordingly, *Still Life with Steak* represented everyday objects with unusual visual interest by placing them directly before us, practically as equals. As the art historian Alexander Nemerov has observed, "This point of view, in which the artist claims no special authority over objects" asserts a "primal identification" with them that is "sympathetic." For Nemerov, the visceral representation of meat in *Still Life with Steak* recalls late eighteenth-century discourse about sympathy and pity for the suffering of "fellow-creatures"—both human and nonhuman—as famously articulated in Jean-Jacques Rousseau's educational treatise *Emile* (1762). Yet Raphaelle's phenomenological imagination went further, exceeding earlier still-life painting by undoing the sense of bodily and emotional distance that even Rousseau preserved as necessary to maintaining control of human identity. In *Still Life with Steak*, says Nemerov, "primal identification is so strong, so fixated, as to nullify the idea of individual progress," producing "a hermetic space," from which nothing socially useful is learned."[41]

Is there not something useful in pondering such an inti-mate connection with things beyond the human? Raphaelle's democratic approach to nonhuman objects and beings questioned the classical order of things and looked forward to modern ecological thought. Also, as discussed elsewhere in this book, the artist's particular configuration of meat and vegetables, far from being "a hermetic space," invited

consideration of a wider world of agricultural relationships that were historically specific to early nineteenth-century America. Indeed, Raphaelle's sensitive, aesthetic depiction of nonhuman things as vital co-constituents of selfhood embodied not closure but radical openness to seeing human beings as materially implicated with their environment.

An Environmental Artist with "no taste for landscape-painting"

John James Audubon (1785–1851) brought a similar sense of identification and openness about nonhuman vitality to the representation of birds. Raised amid revolutions in Haiti and France, he moved to America in 1803 to manage an estate owned by his father outside Philadelphia. Unsuccessful in this or other conventional business, Audubon decided to pursue his passion for shooting and painting birds. By the early 1820s, he conceived the most ambitious project of ornithological illustration in the history of art: *The Birds of America* (1827–38), a luxury publication comprising four vol-umes filled with 435 large hand-colored engravings, each depicting specimens at life size. Audubon hired professional engravers and colorists in Great Britain to reproduce the original watercolor drawings he made over the course of nearly two decades, mostly from birds he had freshly killed in the North American wild. *The Birds of America* was the product of a tremendous collaborative effort involving extensive fieldwork and international travel, family support, tireless promotion, and creative activity. It also entailed the relentless slaughter of birds. Ironically, by the end of the nineteenth century, Audubon had posthumously become the namesake of the first major wildlife conservation organiza-tion in America.[42]

Audubon's artistic enterprise merits special attention because of its complex, interdisciplinary approach. After shooting a bird in the wild, he set about translating its decomposing physical body into a lively two-dimensional representation, using a gridded board, metal pins (for posing the corpses), compass, watercolors, and paper. Later, the professional engraver and hired colorists meticulously repro-duced his original pictures in prints through a multistep, quasi-industrial process carefully monitored by Audubon and his sons. Printed on "double-elephant" folio pages mea-suring more than two by three feet, *The Birds of America* was the largest book ever made when it was completed in 1838.

To accompany the prints, Audubon wrote hundreds of detailed descriptions of the birds examining their behavior and habitats; he compiled these texts in a five-volume publi-cation titled *Ornithological Biography* (1831–39).[43]

Audubon's insistence on depicting the birds at their actual size aptly responded to particular historical conditions, including Buffon's scientific allegations about American bio-logical degeneracy. As a failed businessman ruined in the Panic of 1819, Audubon also may have adopted this approach in order to ensure accuracy and economic value at a time when these seemed to be in short supply. Noting the irony that real birds traveled freely compared to Audubon and his bulky artistic apparatus, the art historian Jennifer Roberts has suggested that the actual-size paradigm produced odd visual effects of perspective, leaving the birds seemingly "exiled" in a shallow foreground space detached from their background landscape habitat. We see such effects, for exam-ple, in the *Red-tailed Hawk*, where two birds in flight appear fighting over a captured rabbit, their bodies vividly crowding the surface of the page while a background mountain range looks as if it were miles away (fig. 29). For Roberts, Audubon's apparent failure to conform to classical conven-tions of landscape representation compromises his reputation as an "environmental" artist.[44]

This assertion raises interesting questions about environ-mental representation in general. Audubon certainly was not an environmentalist by today's standards, but must represen-tation operate according to classical conventions of pictorial continuity and perspective in order to have environmental significance? Is only landscape imagery that adheres to European Renaissance standards of spatial perspective a legitimate form of environmental representation? Is it possi-ble that Audubon's art might register other kinds of environ-mental meaning despite, or even precisely by, disrupting such humanistic conventions and focusing our attention on more-than-terrestrial things—like birds? As mentioned in this book's introduction, landscape aesthetics, important though they are, tend to limit our focus on one part of the environment, namely land, seen from a human perspective. Looking beyond Renaissance landscape conventions for various forms of environmental information was in fact a deliberate strategy of Audubon. A polyglot multimedia artist, he wrote *Ornithological Biography* and other texts to comple-ment *The Birds of America*, producing an assemblage of data that defies and exceeds Roberts's criterion of "true"

FIGURE 29: John James Audubon (American, born Haiti, 1785–1851), *Red-tailed Hawk*. Hand-colored engraving and aquatint on Whatman wove paper by Robert Havell Jr. (American, born England, 1793–1878), plate: 95.5 × 62.1 cm. Published in *The Birds of America* (London: 1827–38), Vol. 1, Pl. 51. Princeton University Library. Rare Books and Special Collections

immersion in a pictorial-environmental field." As Audubon frankly stated in one essay, he had "no taste for landscape-painting," evidently because he found that genre constraining. Certain passages of the *Ornithological Biography* even cued the reader's attention back and forth between text and image by referring directly to specific pictures in *The Birds of America*, effectively integrating visual and nonvisual information as part of the artist-writer's interdisciplinary approach. For example, in the *Ornithological Biography* entry on the "Red-tailed Hawk," Audubon recalls, "It was after witnessing such an encounter between two of these powerful marauders, fighting hard for a young Hare, that I made the drawing, in which you perceive the male to have greatly the advantage over the female, although she still holds the prey firmly in one of her talons." Viewers of Audubon's *Red-tailed Hawk* could also read his verbal description of how the bird "is extremely wary, and difficult to be approached by any one bearing a gun, the use of which it seems to understand perfectly; for no sooner does it perceive a man thus armed than it spreads its wings, utters a loud shriek, and sails off in an opposite direction." Here we have valuable environmental information about nonhuman intelligence and visual recognition. If Audubon's picture did not coherently represent all of this information according to Renaissance conventions of spatial illusion, perhaps this was unnecessary because he trusted his audience to put the pieces together and reach an integrated understanding that was greater than the sum of its parts. No classical landscape painting could provide all of this ecological knowledge, which Audubon communicated through multiple media. Undoubtedly, his ability to do so helps explain why later American environmentalists have seen in his achievement an important source of inspiration.[45]

Looking more closely at *Red-tailed Hawk*, we see a violent encounter between birds as well as their aggressive treatment of a rabbit, whose terror the artist intensely conveyed by showing the captured animal defecating—one of the most startling examples of realism in nineteenth-century art. The violence of Audubon's representation signals an important break from earlier modes of scientific interpretation and illustration premised on theological beliefs about harmony in nature. This is no picturesque retreat or reassuring vision of God's dominion, but rather art that confronts conflict in a world where death is a brutal fact of life. No wonder Darwin, whom the environmental historian Donald Worster has called "the single most important figure in the

history of ecology," was a great admirer of Audubon's work, citing him repeatedly as an authority for information about animal behavior in numerous publications. Darwin attended a lecture by the artist in Edinburgh in 1826 and recalled the event thirty years later by praising Audubon's "interesting discourses on American birds." Audubon's editorial collaborator in writing the *Ornithological Biography* was Darwin's friend, the Scottish naturalist William MacGillivray.[46]

Despite the technical quirks of Audubon's pictures, they convey remarkable knowledge about the birds themselves, not just as violent predators but also as intelligent beings whose behaviors were intimately familiar and fascinating to him, so much so that they sometimes overwhelm his pictorial compositions in *The Birds of America*. To understand his extraordinary appreciation of bird vitality and sentience, we can compare his *Carolina Parrot* (fig. 30) with an earlier depiction of this species by Mark Catesby (ca. 1682–1749) in an important eighteenth-century publication titled *The Natural History of Carolina, Florida and the Bahama Islands* (1731–43) (fig. 31). Catesby's art, among the finest of its kind at the time, adhered to the classical paradigm of scientific illustration that Audubon made obsolete. In contrast to Catesby's stiff specimen in profile, Audubon's flock of parakeets brim with dynamic vitality and communal interaction, bursting from the page as they twist, turn, and gesticulate; one even turns its head to draw the viewer into the depicted scene.[47]

In his *Ornithological Biography* entry on the "Carolina Parrot," Audubon noted that the birds "are destroyed in great numbers, for whilst busily engaged in plucking off the fruits or tearing the grain from the stacks, the husbandman [farmer] approaches them with perfect ease, and commits great slaughter among them.... The gun is kept at work; eight or ten, or even twenty, are killed at every discharge.... I have seen several hundreds destroyed in this manner in the course of a few hours, and have procured a basketful of these birds at a few shots, in order to make choice of good specimens for drawing the figures by which this species is represented in the plate now under your consideration." In words that hauntingly anticipated the extinction of this species less than a century later, Audubon observed, "Our Parakeets are very rapidly diminishing in number; and in some districts, where twenty-five years ago they were plentiful, scarcely any are now to be seen." As the literary historian Christoph Irmscher has observed, the artist still believed in the benevolence and order of a divine creator, but "Audubon's

FIGURE 30: John James Audubon, *Carolina Parrot*. Hand-colored engraving and aquatint on Whatman wove paper by Robert Havell Jr., plate: 83.5 × 59.6 cm. Published in *The Birds of America* (London: 1827–38), Vol. 1, Pl. 26. Princeton University Library. Rare Books and Special Collections

FIGURE 31: Mark Catesby (British, ca. 1682–1749), *The Parrot of Carolina*. Hand-colored etching, plate: 26.2 × 35 cm. Published in *The Natural History of Carolina, Florida and the Bahama Islands [...]* (London: 1731), Vol. 1, Pl. 11. Princeton University Library. Rare Books and Special Collections

universe in *The Birds of America* is, in the final analysis, dominated by waste."[48]

Audubon's environmentalism, inchoate as it was, enabled him to meet birds halfway, observing and at least partially understanding them in a space somewhat like the one that the twentieth-century American artist and environmentalist Robert Rauschenberg would call the "gap" between "art and life." If Audubon's birds seem to collide with the pictorial surface or plane of representation, so did he, by pressing his face against the window, as it were, and straining to see what he called "their manners, and faculties, and worth" as well as their "beauty" and "life." In these and other ways, Audubon's birds—even with their spatial disjunctions—constitute early inklings in the emergence of ecology as a defining idea and mode of perception in modernity.[49]

Birds and the legacy of Audubon serve as an environmental leitmotif of sorts in American art of the late twentieth and early twenty-first centuries. One striking example is the 2005 etching *Dying Words* by Walton Ford (born 1960), depicting a gathering of extinct Carolina parakeets (fig. 32). This humorously macabre work recalls Audubon's celebrated composition of the same species, perched together in cocklebur bushes and communicating in a manner consistent with the older artist's detailed description of them in his *Ornithological Biography*. But Ford's picture also riffs cleverly on another art historical antecedent by arranging the

FIGURE 32: Walton Ford (American, born 1960), *Dying Words*, 2005. Hard-ground etching, aquatint, spit-bite aquatint, drypoint, scraping, and burnishing on white Rives paper, 40.6 × 54.6 cm. Courtesy Paul Kasmin Gallery, New York

birds in a composition modeled after West's magnum opus *The Death of General Wolfe*, showing the mortally wounded British commander surrounded by attentive officers as he expires melodramatically at the conclusion of a victorious battle against the French (see fig. 28). In contrast to West's earnest treatment of Wolfe as a Christ-like martyr for the British Empire, Ford's supine parakeet reads somewhat ambiguously, at once ludicrous in its mocking reference to an art historical prototype and poignant in its acknowledgment of social behavior among birds driven to extinction by human conquest.[50]

As if speaking from beyond the grave of extinction, Audubon's work continues to resonate within the art world and the broader sphere of popular visual culture. In 2014, for example, the National Audubon Society unveiled its Audubon Mural Project, in which a number of New York City street artists were invited to paint pictures of endangered birds on empty walls and metal roll doors in the Hamilton Heights and Washington Heights neighborhoods of Manhattan, where the artist lived during the last years of his life. These ongoing engagements with Audubon's work disclose a kind of vernacular wisdom about the vital agency of his art and of the birds he painted.[51]

Notes

1 Michel Foucault, *The Order of Things: An Archaeology of the Human Sciences* (New York: Pantheon, 1970); Arthur O. Lovejoy, *The Great Chain of Being: A Study of the History of an Idea* (Cambridge, MA: Harvard University Press, 1936).

2 Lovejoy, *Great Chain of Being*, 33, 46–55; Macrobius, quoted in Lovejoy, 63.

3 On Valadés, see Daniela Bleichmar, *Visual Voyages: Images of Latin American Nature from Columbus to Darwin* (New Haven: Yale University Press in association with the Huntington Library, Art Collections, and Botanical Gardens, 2017), 77–80; Don Paul Abbott, *Rhetoric in the New World: Rhetorical Theory and Practice in Colonial Spanish America* (Columbia: University of South Carolina Press, 1996), 41–59; and Francisco de la Maza, "Fray Diego Valadés: Escritor y Grabador Franciscano del Siglo XVI," *Anales del Instituto de Investigaciones Estéticas* 4, no. 13 (1945): 15–44.

4 Ernst Haeckel, *Generelle Morphologie der Organismen* (Berlin: Reimer, 1866), 286–87. For background on Haeckel and "ecology," see Astrid Schwarz and Kurt Jax, eds., *Ecology Revisited: Reflecting on Concepts, Advancing Science* (New York: Springer, 2011), 145–53; and Donald Worster, *Nature's Economy: A History of Ecological Ideas*, 2nd ed. (New York: Cambridge University Press, 1994), 191–93.

5 Sir Walter Raleigh, *The History of the World in Five Books* (London: Printed for Walter Burke, 1614), [xviii–xix]; Mark L. Brake, *Revolution in Science: How Galileo and Darwin Changed Our World* (New York: Palgrave Macmillan, 2009), 89–102.

6 Alexander Pope, *An Essay on Man* (London: Printed for John Wright, 1734), 19, 57.

7 William M. Denevan, "The Pristine Myth: The Landscape of the Americas in 1492," in *American Environmental History*, ed. Louis S. Warren (Malden, MA: Blackwell, 2003), 5. See also Tzvetan Todorov, *The Conquest of America: The Question of the Other*, trans. Richard Howard (Norman: Oklahoma University Press, 1999).

8 Alfred W. Crosby, *Ecological Imperialism: The Biological Expansion of Europe, 900–1900*, 2nd ed., new ed. (New York: Cambridge University Press, 2004); Crosby, *The Columbian Exchange: Biological and Cultural Consequences of 1492* (Westport, CT: Praeger, 2003); Charles C. Mann, *1493: Uncovering the New World Columbus Created* (New York: Vintage Books, 2012), 14.

9 Carolus Linnaeus, "Taenia" (1748), in *Amoenitates Academicae* (Holmiae: Laurentium Salvium, 1751), 2:59, quoted and translated by Sten Lindroth, "The Two Faces of Linnaeus," in *Linnaeus: The Man and His Work*, ed. Tore Frängsmyr (Berkeley: University of California Press, 1983), 16.

10 Carolus Linnaeus, "The Oeconomy of Nature" (1749), in *Miscellaneous Tracts Relating to Natural History, Husbandry, and Physick*, ed. Benjamin Stillingfleet (London: J. Dodsley, Leigh and Sotheby, and T. Payne, 1791), 39–40.

11 On Linnaeus and economics, see Lisbet Koerner, *Linnaeus: Nature and Nation* (Cambridge, MA: Harvard University Press, 2001).

12 Carolus Linnaeus, *Systema naturae* (Leiden: Johannes Wilhelm de Groot, 1735), unpaginated [1, 10–11]. On Diderot and the encyclopedic impulse, see Joanna Stalnaker, *The Unfinished Enlightenment: Description in the Age of the Encyclopedia* (Ithaca: Cornell University Press, 2010). Regarding Linnaeus's influence on later racial science, notably J. F. Blumenbach, see Stephen Jay Gould, *The Mismeasure of Man*, rev. ed. (New York: W. W. Norton, 1996), 403–6. An egregious example of Eurocentric hierarchy appears in Josiah C. Nott and George R. Gliddon, *Types of Mankind: Or, Ethnological Researches, Based upon the Ancient Monuments, Paintings, Sculptures, and Crania of Races, and upon Their Natural, Geographical, Philological, and Biblical History* (Philadelphia: Lippincott, Grambo, 1854). This "scientific" treatise of comparative anatomy buttressed the institution of slavery by advocating the false theory of polygenism, which construed races as different and unequal species. As Nott wrote on page 457, "I do not believe in the intellectual equality of races, and can find no ground in natural or human history for such popular credence. . . . [A] man must be blind not to be struck by similitudes between some of the lower races of mankind, viewed as connecting links in the animal kingdom." This reference to "connecting links" interpreted the Great Chain of Being explicitly in racist terms. On the next page, an anonymous illustration showed a hierarchical arrangement of heads, with Apollo—the Greek god of reason, order, and harmony—symbolically presiding over a generic "Negro" and a "Young Chimpanzee." The racial and cultural implications of this array were clear to classically educated nineteenth-century readers, since the god's visage copied that of the Apollo Belvedere, the most celebrated surviving work of ancient Hellenistic art. As the art historian Kirk Savage has observed, "What is quite literally a comparison of god, man, and animal is nevertheless meant to be read as a comparison of white man, Negro, and animal." Kirk Savage, *Standing Soldiers, Kneeling Slaves: Race, War, and Monument in Nineteenth-Century America* (Princeton: Princeton University Press, 1997), 9.

13 David R. Brigham, *Public Culture in the Early Republic: Peale's Museum and Its Audience* (Washington, DC: Smithsonian Institution Press, 1995); David C. Ward, *Charles Willson Peale: Art and Selfhood in the Early Republic* (Berkeley: University of California Press, 2004).

14 Brigham, *Public Culture*, 5, 37.

15 Arthur S. Marks, "The Statue of King George III in New York and the Iconology of Regicide," *American Art Journal* 13, no. 3 (1981): 61–82.

16 Thomas Paine, *Common Sense* (Philadelphia: W. & T. Bradford, 1776), 79, 83; Ruma Chopra, *Unnatural Rebellion: Loyalists in New York City during the Revolution* (Charlottesville: University of Virginia Press, 2011).

17 Peale quoted in Brigham, *Public Culture*, 1.

18 Charles Willson Peale, "My Design in Forming This Museum" (1792), in *Museum Origins: Readings in Early Museum History and Philosophy*, ed. Hugh H. Genoways and Mary Anne Andrei (New York: Routledge, 2016), 23. Visitors quoted in Brigham, *Public Culture*, 58. Charles Willson Peale, "Walk with a Friend in the Philadelphia Museum," unpublished manuscript, Historical Society of Pennsylvania, quoted in Roger B. Stein, "Charles Willson Peale's Expressive Design: The Artist in His Museum," in *New Perspectives on Charles Willson Peale:*

A 250th Anniversary Celebration, ed. Lillian B. Miller and David C. Ward (Pittsburgh: University of Pittsburgh Press, 1991), 189. For more about Linnaeus's influence on Peale, see Stein, "Charles Willson Peale's Expressive Design," 186–90, and Brigham, *Public Culture*, 36, 45, 57, 58, 71, 75, 113.

19 Stein, "Charles Willson Peale's Expressive Design," 188–89. On the Penn/Holme plan of Philadelphia, see Alan C. Braddock and Laura Turner Igoe, eds., *A Greene Country Towne: Philadelphia's Ecology in the Cultural Imagination* (University Park: Pennsylvania State University Press, 2016), 1–6.

20 Stein, "Charles Willson Peale's Expressive Design," 171. On the Long Expedition, see Kenneth Haltman, *Looking Close and Seeing Far: Samuel Seymour, Titian Ramsay Peale, and the Art of the Long Expedition, 1818–1823* (University Park: Pennsylvania State University Press, 2008).

21 For more on Washington's status as cultural icon, see Barbara J. Mitnick, ed., *George Washington: American Symbol* (New York: Hudson Hills Press, 1999); and Wendy Wick Reaves, *George Washington, an American Icon: The Eighteenth-Century Graphic Portraits* (Washington, DC: Smithsonian Institution Traveling Exhibition Service, National Portrait Gallery, 1982).

22 Benjamin Franklin to Sarah Bache, January 26, 1784, Franklin Papers, American Philosophical Society, http://franklinpapers.org/franklin/framedVolumes.jsp?vol=41&page=281.

23 Franklin's letter was reproduced in numerous American newspapers after the publication of *The Private Correspondence of Benjamin Franklin*, ed. William Temple Franklin (London: Printed for Henry Colburn, 1817). See, for example, "Franklin Waggery," *Lancaster Journal*, July 25, 1817, 3. On the Great Seal, see Richard S. Patterson and Richardson Dougall, *The Eagle and the Shield: A History of the Great Seal of the United States* (Washington, DC: Department of State, 1976). Regarding the ancient Roman "Aquila" symbol, see James Yates, "Signa Militaria," in *A Dictionary of Greek and Roman Antiquities* (London: John Murray, 1875), 1044–46.

24 Brigham, *Public Culture*, 6–9, 12, 29–30, 68–82, 123–24.

25 Mark V. Barrow Jr., *Nature's Ghosts: Confronting Extinction from the Age of Jefferson to the Age of Ecology* (Chicago: University of Chicago Press, 2009), 33–39; Brigham, *Public Culture*, 26–27.

26 Lillian B. Miller, "Charles Willson Peale as History Painter: *The Exhumation of the Mastodon*," in Miller and Ward, *New Perspectives on Charles Willson Peale*, 145–65.

27 On Buffon's theory of American environmental degeneracy, see Lee Alan Dugatkin, *Mr. Jefferson and the Giant Moose: Natural History in Early America* (Chicago: University of Chicago Press, 2009); Barrow, *Nature's Ghosts*, 17.

28 Thomas Jefferson, "Instructions to Meriwether Lewis" (June 20, 1803), Thomas Jefferson Papers, Library of Congress, https://www.loc.gov/exhibits/lewisandclark/transcript57.html.

29 Barrow, *Nature's Ghosts*, 19–23.

30 Barrow, 15–39; Jefferson quoted on 15, 31. See also Elizabeth Kolbert, *The Sixth Extinction: An Unnatural History* (New York: Henry Holt, 2014), 23–46.

31 Barrow, *Nature's Ghosts*, 39–46; Georges Cuvier, "Sur le grand masto-donte," *Annales du Muséum d'Histoire Naturelle* 8 (1806): 270–312; plate 49 facing page 312.

32 Rembrandt Peale and Benjamin Smith Barton quoted in Barrow, *Nature's Ghosts*, 38, 42.

33 Barrow, *Nature's Ghosts*, 38. On the watercolor, see Lillian B. Miller, ed., *The Peale Family: Creation of a Legacy, 1770–1870* (New York: Abbeville Press in association with the Trust for Museum Exhibitions and the National Portrait Gallery, Smithsonian Institution, 1996), 265.

34 For more on this filial comparison, see Lillian B. Miller, "Father and Son: The Relationship of Charles Willson Peale and Raphaelle Peale," *American Art Journal* 25, no. 1/2 (1993): 4–61. On the portrait, see David C. Ward, "Creating a National Culture: Charles Willson Peale's *George Washington at the Battle of Princeton* in History and Memory," *Princeton University Art Museum Record* 70 (2011): 4–17; on its frame, see Elizabeth Baughan and Karl Kusserow, "Framing History in Early Princeton," *Princeton University Art Museum Record* 70 (2011): 18–29.

35 Aristotle, *Poetics*, trans. W. Hamilton Fyfe (Cambridge, MA: Harvard University Press, 1932), 5, 9, 15, 35. On Aristotle and Renaissance art theory, see Anthony Blunt, *Artistic Theory in Italy, 1450–1600* (Oxford: Clarendon Press, 1940).

36 André Félibien, *Conférences de l'Academie royale de peinture et de sculpture pendant l'année 1667* (Paris, 1669), translated in Paul Duro, "Imitation and Authority: The Creation of the Academic Canon in French Art, 1648–1870," in *Partisan Canons*, ed. Anna Brzyski (Durham: Duke University Press, 2007), 96. See also Barbara Anderman, "Félibien and the Circle of Colbert: A Reevaluation of the Hierarchy of Genres," in *Ordering the World in the Eighteenth Century*, ed. Diana Donald and Frank O'Gorman (New York: Palgrave Macmillan, 2006), 143–62.

37 Mark Ledbury, *Sedaine, Greuze and the Boundaries of Genre* (Oxford: Voltaire Foundation, 2000), 19. David Steinberg, "Educating for Distinction? Art, Hierarchy, and Charles Willson Peale's *Staircase Group*," in *Seeing High and Low: Representing Social Conflict in American Visual Culture*, ed. Patricia Johnson (Berkeley: University of California Press, 2006), 34.

38 Allen Staley, *Benjamin West: American Painter at the English Court* (Baltimore: Baltimore Museum of Art, 1989), 52; Edgar Wind, "The Revolution of History Painting," *Journal of the Warburg Institute* 2, no. 2 (1938): 116–27.

39 Staley, *Benjamin West*, 52, for the quotations of Reynolds and West.

40 Joshua Reynolds, *Discourses* (New York: Penguin, 1992), 116 (*Discourse IV*, 1771), 254 (*Discourse XI*, 1782); Terry Eagleton, *The Ideology of the Aesthetic* (Cambridge, MA: Basil Blackwell, 1990).

41 Alexander Nemerov, *The Body of Raphaelle Peale: Still Life and Selfhood, 1812–1824* (Berkeley: University of California Press, 2001), 91, 92.

42 Christoph Irmscher, "Audubon at Large," in *The Poetics of Natural History: From John Bartram to William James* (New Brunswick, NJ: Rutgers University Press, 1999), 188–235; Richard Rhodes, *John James Audubon: The Making of an American* (New York: Vintage, 2004); Carolyn Merchant, *Spare the Birds! George Bird Grinnell and the First Audubon Society* (New Haven: Yale University Press, 2016).

43 John James Audubon, *Ornithological Biography; or, An Account of the Habits of the Birds of the United States of America, Accompanied by Descriptions of the Objects Represented in the Work Entitled The Birds of America, and Interspersed with Delineations of American Scenery and Manners*, 5 vols. (Edinburgh: Adam and Charles Black, 1831–1839).

44 Jennifer L. Roberts, *Transporting Visions: The Movement of Images in Early America* (Berkeley: University of California Press, 2014), 69–115.

45 John James Audubon, "Account of the Method of Drawing Birds employed by J. J. Audubon, Esq. F.R.S.E." (1824), in *Audubon: Writings and Drawings*, ed. Christoph Irmscher (New York: Library of America, 1999), 758; Audubon, "Red-tailed Hawk," in *Ornithological Biography*, 1:269.

46 For references to Audubon, see Charles Darwin, *Journal of Researches into the Natural History and Geology of the Countries Visited during the Voyage of H.M.S. "Beagle" Round the World* (London: John Murray, 1845), 184, 185; Darwin, *On the Origin of Species by Means of Natural Selection* (London: John Murray, 1859), 185, 212, 387; Darwin, *The Expression of the Emotions in Man and Animals* (London: John Murray, 1872), 98. Worster, *Nature's Economy*, 114; Diana Donald, "The 'Struggle for Existence' in Nature and Human Society," in *Endless Forms: Charles Darwin, Natural Science and the Visual Arts*, ed. Diana Donald and Jane Munro (New Haven: Yale University Press, 2009), 90.

47 Mark Catesby, *The Natural History of Carolina, Florida, and the Bahama Islands* (London: Printed by the author, 1731–43), 1: plate 11. On Catesby, see E. Charles Nelson and David J. Elliott, eds., *The Curious Mister Catesby: A "Truly Ingenious" Naturalist Explores New Worlds* (Athens: University of Georgia Press, 2015).

48 Audubon, *Ornithological Biography*, 1:136, 138; Irmscher, *The Poetics of Natural History*, 217.

49 Robert Rauschenberg quoted in *Sixteen Americans* (New York: Museum of Modern Art, 1959), 58; Audubon, "Account of the Method of Drawing Birds," 755, 756. On Audubon's early conservationist sensibility and its limitations, see Daniel Patterson, "Audubon's Conservation Ethic Reconsidered," in *The Missouri River Journals of John James Audubon*, ed. Daniel Patterson (Lincoln: University of Nebraska Press, 2016), 211–304.

50 Steven Katz and Dodie Kazanjian, *Walton Ford: Tigers of Wrath, Horses of Instruction* (New York: Abrams, 2002).

51 "Audubon Mural Project," National Audubon Society, http://www.audubon.org/amp; Matt A. V. Chaban, "Audubon Mural Project Brings 5-Story Flock to Uptown Manhattan," *New York Times*, October 16, 2015.

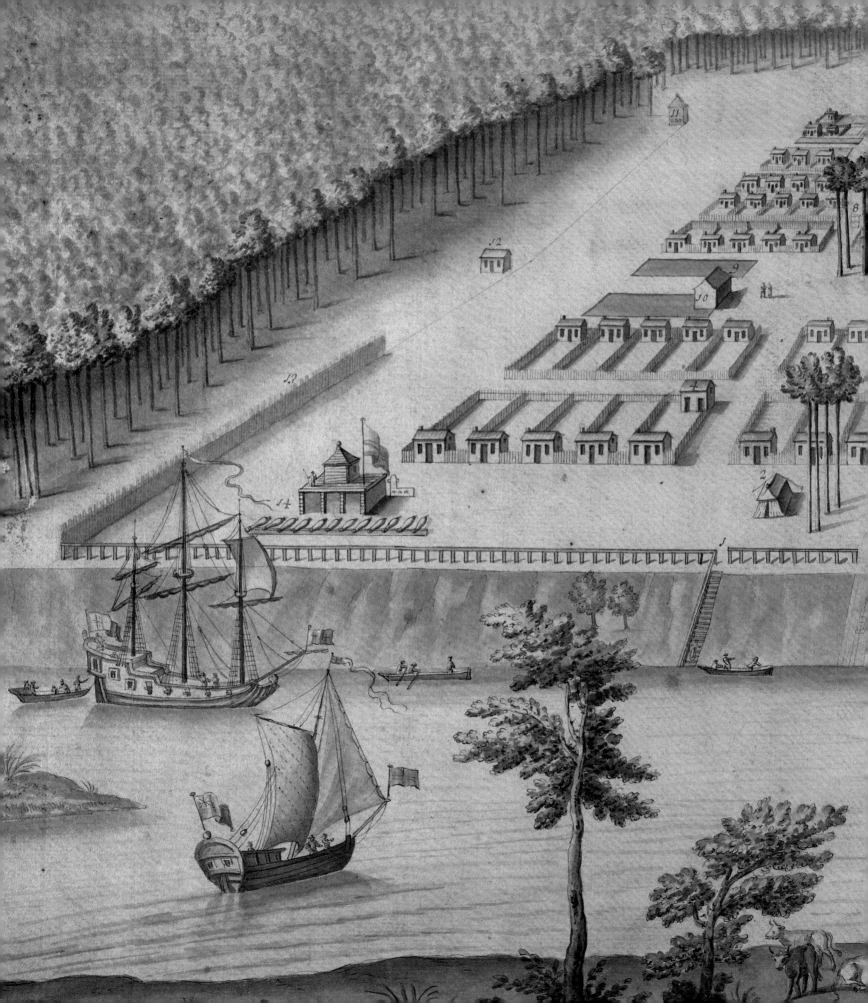

Karl Kusserow

Ordering the Land

Picturing People, Picturing Places

If the impulse to conceptually order the natural world through successive epistemological regimes of divine revelation, natural theology, and Enlightenment science characterized Western thought over time, a similar desire to organize nature's archetypal representation—the landscape view—is apparent from the start in American visual culture as well. In 1590 the artist and publisher Theodor de Bry (1528–1598) issued a group of images illustrating Thomas Hariot's *A Briefe and True Report of the New Found Land of Virginia [...]*, written by a member of Sir Walter Raleigh's second expedition to coastal North Carolina (1585–86), and significant as the earliest English account of North America. De Bry's accompanying engravings, based on watercolors by another expeditioner, John White (ca. 1540–ca. 1593), comprise natural history illustrations, ethnographic portraits, genre and town scenes, maps, and landscape views. Collectively, they present an optimistic, wish-fulfillment vision of America as a place of both great exoticism and promise, in keeping with the essentially promotional, expansionist aims of Hariot's text.

Several of de Bry's engravings picture resource extraction, underscoring the New World's appealing natural abundance (see also his contemporaneous engraving of Indigenous silver miners; fig. 113). *Their manner of fishynge in Virginia* (fig. 33) shows people of the Roanoke or Secotan tribes—Carolina Algonquians—harvesting fish in various ways from the manifestly plentiful waters off Roanoke Island. Although the sight portrayed would have been entirely unfamiliar to its intended European audience of backers and prospective settlers of Raleigh's envisioned colony, the engraving works hard to present the alien tableau in the most favorable light.

Apart from the copious array of fish and fowl, the image itself is composed as a stable grid, structuring the exotic scene with a reassuringly rational rectilinearity. The strips of land at front and back, the frieze-like canoe in the foreground (echoed by others in the distance), and particularly the water's articulation through innumerable layers of parallel lines all impart a horizontal stasis to the view, one regularly bisected at right angles by the spaced weirs in the background as well as by the foreground standing figures. The impression is one of visual fixity and conceptual control despite the foreign subject. Even the peculiar marine life, situated parallel to the picture plane and for the most part horizontally, adheres to the pictorial order and is rendered as generalized, easily understood icons. De Bry additionally adopts the drawing technique of doubling (the repetition of pictorial elements in pairs), which amplifies the depicted plenitude while subtly diminishing the potentially alienating strangeness of its parts, supplying multiple examples of natural oddities that might otherwise appear disconcertingly unique. And by orienting certain important pairs, such as the figures in the canoe, to show corresponding front and back sides, the engraving affords an additional sense of knowledge and subjective control—namely, of the scene existing for the viewer. The overall effect is to render a potentially overwhelming and threatening new environment as not only comprehensible but also capable of—even inviting—colonial dominion.[1]

This was essential, as America was considered by Europeans with a mixture of both trepidation and allure. The royal patent Raleigh received from Queen Elizabeth "to discover, search, find out, and view such remote heathen and barbarous lands ... as to him ... shall seem good, and the same to

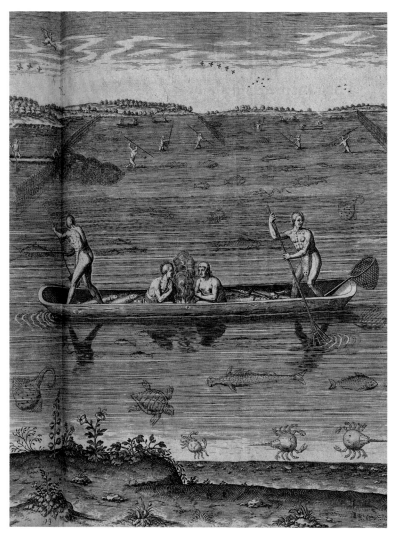

FIGURE 33: Theodor de Bry (Flemish, 1528-1598), after John White (English, ca. 1540–ca. 1593), *Their manner of fishynge in Virginia.* Engraving. Published in Thomas Hariot, *A Briefe and True Report of the New Found Land of Virginia [...]*, (Frankfurt: 1590). The Folger Shakespeare Library, Washington, DC

have, hold, occupy, and enjoy" suggests these countervailing apprehensions of the unknown place ("heathen and barbarous" yet possible to "enjoy"), then as much concept as entity. White later returned to Roanoke Island on a second Raleigh expedition, now intending to establish and govern the first permanent English settlement in North America. He deposited just over one hundred settlers on the island in the summer of 1587 and returned to England for provisions, but by the time he was able to come back three years later, the Lost Colony, as it came to be called, had vanished, indicating the difficulty of early settlement and further conditioning European thoughts about the North American environment. These were complemented during the early seventeenth century by Puritan and especially Pilgrim accounts of, in the words of Plymouth Colony leader William Bradford, whose Pilgrim settlers arrived on the *Mayflower*, "a hideous and desolate wilderness, full of beasts and wild men." Similarly bleak conceptions held sway until midcentury and beyond, as when the Puritan poet and minister Michael Wigglesworth, of the larger Massachusetts Bay Colony based in Boston, described New England as "A Waste and howling wilderness" ruled by Satan. The supposedly uncivilized, unimproved American environment—in actuality inhabited and in various ways productively managed by diverse Indigenous peoples for centuries—served as metaphor as well as perceived reality. By figuring America as wilderness, and wilderness as depraved and irreligious, Europeans justified their conquest and transformation of it by divine right. When the philosopher John Locke evoked the first words of Genesis to contend, with property rights in mind, "In the beginning all the world was America," he solidified a linkage, entrenched by 1689 when he wrote it, of New World nature and godly sanction. America offered up a stage for the sacred project, articulated elsewhere in the book of Genesis, to "subdue ... and have dominion ... over every living thing that moveth upon the earth" (as if nature had no right to exist but to serve humankind).[2]

The menacing connotations of wilderness did not end with the seventeenth century, and the images produced here by Europeans during the early eighteenth century, surviving in numbers finally exceeding the seventy watercolors made by White more than a century before, both reflected and bolstered this understanding—mostly, counterintuitively, through portraits. The art of portraying people would seem an unlikely place to discern environmental attitudes, but in

expressing the relationship of sitters to their often outdoor surroundings, portraits offer the opportunity to explore evolving human relations not just with one another but with everything else. And in any case they are about all we have, since portraits constitute the only pictorial Western art produced in quantity in North America before the end of the eighteenth century. By examining a continuum of American portraits incorporating natural or landscape backgrounds from across the eighteenth century, we can compare and contrast the ways in which each constructs the external world, and discern the sitters' relationship to it. Although American artists relied heavily on European sources in devising their compositions—on prints made after painted portraits, on occasional exposure to the paintings themselves, and more diffusely on mutual immersion in a transatlantic visual aesthetic—they exerted their own agency in the particular sources they chose to adopt, and in how they modified and developed those sources. Many European portraits were set indoors and contain no landscape elements at all. That American artists gravitated toward the inclusion of natural backgrounds suggests they were influenced not only by foreign artistic precedent but also by local conditions and attitudes about their existence at what was considered the margins of the cultivated world.[3]

The German-born artist Justus Engelhardt Kühn (died 1717) painted the most ambitious surviving portraits of early colonial America, all dozen or so of them made for the same three, interrelated Maryland families. His paired portrayals of the Darnall children, Henry III (ca. 1710; Maryland Historical Society) and his sister Eleanor (fig. 34), are staples of American art textbooks, in part because the portrait of Henry includes the earliest known, and deeply troubling, depiction of an African American in American art—a collared servant sequestered, unlike his sister's pet dog, on the opposite side of an elaborate balustrade. Also disconcerting are the portraits' background views onto the realm of nature, which seems anything but natural. Instead, the external world appears fantastical, in elaborate scenes of imaginary gardens with ornamental fountains and baroque architectural trappings—views all the more obviously invented for the failure of the two of them to match. Although the wealthy Darnalls owned some thirty-five thousand acres west of Maryland's Chesapeake Bay and completed a large brick mansion, the Woodyard, in the years immediately preceding Kühn's paintings—which must have been meant to hang

there—both portraits are set before landscapes nothing remotely like what would have been present there or anywhere else in the colonies at the time. Rather, in conjuring baroque, parklike vistas as regimented as the checkered pavement on which Eleanor stands, Kühn and other early émigré artists, familiar with the existence of such places from prints or paintings or firsthand experience abroad, offered a representation of American "nature" that confidently portended the productive, even aestheticized, domestication of a landscape whose actual wild and uncultivated state was considered unappealing and downright threatening. Later portraits, such as the portrayal, some twenty years later, of another young girl likewise set apart by a balustrade from the less elaborate but comparably regulated nature beyond (fig. 35), share a common impulse to bring conceptual control to an unruly world, until actual dominion might be achieved. They serve as visual analogues to the observations of settlers dating back to the previous century, eager to describe progress in transforming the fearsome wilderness: "The hideous Thickets in this place were such, that Wolfes and Beares nurst up their young from the eyes of all beholders, in those very places where the streets are full of Girles and Boys sporting up and downe, with a continued concourse of people."[4]

Similar strategies characterize early American landscape representations in their other limited appearances, such as the drawing of Savannah, Georgia, completed in 1734 by George Jones (active 1733–1734) after Noble Jones (1702/5–1775) (fig. 36). Here artifice also prevails over any possible observed reality as the settlement, merely a year old, is rendered with a systematized linearity that extends even to the trees of the encroaching forest and the wholly prospective layout of the unimproved lots. Like de Bry's fishing scene of a century and a half before, the image's overwhelming rectilinearity imparts stability and coherence to the articulated natural forms, in keeping with their mutual aim of encouraging settlement through nature's rationalization. It is not such a distance from here to the willful symmetries in the backgrounds of Kühn's Darnall children paintings; in each case, a desire to mentally organize and visually shape an untouched environment widely held to be useless and overwhelming allows it instead to be imagined as manageable and fruitfully habitable.

Around the second third of the eighteenth century, such overtly fictive landscape inventions gave way to persuasively

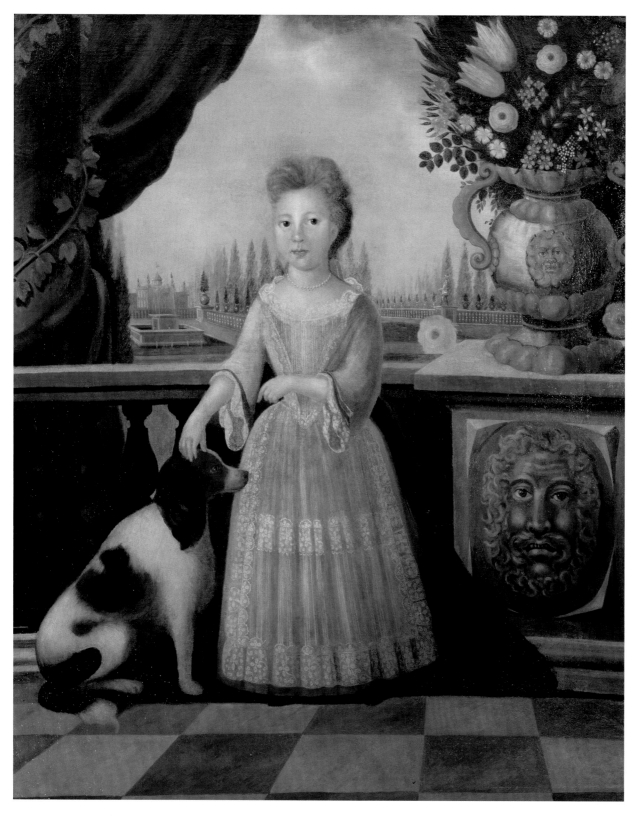

FIGURE 34: Justus Engelhardt Kühn (American, born Germany, died 1717),
Eleanor Darnall, 1704–1796, ca. 1710. Oil on canvas, 137.8 × 111.8 cm. Maryland
Historical Society, Baltimore. Bequest of Miss Ellen C. Daingerfield (1912.1.5)

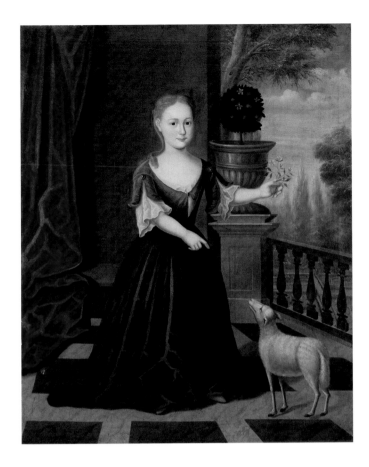

FIGURE 35: Unidentified artist, *De Peyster Girl, with a Lamb*, ca. 1730–35. Oil on canvas, 127.6 × 104.1 cm. New-York Historical Society. Bequest of Catherine Augusta De Peyster (1911.5)

FIGURE 36: George Jones (British, active 1733–1734), after Noble Jones (American, born England, 1702/5–1775), *A View of Savannah as It Stood the 29th of March, 1734*, 1734. Ink on paper, 37.5 × 65 cm. University of Georgia Libraries, Athens. Hargrett Rare Book and Manuscript Library

FIGURE 37: John Smibert (American, born Scotland, 1688-1751), *Portrait of Mrs. Hugh Hall*, 1733. Oil on canvas, 124.5 × 99.1 cm. Denver Art Museum. Funds from 1983 Collectors' Choice Benefit, Acquisition Challenge Grant, Mabel Y. Hughes Charitable Trust, Volunteer Endowment, Mr. and Mrs. Paul Atchison, Mr. and Mrs. Bruce Benson, Mr. and Mrs. William C. Foxley, Mr. and Mrs. Charles Haines Jr., Mr. and Mrs. William R. James, Mr. and Mrs. Frederick R. Mayer, Mr. and Mrs. Robert Petteys, Mr. and Mrs. Walter S. Rosenberry III, Mr. and Mrs. Keith Singer, and anonymous donors (1984.819)

realistic settings. These conceivably actual landscapes, though they retain an air of creative design due to their generic appearance, embody a distinct shift in conceptions of American nature, from one in which a disorderly wilderness is metaphorically tamed through wholesale invention to one in which a more plausible naturalized setting can be appreciated on its own terms. This shift was informed by changes abroad, where Enlightenment discovery led to a dawning understanding of environmental complexity and the subsequent association of the divine with nature in even its wilder aspects. The concept of sublimity and a proto-Romantic appreciation of unregulated nature developed in the writings of Edmund Burke, Immanuel Kant, and later William Gilpin and others, and was materially expressed in landscape painting and design as well as in period portraiture. In America, as settlement advanced and the perceived threat of wilderness receded, the emerging notion of a productive human symbiosis with nature perfectly suited local conditions. It is first broached pictorially in the work of John Smibert (1688–1751), the most advanced painter active in the colonies before 1750. The subject of his 1733 *Portrait of Mrs. Hugh Hall* (fig. 37) occupies a new, liminal space both of and apart from her placid natural surroundings—in contrast to the emphatic separation of the two in the earlier portraits we have seen—and she conspicuously points a finger to relate herself to the adjacent landscape. This device, commonly encountered in religious images in which the finger is pointed upward to connote divine assistance, here signifies nature's beneficence in constructing the world of the sitter. Certainly Mrs. Hall was not literally linked to the sort of nature shown in her portrait—she lived in Boston, and her husband was a merchant with strong family ties to Barbados, not the temperate vales Smibert has conjured for his wife's portrait. Rather, her representation as in harmony with nature responded more generally to changing attitudes here and abroad about it, and to the specific conditions of her American situation.[5]

The few surviving proper landscapes of the period (those unaffiliated with portraits) reveal a similar loosening, naturalizing impulse. British military officer and artist Thomas Davies (ca. 1737–1812) made sketches for *View of the Lines at Lake George, 1759* (fig. 38) while serving in the French and Indian War, and completed the painting based on them some years later. Davies's canvas shows the encampment of British troops at the lake's southern end, following the destruction

FIGURE 38: Thomas Davies (British, ca. 1737–1812), *View of the Lines at Lake George, 1759*, ca. 1774. Oil on canvas, 64.1 × 76.8 cm. Fort Ticonderoga Museum, Ticonderoga, New York

FIGURE 39: Ralph Earl (American, 1751–1801), *Esther Boardman*, 1789. Oil on canvas, 108 × 81.3 cm. The Metropolitan Museum of Art, New York. Gift of Edith and Henry Noss, 1991 (1991.338)

FIGURE 40: Ralph Earl, *Daniel Boardman*, 1789. Oil on canvas, 207.4 × 140.4 cm. National Gallery of Art, Washington, DC. Gift of Mrs. W. Murray Crane (1948.8.1)

of the adjacent Fort William Henry by the French and their Native American allies. Comparing Davies's picture to the earlier but similarly utilitarian Savannah scene—of which it is a kind of mirror image, a view looking over a settlement onto water instead of the reverse—the sense of human integration with the surrounding environment is now far more complete, with the receding tent rows echoed in the ranging hills beyond, their forms in turn softened and conjoined with their watery reflections, and the entire prospect framed by brushy trees. Despite the subject—a military installation hacked out of the wilderness—the image stresses the intermingling of its parts, including people with the encompassing landscape.

As ongoing settlement and cultivation enabled artists to encounter a nature that was in actuality domesticated, their portraits increasingly feature particular environments

within the natural world rather than portraying it as a general construct, as in Smibert's paintings. In 1789 Ralph Earl (1751–1801) painted a portrait of Esther Boardman (fig. 39) seated on a hill before a distant view of New Milford, the Connecticut town her family was instrumental in settling. In this and other Boardman family portraits by Earl—he painted nineteen—we see the realization of an ideal Kühn could only imagine and Smibert approached just figuratively: the co-optation and commodification through human agency of the American wilderness. Enlightenment thought had affirmed knowledge and development in place of the Calvinist narrative of human degradation, and the related efflorescence of natural history posited progress through the improvement and transformation of the physical world. Portraits like Earl's, picturing the subjugation, settlement, and cultivation of nature, finally embodied these aims.[6]

FIGURE 41: Ralph Earl, *Looking East from Denny Hill*, 1800. Oil on canvas, 116.2 × 201.6 cm. Worcester Art Museum, Massachusetts (1916.97)

Esther's portrait makes a fascinating comparison with Earl's larger and grander one of her brother Daniel (fig. 40), which the artist completed the same year. Each is set on a rise along the Housatonic River, looking northwest toward town, where the spire of the Congregational Church, founded by the siblings' grandfather (and Daniel's namesake), locates the scene and grants the sitters a kind of baronial dominion over it. Esther is seated on the ground, Earl's preferred format for young women, and further bound to it by her moss-green gown; her dark ringlets link her to the adjacent trees, and her forearms echo the angle of the slope on which she rests. Compared to the portrait of her brother, we see more of the hillside and less of the town. Daniel stands rather than sits, and seems set before rather than within his natural surroundings. His fashionable pose mirrors the serpentine form of the upright tree opposite, but his elbow points to town, and his white shirt, vest, and breeches tie him to the buildings and fencerows there, and to the sky over them, bringing the cultivated background forward. Daniel's right shirtsleeve, whose ruffled edges connect him to the similarly articulated background fences, likewise has a bridging effect, and the reddish lining of his hat and the hanging seals at his waist draw out other parts of the town.

Whereas Esther's portrait affords us a glimpse of the town through the screen of nature, in Daniel's it is as much the subject as he is. Compared to the earlier portraits we have

seen, both Boardmans evince a new closeness with the environment, but in different ways. Esther is of the woods, allied with the land in its natural state; Daniel is of the town, linked to his surroundings in their transformed state, and with nature as property. The gendered implications of the comparison can be seen to reveal a persistent parallel between the historical domination of both women and nature by male interests of conquest and property, such that sexism and environmental exploitation can each be considered artifacts of patriarchy.[7]

Late in his career, Earl produced a handful of pure landscapes, logical extensions of the views of property so often appearing in his portraits behind their subjects. Indeed, the first of these were themselves portraits of a sort—only of houses not people—expressing the ability of his sitters to now transfer their identities onto the environments they had domesticated, in the tradition of English estate views. Earl's earliest landscape, of the Ruggles homestead in New Milford (1796; current location unknown), is one such picture, showing its modest subject enveloped—even engulfed—by the surrounding landscape, inadvertently expressing the enormity of the unsettled world. It makes an interesting comparison with the artist's last landscape, *Looking East from Denny Hill* (fig. 41), completed a year before Earl's death in 1801. This, by contrast, is a view *from* its patron's property, and is indebted to another European tradition of more expansive

"prospect" views. The later painting looks outward instead of back in, anticipating the emergence of landscape representation that was to flourish in American art during the nineteenth century, and which was also deeply informed by changing perceptions of the relationship between people and their surrounding environments.

The Promise of the Picturesque

Before embarking on his brief career as a landscape artist, Earl painted an unusual portrait that referenced both genres. As if to test the waters, he first produced a portrait of someone else painting a landscape. Earl's portrayal of Colonel William Taylor (fig. 42) came a year after his paintings of Esther and Daniel Boardman, and formed part of a similar

FIGURE 42: Ralph Earl, *Portrait of Colonel William Taylor*, 1790. Oil on canvas, 123.8 × 96.5 cm. Albright-Knox Art Gallery, Buffalo, New York. Charles Clifton Fund, 1935 (1935:14.1)

series of likenesses done for the Taylors, an interrelated New Milford family. William was the son of Nathaniel Taylor, who in 1749 married Tamar Boardman after assuming her father's pastoral duties at the church visible in the back of both Esther's and Daniel's portraits. A farmer, merchant, and Revolutionary War veteran, William Taylor was also an early amateur landscape painter.

Curiously, William's depiction by Earl seems more like that of his female cousin, Esther, than his contemporary male relative, Daniel Boardman, who stands distinct and proprietary before the vista behind him. Taylor is shown seated parallel to the landscape visible through the adjacent open window, and united with it by the pervasive green palette. The arrangement of the composition coheres the scene as well, forming a pictorial and conceptual circle moving counterclockwise from the landscape the sitter has been observing, through the means of his perception—eyes and head—down his extended arm (echoed by the curved arm of the chair) to the instrument for recording his impressions (pen), and finally to their realization on the easel propped before him. The painting thematizes the translation through art of real to represented landscape. Coming on the eve of Earl's own engagement with pure landscape painting—and that of American art, generally—the sort of landscape he shows Taylor creating assumes particular interest, as does the kind of actual landscape deemed worthy of artistic attention.

Compared to topographical views like the one of Savannah in 1734 (see fig. 36), the landscapes set before Taylor are different. Both the vista through the window conjured by Earl and, even more, Taylor's schematic rendition of it are informed by the aesthetic dictates of the picturesque, a pictorial idiom then flourishing in England that found especially fertile ground in America, where it remained the dominant mode of landscape representation for over half a century. Occupying a middle ground between the transcriptive tradition of British estate views and topographical scenes—increasingly disdained for their slavish, mechanical orientation—and the richly imaginative but somewhat outmoded conventions of classical landscape descended from the French master Claude Lorrain (1604/5–1682), the picturesque arose in England during the mid-eighteenth century and was later influentially theorized by William Gilpin, Uvedale Price, and Richard Payne Knight. It responded there to the accelerated enclosure (the transfer of communal properties to private individual plots) and

FIGURE 43: John Taylor (American, 1735-1806), *A Wooded Classical Landscape at Evening with Figures in the Foreground*, 1772. Oil on canvas, 101.6 × 127 cm. Crystal Bridges Museum of American Art, Bentonville, Arkansas (2011.13)

commodification of the land long under way, as well as to the advent of the Industrial Revolution. Each engendered an enhanced appreciation for landscape—as property or as metaphorical escape for an expanded class of urban patrons.[8]

Just how the image Taylor is painting differs from previous types of landscape representation can be seen by comparing it not only to the Savannah view, from which it overtly diverges, but also to a classical Claudean landscape by another American artist named Taylor, from which it more subtly departs. John Taylor (1735–1806) completed *A Wooded Classical Landscape at Evening with Figures in the Foreground* in 1772 (fig. 43). At the time, he resided in England, having moved from Philadelphia a decade earlier. His father had helped Benjamin Franklin found the University of Pennsylvania, and in a 1783 letter Franklin expressed his esteem for Taylor's art while underscoring the lack of an American market to support it: "Our geniuses all go to Europe. In England at present the best History Painter, West; the best Portrait Painter, Copley; and the best Landscape Painter, Taylor, at Bath are all

Americans." In *A Wooded Classical Landscape*, the soft forms, ethereal light, smooth modulation from foreground to background through atmospheric (tonal) rather than linear (geometric) perspective, and the historicizing subject and iconography all epitomize the Claudean landscape, itself an archetype of the beautiful, the aesthetic category codified during the mid-eighteenth century in opposition to the sublime. The picturesque fit somewhere in between these ideals, advocating in place of the grace and ease of the beautiful, or the awe and grandeur of the sublime, a more approachable variety, irregularity, liveliness, and even apparent disorder. Crucially, however, these were to be presented within, and organized by, a methodized approach to representation whose logic and eventual familiarity created the opposite effect— "a sort of irregular symmetry," or controlled diversity, as the British surveyor James Clarke described it in 1787.[9]

To see how this was accomplished, we can return to William Taylor's sketch (see fig. 42). It takes the landscape Earl shows through the window—already picturesque in its

FIGURE 44: William Winstanley (British, active 1793–1806), *View of the North [Hudson] River (Morning)*, ca. 1793. Oil on canvas, 117.5 × 151.8 cm. Mount Vernon Ladies' Association, Virginia. Purchase, 1940 (W-1179)

variability, partial concealment, and suggestion of movement and change as the viewer imagines progressing through it—and transmutes it into a schematized and coherent system of geometric forms. Borrowing from the language of the classical landscape the coulisses (wedges of land pointing inward from alternate sides, moving progressively backward) and repoussoirs (foreground framing devices leading into the scene) that structure Claudean compositions, but simplifying and greatly accentuating their use, Taylor's sketch—and the picturesque, generally—offered a means of controlling and ordering the diverse landscape. This rationalizing effect was of special appeal to Americans, imposing a conceptual logic on nature's complexity and seeming disarray. It allowed them to exchange a nature that was still overwhelmingly wild with one more accessibly pastoral, mitigating their sense of being overmatched by their environmental surroundings. Gilpin himself noted, "The idea of a wild country, in a natural state ... is to the generality of people but an unpleasing one." The picturesque presented a means of conventionalizing unimproved nature and bestowing a benign and familiar order. If its appeal in England was largely aesthetic, in America it offered

the ability to render a vast and unsettled world as lucid and manageable as the sketch on William Taylor's desk.[10]

We have only Earl's picture to know how Taylor's painting actually looked, but there were a few other, professional landscape artists at work in the new United States at the same time. All born in England, they reversed the migration Franklin had described only a decade before, hoping to find in America a viable market among a population now numbering four million. Most came first to Philadelphia, then the nation's capital, including William Birch (1755–1834) in 1794, William Groombridge (1748–1811) around the same time, and William Winstanley (active 1793–1806) by 1793. In April of that year, Winstanley sold to none other than George Washington two large landscapes for the President's House on Market Street, for which Alexander Hamilton soon after expressed admiration: "There are two views of situations on Hudson's River painted by Mr Winstanly [*sic*], in the drawing Room of Mrs. Washington, which have great intrinsic merit." What could it mean for the country's first president to acquire and publicly display scarce landscapes of American subjects, and for Hamilton to deem them full of merit?[11]

Whether Winstanley's paintings even depict the Hudson River is questionable; they are possibly pastiches created by the artist to suggest a place he had not seen. Paired compositions evoking different times of day, the more impressive *View of the North [Hudson] River (Morning)* (fig. 44) is a generalized riverine landscape in the manner of earlier British pastoral landscapists Alexander Cozens, Thomas Gainsborough, and Richard Wilson, artists for whom effect and invention trumped truth to nature. The painting is a paradigm of picturesque composition, providing modulated, stepwise access into the depicted scene, framed at each edge with trees that open up to reveal a view onto smooth, serpentine water. The work's veracity seems not to have mattered. What apparently was desired was a landscape that, in looking much like idyllic England, projected onto untamed America a vision of what might be. A surveyor by training, Washington was an avid and experienced gardener and landscaper, whose cultivated designs for Mount Vernon expressed his values of logic, decorum, and control. In electing to purchase and show such an unlikely bucolic portrayal of the mighty Hudson, he expressed a similar wish to bring art to bear on the domestication of American nature.[12]

If Winstanley had in fact been to the Hudson River, his representation of it was evidently mediated by such concerns. The picturesque allowed, even encouraged, this kind of pictorial manipulation. "Nature's compositions are seldom complete or correct," wrote the Reverend R. H. Newell in 1821. And although "Nature must be the foundation . . . [It] must be raised and improved," noted a 1789 Boston magazine article, "with such additions and combinations, as a fertile imagination may form," concluded Philadelphia's *Portfolio* in 1812. In 1792 Gilpin marked the distinction between beautiful and picturesque scenes as "between those, which please the eye in their *natural state*; and those, which please from some quality, capable of being *illustrated in painting*"—that is, through their manipulation into desirable form. In an American context, such aesthetic management must have been especially alluring, as it entailed the ability to literally move mountains to make nature respond to human aims.[13]

Washington thought Winstanley's paintings so appealing he bought two more the following year, and when he finally returned to Mount Vernon in 1797, he installed the original two prominently in his "New Room" (fig. 45). No ordinary space, this was by far the largest, most formal, most stylistically

FIGURE 45: New Room, Mount Vernon, constructed 1776–87, refurnished 1797–99. In the current installation, the Winstanley paintings flank the projecting fireplace at right. Mount Vernon Ladies' Association, Virginia

up-to-date chamber in Washington's home, the last and grandest of his many improvements. It served as a "show" or statement room, and—in ways difficult to fully grasp today—was meant to represent and convey its proprietor's taste, interests, and beliefs. Like the grand salons of contemporary British country houses, it served as Mount Vernon's picture gallery, where Washington hung his best and favorite works. Many of the twenty-one paintings or engravings displayed in the room at his death in 1799 were fittingly American, including engravings by John Trumbull (1756–1843) of scenes from the Revolutionary War and the artist's portrait of the victorious general at Yorktown (each visible on the back wall in fig. 45). Works of this sort would have been

expected during a time when history was construed largely as biography, its progression a result of the deeds of great men. But Washington's deliberate acquisition of landscapes (his collection eventually included seven) was unusual, and made the New Room effectively the first gallery of American landscape art, conveying an apparent understanding of the physical world's crucial import for the nation's future. The collective message was optimistic, and in such a symbolically resonant space, the Winstanleys fit right in, picturing an American environment made accessible and domesticated through the controlling conventions of the picturesque.[14]

Perhaps out of propriety, none of the multiple copies Washington purchased in 1798 of the engravings by

FIGURE 46: Edward Savage (American, 1761–1817), *The Washington Family*, 1798–1805. Oil on mahogany, 46 × 61.2 cm. Winterthur Museum, Garden & Library, Wilmington, Delaware. Bequest of Henry Francis du Pont (1961.0708)

Edward Savage (1761–1817) after his painting of *The Washington Family* (fig. 46) adorned the New Room, though he clearly approved of the image. Instead one was displayed in the small or family dining room nearby, appropriate for a portrait of the president's relations gathered domestically around a table. But in a sense it would not have been out of place in the grander, rhetorical chamber. Savage's picture shows Washington in military dress surrounded by family at Mount Vernon, engaged in the study of Pierre Charles L'Enfant's design for the proposed capital up the Potomac, which is visible in the background. Like the Trumbull portrait and engravings in the New Room it valorizes the country's first leader, and like Winstanley's landscapes it is concerned with the refashioning of the American environment—in this case literally—for beneficial ends. What distinguishes *The Washington Family* from these untroubled imaginings of America's promise is the presence, among Washington's "relatives," of an enslaved American. Savage's initial study for his family portrait did not include the likeness of William Lee, Washington's favored body servant; instead, a group of background trees served a similar framing role in the composition. In the life-size painting he completed before issuing the engraving, the artist replaced the trees with the figure of a black servant, "borrow[ing] John Riley…to pose as one of Washington's servants," as he "had no black model at hand." Only late in the picture's evolution did Lee appear, apparently an afterthought. It seems ironic that the artist would incorporate a slave in the image only belatedly, as it was enslaved labor that actually accomplished much of the environmental transformation proposed by L'Enfant's plan, which involved extensive draining of the swampy site.[15]

At least Savage eventually included Lee. The same could not be said for Benjamin Henry Latrobe (1764–1820), who in representing the Washingtons did the opposite. In the transition from study to finished version of his image showing the family conversing on Mount Vernon's famed portico, the figure of a black attendant—probably William Lee's brother, Frank—disappears as one of the president is inserted (figs. 47, 48). Latrobe paid an overnight visit to the Washingtons in the summer of 1796, and in his journal recalled a lengthy discussion with the president on that same porch about another land reclamation project, for the Great Dismal Swamp to the south. Washington was one of the original three managers in a company formed to promote its conversion from wetland to profitable, arable real estate.

FIGURE 47: Benjamin Henry Latrobe (British, 1764-1820), *Sketch of a groupe for a drawing of Mount Vernon*, 1796. Graphite and ink on paper. Maryland Historical Society, Baltimore (1960.108.1.2.21)

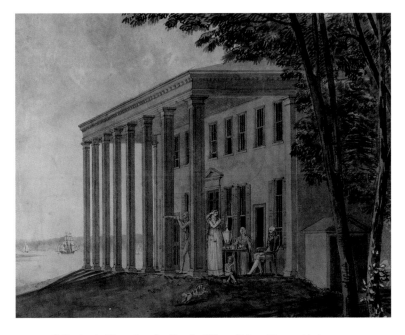

FIGURE 48: Benjamin Henry Latrobe, Detail of *View of Mount Vernon with the Washington Family on the Piazza, July 16, 1796*, 1796. Watercolor, ink, and graphite on paper. Mount Vernon Ladies' Association, Virginia. Purchased with funds provided in part by an anonymous donor, 2013

FIGURE 49: Edward Savage, *The East Front of Mount Vernon*, ca. 1787–92. Oil on canvas, 55.9 × 90.2 cm. Mount Vernon Ladies' Association, Virginia. Bequest of Helen W. Thompson, 1964

Sixty slaves were assembled to dig drainage ditches, but the effort was ultimately unsuccessful, and by the time Washington discussed it with Latrobe, he had sold his stake at a loss. Though the venture failed, one imagines the enslaved individuals tasked with carrying it out had a still bleaker perspective on the project than did its genteel investors. Latrobe's erasure of the slave from the Mount Vernon picture underscores the uncanny invisibility of more than 90 percent of the plantation's human population, even as the environmental engineering projects revolving around this image and Savage's belie that population's indispensability to the business of American empire building—and indicate how different Americans might perceive the same environments quite differently.[16]

The racially bifurcated composition of early American environmental experience is broached again in two other Mount Vernon images by Savage, estate views made around 1790. One shows the mansion's west façade, with Washington and family identifiably promenading in the foreground, while diminutive, unvariegated slaves ring the periphery of the image—something of an inversion of their essential role in enabling every aspect of the scene, from the construction of the building that is its focus to maintenance of its elaborate grounds. Savage's other view depicts the plantation's famed east front overlooking the Potomac (fig. 49). Although human figures are not featured, the image still manages to separate owner from owned by isolating the white mansion from the (literally) colored "House for Families" or slave quarters behind it with a large intervening tree, as well as by the prominent representation of an actual structure that ran between them, a so-called ha-ha, or earthen fence. Savage did not sign either painting, but the appearance of a ship on the Potomac in the lower corner of the latter image calls to

mind a vessel of that name, HMS *Savage*, a British warship that in 1781 was positioned at the same spot on the river as in Savage's painting, threatening to burn Mount Vernon as part of the ongoing hostilities. Seventeen of the estate's slaves took advantage of the ship's proximity to escape servitude (Virginia's Royal Governor had offered "Freedom to All Indented Servts & Slaves [the Property of Rebels] that will repair to his majestys Standard—being able to bear Arms"). Their readiness to flee their known surroundings and join forces against the army led by Washington affirms that life at Mount Vernon was not for everyone the idyllic picture Savage portrays it to be.[17]

A rare and more truthful representation of African American environmental experience can be seen in Francis Guy's *Perry Hall, Slave Quarters with Field Hands at Work* of a few years later (fig. 50). Guy (1760–1820) was a contemporary

of Savage, active during the early nineteenth century around Baltimore. Shortly after his completion of the Perry Hall painting—one of three views of Harry Dorsey Gough's estate showing his human, animal, built, and territorial possessions—Guy's reputation was battered by a series of critiques that his work was insufficiently refined. In what was apparently the first art dispute played out in American critical literature, Eliza Godefroy stated in the Baltimore *Observer* that "if Mr. Guy's genius is a diamond, it is one without polish," the first of several disparagements that eventually caused the artist to respond in a competing journal. Writing in the *American*, Latrobe later described one of Guy's landscapes as containing "some charming parts—some detestable ones." The gist of the criticisms related to the self-taught artist's transcriptive tendencies, as against the inclination of a more stylish artist such as Winstanley toward manipulation and "improvement." While

FIGURE 50: Francis Guy (American, born England, 1760-1820), *Perry Hall, Slave Quarters with Field Hands at Work*, ca. 1805. Oil on canvas, 55.9 × 76.2 cm. Maryland Historical Society, Baltimore (1986-33)

FIGURE 51: George Beck (British, active in the United States, 1748–1812), *Great Falls of the Potomac*, 1797. Oil on canvas, 111.8 × 140.3 cm. Mount Vernon Ladies' Association, Virginia. Gift of Theodore Lyman Jr., 1885 (W-2)

Guy's critics had such technical considerations in mind in delivering their censure, in the case of his unvarnished depiction of slave labor, one wonders whether the subject unsettled viewers as much as its means of portrayal.[18]

The painting's afterlife implies as much. Only a decade following Gough's commission of the work, it was given to one of his former slaves, Esther Hall, along with her freedom. In a not uncommon expression of the confused and conflicted system of human chattelism, Hall was a confidante of Gough's daughter, Sarah, who died shortly before Hall was released from bondage. Sarah's father was himself equivocal about slavery, and although he held fifty slaves at his death, he had freed still more, suggesting Guy's painting may have been uncomfortable to contemplate on the walls of his parlor. It must have been similarly strange for Hall and her descendants, who kept the painting through four generations, knowing that one of the small figures shown working Gough's land may have been their ancestor.[19]

FIGURE 52: John Trumbull (American, 1756–1843), *Niagara Falls from an Upper Bank on the British Side*, 1807. Oil on canvas, 62 × 92.9 cm. Wadsworth Atheneum Museum of Art, Hartford, Connecticut. Bequest of Daniel Wadsworth (1848.4)

Had Washington received from Guy a painting anything like the one the artist delivered to Gough, it would never have been displayed in Mount Vernon's New Room. In that decorous space the most sensational representations of the American environment were dramatic in a different way. Compared to Winstanley's sedate pair of Hudson River vignettes, George Beck's 1797 evocations of another American waterway—*The Potomac River Breaking through the Blue Ridge* and *Great Falls of the Potomac*—are Romantic expressions of nature's vitality (fig. 51; see fig. 45 for a view of both paintings in the New Room). Also an English émigré, Beck (1748–1812) was the most experienced of the early landscape artists at work in this country. He had exhibited at London's Royal Academy and was attuned to advanced artistic practice when he arrived in Maryland in 1793. If Winstanley's pictures of the Hudson epitomize the picturesque, Beck's of the Potomac gesture toward, without fully embracing, the countervailing sublime. Rather than show the scenic stretch of river seen from Mount Vernon's veranda, Beck opted to depict the Potomac in action. Yet in doing so, he was careful to retain the controlling strategies of the picturesque, subordinating the energy of his subject to familiar framing and ordering devices—repoussoirs of tree and clouds, coulisses of rock—so that the dynamic river is ultimately portrayed as contained and nonthreatening. Departing from European contemporaries focused on the sublime, Beck subjugated nature's energies to a pictorial idiom that allowed him to fill his scenes simultaneously with a sense of both power and control. In this he was like artists whose contemporaneous portrayals of the greatest American waterwork, Niagara, frequently rendered the sublime site as finally under the aesthetic jurisdiction of the picturesque (fig. 52). Although visitors to Niagara spared nothing in their verbal panegyrics, in representing it visually they, too, seemed compelled to present even this most exceptional of American environments as within the bounds of rule and order.[20]

A view farther down the Potomac painted by Beck around the same time overlooks Georgetown and the new federal city of Washington in a more typically picturesque way (fig. 53). It served as the basis for an especially successful engraving issued by the artist in 1800 that offers an instructive comparison with the original image, indicating how a classically picturesque view might be subtly adjusted to further enhance its resonance for an audience vested in seeing the American environment as fundamentally accessible and inviting (fig. 54). Beck's original painting presents a view onto the Potomac that is essentially static, one that premises the viewer as observer, not participant. Although broadly the same, the engraving by contrast invites the viewer in through a series of modest but effectual alterations: in the print the road leads gradually downward and around an alluring curve, not into pictorial oblivion, as in the painting, and passage along it is encouraged by the appearance of cart tracks and a pair of distant horsemen in place of an inscrutable group blocking the way; figures move into the scene instead of out from it, and visual impediments in the painting—the house in the middle distance, the prominent island, the highly articulated clouds—are removed, diminished, or softened to accommodate them, replaced by gently rolling hills, a distant bridge, and a sailboat; even the medium itself—crisp aquatint engraving—promotes lucidity and legibility. Beck's print optimally exemplifies the efficacy of the picturesque as a tool of expansionist ideology. "At all times, and everywhere," wrote Englishman William Marshall in *A Review of the Landscape* (1795), "one great end of Landscape painting is to bring distant scenery, and such more particularly as it is wild and not easily accessible, under the eye"—that is, within figurative and conceptual reach. Like the theatrical devices upon which it drew—side screens, backdrop, props—the picturesque was meant to create a space, a world, into which the viewer is invited and drawn. As such, it was the ideal artistic means to present a vast and unsettled American environment as "under the eye" of human dominion.[21]

Beck's basic composition proved so appealing that it became something of a template, later repeated in numerous paintings articulating westward expansion. Around 1830 it was emblazoned on English earthenware plates made for the American market, with the added embellishment of a mounted horse shown prancing into the scene, accentuating the essential impulse of the topos and making it widely available. In England itself, however, the artifice of picturesque manipulation was wearing thin. Writer and editor Sir John Stoddart observed in 1801, "The old mode of composing pictures by certain formulae, like apothecaries' prescriptions, or receipts in cookery, seems (at least in landscape) to have given way to the study of nature." Richard Wilson (1713/14–1782), the leading British landscapist of his generation, in his last works downplayed pictorial orchestration and adherence to classical formulae in favor of a more closely observed

FIGURE 53: George Beck, *Georgetown and City of Washington*, ca. 1797.
Watercolor and gouache on paper, 38.1 × 50.8 cm. Arader Galleries, New York

naturalism. Similarly, in 1802 the young John Constable (1776–1837) wrote to a friend, "For the last two years I have been running after pictures, and seeking the truth at second hand," when, he had come to realize, "Nature is the fountain's head, the source from whence all originality must spring." He thus resolved to "endeavor to get a pure and unaffected representation of the scenes that may employ me." His renowned cloud studies—begun in 1821 and purely observational—were the eventual embodiment of this essentially opposite approach, which characterized British landscape art's move, generally, away from idealizing artificiality toward naturalism, transience, and close study of the environment, as ultimately theorized by John Ruskin (1819–1900).[22]

American art did not soon follow. For a generation of English émigré artists such as Joshua Shaw (1776–1860)—an exact contemporary of Constable—and even later, native-born ones, including Alvan Fisher (1792–1863) and Thomas Doughty (1793–1856), the old picturesque formulas held sway. Doughty's *In the Catskills* (fig. 55), with its prominent framing elements, clear division of fore-, middle-, and

background, and alternating landscape elements leading successively back from left and right, might well have been painted, like Davies's view of Lake George (see fig. 38), during the eighteenth century. It was completed about 1835. The usual explanation for the discrepancy between American and British landscape painting at the time invokes colonial discourse in terms of center-periphery relations (the lag in stylistic transmission between advanced metropole and undeveloped hinterland) and the supposed unsophistication of artists at work outside cosmopolitan hubs, as well as the related lack of an economically viable, informed patronage to encourage development and currency in such places. While perhaps partially credible (although the American Eastern Seaboard in 1830 was no longer such a backwater), in addition to these excusatory explanations, it might more affirmatively be asserted that American landscape paintings appeared the way they did because their forms resonated with their creators' and consumers' environmental perceptions—or, more accurately, predilections. The wilderness was being selectively "tamed," but the project of settlement on a

FIGURE 54: Thomas Cartwright (British, active early 19th century), after George Beck, *George Town and Federal City, or City of Washington*, 1800. Aquatint; sheet, trimmed: 45.3 × 58 cm. Published by Atkins and Nightingale, London and Philadelphia. Library of Congress, Washington, DC. Prints & Photographs Division

continental scale remained overwhelming. In representing the imposing American world as comprehensibly ordered, controllable through manipulation, and invitingly accessible, the picturesque did very different cultural work than in established England. Its retention here well beyond its use there perhaps implies neither ignorance nor intransigence; the leading American landscape artists of the early to mid-nineteenth century, Doughty, Thomas Cole (1801–1848), and Asher B. Durand (1796–1886), all made artistic sojourns abroad (Cole was born there). Rather, it affirms how representing landscapes means representing attitudes about them, attitudes informed by larger ideas about the human relationship to the environment. Cole, although his early works departed considerably from the American norm (as discussed in the next essay), was like his peers in rejecting the foreign trend toward naturalism. In 1825 he wrote to a patron, "If I am not misinformed, the finest pictures which have been produced, both Historical and Landscape, have been compositions…. [The pictures] of all the great painters, are something more than imitations of Nature…. If the

FIGURE 55: Thomas Doughty (American, 1793-1856), *In the Catskills*, ca. 1835. Oil on canvas, 63.5 × 88.9 cm. Reynolda House Museum of American Art, Affiliated with the Wake Forest University, Winston-Salem, North Carolina. Museum purchase (1977.2.5)

imagination is shackled, and nothing is described but what we see, seldom will anything truly great be produced." The picturesque afforded American artists a means to address the perceived essential challenge of the era, "subduing nature," in Alexis de Tocqueville's concise appraisal. Small wonder it lingered here so long.[23]

At midcentury, following Cole's early death, the most esteemed American landscape painter was Durand. In 1855 his hortatory "Letters on Landscape Painting" were published in the *Crayon: A Journal Devoted to the Graphic Arts, and the Literature Related to Them*, an influential periodical founded and coedited by his art critic son. In an apparent move beyond Cole's position, and befitting the journal's new, Ruskinian inclination, Durand's first letter urges the aspiring painter, "go first to Nature to learn to paint landscape," advocating outdoor study and the creation of meticulous plein air oil sketches. Significantly, however, the naturalistic images that resulted were ultimately to form the basis for larger, invented compositions: "And when you shall have learnt to imitate her," Durand continued, "you may then study the pictures of great artists with benefit. They will aid you in the acquirement of the knowledge...to select, combine and set off the varied beauty of nature by means of what, in artistic language, is called treatment, management." The approach Durand espoused thus offered both the naturalism promoted by current artistic theory and the opportunity to manipulate its parts into grander fabrications. The artist did just this in grafting portions of various on-site oil studies, including the crossed logs at the center of *Kaaterskill Landscape* (1850; Princeton University Art Museum), into the larger studio production, *Kaaterskill Clove* (fig. 56), exhibited in 1851 to wide acclaim at New York's National Academy of Design. Durand's method meant he could be "true" to nature while also bringing it "under [his] eye," instilling its complex particulars with appealingly picturesque conventions of order and accessibility. To underscore the latter, his view of the famous Catskill Mountains site adopts an unusual low perspective (most artists depicted the Clove

FIGURE 56: Asher B. Durand (American, 1796–1886), *Kaaterskill Clove*, 1850. Oil on canvas, 101.6 × 152.4 cm. USC Fisher Museum of Art, Los Angeles. The Elizabeth Holmes Fisher Collection (EF:45:03)

FIGURE 57: Asher B. Durand, *Landscape*, 1859. Oil on canvas, 77 × 61.5 cm. Princeton University Art Museum. Gift of J. O. MacIntosh, Class of 1902 (y1955-3249)

FIGURE 58: Asher B. Durand, *Kindred Spirits*, 1849. Oil on canvas, 111.8 × 91.4 cm. Crystal Bridges Museum of American Art, Bentonville, Arkansas (2010.106)

from an elevated position), allowing the buckskin-clad figure shown entering into the scene to become a visual correlative of the viewer, forging ahead into the wilderness.[24]

A similar diminutive figure appears in a later composition by Durand, *Landscape* of 1859, whose generic title suggests its likely invented character (fig. 57). Fully employing the compositional techniques of repoussoir, coulisse, and atmospheric perspective to provide graduated entrance into the scene via diminishing formal elements and gradational tonal modulation, the painting is an archetype of the picturesque landscape of access. In it the American environment is presented as logical and harmonious, appealing and available. Durand wrote, "That is a fine picture which at once takes possession of you—draws you into it—you traverse it—breathe its atmosphere—feel its sunshine." In a detail that might be an illustration of the idea, the figure depicted walking into the artist's inviting tableau

is attired, appropriately enough, in red shirt, white hat, and blue pants.[25]

Landscape is structured quite similarly to Durand's best-known painting, *Kindred Spirits*, completed a decade earlier as a painted eulogy to his friend Cole, who died in 1848 (fig. 58). It shows their mutual friend, poet and editor William Cullen Bryant, standing with Cole on a precipice overlooking another Durandian confection, one again evoking Kaaterskill Clove as well as the waterfall of the same name, both early subjects of Cole, but a topographically impossible combination. Perhaps in homage to his friend's more ruggedly sublime images of the locale, Durand piles up the landmasses undulating up and back into the distance—tumultuously, compared with the smooth declension of the same forms in *Landscape*; this gives the scene, despite the sheltering, ocular foreground, an uncharacteristic forbidding quality. A series of ascending waterfalls, rather than a

FIGURE 59: Asher B. Durand, *Kaaterskill Clove*, 1866. Oil on canvas, 97.2 × 152.4 cm. The Century Association, New York

FIGURE 60: Thomas Cole (American, born England, 1801–1848), *The Clove, Catskills*, ca. 1827. Oil on canvas, 64.2 × 89.2 cm. New Britain Museum of American Art, Connecticut. Charles F. Smith Fund (1945.22)

sloping path, connects foreground to background, so that it is difficult to conceive "traversing," or even moving around much, in Durand's painting for Cole.[26]

Later, in 1866, the artist did paint a more accurate image of the Clove as seen from the opposite end of his 1850 view, and it offers a telling comparison with one by Cole from decades before (figs. 59, 60). Cole's vertiginous *The Clove, Catskills* on an overcast autumn day rejects the viewer's entry through its jarring palette, agitated brushwork, craggy forms, and inclusion of a Native American already occupying the scene. It champions wilderness on its own, sublimely foreboding terms, even as it represents the place—topographically, at least—more faithfully than Durand's *Kaaterskill Clove*, which presents a toned-down, lower, more approachable version of the actual site (fig. 61). Durand's painting shows how far he and other American artists went, with the notable exception of Cole in his early career, to present an account of the American environment made appealing through picturesque convention, a world conducive to entrance, occupation, and settlement.

Durand's art was widely imitated. Woodland scenes by him, invariably including a path through and out of the depicted thicket—again connoting accessibility and occupancy—were repeated by a subsequent generation of closer adherents to Ruskin, notably William Trost Richards (1833–1905). Robert S. Duncanson (1821–1872), an African American artist regarded as among the country's best landscapists, drew from both Durand and Cole in producing his often ethereal pastorals. His *Untitled (Landscape)* (fig. 62)—imaginary like Durand's, yet also all the more meaningful for it—is in the idyllic spirit of that artist's renowned *Morning of Life* (1840; formerly National Academy Museum), which Duncanson may have known from its exhibition in 1840 and 1858 at the National Academy of Design. Durand's painting formed part of an allegorical pair referencing temporality, a common theme at midcentury, whereas Duncanson's work removed itself from time completely, offering a dream of a landscape, replete with temple-like structures in the background and a punt with boatman on a placid lake, all bathed in raking, golden light. Duncanson specialized in such otherworldly scenes, often with literary allusions, and made copies of both Cole's *Garden of Eden* (1828; Amon Carter Museum) and *Dream of Arcadia* (ca. 1838; Denver Art Museum), the latter especially mimetic. The two artists' evocations of Arcadia (a classical pastoral vision of human harmony with nature)

FIGURE 61: Kaaterskill Clove from Haines Falls Bridge, 2009. Photograph by Chris Sanfino

FIGURE 62: Robert S. Duncanson (American, 1821–1872), *Untitled (Landscape)*, late 1850s. Oil on canvas, 61 × 91 cm. Princeton University Art Museum. Museum purchase, Kathleen Compton Sherrerd Fund for Acquisitions in American Art and Mary Trumbull Adams Art Fund (2011-107)

differ mainly in terms of palette: Cole's is crisp and bright, whereas Duncanson's is darker and more muted, including, notably, the skin tones of its imagined inhabitants.[27]

Duncanson stated, "I have no color [race] on the brain all I have on the brain is paint." The artist was the mixed-race grandson of an enslaved Virginian who had been freed by his owner (and likely father). Duncanson's parents moved to upstate New York to escape the increasing hostility toward free blacks in the South, eventually settling in Cincinnati, "The Athens of the West," a center of both artistic and abolitionist activity. Because he was light-skinned, the artist was afforded greater opportunity than other African Americans, and in 1842 three of his early works were accepted for display at the Cincinnati Academy of Fine Arts. He probably was not allowed to study there, however, and his family was not permitted into the exhibition to see his paintings. In light of this and other challenges and indignities Duncanson faced on account of race, it is difficult to conceive that "color" did not have a prominent place in his mind, and art.[28]

Landscape suggests as much. Painted during the late 1850s, it followed the artist's participation in the production, with African American photographer James Presley Ball (1825–1904), of a panoramic painting (now lost) titled *Mammoth Pictorial Tour of the United States Comprising Views of the African Slave Trade*, depicting "the horrors of slavery from capture in Africa through middle passage to bondage," according to an accompanying pamphlet. The painting toured the United States and made explicit its creators' abolitionist stance during a time of cresting racial tension. *Landscape* comments on race as well, only far more subtly, even privately, as close inspection of the painting's three small figures reveals (fig. 63). As evocative as the similarly diminutive characters in Durand's paintings, or the absent one in Latrobe's image of George Washington's porch, Duncanson's figures have been carefully—intentionally—rendered in three distinct skin tones: black, brown, and white. Their insertion by the artist into his serene fantasy landscape, harmoniously interacting, seems to conjure the world he hoped might be, even if the gradually disappearing path leading toward them implies it may remain beyond reach. That Duncanson felt compelled to secretively situate his grouping at the back of a fictive landscape indicates his inability to envision such a scene in the environment he did inhabit, even though the seated white woman looking on from the trees seems his way of directing us to see its possibility. As still more small figures in paintings imply—Savage's African Americans outside Mount Vernon and Guy's slaves at work in Harry Gough's fields—the American experience of the environment was crucially mediated by subject position. Coerced labor, the denial of land ownership, and the American environment broadly as a theater of racial injustice caused witnesses like Duncanson to apprehend it differently. For him the concept of a pristine, uncomplicated American landscape must on some level have been anathema, sullied as it was with iniquity.[29]

As Duncanson's art shows, environmental perception is socially and culturally determined. There are different ways to construe landscape representation, including not at all. Many Native American cultures have long eschewed notions of individual property ownership—real estate—and conceptualized their relationship to the land differently, avoiding mapping or illusionistic pictorial delineation. Such formalized geometries often have little purchase in cultures without the same interests in the regularization of distance and topography. These might instead be considered in relative and experiential terms, inflected by seasonality, environmental conditions, and previous empirical encounter. Among the Inupiaq people of what is now northwestern Alaska, there exists a long tradition of graphic art, expressed principally in ivory carving, above all on the functional handles of the bow drills used to carry it out. The iconography of an early nineteenth-century ivory bow drill is richly embellished

FIGURE 63: Robert S. Duncanson, Detail of *Untitled (Landscape)*, late 1850s

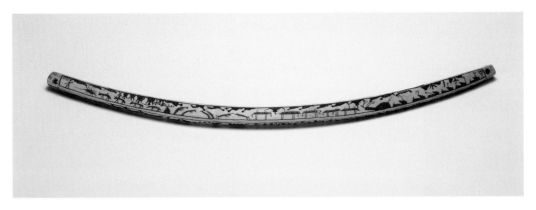

FIGURE 64: Inupiaq, Bow drill, early 19th century. Ivory and dark pigment, 1.8 × 44.8 × 1 cm. Princeton University Art Museum. Bequest of John B. Elliott, Class of 1951 (1998-491)

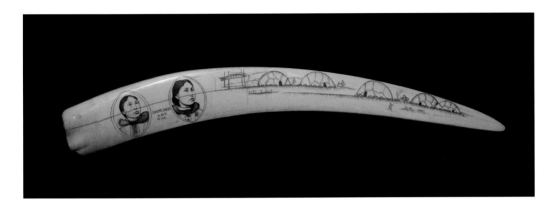

FIGURE 65: Angokwazhuk (Happy Jack) (Inupiaq, ca. 1870-1918), Nome, Alaska, Engraved walrus tusk, 1900-1904. Walrus tusk and graphite, 8.9 × 71.8 × 5.7 cm. Fenimore Art Museum, Cooperstown, New York. Gift of Eugene V. and Clare E. Thaw, Thaw Collection (T0713)

with pictographic activity scenes typical of the domestic routines, hunting, and social events of daily Inupiaq life (fig. 64). The particular activity depicted was determined more by seasonal considerations than by locative ones, indicative of an orientation to the environment based as much on factors of time as place—in contrast to Euro-American landscape practice.[30]

Around 1890 the influx of whaling ships and traders, ongoing since the beginning of the century, and the introduction of mission school education engendered a shift from the old engraving style to a more illusionistic one that introduced spatial, as opposed to experiential, representation of the environment. In order to accommodate the desire for this new type of engraving—produced extensively to serve the curio trade following the Klondike

Gold Rush of 1896—different materials were adapted for use, including broader walrus tusks on which there was room for perspectival scenes. The most renowned carver in the new manner was Angokwazhuk (ca. 1870–1918), known as Happy Jack, who excelled at both veristic reproduction of photographic images and the invention of his own. A walrus tusk he engraved around the turn of the century (fig. 65) features each: vignettes of the artist and his wife from a photograph as well as a village scene incorporating perspectival spatial recession via overlapping and diminution of forms. The contrast between Angokwazhuk's apprehension of his environment and the visualization shown on the earlier bow drill is striking, and one wonders if it accompanied a change in environmental consciousness parallel to the pictorial one. Either way, the art of Inupiaq carvers underscores the

FIGURE 66: Worthington Whittredge (American, 1820-1910), *The Old Hunting Grounds*, 1864. Oil on canvas, 92.1 × 68.9 cm. Reynolda House Museum of American Art, Affiliated with Wake Forest University, Winston-Salem, North Carolina. Gift of Barbara B. Millhouse (1976.2.10)

very different means by which environmental perception can be rendered.[31]

Interestingly, when American artists sought to evoke Indigenous landscapes, it was often in ways that similarly eschewed space (fig. 66), metaphorically denying bodily access and suggesting the foreclosure of Native Americans' continued occupation of their own original environments. The deep space and controlled forms of the picturesque were tools of Anglo-American imperial design, reifying and affirming its aims. Only when Indigenous peoples were depicted gazing elegiacally at landscapes lost to them, or shown giving it away (see Introduction, fig. 3), were they afforded the same privileged view.

Notes

1 On the White/de Bry corpus of Roanoke images, see Michael Gaudio, *Engraving the Savage: The New World and Techniques of Civilization* (Minneapolis: University of Minnesota Press, 2008); for an ecocritical reading, see Timothy Sweet, "Filling the Field: The Roanoke Images of John White and Theodor de Bry," in *A Keener Perception: Ecocritical Studies in American Art History*, ed. Alan C. Braddock and Cristoph Irmscher (Tuscaloosa: University of Alabama Press, 2009), 23–42.

2 Elizabeth I quoted in Louis De Vorsey, "European Encounters: Discovery and Exploration," in *North America: The Historical Geography of a Changing Continent*, ed. Thomas F. McIlwraith and Edward K. Muller, 2nd ed. (Lanham, MD: Rowman & Littlefield, 2001), 44. William Bradford from his *Of Plimouth Plantation*, journal account of ca. 1630, excerpted in *Major Problems in American Environmental History: Documents and Essays*, ed. Carolyn Merchant, 3rd ed. (Boston: Wadsworth, 2012), 73. Wigglesworth quoted in Matthew Dennis, "Cultures of Nature: To ca. 1810," in *A Companion to American Environmental History*, ed. Douglas Cazaux Sackman (Chichester, UK: Wiley-Blackwell, 2014), 222. For Native Americans' environmental impact and management, see Melanie Perreault, "American Wilderness and First Contact," in *American Wilderness: A New History*, ed. Michael Lewis (New York: Oxford University Press, 2007), 15–34; William M. Denevan, "The Pristine Myth: The Landscape of the Americas in 1492," in *The Great New Wilderness Debate*, ed. J. Baird Callicott and Michael P. Nelson (Athens: University of Georgia Press, 1998), 414–42; and William Cronon, *Changes in the Land: Indians, Colonists, and the Ecology of New England*, rev. ed. (New York: Hill & Wang, 2003). For received notions of wilderness, especially as inflected by Judeo-Christian tradition, see "Old World Roots of Opinion," chap. 1 in Roderick Frazier Nash, *Wilderness and the American Mind*, 5th ed. (New Haven: Yale University Press, 2014); and Vittoria Di Palma, *Wasteland: A History* (New Haven: Yale University Press, 2014). Locke's now famous statement first appeared in his *Second Treatise on Government*, dated 1690 but published 1689. Gen. 1:28.

3 European prints—mezzotints in particular—have long been recognized as frequently providing the basis of American portrait compositions; see John Marshall Phillips, Barbara N. Parker, and Kathryn C. Buhler, eds., *The Waldron Phoenix Belknap, Jr. Collection of Portraits and Silver, with a Note on the Discoveries of Waldron Phoenix Belknap, Jr. Concerning the Influence of the English Mezzotint on Colonial Painting* (Cambridge, MA: Harvard University Press, 1955).

4 Edward Johnson, *Wonder-working Providence* (1654), quoted in Merchant, *Major Problems in American Environmental History*, 81–82. On the Kühn portrait, see Kathleen Orr Pomerenk, "Faith in Art: Justus Engelhardt Kuhn's Portrait of Eleanor Darnall" (M.A. thesis, Georgetown University, 2009); and Elisabeth L. Roark, "Keeping the Faith: The Catholic Context and Content of Justus Engelhardt Kühn's Portrait of Eleanor Darnall, ca. 1710," *Maryland Historical Magazine* (Winter 2014): 391–427, each of which argues for the image's extensive religious content in the context of its Catholic patronage. While often compelling, collectively the recondite meanings attributed to seemingly every one of the portrait's details presuppose a highly elaborate knowledge of Catholic symbolism, and Kühn was a devout Protestant. See also Roark, "Justus Engelhardt Kühn (?–1717), Portrait Painter to a Colonial

Aristocracy," chap. 5 in *Artists of Colonial America* (Westport, CT: Greenwood Press, 2003), 73–90.

5 Hugh Hall was a commission merchant, slaver, and distiller—and the subject in 1758 of what is believed to be John Singleton Copley's first pastel (Metropolitan Museum of Art, acc. no. 1996.279). The transformation of environmental beliefs underlying the move from a nature portrayed as contained and controlled to one more freely and realistically rendered is discussed in an American context in "The Romantic Wilderness," chap. 3 in Nash, *Wilderness*, 44–66; also see William Cronon, "The Trouble with Wilderness or, Getting Back to the Wrong Nature," in *Uncommon Ground: Rethinking the Human Place in Nature*, ed. William Cronon (New York: W. W. Norton, 1995), 69–90. On the iconographic significance of the upward-pointing finger, also in an American context, see David Steinberg, "Charles Willson Peale: The Portraitist as Divine," in *New Perspectives on Charles Willson Peale: A 250th Anniversary Celebration*, ed. Lillian B. Miller and David C. Ward (Pittsburgh: University of Pittsburgh Press, 1991), 131–43.

6 Although he lacked the technical proficiency and polish of the better-known American portraitists of his generation, Gilbert Stuart and John Trumbull, Earl painted more ambitious portraits. See Elizabeth Mankin Kornhauser with Richard L. Bushman, Stephen H. Kornhauser, and Aileen Ribeiro, *Ralph Earl: The Face of the Young Republic* (New Haven: Yale University Press, 1991); Kornhauser, "'By Your Inimitable Hand': Elijah Boardman's Patronage of Ralph Earl," *American Art Journal* 23, no. 1 (1991): 4–19; and Robert Blair St. George, "Disappearing Acts," chap. 4 in *Conversing by Signs: Poetics of Implication in Colonial New England Culture* (Chapel Hill: University of North Carolina Press, 1998).

7 This is a central tenet of ecofeminism, a philosophy and political movement—and a type of ecocritical analysis—combining ecological and feminist concerns, viewing each as rooted in male social dominance. See Carolyn Merchant, *The Death of Nature: Women, Ecology, and the Scientific Revolution* (New York: Harper & Row, 1980), which places the problem in historical context; and Karen J. Warren, "Feminist Environmental Philosophy," in *The Stanford Encyclopedia of Philosophy* (Summer 2015 Edition), ed. Edward N. Zalta, https://plato.stanford.edu/archives/sum2015/entries/feminism-environmental/. For the American context, see Annette Kolodny, *The Lay of the Land: Metaphor as Experience and History in American Life and Letters* (Chapel Hill: University of North Carolina Press, 1975); and Kolodny, *The Land Before Her: Fantasy and Experience of the American Frontiers, 1630–1860* (Chapel Hill: University of North Carolina Press, 1984). On ecofeminism and art, see Kelly C. Baum, "Earthkeeping, Earthshaking," in *Critical Landscapes: Art, Space, Politics*, ed. Emily Eliza Scott and Kirsten Swenson (Oakland: University of California Press, 2015), 110–21.

8 Gilpin and Price were the original expositors of the picturesque; Knight explained and expanded their views. See William Gilpin, *Three Essays: On Picturesque Beauty; On Picturesque Travel; and On Sketching Landscape: To Which Is Added a Poem, On Landscape Painting* (London: R. Blamire, 1792); Uvedale Price, *An Essay on the Picturesque, as Compared with the Sublime and the Beautiful; and on the Use of Studying Pictures, for the Purpose of Improving Real Landscape* (London: J. Robson, 1794); Richard Payne Knight, *An Analytical Inquiry into the Principles of Taste* (London:

T. Payne and J. White, 1805). On British art and enclosure, see Ann Bermingham, *Landscape and Ideology: The English Rustic Tradition, 1740–1860* (Berkeley: University of California Press, 1986). For British and American landscape art in relation to each other, see Andrew Wilton and Tim Barringer, *American Sublime: Landscape Painting in the United States, 1820–1880* (Princeton: Princeton University Press, 2002).

9 Franklin quoted in Arthur S. Marks, "An Eighteenth-Century American Landscape Painter Rediscovered: John Taylor of Bath," *American Art Journal* 10, no. 2 (November 1978): 81–82. Edmund Burke categorized the beautiful as against the sublime in *A Philosophical Enquiry into the Origin of Our Ideas of the Sublime and Beautiful* (London: R. and J. Dodsley, 1757). James Clarke, *Survey of the Lakes* (1787), quoted in Malcolm Andrews, *The Search for the Picturesque: Landscape Aesthetics and Tourism in Britain, 1760–1800* (Aldershot, UK: Scolar Press, 1989), 54. On the picturesque, also see Christopher Hussey, *The Picturesque: Studies in a Point of View* (New York: G. P. Putnam's Sons, 1927); and Sidney K. Robinson, *Inquiry into the Picturesque* (Chicago: University of Chicago Press, 1991).

10 Gilpin quoted in Edward J. Nygren, "From View to Vision," *Views and Visions: American Landscape before 1830*, ed. Edward J. Nygren with Bruce Robertson (Washington, DC: Corcoran Gallery of Art, 1986), 18; in the same volume, see especially Amy R. W. Myers, "Imposing Order on the Wilderness: Natural History Illustration and Landscape Portrayal," 105–32. On early American landscape, also see William H. Gerdts, "American Landscape Painting: Critical Judgments, 1730–1845," *American Art Journal* 17, no. 1 (Winter 1985): 28–59. On the continued perception of the overwhelming environment into the nineteenth century, see Alan Taylor, "'Wasty Ways': Stories of American Settlement," in *American Environmental History*, ed. Louis S. Warren (Malden, MA: Blackwell Publishing, 2003), 102–18.

11 Hamilton quoted on webpage "*View of the North [Hudson] River (Morning)*," Mount Vernon website, http://www.mountvernon.org/preservation/collections-holdings/browse-the-museum-collections/object/w-1179/. For the painting's pendant, *View of the North [Hudson] River (Evening)*, see http://www.mountvernon.org/preservation/collections-holdings/browse-the-museum-collections/object/w-1180/.

12 On Washington as a gardener, see Andrea Wulf, "'The Cincinnatus of the West': George Washington's American Garden at Mount Vernon," in *Founding Gardeners: The Revolutionary Generation, Nature, and the Shaping of the American Nation* (New York: Alfred A. Knopf, 2011), 13–34.

13 Newell quoted in Andrews, *Search for the Picturesque*, 30. "Nature must be the foundation" from anonymous article, "Rules for Painting. Founded on Reason," in *Gentlemen and Ladies Town and Country Magazine* (November 1789), quoted in Gerdts, "American Landscape Painting," 31; "with such additions and combinations" from Poussin [pseud.], "Travel," *Portfolio* 4, no. 6 (1812): 84. Gilpin quoted in Andrews, *Search for the Picturesque*, 57. On the ideological implications of picturesque manipulation and convention in an American context, see Bryan Wolf, "Revolution in the Landscape: John Trumbull and Picturesque Painting," in *John Trumbull: The Hand and Spirit of a Painter*, ed. Helen A. Cooper (New Haven: Yale University Art Gallery, 1982), 206–15.

14 For information on the New Room and Washington's collection, see Susan P. Schoelwer, "Design, Construction, Decoration, and Furnishing the New Room, 1774–1799" and "How Did the Washingtons Use the New Room," and Jessie MacLeod, "Furnishing the New Room," Mount Vernon website, http://www.mountvernon.org/the-estate-gardens/the-mansion/the-new-room/.

15 For Washington's purchase of the Savage print, see "The Washington Family," Mount Vernon website, http://www.mountvernon.org/preservation/collections-holdings/browse-the-museum-collections/object/w-2363/. The original study for *The Washington Family*, currently in a private collection, is reproduced in Louisa Dresser, "Edward Savage, 1761–1817," *Art in America* 40, no. 4 (Autumn 1952): 200. On the complex history of the image, see Ellen G. Miles, cat. entry for *The Washington Family*, in *American Paintings of the Eighteenth Century: The Collections of the National Gallery of Art, a Systematic Catalogue*, ed. Ellen G. Miles (Washington, DC: National Gallery of Art, 1995), 146–58; "borrow[ing] John Riley" quoted 152. For the role of slaves in constructing the city of Washington, see J. D. Dickey, *Empire of Mud: The Secret History of Washington, DC* (Guilford, CT: Lyons Press, 2014).

16 For the distinction between Latrobe's study and finished work, see Jessie MacLeod, "Enslaved People of Mount Vernon: Biographies," in *Lives Bound Together: Slavery at George Washington's Mount Vernon*, ed. Susan P. Schoelwer (Mount Vernon, VA: Mount Vernon Ladies' Association, 2016), 6–7. For Latrobe's visit to Mount Vernon, see Edward C. Carter, ed., *The Virginia Journals of Benjamin Henry Latrobe, 1795–1798*, vol. 1 (New Haven: Yale University Press, 1977), 161–72; and Edward C. Carter, John C. Van Horne, and Charles E. Brownell, eds., *Latrobe's View of America, 1795–1820: Selections from the Watercolors and Sketches* (New Haven: Yale University Press, 1985), 22–24, 92–95. On Washington and the Great Dismal Swamp, see Michael A. Blaakman, "Dismal Swamp Company," Mount Vernon website, http://www.mountvernon.org/digital-encyclopedia/article/dismal-swamp-company/. On slavery's fundamental role on environmental perception, see Kimberly K. Smith, *African American Environmental Thought: Foundations* (Lawrence: University Press of Kansas), 2007.

17 Virginia Royal Governor John Murray quoted on webpage "H.M.S. Savage," Mount Vernon website, http://www.mountvernon.org/digital-encyclopedia/article/hms-savage/. For information on slavery on Washington's plantation, see "Slavery," Mount Vernon website, http://www.mountvernon.org/george-washington/slavery/.

18 See J. Hall Pleasants, "Four Late Eighteenth Century Anglo-American Landscape Painters," *Proceedings of the American Antiquarian Society* 52, no. 2 (January 1943): 245–49, Godefroy quoted 247, Latrobe quoted 264; also see Gerdts, "American Landscape Painting," 33–37; and especially John Michael Vlach, *The Planter's Prospect: Privilege and Slavery in Plantation Paintings* (Chapel Hill: University of North Carolina Press, 2002), 51, and more generally chap. 2, "Proofs of Power: The Maryland Estate Paintings of Francis Guy."

19 For Gough's gift to Hall, see Vlach, *Planter's Prospect*, 60. On Gough and slavery, see Dee Andrews, *The Methodists and Revolutionary America, 1760–1800: The Shaping of an Evangelical Culture* (Princeton: Princeton University Press, 2002), 130–31.

20 On Beck, see Pleasants, "American Landscape Painters"; Edna Talbott Whitley, "George Beck: An Eighteenth-Century Painter," *Register of the Kentucky Historical Society* 67 (1969): 20–36; and Daniel Kurt Ackermann, "Research Note: '…that ingenious artist Mr. G. Beck'—George Beck's American Wilderness," *Journal of Early Southern Decorative Arts* 35 (2014), http://www.mesdajournal.org/2014/research-note-that-ingenious-artist-mr-g-beck-george-becks-american-wilderness/#_ftnref26. For representations of Niagara, see Jeremy Elwell Adamson, *Niagara: Two Centuries of Changing Attitudes, 1697–1901* (Washington, DC: Corcoran Gallery of Art, 1985); on Trumbull's depictions of it, see Wolf, "Revolution in the Landscape," 208–12.

21 Marshall quoted in Andrews, *Search for the Picturesque*, 66. On the picturesque's encouragement of the viewer to enter into the depicted scene, see Roger Paden, "Picturesque Landscape Painting and Environmental Aesthetics," *Journal of Aesthetic Education* 49, no. 2 (Summer 2015): 39–61. The relatively new field of environmental aesthetics makes compelling arguments regarding how and why the genre of landscape arose and evolved as it did in relation to broader aesthetic theory; see Allen Carlson, *Nature and Landscape: An Introduction to Environmental Aesthetics* (New York: Columbia University Press, 2009), and *Aesthetics and the Environment: The Appreciation of Nature, Art, and Architecture* (London: Routledge, 2000). Also of interest in explicating the behavioral bases of landscape representation is the prospect-refuge theory articulated by Jay Appleton in *The Experience of Landscape*, rev. ed. (Chichester, UK: John Wiley & Sons, 1996).

22 For an image of the plate, see "Plate with a View of Washington, District of Columbia," Yale University Art Gallery website, https://artgallery.yale.edu/collections/objects/6280. Stoddart quoted in Andrews, *Search for the Picturesque*, 33. On Richard Wilson and his distinct late work, see Martin Postle and Robin Simon, eds., *Richard Wilson and the Transformation of European Landscape Painting* (New Haven: Yale Center for British Art; Cardiff: Amgueedda Cymru-National Museum Wales, 2014); and David H. Solkin, *Richard Wilson: The Landscape of Reaction* (London: Tate Gallery, 1982). Constable quoted in Bermingham, *Landscape and Ideology*, 117. For the shift toward naturalism in British art, generally, see Kathleen Nicholson, "Naturalizing Time/Temporalizing Nature: Turner's Transformation of Landscape Painting," in *Glorious Nature: British Landscape Painting, 1750–1850*, ed. Katharine Baetjer (New York: Hudson Hills, 1993), 31–46; and Michael Rosenthal, *British Landscape Painting* (Ithaca, NY: Cornell University Press, 1982). Ruskin's *Modern Painters I* (1843) argued for "truth to nature" as against pictorial convention.

23 Cole, in a letter dated December 25, 1826, to Baltimore collector Robert Gilmor Jr., quoted in Gerdts, "American Landscape Painting," 49. For Tocqueville's "subduing nature" in broader context, see Nash, *Wilderness*, 23ff. Shaw, Fisher, and Doughty are discussed in Nygren, *Views and Visions*.

24 Durand's "Letters on Landscape Painting" are reproduced in their entirety in Linda S. Ferber, ed., *Kindred Spirits: Asher B. Durand and the American Landscape* (New York: Brooklyn Museum, 2007), 231–52, quoted 233. For these in relation to Cole's "Essay on American Scenery" (1836), see John Davis, "Writings on Landscape by Thomas Cole and

Asher B. Durand," in *America! Storie di pittura dal Nuovo Mondo*, ed. Marco Goldin (Brescia, Italy: Museo di Santa Giulia, 2007), 42–49. The relationship between *Kaaterskill Landscape* and *Kaaterskill Clove* is made in David B. Lawall, *Asher B. Durand: A Documentary Catalogue of the Narrative and Landscape Paintings* (New York: Garland Publishing, 1978), 86, 175; Lawall notes that Durand adopted, but reversed, a pair of prominent trees from another oil sketch in composing *Kaaterskill Clove*, suggesting how freely he manipulated his forms.

25 Durand, "Letters," no. III, quoted in Ferber, *Kindred Spirits*, 236.

26 Kaaterskill Clove and Falls are oriented close but perpendicular to each other, obviating the possibility of Durand's view. Bryan Wolf sees *Kindred Spirits* differently, as domesticating the sublime landscapes of Cole by doing away with any disruptions to the viewer's visual access, offering "a womblike enclosure that protects rather than threatens"; see Bryan Wolf, "All the World's a Code: Art and Ideology in Nineteenth-Century American Painting," *Art Journal* 44, no. 4 (Winter 1984): 328–37, quoted 330.

27 Duncanson's *Garden of Eden* (1852) is at the High Museum of Art, Atlanta; his *Dream of Arcadia* (1852) is at the Brooklyn Museum.

28 Duncanson quoted in Joseph D. Ketner, *The Emergence of the African-American Artist: Robert S. Duncanson, 1821–1872* (Columbia: University of Missouri Press, 1993), 111. Also see David M. Lubin, "Reconstructing Duncanson," chap. 3 in *Picturing a Nation: Art and Social Change in Nineteenth-Century America* (New Haven: Yale University Press, 1994), 107–57.

29 The ways in which race inflected Duncanson's art is discussed in Ketner, *Duncanson*; and Lubin, "Reconstructing Duncanson." For diverging views, see Wendy J. Katz, "Robert S. Duncanson, Race, and Auguste Comte's Positivism in Cincinnati," *American Studies* 53, no. 1 (2014): 79–115; and Margaret Rose Vendryes, "Race Identity/Identifying Race: Robert S. Duncanson and Nineteenth-Century American Painting," *Art Institute of Chicago Museum Studies* 27, no. 1 (2001): 82–99, 103–4. On African American environmental perception, see Smith, *African American Environmental Thought*; and Dianne D. Glave and Mark Stoll, eds., *To Love the Wind and the Rain: African Americans and Environmental History* (Pittsburgh: University of Pittsburgh Press, 2005).

30 See G. Malcolm Lewis, "Maps, Mapmaking, and Map Use by Native North Americans," in *Cartography in the Traditional African, American, Arctic, Australian, and Pacific Societies*, ed. David Woodward and G. Malcolm Lewis, vol. 2, bk. 3 of *The History of Cartography* (Chicago: University of Chicago Press, 1998), 51–182, esp. 176–82; and Mark Warhus, *Another America: Native American Maps and the History of Our Land* (New York: St. Martin's Press, 1997). For Inupiaq ivory engraving, see Christopher Green, "Bow Drills" webpage, *Messages Across Time and Space: Inupiat Drawings from the 1890s at Columbia University* exhibition website, Center for the Study of Ethnicity and Race, Columbia University, https:// edblogs.columbia.edu/AHISG4862_001_2015_1/iii-class-research /inupiat-aesthetics/inupiaq-material-culture-in-conversation-with-the -avery-properties-drawings/the-drill-bow-and-the-inupiaq-graphic -tradition/; and Dorothy Jean Ray, *A Legacy of Arctic Art* (Fairbanks: University of Alaska Museum, 1996), 99–137.

31 It has historically been all too easy to account for the conceptual transition of some Inupiaq artists to a more conventional style of representation in terms of a putative advancement in artistic skills—Western visitors taught natives how to "do" art better—but such racial imperialism elides both the aesthetic strengths of earlier Inupiaq art and its compelling imaging of a different way of construing environmental relations. See Christopher Green, "The Expansion of the Inupiaq Graphic Art Tradition in the Late Nineteenth Century" webpage, *Messages Across Time and Space* exhibition website, https://edblogs.columbia.edu /AHISG4862_001_2015_1/iii-class-research/inupiat-aesthetics/you -cant-teach-what-is-known-sourcing-the-expansion-of-the-inupiaq -graphic-art-tradition-in-the-late-nineteenth-century/; also see Susan W. Fair, "Early Western Education, Reindeer Herding, and Inupiaq Drawing in Northwest Alaska: Wales, the Saniq Coast, and Shishmaref to Cape Espenberg," in *Eskimo Drawings*, ed. Suzi Jones (Anchorage: Anchorage Museum of History and Art, 2003), 35–75. On Angokwazhuk (Happy Jack), see Christopher Green, "Angokwazhuk (Happy Jack) and Guy Kakarook" webpage, in *Messages Across Time and Space* exhibition website, https://edblogs.columbia.edu/AHISG4862_001_2015_1/iii-class -research/inupiat-aesthetics/inupiat-art-and-artists/happy-jack-and -guy-karakuk/; Dorothy Jean Ray, "Happy Jack and His Artistry," *American Indian Art Magazine* 15, no. 1 (Winter 1989): 40–53; and Ray, "Happy Jack and Guy Kakarook: Their Art and Their Heritage," in Jones, *Eskimo Drawings*, 19–34.

Karl Kusserow

The Trouble with Empire

A Painter's Progress:
Thomas Cole and the Dilemma of Development

Despite the meaningful existence of American landscape painting long before 1825 (as we have seen), if the genre has an origin story, it begins only then, with the "discovery" by elderly patrician painter John Trumbull of the tradition's "founder" in young Thomas Cole, five of whose early works Trumbull sighted that autumn in the shop of New York book and art dealer William Colman. Declaring himself "delighted, and at the same time mortified," Trumbull allegedly exclaimed, "This youth has done at once, and without instruction, what I cannot do after 50 years' practice." Trumbull bought one of the prodigy's paintings, and alerted painter William Dunlap (1766–1839), later to write the first American art history, and engraver Asher B. Durand (who had yet to take up landscape painting) to the others, two of which they in turn acquired. By the end of the year, the *New-York Literary Gazette* had weighed in with a panegyric—one among many—headlined "Another American Genius," and so the country's first native tradition in art, known by the 1870s as the Hudson River School, was launched. What inspired such a reception could not merely have been that Cole's paintings were competent landscapes—examples of these by William Birch, Alvan Fisher, and others had been displayed multiple times before in New York at the American Academy of the Fine Arts, of which Trumbull himself was president. Cole's early work caused a stir because two of the three paintings exhibited in Colman's shop, and others that followed in the next few years, were in essence different from the placid, picturesque pastorals that preceded them. Trumbull's own landscapes, themselves often on view at the American Academy, underscore the difference. His *Niagara*

Falls from an Upper Bank on the British Side (see fig. 52) presents America's most sublime scene as distant, domesticated (if that were possible), contained and controlled by picturesque convention. In *The Clove, Catskills* (see fig. 60), by contrast, Cole begins with the vastly more modest cataract at Haines Falls in the Catskills and, while retaining the structure of picturesque composition—framing devices, stepwise spatial recession—distorts and subverts them, placing the viewer on uncertain ground near the edge of a precipice, surrounded by rough, gnarled forms and an exotic Native American. Vision is now circumscribed, ratcheting back and forth between enclosing and releasing forms that are the opposite of the smoothly unfurling picturesque, an idiom from which Cole emphatically departs for the countervailing frisson of the Romantic sublime. While factors including an emerging market-based clientele for paintings, increased opportunity to show them (Cole, already elected a member, exhibited three landscapes at the National Academy of Design's inaugural 1826 exhibition), and a rapidly expanding popular press all played a role in the artist's conspicuous debut, fundamentally it was the novelty of his paintings, and its new relevance at the time, that attracted Trumbull and others to him.[1]

In July of 1826, Cole wrote to Daniel Wadsworth, who had commissioned a copy of *Kaaterskill Upper Fall, Catskill Mountains* (1825), the now lost view Trumbull first acquired, describing the "wild magnificence of the Catskill mountains" where, he later elaborated in his journal, "Summit rose above summit, mountain rolled away beyond mountain [in] a fixed, a stupendous tumult. The prospect was sublime." The artist's apprehension of Catskill nature was in reality perhaps not quite so untrammeled: already Cole was editing out signs of development—"improvement" in contemporary

FIGURE 67: Thomas Cole (American, born England, 1801–1848), *Palenville, Clove Valley, Catskill Mountains*, ca. 1835. Pen and ink on paper, 17.8 × 28.6 cm. Albany Institute of History & Art. Purchase (1949.20.2)

parlance—to emphasize the area's "wild magnificence." In another view of Kaaterskill Falls completed in 1826, he exchanged an observation hut, a platform with railings, and a pair of tourists for a solitary Indian. Some years later he admitted into a drawing of the desolate valley portrayed in *The Clove, Catskills* evidence of the corrosive tanning industry long established there (fig. 67), a scene reminiscent of pictures of the early Industrial Revolution in Cole's native England. A contemporaneous print of *Farnworth, Paper Mills, &c. Lancashire* (fig. 68), for example, shows the extensive industry developing around the artist's birthplace, Bolton-le-Moors. The particular mill depicted was owned by the Crompton family, whose ancestor Samuel invented the spinning mule in 1779, setting in motion the rapid industrialization that would make Bolton a center of the world textile industry. Cole left Lancashire in 1818 as a youth, but old enough to have witnessed the environmental degradation and social unrest accompanying the area's embrace of large-scale manufacturing, which included massive pollution caused by bleach and other toxic agents and the 1812 attack on local mills by so-called Luddites, who decried the automation of industry and its effect on workers. In light of his resulting antipathy toward industrialization, it makes sense that Cole, rather than celebrate human incursion into and subjugation of the landscape like his picturesque predecessors and peers, would instead make a conscious effort to excise evidence of it out of his natural vistas.[2]

Apparently a favorite among the artist's early works was *A Snow Squall* (fig. 69), which Cole showed at both the National Academy's first annual exhibition in 1826 and again the following year at the American Academy. It is perhaps the most sublime of his pure landscapes, with weather, topography, flora, and fauna combining to produce a dizzying scene greatly at odds with the comparatively flat area around the town of Duanesburg, New York, where Cole spent the winter with a patron, and which his picture supposedly evoked. He wrote to Trumbull from there in February 1826, noting that he found the surrounding scenery "fine" but lacking in "character." In amping up, rather than toning down, the "character" of his surroundings, Cole expressed a Romantic sensibility newly expounding wilderness as a force to be not so much contained and conquered as celebrated and revered. This reflected a broader ongoing recalibration that, as the eastern states filled up with people and settled places, existed alongside the picturesque objective of controlling nature for expansionist ends, a stratagem that while still metaphorically apt for the national project of continent-scale imperialism was now more appropriately applied to the vast western expanse of unsettled territory.[3]

The shift Cole's art embodied was shared in contemporary literary productions situated in the same Hudson River environs. Enormously popular novels by Washington Irving (1783–1859) and James Fenimore Cooper (1789–1851) championing the Catskill wilderness and lamenting its loss had

FIGURE 68: Joseph Clayton Bentley (British, 1809–1851), after George Pickering (British, 1794–1857), *Farnworth, Paper Mills, &c. Lancashire*, ca. 1836. Steel engraving with hand coloring, 11.7 × 17.8 cm. Published by Peter Jackson, London

FIGURE 69: Thomas Cole, *A Snow Squall*, 1825. Oil on canvas, 79.4 × 104.5 cm. The R. W. Norton Art Gallery, Shreveport, Louisiana

already appeared when Cole began to do the same. He painted several scenes from one of them, Cooper's *Last of the Mohicans* (1826), the second of five *Leatherstocking Tales*, whose protagonist Natty Bumppo ultimately exclaims from his deathbed, "What the world of America is coming to, and where the machinations and inventions of its people are to have an end, the Lord, he only knows.... How much has the beauty of the wilderness been deformed in two short lives!" These were the first sustained appreciations of American wilderness by major figures, and they articulated a dissenting, cautionary voice within Jacksonian America's headlong embrace of "progress at all costs." Although Cooper

supported Andrew Jackson, Cole, like Irving, was conservative in adopting what would become Whig inclinations (the party was not actually founded until 1834) toward national development by means other than aggressive settlement and territorial expansion. Both, however—Cooper in his writings, Cole in his paintings—engaged the central paradox of how to reconcile antithetical imperatives of progress, expansion, and development with a national ethos rooted in notions of extraordinary, expansive nature. This contest between nature and culture was a defining dilemma of the century, and Cole's evolving response resonated broadly because it was particularly attuned to its nuances.[4]

The Course of Empire, and indeed recycling an abandoned canvas from it. Diagonally riven between wild nature at left and cultivated pastoral at right, between the verdant allure of unruly wilderness and tidy environmental husbandry, *The Oxbow*, unlike *The Course of Empire*, is equivocal, and thematizes choice. Rosa and Claude, wilderness and civilization, nature and culture, early Cole and late Cole press up against each other in a way that defies clarity. It is up to us, the artist seems to be saying, as his gaze meets ours from the thicket (fig. 71). But ultimately Cole tips the balance: the artist's canvas is positioned before field, not forest; the storm is clearing, leaving mists in the meadows; the umbrella is furled, and if the passing squall in some way signifies the

tumult of development, what is left in its wake is not unattractive; the movement of civilization follows the wind "westward" across the canvas. At a fundamental level, *The Oxbow* is a picture of an artist painting, without evident censure, the cultivated—and beautiful—meadows below him.[9]

Cole undertook the same sort of inducement in depicting New Hampshire's Crawford Notch, a scenic pass in the White Mountains, which he first visited in the summer of 1827. The previous year, a catastrophe that conditioned perceptions of the place for years occurred when an avalanche of rocks engulfed the fleeing Willey family, who had settled in the valley, killing all seven of them and two farmhands but ironically sparing the family's house. In part because of

FIGURE 72: Thomas Cole, *Crawford Notch*, 1839. Graphite on cream wove paper, 28.4 × 43 cm. Princeton University Art Museum. Gift of Frank Jewett Mather Jr. (x1940-78.4r)

this, the incident became widely known and was recounted in numerous literary treatments, including Nathaniel Hawthorne's "The Ambitious Guest" (1835). Seen as evidence of human vulnerability in the face of indifferent nature, the narrative was attractive to Cole in his early career, and the following year he produced a print of the site in the sublime manner of his Catskill scenes.[10]

A decade later, New York merchant Rufus Lord commissioned an American scene from Cole to complement an earlier Italian view in his collection by the artist. Intending to match the scale of Lord's existing picture, Cole specified "size 5 ft. by 3 ft. 4 in." in his notes, the same as a canvas completed the previous year of Schroon Mountain in the

Adirondacks. For that painting, Cole had executed a detailed on-site sketch, which he later worked up in oil. Compared to the preparatory sketch, the finished painting tempers signs of environmental incursion, removing indications of human deforestation and showing instead trees felled by natural causes. Cole did the same with the painting for Lord, *A View of the Mountain Pass Called the Notch of the White Mountains (Crawford Notch)* (fig. 73), which is based on a drawing completed during his second visit to the notch in July 1839 with Durand (fig. 72). In the drawing, human-cut stumps predominate, whereas in the painting, weather-blasted trunks prevail. Similarly, the painting shows the depicted structures as smaller, more widely separated, and more sympathetically

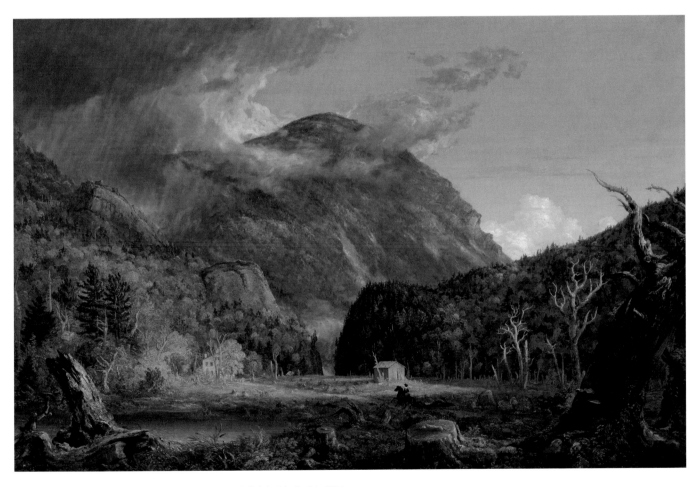

FIGURE 73: Thomas Cole, *A View of the Mountain Pass Called the Notch of the White Mountains (Crawford Notch)*, 1839. Oil on canvas, 102 × 155.8 cm. National Gallery of Art, Washington, DC. Andrew W. Mellon Fund (1967.8.1)

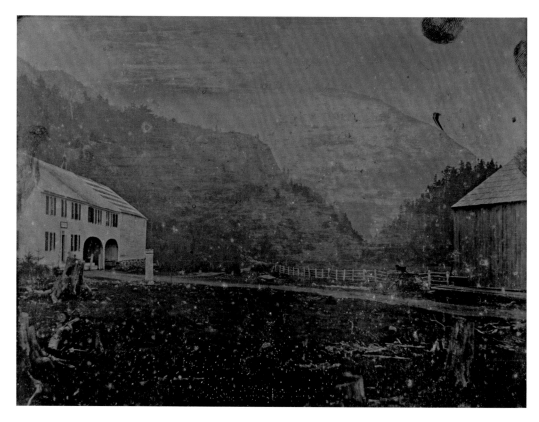

FIGURE 74: Samuel Bemis (American, 1789-1881), *Thomas Crawford's Notch House*, ca. 1840. Daguerreotype, 16.5 × 21.6 cm. Private collection

integrated into the setting. Cole's painting introduces other appealing signs of human presence—the turnpike operating since 1806 is now unobtrusively visible, and on it a colorful rider on a prancing steed approaches a frolicking dog and a man holding hands with a child in the distance, while a laden stagecoach departs through the notch beyond them (see fig. 75). Smoke rises faintly from the chimney of the Notch House, naturalized by the similar mist remaining in the valley from the departing storm. The famous Willey House, with its connotations of a fraught human-nature relationship, is not shown, although it still stood nearby.[11]

A year after Cole's visit, Samuel Bemis, a Bostonian who had purchased land in the notch from Abel Crawford, created a number of daguerreotypes (the first publicly available photographic process) in the vicinity of Cole's picture. These images, possibly the first of all American landscape photographs, make it possible to compare the painting with how the place actually looked at the time. Contemporary engravings showing the Notch House's distinctive fenestration and placement in relation to the notch affirm that the arcaded

building in one of Bemis's photographs is the same one Cole shows a partial view of in the background of his painting. The comparison of photograph (fig. 74) with painting (fig. 75) makes it clear that, far from scattering tree trunks around his images in a spirited indictment of the ravages of the axe and all it implies, Cole actually worked to diminish their effect—as he did with Schroon Mountain—while heightening the blandishments of development. In so doing, he came closer still to the accommodating spirit of his friend Durand, apparently sketching side by side with him, whose already cleaned-up rendition of the scene suggests no need for adjustment (fig. 76).[12]

If *Crawford Notch* shows Cole in midcareer modifying his compositions to downplay the ill effects of progress when moving from sketch to canvas, the tenor of many of his late subjects were already compliant. *New England Scenery* (fig. 77), for example, completed the same year as *Crawford Notch*, might almost have been painted by one of the succeeding generation of Hudson River School artists—Jasper Francis Cropsey (1823–1900), or even a young Frederic

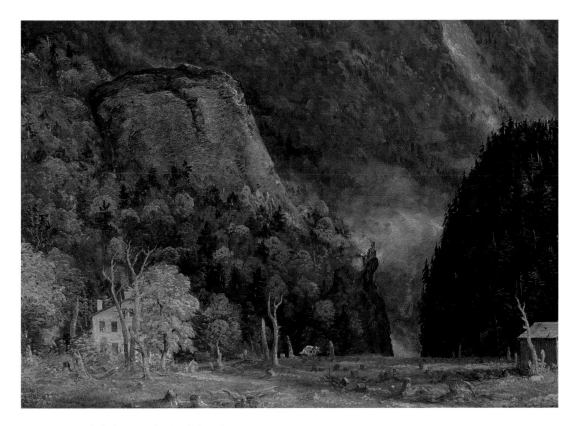

FIGURE 75: Detail of Thomas Cole, *Crawford Notch*, 1839

FIGURE 76: Asher B. Durand (American, 1796–1886), *Notch House, White Mountains, New Hampshire*, 1839. Graphite on paper, 26 × 36.5 cm. New-York Historical Society. Gift of Miss Nora Durand Woodman (1918.95)

FIGURE 77: Thomas Cole, *New England Scenery*, 1839. Oil on canvas, 57.1 × 46.7 cm. The Art Institute of Chicago. Mr. and Mrs. Samuel M. Nickerson Collection (1900.558)

Edwin Church (1826–1900), Cole's student—so comfortably does it accommodate the "middle landscape," the state of equipoise between nature and culture that defined mid-nineteenth-century American landscape painting. Cole had always painted pastoral scenes, but at the end of his career they predominated, and increasingly included signs of civilization in harmony with nature. Two major, closely related works, *The Hunter's Return* (1845; Amon Carter Museum of American Art) and *Home in the Woods* (fig. 78), picture frontier settlement in harmony with verdant woodlands set beneath the same majestic peak, as if the similar homesteads of each painting occupy different positions alongside a common lake. *Home in the Woods* bears more than passing similarity to the structure, massing, and scale of *The Arcadian or Pastoral State* (fig. 79), the second in Cole's *Course of Empire* series, in which, as in *New England Scenery*, an equilibrium of natural and human presences prevails. The succeeding images in the artist's allegorical cycle indicate that such balance

cannot last, but *Home in the Woods* bears no such signs. This may be because the depicted settlers tread lightly on the land; resource extraction (clearing, fishing, and, in *The Hunter's Return*, game hunting) is minimal and, unlike the large-scale deforestation for agriculture abhorrent to Cole, largely invisible. These are not Jeffersonian yeomen hewing farms out of the wilderness, let alone collective commercial enterprises oriented to profit, but an anti-agrarian fiction of settlement without environmental cost. Cole apparently bought the fantasy, as the later *Home in the Woods* enlarges the domestic scene and brings it closer in than in the earlier *Hunter's Return*, and pictures sustenance as easy as going fishing out the front door. At the same time, the painting works to draw attention beyond the human incursions and toward the pristine nature behind them through the converging perspectival lines of hill- and treetops, cabin, foreground blasted trunk, and even the fisherman's pole—as if to point to nature's enduring presence beyond.[13]

Of course, Cole's late wilderness scenes advance another fantasy, as well: that the settlers he portrays occupy vacant territory, waiting to be colonized. For the millions of Native Americans exterminated or exiled through this convenient logic of imperialism, this was hardly the case, and the tragic legacy of their displacement continues to be expressed in works such as *Home in the Wilderness* (fig. 80) by Mohawk artist Alan Michelson (born 1953). A meticulous scale model of the cabin in Cole's painting, it is constructed not of wood but of handmade paper bearing the words of the infamous 1809 Treaty of Fort Wayne, which removed Native Americans from three million acres in Indiana Territory and sparked a rebellion led by Shawnee war chief Tecumseh.

Throughout his career, Cole turned to one scene more than any other, painting at least ten times the view outside his home where Catskill Creek foregrounds the escarpment of the Catskill Mountains in the distance, with the Clove separating Catskill High Peak and Round Top to the south from North and South Mountains on the other side. Beginning a few years after his first visit to the area, and extending to 1845, three years before his death, the views constitute a kind of series, although unlike his other cycles an inadvertent one. Seen in this light, the artist's treatment of the subject at different times has been assessed for what it may imply about his changing approaches and attitudes toward development, and indeed the works lend themselves to such considerations, alternately evincing wishful avoidance, frank

FIGURE 78: Thomas Cole, *Home in the Woods*, 1847. Oil on canvas, 112.7 × 168 cm.
Reynolda House Museum of American Art, Affiliated with Wake Forest University,
Winston-Salem, North Carolina. Gift of Barbara B. Millhouse (1978.2.2)

FIGURE 79: Thomas Cole, *The Course of Empire: The Arcadian or Pastoral State*,
ca. 1834. Oil on canvas, 99.7 × 160.7 cm. New-York Historical Society.
Gift of The New-York Gallery of the Fine Arts (1858.2)

FIGURE 80: Alan Michelson (Mohawk, born 1953), *Home in the Wilderness*, 2012.
Handmade paper, archival ink, and archival board, 30.5 × 66 × 26.7 cm.
Collection of the artist

engagement, and, perhaps, in their chronological concatenation, an evolving ethos regarding "progress."[14]

Apparently the earliest portrayal is from 1827, *View Near the Village of Catskill* (fig. 81), a soft, shadowy pastoral highlighting grazing sheep and a general lushness, with scant signs of humanity beyond a few sequestered houses and two very small figures in the darkened foreground. In the distance, slight smoke from Palenville at the opening of the Clove—perhaps from tanneries—rises before Catskill High Peak, and to the right a spot of sun glints off the façade of the Catskill Mountain House, a tourist hotel beneath South Mountain, which Cole renders to be just barely discernible. A painting of the same size made a few years later, *View in the Catskills* (1828–29; private collection), introduces a fisherman in place of the foreground sheep, and the sentinel tree at left has fallen away of natural causes; otherwise, a similar quietude prevails. In a sketch and two small paintings of around 1833, and later a larger treatment of the scene, the background view is shifted northward, and now North Mountain rises centrally in the distance. The sketch for the

FIGURE 81: Thomas Cole, *View Near the Village of Catskill*, 1827. Oil on panel, 62.2 × 88.9 cm. Fine Arts Museums of San Francisco. Gift of Mr. and Mrs. John D. Rockefeller 3rd (1993.35.7)

FIGURE 82: Thomas Cole, *View on the Catskill—Early Autumn*, 1836–37.
Oil on canvas, 99.1 × 160 cm. The Metropolitan Museum of Art, New York.
Gift in memory of Jonathan Sturges by his children, 1895 (95.13.3)

1833 versions indicates that Cole subsequently added a wooden building to the composition, and in the bigger iteration of 1838, a man on horseback and three distant swimmers now appear. One of the swimmers and the horseman wave to the viewer. Taken together, the six related images display a subtly increasing human presence, in keeping with Cole's work, generally, during those years.[15]

The artist's largest painting of the subject, *View on the Catskill—Early Autumn* (fig. 82), was finished in 1837 on commission from Jonathan Sturges, business partner of Luman Reed, Cole's major patron. Anticipating its realization, Sturges wrote to Cole, "I shall be happy to possess a picture showing what the valley of the Catskill was before the art of modern improvement found a footing there. I think of it often and can imagine what your feelings are when you see the beauties of nature swept away to make room for avarice—we are truly a destructive people."

Sturges was specifically referring to the construction of the Canajoharie and Catskill Railroad, a fitful and ultimately unsuccessful venture under way around Cole's home at the time, and to his great consternation. He wrote Reed in the spring of 1836 complaining, "The copper-hearted barbarians are cutting *all* the *trees* down in the beautiful valley on which I have looked so often with a loving eye," and casting "maledictions on all dollar-godded utilitarians."[16]

Considering the worrisome activity in Cole's beautiful valley, he certainly delivered on Sturges's wish, producing a painting that seems not so much to precede current realities as to stand outside them. With its ineffable balance, fullness of forms, rich greens, and sentimental mother-and-child motif, *View on the Catskill* has an Elysian quality, indicating both artist's and patron's willingness to turn a blind eye to the perils of progress. There is a certain irony, and characteristic sanctimony, in Sturges's condemning the very

FIGURE 83: Thomas Cole, *River in the Catskills*, 1843. Oil on canvas,
69.9 × 102.6 cm. Museum of Fine Arts Boston. Gift of Martha C. Karolik for the
M. and M. Karolik Collection of American Paintings, 1815–1865 (47.1201)

development that enriched him, and ordering up a luxuri-
ous pastiche denying its existence. Later an incorporator and
longtime director of the Illinois Central Railroad, Sturges
instigated its related scheme to develop property alongside
the line. In 1854, while acting president of the railroad, he
hired none other than Abraham Lincoln to defend the com-
pany in a case against William Allen, a landowner with
whom they had negotiated a right-of-way. Allen alleged the
company had excavated fifty thousand cubic feet of soil
from his property—"with Shovels Pickaxes plows scrapers
and other iron instruments dug up turned and subverted the
earth," according to the declaration—and left a ruined land-
scape of unfilled mines and pits. Lincoln and Sturges's rail-
road pleaded not guilty; they lost. Yet despite such evident

disregard for environmental exigencies, only a few years ear-
lier Sturges had famously commissioned another painting,
Durand's *Kindred Spirits* (see fig. 58), like *View on the Catskill*
eulogizing a world he helped usher out of existence. It
becomes difficult not to see Cole and Durand as in some
sense complicit in the denial. However much it may have
pained them, really they had no choice—the American
imperial machine admitted no sustained detraction.[17]

In light of this, Cole's next significant portrayal of his
favored view seems less a critique of development, as some-
times is claimed, than a conciliation of it. *River in the
Catskills* (fig. 83) is certainly different from the others: lighter,
clearer, cleaner. It shows less of Arcadia and more of the
middle landscape of Catskill, New York, late in 1843, when

he completed it; or, rather, Catskill in the previous few years, when the Canajoharie and Catskill Railroad actually functioned. Cole's painting anachronistically includes the train, half-obscured behind greenery and the Catskill Creek bridge over which it progresses toward a small cluster of buildings. As in other views of the scene, livestock graze, a boatman pulls away down the river, and a small figure in the distance, like the one chasing horses in *View on the Catskill*, is now being chased by a dog. Another dog accompanies the man in the foreground, who has just cut down the tree still standing in the earlier painting; logs and brush litter the foreground. The man surveys the scene before him, a *Rückenfigur*, or figure seen from behind—a surrogate for artist and viewer. He sees not the past, but the future, and though altered, the scene remains surely beautiful. Cole hated the railroad, but just as he recognized the inevitability of homes in the woods and strove to represent them positively, he understood the necessity of coming to terms with it. In his final painting of the view, *Catskill Creek, N.Y.* (1845; New-York Historical Society), Cole seems to have done that. In it, it is evening again; one of the sentinel trees at left has been cut down, but one still stands; the oarsman is pulling his boat onto shore; and the railroad, both in reality and in the painting, no longer exists, as if to suggest the ultimate endurance of nature in spite of man's depredations.[18]

In his paintings, Cole was not quite the environmentalist we wish him to be—the term did not yet even exist. It would be simpler, and pleasing, if the works of America's first great landscape artist bore out with the clarity of his writings the heartfelt concern he expressed for the future of nature in America, but, really, they do not. His pictures—and it is through these that both his contemporary agency and his artistic legacy were and are ultimately felt, and thus by them that he must finally be judged—are those of a Romantic aesthetician, concerned with the preservation of the natural energies that inspired and enabled his practice. One sympathizes with his dilemma: how to register in art meant to be beautiful and sellable the ugly truths of development. "The only thing I should doubt in the matter," he wrote in stepping away temporarily from *The Course of Empire* to quickly paint *The Oxbow*, "is that I may be able to sell the picture….It is running a risk of which I should think nothing if my circumstances did not require that everything I do now should be productive." Even in his greatest examination of the nature-culture conundrum,

Cole knew he had to hedge his bets. Ironically, the very conditions of market capitalism he railed against for its reckless pursuit of progress at all costs, environmental and otherwise, also conditioned the tenor of his critique. Although his writings show a different side, evincing a deep empathy for and even identification with nonhuman life—the "Lament of the Forest" evokes Henry David Thoreau's query of the same time, "Who hears the fishes when they cry?"—in his work, the thing that mattered most, Cole was in the end compelled to toe the national party line of progress, to make of his art "a regret rather than a complaint." It was not until the "discovery" of more spectacular, western landscapes that artists and Americans of a succeeding generation considered setting some of nature aside untouched, and that was a change with its own complications.[19]

The Paradox of the Sublime

If Cole's art moved toward a gradual if grudging accommodation of the human presence in nature, a generation later Frederic Edwin Church proceeded in the opposite direction as his equally illustrious career unfolded. That career formally began under Cole's tutelage in Catskill, where between 1844 and 1846 Church was the artist's first and nearly only student (Cole accepted just three during his truncated life). Church arrived well prepared, according to Cole, already possessing "the finest eye for drawing in the world." Something of Church's exacting precocity can be seen in his rendition, while only nineteen, of his teacher's favorite view over Catskill Creek, looking toward the mountains (*The Catskill Creek*, Olana State Historic Site). Painted during the summer of 1845, one imagines teacher and student painting side by side, interpreting the scene. Compared to Cole's many iterations, laden with meaning, Church's view seems more captured than considered, modern in its verism and almost photographic in its realism. Such a work might suggest disregard for his teacher's allegorical inclinations, but when Cole died suddenly a few years later, Church quickly produced a very different sort of landscape showing essentially the same view of the Catskill escarpment. *To the Memory of Cole* (fig. 84) is a substantial work in both size and implication, one more in the manner of the artist it memorializes. The sunlit, garlanded cross evoking Cole's own *The Cross in the Wilderness* (1845; Musée du Louvre), completed while Church was his

FIGURE 84: Frederic Edwin Church (American, 1826-1900), *To the Memory of Cole*, 1848. Oil on canvas, 81.3 × 124.5 cm. Private collection

student; the tree stump at left, another Cole motif signifying life cut short; and the countervailing evergreens at right, beneath which a stream issues and flows toward the distinctive profile of the Catskills and the ethereal sky above them, suggesting renewal and rebirth—all make clear that Church saw landscape painting as a vehicle for both aesthetic appeal and symbolic meaning. He thus set himself on a trajectory distinct from Durand, who after Cole's death assumed leadership of the Hudson River School and whose landscapes, as we have seen, also have meaning, but mostly of a more imputed, less self-conscious sort. It was left to Church, a generation younger than Durand, to adapt Cole's Romantic idiom to midcentury tastes. He did so over the next few years with assured paintings of increasing scope, whose simultaneous inclusion of minute detail established the characteristic tension in his expansive work between part and whole, while articulating ideological themes rich with environmental implication.[20]

In 1851 Church completed *New England Scenery* (fig. 85), embodying the harmonious synergy of humans and nature typical of the artist's paintings through most of the 1850s. Its lateral energies—as distinct from the picturesque's earlier orientation around depth—allowed Church to contrive a

different kind of world, whose breathtaking breadth was only heightened by its granular facture. More an ideal amalgamation of fragments of scenery than a plausible view—as suggested by its at once generic and holistic title—it takes Cole's great symbolic panorama, *The Oxbow* (see fig. 70), a step further and in a different direction. Whereas Cole's painting produced its visual charge from the disequilibrium of its ruptured composition, Church's adheres more closely to the prevailing panoramic paradigm of Durand, Cropsey, and others, whose spectacular formats had similarly begun to dispense with Claudean framing devices and to stress instead sweeping viewsheds. The extreme particularity of Church's work, however, encourages focus on its discrete parts, and amplifies the sense that an entire realm of precise and interrelated pieces has been apprehended, understood, and presented. In this way, Church took landscape representation specifically in the direction of Alexander von Humboldt (1769–1859), the great Prussian polymath—geographer, naturalist, explorer, scientist-philosopher—whom Church venerated intensely. In a long and astonishingly productive career, Humboldt theorized a newly interconnected world that focused not on divine creation (on which Humboldt, an ardent agnostic, was silent) but rather on the functioning of

the wondrously integrated thing created, the cosmos, as he was to title his most influential work. Based on lectures delivered in Berlin in 1827–28, *Kosmos* (*Cosmos*) constituted what Humboldt admitted was his "extravagant idea of describing in one and the same work the whole material world." His keen and intelligent fascination with relations among nature—beyond isolated facts (the preoccupation of earlier taxonomic schemas)—appealed to Church's broad ambitions as an artist and is first comprehensively expressed in *New England Scenery*.[21]

Humboldt's proto-ecological revelations over several decades were rooted in his early travels in Latin America

between 1799 and 1804, especially the Andean regions of what are now Colombia, Ecuador, and Peru. In the second volume of *Cosmos*, which first appeared in English in 1848, and which Church owned, Humboldt included a chapter on "Landscape Painting" wherein he asks, "Why may we not be justified in hoping that landscape painting may hereafter bloom…when highly-gifted artists…shall seize…the manifold beauty and grandeur of nature in the humid mountain valleys of the tropical world?" He could not have summoned a more sympathetic artist than Church to fulfill his wish. Church visited South America twice during the 1850s, and produced major paintings after each trip, although they differ

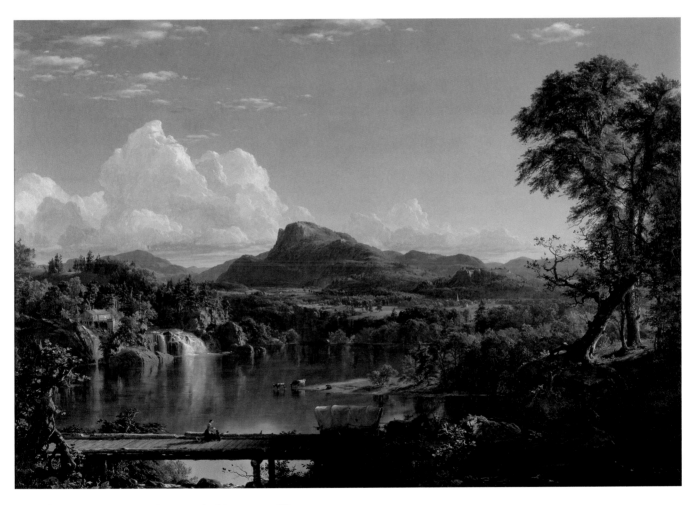

FIGURE 85: Frederic Edwin Church, *New England Scenery*, 1851. Oil on canvas, 91.4 × 134.6 cm. George Walter Vincent Smith Art Museum, Springfield, Massachusetts. George Walter Vincent Smith Collection (1.23.24)

importantly—even antithetically—in their representation of the connected world Humboldt was describing.[22]

The proximate impetus for Church's first journey south was his friend Cyrus Field. A phenomenally successful paper manufacturer, Field had earlier befriended Church in Lee, Massachusetts, where both had family related to the business. Field collected Church's work and had influenced its production before: on an 1851 tour of this country's natural wonders with his wife and the artist, Field commissioned

a painting from Church, *Natural Bridge, Virginia* (1852; Fralin Museum of Art), closely monitoring his sketching sessions and agreeing to purchase the eventual picture only if it matched the rock specimens Field had collected (it did).

With construction of the Panama Railroad under way since 1850, connecting the Atlantic and Pacific Oceans for the first time, speculative interest in South America spiked. That same year, the term "Monroe Doctrine" was coined to describe the position (first articulated in 1823 during the

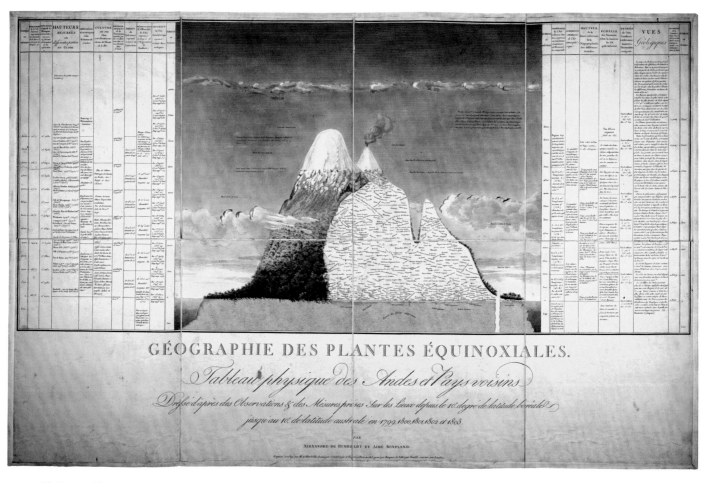

FIGURE 86: Engraved by Louis Bouquet (French, 1765–1814), after a drawing by Lorenz Adolf Schönberger (German, 1768–1847) and Pierre Turpin (French, 1775–1840), after a sketch by Alexander von Humboldt (German, 1769–1859), *Géographie des Plantes Équinoxiales. Tableau Physique des Andes et Pays Voisins* (Paris: Chez Levrault, Schoell et compagnie, 1805). Engraving with watercolor, pen, and ink, 37 × 78.9 cm. Missouri Botanical Garden, Saint Louis. Peter H. Raven Library

presidency of James Monroe) that further European colonial efforts throughout the Americas were inimical to US interests and would be regarded as hostile, effectively ensuring American hegemony in the region. Field, spurred on by the promotional writings of naval officer and oceanographer Matthew Maury (which Church also read), determined to explore opportunities there. He enlisted an enthusiastic Church to accompany him, and in April 1853 the two embarked on a seven-month journey that took them down the spine of the Colombian and Ecuadoran Andes.[23]

Church's trip—instigated, financed, and led by Field—predisposed him to see the region favorably, as a place conducive to development, much as earlier picturesque artists had filtered portrayals of the North American environment through their own preconceptions. As Field's biographer put it, Church "could paint the travel posters for investors." In any case, such an attitude was in keeping with the congenial vision he was already promoting at home. Humboldt's unifying theory bolstered its extension to the very different South American terrain, offering a scientific rationale for Church's coherent view of the world. Humboldt's concept of "the geography of plants" linked physical with botanical geography to account for the distribution of organic life as influenced by varying physical conditions. Developed a half century earlier following the explorer's 1802 ascent of Chimborazo, the Ecuadoran volcano then thought to be the world's highest peak, Humboldt's epiphany regarding altitude, climate, and botanical disposition prompted his ideas about the "mutual dependence and connection" of things "in their relation to the whole," and eventually—by considering latitude as analogous to altitude and developing the notion of isothermal zones—encompassed the entire world. Humboldt produced a drawing, his *Naturgemälde* (literally, "painting of nature," but also connoting unity or wholeness), encapsulating in one, heavily annotated image the essence of his discovery (fig. 86). Showing the profile of Chimborazo and, behind it, the nearby volcano Cotopaxi, the peaks of the *Naturgemälde* are overlaid with botanical notations indicating the ranges of species according to altitude, and flanked by tables with copious additional information. The region's distinctive topography and climate, spanning tropical to alpine zones, had enabled Humboldt to see, and then picture, the gradual progression from one climatic region to another and the implications for the integrated life within them. Humboldt called it "a microcosm on one page."[24]

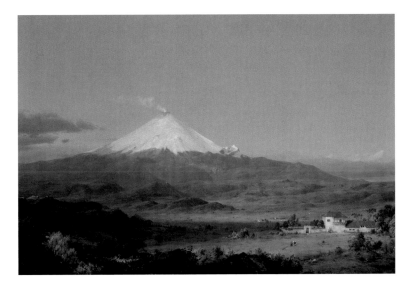

FIGURE 87: Frederic Edwin Church, *Cotopaxi*, 1855. Oil on canvas, 71.1 × 106.8 cm. Smithsonian American Art Museum, Washington, DC. Gift of Mrs. Frank R. McCoy (1965.12)

Church's paintings expressed a similar holistic congruousness. Following his return home in October 1853, and before going back four years later, he produced a dozen substantial South American works, most of them cohered by their harmonious representation of what he had seen. Field owned one of them, showing Cotopaxi rising majestically from the high plain against a clear cerulean sky (fig. 87). Slight smoke drifts from its vent toward soft clouds nearby, linking it to benign nature, and the cone's profile is echoed in the hacienda below, linking it to benign humanity. Church didn't actually see the scene portrayed—his journal records that he waited all day above the hacienda for clouds to disappear, and "about sunset had the satisfaction of a partial view." No matter; the image he constructed, one of grandeur, quietude, and rich, verdant expansiveness, expressed all he wanted to say, capturing both Field's wish for "travel posters" and Humboldt's for accord among nature's diverse parts.[25]

Church visited South America more briefly once more, spending ten weeks during the summer of 1857 with painter Louis Remy Mignot (1831–1870) in Ecuador, where he hoped for a second look at the region's great mountains, especially Chimborazo and Cotopaxi. The painting he completed just before his departure depicts neither, although a substantial peak looms in the background. *View on the Magdalena River* (fig. 88), like Field's *Cotopaxi* and other works resulting from the 1853 trip, is a placid image of human and natural coexistence, set in a Humboldtian realm that ranges

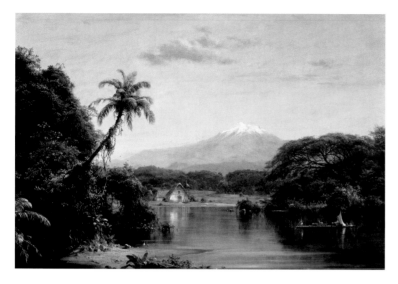

FIGURE 88: Frederic Edwin Church, *View on the Magdalena River*, 1857. Oil on canvas, 60.3 × 91.4 cm. Private collection

from foreground jungle through forest and foothills to background summit, one flowing easily into the other.

In returning to the tropics, Church perhaps sought exotic, vitalizing subjects with which to follow up his recent triumph with *Niagara* (1857; National Gallery of Art, Washington). The trip, in any event, was a success, and upon his return to New York, he began to paint a very different sort of Andean scene, one that was to set the tenor for the dozen or so major, sometimes huge, South American canvases he completed with decreasing frequency over the succeeding fifteen years. *Cayambe* (fig. 89) was executed on commission for Robert L. Stuart, a New York sugar refiner. It depicts the peak Humboldt described as "the most beautiful as well as the most majestic" in the area around Quito,

FIGURE 89: Frederic Edwin Church, *Cayambe*, 1858. Oil on canvas, 76.2 × 122.2 cm. New-York Historical Society. The Robert L. Stuart Collection, the gift of his widow Mrs. Mary Stuart (S-91)

Ecuador's capital, a nicety likely appreciated by Stuart, who owned a folio edition of the book in which Humboldt made the statement. That volume also included a colored engraving of Cayambe after the author's sketch (fig. 90), which presents the mountain rising from a broad valley through gradually melding colored bands, correlating to different climatic zones. Three figures with walking sticks are included, perhaps planning a hike among the foothills.[26]

Church's picture of the same view—of Cayambe from Quito to the south—could not be more different. The massif itself has been dramatized by its more jagged profile, a routine practice for the artist. Far more affectingly, in place of Humboldt's congenial and unified scene, Church offers one pervasively marked by contrast, rupture, and disjunction. The viewer is shown—from an ambiguous position above a cascade leading down a hidden ravine to a gloomy lake below—a world riven, not cohered, by its diverse parts. Hot and cold, land and water, peak and valley, sunlight and moonlight, past (the mysterious stela at left) and present work not so much with as in opposition to one another. This is another world from the one portrayed in *Cotopaxi* three years before—in some ways as disjointed as Cole's *Oxbow*, and the complete opposite of the earlier picturesque, with its imagined access, traversal, and occupation of the depicted scene. The very subject of *Cayambe* seems impossible to reach, isolated pictorially by dark intervening clouds, lake, and ravine; the peak hovers, awesome but unreachable—a nature that is truly "other." It is as if, in trying to portray the Humboldtian cosmos, Church lost the whole in favor of the parts, however spectacular.

Cayambe does not represent the view the artist actually saw in 1857. Church's stay in Quito, where he made a point of residing in the house Humboldt had once occupied, included a trip up the adjacent hill, a local landmark called El Panecillo (because of its shape like a bread loaf), to sketch the view over the city toward Cayambe. A drawing dated June 23, 1857, depicts El Panecillo, which Church called in an inscription the "Hill of the Temple of the Sun," referring to a pre-Incan monument supposedly once sited there. The next day, he marked another drawing "Cayambe from Hill of the Temple de Sol," fixing the location from which it was made and showing a vista that accords closely with both Humboldt's view and the actual one today (fig. 91). Why had Church altered what he saw so extravagantly in producing *Cayambe*, a work that even includes a fake "Incan" ruin,

FIGURE 90: Engraved by Louis Bouquet, after a drawing by Pierre Antoine Marchais (French, 1763-1859), after a sketch by Alexander von Humboldt, *View of Cayambe*, 1810. Aquatint in Alexander von Humboldt, *Researches Concerning the Institutions and Monuments of the Ancient Inhabitants of America, with Descriptions and Views of Some of the Most Striking Scenes in the Cordilleras!*, trans. Helen Maria Williams (London: Longman, Hurst, Rees, Orme & Brown, J. Murray & H. Colburn, 1814), vol. 2, pl. 42. The Wellcome Library, London

further distancing and estranging the view onto Humboldt's unified world?[27]

The different vision of nature that Church advanced in *Cayambe* was not entirely new, even among his South American scenes. Earlier, smaller works (the closely related *In the Tropics* [1856; Virginia Museum of Fine Arts] and *South American Landscape* [1856; Museo Nacional Thyssen-Bornemisza], for example) evince a similarly sublime remove, if not as emphatically, as do paintings of North American subjects beginning around the same time. Among the latter, first expressed in *Sunset* (1856; Munson-Williams-Proctor Arts Institute) and brought famously to fruition in *Twilight in the Wilderness* (1860; Cleveland Museum of Art), Church depicted wilderness as such—entirely undeveloped and unpeopled. Nor was this approach new in American art, generally, as the example of Cole's early work has shown. American attitudes had long been shifting toward an appreciation of intact and untrammeled nature as both a utilitarian and, later, a spiritual resource, a change rooted in the recognition that settlement was prevailing so quickly as to foreseeably threaten remaining unspoiled regions. Hence the move in Church and other artists from a focus on what Americans could do to wilderness to wilderness itself,

FIGURE 91: View of Cayambe from Panecillo looking over Quito. Photograph by Jeremy Horner

FIGURE 92: Frederic Edwin Church, *Cotopaxi*, 1862. Oil on canvas, 121.9 × 215.9 cm. Detroit Institute of Arts. Founders Society Purchase (76.89)

something of a compensatory, rearguard action in light of overwhelming "progress" and development. In a related gesture, the prominent journal of art criticism the *Crayon* strove to characterize American nature as essentially wild—and thus art depicting it as properly oriented the same way. A review of the National Academy of Design's annual exhibition of 1855 stated: "The pictures of most of our native landscapists have another desirable quality, and one which would seem to mark our school of Art—the freedom and air of wildness characteristic of our scenery....Our country *is* wild, and must be looked at by itself, and be painted as it is....Ours is wilderness, or at least only half reclaimed, and untamed nature everywhere asserts her claim upon us, and the recognition of this claim represents an essential part of our Art."[28]

Such nationalistic reasonings, however, do not account for Church's representation of South American nature. One need only compare any one of his three depictions of Cotopaxi from his first trip (see fig. 87; also *Cotopaxi* [1855; Museum of Fine Arts, Houston] and *View of Cotopaxi* [1857; Art Institute of Chicago]) with the violent, operatic *Cotopaxi* of 1862 (fig. 92) to see that something essential has changed. Humboldt provides a partial explanation, with his perception of nature as operating by and for itself, independent of human perquisite, in contrast to centuries of anthropocentric thought from Aristotle (384–322 BCE; "nature has made all things specifically for the sake of man") through Francis Bacon (1561–1626; "the world is made for man") and René Descartes (1596–1650; humans are "the lords and possessors of nature") to Carolus Linnaeus (1707–1778; "all things are made for the sake of man"). But Church had read and admired Humboldt before remaking his art.[29]

Cayambe immediately preceded Church's 1859 magnum opus, *Heart of the Andes* (fig. 93), and served as a rehearsal for it. If the earlier painting presented an oddly atomized view of nature, its enormous successor—five and a half feet tall by ten feet wide—enhanced the effect through scale, composition, and facture. Critics said it was as if several pictures, each minutely detailed, had been stitched together to create one overwhelming image. The result, wrote one based in London, where *Heart of the Andes* was exhibited in 1859, was that "his pictures occasionally break down or fly into scattered fragments, the forms being too subtle for firm cohesion, the colours too iridescent for subordination and unity." Seeking to be all-encompassing, Church's sweeping composition and great detail had the counterintuitive effect of

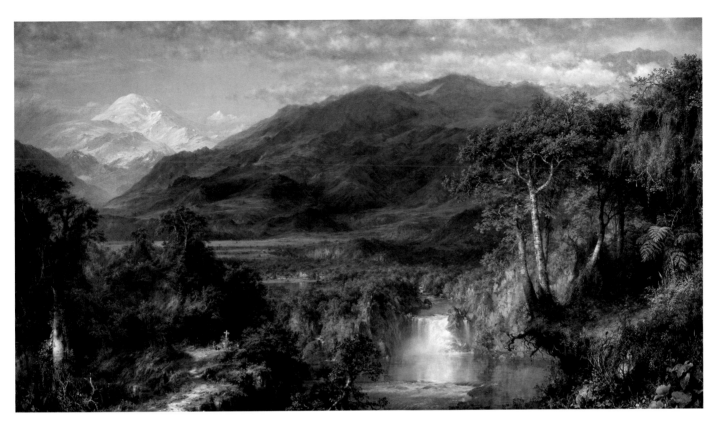

FIGURE 93: Frederic Edwin Church, *Heart of the Andes*, 1859. Oil on canvas, 168 × 302.9 cm. The Metropolitan Museum of Art, New York. Bequest of Margaret E. Dows, 1909 (09.95)

distancing his pictures from the very unity they sought to portray. His extreme particularization, reifying in paint the profusion of nature's details, ironically worked against comprehending them in their now overwhelming totality. Humboldt himself advocated "suppression of all unnecessary detail" as the means through which his overarching unity of life might best be apprehended. Too much detail confused, and thereby removed, the viewer from understanding and access. This seems especially true of *Cayambe*, whose richly detailed foreground sets up a kind of screen before the rest of the picture, which lies inadmissibly beyond. Similarly, in *Heart of the Andes*, the detail engenders looking at, but not entrance into, the depicted realm; it is a spectacle to be regarded, not inhabited.[30]

It may be that among the many jostling parts of Church's later paintings lies his sublimated expression of Charles Darwin's complex and competitive world, one rooted in hard scientific theory, not Humboldt's gentle natural harmonies. Church did not own *Origin of Species* (which did not in any case appear until 1859), and his fundamental

determinism would have precluded his embrace of it. It is perhaps impossible to know what combination of factors led him to shift gears so decisively, but the effect was clear. In representing nature as vast yet precisely detailed, spectacular but removed, and engrossing but uninhabited, he set it apart from human approach and identification, which would seem the opposite of what he was trying to do.[31]

Albert Bierstadt (1830–1902), on the other hand, was more invested in visual theatrics. Born, like Humboldt, in Prussia, Bierstadt immigrated with his family as a child to New Bedford, Massachusetts. Naturalized at age twenty-three, he returned that year to Germany for training in Düsseldorf, whose art academy taught a highly detailed yet also fanciful type of painting. Following four years of travel and study, when he produced alpine scenes anticipating his American work, he settled back in New Bedford. His attachment in 1859 to Frederick W. Lander's trans-Mississippi survey expedition made him among the first artists to view the Rocky Mountains, which he capitalized on with the production of his majestic 1863 painting *The Rocky*

Mountains, Lander's Peak (fig. 94), establishing both his reputation and the trajectory of his career. Over the following dozen years, Bierstadt offered a war-weary, rapidly transforming nation pictures whose enormous size and fresh, dramatic subject matter supplied a visual correlative to notions of American exceptionalism, while underscoring its "manifest destiny to overspread the continent allotted by Providence for the free development of our yearly multiplying millions," a concept first articulated in 1845.[32]

Like Church, Bierstadt dispensed with the rhetoric of the picturesque in favor of the spectacular sublime. With expansion from coast to coast now understood as inevitable, he created works to be looked at more than drawn into and traversed, as in the earlier paradigm. In 1863 he returned to the American West with writer Fitz Hugh Ludlow, each having been captivated by an exhibition of photographer Carleton E. Watkins's mammoth-plate prints of Yosemite. This second journey, lasting eight months, was more extensive than the first and included a trip north to Oregon and Washington Territory in addition to California. Bierstadt's travels furnished him with much of the material he was later to use in his paintings. Among the nearly twenty major examples of these (works roughly five by seven feet and up), with the exception of three views of Yosemite, defined by its status as an open and thus accessible valley, all but one of the landscape compositions highlight terrain in which significant central parts have been separated out and rendered remote, awesome, and removed. The single outlier showing the domestication of such territory is Bierstadt's view down (as opposed to his usual look up) onto Donner Lake in the Sierra Nevada that includes the train sheds of the Central Pacific Railroad, which in 1868 finally breached the pass above it—an understandable concession considering the painting was a commission from the railroad's promoter, Collis Huntington.[33]

Nevertheless, for reasons of nationalism, Bierstadt's audience was inclined to view such inaccessible productions differently from those of Church. A *Harper's Weekly* review of *Lander's Peak*, for example, noted: "And unlike Mr. Church's pictures of the equatorial mountain scenery of America, which from their volcanic and tropical character, however luxuriant, yet forbid hope and leave an impression of profound sadness and desolation, this work of Bierstadt's inspires

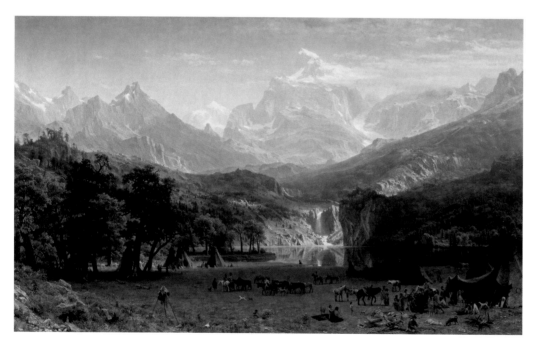

FIGURE 94: Albert Bierstadt (American, born Germany, 1830–1902), *The Rocky Mountains, Lander's Peak,* 1863. Oil on canvas, 186.7 × 306.7 cm. The Metropolitan Museum of Art, New York. Rogers Fund, 1907 (07.123)

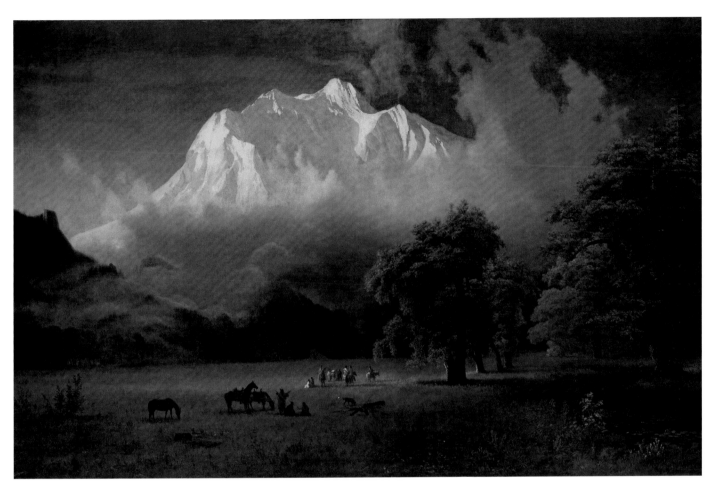

FIGURE 95: Albert Bierstadt, *Mount Adams, Washington*, 1875. Oil on canvas, 138 × 213 cm. Princeton University Art Museum. Gift of Mrs. Jacob N. Beam (y1940-430)

the temperate cheerfulness and promise of the region it depicts, and the imagination contemplates it as the possible seat of supreme civilization." Moreover, Bierstadt's paintings were considered realistic, at least initially, in contrast to Church's "compositions," thus affording their spectacularism a further nationalistic bent.[34]

But increasingly as his career progressed, Bierstadt was dogged by accusations surrounding the artifice of his imagery. In 1867 Mark Twain wryly described the artist's grandest creation, *The Domes of the Yosemite*, as "beautiful—considerably more beautiful than the original," continuing, "As a picture, this work must please, but as a portrait I do not think it will answer. Portraits should be accurate." How Bierstadt altered reality and to what end are suggested by his 1875 painting of Mount Adams in Washington (fig. 95), one of several grand canvases depicting peaks in the Pacific Northwest's Cascade

Range. In portraying it as he did, Bierstadt had the advantage of knowing that—even more than with his views of Yosemite—few easterners had seen the sight depicted, providing him a latitude similar to the one he exercised a few years before when moving from titles that were specific (*Lander's Peak*) to generic (*Sierra Nevada Morning*) for some of his most operatic works.[35]

Bierstadt and Ludlow spent four or five days in the fall of 1863 on the Columbia River, which flows some thirty miles south of Mount Adams from headwaters in the Rocky Mountains to the Pacific Ocean. The following year Ludlow published an article describing this portion of their trip, which makes it clear that the two never left the river and got no closer than this to the peak, which in any case would have been difficult at the time. A photograph from a few years later by Watkins (1829–1916) shows Mount Adams

rising in the distance beyond the river and reveals how removed it in fact was from Bierstadt's nearest vantage point (fig. 96). His nonetheless finely detailed portrayal of it includes, on the left, the peculiar, snub-nosed profile of Sleeping Beauty Peak, a nearly five-thousand-foot andesitic dike, shown in relation to the larger mountain as if from the direction of the river to the south. Yet the distinctive silhouette of Bierstadt's highly articulated Mount Adams is clearly the view from the west. To piece together this manifestly confected portrayal, Bierstadt must have relied on pictorial sources other than his own, which became available in the years between his trip and the execution of the work. Whatever the means, the image he produced is, like Church's *Cayambe*, not the one the artist saw.[36]

Painting what he wanted instead of what was—while pretending otherwise—allowed Bierstadt to craft an image of western nature that was both sensationally appealing and ready for occupation. By arranging his image to feature the peak looming large and showing its most dramatic façade, as well as incorporating a second striking promontory arising from the flat, accessible, parklike plain, Bierstadt presented as alluring a picture of the place as might be imagined.

FIGURE 96: Carleton E. Watkins (American, 1829-1916), *Mt. Adams, from Sunset Hill, Dalles City*, 1867. Albumen print, 45.7 × 55.9 cm. Stanford Libraries. Special Collections & University Archives

Here Mount Adams is separated from the foreground scene merely by the morning mist, whose implied movement to the right seems to draw with it the Indigenous figures already conveniently making their way off the canvas, opening up the space for others to inhabit. In what might have been written to describe *Mount Adams*, the printed testimonial accompanying a popular engraving of *Lander's Peak* referred to "the every-day life of that race which, before the advance of civilization, fades away like the mists of morning before the rays of the rising sun." Genocide is presented as georgic, with the "passing away" of a people, as Bierstadt called it, rendered as natural as the earth's rhythms.[37]

Unacknowledged in Bierstadt's paradisiacal world is that the smooth meadowland depicted beneath Mount Adams was probably not there by accident, but was created by the area's Yakima people through successive planned and controlled burns. The land was not only occupied but also cultivated before the artist's arrival. Such knowledge would not have endeared the work to Jay Cooke, a financier earlier involved in the promotion of Yellowstone, to whom Bierstadt offered to give either this or another painting of the same title if he would agree to buy a larger one of Mount Hood. When the artist made this enterprising proposal in 1872, Cooke controlled the struggling Northern Pacific Railway, which set up colonization offices as far away as Germany and Scandinavia in an attempt to lure settlers westward. Stripped of its true context, however, Bierstadt's Edenic painting might serve just as well as Church's "travel posters" were meant to do for Cyrus Field.[38]

But the trouble with Bierstadt's vision, and Church's mature one as well, is that in rendering nature as spectacular "other," both artists ultimately remove it from the human realm and reify the notion, entrenched since antiquity, that humans and nature are not part of the same world—a great irony in light of Church's embrace of Humboldt's unifying rhetoric. Seen in this way, the vacating Indians in *Mount Adams* perversely connote the evacuation of *all* human presence implicit in such a weltanschauung, to use a Humboldtian term. He said, "The most dangerous worldview is the worldview of those who have not viewed the world." A truly comprehensive view of the world must entail an appreciation of humankind as but a part of the whole, not the reason for it—a piece, however powerfully pervasive, of a radically complex, interconnected web of existence. While seeking to enhance appreciation for nature, Bierstadt

and Church in the end promoted its estrangement. Whereas artists of the picturesque encouraged access and entry into the surrounding environment—a move with its own imperial ramifications—artists of the sublime shut us out.[39]

Thoreau linked such a construction of "wildness" with Bierstadt's nationalistic western expansionism in 1862: "I must walk toward Oregon, and not toward Europe.... We go eastward to realize history and study works of art and literature, retracing the steps of the race; we go westward as into the future, with a spirit of enterprise and adventure....The West of which I speak is but another name for the Wild; and what I have been preparing to say is, that in Wildness is the preservation of the World." The apotheosis of wilderness that Thoreau advances did have real and positive effect in just the place he links it to— the American West, where Watkins's and Bierstadt's and Thomas Moran's images (see fig. 1) all played a role in the formation of Yosemite and Yellowstone national parks, both for "the preservation of the World" and "For the Benefit and Enjoyment of the People," as stated in Yellowstone's founding legislation in 1872 and later inscribed atop Roosevelt Arch at the park's entrance.[40]

Yet today that entrance stands surrounded on one side by "pristine" nature and on the other by "human" nature (fig. 97), vividly illustrating the unintentional implications of setting aside certain parts of nature, exceptional as they may be, and leaving the rest to take care of itself. In seeking to save it, we remove ourselves from nature, and offer no means of envisioning how we might live both productively and ethically *with* it. In 1864, the same year Abraham Lincoln signed the Yosemite Grant Act, initially establishing a small natural preserve there and thereby setting a significant national precedent, George Perkins Marsh (1801–1882) published *Man and Nature*, in which he described humankind's disruptive effect on "natural harmonies," as suggested by the book's subtitle, *Physical Geography as Modified by Human Action*. Although purely historical coincidence, the relationship of the one to the other suggests not only a dawning recognition of humanity's pervasive environmental impact but also the divergent ways by which it might be addressed, with Marsh more comprehensively advocating systemic change in human relations with the natural world, and the Yosemite Grant preserving a part of the natural world from them. Later, others such as John Muir (1838–1914) and

FIGURE 97: Roosevelt Arch at the north entrance to Yellowstone National Park, May 2003. Photograph by Jim Peaco/National Park Service

Aldo Leopold (1887–1948) would add spiritual and ethical dimensions to Marsh's more utilitarian stance, but the essential contest between the two visions has animated and bedeviled American environmental discourse ever since.[41]

Fog

In 1862, a third of a century after Cole first portrayed the rugged scenery of Catskill Clove (see fig. 60), Sanford Robinson Gifford (1823–1880), a leading member of the subsequent generation of Hudson River School artists, completed a very different painting of the same scene—and not simply because it showed the valley from the opposite end. Gifford's *A Gorge in the Mountains (Kauterskill Clove)* (fig. 98) is structured according to the same basic precepts of pictorial design Cole employed, with foreground repoussoir of rocks and trees framing an enfilade of receding ridgelines, picked out by the raking sunlight and leading ultimately to Haines Falls at the end of the Clove, from where Cole's view was taken. The painting is similar as well to Church's expansive works in seeming to encompass not just a vista but an entire realm. Unlike Cole and Church, however, and Bierstadt after them, Gifford focuses less on land and more on air, as underscored by the painting's ocular composition, which echoes and reinforces the circular, central, emanating sun. Atmosphere is its true subject, and was more generally a preoccupation of a group of artists, Gifford among them, active during the third quarter of the nineteenth century and later cohered by the neologism "Luminism." This unofficial group also includes, principally, Fitz Henry Lane (1804–1865), John Frederick Kensett (1816–1872), and Martin Johnson Heade (1819–1904), as well as Church in certain works. As the name suggests, the diverse qualities of light were as central to the quieter, more contemplative Luminist idiom as the objects defined by it. Loosely aligned with the philosophical precepts of Transcendentalism and its imperative to integrate spirit and matter, Luminist painters sought to achieve that communion by instilling a precise and meditative focus in their typically lucent, muted, sparsely and asymmetrically composed, horizontal canvases.[42]

Though *Kauterskill Clove* retains elements of picturesque composition, the Luminists' break with that approach was in general thoroughgoing, and distinct from that of Church and Bierstadt. In place of their emphasis on sublime and portentous substance, the Luminists' frequent attention to

ethereal evanescence signaled a larger crisis in the purpose and ends of landscape representation. Already by the late 1860s, Bierstadt in particular was struggling to reconcile a heroic type of painting with an audience for whom his messages of Manifest Destiny seemed a foregone conclusion. The sequelae of Civil War, ongoing urbanization, industrialization and the economic reorganization it engendered, and the increasing cosmopolitanism of art itself—along with a host of other effects of modernism—made the grand imperial landscape seem a fraught and even retrograde project. Luminism instead offered images of often quotidian scenes, presented not hierarchically, with a clear and particular concentration or focal point, but democratically, with more lateral compositions in which interest is apportioned evenly across the picture plane. As a result, attention is devoted less to looking at a discrete, privileged subject than to observing relations

FIGURE 98: Sanford Robinson Gifford (American, 1823-1880). *A Gorge in the Mountains (Kauterskill Clove)*, 1862. Oil on canvas, 121.9 × 101.3 cm. The Metropolitan Museum of Art, New York. Bequest of Maria DeWitt Jesup, from the collection of her husband, Morris K. Jesup, 1914 (15.30.62)

FIGURE 99: Fitz Henry Lane (American, 1804–1865), *The Fort and Ten Pound Island, Gloucester, Massachusetts*, 1847. Oil on canvas, 50.8 × 76.2 cm. Museo Nacional Thyssen-Bornemisza, Madrid (1982.43)

among multiple areas or subjects—a kind of overall orientation that, in both its ecumenism and interconnectedness, is essentially ecological. Insisting on the equivalent importance of all things observed, Luminism is also implicitly less anthropocentric. The suppression of painterly style and ostensible artistic sensibility in favor of fidelity to optical experience and the recording of natural phenomena as if by conduit bolsters this effect, reifying the famous metaphor of Transcendentalist leader Ralph Waldo Emerson (1803–1882) in describing unity with nature: "Standing on the bare ground,—my head bathed by the blithe air, and uplifted into infinite space,—all mean egotism vanishes. I become a transparent eye-ball; I am nothing; I see all; the currents of the Universal Being circulate through me; I am part or particle of God."[43]

The eldest among the core Luminist practitioners, Lane began his painting career producing ship portraits—relatively formulaic images made on commission to record a vessel's appearance—for the thriving merchant marine of his native Gloucester, Massachusetts. He later expanded his register with more extensive harbor and other littoral views, of which *The Fort and Ten Pound Island, Gloucester, Massachusetts* (fig. 99) is a typical early example. It shows a variety of boats and ships, each adapted to its particular use, in a mundane setting with sailors, fishermen, and others distributed throughout both land and water. There is no special focus other than the interactions among people and their nautical devices, various marine life—kelp, cod, oysters, a hapless starfish, perhaps a horseshoe crab—the wind, and the tide. The picture presents an indiscriminate snapshot of harbor life, which it seems can hardly

FIGURE 100: Fitz Henry Lane, *Ship in Fog, Gloucester Harbor*, ca. 1860. Oil on canvas. 61 × 99.1 cm. Princeton University Art Museum. Museum purchase made possible by the Fowler McCormick, Class of 1921, Fund; the Kathleen C. Sherrerd Program Fund for American Art; and Celia A. Felsher, Class of 1976, and John L. Cecil, Class of 1976 (2017-10)

be contained, with the lumber schooner at left edging toward the frame and the beached one opposite pointing similarly beyond the confines of the canvas. The manipulations of the picturesque and its concern with progression into the scene, along with the sublime's concentration on the singular heroic subject, are eschewed. Exchange, codependence, and connection are the work's themes.

Most of Lane's views are rendered from careful sketches done onshore, gazing out to sea. More seldom, they are taken from a point at sea, looking back to land, a feat accomplished only with difficulty since the artist was paralyzed as a young child and used crutches. Lane's bodily immobility stands in poignant contrast to the gliding vessels he portrayed in nearly all his paintings, in one of which, from late in his career, he positions himself in the middle of Gloucester Harbor, looking toward the same Ten Pound Island seen from the opposite side in the painting

of about a dozen years before. *Ship in Fog, Gloucester Harbor* (fig. 100) is a rare portrayal by Lane of the most difficult of atmospheric effects to render, attempted in only a few of his later works. If *The Fort and Ten Pound Island* implies in its random composition that only a fragment of a wider world can be captured in representation, *Ship in Fog* makes the impossibility of comprehensive vision its very subject. And yet what is shown reveals the intimate connections between each part, and of all with the fog itself. The enveloping vapor seems an apt metaphor for a fundamental problem of landscape imagery—the inability to see anything more than selected surfaces, or to construct anything more than an artifice of nature—even as it expresses the essential ecological character of Lane's work. Touching and inflecting everything, it exists only as the result of forces—temperature, humidity, the movement of air— outside its own.[44]

Lane died in 1865, a few months after the end of the Civil War, but Heade, fifteen years his junior, lived into the twentieth century. Like Lane, he produced hundreds of paintings of water—seascapes, but especially distinctive marsh scenes, of which he made 120—along with some early portraits, late still lifes, and a large group of tropical paintings, the result of three expeditions to Central and South America. Not long after Lane finished *Ship in Fog*, Heade made the first of these, to Brazil. Enthralled since a child with hummingbirds, he undertook a series of small paintings of them, exhibiting twelve in Rio de Janeiro in 1864, pictures he intended to include in an unrealized book on "The Gems of Brazil" (fig. 101). These are intimate, specimen images, works showing individual pairs of particular species against a distant, disconnected backdrop like those in many of Audubon's earlier *Birds of America* engravings. They are wholly unlike—even antithetical to—the extensive South American views more recently completed by Heade's friend Frederic Church. While the difference is partly owing to the distinction between the mountainous Andean regions Church visited and the tropical lowlands Heade saw, the sensibilities informing them are worlds apart. If Church's sweeping vistas are Humboldtian in their attempt to represent nature as a unified system, Heade's are Linnaean in their taxonomic focus on its parts.[45]

After subsequent trips to the tropics in 1866 and 1870, Heade returned to the depiction of hummingbirds, only now he pictured them with varieties of orchid and other flowers, suggesting the symbiotic exchange of nectar for pollination (fig. 102). Although he failed to properly link particular species of bird and flower (his pairings were artistic and symbolic rather than scientific), he nonetheless represented an environment of sorts, thus moving from the typological to the ecological in his depictions of tropical nature. Indeed, these later paintings moved beyond both Linnaeus and Humboldt toward Darwin, who in 1862 described the evolutionary anatomy of orchids as modified over time to ensure cross-fertilization, and in 1876 discussed the evolution of hummingbird bills to adapt to changes in the flowers they pollinated. Heade, an avid conservationist, is thought to have known of Darwin's work and been influenced by it.[46]

Heade's later hummingbird paintings resonate with the far larger series of marsh and swamp pictures he began around 1858, principally in Massachusetts and New Jersey. Constituting half his mature output of landscapes, and a fifth

FIGURE 101: Martin Johnson Heade (American, 1819–1904), *Black-Breasted Plovercrest*, ca. 1863–64. Oil on canvas, 31.1 × 25.4 cm. Crystal Bridges Museum of American Art, Bentonville, Arkansas (2006.87)

of his artistic production overall, these are deceptively similar images—small (rarely larger than fifteen by thirty inches), oblong, detailed—each of which is in fact different; the artist never repeated a composition. The extended series seems as much an aesthetic and intellectual exercise as a transcriptive record of sights observed. Yet their frequent iteration belies a profound identification with the immanent complexity of the subject—the flux of season, tide, and weather. Half solid, half liquid, half wild, half domesticated, and always in a state of mutable interconnectedness, marshland is the archetypal ecological topos of landscape painting. Heade seemed to understand that, and signaled his appreciation by representing his marsh paintings under an exceptional variety of changing atmospheric conditions, from moments of crystalline equipoise, with roseate sunsets beneath clear skies, to darkening, showery afternoons with racing gray clouds, such as those that loom above the solitary fisherman on Pine

FIGURE 102: Martin Johnson Heade, *Orchid with Two Hummingbirds*, 1871. Oil on canvas, 37.8 × 48.3 cm. Reynolda House Museum of American Art, Affiliated with Wake Forest University, Winston-Salem, North Carolina (1976.2.8)

Island Creek in *Newburyport Marshes: Approaching Storm* of about 1871 (see fig. 227). Thoreau shared Heade's appreciation for the generally maligned, liminal wetlands, writing from nearby Concord, Massachusetts, "Though you may think me perverse, if it were proposed to me to dwell in the neighborhood of the most beautiful garden that ever human art contrived, or else of a Dismal Swamp, I should certainly decide for the swamp.... I feel that with regard to Nature I live a sort of border life."[47]

By virtue of their small scale and narrow horizontality, Heade's marsh paintings deny the "promise of the picturesque" extended by artists such as Durand, disallowing the fiction of bodily transport into the scene they employed to convey a sense of environmental control and access. In place of Church's clarity of vision in portraying nature's

FIGURE 103: Winslow Homer (American, 1836–1910), *The Artist's Studio in an Afternoon Fog*, 1894. Oil on canvas, 61 × 76.8 cm. Memorial Art Gallery of the University of Rochester, New York. R. T. Miller Fund (41.32)

harmonious order, and Bierstadt's in rendering imperial desire, Heade offers flux, and Lane, fog—and the Luminists, more generally, a system of perceptual equality that is inherently ecological. But in doing so they deprived American landscape painting of much of its ideological impetus, with an attendant dematerialization of the land evident in paintings such as Heade's marsh scenes, Lane's *Ship in Fog*, and, years later, in another fog painting by the great artist of a succeeding generation, Winslow Homer (1836–1910) (fig. 103). During the summer of 1880, Homer rented the same lighthouse on Gloucester Harbor's Ten Pound Island dimly visible in Lane's earlier painting, and produced there some of the most innovative watercolors of his career, works that placed new emphasis on effects of light, water, and atmosphere, their abstract qualities approaching the limits of realism. Four years later, he settled into a renovated carriage house on Prouts Neck in Maine, which he used as a studio for the rest of his life. The extensive porch wrapped around the small building suggests the act of looking out and seeing, but when Homer turned back in 1894 and represented the studio itself—the site where what he saw became his art— he shrouded it in fog, providing an allegory, like Lane's, of the problems of landscape painting in America as the era of its headlong territorial expansion drew to a close.

Landscape representation, of course, is not a mirror, but an image of a piece of the world mediated by the changing attitudes and concerns of its practitioners. Though understood as such—as a subjective act of objectification—during its rise in baroque Holland, landscape painting by the eighteenth century derived much of its power from the fact that it had come to be seen, on the contrary, as truth—as, indeed, a mirror. As landscape theorist W. J. T. Mitchell has written, "Like money, landscape is a social hieroglyph that conceals the actual basis of its value. It does so by naturalizing its conventions and conventionalizing its nature." Yet the environment is not a scene, is not a representation, and nature is neither static nor two-dimensional. As Americans of the long nineteenth century made of the construct of landscape what they needed it to be for their evolving ends, they in the process both reflected and actualized essential ideas about the relationship of the self to the surrounding world, and about the ways in which that world is constituted, with and without the human hand.[48]

Notes

1 Cole's auspicious emergence in New York is more completely detailed in Ellwood C. Parry III, *The Art of Thomas Cole: Ambition and Imagination* (Newark: University of Delaware Press, 1988), 24–28, Trumbull quoted 25–26; Ellwood C. Parry III, "Thomas Cole's Early Career: 1818–1829," in *Views and Visions: American Landscape before 1830*, ed. Edward J. Nygren (Washington, DC: Corcoran Gallery of Art, 1986), 167–70; Alan Wallach, "Thomas Cole: Landscape and the Course of American Empire," in *Thomas Cole: Landscape into History*, ed. William H. Truettner and Alan Wallach (New Haven: Yale University Press, 1994), 23–24; and Gerald L. Carr, "Initiating and Naming 'The Hudson River School,'" *Thomas Cole National Historical Site Newsletter* (Fall 2011): 4–6. The environmental aspects of his art are explored in Elizabeth Mankin Kornhauser and Tim Barringer, *Thomas Cole's Journey: Atlantic Crossings* (New York: Metropolitan Museum of Art, 2018); Angela L. Miller, "The Fate of Wilderness in American Landscape Art: The Dilemmas of 'Nature's Nation,'" in *A Keener Perception: Ecocritical Studies in American Art History*, ed. Alan C. Braddock and Christoph Irmscher (Tuscaloosa: University of Alabama Press, 2009), 85–109; Angela L. Miller, *The Empire of the Eye: Landscape Representation and American Cultural Politics, 1825–1875* (Ithaca, NY: Cornell University Press, 1993); Barbara Novak, *Nature and Culture: American Landscape and Painting, 1825–1875* (New York: Oxford University Press, 1980); and Stephen Daniels, "Thomas Cole and the Course of Empire," chap. 5 in *Fields of Vision: Landscape Imagery and National Identity in England and the United States* (Princeton: Princeton University Press, 1993), 146–73. The comparison between Trumbull's and Cole's early landscapes is perceptively made in Bryan Wolf, "Revolution in the Landscape: John Trumbull and Picturesque Painting," in *John Trumbull: The Hand and Spirit of a Painter*, ed. Helen A. Cooper (New Haven: Yale University Art Gallery, 1982), 214–15.

2 Thomas Cole to Daniel Wadsworth, July 6, 1826, in *The Correspondence of Thomas Cole and Daniel Wadsworth: Letters in the Watkinson Library, Trinity College, Hartford, and in the New York State Library, Albany, New York*, ed. J. Bard McNulty (Hartford: Connecticut Historical Society, 1983), 1. "Summit rose above summit" journal entry quoted in David Stradling, *The Nature of New York* (Ithaca, NY: Cornell University Press, 2010), 76. For the difference between perception and reality in assessing Hudson River Valley nature, see M. K. Heiman, "Production Confronts Consumption: Landscape Perception and Social Conflict in the Hudson Valley," *Environment and Planning D: Society and Space* 7, no. 2 (June 1989): 165–78. On Lancashire's mills, see Geoffrey Timmins, *Made in Lancashire: A History of Regional Industrialisation* (Manchester, UK: Manchester University Press, 1998); for their impact on Cole, see Tim Barringer, "Thomas Cole's Atlantic Crossings," in Kornhauser and Barringer, *Thomas Cole's Journey*, 21–23.

3 Trumbull quoted in Parry, "Thomas Cole's Early Career," 172. *Snow Squall* is discussed in formal and psychoanalytic terms in Bryan Jay Wolf, *Romantic Re-Vision: Culture and Consciousness in Nineteenth-Century American Painting and Literature* (Chicago: University of Chicago Press, 1982), 183–88, 193–94, 201–5. On changing attitudes toward wilderness, see Roderick Nash, *Wilderness and the American Mind*, 5th ed. (New Haven: Yale University Press, 2014), 44–83.

4 James Fenimore Cooper, *The Prairie* (1827; repr., Cambridge, MA: Belknap Press, 2014), 332. On Cole and politics, see Christine Stansell and Sean Wilentz, "Cole's America: An Introduction," in Truettner and Wallach, *Thomas Cole*, 3–21. For "Nature's Nation," see Perry Miller, "The Romantic Dilemma in American Nationalism and the Concept of Nature," *Harvard Theological Review* 48, no. 4 (October 1955): 239–53, repr. in Miller, *Errand into the Wilderness* (Cambridge, MA: Belknap Press, 1956); and Miller, *Nature's Nation* (Cambridge, MA: Belknap Press, 1967).

5 On Cole's changing patronage, see Alan Wallach, "Thomas Cole and the Aristocracy," in *Reading American Art*, ed. Marianne Doezema and Elizabeth Milroy (New Haven: Yale University Press, 1998), 79–108; and Wallach, "Thomas Cole: Landscape and the Course of American Empire," esp. 33–49. More generally, see Sven Beckert, *The Monied Metropolis: New York City and the Consolidation of the American Bourgeoisie, 1850–1896* (New York: Cambridge University Press, 2001), 17–97, esp. 51–75; and Frederic Cople Jaher, *The Urban Establishment: Upper Strata in Boston, New York, Charleston, Chicago, and Los Angeles* (Urbana: University of Illinois Press, 1982), 157–315.

6 The retitled "Essay on American Scenery" appeared in the January 1836 issue of *American Monthly Magazine* and is reprinted in Thomas Cole, *The Collected Essays and Prose Sketches*, ed. Marshall Tymn (St. Paul, MN: John Colet Press, 1980), 3–19, quoted 8, 6, 17. Cole's critique of profligate development responded to a settler mind-set that, rather than seek equilibrium with flora and fauna, considered the relation a matter of short-lived exploitation, with the prospect of future dedication to agriculture or additional environmental resources just a move away—an outlook Cooper's Natty Bumppo pithily described in *The Pioneers* (1823) as "wasty ways"; see Alan Taylor, "'Wasty Ways': Stories of American Settlement," in *American Environmental History*, ed. Louis S. Warren (Malden, MA: Blackwell, 2003), 102–18.

7 For the original text, see Cole, "Essay," 17; for the revised version, originally published in the May 1841 issue of *Northern Light*, see Thomas Cole, "Lecture on American Scenery," in Cole, *Collected Essays*, 197–213, quoted 210–11. The earlier "The Complaint of the Forest" and the later published "The Lament of the Forest" are both in Thomas Cole, *Thomas Cole's Poetry*, ed. Marshall B. Tymn (York, PA: Liberty Cap Books, 1972), 100–112. On the contest between "progress" and the forest, see Steven Stoll, "Farm against Forest," in *American Wilderness: A New History*, ed. Michael Lewis (New York: Oxford University Press, 2007), 55–72.

8 Cole note and letter to Gilmor quoted in Barringer, "Thomas Cole's Atlantic Crossings," 50.

9 Cole, "Essay," 17. In the visual logic of epic mid-nineteenth century American landscape painting such as *The Oxbow*, left = west and right = east; however, in actuality the view from Mount Holyoke onto the river is oriented differently, with the Oxbow situated to the west of the mountain. For an environmental reading of *The Oxbow* stressing its ambivalence, see Miller, "Fate of Wilderness," 89–99; for one viewing it as a critique, see Elizabeth Mankin Kornhauser, "Manifesto for an American Sublime: Thomas Cole's *The Oxbow*," in Kornhauser and Barringer, *Thomas Cole's Journey*, 63–95. Also see Alan Wallach, "Making a Picture of the View from Mount Holyoke," in *American Iconology: New Approaches to Nineteenth-Century Art and Literature*, ed. David C. Miller (New Haven: Yale University Press, 1993), 80–91.

10 *Distant View of the Slides That Destroyed the Whilley* [sic] *Family* was lithographed and published in New York by Anthony Imbert after Cole's drawing. For extensive information on Cole at Crawford Notch, see Franklin Kelly, "*A View of the Mountain Pass Called the Notch of the White Mountains (Crawford Notch)*," in *American Paintings of the Nineteenth Century, Part I: The Collections of the National Gallery of Art, Systematic Catalogue*, ed. Franklin Kelly (Washington, DC: National Gallery of Art, 1996), 87–95.

11 Lord acquired Cole's *Landscape Composition: Italian Scenery* in 1831 or 1832 (Memorial Art Gallery of the University of Rochester). Cole's notes quoted in Kelly, "Crawford Notch," 89. Nicolai Cikovsky Jr. makes the comparison between the Schroon Mountain sketch, "View of Schroon Mountain Looking North June 28, 1837" (1837; Detroit Institute of Arts), and painting, *View of Schroon Mountain, Essex County, New York, after a Storm* (1838; Cleveland Museum of Art), in "'The Ravages of the Axe': The Meaning of the Tree Stump in Nineteenth-Century American Art," *Art Bulletin* 61, no. 4 (December 1979): 624.

12 The 1838 engraving by John Cousen (1804–1880) after William Henry Bartlett (1809–1854), *The Notch House, White Mountains*, for example, adopts much the same viewpoint as the Bemis photograph but includes the entire Notch House structure, with its paired gable-end windows and two chimneys, like those in Cole's painting.

13 Ellwood Parry posits an identification between Cole himself and his family as the settlers portrayed in *The Hunter's Return*; see Ellwood C. Parry III, "*The Hunter's Return*," *American Art Journal* 17, no. 3 (Summer 1985): 2–17.

14 The implications of Cole's numerous paintings are most fully explored in Alan Wallach, "Thomas Cole's *River in the Catskills* as Antipastoral," *Art Bulletin* 84, no. 2 (June 2002): 334–50, which contains extensive information on the other versions, and interpretations of them, in advancing the argument of the article's title. By contrast, Daniels, in "Cole and the Course of Empire," 161–67, is equivocal and thus more in keeping with the position taken here.

15 *View in the Catskills* is reproduced in Parry, "Thomas Cole's Early Career," 185. The oil sketch for the 1833 paintings is in a private collection; the first resulting work, *Sunset, View on the Catskill*, is at the New-York Historical Society; a replica, *View of Catskill Creek* (formerly *Distant View of Roundtop*), is at the Albany Institute of History and Art. The larger work of 1838, *North Mountain and Catskill Creek*, is in the Yale University Art Gallery.

16 Sturges to Cole, March 23, 1837, and Cole to Reed, March 6, 1836, quoted in Oswaldo Rodriguez Roque, "*View on the Catskill—Early Autumn*, 1837," in *American Paradise: The World of the Hudson River School*, ed. John K. Howat (New York: Metropolitan Museum of Art, 1987), 128–29.

17 Like many successful antebellum New York businessmen, Sturges was often described in terms of probity, piety, and philanthropy; see, for example, the New York Chamber of Commerce eulogy reprinted in William K.

Ackerman, *Historical Sketch of the Illinois Central Railroad* (Chicago: Fergus, 1890), 23–24. For *Allen v. Illinois Central Railroad*, see "Declaration" in "Canals and Railroads Open Illinois," Lincoln Legal Papers Curriculum, https://files.eric.ed.gov/fulltext/ED460029.pdf, 157–58, quoted 157.

18 An 1841 iteration of the view, *Sunset in the Catskills* (Museum of Fine Arts, Boston), features a *Rückenfigur* as well, depicted looking toward the Catskills from a boat in Catskill Creek. Yet another small painting, *Settler's Home in the Catskills* (1842; private collection), features a cabin set unobtrusively in a small meadow on the far bank of the river, in harmony with each.

19 Thoreau asked that question in 1839; it later appears in the opening pages of *A Week on the Concord and Merrimack Rivers* (1849). The schism between Cole's words and pictures is reflected again in his characterization of the appearance, after clearing and construction of the railroad, of the scene portrayed in *River in the Catskills*: "The vicinity of the site from which the view is taken was a favorite haunt of mine—but its beauty has passed away"—and yet, one would be hard-pressed to describe the work as anything but beautiful, even if altered from previous iterations (quoted in Kornhauser, "Manifesto for an American Sublime," 88). For Cole's concerns about the marketability of *The Oxbow*, see Elizabeth Mankin Kornhauser, "*View from Mount Holyoke, Northampton, Massachusetts, after a Thunderstorm (The Oxbow)*," cat. entry in Kornhauser and Barringer, *Thomas Cole's Journey*, 202.

20 Franklin Kelly, *Frederic Edwin Church and the National Landscape* (Washington, DC: Smithsonian Institution, 1988), 19–21. Also see, on the symbolism of *To the Memory of Cole*, J. Gray Sweeney, "'Endued with Rare Genius': Frederic Edwin Church's *To the Memory of Cole*," *Smithsonian Studies in American Art* 2, no. 1 (Winter 1988): 44–71; and Jennifer Raab, *Frederic Church: The Art and Science of Detail* (New Haven: Yale University Press, 2015), 126–28. Cole quoted in Kelly, *Church and the National Landscape*, 2.

21 On *New England Scenery* and its relation to Humboldt, see Franklin Kelly, *Frederic Edwin Church* (Washington, DC: National Gallery of Art, 1989), 46–48; and Kelly, *Church and the National Landscape*, 53–58. On Humboldt, see Laura Dassow Walls, *The Passage to Cosmos: Alexander von Humboldt and the Shaping of America* (Chicago: University of Chicago Press, 2009), Humboldt quoted 217; also Aaron Sachs, *The Humboldt Current: Nineteenth-Century Exploration and the Roots of American Environmentalism* (New York: Viking Penguin, 2006); and Andrea Wulf, *The Invention of Nature: Alexander von Humboldt's New World* (New York: Alfred A. Knopf, 2015).

22 Alexander von Humboldt, "Landscape Painting," in *Cosmos: Sketch of a Physical Description of the Universe*, vol. 2, trans. and ed. Edward Sabine (1848; repr., New York: Cambridge University Press, 2010), 74–91, quoted 84.

23 On American commercial interest in South America at midcentury and its artistic implications, see Katherine Emma Manthorne, *Tropical Renaissance: North American Artists Exploring Latin America, 1839–1879* (Washington, DC: Smithsonian Institution Press, 1989), esp. 52–53; on Field's interest in particular, see Samuel Carter III, *Cyrus Field: Man of Two Worlds* (New York: G. P. Putnam's Sons, 1968), 71–93.

24 Carter, *Cyrus Field*, 81. For Field's and Church's sympathetic interests, see Albert Boime, *The Magisterial Gaze: Manifest Destiny and American Landscape Painting, c. 1830–1865* (Washington, DC: Smithsonian Institution Press, 1991), 61–70. Humboldt's *Naturgemälde* accompanied and served as the basis for his *Essay on the Geography of Plants*, published in French and German in 1807 as the first of what became the thirty-four-volume *Voyage to the Equinoctial Regions of the New Continent*; see Wulf, *Invention of Nature*, 88–89, 126–28, Humboldt quoted 88.

25 The principal works resulting from Church's first Andean trip are, from 1854, *Cordilleras: Sunrise* (private collection), *Tequendama Falls* (Cincinnati Art Museum), *La Magdalena (Scene on the Magdalene)* (private collection), and *Tamaca Palms* (National Gallery of Art, Washington); from 1855, *Cotopaxi* (Smithsonian American Art Museum), *Cotopaxi* (Museum of Fine Arts, Houston), *Mountains of Ecuador* (Wadsworth Atheneum), and *Andes of Ecuador* (Reynolda House Museum of American Art); from 1856, *In the Tropics* (Virginia Museum of Fine Arts) and *South American Landscape* (Museo Nacional Thyssen-Bornemisza); and, from 1857, *View of Cotopaxi* (Art Institute of Chicago) and *View on the Magdalena River* (private collection). For details of the trip, see Pablo Navas Sanz de Santamaría, *The Journey of Frederic Edwin Church through Colombia and Ecuador, April–October 1853* (Bogotá: Villegas Asociados, 2008). Church's journal quoted in David C. Huntington, "Landscape and Diaries: The South American Trips of F. E. Church," *Brooklyn Museum Annual* 5 (1963): 85.

26 Alexander von Humboldt, *Researches Concerning the Institutions and Monuments of the Ancient Inhabitants of America, with Descriptions and Views of Some of the Most Striking Scenes in the Cordilleras!*, vol. 2, trans. Helen Maria Williams (London: Longman, Hurst, Rees, Orme & Brown, J. Murray & H. Colburn, 1814), 100. The publication's images adhered to a picturesque aesthetic; see Alicia Lubowski-Jahn, "The Picturesque Atlas: The Landscape Illustrations in Alexander von Humboldt's *Views of the Cordilleras and Monuments of the Indigenous Peoples of the Americas*" [alternate title of the above referenced work], in *Unity of Nature: Alexander von Humboldt and the Americas*, ed. Georgia de Havenon et al. (New York: Americas Society, 2014), 70–85.

27 The Panecillo sketch, "Cayambé, Morning, from the Temple of the Sun, Quito, June 24, 1857," is at the Cooper Hewitt, Smithsonian Design Museum, New York. Church completed a much smaller version of the painting, probably a finished study, which does not include the stela; it is now in the collection of the Museum of Fine Arts, Boston. Despite contemporary understanding that "it was on the heights of the mountains about Cayambe, that the Incas of old built their palaces and temples of freestone" (from an 1860 review of Church's *Heart of the Andes* quoted in Manthorne, *Tropical Renaissance*, 101), the model for Church's ruin is Mayan, although that civilization never existed remotely near Cayambe; see Kevin Avery, "Maya on the Hudson: Church's *Cayambe* and Cruger's 'Folly,'" *Hudson River Valley Review* 31, no. 1 (Autumn 2014): 50–61. Robert L. Stuart was a bibliophile and owned a set of Lord Kingsborough's nine-volume *Antiquities of Mexico* (London, 1830–48), whose illustrations—much in the manner of Church's ruin—likely provided the example (a relief from the Temple of the Cross at Palenque in Chiapas, Mexico).

Laura Turner Igoe

Creative Matter: Tracing the Environmental Context of Materials in American Art

What can a high chest of drawers (fig. 104) produced in Philadelphia in the mid to late eighteenth century tell us about ecology and environmental history? Conversely, what can the ecology and environmental history of the resources used to make this high chest tell us about its status as a work of fine furniture and decorative art? More than simply a utilitarian object, this work of deluxe furniture undoubtedly shaped its owners' domestic environment in significant ways, captivating viewers with its fine detail, pleasing proportions, and seductive mahogany surfaces. A consideration of the chest's materials and their origins additionally reveals it to be a global assemblage of diverse ecologies and economies, including mahogany from Jamaica, brass pulls wrought in Birmingham, England, and local tulip poplar and white cedar composing the inner skeleton. Varnish from North Africa accentuated the seductive sheen of the mahogany, and glue made from animal carcasses secured the drawer runners. Viewed in this way, the Philadelphia high chest is repositioned as a product of transnational commerce, an assemblage of various constituents and forces within an interconnected web of environmental exchanges and transformations.

Recent scholarship in the humanities and social sciences has focused greater and more nuanced attention on the material properties of things. Accordingly, in terms of interpretive method, many historians of art now look beyond conventional issues of creation, style, iconography, patronage, and consumption in order to consider important new questions about media, processes, movement, and exchange.[1] This growing focus on materiality in an expanded frame requires American art historians to think on a global scale, since wood, silver, pigments, and other substances often traveled great distances before arriving in the artist's studio or workshop.[2] Despite this increasing scholarly interest in matter and movement, very little research has focused on the environmental implications of the procurement and transformation of art materials, especially in a historical context.[3] As the art historian Robin Kelsey contends, "In the act of historical interpretation, we have a habit of separating our pictures from the material processes and economic desires that make them possible and give them form. We admire the art and forget the fuel."[4] A disconnect among material histories, technical studies, and the ecology of art history persists as bridges between these fields are all too infrequently crossed.

The following investigation of several objects in *Nature's Nation* aims to overcome that disconnect by examining their media through an ecocritical lens. My purpose here, in short, is to cut through environmental-historical amnesia about the physical stuff of artworks, a condition resulting from their abstraction as commodities divorced from their origins and transformed through processes of aesthetic production. Ecocritical art history reconnects aesthetic objects with their chains of production by recovering lost or neglected evidence of related environmental conditions that bear on politics, society, and culture. Furthermore, this approach challenges the prevailing anthropocentrism of art history by recognizing the agency of the environments and nonhuman entities with which works of art engage. *Nature's Nation* embodies and encourages the growing interest among scholars in addressing environmental considerations related to the production and reception of art.[5] Far from imposing an anachronistic or "presentist" interpretive framework on the historical past, ecocriticism recovers important environmental dimensions of art historical context that are generally

FIGURE 104: Probably Henry Cliffton (American, died 1771) and Thomas Carteret, Philadelphia, High chest of drawers, ca. 1760. Mahogany, tulip poplar, white cedar, brass, 238.5 × 109.5 × 60.5 cm. Princeton University, Prospect House. Bequest of Mrs. Mary K. Wilson Henry (PP690)

overlooked by traditional methods in the field.[6] As the following case studies reveal, laborers (and those overseeing or enforcing that labor), makers, and consumers were keenly aware of the negative environmental impact and toxic consequences of the extraction and manufacture of certain art materials, both past and present.

The objects investigated in this essay consist of a variety of substances: wood, silver, lead- and zinc-based pigments, marble, turpentine, and more. As representative samples, they illuminate the complex ecological and social history of creative matter, including issues of toxicity, sustainability, and environmental justice. Specificity in interpretation here is important, especially given the range of materials, techniques, themes, and contexts under discussion. Some works of art forcefully draw attention to their assemblage of components while others almost seem to transcend them, but all tend to obfuscate their environmental origins and the social conditions that contributed to their realization.[7] By teasing out these vital material histories, I aim to reveal what might be called the ecological unconscious of art matter.

A Philadelphia High Chest of Drawers

As an assemblage of woods, metal, and animal products, the substantial Philadelphia high chest introduced above implicated artisans, laborers, enslaved Africans, and environments across the British Empire in its making. Donated to Princeton University by the heirs of alumnus Andrew Kirkpatrick, a lawyer and judge in New Brunswick, New Jersey, this chest likely stored clothing and household linens in the bedchamber—a semipublic space in the eighteenth century—where it advertised the wealth and refinement of its owner to close family and friends.[8] The rich, swirling pattern of the chest's exotic mahogany, prized for its durability and gleaming surfaces, in particular denoted its status as a luxury object. Although popular and trade literature visualized connections between furniture and its arboreal origins, the environmental and social costs of mahogany consumption remained invisible within the finished furniture form. Princeton's high chest highlights the unique grain pattern and seductive sheen of the wood, but its Rococo carvings and classical form order and domesticate the wilder and contentious origins of this material, causing the chest to occupy a liminal space between exotic tree and refined commodity.

In *Mahogany: The Costs of Luxury in Early America*, the historian Jennifer Anderson reveals how high demand for the tropical hardwood in Europe and America during the late eighteenth and early nineteenth centuries devastated the local ecology as well as the lives of African slaves and Indigenous peoples in the Caribbean and Central and South America. The British Atlantic market consumed two main types of mahogany: *Swietenia mahogani*, or short-leaf West Indian mahogany from the North Central Caribbean, and *Swietenia macrophylla*, or big-leaf Honduran mahogany found in larger areas in Central and South America. Because it grew in rocky, dry soil, *Swietenia mahogani* gained a favorable reputation for hard, dense wood that was superior in cabinetmaking to *Swietenia macrophylla*, which featured a lighter, spongier wood, due to its sunny, well-watered habitats. This distinction in quality became less meaningful, however, as the availability of the West Indian species declined in the late eighteenth century.[9] Analysis of samples of unvarnished mahogany from the back of the chest's underskirt, conducted by the National Fish and Wildlife Forensic Lab, determined that the mahogany used in the Philadelphia high chest is *Swietenia mahogani*.[10] It is therefore most likely that the mahogany used to construct the chest was harvested in Jamaica, the world's leading exporter of West Indian mahogany until the early 1770s.

It was sugar, not mahogany, that cemented Jamaica's wealth and prominence within the British Empire. Jamaican planters lobbied to make mahogany tax-exempt because they needed to rid the island of the timber, the by-product of clearing land for sugarcane (explored in greater detail in the next section of this essay). British furniture makers adopted the affordable material in the face of a local furniture wood shortage, consuming the highest-quality mahogany that previously was reserved for ship-building. American colonists, who looked to England for current trends and fashions, also embraced the wood as a material symbolic of affluence and sophistication. Mahogany joined other plantation products such as sugar, rum, cotton, pimento, ginger, and coffee in the holds of ships sailing north to the North American colonies, which in turn sent foodstuffs, livestock, English textiles and hardware, oak, pine, and other timber, and even manufactured mahogany furniture back to the Caribbean.[11]

The utility of mahogany, coupled with its slow growth and resistance to artificial cultivation, however, quickly made

FIGURE 105: Day & Son, *Forest Scenery in Honduras—Cutting and Trucking Mahogany,*
1850. Lithograph, frontispiece in Chaloner and Fleming, *The Mahogany Tree:
Its Botanical Characters, Qualities and Uses* (Liverpool: Rockliff and Son, 1850).
Winterthur Museum, Garden & Library, Wilmington, Delaware

it a scarce commodity on Jamaica. By the third quarter of the
eighteenth century, the island's mahogany was nearly
depleted, except for trees in hard-to-access mountain regions
and those hoarded by well-financed individuals. The strenu-
ous labor involved in locating and removing mahogany often
fell to enslaved Africans. Thomas Thistlewood, who oversaw
1,170 acres of grazing land and forest on Jamaica, deployed
male slaves to harvest mahogany on seasonal logging excur-
sions and hired these men out to neighboring estates.
Thistlewood's journal reveals that the Africans who worked
for him were acutely aware of the value of the wood they
labored to extract and transport. For example, in one entry
he reported that during a 1760 rebellion, later christened
Tacky's Rebellion, mutinous slaves stocked their fortified
encampment with "fine mahogany chests filled with clothes,"

extricated from their masters' homes.[12] The labor and trans-
port costs required to gather dwindling mahogany trees
soon exceeded potential profit, so some Jamaican merchants
imported and advertised Honduran mahogany as local in
order to avoid customs duties and obtain a higher price on
the market.[13] A later account of mahogany published by the
Liverpool timber merchants Chaloner and Fleming includes
several lithographs illustrating the felling and transport of
mahogany in the West Indies and Central America. The fron-
tispiece of *The Mahogany Tree* (fig. 105) depicts a number
of Africans reducing, shaping, and lifting enormous logs of
mahogany, overseen by a white foreman. Set in Honduras, the
image documents a clear hierarchy of power within the colo-
nial timber industry, as black bodies strain against the weight
of a massive mahogany log on the left while the foreman

directs the labor from a remove upon his horse. The accompanying text acknowledges that mahogany in Jamaica had "been almost exterminated."[14]

According to Anderson, the reflective, seductive surfaces of a finished piece of mahogany furniture signified an elite commodity in colonial America, aesthetically divorced from the environmental degradation and vast slave-driven imperial network that brought tropical hardwoods to northern shores. As Anderson observes, the transformation from tree to useful luxury object "appealed deeply to many Anglo-Americans precisely because it placed the wild, unfettered natural world at a safe remove," even as environmental and labor conditions affecting the availability of the wood had an impact on furniture forms and styles.[15] Ecocritical close looking, however, reveals that not all the vital attributes of mahogany have been removed or transformed through the processes of commodification and art. Princeton's high chest, for example, celebrates the wood's natural properties by highlighting its rich grain patterns. On the top drawer of the lower portion of the chest, the grain undulates and swirls, echoing the carved leaves that curl around and down the knees of the cabriole legs and accentuating the drawer fronts on the tympanum and scalloped front skirt. Together with the S-curves, carved shells, and rosettes on the scroll pediment, sculptural foliage saturates the high chest with symbols of fecundity and sensuality. This type of ornamentation bestowed high chests with a dynamic, animated presence within the American home, making them "agents or performers within the quotidian environment," according to the art historian K. L. H. Wells.[16] These visual references to natural abundance, however, are ultimately contained and domesticated within a highly ordered furniture form, book-ended by classical columns on either side. The chest, therefore, visualizes a material transformation from wild nature to civilized consumer good, offering an intriguing parallel to the rapidly transforming Jamaican landscape under plantation culture in the late eighteenth century.[17]

Various consumer goods, including wooden furniture, were imaginatively reconnected with their origins in "it-narratives," a popular eighteenth- and early nineteenth-century literary genre in which animated material possessions describe their creation, travels, and experiences.[18] These narratives, however, tended to avoid any deep consideration of the human and environmental costs of material production. For example, in "Transformation of a Beech Tree; or,

The History of a Favourite Black Chair: Related by Itself," the beech in question recounts its transformation from "a healthy, thriving tree … to a mass of materials."[19] When the chair reached a furniture warehouse in London, it encountered tropical hardwood pieces and suggested that, unlike its own black-painted wood, their appearance more explicitly advertised their exotic origins, "for the greater part were of a dark brown complexion and polished surface, which neither resembled the natural colour of my native trees, nor that which had been spread over me by the hand of man."[20] In another it-narrative, a mahogany bedstead, or bed frame, recalls its journey from Jamaica, where it "first spr[a]ng up, under the protection of a wealthy planter," until his owner received "an order for a large quantity of our species."[21] Such stories, while encouraging readers to imagine the past lives of their own furniture pieces, nevertheless did not highlight the ecological or social implications of timber extraction. The bedstead, for example, spends barely a paragraph on its growth and demise in Jamaica, with no mention of the plantation's slaves who likely chopped it down or the growing scarcity of mahogany.

This scarcity was felt through rising prices and evolving furniture styles that accommodated smaller amounts of the prized wood in the form of veneers. Cabinetmakers in particular were invested in the transatlantic networks that supplied them with luxury woods. The Princeton high chest may have been produced by the shop of Henry Cliffton, a Quaker joiner and cabinetmaker active in Philadelphia between 1748 and the year of his death in 1771.[22] No ledgers or account books from Cliffton's shop survive, but extant records of comparable Philadelphia cabinetmakers, including Benjamin Randolph, provide insight into how colonial American artisans profited from the importation of exotic woods. Tax records suggest that much of Randolph's financial success came from investments in privateers, venture cargo, and goods purchased at public auction. His account book contains numerous references to lumber transactions, and it is likely that he imported to Philadelphia mahogany and other exotic woods from Honduras and Jamaica.[23] Randolph and his fellow cabinetmakers were therefore keenly attuned to the variable prices and availability of mahogany related to deforestation, island revolutions, and expanding or contracting colonial access.

Although mahogany is arguably the most visual component of the high chest, other materials with a complex

environmental history also contributed to the piece's construction and decoration. The chinoiserie drawer pulls, for example, were the product of Birmingham's burgeoning brass industry, which transformed that city and region at the advent of the British Industrial Revolution. The design for the chest's fashionable pulls can be found in several extant Birmingham pattern books; cabinetmakers would select hardware from these circulated manuscripts and requisition them through an intermediary commercial merchant.[24] Ordered premade, likely in bulk, the brasses proved too large for the top drawers of the chest's matching dressing table (fig. 106), resulting in their awkward truncation. Thanks to new metal-working techniques such as rolling and stamping, the adoption of the steam engine, and the excavation of canals that connected the city with mines and markets, brass

objects produced in Birmingham were available on the global market at a relatively low cost. These new technologies, however, transformed the physical landscape of the British Midlands through canal construction and the brassworks' enormous consumption of fuel to power its machinery. Brass foundries also posed grave threats to workers' health, as dust from filing the brass and condensed fumes of volatized zinc from the melted metal caused pulmonary diseases that could prove fatal.[25]

Beneath the reflective sheen of mahogany and brass, a number of additional secondary materials compose and reinforce the chest's internal structure. The woods used for the chest's foundational skeleton—tulip poplar and white cedar—were widely available locally in the Delaware River Valley and became staples of a Philadelphia cabinetmaker's

FIGURE 106: Probably Henry Cliffton and Thomas Carteret, Philadelphia, Dressing table, ca. 1760. Mahogany, tulip poplar, white cedar, brass, 74.5 × 87.5 × 55 cm. Princeton University, Prospect House. Bequest of Mrs. Mary K. Wilson Henry (PP691)

FIGURE 107: *Joseph Lownes, Gold Smith & Jeweller, No. 130 Front Street South, Philadelphia*, ca. 1785–1817? Trade card, 10 × 13 cm. American Antiquarian Society (381489)

timber stock during the eighteenth century. Tulip poplar could be found in forests across the region, and white cedar, a soft and durable wood highly valued for its use in shingles, boatbuilding, cooperage, and fencing, as well as furniture, thrived in the Atlantic coastal plains and swamps of southeastern New Jersey.[26] While the locality of these species initially suggests a more innocuous acquisition history, the lack of timber regulation and forest conservation in eighteenth-century North America created wood shortages across the Eastern Seaboard. By 1750 the Swedish explorer and naturalist Pehr Kalm noted that the high demand for cedar led New Jersey inhabitants "not only to lessen the number of these trees, but even to extirpate them entirely....By this means many cedar swamps are already quite destitute of cedars."[27] Timber in easy proximity to navigable waterways became scarce by the beginning of the nineteenth century, and large forests of oak, chestnut, pine, and cedar in New Jersey, directly across the Delaware River from Philadelphia, disappeared almost completely due to agricultural clear-cutting and fuel consumption.[28]

Even less visible to the discerning eye, the chest's glue and varnish represent additional layers of matter with multifaceted environmental histories. To create drawer runners from the secondary woods, cabinetmakers used a hide glue produced by urban "bone boilers"—tradesmen who transformed animal carcasses into fertilizer, soap, candles, and

other products.[29] The varnish accentuating the seductive sheen of the mahogany wood is likely sandarac, a resin obtained from a cypress-like tree in North Africa.

With its intricate carvings and captivating surfaces— all calculated to impress as they shimmered in eighteenth-century candlelight—this luxurious work of colonial American furniture carefully elided the global political ecology embodied in its materials. Approaching this chest from an ecocritical perspective allows us to look beyond its construction in a Philadelphia cabinetmaker's shop and its reception in the Kirkpatricks' home in order to reconnect it with the diverse environments and peoples— from Jamaica to North Africa to Birmingham to the Eastern Seaboard—that contributed to its creation.

A Silver Sugar Bowl

Around the turn of the nineteenth century, the Philadelphia metalsmith and jeweler Joseph Lownes (1758–1820) distributed a trade card that advertised his wares in a fanciful way (fig. 107). The card showcases a variety of silver hollowware items interspersed within and around an exuberant foliate design of curling vines and sinuous trees, positioning silver as if it were a botanical product available in bounteous quantities, ready to be plucked off a branch. The banner statement unfurling along the bottom of the card and connecting various components of a tea set proclaims, "Highest price given old gold & silver." This commercial solicitation inadvertently undermines the sumptuous display of silver fruits by exposing the reality of the transnational silver market as one of recycling and repurposing. Most early American silver items were composed of other melted objects and coins, which were, in turn, fashioned from silver ore extracted from South American mines at significant environmental and social costs. The metal, therefore, was far from the plentiful, "natural" commodity imagined by Lownes's trade card.

A neoclassical sugar urn and cover bearing Lownes's identifying mark (fig. 108) closely resembles the urn in the lower right corner of the metalsmith's trade card. Silversmiths like Lownes adopted the urn shape in the late 1780s when the neoclassical style popularized by the British architect Robert Adam gained widespread acceptance following the Revolutionary War. Many late eighteenth-century sugar urns feature refined pierced galleries and pineapple finials, as displayed on an urn by fellow Philadelphia

silversmiths Joseph Richardson Jr. (1752–1831) and Nathaniel Richardson (1754–1827) (fig. 109).[30] Lownes's sugar urn, however, appears relatively unassuming, with applied beading, an engraved "K" monogram identifying a previous owner, and an urn-shaped finial, providing a miniature visual referent to the vessel's larger form. The urn is a part of the Boudinot Collection at Princeton, consisting of eighteenth-century furniture, decorative arts, portraits, manuscripts, and books that were originally owned by Elias and Hannah Boudinot and their family. A lawyer and statesman, Elias served as a New Jersey delegate and later the president of the Continental Congress, where he signed the provisional peace treaty with Britain in 1783. The son of a Philadelphia silversmith and the director of the US Mint from 1795 to 1805, where he oversaw the transformation of precious metals into coinage, Boudinot was intimately aware of the

FIGURE 108: Joseph Lownes (American, 1758-1820), Sugar urn and cover, ca. 1800. Silver, h. 22 cm. Princeton University Art Museum. Gift of Mr. and Mrs. Landon K. Thorne for the Boudinot Collection (y1954-212 a-b)

FIGURE 109: Joseph Richardson Jr. (American, 1752-1831) and Nathaniel Richardson (American, 1754-1827), Sugar urn and cover, ca. 1790. Silver, h. 20.7 cm. Princeton University Art Museum. Gift of Mr. and Mrs. Landon K. Thorne for the Boudinot Collection (y1954-211 a-b)

economic and physical mutability of silver.[31] As decorative arts scholars have demonstrated, sugar bowls were a fundamental component of an interrelated group of consumables and accessories introduced by colonialism that made up the ritual of tea. Chinese porcelain, West Indian sugar, and South American silver presented on a Jamaican mahogany tea table bespoke the assimilation of the products of global trade into domestic material culture.[32] Both the silver and the sugar contained in Lownes's urn were deeply embedded in a complex colonial economy of cultivation, extraction, and refinement, the devastating effects of which were occasionally recognized but frequently downplayed or ignored by early American consumers.

While we are unable to determine the source of the urn's silver through materials analysis, the majority of eighteenth-century silver originated from Spanish mines in Central and South America.[33] Between 1550 and 1800, Spain extracted and refined at least 136,000 metric tons of silver in Latin America, accounting for 80 percent of global production during that time.[34] Perhaps the most infamous of the Spanish colonial mining sites, the city of Potosí in modern-day Bolivia was renowned for its wealth and splendor as well as its violence and exploitation of Indigenous labor. An eighteenth-century silver repoussé hat (fig. 110), possibly worn by a Native Aymara official during festivals, celebrates

the material affluence of this region. It visualizes a cross-cultural exchange of ideas and forms through its depiction of both South American and European plants and animals, although it ignores the subjugation of Indigenous peoples such as the Aymara that accompanied these encounters. The triangular shape in the center of the hat likely represents the iconic Cerro Rico, or "Rich Hill," where silver was first discovered in 1545.[35]

Cerro Rico also dominates *Description of Cerro Rico and the Imperial Town of Potosí* (fig. 111), by the Potosí-born artist Gaspar Miguel de Berrío (ca. 1706–ca. 1762), in which the mountain towers over the sprawling city in a barren, reddish-hued Andean landscape. Completed for Francisco Antonio López de Quiroga, likely a Spanish merchant or mine owner, the painting documents the mining industry's dramatic transformation of the area with detailed renderings of refineries and artificial lakes built by the Spaniards to supply water needed to power the silver mills. A large red crucifix at the peak of Cerro Rico signifies the harsh labor of silver mining as a divinely sanctioned project.[36] In his 2010 video installation *The Silver and the Cross* (fig. 112), Harun Farocki (1944–2014) used Berrío's work to explore the devastating consequences of European mining on Native peoples and the local environment. Farocki juxtaposed sections of the painting with more recent images of Potosí in order to draw connections between the region's past and current landscape. During a projection of a cropped view of Berrío's red cross and another detail of miners and animals traversing Cerro Rico, a narrator explains, "The Spaniards brought the cross and took away the silver. In doing so, they almost exterminated the Indigenous population."

Spanish mines had an enormous socioecological impact on the communities in which they were located. Enslaved Africans, wage earners, and Indians conscripted through the preexisting Incan *mita* system of forced labor worked long hours in dangerous conditions in Potosí mines. Because silver extraction and refining required fuel throughout the process, mining also profoundly altered local forests, four hundred thousand square kilometers of which were cleared of wood to fuel the industry from the sixteenth to the early nineteenth century.[37] This level of deforestation far surpassed (by a factor of three) that of England's iron industry, which decimated British forests by the late eighteenth century.[38] In denuding the land of trees, mining was somewhat analogous to Caribbean mahogany harvesting, facilitating the spread

FIGURE 110: Possibly Aymara, Festival hat, 18th century. Repoussé silver plaques on velvet, glass beads, wire, 12.5 × 33.7 × 33.7 cm. Brooklyn Museum, New York. Museum Expedition 1941, Frank L. Babbott Fund (41.1275.274c)

FIGURE 111: Gaspar Miguel de Berrío (Bolivian, ca. 1706–ca. 1762), *Description of Cerro Rico and the Imperial Town of Potosí*, 1758. Oil on canvas, 182 × 262 cm. Museo Colonial Charcas, Sucre, Bolivia

of agriculture and livestock production, and significantly transforming existing ecologies and the Indigenous human communities that interacted with them.[39]

By the time Berrío completed his painting in 1758, Potosí was experiencing an economic decline caused by the rapid depletion of Cerro Rico's silver. Miners exhausted the easily accessible silver veins in mere decades and therefore had to extract ore from deeper within the mountain, a more challenging and dangerous task due to flooding and the increasing threat of mine collapse. This ore was also of lower quality and ill-suited to traditional smelting techniques. Spaniards turned instead to mercury amalgamation to assist in the refining process. Milled silver ore was mixed with water, salt, roasted copper pyrites, and mercury into a thick sludge, through which laborers and animals would walk bare-legged for long periods of time in order to facilitate the amalgamation process. Absorbed by the atmosphere, watershed, animals, plants, and people, mercury had a devastating psychological and physical impact on local inhabitants, and it continues to saturate the soil and dust around large, historic mining cities.[40] One anonymous writer in 1759, describing a "thick cloud that forms . . . over the city

FIGURE 112: Harun Farocki (German, 1944–2014), *The Silver and the Cross*, 2010. Two-channel video installation reedited to single-channel video (color, sound), 17 minutes. Collection of Harun Farocki GbR

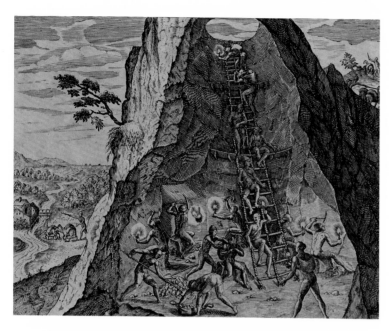

FIGURE 113: Theodor de Bry (Flemish, 1528–1598), *Indian Miners at Potosí.* Engraving. Published in *Americæ nona & postrema pars [...]* (Frankfurt: 1602), Part IX, translation of José de Acosta, *Historia natural y moral de las Indias* (Seville: 1590). Princeton University Library. Rare Books and Special Collections

veins." The article noted that these silver veins "are sunk to such a prodigious depth, that a descent into them is becoming exceeding dangerous. This same place, Potosí, or mount Potosí, which is in the form of a sugar loaf, is reduced literally almost to shell, from the vast quantities of silver which have been torn from its bowels."[43] This description, in its references to "exhalations," "veins," and "bowels," metaphorically animated the mountain as a living organism, whose shifting conditions posed a danger to the miners and which likewise suffered physical harm from their actions.

Two centuries earlier, an engraving of Cerro Rico by Flemish artist Theodor de Bry (1528–1598) revealed European awareness of the mountain's depletion and the predicament of Indigenous laborers (fig. 113). De Bry never visited the Americas, but the book in which his engraving appeared—*Historia natural y moral de las Indias* (1590)—was written by a Jesuit missionary named José de Acosta who had been to Potosí and witnessed such conditions firsthand. According to an early English translation of Acosta's text, "they digge it [silver] with much labour and perill" and "All these mines are at this day very deepe." In words that resonate closely with de Bry's engraving, Acosta also observed:

> They labour in these mines in continuall darknes and obscuritie, without knowledge of day or night. And forasmuch as those places are never visited with the Sunne, there is not onely a continual darkness, but also an extreme colde, with so grosse an aire contrary to the disposition of man, so as such as newly enter are sicke as they at sea. The which happened to me in one of these mines, where I felt a paine at the heart, and beating of the stomach. Those that labour therein use candles to light them, dividing their work in such sort, as they that worke in the day rest by the night, and so they change.[44]

[of Potosí]" determined that "this is without doubt . . . vapors and poisonous fumes . . . from dead animals, from trash heaps, and other fine dust from the ore and from the mercury smoke in the burning and reburning of the [silver]." The author goes on to assert that "this mix of bad vapors and fumes cannot be healthful."[41] In 1794 the lieutenant governor of Chayanta, where Potosí is located, observed that many Indians suffered from severe respiratory problems consistent with the symptoms of mercury poisoning and silicosis from the inhalation of silver dust; he blamed these work-related diseases for "carrying the provinces to their total extermination and depopulation."[42] While Berrío's painting acknowledged certain realities about the silver industry at Potosí, it ignored the city's poisonous atmosphere in order to project the appearance of a thriving imperial mining community.

News of Potosí's notorious conditions nevertheless had circulated around the world for many years. For example, in 1785 the Philadelphia newspaper *Freeman's Journal: or, The North-American Intelligencer* reported a mining disaster at Cerro Rico, where more than one hundred Indigenous miners "were suffocated by a sudden exhalation from the

In the engraving, we see contorted Indigenous bodies descending into and hacking away at the interior walls of Cerro Rico, which already appears "reduced literally almost to shell," as the Philadelphia newspaper article noted in 1785. Indeed, the *Freeman's Journal* article confirmed long-circulating reports of dire labor and environmental conditions in Latin American mines, indicating that some Americans were familiar with the close connection between silver consumption, resource scarcity, and social injustice during the colonial period.

The newspaper's evocation of a "sugar loaf" also recalls the intended function of the silver urn: to hold sugar. Indeed, the urn's form evokes an inverted sugarloaf, a tall cone with a rounded top that served as the end product of a refinement process. As mentioned in the previous section, the growing and processing of sugarcane dramatically transformed environmental, social, and political life in the British West Indies beginning in the seventeenth century.[45] The decimation of forests to establish plantations on many islands was so widespread that wood for fuel and construction had to be imported from North America. Erosion and soil deterioration plagued islands such as Barbados and Saint Kitts as early as the late seventeenth century, and imported agriculture and animals as well as the establishment of road networks, mills, and domiciles greatly affected native plant and animal life.[46]

Sugar plantations were also the primary drivers of slave labor in the British Caribbean in the eighteenth century, spurring many abolitionist pamphlets that emphasized the human cost of the popular sweetener that had become a staple of the middle-class table. William Fox's *An Address to the People of Great Britain, on the Propriety of Abstaining from West-India Sugar and Rum* (1792), published in Philadelphia and reprinted throughout the United States during the late eighteenth century, emphatically linked the consumption of sugar with cannibalism in its destruction of African bodies. According to Fox, "so necessarily connected are our consumption of the commodity, and the misery resulting from it, that in every pound of sugar used . . . we may be considered as consuming two ounces of human flesh."[47] Benjamin Franklin even wrote about the high costs of the sugar trade, noting that a deeper assessment of the human trafficking responsible for the sweetener leads one to imagine "his Sugar not as spotted only [with blood], but as thoroughly died [*sic*] red."[48] A later illustrated abolitionist text, *Cuffy the Negro's Doggrel Description of the Progress of Sugar* (1823), published in London, commented on sugar as both literally and metaphorically polluted. One illustration (fig. 114) shows a baker pouring "blood, and nasty someting [*sic*]" into his sugar cones or loaves. This refers to both the practice of clarifying sugar with cattle blood and the abolitionist allusion to "blood sugar."[49] The sugar urn, too, in recalling the clarified commodity through its cone form, conjures the violence and controversy its production embodied.

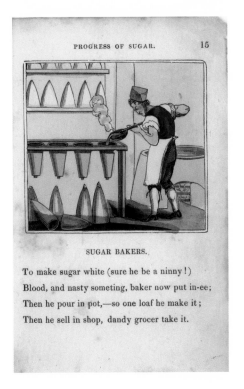

FIGURE 114: "Sugar Bakers." Hand-colored wood engraving, sheet: 17.8 × 10.7 cm. Published in *Cuffy the Negro's Doggrel Description of the Progress of Sugar* (London: E. Wallis, 1823). John Carter Brown Library at Brown University, Providence, Rhode Island. JCB Archive of Early American Images (76-93)

While sugar production and consumption were targeted for criticism by abolitionists, the negative consequences of mining were often downplayed in European consumers' imaginative accounts of silver's origins, which usually envisioned the extraction and refinement of this metal as a civilizing process. A pertinent example of this occurs in Joseph Addison's "Adventures of a Shilling." In this short it-narrative, the shilling recalls its birth "on the Side of a Mountain, near a little Village of Peru" and its subsequent travel to England as an ingot, where it was "taken out of my Indian Habit, refined, naturalized, and put into the British Mode with the Face of Queen Elizabeth on one Side, and the Arms of the Country on the other."[50] The anthropomorphic undertones of this benign story of civilization—from the removal of the coin's "Indian Habit" to its modification and stamping in the "British Mode"—supplies a thinly veiled metaphor for the process of acculturation to which Indigenous peoples in Central and South America were subjected by European colonists. Addison's account of the silver's "naturalization" glosses over the violence that accompanied the forced relocation and labor of American peoples during Spanish colonization.

While the shilling goes on to describe its travels via monetary transactions, it would have been just as likely for the coin to be melted down with several of its siblings to become a silver utensil or vessel, such as a sugar urn.

Despite its intimate connections with systems of colonial oppression in South and Central America, not to mention burgeoning systems of global commerce in commodities, silver was also frequently employed as a material of intercultural diplomatic exchange in the eighteenth century. Lownes, the maker of the Princeton sugar urn, was concerned with the plight of northeastern Native peoples as a member of the Friendly Association, a Quaker organization dedicated to improving peaceful relations with the Lenape Indians during a period of growing tension between Anglo- and Native Americans in Pennsylvania.[51] In the mid-eighteenth century, the Friendly Association commissioned Joseph Richardson Sr. (1711–1784) to create silver ornaments to present to the Lenape. Richardson produced

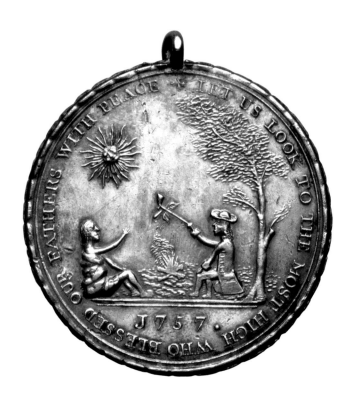

FIGURE 115: Edward Duffield (American, 1720–1801; engraver), Joseph Richardson (American, 1711–1784; maker), *Peace Medal* (from the Friendly Association for Regaining and Preserving Peace with the Indians), 1757. Silver. The Library Company of Philadelphia (OBJ 873)

2,860 arm and wrist bands, brooches, crosses, medals (fig. 115), and other accessories for the association between 1756 and 1757, essentially converting the material responsible for the repression of Indigenous peoples in one hemisphere into symbols of peace for those in another.[52] It is possible that Lownes also produced silver items for the association. Lownes was a founding member of the Pennsylvania Abolition Society and employed a black apprentice, Joseph Head. No signed works by Head have been located, but we know that he showed one of his coffeepots at the Abolition Society in 1787, with Lownes's sponsorship, and was declared a "workman of distinguished abilities."[53] As these examples demonstrate, although Lownes actively worked to improve the status of marginalized peoples, he was unaware of, or perhaps unconcerned by, the global consequences of his chosen material and the extractive labor associated with it.

Even if Lownes and other Philadelphia silversmiths and consumers were troubled by the effect of silver mining on Indigenous populations in South and Central America, texts such as the widely read *Political Essay on the Kingdom of New Spain* (1811), published by the Prussian naturalist-explorer Alexander von Humboldt (1769–1859), would have helped alleviate reservations. Humboldt wrote extensively about mining conditions in Mexico; he was very knowledgeable on the topic, having worked as an inspector for the Department of Mines in Prussia prior to his travels in Latin America from 1799 to 1804. Humboldt conceded that "the working of the mines has long been regarded as one of the principal causes of the depopulation of America," as many Indians perished from fatigue, harsh working conditions, and starvation in places like Potosí.[54] He praised what he thought were improving conditions of mines in Mexico, however, noting that although miners "pass their lives in walking barefooted over heaps of brayed metal, moistened and mixed with muriate of soda, sulphate of iron, and oxyd of mercury, by the contact of the atmospheric air and the solar rays," they "enjoy the most perfect health." Humboldt claimed that, according to physicians working at the mines, "the nervous affections, which might be attributed to the effect of an absorption of oxyd of mercury, very rarely occur. At Guanaxuato part of the inhabitants drink the very water in which the amalgamation has been purified (*aqua de lavaderos*) without feeling any injury from it."[55] Such an endorsement from one of the most popular writers of the early nineteenth century, who frequently chastised nations, including the United States, for their support of slavery and

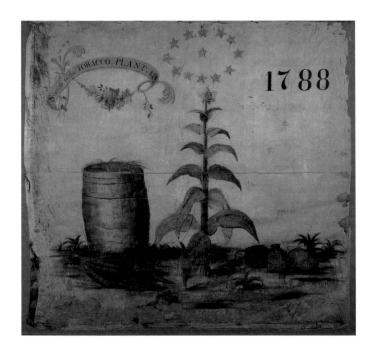

FIGURE 116: *Tobacco Banner*, 1788. Painted silk, framed: 162.6 × 177.2 × 13.6 cm. Friends of the Thomas Leiper House and the Library Company of Philadelphia

mistreatment of Indigenous peoples, would have assured many North Americans skeptical about mining conditions in New Spain. Historian John Richards notes, however, that, "it is hard to conceive how successive generations of miners and their families could have avoided the harmful effects of mercury exposure," despite rosy accounts by European observers such as Humboldt.[56]

Much like the slick surfaces of the mahogany high chest, the reflective exterior and neoclassical ornament of Lownes's sugar bowl repel any reference to the conditions from which its material was extracted. Accounts of the 1788 Grand Federal Procession to celebrate the newly ratified Constitution in Philadelphia provide illuminating insight into American perceptions of silver goods. In the procession, two senior members of the "Goldsmiths, Silversmiths, and Jewellers" trade association carried a silk flag portraying the Genius of America holding a silver urn with the motto "the purity, brightness, and solidity of this metal is emblematical of that Liberty which we expect from our new Constitution."[57] Although a list of participants does not survive, Lownes was likely one of the thirty-five local smiths marching that day. It is productive to compare the description of this flag to that of the Tobacconists, the sole surviving Philadelphia Federal Procession banner (fig. 116). This flag highlighted the tobacco plant as its focal image, drawing a clear connection

between the product's origins and its many consumable forms as it appears in a hogshead barrel on the left and as a roll of plug tobacco and a bladder of snuff on the right.[58] Although the Tobacconists' banner visually recognized the local source of its product and praised it in the accompanying text ("Success to the Tobacco plant"), it made no mention of the slave labor and monoculture plantation farming responsible for this "success." Likewise, the Philadelphia metalsmiths, by emphasizing the "purity, brightness, and solidity" of silver, positioned the metal as untethered from its more contentious economic foundations and environmental sites of extraction in order to elevate it as a blank canvas on which to project ideals of American democracy.

Lead and Zinc in Nineteenth-Century Landscape Painting

While the acquisition and production of mahogany and silver linked early American consumers with complex political ecologies abroad, the creation and usage of nineteenth-century pigments additionally had profound local impact on American workers, environments, and painters themselves. Much like mahogany and silver, pigments were selected for their functionality as well as their aesthetic properties. Artists valued stable and brilliant hues, even as they acknowledged the toxicity of several popular pigments. On the surface, two landscape paintings by Robert S. Duncanson (1821–1872) and Albert Bierstadt (1830–1902), depicting an ambiguous pastoral scene and a magisterial view of Mount Adams respectively, present harmonious perspectives on human engagement with the natural world embedded in the nationalist rhetoric of westward expansion. An analysis of the pigments and binders Duncanson and Bierstadt used, however, discloses a different, more latent narrative about the industrializing color market and its environmental and human health consequences in the nineteenth century. X-ray fluorescence analysis of both works revealed high amounts of lead, confirming the artists' use of poisonous white lead paint, despite the availability of other, more benign, alternatives such as zinc white.[59] Although the hazards of working with white lead were well known in scientific, medical, and even artistic circles at the time, the metal's toxicity did not become a matter of public health debate in the United States until the early twentieth century.[60] The recent crisis in Flint, Michigan, where water from the polluted Flint River caused lead from

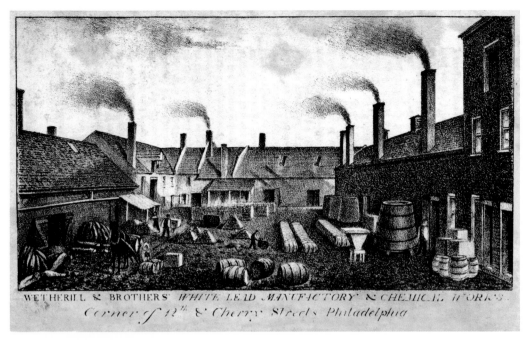

FIGURE 117: William L. Breton (American, ca. 1773–1855), *Wetherill & Brothers' White Lead Manufactory & Chemical Works, Corner of 12th & Cherry Streets, Philadelphia*, 1831. Lithograph, printed by Kennedy & Lucas, Philadelphia; 10 × 18 cm. The Library Company of Philadelphia (P.9830.4)

FIGURE 118: C. H. & A. T. Baxter & Co., Advertising label for Capitol White Lead, ca. 1866. Hand-colored lithograph. Library of Congress, Washington, DC. Prints & Photographs Division

FIGURE 119: Harrison Brothers Co., Advertising label for Lincoln Pure White Lead, ca. 1866. Engraving. Library of Congress, Washington, DC. Prints & Photographs Division

old pipes to leach into the city's drinking water, contaminating thousands of residents, demonstrates that lead poisoning remains a persistent concern today, one that disproportionately affects poor, predominantly black communities around the country.[61]

Thematically, the paintings by Duncanson and Bierstadt project ideas about ownership and cultivation of land at a time of increased westward expansion and development. In Duncanson's *Untitled (Landscape)* (late 1850s; see fig. 62), completed when the artist was living in Cincinnati, Ohio, a winding path just to the right of center directs our gaze to three figures and a boat by a lake. The grandson of a freed Virginia slave, Duncanson addressed race only obliquely in his landscapes, still lifes, and portraits. Close inspection of *Untitled (Landscape)*, however, reveals the figures to be painted in a variety of skin tones, representing different racial types. Duncanson's patrons included abolitionists and members of the Free Soil Party, who opposed the expansion of slavery in the western territories and worked to remove discriminatory laws against freed blacks in Ohio.[62] His depiction of different racial types intermingling within an idealized landscape therefore offered a more egalitarian vision of human interaction with the land that was not restricted by race. Moreover, simply by making such a picture, Duncanson asserted his right—as an African American—to equal access in representing such scenery and taking part in the art world.

Bierstadt's *Mount Adams, Washington* (1875; see fig. 95) is intimately entangled in the rhetoric of westward expansion and new claims of land ownership through surveying and speculation. In the fall of 1863, Bierstadt traveled to Oregon with the author, journalist, and explorer Fitz Hugh Ludlow, on a trip that inspired this painting of the Cascade Range peak.[63] Although Bierstadt produced *Mount Adams* in his New York studio, two recent technological inventions—the railroad and the portable paint tube (the latter invented and patented in 1841 by an American named John Goffe Rand)—made it possible for artists to travel to and depict the American West in situ. Eminent nineteenth-century art critic James Jackson Jarves attributed the success of Bierstadt's landscape paintings to the prevalent "speculating blood" and "zest for gain" in this period.[64] Bierstadt himself speculated in land and mining in California and repeatedly stated his belief that Anglo-Americans should settle the West.[65] In a pamphlet accompanying his famous picture *The Rocky Mountains, Lander's Peak* (1863; see fig. 94), Bierstadt expressed his hope

that, upon the depicted foreground plain, "a city, populated by our descendants, may rise, and in its art-galleries this picture may eventually find a resting place."[66] According to a letter published in the art magazine the *Crayon*, Bierstadt considered the Native Americans who inhabited the regions he painted as "appropriate adjuncts to the scenery." "Now is the time to paint them," he went on, "for they are rapidly passing away, and soon will be known only in history."[67] In *Mount Adams*, the Native American figures face away from the viewer and appear to be vacating the verdant field, as if ceding ground to future Anglo settlers.

Ironically, in producing their paintings of idyllic nature both Bierstadt and Duncanson used paints and grounds containing lead, the mining, refining, grinding, and usage of which created toxic environments for factory workers and artists alike. Lead was mined and refined throughout the United States in the nineteenth century. Samuel Wetherill & Son in Philadelphia was the first American company to manufacture white lead pigment in 1809.[68] A later lithograph by William L. Breton (ca. 1773–1855) shows the industrious manufactory emitting long plumes of smoke from multiple chimneys as white lead dries in kilns and awaits shipment in barrels (fig. 117). As two 1866 advertising labels for white lead demonstrate, companies drew upon patriotic imagery, including the US Capitol and a portrait of Abraham Lincoln, to position white lead as a product of national importance (figs. 118, 119). The Lincoln Pure White Lead label, produced "in memoriam" one year after the president's assassination, asserted, "By its purity & excellent qualities, this lead deserves the name bestowed upon it." Recalling the banner carried by the silversmiths in Philadelphia's 1788 Grand Federal Procession, the Lincoln Pure White Lead label sought to position the toxic material as pure and therefore innocuous. While Duncanson was active in Cincinnati, the city emerged as a center for white lead manufacture—dominated by the Townsend Hills and the Eagle White Lead Companies—to meet the high demand for house paint in the developing Midwest.[69] It is estimated that by 1850, annual production of white lead in the United States exceeded nine thousand tons and increased to over sixty-one thousand tons per year by 1880.[70]

Observers noted the deleterious impact of white lead manufacturing on worker health as early as the seventeenth century, when Philiberto Vernatti described deplorable conditions in a 1677 article for the *Philosophical Transactions* of

London's Royal Society: "The Accidents to the Workmen are, Immediate pain in the Stomack, with exceeding Contorsions in the Guts, and Costiveness that yields not to Catharticks.... Next, a *Vertigo*, or dizziness in the Head, with continual great pains in the Brows, Blindness, Stupidity, and Paralytic Affections."[71] In 1786 Benjamin Franklin reflected upon the poisonous effects of lead that he personally observed during his travels in the United States and abroad. He bemoaned the lack of public concern and action regarding this toxic metal: "You will observe with Concern how long a useful Truth may be known, and exist, before it is generally receiv'd and practis'd on."[72] In the early nineteenth century, the British physician Charles Turner Thackrah attempted to document the effects of lead exposure in laborers manufacturing white lead in England. At one factory in Hull, he noted that the "men and women are sallow and thin, and complain frequently of head-ache and loss of appetite," with several suffering from colic and palsy after several years of employment.[73] Ultimately, Thackrah believed only an alternative pigment would improve the health of manufactory workers: "Will any chemical process avail to prevent the poisonous effects of this mineral? Can any substitute be found for its use in our arts and manufactures?"[74]

Nineteenth-century chemists and authors of painting manuals and handbooks also warned about the health and environmental risks to artists who used lead-based pigments. Although Duncanson's dementia prior to his death in 1872 has been attributed to lead poisoning associated with his early career as a house painter, lead also saturated nineteenth-century fine art pigments, including the toxic white lead ground commonly used by painters of that era and present throughout Duncanson's *Untitled (Landscape)*.[75] Thackrah identified painters as "subject to injurious exhalations, and to absorption of poison by the skin" through exposure to lead dust when grinding white lead with turpentine or a varnish.[76] Painters contracted bilious and gastric disorders, colic, and palsy and, according to Thackrah, were often "unhealthy in appearance, and do not generally attain full age."[77] To counteract lead exposure, the doctor recommended frequent cleaning of the skin and painting implements and improved ventilation.[78] Popular painting manuals and texts such as *Chromatography*, by the chemist George Field, also noted the dangers of using white lead. Field wrote, "Cleanliness in using [white leads] is necessary for health; for though not virulently poisonous, they are pernicious when taken into or imbibed by the pores or otherwise, as are all other pigments of which lead is the basis."[79] In his *Handbook of Young Artists and Amateurs in Oil Painting*, Laughton Osborn cautioned, "In grinding whitelead...there arises an odor that is unpleasant to many persons, and unwholesome to all. It is as well to avoid leaning too closely over the stone or palette, and to throw up the window during either operation."[80]

By the late nineteenth century, lead paints had begun to fall out of fashion thanks to growing awareness of their toxicity. Artists, including Bierstadt and Duncanson, tentatively turned to zinc white as an alternative. First synthesized at the Dijon Academy in France in the 1780s, zinc white is less toxic than lead, but artists failed to embrace the pigment for decades because it initially was more expensive, dried slowly, and exhibited poor coverage.[81] The purchase price of zinc white did not become comparable to that of white lead until 1876. American consumers were especially interested in zinc white because the pigment was manufactured in New Jersey, one of the few places in the world where zinc was extracted.[82] Lead continued to provide the foundation of many pigments, however, whether its inclusion was advertised or not. Past analysis of Bierstadt's *Last of the Buffalo* paintings at the National Gallery of Art (1888) and the Buffalo Bill Center of the West (1889) reveals that the artist used chrome green—a combination of Prussian blue and lead chromate (or chrome yellow).[83] Chrome green was frequently sold under different names in the nineteenth century, including zinober green or cinnabar green. Colormen may have adopted these exotic-sounding names to hide the pigment's incorporation of chrome yellow, which was criticized by some as unstable, liable to darken, and toxic due to its inclusion of lead.[84] Despite the availability of other white pigments, Bierstadt also used commercially primed linen canvas prepared with thick, white lead paint to which he applied thin, relatively opaque layers of oil paint to build up his compositions.[85] Bierstadt's highly artificial approach to composition—implausible combinations of western perspectives and subjects collected during his travels and painted in his studio back East—is widely acknowledged by American art historians. An ecocritical analysis of his industrial materials, however, makes the "nature" of Bierstadt's landscape paintings appear even more highly constructed.

While lead had debilitating effects on its immediate surroundings and the people who came into contact with it, environmental conditions likewise transformed the mineral.

George Field, for example, noted that "the splendid yellow chromates of lead, which withstand the action of the sunbeam, become by time, foul air, and the influence of other pigments, inferior."[86] Bierstadt was keenly interested in preserving and protecting his paintings from premature fading and decay caused by exposure to the elements and pollutants. He was one of a few artists to apply a ground of water-resistant graphite paint to weatherproof his late canvases, although this technique ultimately had a deleterious effect on the appearance and condition of his paintings.[87] As Bierstadt wrote, "It stands to reason that dirt in any form is bad for a picture, it is sure to rot the canvas in time and I have known of so much dirt collecting upon the back of the canvas as to sustain vegitable [sic] life."[88] Here Bierstadt describes his landscape paintings—sublime depictions of American wilderness portrayed with toxic, extractive pigments—as capable of supporting their own miniature ecological habitats, albeit undesirable and potentially destructive ones.

A Carrara Marble *Nydia*

In his 1846 travelogue *Pictures from Italy*, Charles Dickens remarked upon the massive amount of human and animal labor required to extract and transport large blocks of marble from the famous Carrara quarries in Tuscany. He noted that many oxen and men perished while shepherding the stone down the mountains, prior to the introduction of railroads to the region. Dickens struggled to reconcile the seductive surfaces of finished marble statues with the crushing labor he witnessed: "Standing in one of the many studii of Carrara that afternoon … full of beautifully finished copies in marble, of almost every figure, group, bust, we know—it seemed, at first, so strange to me that those exquisite shapes, replete with grace, and thought, and delicate repose, should grow out of all this toil, and sweat, and torture!"[89] In the United States in the late nineteenth century, one of the more ubiquitous marble "exquisite shapes" was *Nydia, the Blind Flower Girl of Pompeii* (fig. 120), by the sculptor Randolph Rogers (1825–1892). A character from Edward Bulwer-Lytton's 1834 novel *The Last Days of Pompeii*, Nydia, an enslaved girl, helps the youth Glaucus and his lover Ione escape Pompeii during the eruption of Mount Vesuvius in 79 CE; she drowns herself after reaching safety because Glaucus does not return her love. Rogers portrayed Nydia, a symbol of feminine sacrifice and fidelity, calling Glaucus's name and straining to hear his response after she is separated from the youth when volcanic ash descends upon the city.[90]

The statue was a popular sensation, with more than fifty marble copies produced in two different sizes between 1867 and 1891. One life-size copy—the same size as the Princeton statue—was prominently displayed in the Great Hall of the Centennial Exhibition in Philadelphia along with Rogers's first commercial success, the biblical subject of *Ruth Gleaning* (fig. 121). Depicting the young Israelite gathering wheat in her future husband's field, *Ruth Gleaning* provides a more restrained counterpoint to the dramatic forward thrust and swirling drapery of *Nydia*, but both are the end result of a long line of production stretching back to Rogers's studio and Italian marble quarries. Working under the direction of the artist, carvers in Rome churned out marble copies of *Ruth* and *Nydia* for the market. A pointing machine allowed for the works to be duplicated, transferring the dimensions of the plaster original to gleaming marble. The American artist Maitland Armstrong echoed Dickens's disturbed reaction to the dazzling products of anonymous human labor when he observed the industrial reproduction of Rogers's masterpiece in his studio: "I once went to [Rogers's] studio and saw seven *Nydias*, all in a row, all listening, all groping, and seven Italian marble-cutters at work cutting them out. It was a gruesome sight."[91] In 1892 *Harper's Weekly* estimated that Rogers earned $70,000 from sales of *Nydia* during his lifetime.[92]

On an obvious narrative level, *Nydia* recognizes the cataclysmic power of nature through a dramatized reaction to the implied volcanic eruption, perhaps most poignantly expressed through the Corinthian capital—symbolic of ancient Rome and classical culture in general—which lies toppled at the figure's feet. Like the mahogany high chest and the silver sugar bowl, *Nydia*, with her swirling drapery and curling hair, celebrates humans' ability to procure, carve, and shape matter. The statue, reveling in the smooth, buttery characteristics of carved marble, still honors its material, which was mentioned frequently in period accounts. The press, for example, championed *Nydia*'s material provenance in its announcement of the statue's donation to the Princeton University Art Museum by Dr. Abraham Coles and his sister in 1896. An anonymous reviewer for the *New York Examiner* praised "the magnificent life-size marble statue of 'Nydia,' made of the best Carrara marble" and "its marble pedestal," repeatedly underscoring the sculpture's esteemed medium.[93] Through its material and its

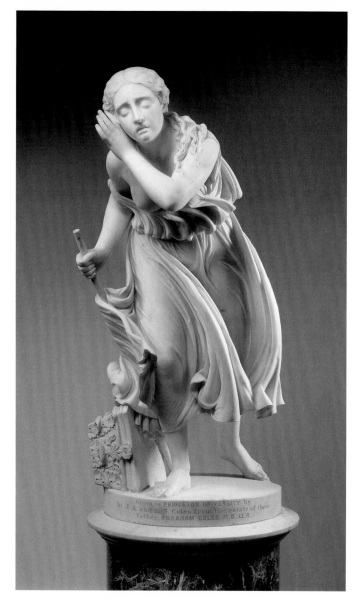

FIGURE 120: Randolph Rogers (American, 1825–1892), *Nydia, the Blind Flower Girl of Pompeii*, first modeled 1855. Marble, 135 × 73.5 × 92.5 cm. Princeton University Art Museum. Gift of Dr. J. Ackerman Coles and Emily Coles (y1945-274)

even exploited Carrara marble in decorating Pompeii, a fact that complements the narrative drama of *Nydia* with a certain degree of indexical realism.[95] Increased international demand for Carrara marble after the mid-nineteenth century catalyzed modernization and restructuring of the local marble industry.[96] An English entrepreneur, William Walton, helped finance Carrara's first modern port, which included a railway, mobile cranes, and sawmills that used hydraulically driven machines to cut more than two thousand tons of marble a year.[97] Thanks to these new technologies, more marble could be quarried cheaply but at a growing socioecological cost.

Explosives used to dislodge large quantities of marble from the Carrara quarries produced prodigious amounts of marble waste, filling the landscape with pulverized debris.[98]

FIGURE 121: Randolph Rogers, *Ruth Gleaning*, first modeled 1850. Marble, 91.4 × 50.8 × 50.8 cm. Private collection, Delaware

allusions to a historic natural disaster, *Nydia* also invites consideration of the environmental and social conditions of the Italian marble quarry, another eroding mountainous landscape in which dust permeated the air like the volcanic ash that separated Nydia from Glaucus.

Carrara marble has long been a desirable and revered stone for sculpture and architecture, most famously used by Michelangelo during the Renaissance.[94] Ancient Romans

A 1903 *Pearson's Magazine* article on the quarries titled "A Marble World" noted, "The air is grey with marble dust."[99] Quarry workers faced poor working and living conditions. Between 1857 and 1879, an average of twenty-five deaths and eighty serious injuries in a workforce numbering approximately four thousand was reported annually.[100] Workers in sawmills labored twelve-hour days, breathing a fine marble dust that permeated the workplace and irritated eyes, noses, throats, and lungs, causing bronchitis, emphysema, pleurisy, silicosis, and pneumoconiosis.[101]

Similar to the environmental transformation wrought by silver mining on South American landscapes, marble quarrying radically altered the Carrara region. The quarries' "architectural" reshaping of the landscape, however, was occasionally commended as a triumph of human industry. According to "A Marble World," the mountains "have been so hewn and blasted for a thousand years, that parts of them have been cut and riven into peaked and pinnacled masses like vast cathedrals."[102] The artist Edward Burtynsky (born 1955), who has photographed marble quarries in Carrara, Vermont, India, and China, describes his interest in the subject as a desire to document "inverted cubed architecture on the side of a hill," which appeared like "inverted pyramids" or "skyscrapers."[103] His *Carrara Marble Quarries #12* (fig. 122) seduces the eye with its depiction of quarry walls, eerily reminiscent of the blank face of an urban high-rise. It gives the impression that the blocks of marble have been hewn and stacked within the quarry instead of blasted and cut out of it. One could also interpret these photographs, however, as gaping wounds or gashes in the mountain, punctuated by brightly colored pools of contaminated water.

Rogers's *Nydia* is saturated with references to the occlusion of sight: Nydia's own blindness, the ash covering Pompeii, and, more obliquely, the dust that irritated the eyes of Carrara quarry laborers. Nydia's pose as she leans precariously forward to better listen for Glaucus's voice recalls the hunched postures of workers transporting heavy marble blocks down from the quarries, as photographed for "A Marble World" (fig. 123). It is unlikely that Rogers consciously made these sorts of visual and material connections between *Nydia* and the conditions of the workers in Carrara quarries, nor would he have intended his audiences to do so. It is the sculpture's material, however, along with the skill of Rogers's workshop in producing carefully calculated reproductions of the plaster original, that made it such a desirable

FIGURE 122: Edward Burtynsky (Canadian, born 1955), *Carrara Marble Quarries #12*, Carrara, Italy, 1993. Chromogenic print, 152.4 × 121.9 cm. Courtesy of the artist and Metivier Gallery, Toronto

Lowering a block from high to low level.

FIGURE 123: "Lowering a block from high to low level," in E. St. John Hart, "A Marble World," *Pearson's Magazine*, February 1903. Princeton University Library

FIGURE 124: Morris Louis (American, 1912–1962), *Intrigue*, 1954. Acrylic resin (Magna) on canvas, 198 × 267 cm. Princeton University Art Museum. Gift of Sylvia and Joseph Slifka in honor of Frederick R. and Jan Perry Mayer (2004-51)

purchase in the nineteenth century, so much so that the *New York Examiner* identified it multiple times in its description. Marble cannot be disassociated from the labor and environmental transformation that enabled its procurement and determined its high cost and status as a luxury material. Attending to the environmental history of *Nydia*'s medium, therefore, brings together subject and material in a new interpretation of marble statuary.

Morris Louis and Turpentine

The Color Field painter Morris Louis (1912–1962) strove to find new means of applying color to his canvases. Although a painting such as *Intrigue* (fig. 124) initially seems to discourage ecocritical analysis, since it eschews traditional subject matter, it is first and foremost about process and materials. Louis made his "Veil" paintings, of which *Intrigue* is an early example, with Magna acrylic paints, produced for him by the paint manufacturer Leonard Bocour.[104] Louis began experimenting with synthetic paints and diverse application techniques after a visit to Helen Frankenthaler's studio in 1953 left him impressed by the effects she was able to achieve using unconventional methods. To create *Intrigue* and his other Veil paintings, Louis thinned Magna color with turpentine and a polybutyl methacrylate called Acryloid F-10, which he purchased directly from the chemical company Rohm & Haas.[105] According to archived receipts, he purchased large quantities of turpentine from Chevy Chase Paint and Hardware Company—at least forty-one gallons in 1955 alone—and ordered Acryloid F-10 from Rohm & Haas in five-gallon increments almost monthly.[106] Based on his receipts for painting supplies in 1958, Louis used approximately nine tubes of paint and four and a half gallons of thinner per painting. The smell of turpentine, which can irritate the skin and eyes and damage the lungs, respiratory system, and central nervous system when inhaled, reportedly pervaded the artist's entire house. Louis died in 1962 at the age of forty-nine from lung cancer, which has been attributed to his prolonged exposure to turpentine fumes.[107]

Turpentine used by Louis had a devastating effect on environments and people in the American South as well. Prior to World War II, pine-derived resources such as tar, pitch, gum, rosin, and turpentine—also called "naval stores"—were used primarily for shipbuilding and repair. Turpentiners extracted the rosin from remote pine forests from early spring to late fall. Trees were debarked, hacked into, and sometimes coated with acid to stimulate gum flow and finally cut down by loggers after a few years of extraction. In the antebellum period, depletion of northern pine forests moved most naval stores production to the South, where it became part of the plantation economy. By the mid-nineteenth century, naval stores ranked third behind cotton and tobacco as the most important export from the American South.[108] Most turpentine workers, before and after the Civil War, were African American. The industry was so closely associated with black labor and bodies that one turpentine operator even developed a grading system using the names of his African American workers and family members whose skin tones most closely matched the rosins' coloring.[109]

Turpentine camps essentially operated as slave labor; workers were paid in credit to the camp store, whipped or punished when disobedient, and hunted down and captured if they escaped. Only after the murder of Martin Tabert, a young white turpentine worker from South Dakota, by a camp boss in 1921 did a Florida legislature investigation conclude that "conditions—not limited to the single camp but existing throughout the turpentine belt . . . were revolting to the most hardened person."[110] Photographs of turpentining and turpentine laborers taken by Dorothea Lange (1895–1965) and Jack Delano (1914–1997) for the Farm Security Administration in 1936 and 1937 visualize harsh working conditions and the effects of the industry on local forests. Lange's photographs show both the scarring of trees (fig. 125) and the scarring of families by the labor of extracting rosin. One photograph of a black woman and five children sprawled across the wooden steps of a ramshackle structure (fig. 126) is descriptively titled *Turpentine worker's family near Cordele, Alabama. Father's wages one dollar a day. This is the standard of living the turpentine trees support.* Lange therefore employed her craft to draw national attention to the inhumane treatment of workers by the turpentine industry.

After World War II, black migration to cities in the northern United States created labor shortages that made it increasingly difficult for turpentine camps to function. Turpentine instead began to be imported from abroad, where it continues to wreak environmental and social havoc, and the industry in America became virtually extinct by the 1980s.[111] As Cassandra Johnson and Josh McDaniel have

FIGURE 125: Dorothea Lange (American, 1895–1965), *Turpentine Trees, Northern Florida*, July 1936. Nitrate negative, 5.7 × 5.7 cm or smaller. Library of Congress, Washington, DC. Prints & Photographs Division, Farm Security Administration—Office of War Information Photograph Collection

argued, although turpentiners developed complex ecological understandings of the forests and climates in which they worked, the turpentine industry devastated numerous southern African American communities, many of which are still impoverished today because of the lingering effects of the industry and its decline.[112]

The gallons of turpentine purchased by Louis at his local Chevy Chase hardware store represent only a minuscule portion of the former naval stores industry consumed in the United States and abroad. Yet, reconnecting the material experimentation and formal abstraction of *Intrigue* with a history of altered ecologies and human communities where turpentine once was or still is produced challenges standard interpretations of Color Field painting as a celebration of flatness or immateriality. A consideration of the thinning agent that Louis chose to dilute and dematerialize his paints reasserts the importance of bodies, plants, and places within his work, even if those subjects are not depicted literally within the picture plane.

. . .

Investigating the environmental context of art materials reveals a complex history of resource acquisition, ecological transformation, and the implication of different human communities throughout the globe. These communities may not be referenced explicitly within art objects, but paying attention to the political ecology of creative matter alerts us to how wood, metal, stone, and other materials have not only shaped the form and reception of art in a conventional sense but also impacted a wider field of stakeholders in surprising ways, whether through scarcity, cost, labor, or toxicity.

Much work remains to be done in exploring the ecological, environmental, and social-justice implications of art materials, including paper, cotton, copper and various extracted minerals, ivory, vellum, feathers, numerous other kinds of nonhuman animal matter, albumen and gelatin used in photography, and countless industrial chemicals. Such an approach to American art may even challenge or subvert established environmentally focused scholarly interpretations of canonical works. For example, how might our view of the Yosemite photographs by Carleton E. Watkins (1829–1916) shift after considering the large amount of photographic chemicals—part of roughly 2,000 pounds of equipment, distributed in 150-pound loads across the backs of twelve mules—he hauled into the newly established national park

to document its landmarks in 1865?[113] Only two years earlier, the physician, poet, and amateur photographer Oliver Wendell Holmes expressed his amazement at the "great collections of the chemical substances used in photography," the annual consumption of which he estimated to be "ten tons for silver and half a ton of gold."[114] Images such as Watkins's

FIGURE 126: Dorothea Lange, *Turpentine worker's family near Cordele, Alabama. Father's wages one dollar a day. This is the standard of living the turpentine trees support,* July 1936. Nitrate negative, 5.7 × 5.7 cm or smaller. Library of Congress, Washington, DC. Prints & Photographs Division, Farm Security Administration—Office of War Information Photograph Collection

FIGURE 127: Carleton E. Watkins (American, 1829–1916), *View from Inspiration Point, Yosemite*, 1879. Albumen print, 39.5 × 54.2 cm. Princeton University Art Museum. Museum purchase, Fowler McCormick, Class of 1921, Fund (2006-34)

View from Inspiration Point, Yosemite (fig. 127) obscure any sign of the photographic infrastructure responsible for such wilderness views. When photographers became more physically removed from the actual development of their images in the twentieth century, they remained implicated in the contamination of the environment, even as their images seemed to celebrate nature conservation. Ansel Adams (1902–1984), for example, developed a close working relationship with Kodak, one of the worst industrial polluters of the twentieth century.[115] (For more on this subject, see Robin Kelsey's essay in this volume.)

Applying an ecocritical lens to art materials uncovers a vast transnational network of people, places, and things that contributed to the production of fine art and material culture. The toxic blowback and slow violence from the creation of these art objects and other commodities cannot be elided or externalized forever. By failing to see the environmental and social impacts of material obtainment and making, and considering the commodity merely at face value, we perpetuate the same omissions and blindness of previous generations. Indeed, knowledge about the environmental history of materials helps us look at art in new, more expansive ways and encourages sustainable approaches moving forward. As we face the cataclysmic consequences of global warming, an ecocritical approach to art history and material culture studies affords an ethically responsible, necessary, and perhaps even inevitable means to reenvision the untenable perception of the environment as the passive, unchanging backdrop to human cultural production.

Notes

Thank you to Alan C. Braddock and Karl Kusserow for supporting this research and for their insightful comments on earlier drafts of this essay. Thanks are also due to Norman Muller, former art conservator, Princeton University Art Museum, and George Scherer, professor of civil engineering, emeritus, at Princeton, for their deep knowledge and assistance in the analysis of art materials. Two National Endowment for the Humanities research fellowships at the Library Company of Philadelphia and Winterthur Museum, Garden, and Library facilitated deeper archival research of materials history, and I am indebted to the resources and generous staff of those institutions.

1 Tim Ingold, *Making: Anthropology, Archaeology, Art and Architecture* (London: Routledge, 2013); Jennifer L. Roberts, *Transporting Visions: The Movement of Images in Early America* (Berkeley: University of California Press, 2014); Ethan W. Lasser, "Selling Silver: The Business of Copley's *Paul Revere*," *American Art* 26, no. 3 (September 2012): 26–43; Ethan W. Lasser, "The Maker's Share: Tools for the Study of Process in American Art," in *A Companion to American Art*, ed. John Davis, Jennifer A. Greenhill, and Jason D. LaFountain (Chichester, UK: Wiley, Blackwell, 2015), 95–110; Martha Rosler et al., "Notes from the Field: Materiality," *Art Bulletin* 95, no. 1 (March 2013): 10–37.

2 Jennifer L. Roberts, "Things: Introduction," lecture, Shifting Terrain: Mapping a Transnational American Art History symposium, Smithsonian American Art Museum, Washington, DC, October 16, 2015, https://www.youtube.com/watch?v=A8GoDdEZAd4.

3 The exception remains studies by cultural historians that explore the environmental history of products such as mahogany and silver, although this research only briefly touches upon the relationship of these histories to the art object; see Jennifer L. Anderson, *Mahogany: The Costs of Luxury in Early America* (Cambridge, MA: Harvard University Press, 2012); Nicholas A. Robins, *Mercury, Mining, and Empire: The Human and Ecological Cost of Colonial Silver Mining in the Andes* (Bloomington: Indiana University Press, 2011); and Peter Bakewell, *Silver and Entrepreneurship in Seventeenth-Century Potosí: The Life and Times of Antonio López de Quiroga* (Albuquerque: University of New Mexico Press, 1988). Technical studies of silver occasionally include the environmental history of the material, but not in any great depth; see, for example, Ian M. G. Quimby, *American Silver at Winterthur* (Winterthur, DE: Henry Francis du Pont Winterthur Museum, 1995).

4 Robin Kelsey, "Ecology, Sustainability, and Historical Interpretation," *American Art* 28, no. 3 (Fall 2014): 13.

5 See, for example, Greg M. Thomas, *Art and Ecology in Nineteenth-Century France: The Landscapes of Théodore Rousseau* (Princeton: Princeton University Press, 2000); Karl Appuhn, *A Forest on the Sea: Environmental Expertise in Renaissance Venice* (Baltimore: Johns Hopkins University Press, 2009); Alan C. Braddock and Christoph Irmscher, eds., *A Keener Perception: Ecocritical Studies in American Art History* (Tuscaloosa: University of Alabama Press, 2009); Kelsey, "Ecology, Sustainability, and Historical Interpretation"; and Emily Eliza Scott, "Feeling in the Dark: Ecology at the Edges of History," *American Art* 28, no. 3 (Fall 2014): 14–19.

6 See Dipesh Chakrabarty, "The Climate of History: Four Theses," *Critical Inquiry* 35, no. 2 (Winter 2009): 197–222.

7 Karl Marx recognized the obfuscation of human labor that occurs in the fetishization of a commodity, but did not consider the environmental implications of commodity production; Karl Marx, *Capital: A Critique of Political Economy*, trans. Ben Fowkes (New York: Penguin Books in association with New Left Review, 1990).

8 James Grant Wilson, *Memorials of Andrew Kirkpatrick, and His Wife Jane Bayard* (New York: Privately printed, 1870). For more on chests of drawers and their gendered function within the eighteenth-century home, see Laura Keim Stutman, "'Screwy Feet': Removable-Feet Chests of Drawers from Chester County, Pennsylvania, and Frederick County, Maryland" (M.A. thesis, University of Delaware, 1999), 39–40.

9 Anderson, *Mahogany*, 14–15.

10 Thanks to Ed Espinoza, deputy director of the National Fish and Wildlife Forensic Lab, for undertaking this analysis. Espinoza's lab used chemometric processing of ambient ionization direct analysis in real time (DART) mass spectrometry to determine the species. The lab employs this technique to distinguish between woods regulated by the Convention on International Trade in Endangered Species of Wild Fauna and Flora (CITES) treaty. Espinoza compared the mahogany samples from the high chest with the readings of other confirmed examples of different species of mahogany. For more on this technique, see Rabi A. Musah et al., "A High Throughput Ambient Mass Spectrometric Approach to Species Identification and Classification from Chemical Fingerprint Signatures," *Scientific Reports* 5 (July 9, 2015), http://www.nature.com/articles/srep11520.

11 Anderson, *Mahogany*, 18–63.

12 Douglas Hall, *In Miserable Slavery: Thomas Thistlewood in Jamaica, 1750–86* (London: Macmillan, 1989), 101, cited in Anderson, *Mahogany*, 80.

13 Anderson, *Mahogany*, 84–85.

14 Chaloner and Fleming, *The Mahogany Tree: Its Botanical Characters, Qualities and Uses, with Practical Suggestions for Selecting and Cutting It in the Regions of Its Growth, in the West Indies and Central America* (Liverpool: Rockliff and Son, 1850), 39.

15 Anderson, *Mahogany*, 15.

16 K. L. H. Wells, "Serpentine Sideboards, Hogarth's Analysis, and the Beautiful Self," *Eighteenth-Century Studies* 46, no. 3 (Spring 2013): 402; see also Morrison H. Heckscher and Leslie Greene Bowman, *American Rococo, 1750–1775: Elegance in Ornament* (New York: Metropolitan Museum of Art, 1992); and Jules David Prown, "Style as Evidence," *Winterthur Portfolio* 15, no. 3 (Autumn 1980): 197–210.

17 For human cultivation of the land as a material technique of empire in the eighteenth century, see Jill H. Casid, *Sowing Empire: Landscape and Colonization* (Minneapolis: University of Minnesota Press, 2005).

18 While the majority of it-narratives were written in England, many circulated in the United States and found their way into local collections such as the Library Company of Philadelphia. For more scholarship on it-narratives, see Jonathan Lamb, *The Things Things Say* (Princeton: Princeton University Press, 2011); and Mark Blackwell, ed.,

The Secret Life of Things: Animals, Objects, and It-Narratives in Eighteenth-Century England (Lewisburg: Bucknell University Press, 2014).

19 "Transformation of a Beech Tree; or, The History of a Favourite Black Chair: Related by Itself" (London: John Harris, 1828), reprinted in Mark Blackwell, ed., *British It-Narratives, 1750–1830*, vol. 4, *Toys, Trifles and Portable Furniture* (Brookfield, VT: Pickering & Chatto, 2012), 320.

20 Blackwell, *British It-Narratives*, 324.

21 "The History and Adventures of a Bedsted" (*Rambler's Magazine* 2 [1784]: 442–46; supplement, 2 [1784]: 494–97), reprinted in Blackwell, *British It-Narratives*, 96.

22 I thank furniture scholar Alan Miller for suggesting this potential attribution. Strong similarities exist between the Princeton chest and a cabriole-leg high chest in the collection of Colonial Williamsburg, inscribed "Henry Cliffton/Thomas Carteret/November 15, 1753"; see Heckscher and Bowman, *American Rococo*, 182, 199; and Eleanore P. Gadsden, "When Good Cabinetmakers Made Bad Furniture: The Career and Work of David Evans," *American Furniture 2001*, ed. Luke Beckerdite (Milwaukee: Chipstone Foundation, 2001): 65–87.

23 Benjamin Randolph, "Receipt Book" (Philadelphia, 1763–77), Col. 337, Winterthur Library; Andrew Brunk, "Benjamin Randolph Revisited," in *American Furniture 2007*, ed. Luke Beckerdite (Milwaukee: Chipstone Foundation, 2007): 2–82.

24 *[Catalogue of Furniture Hardware and Sconces]* ([Birmingham, England], 1770), Winterthur Library; *[Brassfounder's Hardware Catalog]* ([Birmingham, England], 1780), Winterthur Library. Almost all brass pattern books are anonymous. Gentle and Field speculate that this is due to their employment by commercial merchants, who did not want to disclose the source of their wares to wholesalers or individual consumers. Brass manufacturers copied each other's designs, so the same pattern is frequently found in multiple pattern books. Rupert Gentle and Rachael Feild, *English Domestic Brass, 1680–1810, and the History of Its Origins* (London: Elek Books Ltd., 1975), 59–66; Theodore R. Crom, *Trade Catalogues, 1542–1842* (Melrose, FL: Theodore R. Crom, 1989), 181–208.

25 W. C. Aitken, *Early History of Brass and the Brass Manufactures of Birmingham* (Birmingham: Martin Billing, Son, and Co., 1866), 139–42.

26 Donna J. Rilling, "Sylvan Enterprise and the Philadelphia Hinterland, 1790–1860," *Pennsylvania History* 67, no. 2 (Spring 2000): 197; Jacquelann Killian, "United by Water: Cabinetmaking Traditions in the Delaware River Valley, 1670–1740" (M.A. thesis, University of Delaware, 2015), 85–121.

27 Pehr Kalm, *Travels into North America; Containing Its Natural History, and a Circumstantial Account of Its Plantations and Agriculture in General*, trans. John Reinhold Forster (Warrington: William Eyres, 1770), 177; Alfred Muntz, "The Changing Geography of the New Jersey Woodlands, 1600–1900" (Ph.D. diss., University of Wisconsin, 1959), 153–56.

28 Rilling, "Sylvan Enterprise," 196.

29 Donna J. Rilling, "Bone Boilers: Nineteenth-Century Green Businessmen?," in *Nature's Entrepôt: Philadelphia's Urban Sphere and Its*

Environmental Thresholds, ed. Brian C. Black and Michael J. Chiarappa (Pittsburgh: University of Pittsburgh Press, 2012), 75–90. I am indebted to Joshua W. Lane and Gregory J. Landrey at Winterthur for their insight about this chest and its materials.

30 My thanks to Jeffrey Richmond-Moll for sharing his research on the Richardson family and silver in Philadelphia. See also Martha Gandy Fales, *Joseph Richardson and Family: Philadelphia Silversmiths* (Middletown, CT: Published for the Historical Society of Pennsylvania by Wesleyan University Press, 1974), 165, 172.

31 George Adams Boyd, *Elias Boudinot: Patriot and Statesman, 1740–1821* (Princeton: Princeton University Press, 1952).

32 Anderson, *Mahogany*, 30.

33 Quimby, *American Silver at Winterthur*, 1–7; 39–41.

34 Robins, *Mercury, Mining, and Empire*, 4.

35 Festival hat object record, Brooklyn Museum, https://www.brooklynmuseum.org/opencollection/objects/686.

36 Richard L. Kagan, *Urban Images of the Hispanic World, 1493–1793* (New Haven: Yale University Press, 2000), 192–94; Agnieszka Ficek, "Performing Conquest and Resistance in the Streets of Eighteenth-Century Potosí: Identity and Artifice in the Cityscapes of Gaspar Miguel de Berrío and Melchor Pérez de Holguín" (M.A. thesis, CUNY Hunter College, 2015).

37 Daviken Studnicki-Gizbert and David Schecter, "The Environmental Dynamics of a Colonial Fuel-Rush: Silver Mining and Deforestation in New Spain, 1522 to 1810," *Environmental History* 15, no. 1 (January 2010): 110.

38 Studnicki-Gizbert and Schecter, "Environmental Dynamics," 95.

39 See Alfred W. Crosby, *Ecological Imperialism: The Biological Expansion of Europe, 900–1900* (New York: Cambridge University Press, 1986); and Richard H. Grove, *Green Imperialism: Colonial Expansion, Tropical Island Edens, and the Origins of Environmentalism, 1600–1860* (Cambridge: Cambridge University Press, 1995).

40 Robins, *Mercury, Mining, and Empire*, 8; John F. Richards, *The Unending Frontier: An Environmental History of the Early Modern World* (Berkeley: University of California Press, 2003), 367–69.

41 "Descripción o historia geográfica del terreno y lugares conmarcanos de Potosí," 1759, British Library, London, Add. MS 17605, cited in Robins, *Mercury, Mining, and Empire*, 140.

42 Audiencia de La Plata, Archivo y Bibliotecas Nacionales de Bolivia, Minas 129/3, 1–2, cited in Robins, *Mercury, Mining, and Empire*, 141.

43 "London, October 27," *Freeman's Journal: or, The North-American Intelligencer* (Philadelphia), January 19, 1785.

44 José de Acosta, *The Natural and Moral History of the Indies* (1604), trans. Edward Grimston, 2 vols., (London: Hakluyt Society, 1880), 1:206–8.

45 For an overview of colonial sugar plantations in the West Indies, see Richard S. Dunn, *Sugar and Slaves; the Rise of the Planter Class in the English West Indies, 1624–1713* (New York: Norton, 1973).

46 David Watts, *The West Indies: Patterns of Development, Culture, and Environmental Change Since 1492* (New York: Cambridge University Press, 1987), 396; Marco G. Meniketti, *Sugar Cane Capitalism and Environmental Transformation: An Archaeology of Colonial Nevis, West Indies* (Tuscaloosa: University of Alabama Press, 2015), 189–224.

47 William Fox, *An Address to the People of Great Britain, on the Propriety of Abstaining from West-India Sugar and Rum*, 9th ed. (Philadelphia: Benjamin Johnson, 1792), 5. Fox's pamphlet was reprinted that same year in New York by William Durrell, in Boston by Samuel Hall, and in Lancaster, Pennsylvania, by J. Bailey and W. Dickson.

48 Benjamin Franklin, "Franklin's Thoughts on Privateering and the Sugar Islands: Essay," July 10, 1782, Founders Online, https://founders .archives.gov/documents/Franklin/01-37-02-0398.

49 See also the exhibition website for *Sugar and the Visual Imagination in the Atlantic World, circa 1600–1860* (2013), curated by K. Dian Kriz, with assistance from Susan Danforth and Elena Daniele, The John Carter Brown Library, http://www.brown.edu/Facilities/John_Carter_Brown _Library/exhibitions/sugar/index.html.

50 Joseph Addison, "Adventures of a Shilling," in *The Commerce of Everyday Life: Selections from the "Tatler" and the "Spectator,"* ed. Erin Mackie (New York: Bedford/St. Martin's Press, 1998), 184.

51 Michael Goode, "A Failed Peace: The Friendly Association and the Pennsylvania Backcountry during the Seven Years' War," *Pennsylvania Magazine of History and Biography* 136, no. 4 (2012): 472–74.

52 Harrold E. Gillingham, "Indian Silver Ornaments," *Pennsylvania Magazine of History and Biography* 58, no. 2 (1934): 96–126; Fales, *Joseph Richardson and Family*, 37–38.

53 Quimby, *American Silver at Winterthur*, 390. There were a few African American silversmiths working in Philadelphia in the late eighteenth and early nineteenth centuries, including Henry Bray, Anthony Sowerwalt, John Frances, and Peter Bentzon; see Rachel E. C. Layton, "Race, Authenticity and Colonialism: A 'Mustice' Silversmith in Philadelphia and St Croix, 1783–1850," in *Colonialism and the Object: Empire, Material Culture, and the Museum*, ed. Tim Barringer and Tom Flynn (London: Routledge, 1998), 90.

54 Alexander von Humboldt, *Political Essay on the Kingdom of New Spain*, trans. John Black, 2 vols. (New York: I. Riley, 1811), 1:93.

55 Humboldt, *Political Essay*, 1:96.

56 Richards, *The Unending Frontier*, 371.

57 "Grand Federal Procession," *Pennsylvania Gazette*, July 9, 1788; Francis Hopkinson, *Account of the Grand Federal Procession, Philadelphia, July 4, 1778* (Philadelphia: M. Carey, 1788).

58 "Two-Hundred-Year-Old Constitution Parade Banner Comes to Light," *Occasional Miscellany of the Library Company of Philadelphia* (Summer 1988): 1–2.

59 X-ray fluorescence analysis detected trace amounts of titanium, copper, zinc, manganese, chromium, and iron throughout Duncanson's *Untitled (Landscape)*. Some mercury, zinc, iron, and trace amounts of titanium and chromium were present in Bierstadt's *Mount Adams*. Both paintings contained high amounts of lead.

60 Judith Rainhorn, "The Banning of White Lead: French and American Experiences in a Comparative Perspective," *European Review of History/Revue européenne d'histoire* 20, no. 2 (April 2013): 197–216; Christian Warren, *Brush with Death: A Social History of Lead Poisoning* (Baltimore: Johns Hopkins University Press, 2000), 8.

61 The Editorial Board, "Racism at the Heart of Flint's Crisis," *New York Times*, March 25, 2016.

62 Shana Klein, "Cultivating Fruit and Equality: The Still-Life Paintings of Robert Duncanson," *American Art* 29, no. 2 (Summer 2015): 65–85; Joseph D. Ketner, *The Emergence of the African-American Artist: Robert S. Duncanson, 1821–1872* (Columbia: University of Missouri Press, 1993), 94–111.

63 Fitz Hugh Ludlow, *The Heart of the Continent: A Record of Travel across the Plains and in Oregon, with an Examination of the Mormon Principle* (New York: Hurd and Houghton, 1870); Nancy K. Anderson and Linda S. Ferber, *Albert Bierstadt: Art and Enterprise* (New York: Brooklyn Museum in association with Hudson Hills, 1990), 179.

64 James Jackson Jarves, *The Art-Idea: Sculpture, Painting, and Architecture in America*, 4th ed. (New York: Hurd and Houghton, 1877), 238.

65 Albert Bierstadt to W. O. Stoddard, May 8, 1872, and August 19, 1875, The Joseph Downs Collection of Manuscripts and Printed Ephemera, Winterthur Library.

66 Anderson and Ferber, *Albert Bierstadt*, 25.

67 B., "Sketchings," *Crayon* 6, no. 9 (September 1859): 287.

68 Lance Mayer and Gay Myers, *American Painters on Technique: The Colonial Period to 1860* (Los Angeles: J. Paul Getty Museum, 2011), 157; Augustin Cerveaux, "Paints and Varnishes," *Encyclopedia of Greater Philadelphia* (Rutgers University, 2013), http://philadelphiaencyclopedia .org/archive/paints-and-varnishes/; Carey P. McCord, "Lead and Lead Poisoning in Early America: Lead Compounds," *Industrial Medicine and Surgery* 23 (February 1954): 75–80.

69 Douglas Knerr, *Eagle-Picher Industries: Strategies for Survival in the Industrial Marketplace, 1840–1980* (Columbus: Ohio State University Press, 1992), 21.

70 Williams Haynes, *American Chemical Industry* (New York: Van Nostrand, 1945), 1:406, cited in Teresa Osterman Green, "The Birth of the American Paint Industry" (M.A. thesis, University of Delaware, 1965), 67, 72.

71 Philiberto Vernatti, "A Relation in the Making of Ceruss," *Philosophical Transactions of the Royal Society* 12 (1677): 936. See also Philip Ball, *Bright Earth: Art and the Invention of Color*, 1st American ed. (New York: Farrar, Straus and Giroux, 2002), 150.

72 Benjamin Franklin to Benjamin Vaughan, July 31, 1786, Environmental Education Associates, http://environmentaleducation.com/2011/06/28 /ben-franklin-lead-letter/.

73 C. Turner Thackrah, *The Effects of Arts, Trades, and Professions, and of Civic States and Habits of Living, on Health and Longevity: With Suggestions for the Removal of Many of the Agents Which Produce Disease, and Shorten the Duration of Life*, 2nd ed. (London: Longman, Rees, Orme, Brown, Green, and Longman; Simpkin & Marshall, 1832), 103.

74 Thackrah, *The Effects of Arts*, 105.

75 Ketner, *The Emergence of the African-American Artist*, 183–84. According to a basic recipe for commercially prepared grounds in nineteenth-century American paintings, "The canvas is first treated with size or a solution of glue…the priming consists of two coats, the first containing whitening and size, the second lead white and linseed oil"; Arthur Herbert Church, *The Chemistry of Paints and Painting* (London: Seeley and Co., Ltd., 1901), 32. No scholarship on Duncanson's technique or use of materials yet exists, except in relation to his murals at the Taft Museum in Cincinnati; Helen Mar Parkin, "'There Might Be Murals…': The Conservation of the Robert S. Duncanson Murals," *Postprints (American Institute for Conservation of Historic and Artistic Works, Paintings Specialty Group)* 15 (2002): 53–61.

76 Thackrah, *The Effects of Arts*, 106–7.

77 Thackrah, 107.

78 Thackrah, 108.

79 George Field, *Chromatography; or, A Treatise on Colours and Pigments, and of Their Powers in Painting* (London: Charles Tilt, 1835), 69.

80 Laughton Osborn, *Handbook of Young Artists and Amateurs in Oil Painting* (New York, Wiley and Putnam, 1845), 8. For more on the effects of lead poisoning, or plumbism, on artists throughout history, see John F. Moffitt, "Painters 'Born Under Saturn': The Physiological Explanation," *Art History* 11, no. 2 (June 1988): 195–216.

81 Ball, *Bright Earth*, 151.

82 Mayer and Myers, *American Painters on Technique: The Colonial Period to 1860*, 158.

83 Dare Myers Hartwell and Helen Mar Parkin, "Corcoran and Cody: The Two Versions of *The Last of the Buffalo*," *Journal of the American Institute for Conservation* 38, no. 1 (Spring 1999): 48–49. See also Church, *The Chemistry of Paints and Painting*, 192–97.

84 Lance Mayer and Gay Myers, *American Painters on Technique: 1860–1945* (Los Angeles: J. Paul Getty Museum, 2013), 51–52.

85 Hartwell and Parkin, "Corcoran and Cody," 47; Joyce Zucker, "From the Ground Up: The Ground in 19th-Century American Pictures," *Journal of the American Institute for Conservation* 38, no. 1 (Spring 1999): 8. Cotton canvas, although cheaper and made of an American-grown product, had a reputation for warping and shrinking over time; Mayer and Myers, *American Painters on Technique: 1860–1945*, 19–20.

86 Field, *Chromatography*, 51.

87 Dare Myers Hartwell, "Bierstadt's Late Paintings: Methods, Materials, and Madness," *Journal of the American Institute for Conservation* 38, no. 1 (Spring 1999): 33–44.

88 Albert Bierstadt to William MacLeod, June 27, 1877, Archives of the Corcoran Gallery and School of Art, Washington, DC, cited in Hartwell, "Bierstadt's Late Paintings," 39.

89 Charles Dickens, *Pictures from Italy* (London: Bradbury & Evans, 1846), 150.

90 Joyce K. Schiller, "Nydia: A Forgotten Icon of the Nineteenth Century," *Bulletin of the Detroit Institute of Arts* 67, no. 4 (1993): 36–45.

91 Maitland Armstrong, *Day Before Yesterday: Reminiscences of a Varied Life*, ed. Margaret Armstrong (New York: Charles Scribner's Sons, 1920), 194–95, cited in Schiller, "Nydia," 43.

92 "Randolph Rogers, the Sculptor," *Harper's Weekly*, February 6, 1892, 465, cited in Schiller, "Nydia," 43; Millard F. Rogers, *Randolph Rogers: American Sculptor in Rome* (Amherst: University of Massachusetts Press, 1971).

93 *New York Examiner* clipping in the object file for *Nydia*, Princeton University Art Museum. Thanks to the collaborative effort of Norman Muller, George Scherer, Adam C. Maloof, associate professor of geology at Princeton, and Lorenzo Larrazini, professor at the Università IUAV di Venezia, isotopic analysis of a small sample of the statue's marble established that *Nydia* is, as advertised, made of Carrara marble. Maloof performed the isotopic analysis with a small sample of marble from the underside of the sculpture's base with the following results: $\delta^{13}C = 1.99$ and $\delta^{18}O = -1.46$ vPDB. This data was compared to Figure 5b of Carlo Gorgoni et al., "An Updated and Detailed Mineropetrographic and C-O Stable Isotopic Reference Database for the Main Mediterranean Marbles Used in Antiquity," *Proceedings of the Vth ASMOSIA Conference, Boston, June 12–15, 1998* (2002): 1–25. It was determined that these values fall well within the range of Carrara marble and do not overlap with other fine-grained marbles that are very uniform in color.

94 Eric Scigliano, *Michelangelo's Mountain: The Quest for Perfection in the Marble Quarries of Carrara* (New York: Free Press, 2005).

95 August Mau, *Pompeii, Its Life and Art*, trans. Francis W. Kelsey (New York: Macmillan Company, 1899), 36; Alison E. Cooley and M. G. L. Cooley, *Pompeii and Herculaneum: A Sourcebook*, 2nd ed. (New York: Routledge, 2014), 127.

96 Pietro Lorenzini, "Tyranny of Stone: Economic Modernization and Political Radicalization in the Marble Industry of Massa-Carrara (1859–1914)" (Ph.D. diss., Loyola University, 1994), 41.

97 Lorenzini, "Tyranny of Stone," 41–42.

98 Joel Leivick, *Carrara: The Marble Quarries of Tuscany* (Stanford, CA: Stanford University Press, 1999).

99 E. St. John Hart, "A Marble World," *Pearson's Magazine*, February 1903, 142.

100 Lorenzini, "Tyranny of Stone," 111.

101 Lorenzini, 115.

102 Hart, "A Marble World," 143.

103 Edward Burtynsky and Michael Mitchell, *Edward Burtynsky: Quarries* (London: Thames & Hudson, 2007), 9.

104 Bocour first sent Louis Magna acrylics in 1947 and continued to produce custom-made paints for the artist throughout his career. For more on acrylic and Magna, see Jo Crook and Tom Learner, *The Impact of Modern Paints* (New York: Watson-Guptill Publications, 2000), 24–31; and Michael Fried, introd., *Morris Louis, 1912–1962* (Boston: Museum of Fine Arts, 1967), 79–80.

105 A company that first achieved success in its manufacture of a synthetic leather tanning agent, Rohm & Haas, now owned by Dow Chemical, has its own spotty record of environmental pollution and worker safety; see, for example, Mark Jaffe, "Region a Leader in Toxic Spills," *Philadelphia Inquirer*, September 2, 1994; and "Mystery at Rohm & Haas," *Philadelphia Magazine*, October 24, 2007, http://www.phillymag.com/articles/features-mystery-at-rohm-haas/.

106 Personal Business Records, 1948–1963, Morris Louis and Morris Louis Estate Papers, circa 1910s–2007, bulk 1965–2000. Archives of American Art, Smithsonian Institution.

107 See Crook and Learner, *Impact of Modern Paints*, 129.

108 Cassandra Y. Johnson and Josh McDaniel, "Turpentine Negro," in *To Love the Wind and the Rain: African Americans and Environmental History*, ed. Dianne D. Glave and Mark Stoll (Pittsburgh: University of Pittsburgh Press, 2006), 53.

109 Johnson and McDaniel, "Turpentine Negro," 54n7.

110 Johnson and McDaniel, 57n12.

111 Today the majority of turpentine is produced in Portugal, Indonesia, and China. "Turpentine from Pine Resin," Food and Agricultural Organization of the United Nations Corporate Document Registry, http://www.fao.org/docrep/v5350e/V5350e10.htm.

112 Johnson and McDaniel, "Turpentine Negro," 51–52, 61; see also Michael David Tegeder, "Prisoners of the Pines: Debt Peonage in the Southern Turpentine Industry, 1900–1930" (Ph.D. diss., University of Florida, 1996); and Robert B. Outland, *Tapping the Pines: The Naval Stores Industry in the American South* (Baton Rouge: Louisiana State University Press, 2004).

113 Josiah Whitney to William Brewer, December 15, 1865, Bancroft Library, University of California, Berkeley, cited in George Philip LeBourdais, "Notes on Process," in *Carleton Watkins: The Stanford Albums* (Stanford, CA: Iris & B. Gerald Cantor Center for the Visual Arts, 2014), 17.

114 Oliver Wendell Holmes, "Doings of the Sunbeam," *Atlantic Monthly* 12, no. 69 (July 1863): 1–16. In the last decade of the twentieth century, more than half of American silver was used for the production of photographic film; Quimby, *American Silver at Winterthur*, 1.

115 Robert Silberman, "Ansel Adams, the Kodak Colorama and 'The Large Print Idea,'" in *Ansel Adams, New Light: Essays on His Legacy and Legend* (San Francisco: Friends of Photography, 1993), 33–41; Lisa W. Foderaro, "Pollution by Kodak Brings Sense of Betrayal," *New York Times*, March 8, 1989; Robert Hanley, "Eastman Kodak Admits Violations of Anti-Pollution Laws," *New York Times*, April 6, 1990; and Department of Justice, US Attorney's Office, Southern District of New York, "Manhattan U.S. Attorney and EPA Announce Agreement with Eastman Kodak Company for Clean Up of Rochester, New York, Business Park and the Genesee River," press release, March 12, 2014, https://www.justice.gov/usao-sdny/pr/manhattan-us-attorney-and-epa-announce-agreement-eastman-kodak-company-clean-rochester.

Jeffrey Richmond-Moll

"A Knot of Species":
Raphaelle Peale's *Still Life with Steak*
and the Ecology of Food

What we eat assimilates with us, becomes our own flesh and blood,
influences our disposition, our temper....Then to reflect that we
[Americans] are made up of half-boiled potatoes, raw meat, and
doughy pie-crust!

Francis Joseph Grund, "A Chapter on Eating: Part I (The Philosophy and Uses
of Eating)"

In Raphaelle Peale's *Still Life with Steak* (fig. 128), a cut of
beef's fatty folds clasp an orange carrot as if to swallow it
whole. Even in death, this bovine flesh still ingests its feed.
Of the roughly one hundred still-life paintings that Raphaelle
(1774–1825) produced throughout his career, only two depict
meat. The steak and other foodstuffs that appear in them are
often said to reflect seasonal meals, as in the combining of
meat, cabbage, carrots, and beets seen here.[1] Scholars have also
aligned Peale's tabletop scenes with period debates about tem-
perance and indulgence in American Republican culture.[2]
But in the case of *Still Life with Steak*, early nineteenth-
century American theories regarding horticulture, husbandry,
and the physiology of taste suggest another interpretation.
Specifically, Peale's canvas points to period understandings of
the organic and anatomical interconnections between human
and nonhuman life in systems of food production and con-
sumption. Within early nineteenth-century American food-
ways, the artist's contemporaries envisioned animals and plants
coalescing and cooperating with the human body in vital,
mutually constitutive ways.

References to food's vitality and agency do exist in Peale
literature. Scholars note, for example, how Raphaelle's sliced
melons spill generative seeds, how his meat refuses to decay,
and how his viewers seem unable to claim special authority
over these objects, which the artist painted at close range,

from just across the table. But the fruit, meat, and vegetables in
Raphaelle's still-life paintings are seldom considered on their
own terms: as living or once-living organisms. Descriptions of
Melons and Morning Glories (fig. 129), for instance, deem the
fractured melon to be an embodied presence, though only
insofar as it suggests a surrogate for the human body, opened
up like a cadaver on the dissection table. Just as Raphaelle's
paintings have been set apart in the literature from other still
lifes of his era for their impeccably balanced objects and pure
form, so too have the things he painted been interpreted at a
remove from their larger environmental and social networks.
His still-life objects, scholars claim, mark a hermetic, even
antisocial, metaphysical world where individuals can com-
mune with the inanimate.[3] For example, while the art histo-
rian Alexander Nemerov highlights the embodied quality of
Peale's objects, which erode "the position of a secure subject
standing apart from the things he beholds," he ultimately
ascribes this phenomenological experience to the emanation
of the viewer's body into the material world of the painting.
The flesh-and-bone physicality of Peale's two meat pictures,
Still Life with Steak and *Cutlet and Vegetables* (fig. 130), thus
offers not an autonomous object—a cow or a pig—but a sub-
stance that makes the *viewer's* "meatiness" palpable.[4]

Rather than turn to humans as the ultimate basis for
vitality in Peale's painting, this essay emphasizes the agentic
contributions of nonhuman entities and the environment. In
such an ecocritical view, the "meatiness" of the meat itself in
Still Life with Steak retains its own palpability. Art historian
Carol Troyen and others have argued that "Raphaelle's vege-
tables and fruits do not claim membership in a larger ecol-
ogy" but operate in isolation and "exist for contemplation
alone."[5] Yet the nonhuman elements of *Still Life with Steak*

FIGURE 128: Raphaelle Peale (American, 1774–1825), *Still Life with Steak*, 1816–17. Oil on wood, 34 × 49.5 cm. Munson-Williams-Proctor Arts Institute, Utica, New York

FIGURE 129: Raphaelle Peale, *Melons and Morning Glories*, 1813. Oil on canvas, 52.6 × 65.4 cm. Smithsonian American Art Museum, Washington, DC. Gift of Paul Mellon (1967.39.2)

FIGURE 130: Raphaelle Peale, *Cutlet and Vegetables*, 1816. Oil on panel, 46.4 × 61.5 cm. Timken Museum of Art, San Diego. Putnam Foundation (2000:002)

evince a larger biotic community, one that encompasses plants, animals, viewers, and even the artist himself, and that demonstrates how this coexistential network of beings would have been understood in Peale's time. By enticing his audience to imagine themselves in nonhuman forms such as plants and livestock, Peale asserts a vital power that extends beyond the viewer into a wider world outside the picture.

According to period scientists and practitioners, livestock had a voracious appetite for root vegetables, especially the orange carrot and red beet, which both appear in *Still Life with Steak*. Orange carrots were, in fact, one of the least regarded ingredients in nineteenth-century American cuisine; however, they were still grown in most gardens because livestock savored them so.[6] As John Prince of the Massachusetts Agricultural Society argued in 1822, not only were carrot tops and roots "greedily eaten by oxen, cows, sheep, or swine," but they also yielded far more nourishment for animals than more traditional feed sources such as oats or potatoes.[7] Following a visit to the United States between 1817 and 1819, the English journalist William Cobbett likewise noted that beets, though unpopular in England, had been fully embraced among American farmers for the fattening of cattle.[8] Carrots, beets, and other root vegetables

thus offered the most efficient feed for farm animals. As such, Peale's steak presents a later stage in the life of the vegetables he depicts, the carrot and beet having implicitly become bovine flesh and fat through animal metabolism.

Moreover, even in the cool climes and rocky terrain of the North, these hardy storable crops purportedly concentrated the nutritive elements in soil. In an era when public figures voiced concern over soil exhaustion and a potential food crisis, roots offered a sustainable and economical means of nourishing animals *and* the land.[9] In an 1818 address to the Agricultural Society of Albemarle, Virginia, former US President James Madison decried the broken relationship between humans and the land, wherein farmers exploited fertile soil until it was stripped of its nutrients and then abandoned that barren land in search of more unspent terrain farther west. Reproduced and read widely at the time (including, very probably, by the Peales), Madison's speech bolstered the efforts of the agricultural reform movement, which espoused more sustainable farming methods as a means to nurture the American soil and, in turn, its people.[10] Soil depletion was indeed a very real threat in Peale's native Philadelphia as well. With the lands surrounding the city largely exhausted by the 1810s, the Philadelphia Society for Promoting Agriculture devoted its energies to the use of better fertilizers and new crop rotation methods to restore the fecundity of neighboring farmlands.[11] Consistent with such concerns among his Philadelphia patrons and cultural milieu, Peale depicted the same vegetables that practitioners promised would mutually nourish soil, livestock, and humanity, painting them as if emerging from the brown, earthy "ground" of the canvas.[12] Hence his painting constitutes its own self-sustaining ecological system.

The influence of period agricultural and horticultural discourses on Raphaelle's paintings can also be understood through the activities of the Peale family itself. After retiring in 1810 to Belfield, his farmstead outside Philadelphia, Raphaelle's father, Charles Willson Peale (1741–1827), occupied himself with the work of agricultural reform, treating the property like a laboratory for more efficient and productive farming methods.[13] At Belfield, the objects shown in *Still Life with Steak* would have been near at hand. Wild carrots and York cabbage were among the plants grown on the farm, as listed in Charles Willson's extant letters and autobiography, and as depicted in his *Cabbage Patch, The Gardens of Belfield, Pennsylvania* (fig. 131). Further, in correspondence

with his son Rembrandt, Charles Willson wrote, "I am now contemplating to purchase some cattle to fatten for Beef," which he hoped—in addition to the pigs and poultry he was raising—would feed his family and find a profit at market.[14] That he actually raised cows is substantiated by a letter from the following year, wherein Charles Willson informed Rembrandt that he would rather preserve "the Clover field east of the House" for crops than let it "be trampled down by the Cattle."[15] For Raphaelle, then, Belfield enabled direct contact with plant and animal life, and expanded his agricultural literacy in an era before technology distanced consumers from the locations where their food was produced.

That Charles Willson anticipated good income from his meat at market signals another theory regarding agriculture and husbandry: root vegetables produced the most nourishing beef and also the finest tasting to the human palate.[16] Raphaelle's compositional intermingling of roots and steak—as they are enfolded within the cut of beef, one struggles to discern precisely where each vegetable ends and the meat begins—and his inclusion of the very foods cattle consumed before their butchery enact this fleshly, gustatory coalescence of crop and animal. The shared human-nonhuman taste for root vegetables would lead authors to propose the biological cousinage of the human and animal tongue, and horticulturalists to develop root varieties whose delectability for animals and humans mattered equally.[17] Even in the late eighteenth century, scientists observed via dissections the similarity of human anatomy to that of apes and other animals, and noted the kinship between the teeth and intestines of humans and herbivores like cows.[18]

In reinforcing the anatomical and gastronomic entanglement of humans and nonhumans, contemporary texts on diet also asserted the connection between food and temperament. Jean Anthelme Brillat-Savarin's *Physiology of Taste* (1825), for example, associated what one ate with the kind of person one was, while late eighteenth-century prison reformers such as Robert Pigot advocated eliminating meat and alcohol from prisoners' diets as a way to make their hardened characters more mild and sensible.[19] Peale's contemporaries took seriously the power of food, believing that consumption was, in the political theorist Jane Bennett's terms, "a two-way street," that edible matter could shape a person's disposition as that food, once ingested, cooperated within or acted against the human body.[20] Accordingly, in

letters from 1815, Charles Willson described his wish that Raphaelle quit drinking and temper his indulgent diet of richly seasoned foods, which "are ever ruinous to the Stomach." Instead, Raphaelle's father endorsed "simple food [that] makes good blood, good spirits, good health." Charles Willson's advice arose from concerns that his son might suffer another "attack of the Gout in his stomack," from which Raphaelle suffered chronically—"My old inveterate enemy," he called it—and which severely immobilized the artist.[21] Historian Lillian B. Miller has attributed these bouts to excessive drinking, but the disease was also historically associated with indulgent eating habits, especially the excess consumption of meat.[22] Raphaelle's two meat pictures address this directly. Indeed, painted within a year of each other, perhaps even in the same winter of 1816–17, they may have been his cathartic response to a violent attack of gout in mid-1816, which left him medically incapacitated and unable to produce a promised "Painting of fine Peaches" for his patron Charles Graff at the time of the fruit's peak ripeness that August.[23]

In rendering the relationship between humans and nonhumans more enmeshed, and the line between them more ambiguous, contemporary theories of food production and consumption produced a new vision of the body as "an impure, human-nonhuman assemblage."[24] Raphaelle himself was known for his ventriloquist antics, like those at the Black Bear Tavern, where he reveled in projecting pleas and shrieks into cooked game as he thrust the carving blade into the roasts. Such stories suggest his delight in occupying the positions of both consumer and consumed, which thereby became indivisible.[25] So too does Peale reinforce the inseparability of meat, vegetables, and the human body in *Still Life with Steak*, with its web of overlapping and intertwined organic forms. His penchant for double entendre likewise accords with the rich ambiguities between the human self and the nonhuman other in food discourses of this time. By aligning his painting with the physiology of taste, Peale also obliquely engaged with ideas of aesthetic taste, such that the "marble" of this well-larded porterhouse evokes both meat quality and the early nineteenth-century American vogue for classicism, especially in Philadelphia, a city known for its public markets and Greco-Roman architecture. As a work that once hung—like many other of his still lifes—in the dining room of an urban patron, *Still Life with Steak* could have reminded its owners of the country's agrarian "roots,"

even as the painting also signals an emerging aesthetic taste for scenes about human taste within domestic spaces where such tasting occurred.[26]

With human and nonhuman taste mutually entwined in what the science historian Donna Haraway has called "a knot of species," the commingled comestibles in Peale's painting further conjure an organically interconnected subsistence system, whereby plants nourish soil, animals eat plants, people eat plants and animals, and all these minerals return again to the earth.[27] To intend the painting for a dining room display was thus to intervene in one stage of a longer cycle of nourishment and decay. Raphaelle certainly would have been aware of the botanist Carolus Linnaeus's theories of taxonomy and ecology. Charles Willson's belief in a Linnaean natural order was foundational to his Peale Museum in Philadelphia, as discussed by Alan C. Braddock in this volume (see pages 48–54). In the early 1790s, when apprenticed at the museum, Raphaelle helped his father preserve and then arrange animal specimens in habitats, whose backgrounds the young artist painted and which he arranged with foliage and insects to reproduce that animal's typical environment.[28] The human-nonhuman ecology of *Still Life with Steak* thus finds its roots in Raphaelle's deep knowledge of natural systems.

The steak and vegetables in Peale's painting emerge as vibrant embodiments of the potentialities of plant and animal matter itself. After all, unlike pork, which could be cured, in the nineteenth century beef's material properties required that cattle be imported alive and freshly slaughtered near a city's public markets where the meat was sold.[29] Since most markets stood in close proximity to residential areas, urban Americans became well acquainted with the full life cycle of cows, as butchers guided herds through city streets and slaughtered them within smelling distance of people's homes before setting the meat out for sale the next day. Urban cattle drives were a common occurrence, as hundreds of thirsty, frightened animals were funneled through crowded streets to the slaughterhouses (fig. 132).[30] In an 1865 report on New York City's sanitary districts, one inspector demanded an end to this long-standing practice, and implored that killing and butchery take place in the rear of slaughterhouse lots so that "people and children cannot witness it." Residents also encountered meat production's deleterious by-products, given the meat industry's poor waste disposal practices. The 1865 report likewise sought to stem

FIGURE 132: "Cattle driving in the streets—who cares for old women and small children?," in *Frank Leslie's Illustrated Newspaper*, April 28, 1866. Princeton University Library. Rare Books and Special Collections

the continued flow of blood, urine, and fecal matter from slaughterhouses into the gutters of densely populated neighborhoods and even the busiest of thoroughfares.[31] A particularly affluent market town, Philadelphia also sustained high demand for fresh cuts of beef in large volumes. Its citizens were consequently no less immune than New Yorkers to the urban meat economy's environmental damage.

In the spring of 1821 Philadelphia hosted a weeklong festival organized by the leader of the Philadelphia Victuallers, William White, which ended on March 15 with the slaughter of sixty-three cattle, forty-two oxen, four bears, three deer, ten goats, eight mammoth hogs, and many sheep. As John L. Krimmel (1786–1821) documented in his painting of the celebration's culminating event (fig. 133), two hundred of

the trade union's butchers led the procession of 86,731 pounds of meat through the city's streets.[32] Clad in white, mounted on fine horses, and physically separated from the carts carrying their slaughter, the butchers seem to distance themselves from their bloody, violent trade. Likewise, in Nemerov's analysis, the white butcher paper and the dark space below the ledge in Peale's *Cutlet and Vegetables* keep the viewer clean from the bloody cut of bacon (see fig. 130).[33] Yet such an interpretation places these animals beyond arm's length. There was, after all, very little distance between meat producers and meat eaters in this era. Indeed, the day after the Victuallers' grand parade all the meat was sold to the public.[34] Despite a similar darkened space at bottom, *Still Life with Steak* forestalls the sense of separation between viewer and subject as the steak breaches the plane of the tabletop and edges into the viewer's space.[35] Further, in aquatints after Krimmel's painting from the same year, the butchers are not clad in all white, but wear crimson sashes across their white frocks—an ambivalent portrayal of this perpetually blood-stained lot.[36] There was no circumventing the visibility and intimate realities of early nineteenth-century meat production. Instead, the parade rehearses the

stages of animal slaughter that urban residents frequently observed: living livestock (the bull at front), slaughtered meat (the carts behind), street procession, and market sale.

As the art historian Norman Bryson has written, still-life painting's focus on nonhuman things "assaults the centrality, value, and prestige of the human subject."[37] An ecocritical reading of Peale's *Still Life with Steak* further elucidates this founding feature of the genre. Though often described as depicting banal, mute, and undignified subjects, pictures such as *Still Life with Steak* relocate the human body—praised for centuries as the highest object of artistic endeavor—within an entangled set of relationships encompassing soil, plants, animals, and human beings alike. In granting his objects such vitality, Peale points toward an ecological understanding of human-nonhuman interconnectedness even as his picture embodies a premodern moment before meat production became alienated from its productive ecosystems and hidden away from daily life by late nineteenth-century industrialization. In other words, *Still Life with Steak* occupies an epistemological threshold across which, in the art critic John Berger's terms, animals still exchanged a human's gaze—and equally partook in tasting.[38]

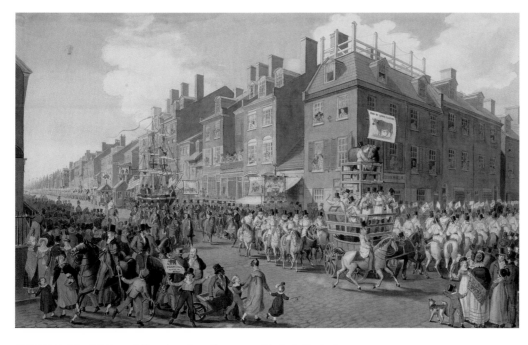

FIGURE 133: John L. Krimmel (American, born Germany, 1786–1821), *Parade of the Victuallers*, 1821. Watercolor on paper, 36.8 × 61 cm. Private collection

Notes

EPIGRAPH: Francis Joseph Grund, "A Chapter on Eating: Part I (The Philosophy and Uses of Eating)," *Graham's American Monthly Magazine of Literature and Art* 30, no. 6 (June 1847): 333.

1 Judith A. Barter, "Food for Thought: American Art and Eating," in *Art and Appetite: American Painting, Culture, and Cuisine*, ed. Judith A. Barter (New Haven: Yale University Press, 2013), 18.

2 See, for example, Nicolai Cikovsky Jr., ed., *Raphaelle Peale Still Lifes* (Washington, DC: National Gallery of Art, 1988); and Alexander Nemerov, *The Body of Raphaelle Peale: Still Life and Selfhood, 1812–1824* (Berkeley: University of California Press, 2001).

3 Cikovsky, *Raphaelle Peale Still Lifes*, 48–50; and Carol Troyen, "Fruit, Flowers, and Lucky Strikes: The Still Life in American Culture," in *The Art of American Still Life: Audubon to Warhol*, ed. Mark D. Mitchell (Philadelphia: Philadelphia Museum of Art; New Haven: in association with Yale University Press, 2015), 26.

4 Nemerov, *Body of Raphaelle Peale*, 92. For a recent response to the fundamental humanism of phenomenology, see Charles S. Brown and Ted Toadvine, eds., *Eco-Phenomenology: Back to the Earth Itself* (Albany: State University of New York Press, 2003).

5 Troyen, "Fruit, Flowers, and Lucky Strikes," 25–26.

6 David Shields, "The Roots of Taste," *Common-Place* 11, no. 3 (April 2011), paras. 7–8, http://www.common-place-archives.org/vol-11/no-03/shields/.

7 John Prince, "Culture of Carrots," *American Farmer*, March 29, 1822, 5.

8 William Cobbett, *American Gardener* (London: C. Clement, 1821), no. 198.

9 Shields, "The Roots of Taste," para. 4.

10 James Madison, "Address to the Agricultural Society of Albemarle," May 12, 1818, *Founders Online*, National Archives, http://founders.archives.gov/documents/Madison/04-01-02-0244. See also Judith A. Barter and Annelise K. Madsen, "'The Symmetry of Nature': Horticulture and the Roots of American Still-Life Painting," in Barter, *Art and Appetite*, 70. See Charles Coleman Sellers, *Charles Willson Peale* (New York: Scribner, 1969), 257, 316, for references to at least two instances in which Madison and Charles Willson Peale were in the same room.

11 Simon Baatz, *"Venerate the Plough": A History of the Philadelphia Society for Promoting Agriculture, 1785–1985* (Philadelphia: Philadelphia Society for Promoting Agriculture, 1985), 12.

12 Uses of the term "ground" in Joshua Reynolds's *Discourses*, for example, indicate how classical artistic theory and practice had naturalized the canvas-as-soil metaphor well before the modern era. Consider Reynolds's critique of Raphael, whose use of color, light, and shadow, he wrote, failed "to make the object rise out of the ground, with the plenitude of effect so much admired in the works of Correggio"; Reynolds, "Discourse V" [1772], in *The Life and Writings of Sir Joshua Reynolds*, ed. Allan Cunningham (New York: A. S. Barnes & Burr, 1860), 75. Thanks to Alan Braddock for raising this connection.

13 David C. Ward, "Charles Willson Peale's Farm Belfield: Enlightened Agriculture in the Early Republic," in *New Perspectives on Charles Willson Peale: A 250th Anniversary Celebration*, ed. Lillian B. Miller and David C. Ward (Pittsburgh: University of Pittsburgh Press, 1990), 292.

14 Charles Willson Peale to Rembrandt Peale, Germantown, Pennsylvania, July 22, 1810, American Philosophical Society Library (APSL), Peale-Sellers Family Collection (PSFC), Charles Coleman Sellers Letterbook 11.

15 Charles Willson Peale to Rembrandt Peale, Germantown, Pennsylvania, August 27, 1811, APSL, PSFC, Letterbook 12.

16 On the nutritional value of fattened livestock, see Thomas Greene Fessenden, "On Making Cattle Very Fat," *New England Farmer*, May 3, 1823, 313.

17 Shields, "The Roots of Taste," para. 6.

18 Tristram Stuart, *The Bloodless Revolution: A Cultural History of Vegetarianism from 1600 to Modern Times* (New York: W. W. Norton, 2007), xxii.

19 Robert Pigot, *The Liberty of the Press* (Paris, 1790), 30–31.

20 Jane Bennett, *Vibrant Matter: A Political Ecology of Things* (Durham, NC: Duke University Press, 2010), 39, 47, 50.

21 Charles Willson Peale to Rembrandt Peale, Belfield, October 9, 1815, APSL, quoted in Cikovsky, *Raphaelle Peale Still Lifes*, 102; Raphaelle Peale to Charles Graff, Philadelphia, September 6, 1816, Archives of American Art, quoted in Cikovsky, *Raphaelle Peale Still Lifes*, 103–4.

22 Lillian B. Miller, "Father and Son: The Relationship of Charles Willson Peale and Raphaelle Peale," *American Art Journal* 25, nos. 1–2 (1993): 22, 50–51, 57n62. See also Stuart, *Bloodless Revolution*.

23 Peale to Graff, September 6, 1816.

24 Bennett, *Vibrant Matter*, xvii.

25 Sellers, *Charles Willson Peale*, 398; Nemerov, *Body of Raphaelle Peale*, 97.

26 Katharina Vester, *A Taste of Power: Food and American Identities* (Oakland: University of California Press, 2015), 36.

27 Donna J. Haraway, *When Species Meet* (Minneapolis: University of Minnesota Press, 2008), 42; Greg M. Thomas, *Art and Ecology in Nineteenth-Century France: The Landscapes of Théodore Rousseau* (Princeton: Princeton University Press, 2000), 6.

28 Linda Bantel, "Raphaelle Peale in Philadelphia," in Cikovsky, *Raphaelle Peale Still Lifes*, 16–17.

29 Roger Horowitz, *Putting Meat on the American Table: Taste, Technology, Transformation* (Baltimore: Johns Hopkins University Press, 2006), 18–19; William Cronon, *Nature's Metropolis: Chicago and the Great West* (New York: W. W. Norton, 1991), 226. The highly precise cuts and the metal pins rendered in *Still Life with Steak* and *Cutlet and Vegetables* indicate Raphaelle's strong awareness of contemporary butchery techniques; see Nemerov, *Body of Raphaelle Peale*, 90.

30 See Peter Atkins, ed., *Animal Cities: Beastly Urban Histories* (New York: Ashgate, 2012), especially Atkins, "Animal Wastes and Nuisances in Nineteenth-Century London," 19–51, and Atkins, "The Urban Blood and Guts Economy," 77–106.

31 *Report of the Council of Hygiene and Public Health of the Citizens' Association of New York upon the Sanitary Condition of the City* (New York: D. Appleton and Company, 1865), 86, 87, 156.

32 James Mease, "Remarks on the late Cattle Procession in Philadelphia, with Directions how to effectually promote the Breed of Cattle," in *Memoirs of the Philadelphia Society for Promoting Agriculture* (Philadelphia: Robert H. Small, 1826), 157.

33 Nemerov, *Body of Raphaelle Peale*, 93–96.

34 Constance Classen, *The Deepest Sense: A Cultural History of Touch* (Champaign: University of Illinois Press, 2012), 97.

35 Nemerov interprets the unique, dark space at the bottom of both meat pictures as producing "a recessional power that pulls the scene a bit further into the distance, away from the observer" (*Body of Raphaelle Peale*, 95); however, the space at bottom could conversely be read as producing a more fully articulated tabletop, which, in turn, projects the meat out from the shadowy background and more fully into the realm of the viewer.

36 For the aquatint version, see the Philadelphia Museum of Art (acc. no. 1961-7-17).

37 Norman Bryson, *Looking at the Overlooked: Four Essays on Still Life Painting* (Cambridge, MA: Harvard University Press, 1990), 60.

38 John Berger, *About Looking* (New York: Pantheon Books, 1980), 5, 14.

Wearing the Wealth of the Land: Chilkat Robes and Their Connection to Place

Miranda Belarde-Lewis | Zuni/Tlingit

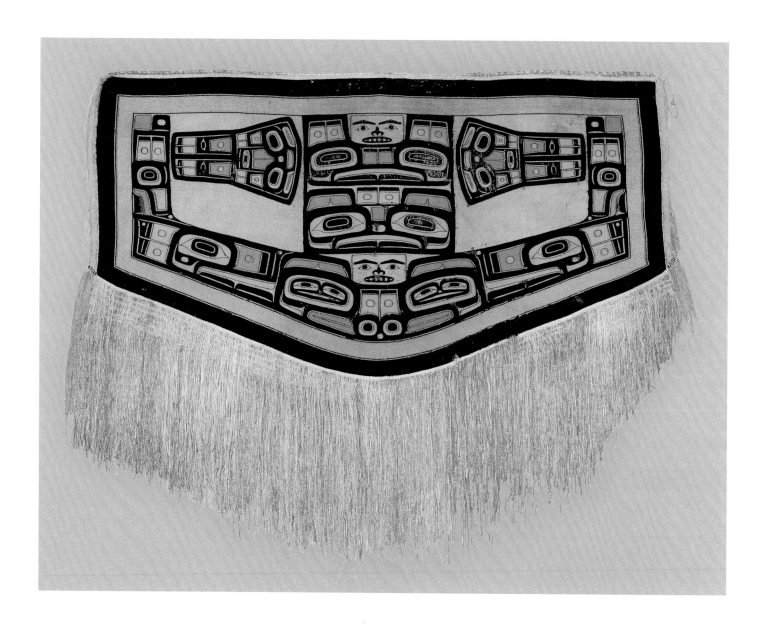

After learning Chilkat, I gained the art of patience, the way of gratitude, the action of compassion. The universe opened its doors with a flood of information; the kind of information not definable, yet powerfully written in our Native art, in the ways of our people, and in our commune with nature.

Clarissa Rizal, Tlingit, master Chilkat weaver

It is an environmental connection—the Indigenous arts are very much that connection, with the place we call home.

Teri Rofkar, Tlingit, master Ravenstail/Spruce Root weaver

For centuries, Indigenous peoples of what is now known as the Northwest Coast of North America have produced extraordinary woven wool blankets and other utilitarian and ceremonial items. These were designed with family crests featuring animals or geometric basket designs of stepped rectangles, diamonds, and intricate, interlaced triangles. Some of the finest weaving in this rich and complex tradition has been produced by members of the Chilkat community, one of the Tlingit-speaking tribes living in southeast Alaska and British Columbia, whose name has been associated with all weavings of this type made there and in other Tlingit, Tsimshian, and Haida communities.

If you have ever had the opportunity to touch, carry, or wear a Chilkat, you will have noticed that it is dense and heavy. The physical weight of a Chilkat robe results from the one thousand yards of warp strands and several pounds of weft yarn used for each adult-size robe. The cultural burden of Chilkat weaving and its associated spiritual practices relates to the immense responsibility of rank, nobility, and clan obligations conferred upon the owner of any Chilkat regalia, and by extension, to the weaver of the regalia. Sourcing the materials and weaving the robes constitute a cultural weight carried by the weavers that includes thousands of years of tradition and language as well as a spiritual connection to the land and to the designs woven into robes, tunics, and dance aprons.

Chilkat robes secured their place as the ultimate indicators of wealth and prestige among the peoples of the northern Northwest Coast of North America long before their introduction to explorers and collectors in the late eighteenth century. In 1994 the textile conservator Katie Pasco declared the robes to be the "most important symbol of the rank and status of members of the hierarchy of the Northwest Coast."[1] An early nineteenth-century Tlingit killer whale robe (so named after its predominant design motif), donated to the Peabody Essex Museum in 1832 by Captain Robert Bennet Forbes, is one of the finest and oldest known examples of Chilkat weaving (fig. 134).

Understanding and appreciating Chilkat weaving requires consideration of both the technical mastery it entails as an art form and its direct embodiment of Indigenous peoples'

FIGURE 134: Tlingit artist, Pacific Northwest Coast, Alaska, *Naaxein (Chilkat Robe)*, early 19th century. Mountain goat wool, cedar bark, leather, 134.6 × 161.9 cm. Peabody Essex Museum, Salem, Massachusetts. Gift of Captain Robert Bennet Forbes, 1832 (E3648)

FIGURE 135: Scenery Cove in Thomas Bay, Petersburg, Alaska

Indigenous Knowledge—an accumulation of skills and an awareness of seasonal cycles based upon thousands of years of observation and interaction with a particular environment.[3] These observations have determined and shaped each group's language, ceremonies, clothing, shelter, foodways, design sensibilities, and aesthetics. The process of acquiring and building Indigenous Knowledge has been severely impacted since the time of first European contact.[4] It has been affected even more relentlessly during the current Anthropocene era when it is becoming clear just how much human factors of overdevelopment and pollution are exacerbating global climate change.

Federal governments delineate the reservations and reserves of federally recognized tribal groups, creating state-imposed borders intended to confine and control Indigenous peoples by "allowing" them to control tribal lands with limited local sovereignty.[5] In a capitalistic regime, land belongs to humans. In stark contrast, generations of Indigenous peoples have viewed themselves as belonging to the land, as both stewards and protectors.[6] A long-standing relationship with the land brings familiarity and knowledge to the people living within their bounded space, linking them to their home territory and influencing all aspects of their culture. The artifacts and artworks of any Native community clearly show this interdependence. In what is now the American Southwest desert, Pueblo potters include iconography of rain and creatures such as turtles and frogs to illustrate our connectedness to and dependence upon water. A rainstorm can bring abundance

physical connection to the land of the Northwest Coast. After examining the nineteenth-century killer whale robe more closely with this connection in mind, this essay concludes with a discussion of a recent community-based robe, *Weavers Across the Waters*, which brings Chilkat weaving into the present.

Bound to the Land

Chilkat woven robes are called *naaxein* in the Tlingit language, referring to their "fringe about the body," which sways during ceremonial dances. Each robe directly expresses its maker's relationship to a "bounded space," just as every aspect of life among the Tlingit, Tsimshian, and Haida peoples of the Northwest Coast also reflects the respective homeland of each tribal nation. Bounded space, as defined by the late Jicarilla Apache/Hispanic philosopher Viola Faye Cordova, refers to the geographic breaks in the surrounding topography that define a group's customary territory. Rivers, lakes, mountains, deserts, oceans, prairies, and forests create the organic "borders" of a group's homeland and imply the understanding and knowledge that across a river, mountain, or forest another tribe or band of people occupies *their* space (fig. 135).[2]

The people belonging to a specific bounded space spent generations acquiring and building what we now call

FIGURE 136: Detail of Tlingit artist, *Naaxein (Chilkat Robe)*, early 19th century

to crops and farmers and brings the frogs out. Thus frogs on Zuni pottery indicate fertility. Just as the frogs and turtles are part of the ecosystem, so are Pueblo peoples. The depiction of animals honors the ways that they have shaped our worlds, influenced our epistemologies, and taken a central place in many of our foundational stories.

The Killer Whale Robe

The killer whale Chilkat robe stunningly provides multiple entry points for the study and appreciation of Chilkat weaving and Tlingit culture. The robe encompasses three areas of importance in Tlingit society: clan affiliation, reciprocity, and wealth. These are in turn related to the basic Tlingit social structure, which consists of two moieties or kinship groups— Raven and Eagle/Wolf. Autonomous villages run by subclans of either moiety dot the southeastern panhandle of present-day Alaska, as they have for thousands of years.[7]

The important Tlingit custom of maintaining balance between the two major kinship groups, the Ravens and Eagles, continues to this day and is most clearly seen following the death of a clan member.[8] When a member of the Raven clan passes, the members of the Eagle moiety provide emotional and logistical support during the funeral. A year or two later, the family members of the Raven side perform reciprocity during the distinctive ceremonial feast *Ku.eex'* (memorial feast), labeled a "potlatch" by anthropologists.[9] In this example, the Ravens would host the Eagles as their honored guests to thank them for being there in a time of desperate need. The presentation of cultural and clan-based wealth by the host moiety at such gatherings recognizes the host's respect for the guests, who are lavished with gifts, feasts, speeches, clan songs, and accompanying dances. The demonstration of wealth by way of the *redistribution of that wealth* is common in many Native communities. As a significant sign of respect for the guests, the host clan creates a display of the *at.óow*, the clan-owned regalia, or "belongings."[10] *At.óow* can take the intangible form of proprietary songs, stories, and speeches but is most recognizable in its tangible forms as ceremonial clothing such as beaded button robes; carved hats adorned with the crest symbols of the clan (usually animals) or woven cedar bark rings; *tinaas* (copper shields); and Chilkat woven robes, tunics, and dance aprons. The killer whale is a clan crest used by the Eagle moiety (fig. 136); this robe would have deeply honored the Raven guests who witnessed its unveiling.

The Peabody Essex Museum's object entry provides a detailed description of the robe's design:

> The horizontal element at the bottom represents the open-mouthed head of a diving killer whale. Rising above the head are fluked tail segments, and attached to either side are lateral fins that extend upward. Connected to each lateral fin is a dorsal fin, the top of which repeats half of the fluked-tail design. Placed horizontally at either side of the dorsal fins are representations of coppers, shield-shaped devices hammered from that metal and used as the Tlingit's primary medium of exchange at potlatches.
>
> Together, the lateral and dorsal fin designs create a profile view of the complete whale. Moreover, the design contains within it several whales, transforming a single killer whale into a pod of whales....The visual punning is an artistic and intellectual achievement unprecedented in this medium.[11]

The "visual punning" described here results from the characteristic formline design of Chilkat weaving and Indigenous Northwest Coast aesthetics in general, defined by flowing lines, U-shapes, ovoids, and trigons that create overlapping, doubling, and interpenetrating patterns.[12] These richly complex clan crest designs have long intrigued ethnographers, anthropologists, artists, collectors, dealers, and art lovers alike.[13] The efforts to decode and decipher the design elements and the stories they tell have filled numerous volumes by generations of scholars. The recognition of Chilkat weaving as a valuable trade commodity and as a symbol of men's wealth is another area of intense study. There has been less scholarly focus, however, on the materials used, the women who wove, and the largely female practice of weaving—all ways in which the robes' connection to their surrounding environment is keenly felt.

The creation of this particular robe most likely resulted from a commission by a wealthy and high-ranking leader of a Tlingit clan or house. This cannot be verified; it is speculated the robe was acquired "in 1825 at Bodega, a Russian settlement on the northern California coast" by the donor who gave it to the East India Marine Society in 1831.[14] However, robes of this caliber and quality would have been presented and introduced during a substantial potlatch most likely spanning several days. The Raven guests at this potlatch would have spoken of it for years.

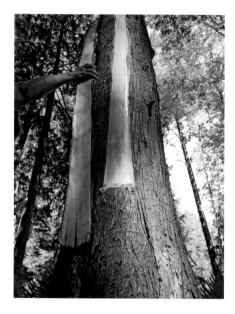

FIGURE 137: Harvesting cedar bark, Washington State

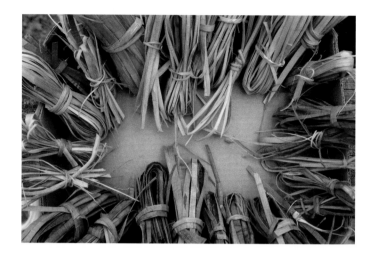

FIGURE 138: Stripped, separated, and wrapped cedar bark prepared for weaving

Connections to Tlingit Life and Land

The design fields of Chilkat robes incorporate the clan-owned crest symbols indicating the moiety and clan of the wearer. The patterns and motifs are in customary Tlingit forms and are fashioned from literal elements of the land—mountain goat wool, cedar bark, and vegetal dyes—reflecting the bounded space of the designer and weaver of the regalia. In most instances, the designer was male and the weaver was female, a characteristic of Chilkat creation that has only recently begun to shift.[15]

Chilkat warps (the strands hanging vertically) are a blend of cedar bark threads and wool. Cedar bark is harvested in the spring by pulling vertical strips from the base of a tree and working one's way up the trunk. If the tree is not being felled, no more than a third of its circumference is harvested. The removal of the strips will scar the tree, but it will continue to grow if the majority of the bark is left on the trunk. This ancient knowledge respects the right of the tree to continue living even while providing a vital resource to humans (fig. 137).

Preparing the stripped cedar bark is a multistep process. After separating the outer layer, the inner bark, or phloem, is immersed in boiling water for several days to remove the sap, leaving the cedar in long dry "threads" (fig. 138).[16] These are then spun with wool from either mountain goats or merino sheep: the spinning process encases the strong wooden

threads and creates a substantial base for the Chilkat weaving. Mountain goat wool was used prior to European contact. Acquiring it required cooperation between men and women: the hunters had to pack the goats back down the mountains, and the women had to skin and clean the wool before the meat and fat became rancid and stained it. Since the eighteenth century, merino wool has largely replaced mountain goat wool and is easier to obtain. However, the recent and relative ease of procuring merino wool does not take away from the immense labor of spinning the two materials together to form the sturdy warp threads that provide the foundation of Chilkat weaving (fig. 139).

Chilkat wefts (the yarn running left to right) are twined around the warp threads to create the border, the raised designs, and the background—all that is visible to the eye in a weaving. It has been estimated that one robe requires at least one thousand yards of warp thread, and it is difficult to determine the yardage required for the wefts of one such adult-size robe.[17] Chilkat and Ravenstail weaver Lily Hope (Tlingit, born 1980), eldest daughter of the Tlingit master weaver Clarissa Rizal (1956–2016), measures the amount of weft, or "weaver" yarn, in pounds:

> I estimate a Chilkat robe takes about four to five total pounds of weaver/weft yarns. I used a pound of yellow and nearly a pound of blue (more yellow, since the border and designs are yellow). I used at least one and a half pounds of

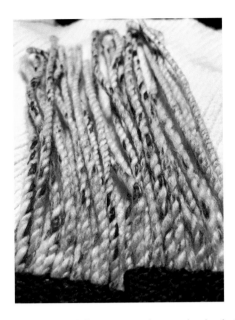

FIGURE 139: Chilkat warp spun from wool and cedar bark

black and likely half a pound of white. That's four pounds and my robe was only fifty-eight inches wide and twenty-eight inches woven down. A seventy-two-inch-wide robe will take at least five pounds of weft yarns to weave.[18]

Estimates vary, but Rizal reckoned the time needed to create a robe—approximately two thousand hours—can easily take a Chilkat weaver twelve to twenty-four months to complete.[19] When asked why she committed herself to such a huge effort, Rizal responded, "Every moment of gathering and preparing the materials, dyeing, drafting up the design, and then actually weaving, constitutes myriad good feelings, so good that I feed off of this type of 'nourishment' that feeds my mind, soul, spirit, and body. The spiritual practice and art of Chilkat weaving is some of the best medicine we have in the Northwest Coast."[20] The medicine Rizal spoke of was not only the satisfaction of completing a massive project that involves the investment of hundreds of hours of work but also the tangible connection to the land, flora and fauna, and traditions and spirit of our ancestors that the work engenders.

Bringing Back the Medicine

The exquisite art of Chilkat weaving was almost lost. When the master weaver Jennie Thlunaut (Tlingit, 1892–1986) died at the age of ninety-four, she was the last of the old weavers. She was from the village of Klukwan, a Tlingit community whose women learned Chilkat weaving from the Tsimshian people. Thlunaut had woven more than fifty Chilkat robes, numerous Chilkat tunics, and many smaller pieces. In the year she passed, she was the recipient of a National Heritage Fellowship awarded by the National Endowment for the Arts. Her granddaughters used the fellowship to hire Rizal to teach them how to weave Chilkat. By then Rizal had woven two smaller pieces and completed a six-week apprenticeship with Thlunaut, making her the only living Native person to have spent so much time studying with Thlunaut (fig. 140). From this invitation to teach Chilkat in 1989 until her own passing in 2016, Rizal dedicated her life as an artist to learning and was esteemed by dozens of weavers as an instructor of Tlingit cultural arts, particularly Chilkat and the related Ravenstail styles of weaving.[21]

Ravenstail—an even older Northwest Coast technique involving twining and surface braiding in bold patterns of predominantly black and white—was instrumentally revived by Cheryl Samuels (Adopted Tlingit, born 1944). The characteristic geometric designs woven in mountain goat wool onto wool warp were studied and re-created by Samuels, who then taught Teri Rofkar (1956–2016), a Tlingit weaver from Sitka, and other Native weavers in the late 1980s.[22] There have been several other influential weaving instructors of the Chilkat and Ravenstail styles, some Native and some non-Native.[23]

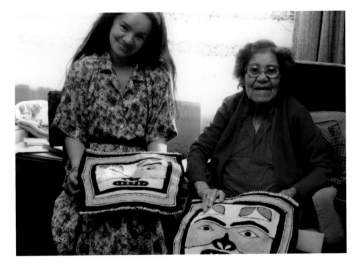

FIGURE 140: Clarissa Rizal and Jennie Thlunaut, 1986

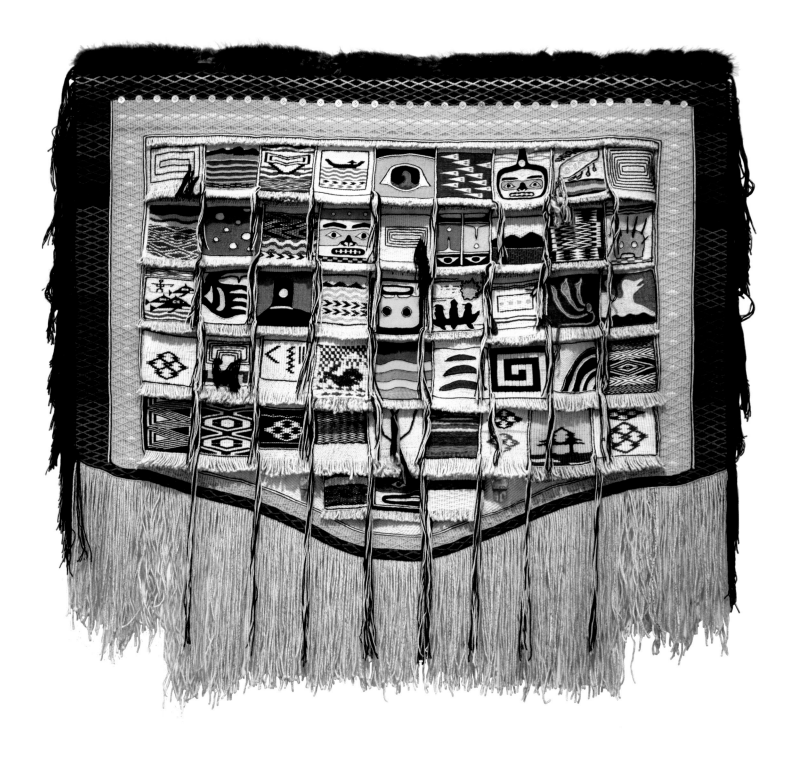

FIGURE 141: More than fifty Tlingit, Haida, Tsimshian, and non-Indigenous weavers, *Weavers Across the Waters*, 2016. Mountain goat wool, merino wool, cedar bark, sea otter fur. The robe is slated to live in the weaver's studio at the Evergreen State College Longhouse Education and Cultural Center, Olympia, Washington. Courtesy of Lily Hope and the Portland Art Museum, Oregon

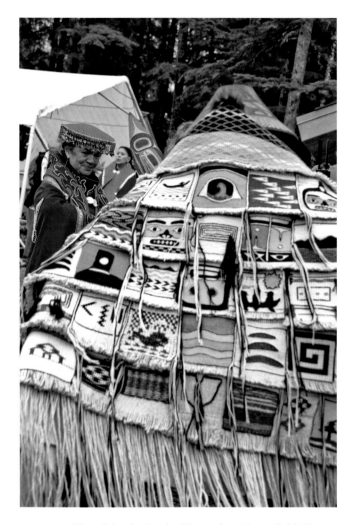

FIGURE 142: Wayne Price dancing the *Weavers* robe at Xunaa Shuká Hít (Huna Ancestor's House), Bartlett Cove, Alaska, with Clarissa Rizal at left, 2016. Photograph by Peter Metcalfe

FIGURE 143: Wayne Price with Karen Taug, Clarissa Rizal, and Marsha Hotch, 2016. Tang and Hotch were also weavers of the robe. Photograph by Peter Metcalfe

The use of Chilkat weavings during *ku.eex'* has remained steady, and the number of weavers learning both Ravenstail and Chilkat styles has grown in the past thirty years. The clearest example of this is the *Weavers Across the Waters* robe (figs. 141–143). In March 2016, as Rizal and the Tlingit weaver Suzi Vaara Williams were discussing traditional crocheted Euro-American "granny square quilts," they asked themselves if it might be possible to make a granny square Chilkat robe.[24] They sent out an online request and forty-seven weavers (including Williams) answered the call, each donating a woven square of his or her own design.[25] Rizal, her daughters, Lily Hope and Ursala Hudson (born 1988), and Teahonna James (Yanyeidí/Dena'ina/Tlingit, born 1988) wove the border in a pattern inspired by James's woven square used for the clasp.

Weavers Across the Waters was a collaborative robe, created with the intention of serving the Native community.[26] Rizal and Williams noted that the robe was to be worn by the high-ranking hosts during the maiden voyages of traditional dugout canoes or at Canoe Journey gatherings.[27] The squares were required to be as follows: woven on Chilkat warp (mixed with cedar); five-by-five inches and woven by a Native or someone formally adopted into a Native clan. Finally, they had to be designed to reflect the canoe world with "symbols of nature, animals, mankind— i.e., mountains, ocean, rivers, lakes, canoes, paddles, faces, claws," all intended to show reverence for the land, water, and animals of the bounded space in the birthplace of Chilkat.[28]

The robe was nearly complete when the Tlingit master carver Wayne Price first danced it to life in August 2016 (see figs. 142, 143). He wore it at the opening ceremony dedicating Xunaa Shuká Hít, the Huna Ancestor's House in Bartlett Cove in Alaska's Glacier Bay, thus fulfilling the ceremonial intention for the robe and Rizal's promise to Thlunaut that she would teach others how to weave. When not on display in a traveling exhibition, the robe will remain in the care of Evergreen State College's Longhouse as a centerpiece of their recently completed fiber arts studio.

Both master weavers Clarissa Rizal and Teri Rofkar passed away in the winter of 2016, and it is to them that I dedicate this essay. Their artistic legacies live on through their children and students, ensuring that the incomparable art of Chilkat and Ravenstail wool weaving will continue. The Chilkat robes of past, present, and future embody the bounded space of the Northwest Coast by uniting plants, animals, and human animals in a robust and resilient tapestry that reflects the immediate connection to, and immense wealth of, the land.

Notes

EPIGRAPH: Clarissa Rizal, artist statement, http://clarissarizal.com/about/artist-statement/. (Note: Clarissa Rizal was formerly Clarissa Hudson.)

EPIGRAPH: Teri Rofkar, lecture, Peabody Essex Museum, Salem, MA, December 2003.

1 Katie Pasco, "The Critical Chilkat: Understanding and Appreciating Chilkat Weaving," *American Indian Art Magazine* 1, no. 3 (Summer 1994): 67.

2 Kathleen Dean Moore et al., eds., *How It Is: The Native American Philosophy of V. F. Cordova* (Tucson: University of Arizona Press, 2007), 186.

3 Indigenous Knowledge has been and is continuously discredited as unscientific by Western scholars and has experienced disruption in the form of state-sponsored violence, federal bans on ceremonies, and assimilation-driven policies to remove children from their families and homelands and place them in hostile boarding schools. Despite the historical and present-day traumas suffered by Native peoples, many of us persist in our individual and communal responsibilities to maintain and cultivate Indigenous Knowledge.

4 The date of first contact with European explorers varies widely, from Leif Erickson in ca. 1000, near Newfoundland/Gulf of St. Lawrence; to Cristoforo Columbo in 1492 in the Caribbean; to the Spaniards in the 1520s in what is now the southwestern United States; and to Alaska in the mid-1700s.

5 Philip J. Deloria, *Indians in Unexpected Places* (Lawrence: University Press of Kansas, 2004); see especially Deloria's chapter on confinement.

6 Moore et al., *How It Is*, 188.

7 For an in-depth look at the culture, clans, language, and history of Tlingit people, see Nora Marks Dauenhauer and Richard Dauenhauer, eds., *Haa Kusteeyí, Our Culture: Tlingit Life Stories* (Seattle: University of Washington Press; Juneau: Sealaska Heritage Foundation, 1994), 6–14.

8 In some Tlingit communities, the moieties are Raven/Wolf instead of Raven/Eagle.

9 Tlingit elders have cautioned against using the term "potlatch" for the ceremonial gathering to mark the end of a mourning period by a clan or family. I use it here knowing the term is contested.

10 Nora Marks Dauenhauer and Richard Dauenhauer, eds., *Haa Tuwunáagu Yís, for Healing Our Spirit: Tlingit Oratory* (Seattle: University of Washington Press, 1990), 12–24. *At.óow* literally translates into "our belongings" and encompasses both tangible and intangible property of each moiety and subclan of the Tlingit community.

11 Peter L. Macnair and Jay Stewart, object entry for Chilkat Blanket, in *Uncommon Legacies: Native American Art from the Peabody Essex Museum,* ed. John R. Grimes, Christian Feest, and Mary Lou Curran (Seattle: University of Washington Press; New York: American Federation of Arts, 2002), 162; Macnair and Stewart cite the scholar of Northwest Coast art Bill Holm in the *Handbook of North American Indians*, vol. 7, *Northwest Coast* (Washington, DC: Smithsonian Institution, 1990), 627.

12 Grimes, Feest, and Curran, *Uncommon Legacies,* 162. See Bill Holm, *Northwest Coast Indian Art: An Analysis of Form, 50th Anniversary Edition* (Seattle: Bill Holm Center for the Study of Northwest Coast Art, Burke Museum, in association with University of Washington Press, 2015) for a detailed description and analysis of Northwest Coast design elements.

13 European and American modernist artists from Pablo Picasso to Jackson Pollock were fascinated by such Indigenous punning and ambiguity; see, for example, W. Jackson Rushing, *Native American Art and the New York Avant-Garde* (Austin: University of Texas Press, 1995).

14 Mary Malloy, "Souvenirs of the Fur Trade, 1799–1832: The Northwest Coast Indian Collection of the Salem East India Marine Society," *American Indian Art Magazine* 11, no. 4 (Autumn 1986): 35.

15 Evelyn Vanderhoop, Haida artist, conversation with author, February 2005.

16 Shadootlaa Tinaa Yeil Guwakaan, email message to author, April 21, 2015.

17 Clarissa Rizal, interview by author, September 23, 2016.

18 Lily Hope, email message to author, November 20, 2017. The robe she refers to is titled *Honoring Our Teachers/Lineage*, commissioned for the permanent collection of the Portland Art Museum, Oregon.

19 Clarissa Rizal, artist statement, http://clarissarizal.com/about /artist-statement/; Pasco, "Critical Chilkat," 64.

20 Rizal, interview by author, September 23, 2016.

21 When Pasco analyzed the details and the complexity of the Chilkat method of weaving in 1994, her primary audience was art dealers and private collectors. She could not have foreseen the incredible revival of Chilkat weaving that was to come. Its revitalization as an art practice for cultural uses did not occur to her; hence, she continued to use the past tense in describing Chilkat weavers, techniques, and indicators of quality.

22 Teri Rofkar, artist-in-residence presentation, Peabody Essex Museum, Salem, MA, 2003.

23 Della Cheney (Tlingit/Haida), Lily Hope, Marsha Hotch (Tlingit, born 1953), Shgen George (Tlingit), Meghann O'Brien (Kwakwaka'wakw/Haida, born 1983), Kay Field Parker (Non-Native), Teri Rofkar, Cheryl Samuels, Ricky Tagaban (Tlingit, born 1990), Evelyn Vanderhoop (Haida, born 1953), and William White (Tsimshian, born 1960) are all well-known Chilkat and Ravenstail instructors.

24 See Clarissa Rizal's website, www.clarissarizal.com.

25 The forty-seven weavers who wove squares are Vanessa Ægirsdóttir, Rebecca Allen, Stephany Anderson, Davina Barrill, John Beard, Georgia Bennett, Della Cheney, Mary Elizabeth Ebona, Chloe French, Sandy Gagnon, Dolly Garza, Gabrielle George, Shgen George, Douglas Gray (two squares), Michelle Gray, Annemarie Hasskamp, Lily Hope, Marsha Hotch, Ursala Hudson (two squares), Pearl Innes, Sally Ishikawa, Teahonna James, Courtney Jensen, Koosnei Rainy Kasko, Sara Kinjo-Hisher, Edna Lamebull, Deanna Lampe, Irene J. Lampe, Alfreda Lang, Joyce Makua, Peter Thomas McKay, Catrina Mitchell, Crystal Nelson, Debra O'Gara, Kay Parker, Marilee Peterson, Mila Rinehart, Annie Ross, Veronica Ryan, Darlene See, Vicki Soboleff, Ricky Tagaban, Karen Taug, Yarrow Vaara, William White, Suzi Vaara Williams, and Margaret Woods.

26 For the online invitation to weavers, see http://www.clarissarizal .com/blog/calling-all-chilkat-and-ravenstail-weavers/.

27 Tribal Journey, or Canoe Journey, is an annual event that began in 1989 and usually is held in Washington State or British Columbia. Tribal families travel by canoe to a rotating, designated destination with a coordinated landing date. After the final landing, the canoe families, their support crews, and the host community take part in a weeklong celebration of the songs and dances of each community. A similar event was started in southeast Alaska to coincide with the biannual event Celebration, hosted by the Sealaska Heritage Institute in Juneau every even-numbered year. The Canoe Journey for Celebration 2016 included canoes traveling from the Tlingit villages of Yakutat, Hoonah, Kake, and Angoon.

28 Instead of accurate representations of the human hand with four fingers and a thumb, weavers were instructed to weave only three fingers and a thumb, as per Jennie Thlunaut's strict instructions to Rizal during her first weaving class with Thlunaut in 1985; http://clarissarizal.com /tributes/clarissas-chilkat-weaving-apprenticeship-with-jennie-thlunaut/.

Alan C. Braddock and Karl Kusserow

An Interview with Mark Dion

FIGURE 144
Mark Dion
(American, born 1961)
Scala Naturae, 1993
Photostat on paper
83.8 × 62.2 cm
Tanya Bonakdar Gallery,
New York and Los Angeles

FIGURE 145
Mark Dion
Scala Naturae, 1993
Stepped plinth, artifacts, specimens,
taxidermic animals, bust
238 × 100 × 297 cm
Private collection

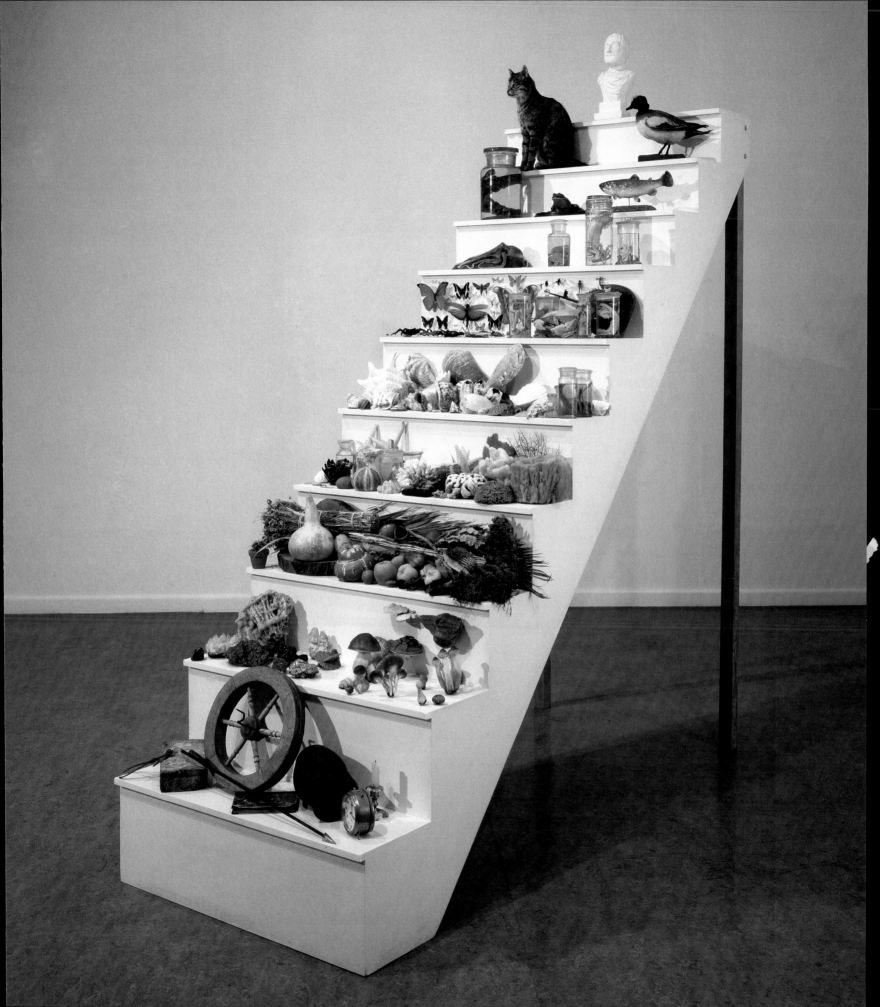

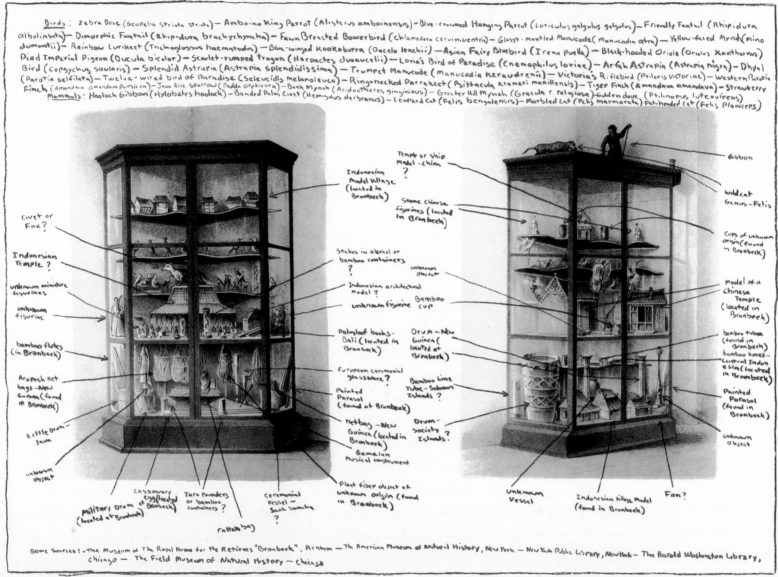

FIGURE 146

Mark Dion

Project for the Royal Home for the Retirees—"Bronbeek," 1993

Screenprint

50 × 65 cm

Van Abbemuseum, Eindhoven, Netherlands (inv. 2075)

ALAN C. BRADDOCK & KARL KUSSEROW Could you tell us about your works titled *Scala Naturae* (figs. 144, 145)? The title and composition bring to mind the ancient idea of the Great Chain of Being, which envisioned nature as a hierarchically ordered scale or stairway of species (see fig. 16). You have written, "The Great Chain of Being and the early taxonomic arrangements and nomenclature firmly set humankind on the throne of the animal kingdom. This powerful idea demands particular scrutiny since the chain of being is a crucial conceptual footprint, which helps to retrace the path of where we have been in order to get a better bearing on where we are and where we are going."[1] Could you expand on the significance of this historical idea for you as a contemporary artist and how your work engages with it? Has its meaning for you evolved in light of recent developments in science related to human biology, species extinction, or other new information?

MARK DION Well, I hope to be clear that my relation to the *scala naturae* or Great Chain of Being is a critical one, which I deal with in a form of comic scorn. The Great Chain of Being is a conceptual tool created by and reflecting a rigidly hierarchical society—a society of slaves and masters. For me, as someone who studies taxonomies and systems of classification, the first thing that becomes apparent is that those who draft the ranking place themselves firmly atop it. The classical *scala naturae* is a pernicious idea with legs. It dominated the European intellectual culture of nature for centuries, and even after it was replaced, it remained a salient visual metaphor. It is a model created by the powerful to make structures of domination appear natural and in union with the will of God. Much of my practice as an artist is to explore touchstones on the pathway of Western thinking about nature. I want to trace how we have evolved our suicidal relation to the natural world, and the Great Chain of Being is one of the most essential and destructive ideas along that path.

I first came across the notion of the Great Chain of Being in the mid-1980s through the writings of Stephen Jay Gould (who also introduced me to Baron Georges Cuvier, Alfred Russel Wallace, and many figures in the history of science I later produced work about). This led me to Arthur Lovejoy's work on the history of the idea.[2] At the time (and still), I was extremely interested in artificial schemes overlaid upon the natural world to create cosmological representations. Other graphic works of mine, such as *Nos Sciences Naturelles* (1992) and *Project for the Royal Home for the Retirees—"Bronbeek"*

(fig. 146), are in this family. The photographs, graphic works, and sculptures I have produced regarding the *scala naturae* are highly ironic and are intended to ridicule how such a notion falls remarkably short of accounting for the vast complexity of the biodiversity on Earth. They are also attempts at lampooning the notion of hierarchy and human-centric thinking in the ordering of life on Earth. I emerge from a pretty punk sensibility in which irony is political, and I have a high degree of respect for the intelligence of my audience and expect that they comprehend the irony in such works. I find these representations comic and scaldingly critical, but recently, I have wondered if a less sophisticated audience might read these works as endorsements.

As you know, scientists today have arrived at a consensus about global warming as a human-caused phenomenon. They also increasingly agree that our species has created a new geological epoch—the Anthropocene—marked by unprecedented human transformation of the planet and anthropogenic biodiversity loss, known as the Sixth Extinction. All of this suggests that our understanding of history has reached a crossroads, where human history and natural history can no longer be separated (if they ever were) and where unintended consequences of human activity over centuries are becoming visible. As an ecologically informed artist who has richly explored the cultural legacy of past scientific paradigms and practices, how do you think about history these days?

The Anthropocene is becoming the new paradigm for organizing thought about the natural world. I often think through the history of dominant ideas about the structure of nature as communicated through collections and displays. The earliest collections are attempts to demonstrate a cosmological order based on the mystery of a divine creator, so wonder and curiosity dominate these idiosyncratic collections. The early Enlightenment collections are motivated by the new tools of systematics and Linnaean taxonomy, but also reflect colonial extraction and domination in a programmatic manner. As evolutionary thinking begins to dominate the life science field, museums become more organized by biogeography, habitat, and other principles that support the idea of natural selection. Ecology is next to dominate our systems of organization, followed closely by environmentalism. Now we are transitioning into the Anthropocene as a salient rubric

for describing our world. I feel that the tendency has been moving toward complex progressive models based on real science, which I find heartening. There have of course been numerous instances in this progression of ideas where pseudoscience, ideology, and the will of conservative powerful elites have set things back (I am thinking of how eugenics and other pseudoscience hijacked evolutionary ideas); however, I feel certain that developments in the natural sciences, including the concept of the Anthropocene, are allowing for better understanding of the connectedness of things.

Our next question is inspired by the biographical statement on your gallery's website, which reads: "Since the early 1990s, Mark Dion has examined the ways in which dominant ideologies and public institutions shape our understanding of history, knowledge, and the natural world. Appropriating archaeological and other scientific methods of collecting, ordering, and exhibiting objects, the artist creates works that address distinctions between objective scientific methods and subjective influences. By locating the roots of environmental politics and public policy in the construction of knowledge about nature, Dion questions the authoritative role of the scientific voice in contemporary society." As curators of the *Nature's Nation* exhibition, we admire and agree with the perspective articulated here, especially the acknowledgment of politics, ideology, and knowledge construction as powerful forces shaping "our understanding of . . . the natural world." Could you discuss particular environmental politics or public policies that you see as being rooted in social constructions of nature? Also, given the scale of human impact in what many scientists now call the Anthropocene, is there still a distinct "natural world"? If so—or if not—how does your work negotiate the meaning of "natural"?

I have had to make changes to that statement recently, because of the part about questioning the authoritative role of the scientific voice. Some people have interpreted this as a disbelief in science, which is not my perspective at all. So the new version states: "By locating the roots of environmental politics and public policy in the construction of knowledge about nature, Mark Dion questions the objectivity and authoritative role of the scientific voice in contemporary society, tracking how pseudo-science, social agendas, and ideology creep into public discourse and knowledge production."[3]

If we are looking for a particular case study of how public policies and environmental politics shape scientific disciplines, we can of course look into how geology is taught and exhibited for public education in various museums and universities with relation to the petroleum and other extraction industries. The influence of large-scale extraction corporations on natural history museum display and university departments is substantial and demonstrable through the funding of exhibition halls and academic facilities and positions.

I think it is clear that it is impossible to conceive of a purely natural realm, outside of human influence. The global scale of climate change makes that crystal clear, but humans have been shaping ecologies for millennia. However, to speak thus can also encourage the "it's all nature" sentiment that is used to justify environmental degradation, neocolonial extraction, and species extinction. There is a truly disingenuous sentiment that argues that since we are part of nature, our actions are natural and therefore part of a natural process. This is used to excuse all sorts of mischief.

I am always astounded that "nature" as such a fundamental thing has so few terms of social agreement and therefore remains such an untethered concept. As someone who travels extensively and works with other artists, environmentalists, and scientists, I have to marvel at the protean aspect of this essential term. What do we mean when we use the word "nature"? Even when I speak with artists who work in a similar vein in Berlin, Bogotá, or Cape Town, at a point in our conversation it becomes quite clear that we do not mean the same thing when we use the term.

How can art—as against other forms of sociocultural expression—have agency in addressing these matters? How is art positioned differently from scientific or political discourse to communicate these environmental concerns?

When I think of my fellow artists working in this shared terrain (David Brooks, Mierle Laderman Ukeles, Brandon Ballengée, Pam Longobardi, Tue Greenfort, Bob Braine, Catherine Chalmers, Henrik Håkansson, Alexis Rockman, Andrew Yang, Mel Chin, Walton Ford, Rachel Berwick, Dana Sherwood, Natalie Jeremijenko), they exhibit a variety of strategies and methodologies to engage ecological issues. Some of the artists are activists, some are scientists, some work more like social historians or engage the

specific visual culture of natural history, but they are all artists who speak with a complexity, passion, and humor that would be difficult to articulate with science or conventional didactic politics. Art is a powerful tool of thought because it makes use of hybrid discursive strategies. It can express complicated feelings of ambivalence, contradiction, mourning, uncertainty, bemusement, melancholy. It also can deploy humor, irony, metaphor, wonder, beauty, and a variety of other expressive forms alien to science and many forms of political debate.

For more than a quarter century you've produced work critiquing the cultural construction of nature. Over that time, what has changed (externally and in your artistic practice)? What has stayed the same? Can you comment on the (changing) relationship in your work between "green" art and institutional critique?

External to my work, on virtually every front I have engaged, things have become dramatically worse. The situation of tropical forests, coral reefs, forests, endangered species, pernicious invasive species, Arctic ecology, fisheries, and pollution has turned from bad to cataclysmic. For my own thinking and practice, this has resulted in a turn to pessimism and melancholy.

Perhaps within institutions there is a silver lining. The fields of postcolonial studies, museum and critical studies, environmental and animal studies have developed and grown in complexity and popularity over the same period. While some art museums have kept pace with the expansive cultural discourse about other issues, they have remained largely indifferent to the discourse of ecology. Natural history museums have not exactly been champions of a progressive environmental agenda. Fortunately, activist groups such as Beka Economopoulos and Jason Jones's the Natural History Museum and others are now forcing them into the politics of our time through direct action.

We know that you have commented publicly on the ethical responsibility of artists to avoid killing animals or causing them to suffer. At the same time, there seems to be an interesting contradiction—or at least a tension—in your practice of collecting and display, whereby you remove animals and other

"natural" things from their environments, their particular ecological relationships, and thereby change them irrevocably through art. Can you comment on this process of transformation in your work and the dynamic systems you study?

While I certainly try to eliminate animal suffering as much as possible, I use dead animals in my work often and have certainly killed my fair share of them, particularly invertebrates. Animals die each minute of every day for things less important than art making. Still, I am very careful about animal protection and welfare rules and I try to be ethical in my acquiring of animal bodies. For example, I would not buy coral or shells from a professional dealer, but rather I collect them myself or pick them up in yard sales, or for coral I use resin reproductions. I try to employ taxidermists who work with roadkill, rather than hunting wild animals. To many of my post-humanist peers, my practice is unacceptable and entirely reprehensible.

Of course my work is extremely focused on the inherent violence at the foundation of Western scientific inquiry. This seems to me a cornerstone of the Western tradition and something that perhaps separates it from other cultures of nature—the notion of collecting, killing, dissecting, preserving as foundational to knowledge is one of our greatest contradictions (fig. 147). I work beside conservation biologists who love their subjects (fishes, birds, etc.), and although it gives them no joy, they have no hesitation in killing them in vast numbers for their research. The civilization of death and violence that is "natural history," and perhaps the culture of collection in general, is one of my consistent lines of inquiry. This is a topic also closely examined in *Anatomy Theater*, the opera David Lang and I produced, which deals with the history of human dissection (fig. 148). The opera takes the form of a confession before a public hanging and anatomy demonstration. Four characters fight over the meaning of the corpse from their different perspectives, in a work that broadly explores misogyny in the foundations of Western professional medicine.

Now for a self-critical question that invites you to interrogate our exhibition. As an artist who has creatively examined museums as sites of display and knowledge construction, do you feel such an exhibition project has value or does it risk oversimplifying environmental history? As curators, we

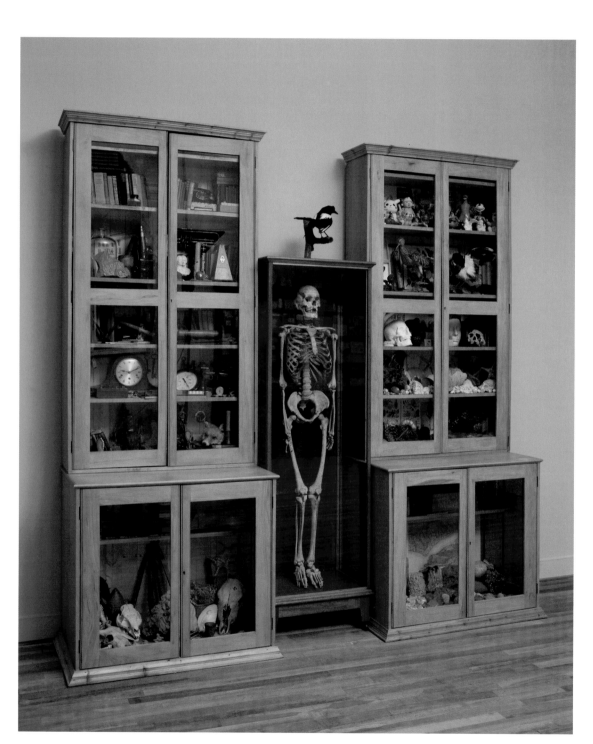

FIGURE 147
Mark Dion and Robert Williams
(British, born 1960)
Theatrum mundi: Armarium, 2001
Wooden cabinet, mixed media
281 × 280.5 × 63 cm
Installation view, *The Macabre
Treasury*, Museum Het Domein,
Sittard, Netherlands, 2013

FIGURE 148
Anatomy Theater, 2016
Music by David Lang
(American, born 1957)
Libretto by Mark Dion
and David Lang
Set design and production by
Mark Dion and Ridge Theater
LA Opera performance,
REDCAT, Los Angeles

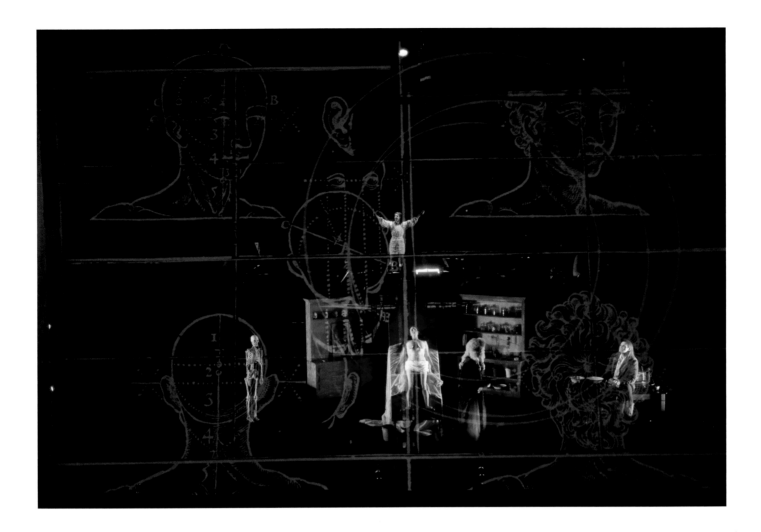

have tried to be sensitive to the sorts of political and episte-mological issues raised by your work, but we wonder if you detect pitfalls in our approach. How might we best shape understanding and construct knowledge in the context of an exhibition? Have you formed any general conclusions or opinions about the strengths and weaknesses of art muse-ums in publicly addressing environmental concerns?

Far from being critical with regard to your project, I applaud the energy, focus, and effort. There are so few arenas to have this essential discussion about how artists respond to chang-ing landscapes. My deepest critique is that this endeavor has not been attempted often enough. In my thirty years of being an artist focused on the visual and material history of natural history, I can count on one hand, with fingers to spare, the exhibitions that attempted to grapple with some of the

concepts you are investigating. Of course, this is a topic of extraordinary complexity and depth, but the conversation must begin somewhere. No one exhibition can encompass all the positions and nuances in how artists have thought about the environment, but it is my hope that the rigorous intellec-tual approach that your project embodies will inspire others. I would like *Nature's Nation* to be contagious.

Notes

1 Untitled artist's statement in Kynaston McShine, ed., *The Museum as Muse: Artists Reflect* (New York: Museum of Modern Art, 1999), 98.

2 Arthur O. Lovejoy, *The Great Chain of Being; A Study of the History of an Idea. The William James Lectures Delivered at Harvard University, 1933* (Cambridge, MA: University of Harvard Press, 1936).

3 Artist's biography, http://www.tanyabonakdargallery.com/artists /mark-dion/modal/bio.

Industrialization and Conservation

Alan C. Braddock

"Man and Nature": Visualizing Human Impacts

In an influential 1863 essay, the French poet and art critic Charles Baudelaire (1821–1867) observed that "modernity" was fundamentally defined by change. Therefore, he believed, painters should capture "the ephemeral, the fugitive, the contingent" in art as a way of expressing the "present-day beauty" of "their own period." Writing amid the physical and social upheavals of Second Empire France, including Baron Georges-Eugène Haussmann's colossal urban renewal project in Paris, Baudelaire viewed the modern artist as a *flâneur* wandering the city's grand new boulevards, bars, and public parks in search of evanescent fashions, energies, sounds, and movements that characterized the era. For Baudelaire, transience and transformation made modernity an aesthetic spectacle, affording opportunities to revitalize painting with innovative forms and subjects. Repudiating ethics, Baudelaire declared, "Nature teaches us nothing, or practically nothing," so modern art must control and transcend "her." Haunted by memories of the French Revolution and the Reign of Terror, Baudelaire condemned "Mother Nature who has created patricide and cannibalism, and a thousand other abominations that both shame and modesty prevent us from naming." Praising art and cosmetics as "beautiful and noble" forms of "artificial, supernatural" human "reason and calculation," Baudelaire celebrated their "sublime deformation of Nature, or rather a permanent and repeated attempt at her *reformation*." Such thinking expressed dominant aims of the European avant-garde, a movement dedicated to humanistic change-as-progress in modern art's break from the ancient traditions of classicism. Baudelaire's thinking influenced aesthetic theory and criticism for generations and still frames interpretations of modernism in the discipline of art history today.[1]

Writing in Italy during the same year, the American diplomat, art collector, and historian George Perkins Marsh (1801–1882) also recognized change as a defining characteristic of modernity, but he viewed the matter very differently. Marsh had a global, interdisciplinary outlook informed by environmental history, ethics, and art. In the preface to his book *Man and Nature; or, Physical Geography as Modified by Human Action* (1864), a landmark in early ecological writing, Marsh stated his purpose:

> The object of the present volume is: to indicate the character and, approximately, the extent of the changes produced by human action in the physical conditions of the globe we inhabit; to point out the dangers of imprudence and the necessity of caution in all operations which, on a large scale, interfere with the spontaneous arrangements of the organic or the inorganic world; to suggest the possibility and the importance of the restoration of disturbed harmonies and the material improvement of waste and exhausted regions.[2]

Examining complex environmental relationships over time, Marsh expressed concern about the implications of humanity's "modern ambition" to conquer "physical nature" and the projects "which quite eclipse the boldest enterprises hitherto undertaken for the modification of geographical surface." He also forcefully critiqued myths about the abundance and inexhaustibility of the earth as a natural resource—myths whose unraveling we began to observe in the previous essays in this volume. Broadly speaking, Marsh shared Baudelaire's anticlassicism, but whereas the Frenchman blithely glorified change and "sublime deformation of Nature" as aesthetic opportunities, Marsh saw a disturbing trend toward planetary

depletion and destruction wrought by humankind. In his view, damage caused by imprudent human activity demanded creative engagement and "restoration." Raised in rural New England, Marsh noticed the negative effects of deforestation—erosion, topsoil loss, river silting, fishery decline—near his home in Woodstock, Vermont (now a national historical park). As an art collector, Marsh had a taste for Old Master engravings that was fairly conventional, but he acquired many works depicting decrepit beggars, suggesting personal sensitivity to loss, poverty, and degradation. In financial straits after business failures, he sold his collection to the Smithsonian in 1849—the institution's inaugural acquisition.[3]

The divergent perspectives of Baudelaire and Marsh circa 1863 delineate key vectors of thought separating art history from ecology and environmental history until very recently. As a prominent poet and critic uninterested in ecology or ethics, Baudelaire epitomized the insular anthropocentrism of modernist aesthetics in its most humanistic form. By comparison, Marsh the worldly expatriate freely traversed multiple disciplines, geographies, and domains of knowledge. Explicitly challenging received wisdom, he explained how real forests, animal species, and other vital entities in effect were passing out of existence. To use Baudelaire's words, Marsh revealed that they were "ephemeral," "fugitive," and "contingent" as a result of human activity. As Marsh wrote in an 1860 letter to Spencer Fullerton Baird at the Smithsonian, whereas some "think that the earth made man, man in fact made the earth."[4]

Man and Nature confirmed that assertion by tracing patterns of human-caused transformation since the Roman Empire. According to Marsh, ancient Rome enjoyed "natural advantages" only to squander them, leaving its "fairest and fruitfulest provinces [in North Africa, the Middle East, and southern Italy] ... completely exhausted" and "so diminished in productiveness as ... to be no longer capable of affording sustenance." Through his wide-ranging travels and historical research, Marsh discovered unsettling planetary evidence of human "modification" from antiquity to the present. Describing the modern fur trade, he offered an acute ecological analysis of Baudelaire's domain, observing that "the convenience or the caprice of Parisian fashion has unconsciously exercised an influence which may sensibly affect the physical geography of a distant continent." Marsh called for not only the "restoration of disturbed harmonies" but also a well-cultivated "art" of "seeing" to aid "the study of

nature," an idea surely fostered by his collecting and connoisseurship. Although art historians followed Baudelaire and his brand of disciplinary self-enclosure for more than a century, the Anthropocene—our new geological epoch of human making—increasingly reveals the relevance of Marsh's global, historical, and ethical perspective.[5]

Published just before the Prussian naturalist Ernst Haeckel introduced the term "ecology," Marsh's *Man and Nature* already intuitively articulated the concept in statements such as this:

> The organic and inorganic world are ... bound together by such mutual relations and adaptations as secure, if not the absolute permanence and equilibrium of both, a long continuance of the established conditions of each at any given time and place, or at least, a very slow and gradual succession of changes in those conditions. But man is everywhere a disturbing agent.[6]

Marsh knew his transnational critique of human planetary impact was innovative. He distinguished his approach from that of earlier geographers, including Alexander von Humboldt (1769–1859), whose "attractive study" had revealed "how far external physical conditions, and especially the configuration of the earth's surface, and the distribution, outline, and relative position of land and water, have influenced the social life and social progress of man." But while Humboldt and others offered important insights, Marsh believed they failed to account for the magnitude of *human impact*, how "man has ... modified, if not determined, the material structure of his earthly home."[7]

Marsh furthermore rejected the idealism of Humboldt and other Romantic scientists who believed in the inevitability of human progress. A modern realist, Marsh viewed nothing as given, foreordained, or absolute, including human agency. "In reclaiming and reoccupying lands laid waste by human improvidence or malice," he said, "... the task of the pioneer ... is to become a co-worker with nature in the reconstruction of the damaged fabric which the negligence or the wantonness of former lodgers has rendered untenantable." By describing humanity as "a co-worker with nature," Marsh challenged anthropocentrism even as he placed responsibility directly on humankind for the earth's increasingly "damaged fabric." He thus broached the idea of symbiotic coevolution, linking humans and nonhumans. This

still-current idea, antithetical to Baudelaire's view, drew inspiration from Charles Darwin's *On the Origin of Species* (1859) and other revisionist scientific texts, many of which Marsh read.[8]

With uncanny foresight, *Man and Nature* addressed a list of concerns that reads like a twenty-first-century environmental report: climate change, deforestation, flooding, mudslides, industrial water pollution, desertification, lost soil fertility and animal habitat, overfishing, species extinction, invasive versus native plants, renewable energy, and more. Anticipating recent discourse about environmental justice, Marsh scathingly critiqued inequality and empire, including the "brutal and exhausting despotism which Rome herself exercised over her conquered kingdoms, and even over her Italian territory." He also condemned medieval feudalism in Europe, saying, "Man cannot struggle at once against crushing oppression and the destructive forces of inorganic nature." Attentive to historical complexity, Marsh asked, "Who can wonder at the hostility of the French plebeian classes toward the aristocracy in the days of the Revolution?," while acknowledging that the revolution unleashed "destructive causes," including a "general crusade against the forests … to be ascribed, in a considerable degree, to political resentments."[9]

Marsh particularly scorned "joint-stock companies," for they "have no souls; their managers, in general, no consciences"—an opinion he formed as a railroad commissioner in Vermont during the 1850s. Fulminating at "the rottenness of private corporations," he declared them "most dangerous enemies to rational liberty, to the moral interests of the commonwealth, to the purity of legislation and of judicial action"—critiques of unregulated capitalism that resonate today. Invoking the earth-as-house metaphor at the root of "ecology" (from the Greek *oikos* for home or household), Marsh observed that "we are, even now, breaking up the floor and wainscoting and doors and window frames of our dwelling, for fuel to warm our bodies and seethe our pottage, and the world cannot afford to wait till the slow and sure progress of exact science has taught it a better economy." He went so far as to challenge Western standards of scientific objectivity by privately expressing an unorthodox animism, writing in 1871 to the eminent American scholar Charles Eliot Norton, "The bubbling brook, the trees, the flowers, the wild animals were to me persons, not things." Like most nineteenth-century white people (including

Baudelaire), Marsh occasionally used stereotypical language about "ruder races" and "persons with imperfectly developed intellects in civilized life," but he also recognized that "they nevertheless seem to cherish with brutes, and even with vegetable life, sympathies which are much more feebly felt by civilized men." In other words, for Marsh "civilized men" had no monopoly on environmental insight. Unlike most Americans, he doubted optimistic claims about improvement and progress, explaining his motivation for writing *Man and Nature* by saying he wanted to reveal "the evils resulting from too extensive clearing and cultivation, and other so-called improvements."[10]

As a collector of Old Master prints, Marsh left no criticism of nineteenth-century art. What would he have thought about a painting such as *American Progress* (fig. 149) by John Gast (1842–1896)? This triumphant vision of continental conquest shows various modern forces—railroads, steamships, miners, farmers—presided over by an airborne allegorical figure stringing telegraph wires across an expanse so great we even detect Earth's curvature at the horizon, revealing a burgeoning geodetic awareness of world-systems. The vastness of Gast's view broadly echoed Marsh's global perspective, but its politics did not. As an imperial celebration of Manifest Destiny and "improvement" at the expense of Native Americans, buffalo, and the land, *American Progress* diametrically opposed the historian's ecological ethics. More congenial to the tastes of Marsh, perhaps, would have been Sanford Robinson Gifford's *Hunter Mountain, Twilight*, representing a landscape in the Catskill region of upstate New York (fig. 150). In this melancholy scene of deforestation, Gifford (1823–1880) presented a hillside once populated by hemlock trees but now denuded by clear-cutting. The remaining stumps metaphorically conjure human lives truncated by America's recent Civil War even as they embody the ongoing impacts of modern industry, since hemlocks provided tannin essential to the region's many leather tanneries. Upon its completion in 1866, *Hunter Mountain, Twilight* was immediately purchased by the painter's friend and patron James Pinchot, a wealthy New York merchant, philanthropist, and art collector. Pinchot would later draw inspiration from Marsh's writings in founding the Yale School of Forestry and in reforesting the land around his rural Pennsylvania mansion, Grey Towers. In a remarkable historical turnabout, Pinchot's son Gifford—named in honor of the artist—became the first chief of the US Forest Service in 1905.[11]

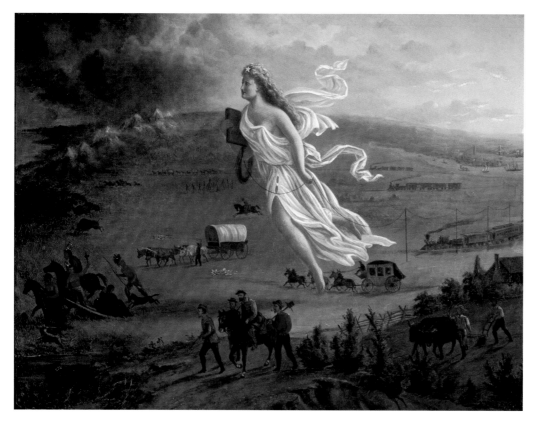

FIGURE 149: John Gast (American, born Germany, 1842–1896), *American Progress*, 1872. Oil on canvas, 29.2 × 40 cm. Autry Museum, Los Angeles. Museum purchase (92.126.1)

Many writers have cited Marsh as an important forerunner of modern environmentalism and ecological thought. In *The Brown Decades: A Study of the Arts in America, 1865–1895* (1931), Lewis Mumford called *Man and Nature* "the fountainhead of the conservation movement." In 1955 Mumford honored Marsh by organizing a major symposium at Princeton University on "Man's Role in Changing the Face of the Earth" attended by dozens of international ecologists. Marking the centennial of *Man and Nature* in 1965, David Lowenthal identified it as "the first book to controvert the myth of superabundance and to spell out the need for reform." A 2011 study by several scientists, including Nobel Prize winner Paul Crutzen, acknowledged Marsh's *Man and Nature* as a conceptual antecedent for understanding the Anthropocene.[12]

In light of Marsh's prophetic, wide-ranging approach to environmental history, the time has come to recognize his importance in laying the foundations for an ecocritical history of American art. This may surprise readers expecting homages to more familiar literary ancestors—such as Ralph Waldo Emerson, Henry David Thoreau, or John Muir—but Marsh exhibited greater interdisciplinary range, historical research, artistic awareness, and ethical insight. He therefore provides a more useful touchstone for the present section, which adapts the title of Marsh's landmark book. The art discussed in the following pages variously registered mounting evidence of what he called "physical geography... modified by human action" in the late nineteenth century, amid accelerating industrial growth and emerging conservationist awareness of changing environmental conditions.

The Global Civil War

No event of the nineteenth century did more—so quickly—to modify physical and social geography in the United States than the American Civil War (1861–65). This conflict between pro-Union states and the secessionist Confederacy ended legal slavery but also destroyed much life, land, and

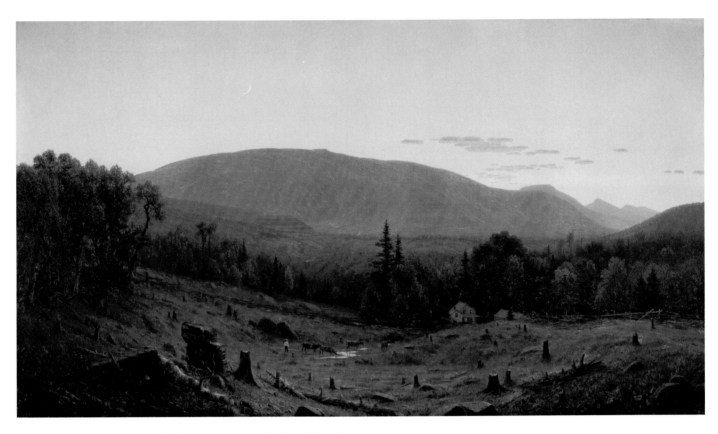

FIGURE 150: Sanford Robinson Gifford (American, 1823–1880), *Hunter Mountain, Twilight*, 1866. Oil on canvas, 77.8 × 137.5 cm. Terra Foundation for American Art, Chicago. Daniel J. Terra Collection (1999.57)

property, especially in the South, where most of the military battles were fought. According to recent accounts, as many as 750,000 soldiers died along with a million military horses and mules and some two million trees. Economists calculate the conflagration cost North and South more than $6 billion in combined government expenditures, physical destruction, and human capital, as well as more than $7 billion in indirect costs from lost consumption (1860 value). The war brought to a head long-standing ideological differences over labor and land use, pitting the industrialized North against the largely agrarian, slave-holding South.[13]

A few years before the conflict erupted, the Connecticut-born artist Luther Terry (1813–1869) attempted to summarize and reconcile those defining regional differences in *An Allegory of the North and South* (fig. 151). Terry's painting depicts a personification of America in the center, holding the fasces of national unity and wearing the Stars and Stripes with a Phrygian cap denoting liberty, flanked by female embodiments of her two regions. Seated at left, the brunette

South looks demurely at the beholder, dressed in a low-cut blouse and leaning on a cotton bale emblematically harvested by enslaved African Americans in the background field, connoting her main source of wealth. At right, the fair and modestly attired North points to a book of "useful arts," instructing her Southern sister in modern science and industry, epitomized by the orderly New England town and textile mill behind her. These background details indicate the North's technological dominance but also its reliance on Southern raw materials, especially cotton. A horn of plenty, referring to national harmony and shared abundance, spills produce jointly at their feet. Although the picture idealizes American nationalism in terms of regional cooperation, we will see shortly how the Civil War exposed tensions and entanglements that enmeshed both North and South within a global matrix of international art, commerce, and political ecology.[14]

Recent environmental histories of the Civil War have generally focused on battlefield conditions, exploring in detail the intimate local realities of conflict. For example,

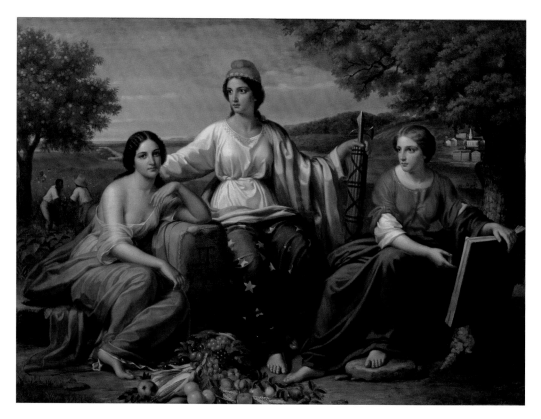

FIGURE 151: Luther Terry (American, 1813–1869), *An Allegory of the North and South*, 1858. Oil on canvas, 127 × 177.8 cm. Greenville County Museum of Art, South Carolina. Anonymous donor

Mark Fiege has extensively examined the pivotal 1863 Battle of Gettysburg, which, he says, "turned on the inescapable ties between people and the material world in which they lived," the "ability—or inability—of each side to procure resources from nature," and "the use and control of terrain." Similarly, Kathryn Shively Meier has studied the environmental challenges faced by common soldiers during the 1862 Shenandoah Valley and Peninsular Campaigns in Virginia, revealing how "strange terrain, tainted water, swarms of flies and mosquitoes, interminable rain and snow storms, and oppressive heat" led the combatants to create "self-care habits" and "informal networks of environmental information and health care based on their prewar experiences" to combat "their deadliest enemy—nature." Interpretations of the war by these environmental historians thus emphasize specific domestic contexts and circumstances, not the broader global political ecology of the conflict.[15]

Using a somewhat wider perspective, other environmental historians have studied the Civil War in terms of agriculture, supply chains, and the impact of Northern scorched-earth military strategies on Southern landscapes. For example, Lisa M. Brady describes the conflict as a "war upon the land," driven by Northern cultural desires to impose "control over nature" and perceptions of the South as a disorderly, unkempt society. Such perceptions were most famously articulated by the prominent Yankee landscape architect Frederick Law Olmsted (1822–1903), who toured the South during the 1850s. In *The Cotton Kingdom* (1861), Olmsted observed, "Coming directly from my farm in New York to Eastern Virginia, I was satisfied ... that the proportion of men improving their condition was much less than in any Northern community; and that the natural resources of the land were strangely unused, or were used with poor economy." Moreover, he noted disparagingly, "for every mile of roadside upon which I saw any evidence of cotton production, I am sure that I saw a hundred of forest or waste land." As we have seen, "economy" and "ecology" are etymologically related terms describing complex systemic relationships, usually with political inflections. Although "ecology" was first articulated in 1866 by Haeckel, we can count Olmsted

among earlier writers who anticipated the concept, in this case by casting aspersions on Southern agriculture.[16]

Responding to perceived disarray, Union military leaders decided Southern landscapes might as well be destroyed. Accordingly, Northern commanders adopted a strategy of total war, devastating what Brady calls the Confederate "agroecology." Officially codified in General William T. Sherman's Special Field Order No. 120 of November 9, 1864, the Northern strategy authorized massive foraging raids, called *chevauchées*, in enemy territory to sustain Union forces as they marched through the South, asserting overwhelming federal power and disrupting Confederate supply lines. Sherman expressed the import of this policy in letters from the field, declaring, "We have devoured the land" and

given "a demonstration to the World, foreign and domestic, that we have a power which [president of the Confederacy Jefferson] Davis cannot resist."[17]

In May 1864 Union General Ulysses S. Grant embarked on his momentous Overland Campaign in Virginia against forces led by Confederate General Robert E. Lee, beginning with the Battle of the Wilderness near Spotsylvania. Period photographs of this battlefield often juxtapose bleaching skeletons of dead soldiers with broken trees in the thick forest underbrush that gave the site its name (fig. 152). The tangled environment there resulted from unmanaged secondary growth after decades of earlier clearing by local residents to fuel industrial furnaces. As Brady observes, the Spotsylvania area was viewed negatively as a "wilderness"

FIGURE 152: G. O. Brown (American, active 1860–1889), *Battlefield of the Wilderness: View in the Woods in the Federal Lines on North Side of Orange Plank Road,* 1864 or 1865, printed 1880–1889. Albumen print. Library of Congress, Washington, DC. Prints & Photographs Division, Civil War Photograph Collection

caused by human mismanagement and neglect, producing conditions similar to those Olmsted had called "forest or waste land." By 1864 Northern military policy sought to transform even productive Southern farmland into barren territory in order to prevail.[18]

Elsewhere at this time, however, "wilderness" began to acquire positive new meanings. In 1864 President Abraham Lincoln granted the state of California almost 750,000 acres of dramatic forest and valley land along the western slopes of the Sierra Nevada Mountains for America's first public wilderness park, Yosemite. After visiting Yosemite in 1865 and seeing pictures of the area by Carleton E. Watkins (1829–1916) and Albert Bierstadt (1830–1902) (fig. 153), Olmsted described the park's origins in a report for the federal government:

> It was during one of the darkest hours, before Sherman had begun the march upon Atlanta or Grant his terrible movement through the Wilderness, when the paintings of Bierstadt and the photographs of Watkins, both productions of the War time, had given to the people on the Atlantic some idea of the sublimity of the Yo Semite [sic].[19]

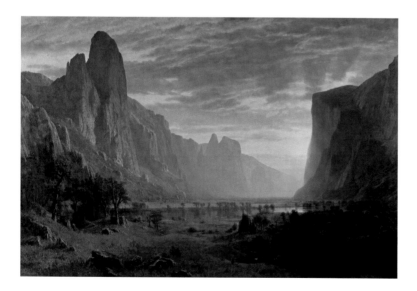

FIGURE 153: Albert Bierstadt (American, born Germany, 1830-1902), *Looking Down Yosemite Valley, California*, 1865. Oil on canvas, 163.8 × 245.1 cm. Birmingham Museum of Art, Alabama. Gift of the Birmingham Public Library (1991.879)

Endorsing the park's aesthetic "union of the deepest sublimity with the deepest beauty," Olmsted also touted its tourism potential and therapeutic psychological benefits, celebrating its "chasm" and areas "overgrown by thick clusters of trees" as elements of "natural scenery" that could counteract a "general feebleness" of "mental faculties." According to Olmsted, such mental enfeebling was produced by "excessive devotion of the mind to a limited range of interests," including "the laying up of wealth" and attention to "small and petty details," resulting in "a savage state; that is, a state of low development." As an experience for achieving "reinvigoration" of the mind, he said, "natural scenery is more effective upon the general development and health than that of any other." By the late 1850s California journalists likewise described Yosemite as a "wilderness," not in the pejorative sense but as a term of praise. In 1862 Henry David Thoreau declared more broadly, "in Wildness is the preservation of the world."[20]

During the Civil War era, then, we see clear evidence of a historic shift from "wilderness" as a moral condemnation of "waste land" (epithets invoked by Olmsted and Sherman against the South) to the modern national-conservationist vision of recreational, aesthetic, and spiritual retreat. Echoing these sentiments four decades later, Muir wrote, "Thousands of tired, nerve-shaken, over-civilized people are beginning to find out that going to the mountains is going home; that wildness is a necessity." But not everyone had the same capacity for appreciating and benefiting from such a retreat, according to Olmsted, Muir, and many other Euro-Americans. As Olmsted opined in his Yosemite report, "The power of scenery to affect men is, in a large way, proportionate to the degree of their civilization and to the degree in which their taste has been cultivated. Among a thousand savages there will be a much smaller number who will show the least sign of being so affected than among a thousand persons taken from a civilized community." Similarly, while Muir could praise the "glorious psalm of savage wildness" in Yosemite's waterfalls and other nonhuman phenomena, he was less enthusiastic about Native Americans, disparaging them as "these dark-eyed, dark-haired, half-happy savages" who lead a "strangely dirty and irregular life" in "this clean wilderness" of "pure air and pure water." Calling them "mostly ugly, and some of them altogether hideous," Muir even felt Native people had "no right place in the landscape." Earlier, during the Civil War

2391. Wounded Trees at Gettysburg.
[FOR DESCRIPTION OF THIS VIEW SEE THE OTHER SIDE OF THIS CARD.]

FIGURE 154: Mathew B. Brady (American, 1823–1896), *Wounded Trees at Gettysburg*, ca. 1863. Stereograph (albumen silver prints); image (left): 7.9 × 7.9 cm; image (right): 7.9 × 8.1 cm; mount: 10.2 × 17.8 cm. George Eastman Museum, Rochester, New York. Museum accession (1981.7093.0013)

in 1862, Muir had described the conflict in roughly analogous terms of visual blight, writing in a letter to his sister Sarah, "This war seems farther from a close than ever. How strange that a country with so many schools and churches should be desolated by so unsightly a monster." Although eligible for military service, Muir chose not to volunteer and even left the United States to explore Canada during the final year of the conflict—the first of his many wilderness rambles.[21]

Art historical accounts of the Civil War, like those written by most environmental historians, emphasize battlefields, camps, soldiers, or home-front scenes in various media. Historians of art have generally concentrated on the representation of regional differences, racial identities, slavery, emancipation, gender, and other sociopolitical matters relating directly to the war, its domestic reverberations, or its subsequent memorialization throughout the country. Many monographs explore relevant work by prominent American artists, while recent museum exhibitions have interpreted the struggle as a watershed in the national aesthetic mood, especially in landscape painting and photography.[22]

Rare scholarship addressing environmental issues in Civil War art has similarly focused on local, regional, or national landscapes. For example, Maura Lyons describes the

depiction of "wounded trees" and other war-related imagery in "Northern landscapes" as "new and disturbing representations of the relationships between humans and nonhuman nature." According to Lyons, photographers such as Mathew Brady (1823–1896) (fig. 154) and G. O. Brown (active 1860–1889) (see fig. 152) tapped a "long-standing culture of anthropomorphism" by underscoring "the correspondence between wounded trees and bleached human bones" or injured human bodies while expressing "the uncertainties and powerful emotions that seized Americans during the Civil War." In Brady's photograph, a man lies on the battlefield surrounded by trees riddled with bullet holes, suggesting they are analogously "wounded." Thirty years before, Thomas Cole (1801–1848), founder of the Hudson River School of landscape painting, had written that "trees are like men," making them worthy of respect and representation.[23]

American artists of the Civil War often adapted Romantic ideas and models to new realities in the catastrophic sectional conflict. After the Battle of Gettysburg, for example, the Northern illustrator Thomas Nast (1840–1902) published an engraving titled "The Result of War—Virginia in 1863" in *Harper's Weekly*, using Hudson River School compositional conventions to present a tragic allegory of national

FIGURE 155: Thomas Nast (American, born Germany, 1840-1902), "The Result of War—Virginia in 1863." Engraving, 36.5 × 54.5 cm. Published in *Harper's Weekly*, July 18, 1863. Princeton University Library

destruction (fig. 155). Nast's nocturnal view of picturesque ruins, water, trees, weeds, and animals—with no human beings in sight—recalls *Desolation*, the final canvas in Cole's celebrated 1836 series *The Course of Empire*.[24]

Not all Civil War artists relied on prototypes of the Hudson River School, however. Diverging from that hegemonic Northeastern tradition, the Southern painter John Gadsby Chapman (1808–1889) deployed an older European stylistic precedent in painting *Charleston Bay and City* (fig. 156). His 1864 picture interprets the Confederate bastion—complete with warships and fortress—like a view of Venice by the eighteenth-century Italian artist Canaletto (1697–1768). Born in Virginia, Chapman spent more than two years as an art student in Italy (1828–31), including a visit to Venice. *Charleston Bay and City* was based partly on sketches by his artist son, Conrad Wise Chapman (1842–1910), a Confederate soldier who had drawn the military gunboats firsthand. Synthesizing these sketches with Rococo landscape trappings, John Gadsby Chapman's painting projects an elegant image of natural serenity, power, and cultural legitimacy for the capital of the Southern state that initiated the rebellion. Later that year, Union forces led by General

Sherman on his land-devouring march from Atlanta would reduce Charleston to a wilderness of ruins.[25]

The most celebrated example of environmental representation in Civil War art is the battle-scarred background landscape in *Prisoners from the Front* by Winslow Homer (1836–1910) (fig. 157). Produced in 1866, after the war, this painting provided a pictorial summa of the conflict and established Homer's reputation as a leading American artist when it garnered strong praise in the Northern press during a debut exhibition at New York's National Academy of Design in 1866. The picture commemorated events surrounding the capture of Confederate soldiers at the Battle of Spotsylvania, Virginia, in 1864 by Union forces under the command of Brigadier General Francis Channing Barlow, a relative of the painter. We see Barlow at right, facing three unidentified Confederate prisoners guarded by Union troops. Symbolically resting at the feet of these figures appear abandoned Confederate rifles and a broken branch of Virginia pine. More troops and truncated trees appear in the background.[26]

New York art critics said nothing about Homer's war-torn landscape, probably because its meaning seemed too obvious to mention. Generally sympathetic with the Union, they

FIGURE 156: John Gadsby Chapman (American, 1808–1889), *Charleston Bay and City*, 1864. Oil on wood, 29.2 × 39.4 cm. The American Civil War Museum, Richmond, Virginia

FIGURE 157: Winslow Homer (American, 1836–1910), *Prisoners from the Front*, 1866. Oil on canvas, 61 × 96.5 cm. The Metropolitan Museum of Art, New York. Gift of Mrs. Frank B. Porter, 1922 (22.207)

only addressed the human drama, praising the artist for epitomizing perceived differences in character between stereotypically disciplined Northern men and reckless, disorderly Southerners. Yet, as noted earlier, similar perceptions had informed Northern views of the Confederacy as a society incapable of imposing control over the land. Visually acknowledging this environmental dimension of the war, Homer revealed the context and cost of battle in *Prisoners from the Front* by representing the landscape as a barren brown field with broken tree stumps extending into the distance. Such imagery appears in other Civil War pictures by Homer, whose job as an embedded artist-journalist for *Harper's Weekly* regularly led him to witness such devastation.[27]

Prisoners from the Front expressed Homer's Northern sense of political ecology both thematically and formally in terms of composition, color, and technique. All the human figures and horses are enclosed within a pictorial field of drab earthen tones, except for the foreground protagonists, whose heads protrude into the gray sky, catching our eyes and focusing our attention. Barlow's dark blue uniform stands out sharply within his surroundings, but the dirty grayish-brown tones of the Confederates' outfits fictively merge them with the broken land, suggesting they "naturally" belong to it. Thus, while the composition renders both North and South as affected by the war, strategic formal and environmental cues clearly distinguish the victors from their vanquished adversaries, whose unruly character seems interchangeable with the Southern soil.

Although Homer did not use the word "ecology," at least not in any surviving documents, he recognized the environmental implications of war. Further evidence of this appears in a published "Campaign Sketch" representing the military practice of foraging, in which Union soldiers systematically took provisions from farms in enemy territory to feed themselves and disrupt Confederate supply systems (fig. 158). Whereas General Sherman viewed this practice as a necessary strategy of total warfare, Homer treated it with lighthearted humor and condescension across races and species. As the white Union soldiers merrily abscond with a steer they will butcher for food, the animal's terrified look parallels the alarmed expression of a black man with arms upraised in the background. The arrival of Northern troops in the South meant emancipation for African Americans, but it also entailed theft of livestock and other vital supplies.

Homer's pictures offered no categorical indictments of war or clear expressions of modern environmentalist sentiment. As a loyal US citizen and journalist with official military clearance, he accepted the plundering of Southern resources as necessary to Northern victory. Homer certainly sensed moral complexities, but his art ultimately endorsed the Union cause.[28]

For all Americans, especially Southerners, the Civil War produced unprecedented devastation on an unfathomable scale. The conflict shattered lives and environments while posing tremendous cultural, psychological, and artistic challenges. How to make sense of it all? Familiar agricultural ideas about harvesting and crop growth provided a broadly

FIGURE 158: Winslow Homer, *Campaign Sketches: Foraging*, no date. Lithograph, 27.3 × 21.6 cm. Smithsonian American Art Museum, Washington, DC. Transfer from the National Museum of American History, Division of Graphic Arts, Smithsonian Institution (1971.233)

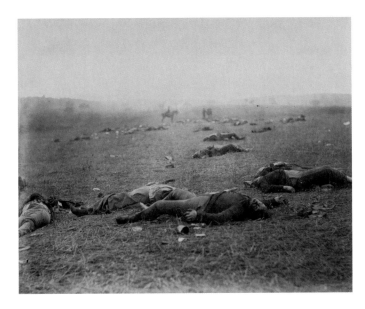

FIGURE 159: Timothy O'Sullivan (American, ca. 1840-1882), *A Harvest of Death, Gettysburg, Pennsylvania*, 1863. Albumen print, 17.8 × 22.1 cm. Published in Alexander Gardner, *Photographic Sketch Book of the War* (Washington, DC: Philp & Solomons, 1865). Library of Congress, Washington, DC. Prints & Photographs Division

circumstances evoked even richer biblical notions concerning wheat's traditional use in making Eucharistic bread, which Christians equated with the body of their martyred savior. For Gardner's Northern viewers, then, killing Confederates could be seen as a somber but necessary sacrifice to preserve the Union. By framing death on a Pennsylvania battlefield with hallowed religious-agricultural tropes, Gardner naturalized the shock of modern warfare, making it seem familiar, righteous, and holy—a tribute to the nation on sacred ground. As we have already seen with Marsh and other nineteenth-century Americans, environmental perceptions were inextricable from moral and social concerns.[30]

Civil War imagery also adduced metaphors of agricultural growth—not just death—in visualizing the opposing forces. Another illustration by Nast titled "Symptoms of Spring—Uncle Abram's Crop Begins to Shoot," published in 1864, represents President Lincoln as a farmer cultivating Union soldiers as if they were plants "shooting," or sprouting up, in neat rows like cornstalks (fig. 160). Lincoln's vegetal army propagates as though an inexorable force of nature, ready to confront the oversize Confederate figure seated in the bare wasteland of "Dixie" on the other side of a stone wall.

comprehensible body of metaphors with which to process the calamity. In 1860 four out of five Americans still resided in rural areas, so artists regularly drew inspiration from a deep well of agrarian associations. Agricultural tropes, together with the aforementioned military notions of devouring the land, indicate the pervasive influence of the farm environment as a touchstone in shaping American perceptions. Artistic references to age-old traditions of farming naturalized the physical and psychological damage of war as if it were part of a timeless agrarian cycle.[29]

A memorable example appears in Timothy O'Sullivan's 1863 photograph *A Harvest of Death, Gettysburg, Pennsylvania*, taken after a pivotal battle and published two years later in Alexander Gardner's *Photographic Sketch Book of the War* (fig. 159). As was the case for all Civil War–era battlefield photographers, O'Sullivan (ca. 1840–1882) had to shoot the picture following the conclusion of hostilities, because slow and cumbersome glass-plate camera equipment made real-time action images impossible. The title *Harvest of Death*, concocted by Gardner, gives the stark scene moral significance by associating the bodies of dead Confederate soldiers cut down on the battlefield with crops, tapping a long-standing Christian personification of Death as the Grim Reaper gathering souls. The "harvest" metaphor was ready-made, for the Battle of Gettysburg occurred on a wheat field, now solemnly irrigated with blood. These

FIGURE 160: Thomas Nast, "Symptoms of Spring—Uncle Abram's Crop Begins to Shoot." Lithograph, 40 × 56.5 cm. Published in *Frank Leslie's Budget of Fun*, April 1, 1864. The Ohio State University Billy Ireland Cartoon Library & Museum, Columbus (PN6700 F7 no 73)

Meanwhile the visage of Samuel P. Chase, Lincoln's treasury secretary, pokes above the Northeastern horizon like a rising sun, symbolically illuminating and nurturing the Union military crop with financial support.[31]

Americans obviously did not all share the same environmental experience or viewpoint regarding the Civil War. For enslaved African Americans, whom white Southerners generally perceived as subhuman property, the political ecology of everyday life posed daunting existential challenges. Work usually lasted from dawn to dusk or longer, either in fields or in the "master's" home—environments of continual surveillance, intimidation, harassment, physical stress, and deprivation. The slightest transgression could lead to torture or death. During short periods of private time allotted to enslaved people, they attempted to raise families, build communities, grow their own food, and maintain modest households, all the while subject to the whims of their owners, who could capriciously sell or abuse them with virtual impunity. The environmental historian Mark Fiege has described some of the ways in which enslaved African Americans negotiated their oppressive environments. For example, plantation field workers subtly adjusted their labor to the pace and life cycle of the cotton plant in order to save energy, circumvent conflict, create extra time to cultivate private gardens, or otherwise optimize their difficult predicament.[32]

The clandestine nature of such activity eluded artistic representation, but other environmental dimensions of black life surrounding the Civil War found expression in many works, including creative objects produced by African Americans themselves. For example, David Drake (ca. 1800–ca. 1870), an enslaved man living on a plantation in Edgefield, South Carolina, signed his name, "Dave," prominently at the top of a glazed stoneware jug he made in 1858 (fig. 161). This was one of more than a hundred ceramic works created by Drake, a master potter, during the middle of the nineteenth century before emancipation. Like many of his pots, it also carries a verbal inscription, the mere existence of which defied the systematic prohibition against literacy among enslaved people. Though difficult to read in photographs, the inscription takes the form of a poetic astronomical reference: "Follow the Drinking Gourd / For the old man is a-waiting for to carry you to freedom." The "Drinking Gourd" referred to the Big Dipper, a constellation that pointed to the North Star. Drake used environmental knowledge—in the form of vernacular astronomy—to turn his pots into lyrical guides for runaway slaves on how to escape from bondage and find freedom in the North.[33]

The theme of the runaway or fugitive slave became a popular sensation in nineteenth-century media of all kinds, thanks especially to the international fame of Harriet Beecher Stowe's antebellum abolitionist novel *Uncle Tom's Cabin* (1852). Stowe's celebrated book included a harrowing episode involving the winter escape of an enslaved woman named Eliza, who courageously carried her infant child across the frozen Ohio River from Covington, Kentucky, to freedom in the Northern city of Cincinnati. In the visual arts, fugitive slave iconography varied widely, but one example giving particularly dramatic attention to environmental context is *Slave Hunt, Dismal Swamp, Virginia*, painted by Thomas Moran (1837–1926) during the Civil War (fig. 162). The picture represents a black man and woman with a child in her arms in the left foreground of the marshy, overgrown swamp, fleeing captors with hunting dogs in the distance at right. White Americans traditionally disdained swamps as wastelands that resisted economic development and nurtured malaria, among other unsavory things, giving rise to many negative associations. The very name of the Great Dismal Swamp, an

FIGURE 161: David Drake (American, ca. 1800–ca. 1870), Food storage jar, 1858. Stoneware, h. 51.4 cm. Private collection

enormous marshy area straddling the Virginia–North Carolina border, exemplified such perceptions.[34]

Yet Moran's picture projects a more complex environmental perspective inflected by the political ecology of slavery. Whereas the white slave-trappers and their hunting dogs encounter the swamp as an obstacle to be overcome, the lush foreground vegetation of this semiaquatic environment connotes something else for the fleeing African Americans, who often used such places as protective havens and passageways to freedom. As Stowe wrote in her 1856 novel *Dred: A Tale of the Great Dismal Swamp*—likely Moran's inspiration— "What the mountains of Switzerland were to the persecuted Vaudois, this swampy belt has been to the American slave," for "the near proximity of the swamp has always been a considerable check on the otherwise absolute power of the overseer." More recently, the historian Daniel Sayers has

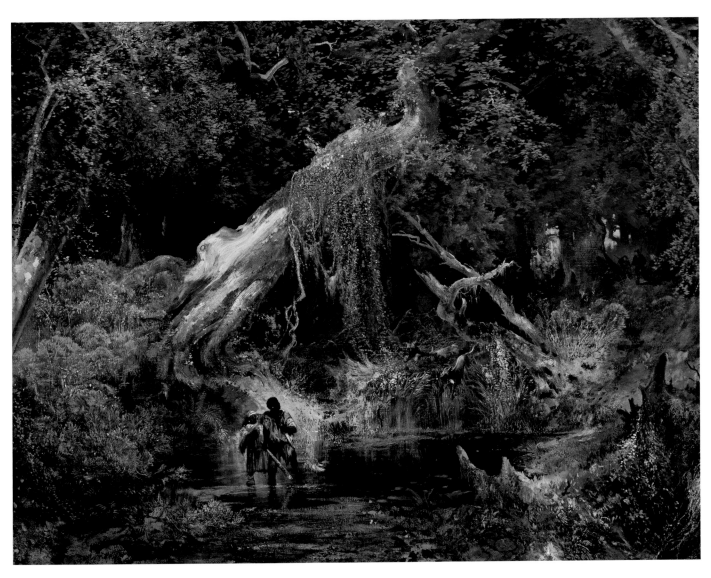

FIGURE 162: Thomas Moran (American, born England, 1837-1926), *Slave Hunt, Dismal Swamp, Virginia*, 1861-62. Oil on canvas, 109.2 × 134.6 cm. The Philbrook Museum of Art, Tulsa, Oklahoma. Gift of Laura A. Clubb (1947.8.44)

called the Great Dismal Swamp "a desolate place for a defiant people." Accordingly, Moran's picture redeemed this wetland as having value for African Americans, whose perspective the painting dramatically emphasizes by placing the fugitives directly before us. They even guide our gaze by turning to watch their pursuers through the dense forest. The fugitive man holds a bloody knife with which he has just killed one of the trapper's dogs.[35]

A Northern artist of English origin, Moran sided with the Union and painted *Slave Hunt* for an English abolitionist patron while visiting London. This helps explain why he depicted the swamp environment not as a negative wilderness or sinister place, as had most previous artists, but rather as an exotic refuge of warmth, color, and even visual allure. The swamp's strange beauty signals resistance to Southern white control. In Moran's picture, aesthetics conspire with environmental vitality to connote "freedom." As the runaways advance into the marshy foreground, they confront the viewer with urgent issues of political ecology and ethics. When we recognize that the fugitives comprise a family unit, recalling the biblical Holy Family on the Flight into Egypt, their empathetic appeal gains even greater moral and historical significance.[36]

Moran's artistic synthesis of American and European cultural ideas provides one indication of the global scope of the Civil War. Since American democracy challenged an older aristocratic order of things, its survival mattered to aspiring republicans everywhere. General Sherman acknowledged this when he touted Northern military strategy to the "world, foreign and domestic," clearly expressing awareness of the international stakes and perceptions of the war. Marsh evinced similar global understanding in an 1861 letter to Secretary of State William Seward, describing the conflict as "a contest between the propagandists of domestic slavery and the advocates of emancipation and universal freedom," warning that "our hold upon the sympathy and good will of the governments, *and still more of the people of Europe*, will depend upon the distinctness with which this issue is kept before them" (emphasis in original). In his 1863 Gettysburg Address, President Lincoln spoke in worldly terms when he said, "government of the people, by the people, for the people, shall not perish from the earth." Sherman, Marsh, Lincoln, and many others knew the Union's failure could result in the permanent institutionalization of slavery, irrevocably shaping the United States not just internally but also

in its international relations. With these considerations in mind, historians now view the American Civil War as a global phenomenon—militarily, politically, economically, and environmentally. This expansive perspective invites art historical consideration of works, subjects, environments, and materials reaching well beyond this country.[37]

For instance, let us ponder a painting by the French artist Édouard Manet (1832–1883) depicting *The Battle of the USS "Kearsarge" and the CSS "Alabama"* (fig. 163). Manet produced the picture as part of a series of related works after a sea battle in which the Union warship sunk a Confederate raiding vessel off the coast of France in 1864. The artist did not witness the encounter but instead relied on news reports and his own aesthetic judgment in composing the series. In this example, the most dramatic of all, Manet placed the sinking *Alabama* in the upper center of the canvas, its damaged stern burning and partially submerged. The *Kearsarge* appears in the distance at left, obscured behind smoke billowing from the Confederate vessel. Two unidentified boats sail nearby, one in the left foreground flying French colors and another in the distance at right, ready to rescue survivors. The artist's animated brushwork and vertical composition render the action with unusual drama for a maritime scene.[38]

Manet's picture highlights several important points about the American Civil War as a global phenomenon. Set in European waters, the painting addressed hostilities that obviously extended beyond the United States and North America. The painter's reliance on media reports reveals how this "civil" conflict attracted international attention. As a republican artist in imperial France, Manet opposed the aristocratic, Confederate-sympathizing government of Emperor Napoleon III. Other pictures by him similarly critiqued French colonialism, including several ensuing portraits of the *Kearsarge*, confirming his admiration for the Union vessel and the values it embodied.[39]

Manet's work also underscores a fundamental truth about the global political ecology of the American Civil War. As a result of business relationships involving the production and international exchange of cotton from the American South, the *Alabama* was one of several Confederate military vessels built in the Birkenhead shipyards near Liverpool, England, with financing from British commercial textile interests. Confederate agent James Bulloch arranged for its construction there with funding from the Fraser Trenholm Company, a Liverpool cotton broker. As noted by the historian Sven

FIGURE 163: Édouard Manet (French, 1832–1883), *The Battle of the USS "Kearsarge" and the CSS "Alabama,"* 1864. Oil on canvas, 137.8 × 128.9 cm. Philadelphia Museum of Art. John G. Johnson Collection, 1917 (Cat. 1027)

Beckert, "Liverpool, the world's largest cotton port, was the most pro-Confederate place in the world outside the Confederacy itself. Liverpool merchants helped bring out cotton from ports blockaded by the Union navy, built warships for the Confederacy, and supplied the South with military equipment and credit." International cotton cultivation, trade, and textile manufacture had fostered the Industrial Revolution, slavery, and modern market capitalism—all of which were underlying economic causes of the American Civil War. The global "empire of cotton," as Beckert describes it, depended on the ecology and economics of a single plant species, which reshaped the world and precipitated a war with international consequences.[40]

Like other cosmopolitan republicans of the period, Manet probably knew of the *Alabama*'s Liverpool cotton connections from reading newspaper accounts about British and French industrial ties to the Confederacy. In celebrating the destruction of the vessel, Manet endorsed American democracy and abolition. Ironically, by this time American cotton had insinuated itself into all sorts of modern consumer products, including art materials. Cotton, which was exported from the

United States on a large scale, began to displace traditional linen (made from flax) in painters' canvases during the early nineteenth century. With the increasing abstraction and global flow of industrial commodities in modernity, painters of Manet's generation inadvertently became entangled in American cotton production and slavery.[41]

Cotton cultivation had already dramatically transformed landscapes and economies around the globe during the years leading up to the American Civil War. Historically, India was the world's leading cotton producer, but this role shifted to the United States in the early nineteenth century when Americans aggressively acquired Native lands for cultivation with low-cost slave labor to feed the rapidly growing British and domestic textile industry. In 1830 President Andrew Jackson signed the Indian Removal Act, relocating Cherokee and other Native American communities from the Southeast to areas west of the Mississippi River, facilitating the expansion of cotton farming. America's ensuing sectional conflict therefore participated in an international contest over land and labor rooted in European colonialism. Beckert refers to the engine driving this contest as "war capitalism," involving the systematic expropriation and clearing of Indigenous territories for cotton production in various colonial-imperial contexts. Since cotton also rapidly leached nutrients from soil, its expanding growth increased demand for "virgin" land and slave labor across the South, exacerbating regional tensions and setting the stage for civil war.[42]

Well before the war erupted, the international environmental and social impacts of textile production based on American cotton were impossible to ignore. During an 1835 visit to Manchester—Britain's textile manufacturing center— the eminent French writer-traveler Alexis de Tocqueville described the pollution: "Black smoke covers the city. The sun seen through it is a disk without rays.…A thousand noises disturb this damp, dark labyrinth.…[From] this foul drain the great stream of human industry flows out to fertilise the whole world. From this filthy sewer pure gold flows." An 1852 painting titled *Manchester from Kersal Moor* by the British artist William Wyld (1806–1889) testified to such conditions even as it attempted to naturalize them aesthetically (fig. 164). Representing the city as a distant forest of hazy mills and smokestacks, Wyld uneasily reconciled industry with the attractive rural landscape in the foreground. At this time, the vast majority of cotton processed in Manchester came from plantations in the American South.[43]

FIGURE 164: William Wyld (British, 1806–1889), *Manchester from Kersal Moor*, 1852. Watercolor, touches of gouache, with gum arabic and scratching out, 31.9 × 49.1 cm. Royal Collection Trust, United Kingdom

During the 1860s Union naval blockades against Confederate shipping caused a "cotton famine," shuttering British factories and driving thousands of Manchester's wage laborers into soup kitchens. Speculators thrived from the economic instability by creating a futures market while textile manufacturers found alternative sources of cotton in India, Egypt, Brazil, and Turkey. This shift in production transformed local economies and environments in the latter countries by altering supply chains and clearing new land or replacing food crops with cotton. Beckert notes that America's Civil War brought about "the world's first truly global raw materials crisis, and proved midwife to the emergence of new global networks of labor, capital, and state power." The pictures by Wyld and Manet testify to the effects of such networks.[44]

The cotton crisis was temporary, however, as postbellum economic normalization led to the resumption and expansion of American cotton production. Slavery in the United States was abolished, but a new global order emerged in which international market forces imposed an integrated system of wage labor for cultivating, processing, manufacturing, and shipping cotton around the world. Lawyer and former Union military general Francis Channing Barlow—whom Homer depicted in *Prisoners from the Front* (see fig. 157)—put the matter bluntly in an 1865 letter to a friend, discussing the viability of purchasing a Southern cotton plantation after the war: "Making money there is a simple question of being able to make the darkies work." In the American South and in other cotton-producing nations during the late nineteenth century, the answer to this labor question involved a coercive system of sharecropping, compulsory contracts, and debt peonage, effectively reinstating aspects of antebellum slavery under the guise of free-market capitalism. African Americans in the former Confederacy had embraced emancipation, but the late nineteenth century brought daunting new challenges, including state-sponsored racial segregation laws—a repressive regime known as Jim Crow.[45]

Contrasting artistic perspectives on this postbellum political ecology appear in Homer's *The Cotton Pickers* of 1876 (fig. 165) and William Aiken Walker's *A Cotton Plantation on the Mississippi* of 1883 (fig. 166). Both paintings represent cotton harvesting as a labor-intensive agricultural routine, but the similarity ends there. Walker (ca. 1838–1921), a Confederate veteran from South Carolina, treated cotton cultivation in a folksy, upbeat manner as an orderly task performed by contented black laborers in a neat, sunlit community near the river. Homer, a Northern artist who revisited Virginia a decade after his wartime reporting there, approached the same activity as a form of economic captivity and environmental homogeneity, couched in cosmopolitan aesthetics. In *The Cotton Pickers* we see a pair of young African American women working an enormous field. The sea of ripe white cotton fiber around them provides a striking aesthetic motif that also acknowledges historical realities about large-scale monoculture during the late nineteenth century. Here the women's physical fatigue mirrors exhaustion of Southern soils by the expansive, nutrient-sapping plant. A solitary tree in the distance at right alludes melancholically to the massive deforestation making such immense cotton fields possible. Whereas Homer's *Prisoners from the Front* displayed a war-devoured Virginia battlefield with stumps stretching to the horizon, *The Cotton Pickers* presents a vast cash crop embodying postbellum economic normalization in the South. Slavery may have ended for these working women, but they remain trapped on the plantation by a reconstructed cotton empire that continued to deny them mobility or equality. Under this homogenizing regime, such laborers endured low wages, segregation, alienation, and frustration. As an anonymous critic observed about *The Cotton Pickers* in the *New York Evening Post* in 1877, the women look "unhappy and disheartened," even "defiant and full of hatred." Another early reviewer, Francis Hopkinson Smith, explained in 1894 that he was "haunted" for days by

FIGURE 165: Winslow Homer, *The Cotton Pickers*, 1876. Oil on canvas, 61.1 × 96.8 cm. Los Angeles County Museum of Art. Acquisition made possible through Museum Trustees (M.77.68)

FIGURE 166: William Aiken Walker (American, ca. 1838–1921), *A Cotton Plantation on the Mississippi*, 1883. Oil on canvas, 69.5 × 95.3 cm. Gilcrease Museum, Tulsa, Oklahoma. Gift of the Thomas Gilcrease Foundation, 1955 (0126.1206)

Homer's picture, praising the foremost figure by saying, "The whole story of Southern slavery was written in every line of her patient, uncomplaining face." But Homer's picture also reads somewhat ambiguously owing to its cosmopolitan aesthetic beauty. The art historian Randall Griffin notes how the black women recall analogous field workers in nineteenth-century French paintings by Jean-François Millet and Jules Breton while the cotton brings to mind fields of wheat and flowers in those same paintings. In 1916 the *American Art News* reported that a "wealthy English cotton spinner" acquired the work, which "is finely original and alluring, and when across the seas will do honor to the land that made it."[46]

Prospecting

By the second half of the nineteenth century, another transformative industrial product began to rise as a global commodity and to engage artists: petroleum. The historian Timothy Mitchell has attributed the development of petroleum as a major energy source to its liquidity and availability, enabling a "reorganisation of energy flows" that displaced other fuels such as wood, spermaceti (whale oil), and even coal. Although coal powered the Industrial Revolution and remains in use today, its importance has declined since the emergence of petroleum. A relatively static material, coal required constant physical labor by an extensive organized workforce conducive to unionization, whereas oil needed fewer people to extract, refine, and distribute it. As Mitchell observes, "oil flowed along networks that often had the properties of a grid, like an electricity network, where there is more than one possible path and the flow of energy can switch to avoid blockages or overcome breakdowns," including those caused by strikes and national borders. From the viewpoint of many modern business leaders and their political allies, petroleum was therefore an ideal commodity because its production and fluid dissemination could be largely automated, circumventing organized labor and producing great wealth for those controlling the industry. But the liquidity of petroleum also facilitated a pervasive political

ecology that Mitchell calls "carbon democracy," as governments and corporations around the world increasingly tied their fortunes to oil. These conditions created global dependency on fossil fuels and petrochemicals, the consumption of which has led to resource wars, pollution, environmental inequities, and a warming planet.[47]

What are the artistic implications of oil? Author Amitav Ghosh critically examines petroleum as both energy resource and cultural phenomenon in a recent study about creative engagements with climate change. "For the arts," he says, "oil is inscrutable in a way that coal never was: the energy that petrol generates is easy to aestheticize—as in images and narratives of roads and cars—but the substance itself is not. Its sources are mainly hidden from sight, veiled by technology, and its workers are hard to mythologize, being largely invisible." According to Ghosh, the fluid energy and speedy distribution of oil promoted modern economic discourse about "progress," along with cultural notions of "irreversible forward movement, led by an avant-garde," whose formal experimentation stood in contrast to Social Realism. For a long time, Ghosh observes, vanguard modernism consigned Social Realism to "the netherworld of backwardness," but "the last laugh goes to that sly critic, the Anthropocene, which has muddied, and perhaps even reversed, our understanding of what it means to be 'advanced.'" What once looked like progress in art and commerce now looks tainted by the catastrophic effects of climate change.[48]

With Ghosh's comments in mind, let us consider an illuminating example of environmental representation in nineteenth-century American realist painting. In 1864 or early 1865, the year Marsh's *Man and Nature* appeared in print, the itinerant artist David Gilmour Blythe (1815–1865) completed a small picture critically representing destructive impacts of oil drilling during the initial boom years of the modern petroleum industry in the United States (fig. 167). *Prospecting* shows a scraggly, destitute traveler standing before a landscape littered with oil derricks, obscured by an atmosphere of smoke and haze. Shin-deep in industrial effluvia, the solitary figure with goatee and mustache carries a liquor jug, a red satchel, and a bundle of "GREEN BACKS"

FIGURE 167: David Gilmour Blythe (American, 1815-1865), *Prospecting*, ca. 1864-65. Oil on canvas, 44.4 × 36.8 cm. The Westmoreland Museum of American Art, Greensburg, Pennsylvania. Bequest of Richard M. Scaife (2015.20)

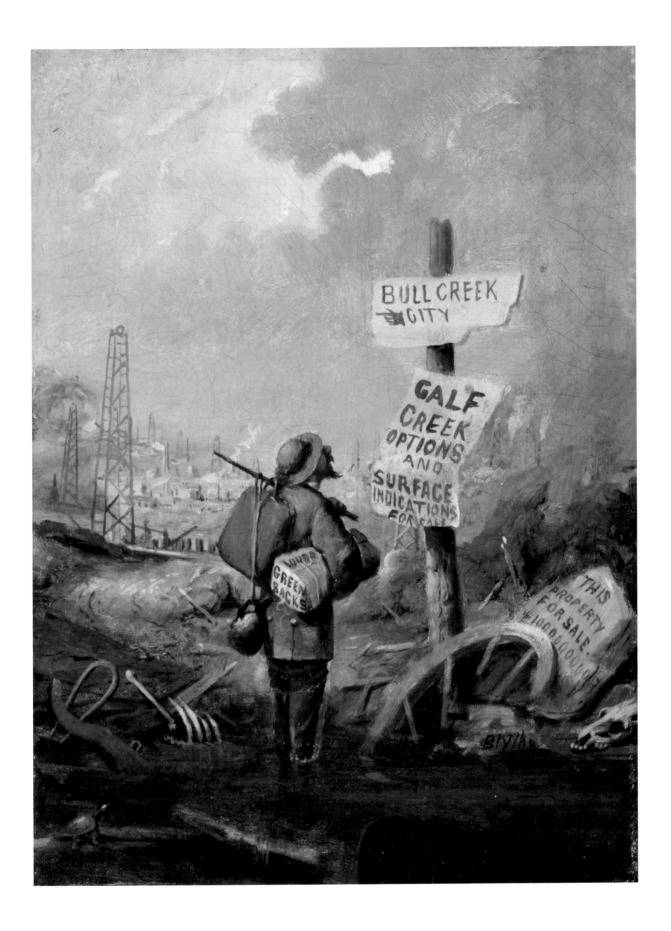

alluding to rampant inflation associated with the oil rush. Scholars believe this to be a self-portrait of Blythe, an artist whose characteristic beard, poverty, and alcoholism served as leitmotifs through much of his career.[49]

Casting himself here as a drifter searching for better prospects, Blythe pauses to read signs soliciting investment in petroleum development and related real estate. Surrounding him are the ruins of an older, pastoral order, including desiccated animal bones, an abandoned ox yoke, a broken wagon wheel, and splintered boards recalling trees that once may have stood in the background landscape now occupied by oil derricks. A barrel of "CRUDE" floating in the mire announces the agent of destruction with a sardonic pun, alluding to the coarse new industrial order of raw profiteering and speculation in oil. The only other sign of organic life is a lowly turtle, who stares up from a bare patch of earth in the lower left corner with a gaze echoing the man's puzzled look. Like the turtle, this human wanderer moves slowly compared with the hasty commercial development all around, highlighting a spatial-temporal rift between living organisms and inorganic mechanisms of industrial "progress." Man and animal seem to share a common evolutionary predicament as sentient beings alienated from a world transformed by the engine of fossil fuel.

Amid the foreground wreckage of *Prospecting* we also read the artist's signature written in orthography similar to that of the blaring signs. Given his penchant for puns, Blythe's name here suggests "blight," associating environmental degradation with his own personal problems. Inflation has likely made his bundle of bills as worthless as the surrounding detritus. Blythe was not alone in perceiving the early oil boom as an occasion for mordant visual metaphor and verbal wordplay about economic excess. An anonymous *Harper's Weekly* cartoon of 1865 used the punning title "Deep Speculation" to render the oil fever sarcastically as a kind of mental affliction or nightmare, in which demons drill into the brain of a sleeping investor besieged by stock reports, certificates, and bloated prices (fig. 168). Judging from Blythe's timely awareness of such conditions, we can infer he regularly read the news.

What makes *Prospecting* distinctive and unprecedented, however, is its vivid send-up of the petroleum craze in the fine art medium of oil painting. This acerbic, realist depiction of ecological degradation in a modern industrial landscape departed dramatically from painterly aesthetic conventions. We would be hard-pressed to find a comparable

representation in the medium of oil anywhere up to this time. Compare Blythe's unusual picture, for example, with the picturesque blandishments of Asher B. Durand (1796–1886) (see fig. 57), whose "Letters on Landscape Painting" (1855) exhorted artists to create "companionable" work at once "soothing and strengthening" to the beholder. Durand invited the presumptive male viewer to "look into the picture instead of on it" by offering "many a fair vision of forgotten days [that] will animate the canvas, and lead him through the scene." In contrast to that "fair vision" of a nostalgically idealized nature, Blythe's little picture delivered a starkly repellent environmental parody of both modern industry and landscape painting conventions. Rejecting picturesque aesthetics, Blythe doubtlessly understood the title *Prospecting* with deep irony. Although "prospect" historically carried optimistic associations of futurity and unfettered viewing, "prospecting" invoked a crassly modern sense of extractive, economic speculation in an era of boom-and-bust cycles and get-rich-quick schemes. Blythe's painting affords no aesthetic "prospect" worthy of the name, for we find our view blocked by industrial pollution and blight, making it difficult to imagine any future in such a place, particularly after the wells run dry.[50]

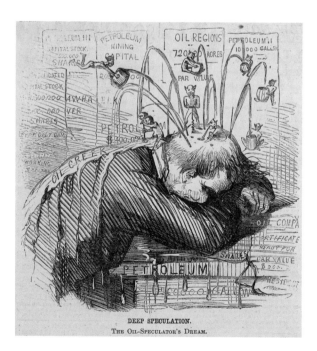

FIGURE 168: "Deep Speculation: The Oil-Speculator's Dream." Published in *Harper's Weekly*, February 11, 1865. Princeton University Library

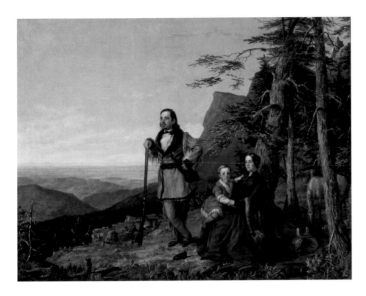

FIGURE 169: William Smith Jewett (American, 1812–1873), *The Promised Land—The Grayson Family*, 1850. Oil on canvas, 128.9 × 162.6 cm. Terra Foundation for American Art, Chicago. Daniel J. Terra Collection (1999.79)

Prospecting provides a forceful counterpoint to dominant visions of Manifest Destiny, exemplified by William Smith Jewett's *The Promised Land* (fig. 169), a work heroically portraying the pioneer family of Andrew Jackson Grayson on their trek through the Sierra Nevadas to San Francisco and the California Gold Rush. In his picture Jewett (1812–1873) commemorated a journey the Graysons completed in 1846, less than a year after the journalist John O'Sullivan famously declared in the *Democratic Review* that it is "our manifest destiny to overspread the continent allotted by Providence for the free development of our yearly multiplying millions." With its exhilarating westward view of the Sacramento River Valley bathed in gold, *The Promised Land* echoes O'Sullivan's expansive sense of divine providence, imperial entitlement, and optimism. The Graysons' future prospects look very bright indeed, their family destiny not only manifest but seemingly assured by the golden horizon before them and the regal ermine coat worn by their son. By 1850, when Jewett painted this retrospective group portrait, Andrew Grayson was a successful California businessman engaged in various speculative ventures associated with gold and real estate. As a celebratory image, *The Promised Land* sidestepped the devastating environmental impacts of gold mining, including deforestation, which exacerbated a major flood in Sacramento in 1850—the first of several inundations there during the second half of the nineteenth century. Compared with Jewett's picture, Blythe's *Prospecting* turned

the breezy confidence of Manifest Destiny on its head by critically revealing the ecological and economic downside of extractive capitalism.[51]

Paralleling Marsh's reproach of "so-called improvement," Blythe's desublimating vision of progress in *Prospecting* diverged dramatically from Romantic spectacles of modern industry. Since the eighteenth century, European artists had rendered factories and other "Satanic mills" using the aesthetic language of the sublime in order to historicize their unprecedented energy and drama. The longevity of such industrial Romanticism can be seen well into the nineteenth century, as in *Burning Oil Well at Night, near Rouseville, Pennsylvania* by James Hamilton (1819–1878) (fig. 170), depicting an American petroleum fire. Recalling earlier European images of volcanic eruptions, Hamilton's pyrotechnic picture attracts the eye but has none of Blythe's biting wit.[52]

Prospecting also differs substantially from matter-of-fact industrial imagery that proliferated in photography during the period, as in a series of pictures by Watkins documenting hydraulic gold mining at the "Malakoff Diggins" in Nevada

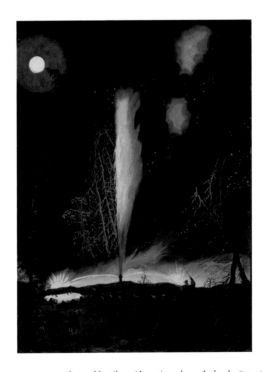

FIGURE 170: James Hamilton (American, born Ireland, 1819–1878), *Burning Oil Well at Night, near Rouseville, Pennsylvania*, ca. 1861. Oil on paperboard, 55.9 × 40.9 cm. Smithsonian American Art Museum, Washington, DC. Museum purchase (1977.50)

County, California (fig. 171). In order to accelerate and maximize extraction, miners used high-powered water hoses to wash away tons of earth, exposing valuable ore. The process clogged rivers with eroded silt and left behind a devastated landscape, which the environmental historian Gareth Hoskins has called "a kind of industrial Grand Canyon." Although Watkins's *Malakoff Diggins* broadly resembles *Prospecting* by revealing the human capacity to modify terrain on a large scale, the photograph belongs to an archival genre quite distinct from Blythe's painted diatribe. After all, Watkins was a lifelong friend and beneficiary of the railroad tycoon Collis Huntington, with whom he had moved to San Francisco in 1851 in pursuit of gold. That venture was unsuccessful, but their ongoing association proved very profitable to the photographer in other ways, notably by providing access

to an elite circle of patrons and free train travel to take pictures. *Malakoff Diggins* offers no indictment of industrialism; Watkins produced his hydraulic mining photographs on commission as a business archive for the very firm conducting the operations depicted, the North Bloomfield Gravel Mining Company.[53]

Recent scholarship on Blythe's *Prospecting* has construed the picture as an allegory about the birth of petroleum in western Pennsylvania, where the artist lived and worked during much of his last decade. Such interpretation recycles a familiar American story about the beginnings of industrial petroleum extraction at Oil Creek, near Titusville, Pennsylvania, a hundred miles north of Pittsburgh. There, in 1859, an entrepreneur named Edwin Drake and his hired assistant William Smith struck "black gold," drilling

FIGURE 171: Carleton E. Watkins (American, 1829–1916), *Malakoff Diggins, North Bloomfield, Nevada County, Cal.*, ca. 1869. Albumen print, 38.1 × 52.4 cm. Stanford Libraries. Special Collections & University Archives (917.94.W335 FF BB)

a commercial oil well using a steam-powered salt-well borer with metal piping.[54]

The problem with this mythic narrative about American origins is that it privileges Western technology and ignores the fact that large-scale oil extraction has a much older, international history. As noted by Ghosh, "the history of Burma's oil industry goes back much further, possibly even a millennium or more," and "oil from natural springs, sinks, and hand-dug pits has of course been used in many parts of the world since ancient times." Among other sources, Ghosh quotes a 1795 British report describing Burmese "earth oil" stacked in "immense pyramids of earthen jars" and "several thousand jars filled with it ranged along the bank." When the British invaded Burma, seizing its oil operations in 1885, knowledge of this early industrial activity was forgotten, accommodating other origin myths. The resulting historical erasure and reinscription paralleled the dispossession of Indigenous land for the construction of American "wilderness" parks.[55]

Embracing the famous American origin story about Drake, art historians have assumed that Blythe set *Prospecting* in the "Petrolia" region of northwestern Pennsylvania, near Pittsburgh, where the painter resided off and on since 1856. Closer scrutiny of evidence plainly visible in the painting, however, reveals that Blythe explicitly referred to oil drilling in West Virginia. The prominent, uppermost sign reading "BULL CREEK CITY" names a specific site of rapid petroleum development during the 1860s: Bull Creek, a small tributary of the Ohio River in Pleasants County, West Virginia, only a few miles from the important oil depot of Parkersburg. In one of many contemporary newspaper reports, the *Daily Intelligencer* of Wheeling, West Virginia, published an article on May 6, 1864, about "The Oil Excitement on Bull Creek and Vicinity," saying, "Since Gilfillan and Co. struck oil on Bull creek [*sic*] some weeks ago, the whole country has been filled with speculators, who have wandered all over Tyler, Wetzel, Pleasants, Ritchie and other counties [of West Virginia] in search of surface indications." No nineteenth-century maps or newspapers verify the existence of a community named "Bull Creek City," but Blythe's painted sign in *Prospecting* points to the center of the scene, indicating with dark irony that the "city" in question appears directly before us and that the traveling figure stands in Bull Creek itself.[56]

Blythe therefore intended "Bull Creek City" as a caustic joke about the wholesale transformation of that waterway

FIGURE 172: Jacob Haehnlen (American, 1824–1892), Bull Creek Oil Company, Pleasants County, West Virginia, stock certificate, 1864. Engraving, 27.1 × 18 cm. Private collection

and the surrounding agricultural region by rapid petroleum development, which already extended well beyond Pennsylvania. Although Bull Creeks exist elsewhere around the United States—including one in Columbiana County, Ohio, about twenty miles north of Blythe's boyhood home in East Liverpool, Ohio—the artist clearly had in mind the waterway in the oil-rich region of Pleasants County, West Virginia. This fact is confirmed by another sign he depicted in *Prospecting* that reads "CALF CREEK OPTIONS AND SURFACE INDICATIONS," referring to Calf Creek, a stream running parallel to Bull Creek about one mile north in Pleasants County, where oil drilling was also then under way. Engraved stock certificates for two of the many oil companies operating in this area—the Bull Creek Oil Company and the Calf Creek Oil Company—prove that Blythe's *Prospecting* refers directly to petroleum development there, for West Virginia is the location given for both firms (fig. 172). Contemporary newspapers verify that these companies were founded in 1864 with oil leases on farm property at Bull Creek and Calf Creek in West Virginia, confirming that Blythe must have painted *Prospecting* in either 1864 or 1865 (the year he died). Perhaps he even saw such certificates, since his picture seems to parody their engraved illustrations with idealizing views of petroleum industrial operations.[57]

What was Blythe's interest in West Virginia oil production? As an itinerant painter, he had traveled around the

western Allegheny region of western Pennsylvania, north-central West Virginia, and eastern Ohio in search of portrait commissions for years after growing up in East Liverpool, a town located about one hundred miles directly north of Pleasants County. These were his old stomping grounds. Regardless of whether Blythe actually ever visited Bull Creek or Calf Creek, he very likely read enough about the oil boom in newspaper accounts to know the petroleum industry had become a *regional* phenomenon, not just a Pennsylvania concern. Blythe's expansive critical perspective, informed by history and contemporary media, paralleled that of Marsh and Manet.

The development of West Virginia oil fields also became a matter of urgent national consequence during the Civil War, exemplifying petroleum's power to provoke resource wars. The residents of the region, formerly part of Virginia, seceded from the Confederacy in 1861 and sought admission to the Union. In May 1863, one month before federal approval of West Virginia statehood, Confederate generals William Jones and John Imboden led a raid of fifteen hundred guerrillas into the territory to disrupt railroad traffic and destroy oil operations valuable to the Union war effort. At the Battle of Burning Springs, Jones with his forces wrecked drilling equipment and burned twenty thousand barrels of oil, later reporting to General Robert E. Lee that the Little Kanawha River became "a sheet of fire." This only temporarily slowed oil production in the region, though. One writer at the time could note that "in 1864 confidence began to revive. Well boring was started anew. . . . At the close of the year the excitement was intense."[58]

Blythe supported President Lincoln and the Union, but instead of celebrating the revival of oil production in West Virginia, he envisioned the petroleum industry there in *Prospecting* as a destructive force in its own right. Although the picture contains no reference to the sectional conflict, it presents the extractive industry as another war upon the land, destroying the area's pastoral beauty by reducing it to a wilderness of industrial towers and pollution, nearly devoid of organic life. The critical realism of *Prospecting* anticipates by four decades the investigative journalist Ida Tarbell's famous muckraking account of the petroleum industry in *The History of the Standard Oil Company* (1904), which included this passage describing a shutdown of operations by independent petroleum producers responding to John D. Rockefeller's emerging monopoly circa 1870:

The crowded oil farms where creaking walking-beams sawed the air from morning until night, where engines puffed, whistles screamed, great gas jets flared, teams came and went, and men hurried to and fro, became suddenly silent and desolate, and this desolation had an ugliness all its own—something unparalleled in any other industry of this country. The awkward derricks, staring cheap shanties, big tanks with miles and miles of pipe running hither and thither, the oil-soaked ground, blackened and ruined trees, terrible roads—all of the common features of the oil farm to which activity gave meaning and dignity—now became hideous in inactivity.[59]

Foreshadowing Tarbell's description of "awkward derricks" and "oil-soaked ground," Blythe's picture rendered the fossil-fuel industry as a source of economic development and national power with a tremendous cost. *Prospecting* vividly attests to environmental transformation, economic exploitation, and the artist's personal sense of alienation from a region he had known since his youth.

Constructing the View: Urban Ecology and Environmental Reform

In addition to the large-scale modifications of rural land wrought by war and industry during the second half of the nineteenth century, dramatic changes occurred in the ecology and physical geography of cities. Rapid population growth, swelling congestion, accelerating commerce, worsening pollution, inadequate sanitation, the rise of tall buildings, and other modern phenomena radically altered urban environments. New York City, the fastest growing metropolis in the Americas, had 96,000 inhabitants in 1810 and 942,000 by 1870—nearly a tenfold increase in sixty years. (Mexico City's population, by comparison, was 500,000 in 1900.) These developments led civic leaders and ordinary citizens to raise alarms about the effects of urban conditions on social cohesion and public health, prompting reformers to respond in various ways. In American cities, the most visible and enduring reform initiative during this period was the movement to create large public parks modeled on European prototypes. New York's Central Park, built between 1858 and 1873, was the first major expression of this movement in the Americas (fig. 173).[60]

FIGURE 173: John Bachmann (American, active 1850-1877), *Central Park. New York,* 1863. Ink on paper, 45 × 50 cm. The New York Public Library. Lionel Pincus and Princess Firyal Map Division

For years leading up to the creation of Central Park, advocates had touted both the sanitary and the aesthetic benefits of large, well-designed open spaces as sites of beauty, recreation, and fresh air, ostensibly separated from urban economic activity. In *Letters from Abroad to Kindred at Home* (1841), the American novelist and traveler Catharine Maria Sedgwick (1789–1867) praised the attractive public parks she saw in London as "the lungs of a city; its breathing-places," comparing them favorably to the diminutive squares then available in "our city of New-York." "I wonder," she observed rhetorically, "if some of our speculating *lot-*mad people would not like to have the draining of their adorning-waters" or "the spirit of health and the healthiest pleasure from these beautiful grounds." Picking up this sanitary-aesthetic discourse, the poet and journalist William

Cullen Bryant (1794–1878) wrote an 1844 editorial in the *New-York Evening Post*, calling for "A New Public Park" in Manhattan as a "pleasure ground for shade and recreation." Bryant noted that while "all large cities" in Europe "have their extensive public grounds and gardens," in New York "commerce is devouring inch by inch the coast of the island, and if we rescue any part of it for health and recreation, it must be done now."[61]

By the mid-nineteenth century, however, leading promoters framed urban parks as a means of social engineering. Between 1848 and 1851, the American landscape architect Andrew Jackson Downing (1815–1852) published a series of letters in his journal the *Horticulturist* endorsing the creation of a large public park in New York. Similar to Sedgwick and Bryant, Downing praised European-style urban parks as

affording "breathing space for pure fresh air," "recreation ground for healthful exercise," and "pleasant roads for riding or driving." But he augmented this conventional argument with a moral vision of social uplift and cultural refinement informed by the picturesque aesthetic sensibilities of his wealthy suburban patrons, who preferred "rural art and rural taste." Celebrating the urban park as "republican in its very idea and tendency," Downing asserted that "it takes up popular education where the common school and ballot-box leave it, and raises up the working-man to the same level of enjoyment with the man of leisure and accomplishment," giving access to "the higher realms of art, letters, science, social recreations, and enjoyments." As the environmental historian Dorceta Taylor observes, by "blending the arguments of rural lifestyle advocates, the sanitary reform movement, and the emerging park movement," Downing "became one of the first to articulate a comprehensive vision for American urban parks … as a valuable source of cultural enlightenment." Environmental issues again were entangled in a larger matrix of moral and social concerns. The emergence of the modern urban park must be understood as the product of a complex political ecology.[62]

Downing would have been the obvious choice among city leaders to design Central Park, but he died suddenly in a steamboat explosion on the Hudson River in 1852, so the newly formed park commission instead selected his protégé, Frederick Law Olmsted. We have already encountered

Olmsted in other contexts, but Central Park was his first important work of landscape architecture and a momentous example of urban environmental reform. In 1858, collaborating with the English immigrant architect Calvert Vaux (1824–1895), another Downing protégé, Olmsted submitted the winning entry in a park design competition held by the commission (fig. 174). Olmsted and Vaux called their entry the *Greensward Plan*, a title deliberately evoking Downing's picturesque ideals of "rural art and rural taste." The plan envisioned various country-like terrains—open meadows, meandering paths for pedestrians and carriages, a wooded "ramble," an arboretum, and a promenade leading to an elegant architectural "terrace" with lake—affording a multitude of spaces and viewing experiences, all carefully screened from the surrounding metropolis by trees. Vaux was the better-trained landscape architect, but Olmsted used political connections, organizational skills, and journalistic abilities to position himself as the primary intellectual force driving the project. Appointed architect in chief from 1858 to 1873, Olmsted oversaw construction of the park on 843 acres of land in Manhattan on a rectangular plot bounded north to south by 110th and 59th Streets and east to west by Fifth and Eighth Avenues.[63]

The park's "construction" needs emphasis here, for its success in producing an illusion of timeless, organic nature tends to obscure its artificiality. Not unlike wilderness parks created during the same period, including Yosemite and Yellowstone, Central Park was an invented space embodying specific

FIGURE 174: Frederick Law Olmsted (American, 1822–1903) and Calvert Vaux (American, born England, 1824–1895), *Greensward Plan for Central Park*, 1858. Ink on paper, 109.2 × 335.3 cm. New York City Municipal Archives

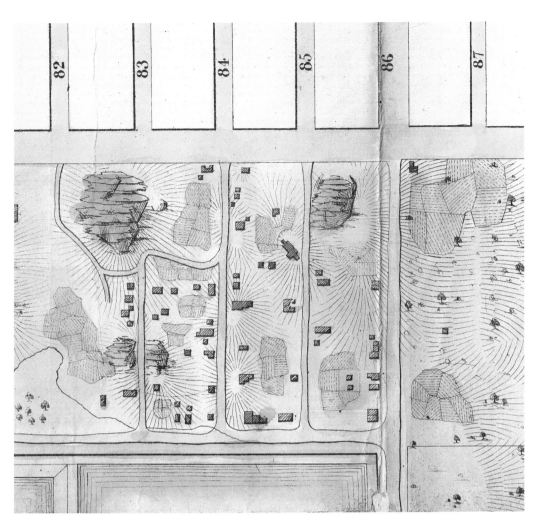

FIGURE 175: Egbert Ludovicus Viele (American, 1825–1902), Detail of Seneca Village from *Map of the Lands Included in Central Park, from a Topographical Survey*, 1856. Ink on paper. Courtesy Geographicus Rare Antique Maps

cultural assumptions while dislocating earlier inhabitants. Building it evicted approximately sixteen hundred residents of the area, mostly working-class Irish, Germans, and African Americans, including the predominantly black community of Seneca Village—a town with three churches, two schools, and two cemeteries, once located on land now occupied by the park near Central Park West between Eighty-Second and Eighty-Ninth Streets (fig. 175). The project also required the removal of some ten million cartloads of stone and other materials as well as the importation of more than eighteen thousand cubic yards of topsoil along with four million trees, plants, and shrubs. As noted by the historians Roy Rosenzweig and Elizabeth Blackmar, park builders used 166 tons of

gunpowder—"more than the amount fired at the Battle of Gettysburg"—in order to cut through massive deposits of gneiss and granite. In 1866, midway through the park building project, this massive earthworks campaign employed twenty thousand laborers and cost $5 million. Constructing the illusion of nature at Central Park was an enormous undertaking, inversely mirroring the Union's destructive military campaign against Southern landscapes during the Civil War.[64]

The park's artificiality appears clearly in the multimedia "presentation boards" Olmsted and Vaux submitted with their *Greensward Plan* competition entry, providing before-and-after views of particular places in order to advertise their projected appearance upon completion. In the center of one board

titled *Greensward Study No. 4: View Northeast toward Vista Rock* (fig. 176), we see a photograph by Mathew Brady showing the "Present Outlines" of an empty field looking toward the elevated area known as Vista Rock. A tiny map above the photograph indicates this location within the park while a small painting below depicts the "Effect Proposed" for this very site, including an artificial lake, planted trees, and gazebo. Not

shown here is the elaborate underground hydraulic system that would make the lake possible. For park commission judges, the dramatic contrast between drab black-and-white photograph and colorful future landscape must have seemed magical. Many visitors to the park today have little or no idea about the scale of this transformation or the infrastructure supporting its picturesque "natural" scenery.[65]

Other depictions of Central Park before its completion eerily document a lost landscape gradually erased by the project. One picture, produced in 1858 by Vaux's brother-in-law Jervis McEntee (1828–1891), presents an unremarkable view resembling that in Brady's photograph (fig. 177). Although rendered in color, the terrain here conveys a similar sense of bland emptiness and availability, affirming its readiness for reconstruction as a park. A later painting by Ralph Albert Blakelock (1847–1919), titled *Old New York: Shanties at 55th Street and 7th Avenue* (1875; Milwaukee Art Museum), represents houses of working-class residents still occupying park grounds nearly two decades later. Tinged with nostalgia about the city's vanishing past, Blakelock's picture expresses a mood of inevitability about impending change.[66]

As we know from his description of Yosemite, Olmsted believed picturesque scenery had an edifying, therapeutic effect upon viewers whom he considered capable of "civilization." While denying "savage" Native Americans that capability at Yosemite, he envisioned "the visitor" to Central Park—a category presumably including all urban residents—as being "in the best sense … the true owner" of its public space and therefore receptive to its positive effects. Accordingly, Olmsted's 1858 report to the commission describing the *Greensward Plan* emphasized the future park's aesthetic benefits as a built landscape with views that would cultivate "agreeable sentiments." With a choreographic sense of visual design he explained how at one location, for example, trees "will come prominently into view" while at other points visitors would experience "a picturesque approach," "picturesque scenery," a drive "commanding the principal views in this vicinity," "views obtainable from Vista Rock," and "extensive views over the park," among other carefully crafted forms of "landscape attraction." In constructing these views, Olmsted declared, "the idea of the park itself should always be uppermost in the mind of the beholder."[67]

In order to keep that idea literally "uppermost" in the beholder's mind and accommodate urban commercial traffic, Olmsted strategically designed four sunken transverse roads

FIGURE 176: Frederick Law Olmsted and Calvert Vaux, *Greensward Study No. 4: View Northeast toward Vista Rock,* 1858. Ink, albumen silver print, and oil on paper, 71.1 × 53.3 cm. New York City Municipal Archives

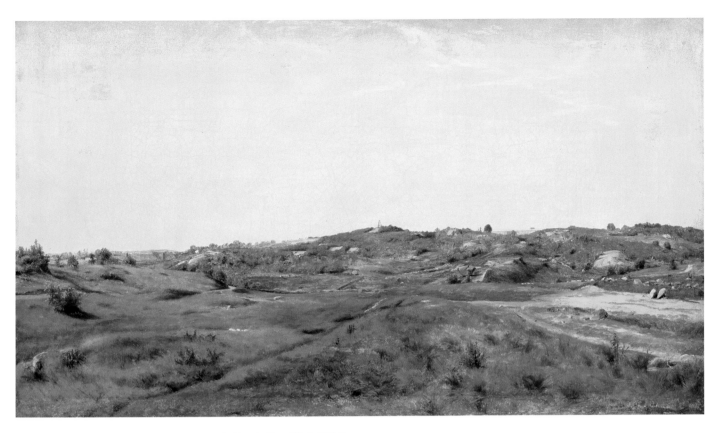

FIGURE 177: Jervis McEntee (American, 1828-1891), *View in Central Park, N.Y.C.*, 1858. Oil on canvas, 34.3 × 60.3 cm. New-York Historical Society (1962.49)

cutting through the park below its picturesque surface at different points. With pragmatic resignation, he explained that "inevitably they will be crowded thoroughfares, having nothing in common with the park proper, but every thing at variance with those agreeable sentiments which we should wish the park to inspire." Viewing business and pollution as metabolic forces to be managed, Olmsted said the roads "must be constantly open to all legitimate traffic of the city, to coal carts and butchers' carts, dust carts and dung carts… a turbid stream of coarse traffic, constantly moving at right angles to the line of the park itself." A contemporary lithograph represents one sunken road from the perspective of that "turbid stream," consisting of livestock, horse carriages, and assorted human types, above which the thickly planted park grounds stand in a separate precinct devoted to Olmsted's carefully constructed views (fig. 178).[68]

Historians of urbanism and landscape architecture generally interpret Central Park as a complex cultural synthesis of elite interests, including picturesque aesthetics, high-value real estate, and social reform of the masses through morally

FIGURE 178: Sarony, Major & Knapp, *Archway under Carriage Drive for Traffic Road across the Park*. Lithograph. Published in *Third Annual Report of the Board of Commissioners of the Central Park* (New York: Wm. C. Bryant & Co., 1860). Princeton University Library. Rare Books and Special Collections

uplifting experiences of nature. For most scholars, the park expresses Olmsted's paternalism and self-proclaimed "natural aristocracy" of taste in response to rapid urban population growth and mass immigration. Comparing the park's scenery with Hudson River School landscape paintings, for instance, Matthew Gandy quotes the influential Marxist writer Raymond Williams, who described such "agrarian bourgeois art" as a fetishized commodity in which we see "rural landscape emptied of rural labour and of labourers … from which the facts of production had been banished." Similarly, Heath Massey Schenker calls Central Park a "melodramatic landscape … rooted in nineteenth-century bourgeois culture," a hybrid of industrial capitalism and older "landscape aesthetics that flourished among the landed aristocracy in England during the eighteenth century."[69]

These scholarly critiques of elitism in urban reform help us understand the dominant forces driving the construction of nature at Central Park, but they tend to ignore or downplay other historical agents that shaped the park, including working people and minorities who asserted their right to public space. Park usage evolved over decades in a long, complex process of political negotiation and conflict. Visitation was never monolithic, even in the early years. In 1860 the *New York Times* reported the park already "was visited during the day by hardly less than ten thousand persons" in an article headlined "How New York Breathes on Sunday: The Working Men of the Metropolis Filling Their Lungs for the Week." In December that same year, the *New York Herald* reported "Fifty Thousand Visitors to the Park," noting that "Sunday being a day of leisure and recreation to the working classes of the community, thousands of these took advantage of their opportunity to visit the great public resort." Many similar articles appeared in the press during the 1860s and 1870s, often highlighting the park's large crowds and its health benefits as the city's "lungs." Although the park labor force was racially segregated during the nineteenth century, newspapers noted the presence of black and other minority visitors. In 1875, for example, the *New York Herald* described how "a wondrous variety of faces thronged the neighborhood of the music stand," such that "blondes, brunettes, creoles, quadroons, octaroons [sic] and blacks were among the types of complexion to be seen." A diverse public space from the beginning, Central Park attracted more than just elite white residents who owned expensive real estate along Fifth Avenue.[70]

Gandy concludes his analysis with a grudging acknowledgment of the park's unexpected benefits, despite its elite conceptual origins:

> The fact that Central Park has been admired and appreciated by generations of New Yorkers is an ironic outcome of the combination of an Anglophile aesthetic vision with sophisticated real estate speculation. The transformation of Central Park into a popular and enduring public space disrupted Olmsted's rarefied vision yet reveals the extent to which the park was as much the creation of a whole city and its people as the work of any single individual.[71]

We might expand on Gandy's observation to include the trees, plants, flowers, rocks, air, birds, and other nonhuman entities responsible for helping to generate the park's ongoing vitality. Recognizing this complex array of agents does not erase politics or history; it enriches our understanding of the park as an environment that was never foreclosed by its picturesque framing in the *Greensward Plan*. That is, Central Park is not simply the product of elite aesthetics and social engineering but rather a larger living assemblage that has far exceeded the vision of Olmsted, Vaux, and their fellow civic reformers.

Contemporary artists have addressed the complexity of this assemblage. In 2015, for example, Karyn Olivier (born 1968) brought together some of the historical threads under discussion here in a temporary installation at Central Park titled *Here and Now/Glacier, Shard, Rock* (fig. 179). Located near the Harlem Meer in the northernmost area of the park, her installation consisted of a dynamic lenticular billboard with changing images of a glacier, a pottery shard from Seneca Village, and rocks. These objects from different epochs of the park site came in and out of view depending on the beholder's perspective. As one observer explained, the work "elegantly reminds us of the constantly mutable nature of the Park and its history," including its geological past and its modern political ecology. *Here and Now* reframed Olmsted's picturesque landscape from Olivier's viewpoint as an African American woman attentive to human difference and nonhuman agency.[72]

In addition to Central Park, Olmsted designed dozens of other urban parks in cities across North America during the late nineteenth century as part of the City Beautiful movement, including Boston, Brooklyn, Buffalo, Chicago, Detroit,

FIGURE 179: Karyn Olivier (born Trinidad and Tobago, 1968, active in the United States), *Here and Now/Glacier, Shard, Rock*, 2015. Sculptural billboard installation, Central Park, New York. Courtesy of the artist

Montreal, and Washington, DC. One major project he did not design, however, was Philadelphia's Fairmount Park, built along the banks of the Schuylkill River northwest of the city center. Named after a hill overlooking the river that Philadelphia founder William Penn had called "Faire Mount," the park initially took shape during the early nineteenth century, when the city opened a public waterworks there with surrounding gardens and pathways. By the 1850s water pollution from industry along the Schuylkill prompted Philadelphia's leaders to commission a park designed on Downing-style picturesque principles. But its small size (130 acres) could not keep up with rapid population growth and worsening contamination from the city's proliferating cesspools, slaughterhouses, mills, and tanneries upstream. In 1867 a new Fairmount Park Commission expropriated

additional land, removed industrial operations along the river, and incorporated nearby historic estates into an expanded public space encompassing two thousand acres—more than twice the size of New York's Central Park. Overseen by the German landscape architect Hermann J. Schwarzmann (1846–1891), construction of Fairmount Park unfolded quickly, enabling Philadelphia to host the 1876 Centennial Exposition, a world's fair on the site attended by ten million visitors.[73]

During the 1870s Philadelphia's leading artist, Thomas Eakins (1844–1916), produced a series of paintings depicting outdoor life around the city, including sporting activities on the Schuylkill River and other waterways. Having just returned from four years of academic art training in Europe, Eakins created *The Champion Single Sculls (Max Schmitt in a Single Scull)* (fig. 180) for an 1871 exhibition at Philadelphia's

Union League Club, an organization of wealthy military veterans and civic leaders, some of whom were influential in planning Fairmount Park and the Centennial Exposition. Set on a stretch of the Schuylkill River northwest of downtown Philadelphia where the park was then under construction, *The Champion Single Sculls* represents the artist's friend Max Schmitt, a lawyer and competitive rower, practicing his athletic pastime. The muscular Schmitt appears in the foreground boat, calmly gliding and gazing toward us on a clear autumn day in the late afternoon. Downstream is a boat inscribed "EAKINS" manned by the artist, a self-portrait testifying to his friendship with Schmitt and knowledge of the sport as a fellow member of the Undine Barge Club, one of Philadelphia's private men's rowing clubs on Boathouse Row. Farther south appear various realistic details and emblematic markers of Philadelphia, including a family of ducks, a group of Quakers rowing an old-fashioned boat, modern bridges, and Sweetbriar, one of the historic rural estates incorporated into Fairmount Park. Not visible, however, is the substantial demolition and park construction work then under way along the river or the remaining signs of modern blight that still tainted the Schuylkill watershed, both ecologically and aesthetically. In other words, Eakins here crafted an ideal prospect—a filtered view—consistent with the urban reform vision of civic leaders in charge of implementing it. The picture also tacitly affirmed conditions of white privilege and racial exclusivity then defining the Union League and Boathouse Row, including the Undine Barge Club, which remained segregated well into the twentieth century.[74]

In his 1876 *Rail Shooting on the Delaware* (fig. 181), another painting of Philadelphia outdoor life, Eakins represented a hunting scene in The Neck, a marshy area near the convergence of the Delaware and Schuylkill Rivers. Located two miles downstream from Fairmount Park, south of central Philadelphia, this rural wetland region was then inhabited by poor, working-class blacks and immigrants. The area also served as a convenient getaway for well-to-do urban excursionists such as the artist's friend Will Schuster, whom we see here hunting marsh birds from a boat propelled and steadied by an unidentified African American laborer. Both men stand still, each concentrating intently on his respective task, their minutely detailed physiognomies and bright shirts contrasting vividly with the vaguely painted background marsh vegetation. Despite the meticulous realism of these figures, *Rail Shooting on the Delaware* presents another idealized view of an emblematic Philadelphia regional sporting activity enjoyed by men like Eakins with the auxiliary labor of others. Here the artist acknowledged the presence and skill of black people, but he tactfully omitted the humble dwellings of local residents and all signs of industrial modernity then transforming the area, including the notorious pollution from an enormous oil refinery and the Philadelphia Naval Yard, a massive new military complex occupying League Island, at the southern tip of The Neck.[75]

When the national magazine *Scribner's Monthly* published an essay by the travel writer Maurice Egan in 1881 describing The Neck as a rustic rural retreat for middle-class urban readers, the article reproduced *Rail Shooting on the Delaware* along with illustrations by Eakins's students. In contrast to Eakins's anodyne representation of white leisure and black labor, his students examined the social and environmental realities of the area in a more pointed manner. For example, an illustration by Henry Rankin Poore (1859–1940) titled "Outdoor Tenants" revealed evidence of poverty by showing an untended infant crawling on the broken porch of a ramshackle house with chickens and sleeping dogs in the front yard. Another illustration, by Joseph Pennell (1857–1926), depicted the modern refinery with smokestacks belching black soot into the air while the "rainbow-hued pools" of oily water mentioned in Egan's text appear in the foreground. During these years, Eakins was a young, ambitious

FIGURE 180: Thomas Eakins (American, 1844-1916), *The Champion Single Sculls (Max Schmitt in a Single Scull)*, 1871. Oil on canvas, 81.9 × 117.5 cm. The Metropolitan Museum of Art, New York. Purchase, The Alfred N. Punnett Endowment Fund and George D. Pratt Gift, 1934 (34.92)

FIGURE 181: Thomas Eakins, *Rail Shooting on the Delaware*, 1876. Oil on canvas, 56.2 × 76.8 cm. Yale University Art Gallery. Bequest of Stephen Carlton Clark, B.A. 1903 (1961.18.21)

FIGURE 184: Thomas Pollock Anshutz (American, 1851–1912), *The Ironworkers'*
Noontime, 1880. Oil on canvas, 43.2 × 60.6 cm. Fine Arts Museums of San
Francisco. Gift of Mr. and Mrs. John D. Rockefeller, 3rd (1979.7.4)

subject to such conditions, said this writer, "it is not their
labor, simply, against capital, but *life* and labor." More than
just an artistic exercise, *The Ironworkers' Noontime* registered
the political ecology of urban industrial work at a moment
of growing public tension and concern.[81]

Perhaps the pithiest verbal expression of emerging aware-
ness about the influence of city environments on human
behavior and quality of life came from Felix Adler, the
founder in 1876 of the Society for Ethical Culture and an
activist in New York's Reform Judaism community. Accord-
ing to Adler, "It is not the squalid people that make the
squalid houses, but the squalid houses that make the squalid
people"—a statement quoted by Riis in an 1884 article
titled "The Tenement House Question" for the *New-York*

Daily Tribune. In *How the Other Half Lives*, Riis reformulated
Adler's insights, declaring, "In self-defence, you know, all
life eventually accommodates itself to its environment, and
human life is no exception." This universalizing voice
went hand in hand with Riis's propensity for using ethnic
and racial stereotypes, sometimes denigrating entire human
groups—particularly the Chinese—for their perceived
inability to overcome ingrained habits and live up to his
standards of social behavior.[82]

Riis's most well-known picture, titled *Bandits' Roost, 59½*
Mulberry Street (fig. 185), depicts a crowded tenement alley in
lower Manhattan near his newspaper office. As with all his
photographs, Riis intended this to represent the grim living
conditions among the urban poor as a threat to public health

and social order, premised on the aforementioned beliefs about environmental influence. His picture's title insinuates that this notoriously cramped and grimy slum area, known as Mulberry Bend, functioned as an incubator of crime—a threat suggested by the menacing looks and poses of the working-class residents, one of whom holds a large wooden stick or club. Consistent with Riis's statement that "all life eventually accommodates itself to its environment," the titular "roost" metaphor eroded assumptions about human exceptionalism by associating this urban neighborhood with an animal's nest.[83]

It is important to understand the circumstances in which photographs such as *Bandits' Roost* were originally created and published, because Riis's later aesthetic canonization by modernist artists, curators, and art historians has distorted his work by decontextualizing it. For one thing, Riis did not actually operate the camera himself for this particular picture. Instead, he supervised its exposure, somewhat like a film director or choreographer. *Bandits' Roost* was one of several early "Jacob Riis" photographs taken sometime during 1887 or early 1888 by Richard Hoe Lawrence (1858–1936) and Henry Granger Piffard (1842–1910), collaborators recruited from the Society of Amateur Photographers of New York. Operating a stereographic camera under Riis's direction, Lawrence simultaneously exposed two negatives with slightly different (stereoscopic) views, only one of which you see here. In nocturnal settings Piffard or Riis exploded a flash by igniting magnesium powder in a cartridge shot from a revolver (as in fig. 182). Riis included *Bandits' Roost* in his debut lecture with lantern slides at the photography society in January 1888, an event arranged by members Lawrence and Piffard. After that lecture they went separate ways and Riis began to take his own pictures.[84]

In 1890 Riis's publisher, Charles Scribner's Sons, reproduced *Bandits' Roost* in *How the Other Half Lives* using an innovative halftone process, which rendered the photograph with a grainy texture that looks fuzzy to our twenty-first-century eyes (fig. 186). For Riis's contemporaries, though, its photographic realism powerfully affirmed the book's argument. As the historian Bonnie Yochelson notes, "By not masking the disorienting graphic qualities of the photographs, the publisher encouraged readers to experience them as proof of the deplorable social conditions that Riis was seeking to improve." In contrast to the appearance of *Bandits' Roost* in the first edition of Riis's book, the modern print reproduced in

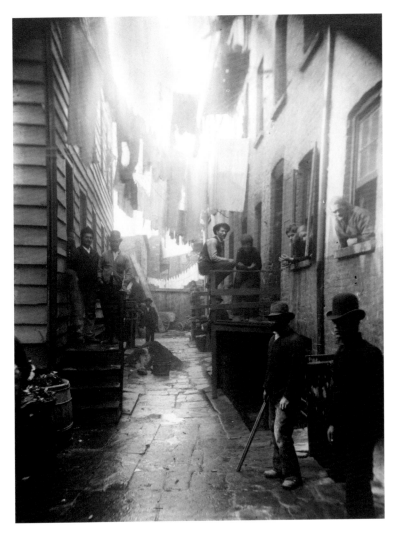

FIGURE 185: Richard Hoe Lawrence (American, 1858-1936) and Henry Granger Piffard (American, 1842-1910) for Jacob August Riis, *Bandits' Roost—A Mulberry Bend Alley* [*Bandits' Roost, 59½ Mulberry Street*], ca. 1888, printed ca. 1957 by Ansel Adams (American, 1902-1984). Gelatin silver print, 45.7 × 35.6 cm. Museum of the City of New York. Jacob A. Riis Collection (57.338)

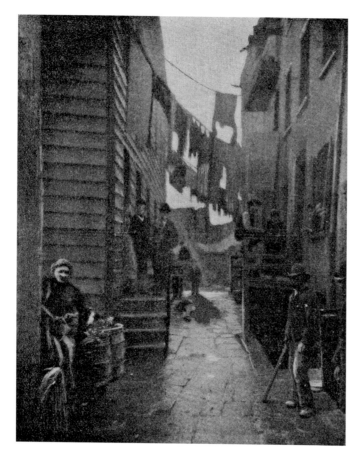

FIGURE 186: *Bandits' Roost*, ca. 1888, in Jacob August Riis, *How the Other Half Lives: Studies among the Tenements of New York* (New York: Charles Scribner's Sons, 1890). Princeton University Library. Rare Books and Special Collections

figure 185—an enlargement made by Ansel Adams from an original negative—presents a cleaner version more appealing to modernist aesthetic sensibilities. Of the two stereographic negatives, Adams selected the one that cropped out the woman with two children standing at left. This choice downplayed Riis's intended sense of tenement overcrowding and related public health concerns, which he underscored in the accompanying text with troubling statistics about high mortality rates among poor children in Mulberry Bend. The book also referred repeatedly to negative effects of what he called the "tenement house system."[85]

After publishing *How the Other Half Lives*, Riis became a celebrity, earning accolades from critics and even the friendly admiration of President Theodore Roosevelt, who called him "the best American I ever knew." For a few more years, Riis continued to take photographs, give lectures, and publish newspaper articles promoting urban environmental reform. In 1891 he turned his attention away from Lower East Side

tenements to dangerous pollution affecting other areas, including the city's public water source and several trash dumps near urban wharves. In an article titled "Some Things We Drink," Riis "sounded the warning" about tainted water, examining "every stream that discharged into the Croton River" while photographing "chicken killeries"—a critical exposé about slaughterhouses anticipating by more than a decade Upton Sinclair's 1906 novel *The Jungle* set in Chicago's meatpacking district. In 1892 Riis published a piece headlined "Real Wharf Rats: Human Rodents That Live on Garbage under the Wharves," describing the abominable habitations and working conditions of immigrant Italian ragpickers at the Rivington Street Dump. Noting these dump dwellers lived with "myriads of rats and bands of frowsy, ill-favored curs, and here and there a goat, that feed with them off the refuse of the ash barrels on equal terms," he also offered expressions of sympathy, concluding his article by asking ambiguously, "Ought the police to let them stay? Can they drive them out at all? Some say they can't." His photograph *In Sleeping Quarters— Rivington Street Dump* (fig. 187), reproduced as a line drawing in the latter article, projects similar ambiguity. While displaying abject poverty, the image also registered a sense of human resilience, agency, and order in the ragpicker's unflinching stare and material possessions, including a decorative picture carefully hung from the hovel wall. Here, amid squalor, we glimpse the complexity of Riis's vision of "self-defence," whereby "life eventually accommodates itself to its environment."[86]

If Riis disavowed artistic intentions in representing poor urban residents and environmental conditions, a younger group of painters approached similar subject matter in New York circa 1900 with explicit aesthetic ambitions. Leading figures in this group—George Bellows (1882–1925), William Glackens (1870–1938), George Luks (1867–1933), Everett Shinn (1876–1953), John Sloan (1871–1951), and their influential teacher Robert Henri (1865–1929)—all had professional roots in Philadelphia. Henri studied at the Pennsylvania Academy, traveled in Europe, and then returned to Philadelphia, where he mentored Glackens, Luks, Shinn, and Sloan in fine art theory and practice during the 1890s. Leveraging their experience as illustrators for the *Philadelphia Press* newspaper, Henri encouraged them to use a journalistic humanism in picturing the fleeting vitality of urban modernity. Shortly after 1900 the pupils joined several other young artists in studying with Henri at the New York School of

Art. Exploring the city's gritty immigrant neighborhoods in search of subject matter, they worked not as social activists or urban reformers like Riis but rather as sympathetic observers akin to Baudelaire's *flâneur*, aspiring to produce a new national art centered on the lives of ordinary people. Henri articulated their shared goal of creating "an American art" in earthy, masculine terms:

> For successful flowering it demands deep roots, stretching far down into the soil of the nation, gathering sustenance from the conditions in the soil of the nation, and in its growth showing, with whatever variation, inevitably the result of these conditions....But before art is possible to a land, the men who become the artists must feel within themselves the need of expressing the virile ideas of their country....First of all they must possess that patriotism of soul which causes the real genius to lay down his life, if necessary, to vindicate the beauty of his own environment.[87]

Whereas Riis believed "environment" influenced public health and demanded reform, Henri viewed it as something deeply rooted in "the soil of the nation," an object of "beauty" that only demanded vindication, not change. Riis the photojournalist was no less proud of America, but he never espoused such aesthetic quietism. Henri's essentialist terminology about "roots," "soil," and "his own environment" originated in the evolutionary naturalism of European social Darwinists such as Hippolyte Taine and Herbert Spencer, whose ideas also influenced his American heroes, Thomas Eakins and Walt Whitman.[88]

Henri's disciples developed a somewhat broader perspective that occasionally approached Riis's reformist environmentalism. For example, in an etching from a series produced in 1905–6 titled *New York City Life*, Sloan examined social and environmental conditions of urban tenement life in the summertime, when working-class residents escaped the heat of their poorly ventilated apartments by sleeping on roofs in the open air (fig. 188). Riis had described this phenomenon with unflinching realism, saying, "On very hot nights a sort of human shower regularly falls in the tenement districts of sleepers who roll off the roofs where they have sought refuge from the stifling atmosphere of their rooms." Sloan's *Roofs, Summer Night* presents a more peaceful vision of humanity coping with these difficult conditions. Reconciling Henri's

FIGURE 187: Jacob August Riis, *An Italian Home under a Dump* [*In Sleeping Quarters—Rivington Street Dump*], ca. 1890. Lantern slide from a gelatin silver transparency, 10.2 × 12.7 cm. Museum of the City of New York. Jacob A. Riis Collection (90.13.2.106)

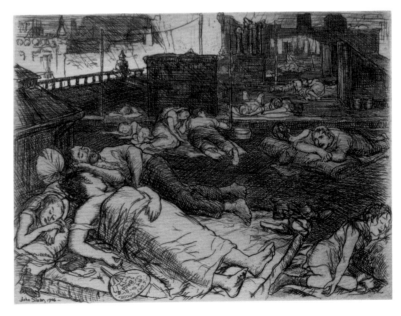

FIGURE 188: John Sloan (American, 1871-1951), *Roofs, Summer Night*, from the series *New York City Life*, 1906. Etching, 13.3 × 17.8 cm. The Metropolitan Museum of Art, New York. Gift of Mrs. Harry Payne Whitney, 1926 (26.30.23)

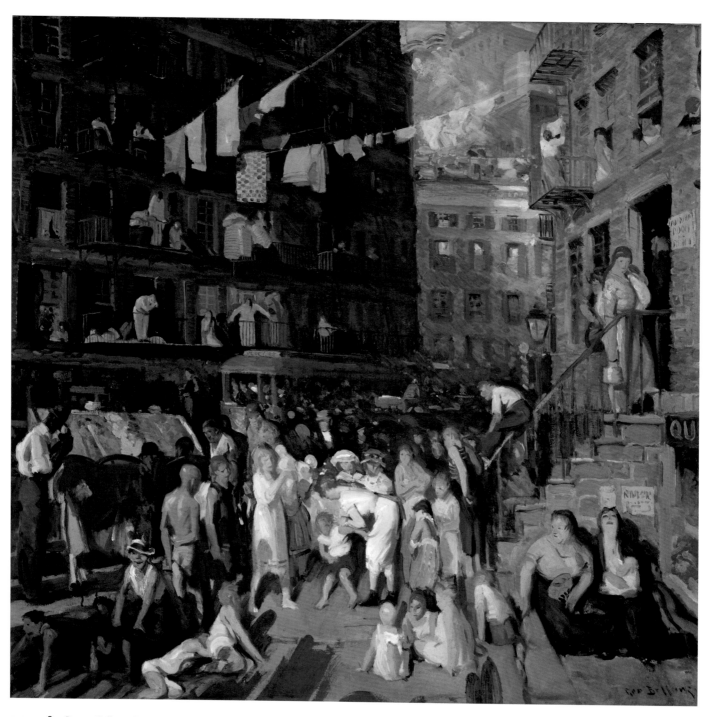

FIGURE 189: George Bellows (American, 1882–1925), *Cliff Dwellers*, 1913. Oil on canvas, 102.1 × 106.8 cm. Los Angeles County Museum of Art. Los Angeles County Fund (16.4)

aesthetics with Riis's idea of environmental "self-defence," Sloan depicted working-class resilience in the face of poverty and heat. Wavy etched lines capture the vibrant materiality of perspiration-drenched clothing and soaked strands of hair, but we see no falling bodies.[89]

With lustier humor, Bellows's large oil painting *Cliff Dwellers* of 1913 (fig. 189) represents the crowded tenements of lower Manhattan in daytime, albeit with dramatic contrasts of light and shadows cast by tall buildings obscuring the sun. Here we see an ocean of urban, working-class humanity. Children conspicuously inhabit the foreground pavement, some accompanied by adults and others unattended. A shirtless man stands immodestly beside a pair of young women, one of whom carries an infant. Racial and ethnic diversity is evident as well, for we observe a black man at left and several pale-skinned people with red hair connoting Irishness. Behind the central scene flows a street full of traffic including a wagon and packed streetcar. A veritable jigsaw puzzle of apartment buildings looms above, their residents observing the swirl of activity below from windows and balconies draped with laundry. At right, shop signs clamor for attention near two women seated on the pavement, one holding a fan and the other asleep cradling a child, her head tilted back and mouth open snoring.

Bellows's title for the picture invokes a popular metaphor comparing urban residents to ancient cliff-dwelling peoples of the Southwest, a group made nationally famous by an anthropological exhibition at the World's Columbian Exposition in Chicago in 1893. Referencing that exhibition, the author Henry Blake Fuller published a realist novel titled *The Cliff-Dwellers* (1893) critically examining aggressive economic ambition and social depravity in Chicago, a city well known for its modern skyscrapers and real estate speculation. When Bellows painted his picture two decades later, "cliff dwellers" had become a more generalized reference to urban residents of various class groups in cities around the country. By using the familiar cliché to describe working-class immigrants in Lower Manhattan, Bellows intended a humorously patronizing reference. As the art historians Robert Snyder and Rebecca Zurier observe, "the tenement's residents are not just inhabitants of vertical structures but, by implication, a primitive people; the effect is condescending." The artist's elaborate color calculations based on the arcane theory of tonal "chords" espoused by Hardesty Gilmore Maratta (1864–1924) reinforce a sense of aesthetic detachment from

considerations of socioenvironmental reform. Bellows's middle-class, Midwestern upbringing in Columbus, Ohio, also gave him a "native" perspective quite different from that of his alien immigrant subjects, making the titular reference to ancient Indigenous "cliff dwellers" richly ironic.[90]

And yet *Cliff Dwellers* projects an upbeat sense of vitality about urban working-class people and their environment, consistent with the humanism of Henri and the sympathetic observations of Riis. Despite obvious overcrowding, the community depicted here exudes lively color and joy, not defeat or victimization. Despite the evidence provided by Riis and other public health reformers about negative environmental impacts of congested and polluted tenements, *Cliff Dwellers* credits poor urban residents with more than a little capacity to survive and even thrive in such conditions. Moreover, Bellows clearly thought about issues of social and environmental inequity in relation to *Cliff Dwellers*, for he reproduced the composition that same year in a lithographic transfer print titled *Why Don't They All Go to the Country for a Vacation?*, referring sardonically to the economic constraints preventing poor people from leaving the city and experiencing more genteel, suburban forms of leisure than those available at Central Park.[91]

Like Sloan, Bellows was a political leftist who contributed illustrations to the socialist periodical the *Masses* during these years. In the medium of magazine illustration (for which Bellows may have created *Why Don't They All Go to the Country for a Vacation?*), he and Sloan more forcefully addressed political issues. According to the *Masses* editor Art Young, however, their aesthetic blend of humanistic optimism and humor did not sufficiently advance the journal's activist goals. Young condemned Sloan and Bellows for preferring "art" to "policy," saying, "They want to run pictures of ash cans and girls hitching up their skirts in Horatio Street [in Manhattan's West Village]—regardless of ideas." This criticism, formulated explicitly in terms of urban environmental conditions, tarred the artists with an epithet by which they became known in art history: the Ash Can School.[92]

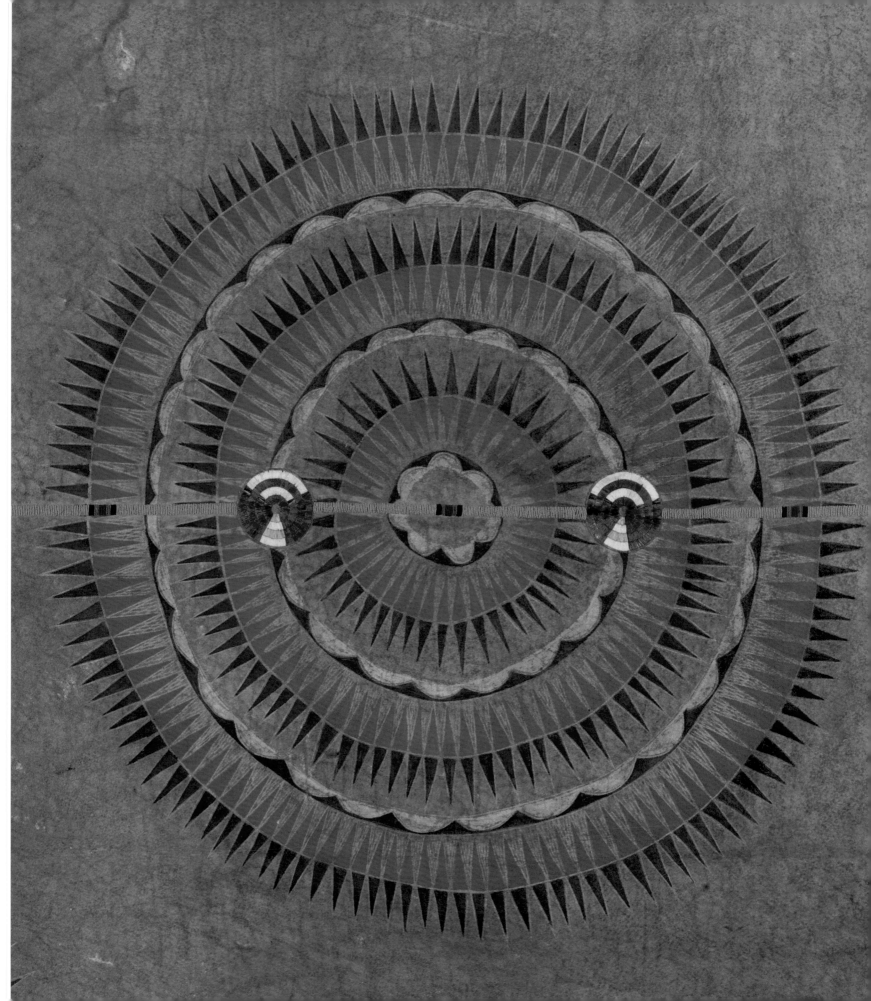

Alan C. Braddock

Icon of Extinction and Resilience

In 1882 an unidentified Lakota woman at the Standing Rock Reservation in the Dakota Territory created a man's robe by tanning the hide of an American bison (*Bison bison*, commonly known as the American buffalo), adding abstract patterns of paint and woven dyed porcupine quills to produce a garment with utilitarian and spiritual significance (fig. 190). Wrapped around the body, fur side in, the robe was designed to provide warmth and express Lakota beliefs about the cosmic relationship between human and nonhuman beings. The central painted pattern, known as a sunburst or feathered sun, consists of three concentric circles of abstract red-and-blue eagle feather motifs, and symbolizes Lakota unity while simultaneously recalling a chief's war bonnet, the sky, and the star in our solar system—source of all life on Earth. The eagle, considered a spiritual pathfinder by virtue of its soaring flight, keen vision, and great strength, serves as an avatar for many Indigenous peoples of the Plains, including the Lakota. During the eighteenth century, in response to European settler colonialism, Lakota people had moved into the Plains from the Great Lakes region, adopting the imported horse and a mobile lifestyle focused on hunting buffalo. This required environmental knowledge of astronomy and geography in order to survive amid changing seasons and herd migrations. As the Lakota scholar David C. Posthumus observes, "Nomadic Lakotas based their seasonal migratory patterns on the bison." In addition to honoring the eagle's flight in the celestial realm where ancestors reside, the feathered sun visualizes Lakota understanding of the buffalo as a kinship relative and spirit being (*Ṫhatȟáŋka*) as well as an embodiment of essential solar potency (*tȟúŋ*), meaning that those who eat and wear the animal absorb sacred cosmic energy (*Wakȟáŋ Tȟáŋka*).[1]

Evidence of the diffusion and continuity of such beliefs among various Plains Indigenous communities can be seen by comparing the Lakota buffalo robe with a robe painted about fifty years earlier by Mató-Tópe (Four Bears) (ca. 1784–1837), chief of the Mandan people, a community that lived along the Missouri River in what is now North Dakota (fig. 191). In this work, collected by a Swiss trader named Alphons Schoch in 1837, we see the familiar sunburst feather pattern with variously colored circular orbs in the center. Surrounding the central solar design, however, Mató-Tópe has depicted himself as a victorious warrior in a series of military battles, wearing red body paint, feathered headdresses, and holding feathered shields and spears. In Plains Native communities, painting such figurative imagery was the prerogative of male warriors, whose self-representations narrated history and validated their status. Mandan women would have prepared Mató-Tópe's robe by skinning and tanning the hide of a buffalo (likely hunted by him), and a woman may also have painted the abstract feathered sun motif, but only the chief was allowed to depict himself in battle.[2]

The Lakota buffalo robe, in addition to expressing enduring beliefs within Plains Native cosmology, embodies particular historical conditions at an especially fraught moment in the Indigenous-colonial encounter. In the early 1880s, the US government forced Lakota and other Plains Native communities onto reservations following years of encroachment, broken treaties, and military conflict. This struggle was punctuated by the Battle of the Little Bighorn in 1876, when Lakota, Northern Cheyenne, and Arapaho warriors famously defeated the Seventh Cavalry, led by Lieutenant Colonel George Armstrong Custer, who was killed along with more than two hundred of his troops. Soon thereafter federal

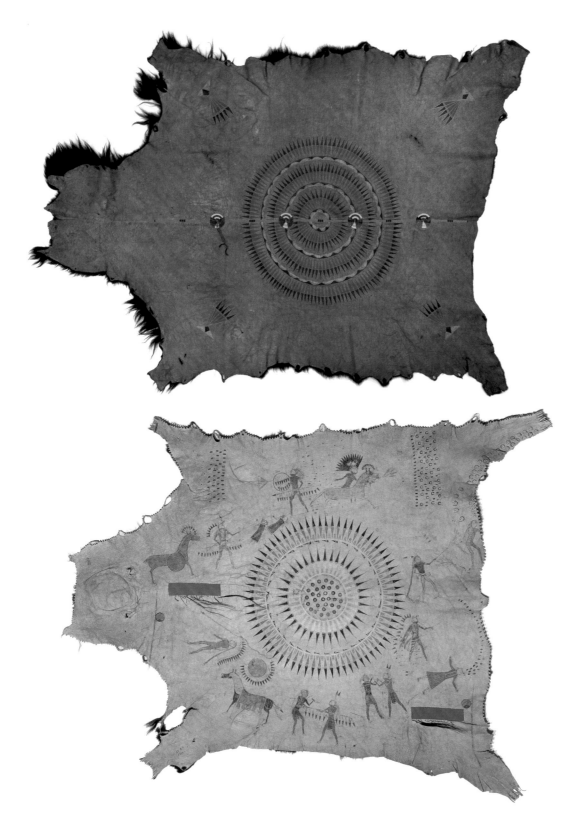

FIGURE 190: Lakota, Standing Rock Reservation, *Buffalo Robe*, 1882. Bison hide, sinew, beads, porcupine quills, pigment, 182.9 × 248.9 cm. University of Pennsylvania Museum of Archaeology and Anthropology, Philadelphia. Purchased from James H. McLaughlin, 1911 (NA3987)

FIGURE 191: Mató-Tópe (Four Bears) (Mandan, ca. 1784–1837), *Buffalo Skin Robe*, ca. 1837. Bison hide, wool stroud, sinew, porcupine quills, human and horse hair, pigment, 160 × 210 cm. Bernisches Historisches Museum, Bern, Switzerland (E/1890.410.0008)

authorities reasserted control in the region by taking additional land and prohibiting the traditional Sun Dance (*wiwáyáǧ wachípi*), a Lakota calendrical ritual of renewal and regeneration associated with the annual communal buffalo hunt. By the early 1880s, Indigenous peoples of the the Plains were systematically forced into captivity and assimilation within Anglo-American market capitalism, including the production of buffalo robes for sale.[3]

The Lakota robe reproduced in figure 190 was purchased in 1882 by John McLaughlin (1842–1923) shortly after his appointment as the US "Indian agent" at Standing Rock. Canadian by birth, McLaughlin had immigrated in 1863 to Saint Paul, Minnesota, where he married Marie Louise Buisson (1842–1924), a Mdewakanton woman of Quebecois-Scottish ancestry with whom he raised seven children. After serving at other US Army outposts and agencies in the Dakota Territory, McLaughlin was posted to Standing Rock in 1881, and tasked with encouraging the Lakota and Dakota to assimilate. There he also implemented the Dawes Act of 1887, which divided Native reservation lands into private allotments for subsistence farming by Natives and non-Natives, effectively ending Indigenous nomadism and communal land-use traditions. On December 15, 1890, McLaughlin ordered the arrest of Tȟatȟáŋka Íyotake (Sitting Bull) (1831–1890) in an effort to stop this celebrated Hunkpapa Lakota holy man and leader from participating in the Ghost Dance, a pan-tribal series of spiritual ceremonies dedicated to reanimating lost ancestors, reviving decimated buffalo herds, and conjuring away white settlers. Sitting Bull's death in the fight surrounding his arrest exacerbated tensions between Natives and whites leading up to the Wounded Knee Massacre at Pine Ridge Reservation on December 29, 1890, when the Seventh Cavalry killed some two hundred Lakota men, women, and children. The Lakota buffalo robe, produced in the face of ongoing subjugation and violence, asserts unbroken Indigenous spiritual belief and cultural resilience.[4]

Still more can be said about this remarkable creative work, for it also illuminates the complex environmental history of the Plains as a region radically transformed by Anglo-American settler colonialism in the nineteenth century. In addition to destroying Indigenous human communities, US soldiers, railroads, agriculture, commercial hunting, and the hide trade brought bison to the brink of extinction. Before colonization, as many as thirty million bison had inhabited a range extending east to North Carolina, but they

particularly thrived in the semiarid Plains environment on the region's historic drought-tolerant short grasses, which supported enormous herds during the summer rutting season. The advent of European agriculture and horses in the Plains after the seventeenth century, along with the region's periodic droughts, altered an already volatile ebb and flow in the bison population. As the environmental historian Andrew Isenberg notes, "Beginning in the 1840s, the presence of increasing numbers of Euroamericans in the plains displaced the bison from their customary habitats." Moreover, the introduction of European livestock, diseases, and commerce devastated Indigenous communities, entangling survivors in an increasingly destructive economy of market hunting for bison hides and tongues. Trade in those animal parts expanded rapidly during the 1840s and peaked during the 1870s, when, Isenberg says, "Euroamerican hunters slaughtered millions of bison" with the blessing of federal authorities, who viewed extermination of the species as a method for undermining Native societies and establishing the reservation system. Produced at a time when only a few hundred wild buffalo remained on the Plains, the Lakota robe proclaimed the bison's sacred cosmic significance as the animal was disappearing and as Indigenous peoples were themselves faced with violent change at the hands of American military, religious, and political institutions. As the Lakota artist and scholar Arthur Amiotte describes, "While these transformative institutions were being put into place before the 1887 Dawes Land Allotment Act, Native cultures experienced a hiatus during which their resources were depleted and their lifestyle denied. The bison were methodically decimated to near extinction."[5]

Anthropogenic Extinction

In this book we have already encountered considerable artistic evidence and interpretation of environmental change relating to Euro-American settler colonialism, empire, war, and industry. Emerging knowledge of scarcity, inequity, and extinction resulting from such activities has revealed nature to be a dynamic matrix of complex and often violent interactions, not the eternally static or harmonious realm of the classical Great Chain of Being. During the nineteenth century, environmental transformation acquired new meaning when the capacity of human beings to exterminate an entire species became an international cause célèbre. In the 1840s British

scientists determined conclusively through historical and oste-ological analysis that the dodo (*Raphus cucullatus*) had been a victim of anthropogenic or human-caused extinction. Writing in their treatise *The Dodo and Its Kindred* (1848), the naturalist Hugh Strickland and the anatomist Alexander Melville declared the dodo and related birds that once inhabited the Indian Ocean island of Mauritius to be the "first clearly attested instances of extinction of organic species through human agency." After thriving for centuries in its benign island habitant, the dodo disappeared within less than two hundred years after the arrival of European sailors, who hunted the flightless bird mercilessly for food beginning in the early sixteenth century. Last seen alive in the wild on Mauritius in 1681, the dodo subsequently became a cultural metaphor of ludicrous failure and stupidity, or what the environmental historian Mark Barrow calls "a classic case of blaming the victim." In one of its many famous metaphorical guises during the nineteenth century, the dodo appeared in an illustration by the British artist John Tenniel (1820–1914) for Lewis Carroll's *Alice's Adventures in Wonderland*, absurdly bestowing on Alice a prize thimble for running a "caucus-race" to dry her hair (fig. 192).[6]

During the nineteenth century, the bison became an American national icon of anthropogenic extinction, or near extinction, when commercial hunting nearly extirpated the species, except for a few small, isolated herds in Alberta and at Yellowstone National Park. Assessing this development, Isenberg carefully avoids attributing the destruction of the species solely to human causes, noting that "a host of eco-nomic, cultural, and ecological forces herded the bison toward their near-extinction." Nevertheless, he demonstrates that many Euro-Americans viewed the buffalo's demise—along with the relocation of Native people to reservations—as an inevitable fact of Manifest Destiny. For example, in 1868 General William T. Sherman observed, "It will not be long before all the buffaloes are extinct near and between the railroads." A few years later, the natural scientist Joel Asaph Allen wrote in his book *The American Bisons, Living and Extinct* (1876) that "the period of extinction will soon be reached." In light of such evidence, Isenberg concludes that the mass slaughter of bison between 1870 and 1883 was not the result of a belief "that nature provided an inexhaustible supply," but rather shows that Euro-Americans "anticipated the extinction of the species." In other words, the myth of divine earthly plenitude, which George Perkins Marsh began

FIGURE 192: John Tenniel (British, 1820-1914), Illustration in Lewis Carroll (Charles S. Dodgson), *Alice's Adventures in Wonderland* (London: Macmillan, 1865). Princeton University Library. Rare Books and Special Collections

to dismantle in *Man and Nature* (1864; see pages 35, 129–30), unraveled as the bison's imminent demise entered public discourse. Putting this into an international context, Isenberg describes the bison's collapse as "part of a global decline of mammalian diversity in the nineteenth century"—a develop-ment many scholars now associate with the broader histori-cal patterns of planetary transformation in the Anthropocene. Although the bison was saved from complete extinction by late nineteenth-century conservation efforts, Isenberg's description of its "destruction" as a species accurately captures the scale of ecological transformation resulting from the animal's effective disappearance in the wild. The histori-cal importance of nationalism in determining the bison's survival in small, managed herds on highly controlled pre-serves vividly demonstrates the role of political ecology and culture in constructing ideas about nature.[7]

When did people begin to recognize the American bison's anthropogenic decline in modernity? Although Plains Indians undoubtedly noticed this phenomenon, Posthumus credits the Euro-American painter George Catlin (1796–1872) as one of

the first to remark that buffalo were disappearing. Traveling around the Missouri River valley in 1832, when he met and painted a portrait of Mató-Tópe, Catlin wrote that the bison was "so rapidly wasting from the world, that its species must soon be extinguished." His comment echoed a similar lament by Catlin about Native Americans as "melting away at the approach of civilisation" and therefore "*doomed*" to "perish." In response to what he perceived as the buffalo's impending extinction, Catlin suggested the federal government create "a *nation's Park*" in the Plains where bison and Native peoples "*might* in future be seen (by some great protecting policy of government) preserved in their pristine beauty and wildness." With that racist statement, which imagined bison and Indigenous humans as part of the same tourist spectacle, Catlin was also among the first to imagine the national park system, but the federal government waited several decades before taking action along these lines.[8]

Although better known for his portraits of Native Americans, Catlin also depicted bison on several occasions. He usually showed the animals in groups being hunted communally by Native Americans on the Plains, as in *Buffalo Chase, A Surround by the Hidatsa* (1832–33; Smithsonian American Art Museum), illustrating an equestrian technique of corralling and mass killing. In a departure from such genre scenes, Catlin's *Dying Buffalo, Shot with an Arrow* portrayed a bull in its death throes, bleeding profusely from its nose and wounded belly (fig. 193). This striking picture confronts the viewer with a single animal in distress, tongue hanging out and eyes turned heavenward—a pose seemingly conceived to provoke empathy in the viewer. We should be careful, however, not to interpret Catlin's picture or his remarks about preserving buffalo (or Native peoples for that matter) as uncomplicated expressions of environmentalist sentiment or solidarity. In his published *Letters and Notes on*

FIGURE 193: George Catlin (American, 1796–1872), *Dying Buffalo, Shot with an Arrow*, 1832–33. Oil on canvas, 60.9 × 73.7 cm. Smithsonian American Art Museum, Washington, DC. Gift of Mrs. Joseph Harrison Jr. (1985.66.407)

expressed by another." The illustrator's buffalo ventriloquism was not necessarily an endorsement of the emerging animal-welfare movement in the United States, where the American Society for the Prevention of Cruelty to Animals (ASPCA) was founded in 1866 by Henry Bergh, a vocal critic of bison slaughter. Nevertheless, Nast's illustration reveals the popular currency of concerns about nonhuman intelligence and bison extinction, refracted by class difference.[12]

By 1876, when the United States celebrated its centennial, the American bison had become a national icon and

FIGURE 196: Karl L. H. Müller (American, born Germany, 1820–1887), manufactured by Union Porcelain Works, Brooklyn, *Century Vase*, ca. 1876. Porcelain with paint and gilt decoration, 55.2 × 30.5 × 30.5 cm. National Museum of American History, Smithsonian Institution, Washington, DC. Division of Home and Community Life (312735)

historical symbol. Proof of this fact can be seen in the *Century Vase*, created by Karl L. H. Müller (1820–1887) for the US Centennial Exposition in Philadelphia in 1876 (fig. 196). The German-born sculptor worked for the Union Porcelain Works in Brooklyn, America's premier porcelain manufacturer. A decorative object produced in many versions, the *Century Vase* took the form of a kalpis, or ancient Greek water-carrying vessel with two handles, traditionally ornamented with scenes expressing social and moral obligations. Translating this ancient form, Müller's vase echoed the contemporary themes of many Centennial-era works of art in displaying various US national symbols, including cameos of George Washington, reliefs with mythic stories of American history such as William Penn's treaty with the Lenape Indians, references to technological innovations (reapers, sewing machines, telegraph poles, steamships), and native species of nonhuman animals. This imagery varies somewhat from version to version, but all examples of the *Century Vase* prominently display a pair of American bison head handles on the vessel's shoulder, perpendicular to a pair of Washington cameos, indicating their centrality to national identity. The bison heads symbolically serve a lead role in the construction of American mythology. Moreover, by juxtaposing bison with Washington in this way, the *Century Vase* firmly placed both of these icons in the past, consistent with the prevailing sense of nostalgia surrounding the Centennial. The *Century Vase* thus alluded obliquely to contemporary reality, since the bison as a species was rapidly receding into historical memory.[13]

"Our National Animal"

The buffalo's iconic national status in US conservation discourse became official when William Hornaday (1854–1937) published a government-sponsored scientific report for the Smithsonian Institution titled "The Extermination of the American Bison." Trained as a zoologist and taxidermist at Iowa State Agricultural College, Hornaday initially pursued a conventional naturalist's career—hunting animal specimens and artistically mounting them in museum dioramas—but he changed course after discovering the "almost complete extermination" of the bison during an expedition to Montana in 1886. His extensive Smithsonian report recounted the facts of that expedition along with the bison's "life history," the causes of its disappearance and the effects on Indigenous peoples,

including "destitution and actual starvation," while advocating potential "legislation to prevent useless slaughter" and proposals for "preservation of the species from absolute extinction." In a prefatory note, Hornaday expressed his hope that his account "may serve to cause the public to fully realize the folly of allowing all our most valuable and interesting American mammals to be wantonly destroyed in the same manner." Hornaday's report constituted the first major government treatise on wildlife conservation in America.[14]

Recognizing the power of images to help make his case, Hornaday included a number of engraved illustrations in the report. Some of these were based on photographs recently taken in the West while others reproduced historical paintings, including three pictures by Catlin representing Native American hunting practices. The report also reproduced two new paintings Hornaday commissioned for an "Extermination" exhibit he organized for the Smithsonian's contribution to an 1888 exposition in Cincinnati. These paintings, both by the Canadian-born Washington-based artist James Henry Moser (1854–1913), distilled modern bison hunting and its effects with stark realism. One depicts the technique of "still-hunting," a systematic, one-by-one mass killing that exploited a buffalo herd's inability to notice and react to individual deaths among its members (fig. 197). Here we see a commercial hunter lying on high ground with a repeating rifle, extra ammunition belt, and pouch full of skinning knives, methodically killing bison after bison. As Hornaday observed in "The Extermination of the American Bison," "Of all the deadly methods of buffalo slaughter, the still-hunt was the deadliest. Of all the methods that were unsportsmanlike, unfair, ignoble, and utterly reprehensible, this was in every respect the lowest and the worst. Destitute of nearly every element of the buoyant excitement and spice of danger that accompanied genuine buffalo hunting on horseback, the still-hunt was mere butchery of the tamest and yet most cruel kind."[15]

In *Where the Millions Have Gone*, Moser's second painting for Hornaday, we see the grim result of still-hunting and commercial consumption in a vast field populated only by grass, severed bison heads, and bleaching bones (fig. 198). In the Smithsonian report, this image accompanied Hornaday's written recollection of visiting Montana in 1886:

Over many portions of the northern range the traveler may even now ride for days together without once being out of

FIGURE 197: James Henry Moser (American, born Canada, 1854–1913), *Still Hunt*, 1888. Oil on canvas, 116.2 × 156.2 cm. Gateway Arch National Park, Saint Louis/National Park Service

FIGURE 198: James Henry Moser, *Where the Millions Have Gone*, 1888. Oil on canvas, 116.2 × 154.9 cm. Gateway Arch National Park, Saint Louis/National Park Service

sight of buffalo carcasses, or bones.... Go wherever we might, on divides, into bad lands, creek bottoms, or on the highest plateaus, we always found the inevitable and omnipresent grim and ghastly skeleton, with hairy head, dried-up and shriveled nostrils, half-skinned legs stretched helplessly upon the gray turf, and the bones of the body bleached white as chalk.[16]

Moser's pairing of thematically related paintings recalled earlier Romantic moral narratives in art, but the realism of his vision provided a timely accompaniment to Hornaday's fact-based critical report. Together *Still Hunt* and *Where the Millions Have Gone* reinforced a pervasive visual culture of morbid imagery in various media representing mass slaughter of bison on the Plains. In a particularly grisly example, an anonymous 1892 photograph documented the monumental scale of the carnage by showing a mountain of buffalo bones at a Michigan carbon factory (fig. 199). As Hornaday explained, "no sooner did the live buffaloes begin to grow scarce than the miles of bleaching bones suggested the idea of finding a use for them. A market was readily found for them in the East, and the prices paid per ton were sufficient to make the business of bone-gathering quite remunerative. The bulk of the bone product was converted into phosphate for fertilizing purposes, but much of it was turned into carbon for use in the refining of sugar." Noting late nineteenth-century concerns about declining soil productivity resulting from clear-cutting and destructive agricultural practices, the art historian Claire Perry has observed that "the endless sea of bison skeletons scattered over the prairie beckoned as the solution."[17]

In 1888, almost precisely contemporaneous with Hornaday's illustrated report, Albert Bierstadt (1830–1902) produced a monumental late work titled *The Last of the Buffalo* (fig. 200). The picture culminated Bierstadt's career as a grand landscape painter in the Hudson River School tradition while offering a topical commentary of sorts on the bison's imminent extinction. It depicts a western site at the foot of the Wind River Mountains in Sweetwater County, Wyoming Territory, an area located roughly two hundred miles south of Yellowstone National Park. Contradicting the painting's title and current realities out West, *The Last of the Buffalo* nostalgically evokes a halcyon past, when equestrian Native Americans freely hunted abundant herds using spears, bows, and arrows. A sea of bison stretches toward

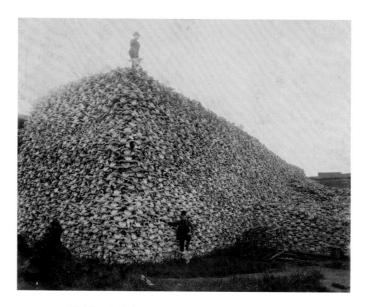

FIGURE 199: Unidentified photographer, *Men Standing with Pile of Buffalo Skulls, Michigan Carbon Works,* 1892. Photographic print mounted on mat board, 19.1 × 24.1 cm. Detroit Public Library. Courtesy the Burton Historical Collection (DPA4901)

the picture's horizon as a dramatic life-or-death struggle between one hunter and his prey unfolds in the middle foreground. More hunters on horseback, wielding bows and arrows, enter the picture at the distant right. At left, a young buffalo stands watching as the central bull, already punctured with arrows, lunges toward horse and rider. Closer to the viewer in the immediate foreground, near a footpath worn by the migrating herds, rest the corpses and bleached bones of numerous buffalo killed over time. These details imply a perennial cycle of death and renewal, but they also ominously echo other recent images of slaughter, as in Moser's pictures, giving Bierstadt's painting an ambiguous sense of timelessness and timeliness.[18]

In 1887 Bierstadt had joined Theodore Roosevelt and other prominent eastern white men in forming the Boone and Crockett Club, a private hunting organization. By that time, the artist was a respected elder statesman in his profession but his career had begun to wane, along with the fortunes of Romantic landscape painting in general, as art collectors and exhibitors of the Gilded Age increasingly turned their attention to Impressionism and the Aesthetic Movement. Aware of the bison's status as a national cause célèbre among his elite circle of gentlemen hunters, Bierstadt produced *The Last of the Buffalo* in a bid to reassert his artistic relevance. While the plight of this endangered species ostensibly inspired him to paint the picture, Bierstadt's

environmentalism was compromised by aesthetic and social biases. In a published interview with the *New York World* in 1889, the artist said, "I have endeavored to show the buffalo in all his aspects and depict the cruel slaughter of a noble animal now almost extinct. The buffalo is an ugly brute to paint, but I consider my picture one of my very best." Bierstadt's comments and imagery implied that Native American hunters were largely responsible for the bison's "cruel slaughter" and imminent extinction. Did he honestly believe this? As an experienced western traveler and member of the Boone and Crockett Club, the artist certainly knew of dire contemporary reports on the buffalo's plight circa 1889, including Hornaday's Smithsonian study with pictures by Moser and vivid descriptions of US government-endorsed efforts to eradicate the buffalo, undermining Indigenous communities. In contrast to

the realism of Hornaday and Moser, *The Last of the Buffalo* offers a mythic vision of western plenitude, in which only Native Americans appear as killers. Despite what he told the *New York World*, Bierstadt discreetly avoided depicting the most destructive contemporary agents of death, namely Euro-Americans. Instead, consistent with dominant beliefs about Manifest Destiny, his picture projected a wistful, evolutionary sense of inevitability in consigning bison and Native peoples to the past, not unlike the *Century Vase*.[19]

Some writers have struggled to accept the evolutionary implications of Bierstadt's *The Last of the Buffalo*, preferring to find more politically palatable meanings. For example, in describing a recent exhibition of the painter's work, the sponsoring museum declared, "He attempted to honor the dignity of Native peoples in the West like the Sioux

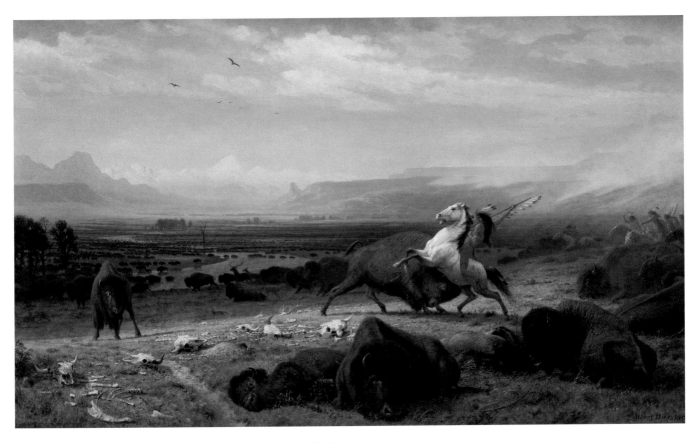

FIGURE 200: Albert Bierstadt (American, born Germany, 1830-1902), *The Last of the Buffalo*, 1888. Oil on canvas, 180.3 × 301.6 cm. National Gallery of Art, Washington, DC. Corcoran Collection, Gift of Mary Stewart Bierstadt (Mrs. Albert Bierstadt) (2014.79.5)

FIGURE 201: Winslow Homer (American, 1836-1910), *A Huntsman and Dogs*, 1891. Oil on canvas, 71.4 × 121.9 cm. Philadelphia Museum of Art. The William L. Elkins Collection (E1924-3-8)

[Dakota, Lakota, Nakota] and Shoshone, and to inspire empathy for the remnant herds of buffalo in Yellowstone National Park as the species neared extinction." Other scholars have found in Bierstadt's painting an ironic commentary on the present, one that critically preserved "the last of the buffalo" on canvas if not in reality. But such irony seems to have eluded both the artist and his contemporaries. So much seems clear from an 1889 review by Henry Guy Carleton, who concluded his long celebratory account of the painting by asserting, "A great tragedy is the subject Mr. Bierstadt chose, and in breadth and spirit, in color and exquisite minuteness of detail he has shown the hand of a master." No sense of bitter irony here. Instead, *The Last of the Buffalo* projects an operatic sense of tragedy, wherein the buffalo's fate—linked to that of the Native American in an evolutionary drama—comes across as poignantly inexorable rather than the result of commercial greed or ethical failure. Bierstadt could verbally acknowledge the impending destruction of the species in a newspaper interview, but his aesthetic commitment to the Romantic sublime prevented him from

depicting the decisive engines of modern slaughter or its impact on Native Americans. As an artist, Bierstadt was neither an ironist nor a realist. His work catered to a conservative taste for grand illusions celebrating American progress and civilization.[20]

Bierstadt's art clearly differed from that of his realist contemporary Winslow Homer (1836–1910), who executed a series of pictures around this time pointedly critiquing unethical hunting practices in the Adirondacks, where the state of New York had established a large public wilderness park in 1885. In *A Huntsman and Dogs* (fig. 201) and related works, Homer represented commercial hunters interested in neither sport nor food but rather saleable trophy antlers and hides. Though not a Boone and Crockett member, Homer here complemented a consciousness-raising campaign by the club that opposed wasteful, unsportsmanlike destruction of wildlife in the park during the 1890s. Reminiscent of other works we have seen by Homer in its complex figure-ground relationship, *A Huntsman and Dogs* presents its human and nonhuman protagonists as agents embodying broader forces of

environmental transformation in the region. The human figure, based on a working-class hunter whom Homer had met in the Adirondacks, looks powerful and resourceful but not exactly heroic. Flanking the hunter, who holds the hide and antlers of a dead stag draped over his shoulder, two hounds with mottled colors and jumping postures echo the forms of the foreground tree stumps, alluding to the clear-cutting that has denuded the background landscape. In this both realistic and conceptually coherent composition, Homer offered a complex meditation on class, economics, and environmental change.[21]

In 1905 Hornaday led a group of like-minded conservationists in establishing the American Bison Society, an organization dedicated to preserving the species. Early publicity literature of the society referred to the bison as "our national animal" and advocated for its protection: "The American Bison or Buffalo, our grandest native animal is in grave danger of becoming extinct; and it is the duty of the people of today to preserve, for future generations, this picturesque wild creature which has played so conspicuous a part in the history of America." Barrow notes how "nationalism and nostalgia loom large" in this group's ideas and actions, which included the creation of bison preserves to protect and rebuild small, fragmentary herds that survived in the West. An element of nativist xenophobia also informed the organization from the beginning, for both Hornaday and fellow society founder Madison Grant—a leading eugenics theorist and white supremacist—viewed bison preservation as a white man's burden. In his book *Our Vanishing Wildlife* (1913), Hornaday praised "gentlemen sportsmen" and game laws, but he scapegoated immigrants and blacks for subsistence hunting while ignoring larger economic and ecological factors of habitat loss from commercial real estate development and industry.[22]

The Last of the Buffalo? Indigenous Perspectives

In discussing the bison, Posthumus offers a number of historical and contemporary Indigenous perspectives that provide critical alternatives to those of Hornaday and the Euro-American artists examined so far. In particular, Posthumus emphasizes Lakota belief in the bison as a non-human spirit or *wakȟáŋ* being that "could not die out." "To nineteenth-century Lakotas," he says, "bison decline was not irreversible but could be resolved through the proper rituals" of propitiation. Moreover, notes Posthumus,

"essential to comprehending the Lakota view of bison decline is the ancient, pervasive, and fundamental belief that spirits, much like humans, could be offended," resulting in "general misfortune and hardship" as bison "retreat into the earth, leading to scarcity." Although violations of social codes by Indigenous peoples themselves could produce such effects, numerous Lakota seers over the past century and a half have blamed white invaders for offending the bison, not only with bullets but also with sounds and smells known to be unpleasant to the species, including steamboat whistles and the scent of bacon, among other things.[23]

Among the important rituals for propitiating bison, Posthumus highlights the Ghost Dance, which Indigenous peoples of the Plains fervently embraced circa 1890 in an effort to "dance back the buffalo" and thereby reverse its migration into the earth after a multitude of offenses. Many artifacts associated with the Ghost Dance survive, including a double-sided rawhide drum attributed to the late nineteenth-century Chaticks si Chaticks artist and medicine man George Beaver (fig. 202). On one side of the drum appears a speckled hail pattern and central five-pointed star, signifying nighttime ceremonies, while the opposite side prominently features the Thunderbird, a powerful spirit being associated with storms and lightning. Native Americans across the Plains had taken up the Ghost Dance in an expression of Indigenous solidarity and renewal, but the US military violently halted such activities with the Wounded Knee Massacre on December 29, 1890. This event, says Posthumus, "shattered the hope of reunion between the bison and the Lakotas." In the face of enduring repression, however, Indigenous peoples and the bison have survived and regenerated their communities. A return of historical bison populations is highly unlikely given the magnitude of habitat loss, but small, self-sustaining wild herds on public lands in Yellowstone, Alberta, and the Janos Biosphere Reserve in Mexico total about fifteen thousand, with another five hundred thousand bred in captivity on private lands. Meanwhile, Lakota and other Native peoples of the Plains have undertaken a cultural revival of beliefs and practices associated with the species.[24]

These revitalization efforts have taken many forms, from the resumption of traditional hunting practices to political activism in defense of tribal sovereignty and environmental protection of sacred land. Art has played a critically important role as well. For example, Kent Monkman (born 1965), a Cree First Nations artist from Canada, uses decolonial

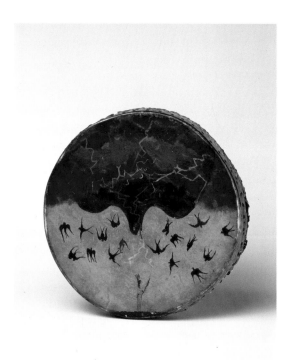

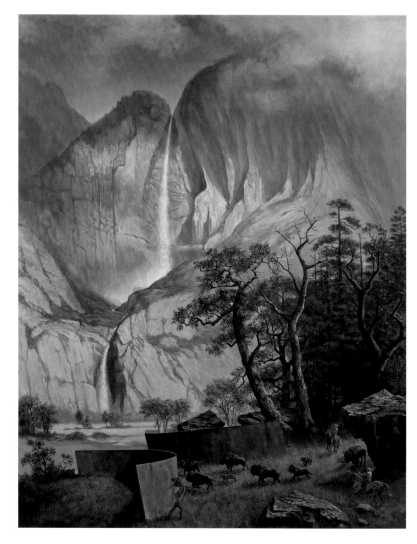

FIGURE 203: Kent Monkman (Cree, born 1965), *The Fourth World*, 2012. Acrylic paint on canvas, 151.1 × 120.7 cm. Denver Art Museum. Gift from Vicki and Kent Logan (2014.224)

FIGURE 202: George Beaver (Chaticks si Chaticks, active late 19th century), Double-sided drum, ca. 1890. Rawhide, wood, iron nails, tacks, pigments, diam. 45.7 × h. 8.9 cm. Fenimore Art Museum, Cooperstown, New York. Gift of Eugene V. and Clare E. Thaw, Thaw Collection (T0086)

strategies of reappropriation and mimicry to create unexpected juxtapositions as a way of critiquing the Euro-American tradition of landscape painting. In *The Fourth World* (fig. 203), Monkman depicts a group of white men playing Indian, riding bareback on horses as they corral a herd of buffalo through a Minimalist sculpture by Richard Serra, curiously situated at the base of Yosemite Falls. These are the same Yosemite Falls made iconic by nineteenth-century Euro-American artists such as Bierstadt and Thomas Hill (1829–1908), who painted an 1880 picture that Monkman here cribs and refracts. The title phrase, "The Fourth World," refers to the poorest communities on Earth, including those of global Indigenous peoples still suffering from the effects of colonization. By parodying dominant Anglo-Western landscape painting, Monkman critically associates that artistic tradition with the historical processes of colonization and Native dispossession. And yet, at the same time, Monkman's meticulous attention to the techniques of that tradition recognizes the captivating power of such imagery for many viewers today. In other words, *The Fourth World* acknowledges

and leverages the aesthetic allure of historical landscape art even as it urges viewers to remember Indigenous history and imagine nature in other ways, without recourse to ideas about the sublime, the pristine, or the pure.[25]

In 2013 the Dahl Arts Center in Rapid City, South Dakota, sponsored an exhibition titled *Pte Oyate (Buffalo Nation)*, consisting of works by contemporary Lakota artists examining the sacred human-bison bond. In one sculptural installation, the artist and poet Layli Long Soldier (born 1972) used wire mesh to envision a multitude of bison reemerging from the sacred Black Hills (fig. 204). The artist augmented her installation with poetry, including the statement "A body beneath a robe means I am human I am dependent," expressing a respectful sense of connection to bison associated with wearing the kind of hide garment discussed earlier. Long Soldier's innovative, multimedia expression of trans-species reverence exemplifies what Posthumus calls "the enduring significance of the bison" as a spiritual being through which past and present converge, revealing a much richer history than the one envisioned by Euro-Americans alone.[26]

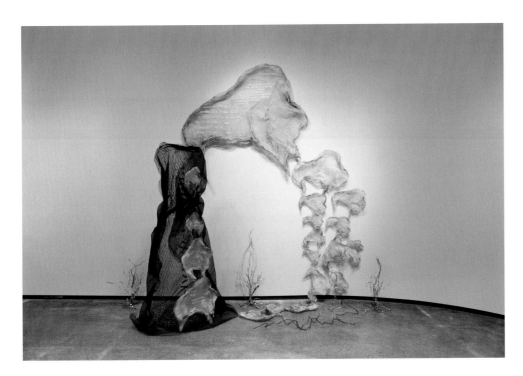

FIGURE 204: Layli Long Soldier (Oglala Lakota, born 1972), *Buffalo Book*, 2013. Wire mesh and poetry on paper, dimensions variable. Courtesy of the artist and Dahl Arts Center, Rapid City, South Dakota

Notes

1 Standing Rock Sioux Tribe, "History," https://www.standingrock.org/content/history. On Lakota migration and cosmology, including the eagle and buffalo, see David C. Posthumus, "A Lakota View of Pté Oyáte (Buffalo Nation)," in *Bison and People on the North American Great Plains: A Deep Environmental History*, ed. Geoff Cunfer and Bill Waiser (College Station: Texas A&M University Press, 2016), 278–309, quoted 283; Arthur Amiotte, "Artists of Earth and Sky," in *The Plains Indians: Artists of Earth and Sky*, ed. Gaylord Torrence (New York: Skira Rizzoli, 2014), 35–45; Rani-Henrik Andersson, *The Lakota Ghost Dance of 1890* (Lincoln: University of Nebraska Press, 2008), 6, 54, 58, 60, 68; Von Del Chamberlain, John B. Carlson, and M. Jane Young, eds., *Songs from the Sky: Indigenous Astronomical and Cosmological Traditions of the World* (College Park, MD: Center for Archaeoastronomy, 2005); and Ronald Goodman, *Lakota Star Knowledge: Studies in Lakota Stellar Theology* (Rosebud, SD: Sinte Gleska University, 1992). On bison hunting as a "solar economy," see Andrew C. Isenberg, *The Destruction of the Bison: An Environmental History 1750–1920* (New York: Cambridge University Press, 2000), 68. Regarding the sunburst/feathered sun motif, see George P. Horse Capture, "From Museums to Indians: Native American Art in Context," in *Robes of Splendor: Native North American Painted Buffalo Hides*, ed. George P. Horse Capture, Anne Vitart, and W. Richard West (New York: New Press, 1993), 87–88.

2 On Mató-Tópe's robe, see Torrence, *The Plains Indians*, 130–31. For a discussion of the gendered division of labor in nomadic Plains communities, in which the economic status of women was "markedly unequal to that of men," especially with the rise of the robe trade, see Isenberg, *Destruction of the Bison*, 5, 47, 95–101, quoted 96.

3 Andersson, *Lakota Ghost Dance*, 15, 21–22, 51, 94, 214, 226, 265, 296–97, 299.

4 On McLaughlin, see Andersson, *Lakota Ghost Dance*, 21, 66–67, 86, 103, 106–8, 113–17, 123, 142–49, 226–27, 232, 245–46. For a discussion of Wounded Knee, see Jerome A. Greene, *American Carnage: Wounded Knee, 1890* (Norman: University of Oklahoma Press, 2014).

5 Isenberg, *Destruction of the Bison*, 3, 6, 90, 92; Amiotte, "Artists of Earth and Sky," 40.

6 Mark V. Barrow Jr., *Nature's Ghosts: Confronting Extinction from the Age of Jefferson to the Age of Ecology* (Chicago: University of Chicago Press, 2009), 52; Hugh E. Strickland and Alexander G. Melville, *The Dodo and Its Kindred, or The History, Affinities, and Osteology of the Dodo, Solitaire, and Other Extinct Birds of the Islands Mauritius, Rodriguez and Bourbon* (London: Reeve, Benham and Reeve, 1848), quoted in Barrow, *Nature's Ghosts*, 53.

7 Isenberg, *Destruction of the Bison*, 163; Sherman and Allen quoted 128 and 153, respectively. Christophe Bonneuil and Jean-Baptiste Fressoz, *The Shock of the Anthropocene: The Earth, History and Us*, trans. David Fernbach (London: Verso, 2016); Andrew S. Goudie and Heather A. Viles, *Geomorphology in the Anthropocene* (Cambridge: Cambridge University Press, 2016), 20. On the American bison as among the "approximately one-fifth of animal symbols [that] are presently increasing in population," see Brandon Keim, "The Precarious State of Earth's National Animal Symbols," Anthropocene, June 21, 2017, http://www.anthropocenemagazine.org/2017/06/animal-national-symbols/.

8 Posthumus, "A Lakota View," 279, 301n6; George Catlin, *North American Indians: Being Letters and Notes on Their Manners, Customs, and Conditions, Written during Eight Years' Travel amongst the Wildest Tribes of Indians in North America, 1832–1839* (Philadelphia: Leary, Stuart, 1913), 1:17, 294–95. See also John Hausdoerffer, *Catlin's Lament: Indians, Manifest Destiny, and the Ethics of Nature* (Lawrence: University Press of Kansas, 2009).

9 George Catlin, *Letters and Notes on the Manners, Customs, and Condition of the North American Indians* (New York: Published by the author at the Egyptian Hall, Piccadilly, 1841), 1:27. For Peale and the mastodon, see pages 54–57 in this volume.

10 W. E. Webb, *Buffalo Land: An Authentic Account of the Discoveries, Adventures, and Mishaps of a Scientific Sporting Party in the Wild West* (Cincinnati and Chicago: E. Hannaford, 1872), 311–12.

11 Isenberg, *Destruction of the Bison*, 130, 131. See also Jennifer Hansen, "A Tanner's View of the Bison Hunt: Global Tanning and Industrial Leather," in Cunfer and Waiser, *Bison and People*, 227–44.

12 Charles Darwin, *The Descent of Man, and Selection in Relation to Sex* (New York: Appleton, 1871), 1:51–52. On Bergh and the ASPCA, see Isenberg, *Destruction of the Bison*, 144–45. Thomas Nast depicted Harry Bergh and Charles Darwin in another illustration directly addressing prevention of cruelty to animals. See "Mr. Bergh to the Rescue," *Harper's Weekly*, August 19, 1871, 20.

13 "1870–1900: Industrial Development; Century Vase, 1876," National Museum of American History, Smithsonian Institution website, http://americanhistory.si.edu/american-stories/1870-1900-industrial-development. For a discussion of historicism and nostalgia at the Centennial, see Bruno Giberti, *Designing the Centennial: A History of the 1876 International Exhibition in Philadelphia* (Lexington: University of Kentucky Press, 2002), 91; and Robert W. Rydell, *All the World's a Fair: Visions of Empire at American International Expositions, 1876–1916* (Chicago: University of Chicago Press, 1984), 9–37. On the kalpis form, see Colette Hemingway and Seán Hemingway, "Greek Hydriai (Water Jars) and Their Artistic Decoration," Heilbrunn Timeline of Art History, July 2007, Metropolitan Museum of Art website, http://www.metmuseum.org/toah/hd/gkhy/hd_gkhy.htm. For a discussion of recent ceramic works by the artist Robert Lugo, parodying the *Century Vase* (but also anthropocentrically erasing the bison), see Sarah Archer, "Ceramic Vases That Contain All the Beauty and Ugliness of US History," *Hyperallergic*, June 8, 2016, https://hyperallergic.com/304153/ceramic-vases-that-contain-all-the-beauty-and-ugliness-of-us-history/.

14 William T. Hornaday, "The Extermination of the American Bison, with a Sketch of Its Discovery and Life History," *Annual Report of the Smithsonian Institution for the Year Ending June 30, 1887*, part 2 (Washington, DC: Government Printing Office, 1889), 367–548, quoted 369, 372, 514, 526, 528. On Hornaday and the bison, see Barrow, *Nature's Ghosts*, 108–34.

15 Nancy K. Anderson and Linda S. Ferber, *Albert Bierstadt: Art & Enterprise* (New York: Brooklyn Museum, 1990), 102–3; *Official Guide of the Centennial Exposition of the Ohio Valley and Central States* (Cincinnati: Mullen, 1888), 71; Hornaday, "Extermination," 465.

16 Hornaday, "Extermination," 508–9.

17 Hornaday, 445; Claire Perry, *The Great American Hall of Wonders: Art, Science, and Invention in the Nineteenth Century* (Washington, DC: Smithsonian American Art Museum, 2011), 128.

18 Anderson and Ferber, *Art & Enterprise*, 62–64, 100–105, 253–55, 258–59, 285–86.

19 Bierstadt in *New York World*, March 7, 1889, quoted in Gordon Hendricks, *Albert Bierstadt: Painter of the American West* (New York: Abrams, 1975), 291; Anderson and Ferber, *Art & Enterprise*, 102; Alan C. Braddock, "Poaching Pictures: Yellowstone, Buffalo, and the Art of Wildlife Conservation," *American Art* 23, no. 3 (Fall 2009): 36–59; on Bierstadt and the Boone and Crockett Club, see 49–50.

20 Nancy McClure, "Buffalo Bill Center of the West Plans Special Bierstadt Exhibition in 2018," August 4, 2017, Buffalo Bill Center of the West website, https://centerofthewest.org/2017/08/04/bierstadt -exhibition-2018/; Anderson and Ferber, *Art & Enterprise*, 103; Henry Guy Carleton, review in *New York World*, March 10, 1889, quoted in Hendricks, *Bierstadt*, 258.

21 Randall C. Griffin, *Winslow Homer: An American Vision* (New York: Phaidon, 2006), 147–67. On the Boone and Crockett Adirondack campaign, see William Cary Sanger, "The Adirondack Deer Law," in *Trail and Camp-Fire: The Book of the Boone and Crockett Club*, ed. George Bird Grinnell and Theodore Roosevelt (New York: Forest and Stream, 1897), 264–78.

22 Barrow, *Nature's Ghosts*, 114–24, 131–34, quotes on 120, 131.

23 Posthumus, "A Lakota View," 294, 295.

24 Posthumus, 297–301. See also Karen Kramer Russell, *Shapeshifting: Transformations in Native American Art* (New Haven: Yale University Press, 2012), 93–95; K. Aune, D. Jorgenson, and C. Gates, "*Bison bison*," IUCN Red List of Threatened Species, International Union for Conservation of Nature (IUCN) website, http://www.iucnredlist.org /details/full/2815/0.

25 On Monkman and the idea of the "Fourth World," see Sourayan Mookerjea, "Canada," in *Contemporary Literary and Cultural Theory: The Johns Hopkins Guide*, ed. Michael Groden, Martin Kreiswirth, and Imre Szeman (Baltimore: Johns Hopkins University Press, 2012), 97.

26 Posthumus, "A Lakota View," 300; Deanna Darr, "Exploring the Buffalo Bond: 'Pte Oyate' Exhibit Links Art, Culture," *Rapid City Journal*, December 12, 2013, http://rapidcityjournal.com/blackhillstogo/explore /on-the-cover/exploring-the-buffalo-bond-pte-oyate-exhibit-links -art-culture/article_a76dae7b-839f-5dfa-8313-e0a40218e753.html. Long Soldier participated in the *Pte Oyate* exhibition after receiving degrees in fine arts at the Institute of American Indian Arts in Santa Fe and Bard College in upstate New York, but since then she has received numerous awards for her poetry, which includes the volume *Whereas* (Minneapolis: Graywolf Press, 2017). See Natalie Diaz, "A Native American Poet Excavates the Language of Occupation," *New York Times*, August 4, 2017.

Timothy Morton

On Being Still in Eden:
Mesopotamia Once More, with Feeling

The force of an apostrophe: "nature's nation." One assumes the apostrophe and the *s* denote something like "the nation that belongs to nature." And one assumes this has a certain resonance to do with Europe: "the nation that, as opposed to its European predecessors, belongs to nature."

Or is the apostrophe plus *s* indicating a contraction of the verb *to be*? In other words, does the phrase mean *nature is, in fact, nation*? Does the phrase say something like *the concept of nature is, in fact, a displaced version of the concept of nation*?

In the first case, nation "belongs to" nature. What can this mean? It might mean that nation is a part of nature, as either a physical or a conceptual horizon, or as some kind of mixture of both. Or it might mean that the nation defined here—the good old USA—is constituted insofar as it *has to do with* or *is caught up in concern for* something like nature. I am going to use this second definition, as it seems to absorb the first one. Being a part of a physical extensional space or being an aspect of a concept can both be expressed more openly as having to do with or being concerned with the realm of meanings associated with nature.

It is worth noting here, unnecessarily perhaps, that either word on its own would be quite a headache. Raymond Williams observed long ago that "nature" is one of the most polyvalent, ambiguous words in the entire English language. The significant question, however, is why? Is it not that the concept is evidence of something happening "everywhere," like the microwave background radiation one can see when one sees "snow" on an old TV, the remainders of the Big Bang that pervade the entire universe? If a word gets every-where and its conceptual resonance is all over the place, might this not be evidence that it is foundational, or at least close-to-foundational? Logically foundational, rather than

chronologically. This is not about when the word arose. This is about when the realm of resonance arose that the word "nature" captures.

I believe that this realm arose at a very precise moment, far back in the very long contextual history of whatever kind of nation the United States might be. We are talking here about what happened in 10,000 BCE, otherwise known as "the origins of civilization," otherwise known as the Neolithic. Geologically, this moment is known as the commencement of the Holocene. In August 2016, a Working Group of the International Commission on Stratigraphy ratified the concept of the Anthropocene, the geological period that comes next.[1] This essay will address that quite explicitly very soon.

For now, let us proceed with a brief sketch of what happened at the start of the geological epoch known as the Holocene, which corresponds to the moment in human history we call the Neolithic. What constitutes this epoch? For humans alive at the time, the Holocene meant global warming. And the way this manifested in their world—the phenomenology of the Neolithic—was roughly that the food ran away or migrated in that slower form of movement we associate with plants. In the words of a popular book about coping with personal and professional change, who moved my cheese?

As if in a state of shock, some humans *stopped* moving. Perhaps some potential lunches and dinners had simply moved out of hunter-gathering range. This is the transition space between the Paleolithic and the Neolithic. Agriculture as formulated in Mesopotamia, or parts of North and Latin America, or parts of China and Africa and Indonesia, had to do with storing crops and planning for at least the following

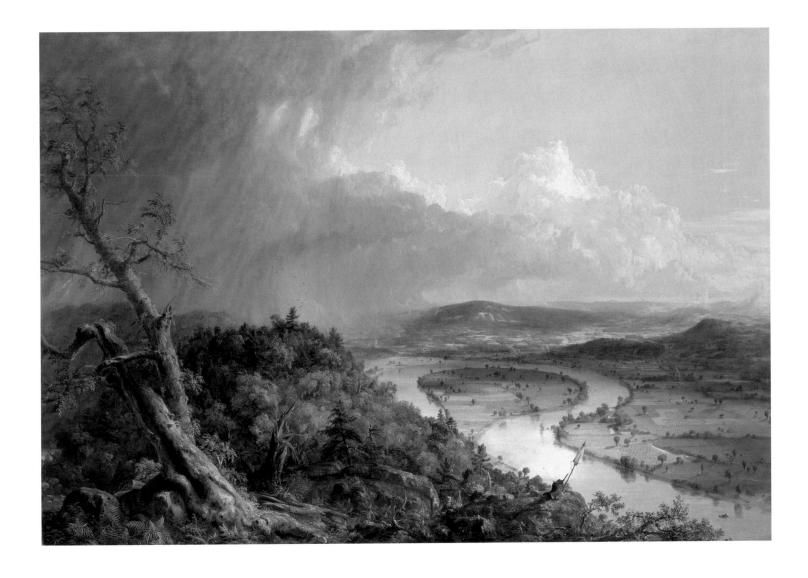

year's harvest. And this required buildings, and that required houses and fields, which is very, very roughly how the city-state arose, one of the early versions of post-Neolithic culture. (For contingent reasons having to do with nonhumans, such as wheat that the Mesopotamians were harvesting, so-called Western so-called civilization became the most successful version of the program.)[2]

Perhaps there is no *sub specie aeternitatis*, because perhaps things are finite—I would like to argue that they are, but that isn't a matter for this essay. But there is most definitely a perspective that grasps the ten-thousand-year format we are dealing with here as its reference frame. "To contextualize" in the humanities at present, based on the cheap received wisdom of ideas about ideas about what happens in theory class, means to situate relative to human culture, defined as bounded by a particular nation-state within a time frame

FIGURE 205: Thomas Cole (American, born England, 1801–1848), *View from Mount Holyoke, Northampton, Massachusetts, after a Thunderstorm—The Oxbow*, 1836. Oil on canvas, 130.8 × 193 cm. The Metropolitan Museum of Art, New York. Gift of Mrs. Russell Sage, 1908 (08.228)

roughly of a decade. But the fascinating and disturbing thing about ecological awareness is that it raises deep questions about contextualization. When is a painting happening? In 1850? In the nineteenth century? In modernity? In agricultural civilization? In the time of humans on earth? Where does the painting happen? In the artist's studio? In the city in which she lived? In her country? Her continent? On Earth? In the solar system? The point about these questions is that they are far from facetious. Given ecological awareness, they become profoundly nontrivial.

Moreover, *to whom* or *concerning whom* does the painting happen? The artist and her circle? The general public? Humans? All conscious life-forms? And so on. Contextualism as currently construed is, when we think about it through the lens of ecological criticism, an ironic way of *containing* the potential explosiveness of context. (This explosion is also happening *inside* the painting, such that the boundary between its "inside" and its "outside" is never thin or rigid.) Ecological criticism provides a way to *increase* massively the number of contexts in which we understand a work of art, and to *flatten* the hierarchy of contextual scales on which we understand that work. The "humans living in 1850s America" scale is just one of many, and there can be no one scale to rule them all, because there is no top level, no VIP lounge from which to see all of history—including the history of the cyanobacteria and the rock strata—unfolding. We used to call it "natural history," but this essay will provide the deep reason why it is impossible to call it that, why just *history* will do very nicely.

So some readers are now biased to think that I am generalizing or even universalizing or talking ahistorically when I talk about "civilization" and vast time spans and so on. But these are not universal spatiotemporal containers of everything else. They are very large, relative to the 1850s in the United States, but they are not infinite. And they certainly aren't universal. They can't explain everything. This is perhaps the first bewildering insight that dawns when criticism tries to factor in nonhumans, which is just what ecological reality requires.

From the perspective of geological time, the last twelve thousand years can be compressed into a rather sick joke: in order to avoid global warming, some humans created much worse global warming. In order to avoid the mild warming associated with the Holocene, some humans acted so as eventually to have created the Anthropocene, a geological period marked by the accumulation of human-made strata—concretes, plastics, carbon compounds, nucleotides, etc. The Anthropocene is not an arrogant or hubristic concept at all, nor is it an imperialist one. It simply means that there now exists a definite layer of human-made stuff in the ground. The Anthropocene names a truly antianthropocentric concept, because it is the term for the time in which nonhuman beings—concrete blocks and whales—intersect decisively with humans, construed not as some racist or patriarchal essence, but as a massively distributed entity that one cannot directly point to—a *hyperobject*. The humans who made global warming happen get to see themselves as a being among beings, not as the master or as the Subject or as History or as economic relations or as Dasein or any of the versions of the entity that gets to decide what is real, the post-Kantian Decider.

To avoid the Holocene, civilization created the Anthropocene. This is the plot of every tragedy, which is an agricultural-age aesthetic mode for computing the contours of that age. Tragedies take the form of hubristic attempts to transcend the web of fate that end up *creating more strands* in that web. The more you try to escape, the more you are entangling yourself. From a distance, this looks funny. It's tragic on the inside.

The attempt to escape the web of fate—and its prepatriarchal connotations without doubt—operates like an algorithm. One sets up physical and conceptual boundaries between the human and the nonhuman. Within the human domain, this boundary is reproduced as a strict social hierarchy and the division of labor, not simply for convenience's sake but as a function of how the algorithm—which I call agrilogistics—functions.[3] Algorithms are automated human emotion, affect, and other psychic states. For instance, the algorithms that run the stock markets of the world are in a sense automated *fear*. Catastrophes—tragic "downturns"—such as the New York Stock Exchange's "flash crash" of May 2010 result from this automation.

So did the catastrophe we call global warming. Agricultural space, worked over and over by the agrilogistical program, eventually generated enough humans that industrial machinery is now required to maintain it—to keep it expanding, because agrilogistics is inherently expansive. Industrial agricultural machinery such as the steam engine soon gives rise to industrial society as such. Fossil fuels are required to power it, which rapidly leads to global warming and its

fallout for nonhumans, the sixth mass extinction event in the history of life on Earth. (The end-Permian extinction was also caused by global warming.)

In painterly terms, what agrilogistics does is to establish a difference between a human foreground and a nonhuman background. Some nonhumans are required within human social space, defined as *cattle*. There are etymological links between *cattle*, *chattel*, and *capital*.[4] Because of how the human–nonhuman boundary is reproduced inside the system, a difference arises between men and women, who are now also defined as chattels: patriarchy arose quite soon after the agrilogistical program began to run.[5]

The foreground–background distinction is supposed to be thin and rigid. We can surmise this by considering the ambiguous status of cats. Cats, unlike dogs, were not domesticated until after 10,000 BCE. They simply showed up to eat the rats that ate the corn in the house that Jack built, so to speak. But agrilogistical space is inherently anthropocentric, requiring human ingenuity and power to make it run. Bees and cats are somewhat of an embarrassment. Hence the ambiguous status of cats: aliens look like cats, because cats are the first aliens, *intraterrestrial* rather than extraterrestrial. They are idealized (turned into Egyptian gods, for instance) or demonized (witches' familiars). Cats show that the boundary between the human and nonhuman realms is neither thin nor rigid—indeed, it does not truly exist. Hence perhaps the contemporary obsession with whether to keep cats indoors or let them wander outside. The notion of the "outside cat" depends upon a notion of outside that means something like "reassuringly outside human-built space," which is a terrible and often fatal lie, because things that happen outside, such as roads and cars, are like a warzone for cats. One might even parody Jacques Derrida and say that "there is no outside-text" literally also means there is no outside cat.[6] "Outside cats" might be required for us to believe that there is indeed an outside of human space. It is *less* anthropocentric at this point to recognize that nowhere on Earth's surface is this now the case: antibiotics for instance are now found in almost every bioregion, no matter how remote.

The reified background to the reified human foreground is usually called nature. In this sense one can see how the concept *nation* is already in existence as a subset of the concept *agricultural civilization*, which establishes the human–nature dichotomy. What is called nature is always elsewhere: underneath (human) appearances, in my genes, under the street, over yonder in the mountains, just around that corner, over there in the forest. Anthropocentric phenomenology is precisely this "elsewhere-ing" of the nonhuman. The paradox is that now that agricultural civilization version 9.0 (or what have you) covers most of Earth's surface, now that agriculture as such (let alone industry) is responsible for an alarmingly large proportion of global warming gases, most humans intuit that there is no such thing as elsewhere, no such place as "away," such that when one flushes the toilet, one doesn't expect the waste to go to a magically different dimension, but to the wastewater treatment plant or the Atlantic ocean. Nature is the noise made by a certain part of the agrilogistical program as it runs.

Nature is supposed to be pleasantly smooth and periodic—cycling. Civilization is thought to progress in linear fashion, though when we factor in nonhumans that progress looks an awful lot more like a long retreat from desertified environments, starting in Mesopotamia and ending up in the Great Central Valley of California. Somehow, magically, the background cycles politely while the progress (or retreat) is happening in the foreground. Perhaps the *locus classicus* for periodic nature is the medieval European view of a nicely harmonious series of interlocking cycles, or the almost disturbing comfort of Ecclesiastes ("A time to sow and a time to reap…"), let alone calendars and clocks and year planners and academic or financial years and other measuring devices that reproduce this ideology of cycling in physical form.

Human concepts of periodic nature (such as medieval ideas concerning the cycle of the seasons) are based on the actual periodicity of Earth systems in the Holocene, its remarkable climate stability. Some geologists and chemists speculate that the periodic cycling we associate with the Holocene was itself a byproduct of agrilogistical functioning.[7] Human input was already powerful enough to influence Earth systems such as the nitrogen cycle, maintaining it in "balance"—until it didn't. At the very least, the periodic cycling of Earth systems was an unfortunate fact because it lulled civilization into a false sense of security, forming a reliable background that appeared inviolable—until it wasn't. For the very machinery that may have maintained the periodicity is exactly what is now causing the sixth mass extinction event and the gigantic spike in Earth systems data that geology now calls the Anthropocene.[8]

This spike, starting in 1945, marks the start of what is called the Great Acceleration of the Anthropocene. Many

take this to be the signal of its beginning, but some scientists and myself incline toward a "diachronous" boundary between the Holocene and the Anthropocene. Consider another kind of period, called murder. Does it happen when the bullet enters the victim's brain? When the gun was fired? Or when the murderer decided to fire the gun? Or might it be better to think of all these events as a cluster, smeared out in time? The "golden spike," as it were, is the moment when the agrilogistical bullet finally enters the head of Earth systems. But the bullet was at the very least being loaded in 1784 when the steam engine with its coal furnace was invented, as Paul Crutzen and Eugene Stoermer observe in their original essay on the Anthropocene.[9] Scientists are constrained to look at geological signals in Earth's crust, while humanities scholars have adumbrated these signals with human history, sometimes confusing scientific protocols with nefarious intentions to whitewash the history of white people. Social signals include the 1610s, when European colonialism in America began to result in massive deforestation. And then there's the fact that all these signals are symptoms of agrilogistics, which had been running for some time. Whiteness as such is a signal. At higher latitudes, wheat contains too little vitamin D for human health. So some humans became more efficient solar panels.

When we look back and consider human social signals, we see that the story was definitely not a Fall narrative in which humans suddenly stabbed "nature" with a golden spike in 1945. The era of harmonious cycles was part of a buildup. In this sense the periodic cycling of the Holocene was like the harmonious brain waves that precede a stroke, or the harmonious tectonic waves that precede an earth- quake. These waves *just are* the stroke or the earthquake in their benign-seeming form. Benign, that is, if you have been trained by agrilogistical social space to consider cycling benign. Just ask a glass being sung at by a loud opera singer whether this is necessarily correct. Just before it shatters— which is why it shatters—the glass begins to undulate regu- larly as if it were having something like an orgasm. This harmonious undulation is a telltale sign of its imminent demise. So the very phenomenon that appears to be a signal of stability—the periodic cycling of the Holocene—turns out to be a signal of its eventual collapse; indeed, of its *immi- nent* collapse, from a Holocene-long perspective. No sooner had agrilogistics begun to run, from a geological perspective, than it generated intense global warming.

When we restore its disturbing registers and implications, what is called nature becomes fully uncanny. Nature is sup- posed to be not uncanny at all; the supernatural and para- normal are precisely those phenomena that are not "natural" in the sense we are using. But nature is an uncanny symp- tom of an uncanny being, as a glance at the second chorus of Sophocles's *Antigone* readily demonstrates: ourselves. "Many are the disturbing beings on Earth, but none are more disturbing than man," they sing. Why are humans dis- turbing? *Because they plow.* They plow the fields, they plow the ocean, they plow armies of other humans. They are *deinoteron*, more disturbing than any other being. The chorus is composed of masked humans, so that the effect of this moment in the tragedy is not unlike the scary moment when someone looks in the mirror, expecting to see not their regular old reflection but some kind of monster.[10]

The regularity of the agrilogistical system, along with its displaced idealized image, the cycling of nature, is exactly what caused the Anthropocene. This regularity implies three logical axioms that drive the logistics, hardly ever brought to light or questioned within the philosophical space of agrilogistics, except recently by deconstruction: (1) The Law of Noncontradiction is incontrovertible; (2) To exist means to be constantly present; (3) Existing is better than any quality of existing. Let me explain.

Smooth functioning itself is a myth that requires constant maintenance to look good. Great swathes of agrilogistical social, psychic, and philosophical space are devoted to the smooth functioning of smooth functioning. To function smoothly is to be constantly present. You can tell something exists because it keeps going, underneath its appearances— it smoothly slides along despite being decorated with differ- ent kinds of accidental property. This is the default ontology hardwired into agrilogistical social space long, long before it was formalized—for example, in ancient Greece.

Things in general are taken to be ontologically smooth, consistent, noncontradictory lumps, like protein-rich wheat kernels, engineered by early Neolithic societies and refined ever since. Wheat flowers are minimized; appearance is minimized and belittled—even sometimes seen as evil, as in the case of femininity. Logical contradiction—between *p* and *not-p* at the same time—is forbidden, and existing means being constantly present, and existing is always better than any quality of existing. As noted, these are the three implicit logical axioms driving the agrilogistical program.

The program is made of human anxiety: worry about where the next meal is coming from, and an ontological anxiety that is the default condition of being conscious. Agrilogistics, which gives rise to nature, is automated human anxiety. Constant maintenance, never deviating from the mission, resulting in massive human population growth—because more existing is always better, given the third logical axiom—is the result of this automatic anxiety.

Nature is automatic anxiety trying to cover itself over.

We are now in a much better position to think about what "nature's nation" might mean. Nature's nation must in the final analysis mean a nation-state that is much more efficient in its agrilogistical functioning than others. There is some kind of "fit" between human and nonhuman space, such that agrilogistics is imagined to be a great adaptation to the mild global warming of the Holocene, minimizing social and ontological anxiety. Anxiety arises when things do not appear exactly as they seem to be: something is "wrong" but this wrongness cannot be located anywhere. Agrilogistical functioning smoothens out this wrongness, treating it as an anomaly rather than as a default condition. And nature's nation must be the smoothest of all. The reassuring feminine vowel rhyme of *nature* and *nation* seems to hold out this promise. America has cleaved to periodic cycling much more closely than its European forebears, says the phrase. Smooth efficiency is winning: hallelujah. One could rephrase "nature's nation" as an injunction: "If we run the program again, perhaps this time we'll get it right. *Encore un effort*! Mesopotamia, once more with feeling!" One imagines that a reason for the emergence of the Hudson River School was a historical context in which something like the concept of nature's nation was beginning to be available to artists.

But we know that nature is just how the catastrophe looks when it's not doing as much damage to Earth as it might be. The Anthropocene doesn't destroy nature. The Anthropocene *is nature* in its toxic nightmare form. And conversely, nature is the latent form of the Anthropocene waiting to emerge as catastrophe.

So far, so utterly depressing. The good news is that smooth functioning is not ontologically possible, which is the deep reason for why attempts to impose it in social, psychic, or philosophical space are necessarily violent. The good news is that all kinds of non-Neolithic phenomena leak through. The idea that the Paleolithic was some kind of horrible or idyllic primitive state that we humans have

irreversibly abandoned is an artifact of agrilogistical functioning. The Garden of Eden is a place to which we can't return; for some reason we are permanently excluded from it, because of sin—which Hinduism names directly: the original sin was agriculture as such![11] What a tragic format—seeing yourself holding the murder weapon, you carry on murdering because you can't help it. This is why tragedy and agricultural religion, which is precisely religion as such, are utterly useless as modes for uncovering non-Mesopotamian phenomena. They are useless because they are symptoms of Mesopotamian agrilogistics, explaining itself to itself. Ecological discourse should exit the possibility space of tragedy as soon as possible.

Agrilogistics never really functions smoothly. It only looks like that when you think, as a capitalist economist does, for example, that nonhumans are incalculable and therefore irrelevant "externals." By the same token, Marxist use value has nothing to do with the nonhuman as such—use value is how a plant appears when you cook it and eat it. What is called nature in Marxism is always only an aspect of human metabolic systems, which is why Marxism has traditionally been wary of ecology. Ecology names an economic domain that is larger than merely human social space; but the Hegelian strand within Marxism cannot tolerate this largeness. All existing agrilogistical formats appear to function smoothly only from within anthropocentric space. Just ask a vole running away from a plow.

This means that divergent phenomena are always popping up in agrilogistical space (social, psychic, philosophical). Take that rather late product of such a space, the picturesque landscape. The reified picture of reified nature—designed always-already to look like a picture, glimpsed in sepia through the protocamera lens of the Claude glass—also encodes Paleolithic fantasies. The most popular landscape painting maps directly onto the needs of hunter-gatherers: there's a conveniently shady tree under which the viewer appears to be standing, looking out of this protective covert at a readily available body of water, surrounded at the horizon by sheltering mountains. A subtropical savannah bleeds through into the charming interstices of European agrilogistical space where gypsies and banditti amuse the traveler.

Thomas Cole (1801–1848) in his *View from Mount Holyoke, Northampton, Massachusetts, after a Thunderstorm—The Oxbow* (fig. 205) maps this space powerfully. On the one hand, the catascopic (downward-gazing) view holds and contains and

empowers the viewer, while the infinity suggested by the aerial perspective evokes the Kantian sublime, that feeling of inner freedom activated by such things as magnitudes that transcend the human ability to grasp them. But the openness of this freedom goes beyond concept, so that the feeling of ownership is only one of a felt variety of ways to enjoy the image. The Paleolithic savannah-like quality of the landscape is another mode altogether. Thus we encounter the painting at two scales simultaneously, at least. There is the scale of the current state of the agrilogistical program, the United States in the early nineteenth century. Then there is the wider scale of the gaze associated with the Paleolithic, still in effect, so that we need a new term to describe it. Perhaps the best would be "arche-lithic," a term that might suggest Derrida's notion of "arche-writing," a differential, playful force that subtends all attempts at pinning down a constantly present meaning.

Something similar could be said of *Landscape* (1859; see fig. 57) by Asher B. Durand (1796–1886), only more so. We appear to be falling or sliding down a slope in front of the picture plane, descending below the treetops while we take in the sublime aerial perspective. There is a strong feeling of movement. This is not a movement to grasp or maintain or own, but something like the delightful, disturbing slipperiness of the "savage place" described in Samuel Taylor Coleridge's "Kubla Khan": "But oh! that deep romantic chasm which slanted / Down the green hill athwart a cedar cover!"[12] Victorious catascopy is impossible: the feeling is that we will be looking up at the trees and the shimmering luminosity in the distance, and increasingly so, as time goes by. We are falling into an agrilogistically distorted nonagrilogistical space, the space of the arche-lithic, as if the nonagrilogistical had leaked out of the frame enough to cause a flood that pulls us downward into the dark, "savage [forest] place." Or better, we are *teetering*, about to plunge—the viewer occupies a place of resting-in-movement. This feeling of resting-while-moving defeats the modern sense that "active" is rigidly demarcated from "passive." It's not a nice Neoplatonic symmetry—in that view, *stasis* is the net effect of movement-in-place, like a spinning sphere. This kind of movement-in-stillness is more ambiguous, more strangely playful.

"We are still in Eden," writes Thomas Cole of the type of landscape he is trying to render in paint.[13] Yes: agrilogistics appears to have hit the reset button by upping sticks and relocating to the United States. The wishful utopian thinking immediately suggests its opposite: *being still in* has the force of *we almost had to leave, but we were able to linger at the gates of paradise*. Superimposed on this is perhaps a reassurance that the aesthetic and spiritual qualities of European landscape have not been forsaken. Of course, the trouble is that agrilogistics means *never being in Eden*, which is only an agrilogistical term for nonagrilogistical space. Agrilogistics is predicated on having been booted out of paradise. The plaintive untruth of Cole's assertion thus works against its assertiveness, but not necessarily in a bad way. In the transition from one place to another, something different leaks through, if only in the unremarked-upon difference as such, located here in the word "still." This word functions rather like the "stillness" I was remarking on in Durand's *Landscape*. Cole implies that agrilogistics is restarting—"the ravages of the axe are daily increasing"—but something is pouring through the gaps.[14] The belatedness of this notion (America had been farmed by white people for a considerable time when Cole wrote it down) also generates a weird, productively unsatisfying distortion, like someone overemphasizing a point.

Durand also wants to transcend the possessive logic of the picturesque. Toward that end, his letters enjoin the reader to paint only what one sees directly.[15] This works against the whitewashing quality of Durand's sense that the United States consists of "untrodden wilds"—surely they are trodden by Native Americans.[16] And Durand is quite explicit that "the rich merchant and the capitalist" love landscape painting as one might love an oasis in a desert—that agrilogistics had created.[17] But landscape paintings also evoke abandoned childhood feelings, argues Durand. In these abandoned feelings we again glimpse a reserve of arche-lithic psychic space, a shadowy flickering of something different from owning land or working it, the philosophical basis of ownership.[18] A faint shimmer of something else flickers across the prose.

In his essay on "The Romantic Dilemma in American Nationalism and the Concept of Nature" (1955), the literature scholar Perry Miller describes how the belief in "nature's nation" wants to reset agrilogistics. The question is, how much, and the deeper question is, how much of a reset is possible within the dynamics of its functioning? Perhaps Miller even wants to break out of it: his citation of the painter Jasper Francis Cropsey's angry words about

axes and "civilization" seems to suggest so, along with his awareness that the reader might think he is talking "nonsense."[19] An excess in the spirituality with which America is apprehended by white Americans, he argues, works against the utilitarianism, that philosophical rationalization of agrilogistics, that is hardwired into agrilogistical space long before its formalization by Jeremy Bentham and others.[20] Despite what I have said about nature and nation, Miller tries to hear in these distorted and distorting terms the sound of something else.

Miller's moves here correspond roughly to the spiritual top level of consumerism, the Romantic or bohemian mode, of which the consumption of landscape and of landscape painting might be a good example.[21] Such a level allows for paradoxical modes of inhabiting agrilogistical space, modes that have nothing to do with utility. The possibility of an exit route from agrilogistical social, psychic, and philosophical space glimmers faintly from this place, in which consumers allow objects, entities, things of all kinds to call to them, seduce them, pull them in like that covert in Durand's painting, almost as if consumers began to see them as agential in some sense—a seeing that is definitely not commodity fetishism. Hidden in the mystical Puritan code is a noncoercive connection to beings that aren't human, in a mode of attunement. Such a tuning is very different from the grasping, planning, projecting, and owning that agrilogistics establishes. It is akin to what I have been calling stillness: neither active nor passive, an almost unspeakable and creative state that is logically prior to doing and making. Perhaps in the aesthetic experience of landscape painting there might operate not a fake reconciliation of politically opposed domains, but a fumbling toward a new theory of action, whose basic unit is not the Neoplatonic Christian blunt instrument so many seem keen to repeat (often unconsciously), but rather something like appreciation or attunement. Stillness names this something—not totally inert, not slicing decisively into inert things. Something lingers in the nostalgia: a nostalgia for a future in which humans have put down their destructive tools.

Notes

1 Damian Carrington, "The Anthropocene Epoch: Scientists Declare Dawn of Human-Influenced Age," *Guardian*, August 29, 2016.

2 Jared Diamond, *Guns, Germs, and Steel: The Fates of Human Societies* (New York: Norton, 1999).

3 Timothy Morton, *Dark Ecology: For a Logic of Future Coexistence* (New York: Columbia University Press, 2015), 38–40, 42–55.

4 *Oxford English Dictionary*, entry for "cattle, *n.*," I.1, 2.a., 3, 4, oed.com (Oxford University Press, 2016).

5 Jared Diamond, "The Worst Mistake in the History of the Human Race," *Discover Magazine*, May 1987, 64–66.

6 Jacques Derrida, *Of Grammatology*, trans. Gayatri Chakravorty Spivak (Baltimore: Johns Hopkins University Press, 1987), 158.

7 I am grateful to Jan Zalasiewicz for discussing this with me.

8 Andrey Ganopolski, R. Winkelmann, and H. J. Schellnhuber, "Critical Insolation–CO_2 Relation for Diagnosing Past and Future Glacial Inception," *Nature* 529 (January 14, 2016): 200–206; Michel Crucifix, "Climate Science: Earth's Narrow Escape from a Big Freeze," *Nature* 529 (January 14, 2016): 162–63.

9 Paul J. Crutzen and Eugene F. Stoermer, "The 'Anthropocene,'" *Global Change Newsletter*, no. 41 (May 2000): 17–18.

10 Sophocles, *Antigone*, http://classics.mit.edu/Sophocles/antigone.html, last modified 2009.

11 *The Ramayana of Valmiki*, trans. M. L. Sen (New Delhi: Munshiram Manoharial, 1976).

12 Samuel Taylor Coleridge, "Kubla Khan," in *Coleridge's Poetry and Prose*, ed. Nicholas Halmi, Paul Magnuson, and Raimonda Modiano (New York: Norton, 2004), lines 12–14.

13 Thomas Cole, "Essay on American Scenery," in *American Art to 1900: A Documentary History*, ed. Sarah Burns and John Davis (Berkeley: University of California Press, 2009), 270.

14 Cole, 270.

15 Asher B. Durand, "Letters on Landscape Painting," in Burns and Davis, *American Art to 1900*, 291.

16 Durand, 293.

17 Durand, 294.

18 Durand, 295.

19 Perry Miller, *Nature's Nation* (Cambridge, MA: Belknap Press of Harvard University Press, 1967), 197–98.

20 Miller, 199–200.

21 Colin Campbell, *The Romantic Ethic and the Spirit of Modern Consumerism* (Oxford and New York: Basil Blackwell, 1987).

Anne McClintock

Ghostscapes from the Forever War

FIGURE 206: Fazal Sheikh (American, born 1965), *Latitude: 31°1'5" N/ Longitude: 34°57'5" E*, November 14, 2011, from the series *Desert Bloom*. Remnants of an extension to the Bedouin village of Rakhma, of the 'Azāzme tribe. Inkjet print, 40 × 59.7 cm. Courtesy of the artist

GHOST: But that I am forbid
To tell the secrets of my prison-house,
I could a tale unfold whose lightest word
Would harrow up thy soul, freeze thy young blood.

William Shakespeare, *Hamlet*

Perhaps more than any other people, Americans display a
consistent amnesia concerning their own past, as well as the
history of those around them.

Pentagon Report, January 2005

Imperial Ghosting: The Administration of Forgetting

Why ghosts? After 9/11, in the shadowlands of empire, in the terminology of the CIA and the Pentagon, in countless films and books, the US global war came to be haunted by the persistent evocation of ghosts. Consider: ghost wars, ghost prisons, and ghost planes. Ghost sites, ghost ships, and ghost money. The orange ghosts of Guantánamo and the Grey Ghost of Bagram.[1] At the same time, within the United States the ancient cult of the paranormal rose up with startling intensity: the whispering phantasmagoria of vampires, zombies, and ghosts that now haunt American films and television series, best-selling novels and social media, boardrooms and bedrooms, as dreamworld and catastrophe. A hinge connects the national cult of the paranormal (the dead who refuse to die) with the casualties of the US global war (the dead we cannot see), who return as unmourned revenants from the ruined dronescapes and torture labyrinths of the faraway Forever War. But the hinge between nation and empire has been ghosted.

How do we account for the persistent ghosting from official US history of its foundational violences—slavery, the genocide of Native peoples, the atomic obliterations of Hiroshima and Nagasaki, the centuries of ecocides and onslaughts on the environment—without understanding how these great, administered forgettings have come to haunt our current moment with accusatory phantasms and remorseless cycles of violence? For when a nation refuses to remember, neither acknowledging nor accounting for the past, it enters the geography of haunted places, and violence is destined to recur with relentless repetition.[2]

How do we write a history of fragments?[3] Put another way, Avery Gordon asks: "How do we reckon with what modern history has rendered ghostly?"[4] The largest ghost is imperialism itself. The fundamental edict of US imperialism is that it is no empire at all. Matthew Jacobson describes the "extraordinary ingenuity with which Americans have been able to forget their imperialist past (and so absolve their imperialist present)."[5] Michelle Cliff writes of the half-denied memory of slavery in which "the past coexists with the present in this amnesiac country in this forgetful century."[6] Philip J. Deloria (Dakota) notes: "Indeed, in American History texts today, the Indian people living between 1890 and 1934 often simply vanish from the master narrative."[7] As Toni Morrison puts it, "the American dream is innocence and clean slates and the future."[8]

Imperial ghosting takes the form of a doubleness. What I call the administration of forgetting—the calculated, administered, and often brutal amnesias by which a state or political entity seeks to erase its violence—nonetheless leaves telltale traces as a kind of counterevidence. Violence seldom erases what it effaces; it leaves shadows of what it

tries to encrypt. Ghosts point to these places where denied, erased, or unresolved violence has taken place.[9] The administration of forgetting throws uncanny disturbances across generations, creating the temporal palimpsests and visual anachronisms of imperial déjà vu.

Nicolas Abraham and Maria Torok's terms "crypt" and "phantom" are suggestive here.[10] The crypt represents an inadmissible crime or guarded secret in a person's life or in a generation: an event so unspeakable that it has to be sealed off from the conscious life of the individual or from the collective memory of the people. But the entombed secret leaves memory-traces, so that the trauma or guilt is borne ghostlike from one generation to another.

The phantom, then, is the trace of a trauma or crime passed on to the next generation, who become the unsuspecting bearers of nameless sufferings, inexplicable guilts, or unresolved enigmas. For Abraham and Torok the phantom works its silent havoc and disarray through disturbances in language, the crypt half glimpsed in gaps in historical narratives, half submerged in national secrets, half present in disjointed family stories.

Here I expand Abraham and Torok's focus on language to include transgenerational hauntings that take other guises: visual disturbances in photographs and paintings, unruly bodily gestures, and the ecological scarrings on landscapes that I call shocked space and torn time. I am preoccupied, in particular, with the gestures of refusal captured in photographs that point to the animating presence in history of the officially forgotten. For it is crucial to remember that those who live in the imperial ghostscapes are not ghosts at all, but ordinary people under extraordinary circumstances.

Ghostscape I: Shocked Space—Negev/Naqab

The ultimate mark of power may be its invisibility; the ultimate challenge the exposition of its roots.
Michel-Rolph Trouillot, *Silencing the Past*

Phantoms of disappeared violence may appear as environmental scars, ecological disturbances, and accusatory apparitions on the landscape itself. I call these ecological phantoms *ghostscapes*: geographies of torn or toxic land; the faint traces of vanished settlements; archaeological mounds or ruins over which the dust seems uncertainly

to have settled; sealed-off areas of half-buried munitions; eerie ecologies such as bleached coral reefs, ghost forests, and skeleton trees; evacuated nuclear plants; abandoned military borderlands; and industrial wastelands.

Put another way, ghostscapes are damaged landscapes where specters of concealed violence still haunt the tattered margins of the visible. Take the flinty ghosts of the Irish famine roads dug by starving wraiths in the nineteenth century, still haunted by the history of mass hunger and forced labor. Or the atomic shadows blasted onto stone in Hiroshima and Nagasaki by the nuclear weapons of monstrous light. Or the crimson-black smears of oil mixed with Corexit that stretched to every horizon in 2010 after the BP Gulf of Mexico oil disaster (see fig. 215).

Consider one such ghostscape (fig. 206). Between 2010 and 2015 the photographer Fazal Sheikh (born 1965) traveled through Israel/Palestine taking aerial photographs of the Negev/Naqab and evidence of the Israeli campaign of forcibly evicting the Bedouin from the fertile northern threshold of the desert and concentrating them in settlements in broken, arid areas.[11] Much of the cleared areas are now vast, closed-off military zones. But even as the Israeli state attempted to remove the Bedouin, and then erase evidence of the removals from official history and maps (the administration of forgetting), stubborn traces of the Bedouin remain on the landscape itself, made visible in Sheikh's aerial photographs as archaeological apparitions on the land. Sheikh's images reveal what the military wants to conceal: traces of evacuated settlements, ghosts of fields that no longer exist, blocked-up watering holes and wells. *Latitude: 31°1′5″ N/ Longitude: 34°57′5″ E* captures a closed military site, where dark circles reveal the prior existence of destroyed livestock pens, the urine and dung soaking and darkening the earth over time. The stains are indelible evidence of prior Bedouin inhabitance, like the faded blood of a secret that cannot be expunged from the fragile fabric of the desert's memory. Sheikh's photographs offer what James Baldwin called "evidence of things not seen."[12] Thin scratchings far below, barely visible, reveal the presence of the Bedouin who have returned to plow their fields; phantasmic markings, like a kind of ghostly braille on the earth, make legible the Bedouin's tenacious will to return.

Ghostscape II: The Tricky Mirror of Colonial Photography

We are never so steeped in history as when we pretend not to be.
Michel-Rolph Trouillot, *Silencing the Past*

I suspect that all these stories are designed to reassure us that no crime was committed. We've made a legend out of a massacre.
James Baldwin, *I Am Not Your Negro*

Must we go over Curtis—again?

Consider a photograph by Edward Sheriff Curtis (1868–1952) of two Piegan men and a clock (fig. 207). Between 1907 and 1930, funded by the railroad financier J. Pierpont Morgan and backed by President Theodore Roosevelt, Curtis set out with the immodest ambition of capturing in one monumental archive—forty thousand photographs— what he saw as the tragic but foredoomed vanishing of Indigenous peoples. Curtis's grandiose vision was to capture for immortality a permanent record of Native tribes and embalm them in the gold-tinted glow of his photographs before they were engulfed in eternal shade.[13]

Yet you may ask: where is the clock? Look closely and you will see a visual blurring between the two men, Yellow Kidney and Little Plume.[14] What looks like a basket, slightly spectral, marks the place of a deliberate disappearance. For this is not the original photograph. In the original, a clock is placed between the two men (fig. 208). Curtis removed the clock, with all its unseemly connotations of modernity, by retouching the photograph, embalming the men in a perpetual archaic past in which, in Curtis's mortuary imaginings, the men become living monuments to their own tragic vanishing.

"See here, says the trickster," writes Gerald Vizenor (Anishinaabe/enrolled member of the Minnesota Chippewa Tribe), "Curtis has removed our clocks, colonized our cultures, and denied us our time in the world."[15]

As the colonial railroads carved the continent into corridors, destroying the vast bison herds, disrupting Native trading and migration routes, devastating cultures and environments, so clocks carved time into rigid lines of rationalized chronology. But the Piegan men placed the clock there for a reason. Clocks might have been objects of status for everyone, but did this clock point to something else? Clocks would have been as familiar to Native peoples by 1909 as they were to colonial settlers. Native nations had been

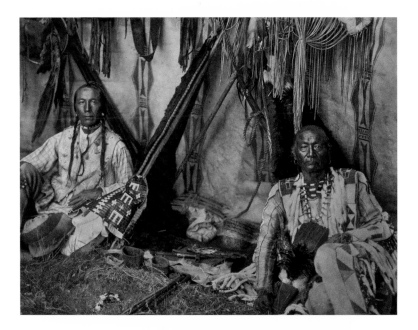

FIGURE 207: Edward S. Curtis (American, 1868–1952), *In a Piegan Lodge*, ca. 1910. Photogravure, 30.1 × 39.5 cm. Published in Curtis, *The North American Indian* (Seattle: E. S. Curtis, 1907–30), Port. 6, Pl. 188. Princeton University Library. Rare Books and Special Collections

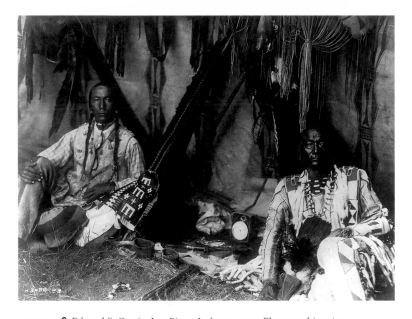

FIGURE 208: Edward S. Curtis, *In a Piegan Lodge*, ca. 1910. Photographic print, 15.3 × 20.2 cm. Library of Congress, Washington, DC. Prints & Photographs Division. Edward S. Curtis Collection

engaging for centuries with emergent capitalist, industrial technologies and commodities. Why did Curtis remove the clock? Was its white face too accusatory? Did its hands point to something outside the frame that he did not want to see?

Vizenor notes: "On the frontier, white settlers were offered free guns with the purchase of sewing machines.... The tribes were offered free clocks with a peace medal and were imprisoned on a reservation."[16]

I am preoccupied here less with what Curtis's photographs reveal than with what they conceal, what lies half hidden, haunting the edges of historical memory. Curtis's life bore witness to virtually every major social turbulence from the post–Civil War period to the middle of the twentieth century: the fatal land enclosures by barbed wire and the railroads; the ecocide of the bison; the imprisonment of Native nations in the reservations; the Dawes Act (1887); the catastrophic allotment and assimilation policies; the starvation years; the brutal removal of children to white-run boarding schools; the rise of corporate finance and railroad speculation; assembly-line manufacture; and the Depression years.[17] But virtually no trace of these historic events appears in Curtis's photographs, except as half-hauntings and intimations.

Curtis staged *In a Piegan Lodge* around 1909, by which time most Native communities had been forced onto the desolate fragments of the reservations. What we don't see in Curtis's archive is that these people were remnants of genocide, inhabiting not some tribal archaic—"thought to be pre-modern in their isolation," as Deloria puts it[18]—but living in that most contemporary of geopolitical spaces, the concentration camps of the reservations. These were arguably the first concentration camps, before the British interned the Boers during the Anglo-Boer War, before the industrialized European camps of the twentieth century.[19] The ghosted clock in the photograph makes it apparent that the ruins of Indian country were not the *precursor* to settler colonialism but its *consequence*.[20]

I am interested in particular in the tricksters in Curtis's photographs, evidence of the resistance and refusals of Native people to colonial photography. Louis Owens (Choctaw/Cherokee) offers the image of the tricky mirror as a figure for Euro-American/Native relations. He writes, "The tricky mirror is that Other presence that reflects the Euramerican consciousness back at itself, but the side of the mirror turned toward the Native is transparent, letting the Native see not his or her own reflection but the face of the Euramerican beyond the mirror."[21]

John Berger writes: "The camera relieves us of the burden of memory....The camera records in order to forget."[22] What does the tricky mirror of colonial photography record—in order to forget?

Curtis's photograph appears to depict two men lounging at leisure in their lodge. The caption is in the present tense, holding the men captive in the perpetual present of anachronistic space.[23] Arrayed about the men are the paraphernalia that Vizenor calls "ethnostalgia," the staged accessories of "the old time": the long medicine bundle, the eagle wing fan, the deerskin articles for horse riding, and notably the bison shield, though the slaughtered bison were long gone.

By exhibiting his right to be invisibly there, Curtis displays his privileged relation to colonial power: the right to *trespass*. This may be a lodge, but it is also a haunted house. Ghosts mark an unwelcome trespass from outside to inside. Curtis haunts these men as they haunt him.[24]

The Piegan men certainly seem to resent his presence. Little Plume, on the right, appears especially displeased, his eyes glitteringly hard and cold. For men posed at leisure, they seem strikingly tense and withholding. I see nothing welcoming in their faces. Here are none of the clichés of Romantic pictorialism, stoicism, or dignity in defeat. Curtis may display his power to choreograph the scene like a diorama, but the men refuse to be mortuary objects in his simulated museum of colonial nostalgia.[25] They look at him with unflinching stares and barely withheld distaste. Across the years, the men's eyes pierce me.

Look at the men's hands. If Little Plume can't stop Curtis's preposterous insistence that the prop of the eagle fan be set in his lap, he can at least refuse to hold it properly. His right hand is clenched into a fist. Yellow Kidney's long fingers draw the gaze to something Curtis might have thought about more carefully before taking his photograph: the machine-stitched shirt. Manufactured clothing, new technologies, and sundry household commodities such as clocks, sewing machines, telephones, electricity, trains, cameras, and cars had been a lived reality for many Indigenous peoples for years.[26] Curtis could remove the clock, but did Yellow Kidney refuse to remove the shirt? We do not know; it is simply there. Eric Hobsbawm wrote: "When you say cotton, think of empire."[27] The shirt remains, a stubborn accusation and visible reminder that the history of slavery,

industrial capitalism, and Native dispossession were woven into the same historical fabric.

In Curtis's image, the Piegan men wear ceremonial clothing, but as Owens points out, these cannot properly be called clothes; they are colonial props.[28] In this image the men's clothes are no longer customary; they are costumery.

If Curtis portrayed himself as the lone, triumphal taxidermist of the vanishing Indian soul, this entailed two well-established colonial tropes, and two ghostings. If for Karl Marx the specter haunting Europe was communism, the specter haunting Curtis was colonial capitalism. Curtis's work was by no means an epic, solo male venture but rather a huge collaborative enterprise in which Native Americans contributed significantly to the project as photographers—like his prodigious assistant Alexander Upshaw (Apsáalooke, 1874/5–1909)—interpreters, cultural brokers, cooks, and laborers.[29] But the most notable ghosting was of the ravages of settler violence everywhere around Curtis but nowhere visible in his photographs.

Christopher Lyman first noted how Curtis assiduously avoided photographing any signs of settler colonialism, ghosting them from of his images when they inadvertently appeared. He physically removed cars, parasols, suspenders, the tags on machine-made tepees.[30] We don't see trains, railroads, barbed wire, contemporary houses. As Vizenor writes, Curtis paid Native men to wear anachronistic costumes and enact simulated, often illegal ceremonies: "specters from the tribal past... discontinuous artifacts in a colonial roadshow."[31] He could have photographed Native people, Vizenor notes, "perched at pianos, dressed in machine stitched clothes, or writing letters to corrupt government agents."[32] Photographer Larry McNeil (Tlingit/Nisga'a, born 1955) sardonically asks why Curtis did not photograph people "in front of their houses with their cars in the driveway, as he probably actually found many of them."[33] McNeil stresses that "what is unspoken in Curtis' 'Vanishing Race' photographs is that the Indians did not vanish of their own accord" and "America will still not admit that what they did was simply murder on a grand scale."[34]

Little attention, however, has been paid to the ways Curtis also engineered the environment to stage his invented scenes of "primordial" nature, nor how his photographs can be read as symptomatic ghostscapes of the larger ecological catastrophes of settler colonialism. Curtis avoided capturing the environmental ruins that lay about him; instead, he elaborately filled canals with debris to metamorphose them into Edenic

pools and posed women and men beside them. He staged Indian prisoners as "warriors" musing nostalgically over pristine landscapes. Most invidiously, he ritualistically created a geography of enmity, performing fictive "war parties" by paying or persuading men who were effectively prisoners *of* war to reenact illegal, anachronistic fictions of being *at* war, the imperial trope of "the hostile" that I call the victim-victor reversal.[35]

Curtis poses a Mandan man holding a bison skull to the sunset skies, a rakish feather in his hair, simulating a ceremony staged when the Mandan had been relegated to reservations and such ceremonies were prohibited as crimes (fig. 209). Curtis's bison skull is a phantom pointing to a double erasure: the deliberate genocide by white invaders

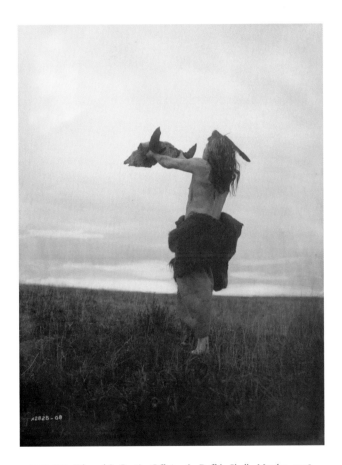

FIGURE 209: Edward S. Curtis, *Offering the Buffalo Skull—Mandan*, 1908. Gelatin silver print, 20.2 × 15.3 cm. Published in Curtis, *The North American Indian* (Seattle: E. S. Curtis, 1907–30), Vol. 5, facing p. 16. Library of Congress, Washington, DC. Prints & Photographs Division, Edward S. Curtis Collection

of Native peoples and the mass extermination of the bison. Next to Curtis's simulation one can place a different image, the anonymous photograph of a towering pyramid of bison skulls, a sepulcher of mortality testifying to the impact of colonial ecocide. On top a single white man stands triumphant in that studied imperial pose of masculine mastery over subjected nature (see fig. 199).

As late as 1906, in a famous image, Curtis posed a young Apache standing next to a forested rock pool (fig. 210). The caption reads: "This picture might be titled 'Life Primeval.' It is the Apache as we would mentally picture him in the time of the Stone Age." In around 1932 the photographer Horace Poolaw (Kiowa, 1906–1984) photographed his smiling eldest son, Jerry, sitting barefoot in T-shirt and shorts on a log at the edge of the Washita River (fig. 211).[36] It is difficult to imagine that Poolaw wasn't ironically aware of the subversive contrast his beaming boy made with countless images of unsmiling Indians posed by white photographers in "pristine" nature, where the invention of "wilderness" became the alibi and accomplice of territorial dispossession.

But a question remains. What relentless vision so animated Curtis that he crisscrossed the American continent one hundred twenty-five times, photographing more than eighty Native nations? Alan Trachtenberg claims: "There is no clue, not one word to what possessed him."[37]

Unless one looks in the crypt.

FIGURE 210: Edward S. Curtis, *The Apache*, ca. 1906. Photogravure, 40 × 29.3 cm. Published in Curtis, *The North American Indian* (Seattle: E. S. Curtis, 1907-30), Port. 1, Pl. 7. Princeton University Library. Rare Books and Special Collections

FIGURE 211: Horace Poolaw (Kiowa, 1906–1984), Horace's eldest son, Jerry Poolaw (Kiowa), at the Washita River. Mountain View, Oklahoma, ca. 1932. Digital image from a 5-by-7-inch black-and-white negative. Courtesy Estate of Horace Poolaw (57FK14)

One answer lies buried in an unpublished memoir that, I suggest, motivated Curtis's phantasmagoria of forgetting. As a boy in Minnesota, Curtis grew up in the shattered aftermath of the brutal settler suppression of the Dakota uprising.[38] Curtis recalls reading a book by candlelight and being transfixed in horror by a gruesome image of thirty-eight Dakota simultaneously executed by hanging at Mankato, Minnesota, on December 26, 1862. The hanging was the largest mass execution in US history. "All through life," Curtis wrote, "I carried a vivid picture of that scaffold with thirty-nine [sic] Indians hanging by the end of a rope."[39]

Curtis's lifelong vocation became an alchemy of erasure—ethnic cleansing at the level of the image erasing ethnic cleansing at the level of history. As settler violence forcibly removed Native peoples from their land, so Curtis forcibly removed all signs of settler violence from his images.[40] In turn his images become cryptic. Phantoms remain, inviting us to animate the possibilities of alternative histories and alternative futures.

FUGUE II: AUTOMOBILITY AND INDIGENOUS REFUSALS

We are not marginal, and in the twenty-first century we are everywhere and nowhere, invisible and standing right next to you.
Paul Chaat Smith (Comanche), *Everything You Know about Indians Is Wrong*

For Aboriginal/Indigenous communities, it has always been traditional to utilize the latest technology.
Hulleah J. Tsinhnahjinnie (Taskigi/Diné), "Visual Sovereignty"

One of the most pernicious and tenacious forms of colonial ghosting is to align Native cultures with "tradition" and settler cultures with "modernity," the opposition freighted with complicity in the racist temporalities of so-called Native primitiveness and European technological progress.[41] As Paul Chaat Smith (Comanche) writes: "Indian experience, imagined to be largely in the past and in any case at the margins, is in fact central to world history.... The first 'truly modern moment' of colonial contact happened centuries ago."[42]

Photography arrived among Indigenous communities in America with the same startling speed and allure as it did among colonial settlers.[43] As McNeil points out: "North American Indigenous people have used photography nearly as long as White Man, and for our own ends."[44] From the outset, Native people chose to be active collaborators with the camera, producing their own images, sitting for studio photographs and weddings, commissioning family portraits by the thousands, striking elegant poses in customary regalia, posing for political portraits, and mugging for the camera, exploiting from the beginning the potentials and perils of reinventing and redirecting the camera's gaze.[45]

But as photography became increasingly commercialized, and as Native communities were swept up by the larger devastations of settler colonialism, they were also increasingly subjected to compulsory photography by bureaucrats, missionaries, police, ethnographers, and tourists.[46]

One can identify at least four forms of Indigenous refusal of the colonial camera.[47] First, fleeting gestures of Native refusal are caught unwittingly in colonial photographs, making visible Native defiance, flight, or disapproval, creating phantasmic disturbances marking places of contested power.[48] In numerous archival photographs, faces and hands blur as people turn from the camera's intrusion: a Diné woman dashes into a hogan, her figure an illegible smudge; a slave woman angrily holds up her hands to protect her face; an Apache woman obscures herself in a shimmering veil of hair.[49] In military, police, and school photographs, prisoners' or students' hands can be seen clenched into fists, arms crossed. Eyes glare. In an image of dancers at Taos Pueblo, a man dashes at the unwelcome camera, his face contorted with rage. These Native refusals are not the "idiotic 'Spirit Capture' babble," as McNeil notes, but clear objections to unwanted intrusions.[50]

Second, colonial texts record acts of hostility toward colonial photographers. Curtis, for one, may have presented himself as the Sacred Scribe of the tribes, but people threw dust, mud, stones, and clubs at his camera and rode horses at his equipment, trying to topple him over. He was shot at four times.[51]

Third, Indigenous subjects used compulsory photography for their own ends, posing or dressing in ways that challenged or disrupted the colonial gaze. Few did so with more creative intention and self-fashioning than the Chiricahua Apache chief and longtime prisoner Goyathlay (Geronimo) (1829–1909). He posed for Curtis in a heavily retouched photograph as a "historical old Apache" as well as in ordinary European clothes, as a US Army scout, and with his family in his garden plot as a prisoner at Fort Sill army base. In a photograph at Fort Sill, Geronimo stands against a wall with an aspect of defiant self-composure, dressed in crumpled European clothes—

white hat, jacket, white shirt, and knee boots, but bare legged—his arms crossed, scowling at the photographer with an indifferent disdain that passes right through the camera.

As the artist Jimmie Durham[52] puts it: "Geronimo, as an Indian 'photographic subject' blew out the windows. He reinvented the concept of photographs of American Indians.... Even when he was 'posed' by the man behind the camera, he seems to have destroyed the pose and created his own stance."[53] In an iconic 1905 image Geronimo sits commandingly in a "Cadillac" (actually a Locomobile Model C) with three Native companions who wear tribal clothes and feathered headdresses (fig. 212). He firmly grips the wheel, impeccably attired in a shiny black top hat, white shirt, black trousers, and waistcoat. He glares intently into the camera as if *demanding* that the viewer recognize how aware he is of playing an "Indian in an unexpected place," to borrow Deloria's resonant phrase.[54]

We can't know for sure if Geronimo chose to sit in the car, or if the scene was staged as part of a Wild West show to, as Deloria suggests, "imagine Indian automobility as anomalous,"

FIGURE 212: Attributed to James "Bennie" Kent (American, born England, 1866–1945), Chiricahua Apache leader Geronimo behind the wheel of a Locomobile Model C at 101 Ranch, near Ponca City, 1905. Courtesy University of Oklahoma Libraries, Norman. Western History Collections (Ferguson 745)

awakening the "ghostly presences" of white racist expectations.[55] But Geronimo, as Durham puts it, is deliberately "messing with established reality here....Look at his face getting in your face ... he puts on your hat, takes the wheel, and stares the camera down."[56] Geronimo also created a thriving business in personal appearances and autograph-signings at expositions.[57] What could be more ironic than Geronimo, a prisoner, making white people pay for his autograph (the capitalist sign of individual possessive authenticity), with an invented name that was not even his own? The joke is Geronimo's.

Cars appear with ritualistic regularity in photographs by Indigenous photographers, marking the place of a refusal. What Deloria calls "automobility" captures Indigenous peoples' resolve to reanimate the reservation ghostscapes: "Automotive mobility helped Indian people evade supervision and take possession of the landscape, helping make reservations into distinctively tribal places."[58] As Laura Smith writes: "New technological modes of transportation did not obliterate indigenous life ways. They revitalized them."[59]

The most powerful strategy against the colonial camera, however, was for Native photographers to use the camera for their own ends, to insist on mobility, contemporaneity, self-possession, humor, and the right to self-fashioning.[60] Poolaw, for one, deploys a cross-cultural dynamic that simply ignores the separation of "modernity" from "tradition," mixing technologies, chronologies, and genders to make his subjects visible as inextricably modern and Native, Indigenous and American. He poses in a US aircraft in a feathered headdress and uniform, holding a camera. He poses his son Robert "Corky" and daughter, Linda, cross-dressed as cowboys with drawn guns, making visible the colonial violence embodied in gun and camera, while at the same time refusing the categories of race and gender as fixed by nature (fig. 213). Poolaw's deliberate stagings of contrapuntal time are nonchalantly offered as ordinary, everyday events, strategically undoing decades of the administration of forgetting that positioned Natives, in Rayna Green's sardonic phrase, as the "Potentates of the Potlatch, the Last-Ofs."[61]

Much as we may want to leave Curtis behind, that day is not yet come; he hovers still. But Curtis's phantoms are currently being reanimated with contemporary voices by Indigenous photographers who "subvert the very premise on which the originals were created."[62] As Henrietta Lidchi and the photographer Hulleah J. Tsinhnahjinnie

(Taskigi/Diné, born 1954) point out: "For Native communities, archives formerly identified as a place of subjugation are now more frequently the sites of reclamation and retrieval."[63]

Larry McNeil's distinctive style draws on a Tlingit aesthetic that "extends back for thousands upon thousands of years," while ironically staging the "more bizarre aspects" of Curtis's simulations to produce an entirely new imagery. In *Tonto's TV Script Revision* (2006), McNeil irreverently opens the Curtis crypt wide, combining clashing histories and genres into a visual mash-up, where Tonto brings "the criminal" Richard Pratt (founder of the notorious Carlisle Indian School) to justice by dunking his head into a washbasin, while the Lone Ranger, wearing baby-blue Superman cowboy tights, holds a gun on Curtis, himself uncomfortably clad in a fake Indian costume. McNeil places himself in the image: he is reflected in a mirror taking photographs of the whole unruly scene.[64]

Elizabeth Edwards argues that the Western theoretical obsession with photographs as reliquaries of loss cannot convey the contemporary vitality of Indigenous artists reanimating archival images into innovative forms of sovereignty, regeneration, and new futures.[65] The lush, digital layerings of images by Rosalie Favell (Métis [Cree/English], born 1958) and Tsinhnahjinnie's series *Portraits Against Amnesia* (2003) evoke and refuse Curtis's phantoms in opulent, extravagant, and celebratory ways.[66] In the wake of the centenary of the publication of Curtis's books, vibrant exhibitions by Native artists are challenging his contentious legacy. Prominent artists such as Wendy Red Star (Apsáalooke, born 1981), Will Wilson (Diné, born 1969), and Zig Jackson (Mandan/Hidatsa/Arikara, born 1957), among others, directly engage Curtis to "privilege the contemporary Native voice over the voice of Curtis."[67]

In her painting *The Browning of America* (2000), Jaune Quick-to-See Smith (Salish member, Confederated Salish and Kootenai Nation, born 1940) unpaints the colonial ghostscape by refusing the map of America as a document of territorial appropriation, or what the Mvskoke poet Joy Harjo calls "a patchwork of guilt" (see fig. 8).[68] Smith presents the map of America as a landscape of environmental and cultural mourning, but also as a ceremony animating the memory of prior habitation and survivance. The daubs and trickling smears of paint become a translucent membrane through which the torn time of the Indigenous past is reclaimed, and the shocked space of colonial violence

FIGURE 213: Horace Poolaw, Robert "Corky" and Linda Poolaw (Kiowa/Delaware) dressed up and posed for the photo by their father, Horace. Anadarko, Oklahoma, ca. 1947. Digital image from a 4-by-5-inch black-and-white negative. Courtesy Estate of Horace Poolaw (45HPF57)

inhabited by Indigenous memory. The blood-red smear scraped down the central Great Plains recalls the Chickasaw writer and poet Linda Hogan's depiction of colonial maps as vistas of violence that cannot be unimagined except as maps in the blood. Smith's gesture of refusal embodies the Diné poet Sherwin Bitsui's vision "in the cave on the backside of a lie ... the birth of a new atlas."[69]

FUGUE III: REVENANTS, INDIAN COUNTRY, AND THE FOREVER WAR

It is so hard to know the limit to denial of the past.
Friedrich Nietzsche

Why should the hauntings of Curtis's "Indian Country" still matter? One cannot overstate how pervasively that trope has been used by the United States military to characterize as yet unsubjugated territories in active war zones around the world.[70] Throughout US history, to be in Indian Country was to be behind enemy lines, in the Philippines, Japan, Vietnam, the Persian Gulf, Iraq, Afghanistan, Yemen, and beyond. In Vietnam, Colin Powell, then a second lieutenant in the army, called the My Lai massacre "understandable as the troops were stuck in 'Indian Country.'"[71] White US soldiers wear "war paint" and Indian patches, while hundreds of

Fort Apaches and Fort Geronimos are scattered throughout the US global war. Proportionately more Native people serve in the US military than any other group, firing Tomahawk missiles and fighting in vehicles named after their own dispossessed peoples: Blackhawk, Chinook, Apache. (Every air force helicopter is named for a Native tribe.) The trope of Indian Country is a phantom, an anachronistic disturbance that marks the ghostly recurrence of transgenerational guilt unatoned.

The fact that the United States has never dealt with its genocidal past means that the hauntings of Indian Country and imperial violence are destined to return. Indian Country is a form of imperial ghosting, a floating country of the imperial imagination, globally dispersed and perpetually shifting, a no-place and an everywhere. Double-sided with respect to power, Indian Country is both the geographical marker of a profound sense of US military impotence and chaos, and the historical marker of a fantasy of omnipotence, the future imagined as preordained by a past that guarantees military victory as manifest destiny.

Consider a military photograph taken in Colorado on October 7, 2003, shortly after the illegal invasion of Iraq (fig. 214). Defense Secretary Donald Rumsfeld visited Fort Carson, named after the infamous Kit Carson (1809–1868), who was dispatched to exterminate the Diné, Mescalero Apache, and Kiowa by massacre and deliberate destruction of food sources, culminating in the Long Walk to the

FIGURE 214: Secretary of Defense Donald H. Rumsfeld at Fort Carson, Colorado, October 7, 2003. United States Department of Defense

concentration camp of Bosque Redondo. In his address in 2003 to the Third Cavalry Regiment, Rumsfeld invoked the ghost of Kit Carson: "In the global War on Terror," he said, "US forces have lived up to the legend of Kit Carson.… Every one of you is chosen by destiny. Every one of you is like Kit Carson."[72]

Behind Rumsfeld stand members of the Third Cavalry on their way to Iraq, but rising behind them, oddly elevated as if on a ridge in a Hollywood western, ghostly soldiers line the sky dressed in period costumes of the Third Cavalry that hunted down the Diné. The scene was choreographed to legitimize the invasion of Iraq by equating it with the occupation of Native lands. In 2004 Rumsfeld revisited Fort Carson and unveiled a statue of Kit Carson. Once more, men donned period costume and charged at the "enemy." But who is the enemy here: the ghosted Natives of the past or modern insurgents against US occupation? Imperial déjà vu.

It was therefore predictable but no less bizarre that the Obama administration's plan to assassinate Osama Bin Laden would be called "Operation Geronimo": a symbolic name theft, or phantom, that produced a storm of Native protest. "Indian Country" now circumscribes the globe and has become the forever frontier of the Forever War.

FUGUE IV: OILSCAPES AND IMPERIAL DÉJÀ VU

This is the map of the forsaken world.
This is the world without end
Where the forests have been cut away from the trees
These are the lines wolf could not pass over.
Linda Hogan (Chickasaw), "Map"

In 2010 in the Gulf of Mexico, the forever spill became the Forever War. On April 20 the BP Deepwater Horizon rig exploded, a crimson and gray apocalypse pitching and sinking, taking with it eleven men dead. The Gulf of Mexico disaster became the largest environmental crisis in US history; it also became the largest ghosting of an environmental crisis, and the Gulf became a ghostscape.[73]

A calamity of untold magnitude unfolded and alongside it a strange militarization emerged, as the language for managing the crisis became the language of war. War talk fired from the media, the Coast Guard, and local officials alike. Louisiana Governor Bobby Jindal: "We need to see that this is a war; a war to save Louisiana." Billy Nungesser, president

of the Plaquemines Parish: "We will persevere to win this war." Democrat James Carville: "This is literally a war." General Russell Honore: "We need to act like this is World War III....We've got to find the oil and kill it."

Militarizing the catastrophe became the invisible norm, and a dangerous circularity took shape as the crisis was managed in the same terms that produced the crisis: that of war. Militarizing the environmental catastrophe *as* a war became a cover-up for not seeing the environmental catastrophe *of* war. The war talk ghosted the fact that militarization is the largest single cause of environmental destruction in the world; the US military is the largest single polluter on the planet, and the Department of Defense is the largest single consumer of oil in the world.[74]

Three ghostings were played out in the Gulf: the disappearance of the story by the media blockade; the disappearance of the oil by the toxic dispersant Corexit; and the disappearance of the private contractors who were all over the Gulf states. Shortly after the blowout, an extraordinary ruling was passed: no media could go within sixty feet of oil-affected areas, workers, birds, boats, or boom, or risk $40,000 fines or felony charges.[75]

Why? BP had agreed to pay damages for "verifiable evidence," and to hide the evidence, military planes "carpet-bombed" five Gulf states with massive amounts of Corexit, which doesn't remove the oil but only disperses it. Corexit is a form of slow violence, an alchemy of erasure, a sorcerer's bargain with life and death. But when mixed with oil, Corexit turns an uncanny pink, and for miles, vast telltale smears stretched across the Gulf, revealing the cover-up in the very act of concealing it (fig. 215). Now in the Gulf, a lifeless ghostscape—officially called the "kill zone"—stretches for hundreds of miles.

In a photograph by Richard Misrach (born 1949) titled *Swamp and Pipeline, Geismar, Louisiana* (1998), spectral trees lean out of a pallid swamp, the water an eerie green cut across by the blood-rust artery of an oil pipeline (fig. 216). At first glance, the image is strangely ethereal, almost beautiful: that silky water, that pale green. But a visual disturbance mars the scene, troubling the eye. Nothing connects the smooth, viscid water in the foreground with the tangled ghost-swamp behind. The red pipeline seems to float over the water. The pipeline is an industrial hinge between the smooth foreground and the tangled devastation behind, but the cause of the chaos remains hidden. The photograph

FIGURE 215: Anne McClintock (American, born Zimbabwe), *Phantom. Oil Mixed with Corexit*, Louisiana, July 2010. Courtesy of the artist

is a crypt that both conceals and reveals decades of devastation by the petrochemical industry.

Through the damaged and vanishing marshes, massive superhighways like giant causeways have been cut for the huge oil tankers on their way to the Gulf. These canals are fatal arteries that draw salt water into the marshes. The salt kills the once abundant forests, leaving vast, splintered regions that locals call "ghost forests" and "skeleton trees." The fragile, filigree wetlands are a ruined ghostscape; the once lush forests and wildlife gone. Louisiana is now among the fastest disappearing lands on earth. Every hour, Louisiana loses wetland the size of a football field.

And fugue-like, Indian Country returns. Out of the forlorn marshes, handmade signs tilt out of the grasses, scrawled with the words "Indian Country."

Deep in the southern Louisiana bayous, not far from the Deepwater Horizon site, Biloxi-Chitimacha-Choctaw Indians cling to a drowning sliver of land called Isle de Jean Charles. Once the size of Manhattan, Isle de Jean Charles is now a quarter mile wide and two miles long. The Islanders are being hailed as the first community of federally funded "climate refugees" in the United States. But when I spent time there, traveling with Chief Albert Naquin, Tommy Dardar, and other tribal members, I found a more complex story of double displacement. Many of the islanders'

ancestors had survived the forced removals of the nineteenth century, fleeing south from the military forces celebrated by Rumsfeld to southern Louisiana, where, for more than a century, they had sustained themselves and their cultures in the abundant, hidden marshes.

Now the Biloxi-Chitimacha-Choctaw face forced removal once more: as the waters rise and the land sinks under decades of devastation caused by the combined onslaughts of the petrochemical industry and climate change. The Indians are caught in a double limbo, torn between the desire to remain on their island and the need to flee the rising waters, as well as in the deadly paradox of being recognized as climate refugees but not being recognized as an existing tribe. Colonial déjà vu.

FIGURE 216: Richard Misrach (American, born 1949), *Swamp and Pipeline, Geismar, Louisiana*, from the series *Cancer Alley*, 1998, printed 2017. Pigmented inkjet print, 50.8 × 61 cm. Collection of the artist; courtesy Fraenkel Gallery, San Francisco; Pace/MacGill Gallery, New York; and Marc Selwyn Fine Arts, Los Angeles

What is not widely known is that the militarization of the Gulf catastrophe in 2010 was the tryout for what the Pentagon now calls a "revolution in warfare": using climate change to justify perpetual war. Admiral Thomas J. Lopez puts it bluntly: "Climate change will provide the conditions that will extend the war on terror."[76] Climate change has become the Pentagon's new, improved "hostile"; climate justice activists are being put on "terrorist" lists, and the entire planet now offers myriad "Ground Zeros" for military intervention, from the South China Sea to the Arctic Circle to Standing Rock.

At Standing Rock, in the deadly freeze of winter, militarized police and private contractors turned water cannons, dogs, ammunition, and super-surveillance on the Water Protectors, including elders and children, many of them descendants of the Dakota who had fled north from the ethnic cleansing of the Očhéthi Šakówiŋ in 1860s Minnesota. Colonial déjà vu.

FIGURE 217: Ali Rez, Saks Afridi, Assam Khalid, Akash Goel, JR, Insiya Syed, Noor Behram, Jamil Akhtar, and the InsideOut project, *#NotABugSplat*, 2014. Art Installation in Khyber Pakhtunkhwa, Pakistan. Launched with the support of Reprieve/Foundation for Fundamental Rights

FUGUE V: MIRRORS OF REFUSAL AND KWEL' HOY (WE DRAW THE LINE)

As artists, we live on the periphery. But we are the mirrors. We are the reflective points that break through a barrier.

Cannupa Hanska Luger (Mandan/Hidatsa/Arikara/Lakota)

Fugue-like, the mirrors return.

Near Standing Rock at the Oceti Sakowin Camp, the Water Protectors created mirror shields to protect themselves from water cannons and bullets and to reflect back the images of the police (see fig. 288). The artist Cannupa Hanska Luger (born 1979) explains: "This project speaks about when a line has been drawn and a frontline is created....The mirror shield is a point of human engagement and a remembering that we are all in this together."[77]

Across the United States, Indigenous artists are drawing the lines of countermemory and refusal: from the Standing Rock mirror shields to the Lummi Nation's totem pole journey, *Kwel' Hoy* (We Draw the Line) (2017–18), to the artist collective Postcommodity's *Repellent Fence/Valla Repelente* (2015; see fig. 14) and beyond.

And half a world away, in a region of Pakistan where civilians are regularly killed by drones, an extraordinary art installation, *#NotABugSplat*, mirrors back a challenge to the US drone war (fig. 217).[78] Villagers made a vast

magnification from part of a photograph of a young girl orphaned by a drone attack. The magnified image was laid out in a field, so that US drone operators have to acknowledge that it is people they are killing. As the child looks back at the drones, the world swivels on its axis, and ordinary people in the dronescape refuse to live under the god-vision of Western eyes. The child gazes back at the United States with a haunting challenge to be witnessed as human.

Theodor Adorno and Max Horkheimer insisted: "Only the conscious horror of destruction creates the correct relationship with the dead....The past becomes a source of anger....It becomes a wound."[79] So, we must animate the histories that have been officially forgotten. We must atone for the dead and bring justice to the living. And we must learn to speak with ghosts, for specters disturb the authority of super-vision, and the hauntings of popular memory will return to challenge the great forgettings of official history.

As Eduardo Galeano said: "History never really says goodbye. History says: see you later."[80]

Notes

EPIGRAPHS: *Hamlet*, in *The Complete Works of William Shakespeare*, ed. William G. Clark and William A. Wright (New York: Hearst's International Library, 1914), 1015, act 1, scene 5. Supporting papers to a task force report on the crisis in Iraq for the Pentagon's Defense Science Board, January 2005, cited in John W. Dower, *Cultures of War: Pearl Harbor, Hiroshima, 9-11, Iraq* (New York: W. W. Norton, 2010), 74–75. Michel-Rolph Trouillot, *Silencing the Past: Power and the Production of History* (Boston: Beacon Press, 1995), xix. Trouillot, *Silencing the Past*, xix. James Baldwin quoted in *I Am Not Your Negro*, comp. and ed. Raoul Peck, from texts by James Baldwin (New York: Vintage Books, 2017), 22. Paul Chaat Smith, *Everything You Know about Indians Is Wrong* (Minneapolis: University of Minnesota, 2009), 10. Hulleah J. Tsinhnahjinnie, "Visual Sovereignty," in *Diversity and Dialogue: The Eiteljorg Fellowship for Native American Fine Art, 2007*, ed. James H. Nottage (Indianapolis: Eiteljorg Museum of American Indians and Western Art, 2008), 18. Friedrich Nietzsche, "On the Uses and Disadvantages of History for Life," in *Untimely Meditations*, ed. Daniel Breazeale, trans. R. J. Hollingdale (Cambridge: Cambridge University Press, 1997), 76. Linda Hogan, "Map," in *The Book of Medicines: Poems* (Minneapolis: Coffee House Press, 1993), 37. Cannupa Hanska Luger, "Mirror Shield Project," artist's website, http://www.cannupahanska.com/mniwiconi/.

1 "Grey Ghost" was the name given by the male prisoners at Bagram Air Base to Aafia Siddiqui, the Pakistani scientist and only female prisoner reported to have been held at Bagram. Donald Rumsfeld called the prisoners at Guantánamo "dead men walking." See my essay "Paranoid Empire: Specters from Guantánamo and Abu Ghraib," in *States of Emergency: The Object of American Studies*, ed. Russ Castronovo and Susan Gillman (Chapel Hill: University of North Carolina Press, 2009), 88–115.

2 This essay is drawn from my forthcoming book *Unquiet Ghosts of the Forever War* (Duke University Press). I first presented the argument of the book at the conference "Capture 2012: Photography, Nature, and Human Rights," Yale University Law School, October 12–13, 2012.

3 I engage this question by using the form of the fugue. By fugue I mean a contrapuntal process in which a theme is introduced, then developed or complicated by multiple voices. Psychiatric fugue states emerge from memory loss, movement, ruptures of time, and disturbances of space, making improbable connections between unlikely things. The word derives from the Latin *fugare* (to chase) or *fugere* (to flee), as in chasing or fleeing phantoms.

4 Avery Gordon, *Ghostly Matters: Hauntings and the Sociological Imagination* (Minneapolis: University of Minnesota Press, 2008), 18.

5 Matthew Frye Jacobson, "Imperial Amnesia: Teddy Roosevelt, the Philippines, and the Modern Art of Forgetting," *Radical History Review*, no. 73 (Winter 1999): 116.

6 Michelle Cliff, "History as Fiction, Fiction as History," *Ploughshares* 20, no. 2/3 (Fall 1994): 198.

7 Philip J. Deloria, *Indians in Unexpected Places* (Lawrence: University Press of Kansas, 2004), 225.

8 Toni Morrison, "'Five Years of Terror': A Conversation with Miriam Horn," *U.S. News & World Report*, October 19, 1987, 75. I am indebted to Avery Gordon, Toni Morrison, Saidiya Hartman, Jenny Sharpe, Marianne Hirsch, Gabriele Schwab, Russ Castronovo, Renee Bergland, and Jacques Derrida, to whose explorations of ghostly matters I owe a great deal.

9 I use the term "ghosting" as opposed to "erasures" because ghosting implies attempts at disappearance, disavowal, or erasure that are incomplete or unsuccessful, resulting in transgenerational effects that linger across time and space. Agency and material presence are thereby given to those who are, inadequately, called "ghosts," as well as mobilizing possibilities for regeneration or refusal. Phantoms have material effects with palpable power and presence. For the disenfranchised, in particular, phantoms are not necessarily to be exorcised but rather can become a source of regeneration and recognition.

10 Nicolas Abraham and Maria Torok, *The Shell and the Kernel: Renewals of Psychoanalysis*, ed. and trans. Nicholas T. Rand, vol. 1 (Chicago: University of Chicago Press, 1994). In *Ghostly Matters*, Avery Gordon discusses hauntings in terms of Freud's notion of the uncanny, which she sees as deriving for Freud from two sources: "repressed infantile complexes" and the return of "primitive belief" (Gordon, *Ghostly Matters*, 50). For my purposes, Abraham and Torok's transgenerational and historically inflected figures of the crypt and the phantom open up more generative routes to a critique of colonial power and settler domination without the racist undertow of Freud's theory of the uncanny.

11 Eyal Weizman and Fazal Sheikh, *The Conflict Shoreline: Colonization as Climate Change in the Negev Desert* (New York: Steidl, 2015), 41. See also Sheikh, *Erasure Trilogy* (New York: Steidl, 2015); and Weizman "Violence at the Threshold of Detectability," *e-flux* 64 (April 2015), http://www.e-flux.com/journal/64/60861/violence-at-the-threshold -of-detectability/.

12 James Baldwin, *The Evidence of Things Not Seen* (New York: Holt, Rinehart & Winston, 1986).

13 There is a considerable body of literature on Edward S. Curtis. See especially Mick Gidley, *Edward S. Curtis and the North American Indian, Incorporated* (Cambridge: Cambridge University Press, 1998); Mick Gidley, ed., *Edward S. Curtis and the North American Indian Project in the Field* (Lincoln: University of Nebraska Press, 2003); Anne Makepeace, *Edward S. Curtis: Coming to Light* (Washington, DC: National Geographic Society, 2001); Christopher Cardozo, ed., *Sacred Legacy: Edward S. Curtis and the North American Indian* (New York: Simon & Schuster, 2000); Christopher Cardozo, ed., *Native Nations: First Americans as Seen by Edward S. Curtis* (Boston: Little, Brown, 1993); Shamoon Zamir, *The Gift of the Face: Portraiture and Time in Edward S. Curtis's The North American Indian* (Chapel Hill: University of North Carolina Press, 2014); and Timothy Egan, *Short Nights of the Shadow Catcher: The Epic Life and Immortal Photographs of Edward Curtis* (Boston: Houghton Mifflin Harcourt, 2012).

14 The Piegan are members of the Blackfoot Confederacy; Curtis's image was taken in northern Montana about 1909 and published in 1911. Between 1900 and 1910, abetted by the legalized land theft of the 1887 Dawes Allotment Act, more than eighteen million acres of Native tribal lands were taken by the US government through policies of forced allotments and sales of "surplus land," destroying Native economies and devastating Indigenous modes of Native governance and cultural

integrity. In the preceding thirty years, Native communities had lost eighty-seven million acres of land. See Judith Nies, *Native American History: A Chronology of the Vast Achievements of a Culture and Their Links to World Events* (New York: Ballantine Books, 1996), 320.

15 Gerald Vizenor, "Socioacupuncture: Mythic Reversals and the Striptease in Four Seasons," in *The American Indian and the Problem of History*, ed. Calvin Martin (New York: Oxford University Press, 1987), 182.

16 Vizenor, "Socioacupuncture," 183.

17 What Ned Blackhawk (Te-Moak, Western Shoshone) calls "the traumatic storms of white expansion" reduced Native nations to an estimated 5 percent of their original number; by 1891, the first census numbered remaining Native peoples at 277,000 from an estimated 10 million. Blackhawk, *Violence over the Land: Indians and Empires in the Early American West* (Cambridge, MA: Harvard University Press, 2006), 293.

18 Deloria, *Indians in Unexpected Places*, 139.

19 See Carlos B. Embry, *America's Concentration Camps: The Facts about Our Indian Reservations Today* (New York: D. McKay, 1956). See also Vine Deloria Jr., *For This Land: Writings on Religion in America* (New York: Routledge, 1998), 244.

20 Here I follow Kyle Powys Whyte's (Potawatomi) definition of settler colonialism: "As an injustice, settler colonialism refers to complex social processes in which at least one society seeks to move permanently onto the terrestrial, aquatic, and aerial places lived in by one or more other societies who already derive economic vitality, cultural flourishing, and political self-determination from the relationships they have established with the plants, animals, physical entities, and ecosystems of those places." Whyte, "The Dakota Access Pipeline, Environmental Injustice, and U.S. Colonialism," *Red Ink* 19, no.1 (Spring 2017): 158.

21 Louis Owens, *I Hear the Train: Reflections, Inventions, Refractions* (Norman: University of Oklahoma Press, 2001), 217.

22 John Berger, *About Looking* (New York: Vintage, 1992), 59.

23 I elaborate the idea of anachronistic space throughout *Imperial Leather: Race, Gender and Sexuality in the Colonial Contest* (New York: Routledge, 1995).

24 As Gordon writes, "To be haunted is to be tied to historical and social effects." *Ghostly Matters*, 190.

25 See Darieck Scott, *Extravagant Abjection: Blackness, Power and Sexuality in the African American Literary Imagination* (New York: New York University Press, 2010); and Harvey Young, *Embodying Black Experience: Stillness, Critical Memory, and the Black Body* (Ann Arbor: University of Michigan Press, 2010), for valuable discussions of power, stillness, and abjection in Black Diasporic experience.

26 Zamir, in his insightful analysis of Curtis's photographs, explores what he calls a "crisis of temporality" faced by Native peoples as a result of decades of cultural devastation. "Native American history therefore came to an end in so far as the forms of traditional cultural life that had conceptualized meaningful action and subjecthood came to an end." *Gift of the Face*, 20. I endorse Zamir's stress on Curtis's sitters'

collaborative agency but feel he risks exculpating Curtis's complicity in collapsing Native life with the temporality of "tradition": Native people found themselves "dislocated in time, pushed out of their own time and history" (20) in a way that risks erasing the centuries of complex collaborations and conflicts between Indigenous and non-Indigenous peoples.

27 Eric Hobsbawm, *Industry and Empire: From 1750 to the Present Day* (New York: New Press, 1999), 83.

28 Louis Owens, *Mixedblood Messages: Literature, Film, Family, Place* (Norman: University of Oklahoma Press, 1998), 160–61.

29 For Alexander Upshaw's relation to Curtis, see Shamoon Zamir, "Native Agency and the Making of 'The North American Indian': Alexander B. Upshaw and Edward S. Curtis," *American Indian Quarterly* 31, no. 4 (Fall 2007): 613–53. On the collaborative context of photography, see Ariella Azoulay's groundbreaking *The Civil Contract of Photography* (New York: Zone, 2008).

30 Christopher M. Lyman, *The Vanishing Race and Other Illusions* (New York: Pantheon, 1982), 181.

31 Vizenor, "Socioacupuncture," 182.

32 Vizenor, 183.

33 Larry McNeil, "American Myths and Indigenous Photography," in *Visual Currencies: Reflections on Native Photography*, ed. Henrietta Lidchi and Hulleah J. Tsinhnahjinnie (Edinburgh: National Museums Scotland, 2009), 119.

34 McNeil, "American Myths and Indigenous Photography," 118, 117.

35 See my essay "Imperial Ghosting and National Tragedy: Revenants from Hiroshima and Indian Country in the War on Terror," *Publications of the Modern Languages Association (PMLA)* 129, no. 4 (October 2014): 819–29.

36 Nancy Marie Mithlo (Chiricahua Apache), ed., *For a Love of His People: The Photography of Horace Poolaw* (New Haven: Yale University Press, 2014). See also Laura E. Smith, *Horace Poolaw: Photographer of American Indian Modernity* (Lincoln: University of Nebraska Press, 2016).

37 Alan Trachtenberg, *Reading American Photographs: Images as History, Mathew Brady to Walker Evans* (New York: Hill & Wang, 1990), 73.

38 See John A. Haymond, *The Infamous Dakota War Trials of 1862: Revenge, Military Law and the Judgment of History* (Jefferson, NC: McFarland, 2016); "The Sioux Uprising of 1862," http://www.d.umn .edu/~bart0412/project.htm; Nies, *Native American History*, 267; Gary Clayton Anderson and Alan R. Woolworth, eds., *Through Dakota Eyes: Narrative Accounts of the Minnesota Indian War of 1862* (St. Paul: Minnesota Historical Society Press, 1988); and Roxanne Dunbar-Ortiz, *An Indigenous Peoples' History of the United States* (Boston: Beacon Press, 2014).

39 Cited in Makepeace, *Edward S. Curtis*, 20.

40 What we can't see in Curtis's choreography of concealment are the fiery oil spires in James Hamilton's painting *Burning Oil Well at Night, near Rouseville, Pennsylvania* (ca. 1861; see fig. 170), made seven years before Curtis was born in 1868. We can't see the petrochemical waste of

David Gilmour Blythe's *Prospecting* (ca. 1864–65; see fig. 167), or the wounded trees at Gettysburg in Mathew Brady's stereograph (ca. 1863; see fig. 154), the shocked space and gauged landscapes of iron mining in Homer Dodge Martin's painting *The Iron Mine, Port Henry, New York* (ca. 1862; see fig. 218), or the ravaged tree stumps in Winslow Homer's ghostscape *A Huntsman and Dogs* (1891; see fig. 201).

41 Settler attempts to render Native communities invisible as self-governing communities were mirrored by the hypervisibility of their use as commodity spectacles and icons in tourist culture, staged railroad exhibitions, Wild West shows, and advertisements. Native peoples have also been ghosted into the countless names of cities, streets, lakes, and landmarks as ambivalent objects of colonial anxiety, violence, and desire.

42 Paul Chaat Smith, *Everything You Know about Indians Is Wrong* (Minneapolis: University of Minnesota Press, 2009), 10.

43 Paul Chaat Smith, "Every Picture Tells a Story," in *Partial Recall*, ed. Lucy R. Lippard (New York: New Press, 1992), 97. See also Martha A. Sandweiss's classic *Print the Legend: Photography and the American West* (New Haven: Yale University Press, 2002), especially chap. 6, "Mementoes of the Race," 207–73.

44 McNeil, "American Myths and Indigenous Photography," 110.

45 "I don't know, maybe they dug it. Maybe it was fun … our true history is one of constant change, technological innovation, and intense curiosity about the world." Smith, "Every Picture Tells a Story," 98. For a survey of Native photographers and sitters during the early period, see Alfred L. Bush and Lee Clark Mitchell, *The Photograph and the American Indian* (Princeton: Princeton University Press, 1994).

46 Susanne Regener uses the term "compelled photography" for images taken without permission. Regener, *Fotografische Erfassung: Zur Geschichte medialer Konstruktionen des Kriminellen* (Paderborn, Germany: Wilhelm Fink Verlag, 1999), 16. Cited in Tina M. Campt, *Listening to Images* (Durham, NC: Duke University Press, 2017), 75. Campt uses the term "compulsory" photos to convey compelled photographs where permission might have been granted, albeit reluctantly. For earlier analyses, see Berger, *About Looking*, 52, for the almost instant inscription of the camera for bureaucratic and police use; and Alan Sekula, "The Body and the Archive," *October* 39 (Winter 1986): 3–64.

47 I first presented my argument regarding photographic refusals in my talk "Archives of Refusal" at the conference "Radical Archives," New York University, April 11–12, 2014.

48 In 1998 Gerald Vizenor questioned the representation of Indigenous peoples through a modernist aesthetics of tragedy, victimhood, and nostalgia steeped in notions of Native absence rather than presence, in *Fugitive Poses: Native American Indian Scenes of Absence and Presence*, Abraham Lincoln Lecture Series (Lincoln: University of Nebraska Press, 1998). There is now a rich body of contemporary black critical work that deploys the concept of "fugitivity" as a critical idiom of the African Diaspora. Throughout *Listening to Images*, Campt produces a black feminist reading of fugitivity in photographic archives of the African Diaspora "to reclaim the black quotidian as a signature idiom of diasporic culture and black futurity," 9. Angela Davis talks of the neglected

history of black photographers in *Women, Culture and Politics* (New York: Random House, 1984). A vibrant body of recent work on Black Studies and Visual Cultural Studies includes Simone Browne's *Dark Matters* (2015), Krista Thompson's *Shine* (2015), and Nicole Fleetwood's *On Racial Icons* (2015), among others.

49 Tim Johnson, ed., *Spirit Capture: Photographs from the National Museum of the American Indian* (Washington, DC: Smithsonian Institution Press, 1998), 63. Many of the images in Indian inspector Frank Churchill's collection, from which most of the photographs in this volume are drawn, are labeled simply "woman covering her face who did not want her picture taken" (*Spirit Capture*, 64). See also James Faris, *Navajo and Photography: A Critical History of the Representation of an American People* (Salt Lake City: University of Utah Press, 2003).

50 McNeil, "American Myths and Indigenous Photography," 120. See also Smith, "Every Picture Tells a Story," 97.

51 Curtis writes: "I have grown so used to having people yell at me to keep out, and then punctuate their remarks with mud, rocks, and clubs that I pay little attention to them if I can only succeed in getting my pictures before anything hits me," cited in Lucy Lippard, "Introduction," in Lippard, *Partial Recall*, 25.

52 I am aware of the controversy surrounding Jimmie Durham's tribal identity but am not in a position to make any definitive judgment myself on this issue. For an introduction to Durham's contested identity, see some of the renewed public conversation following the retrospective *Jimmie Durham: At the Center of the World* (Hammer Museum, 2017), notably America Meredith, "Why It Matters That Jimmie Durham Is Not Cherokee," *Artnet*, July 7, 2017, https://news.artnet.com/opinion/jimmie-durham-america-meredith-1014164; and Anne Ellegood, "Understanding the Complexities of Jimmie Durham's Native Identity," *Artnet*, August 2, 2017, https://news.artnet.com/opinion/anne-ellegood-jimmie-durham-1033907.

53 Jimmie Durham, "Geronimo!," in Lippard, *Partial Recall*, 56. See Angie Debo, *Geronimo: The Man, His Time, His Place* (Norman: University of Oklahoma Press, 1976), 400, 427. See also Barbara Dayer Gallati, "Blurring the Lines between Likeness and Type," in *American Indian Portraits: Elbridge Ayer Burbank in the West (1897–1910)*, ed. M. Melissa Wolfe (Youngstown, OH: Butler Institute of American Art, 2007), 27–28.

54 See Deloria's insightful discussion of the complex resonances of the image in *Indians in Unexpected Places*, 136–71.

55 Deloria, 4.

56 Durham, "Geronimo!," 58. Deloria points out that Geronimo had probably seen many American technological innovations firsthand and knew more about cars than his non-Indian neighbors, having traveled widely as a prisoner to expositions and ridden on horseback in Theodore Roosevelt's 1905 inaugural parade and motorcade. Living under house arrest at Fort Sill, Geronimo apparently drove a Cadillac around the grounds and in 1905 rode in a car as it chased a bison around a rodeo ring in a Wild West spectacle. Deloria, *Indians in Unexpected Places*, 140.

57 Sandweiss, *Print the Legend*, 230. Likewise, Hunkpapa Sioux Chief Sitting Bull (1831–1890) signed a contract with Buffalo Bill's Wild West Show in 1885 and "demanded the exclusive right to sell souvenir pictures of himself and to charge a fee to patrons who wanted to pose with him for a tintype." Smith, "Every Picture Tells a Story," 98.

58 Deloria notes that Blood artist Gerald Tailfeathers (1925–1975), in his painting *Blood Camps*, refuses "any distinction between the contemporary and some other kind of Indian world" by placing a car between a tent and a tepee, with a harnessed horse calmly looking on (*Indians in Unexpected Places*, 156). Lindsey B. Green-Simms, in *Postcolonial Automobility: Car Culture in West Africa* (Minneapolis: University of Minnesota Press, 2017), explores global modernity in West Africa through the image of the car "as an everyday practice, an ethos, a fantasy of autonomy, and an affective activity," back cover. Artist Jonathan Calm explores representations of black automobility in his traveling solo exhibition *African-American Automobility: The Dangerous Freedom of the Open Road*, Stanford Art Gallery, Stanford University, January 23–March 18, 2018.

59 Smith, *Horace Poolaw*, 34.

60 Horace Poolaw, Alexander Upshaw, Larry McNeil, Hulleah J. Tsinhnahjinnie, Rosalie Favell, and Victor Masayesva (Hopi, born 1951), among others.

61 Rayna Green, "Rosebuds of the Plateau," in Lippard, *Partial Recall*, 47.

62 Carol Payne and Jeffrey Thomas, "Aboriginal Interventions into the Photographic Archives," *Visual Resources* 18, no. 2 (2002): 109–25.

63 Henrietta Lidchi and Hulleah J. Tsinhnahjinnie, introduction to *Visual Currencies*, xviii.

64 McNeil, "American Myths and Indigenous Photography," 110, 120–21.

65 Elizabeth Edwards, "Photographs and the Sounds of History," *Visual Anthropology Review* (2005): 21, 27–46. Curtis's imagery also remains a source of continuity and remembrance, particularly for descendants of the original sitters (Owens, *Mixedblood Messages*, 192).

66 Dalton Walker, "Beyond Curtis," *Native Peoples* (March–April 2016): 57.

67 See the exhibition *As We See It: Contemporary Native American Photographers*, cocurated by India R. Young and Suzanne Newman Fricke, which traveled internationally from 2014 to 2018 and featured the work of Jamison Chas Banks (Seneca-Cayuga/Cherokee, born 1978), Anna Hoover (Unangax̂, 1985), Tom Jones (Ho-Chunk, born 1964), Larry McNeil, Shelley Niro (Mohawk, born 1954), Beverly Singer (Diné/Santa Clara Pueblo, 1954), Wendy Red Star, Matika Wilbur (Swinomish/Tulalip, born 1984), Will Wilson, and Tiffiney Yazzie (Diné, born 1986). A 2016 exhibition at the Portland Art Museum titled *Contemporary Native Photographers and the Edward Curtis Legacy* featured Zig Jackson, Wendy Red Star, and Will Wilson. The Palm Springs Art Museum's 2016 exhibition *Changing the Tone: Contemporary American Indian Photographers* included work by Nicholas Galanin (Tlingit/Unangax̂, born 1979), Kent Monkman (Cree, born 1965), Shelley Niro, and Lewis deSoto (Cahuilla, born 1954).

68 Joy Harjo, "Creation Story," cited in Dean Rader, "The Cartography of Sovereignty," chap. 2 in *Engaged Resistance: American Indian Art,*

Literature, and Film from Alcatraz to the NMAI (Austin: University of Texas Press, 2011), 70.

69 Sherwin Bitsui, "Atlas," in *Shapeshift* (Tucson: University of Arizona Press, 2003), 7.

70 See Winona LaDuke (enrolled member of the Mississippi Band Anishinaabeg [Ojibwe] of the White Earth reservation), *The Militarization of Indian Country*, Makwa Enewed, American Indian Studies Series (East Lansing: Michigan State University Press, 2013).

71 Quoted in Charles Lane, "The Legend of Colin Powell," *New Republic*, April 17, 1995, 21. The center of Mogadishu was called "Indian Country" during the Black Hawk Down crisis, as were uncontrolled parts of Baghdad and Fallujah. The Japanese were frequently referred to as "Indians" and Japanese warfare was described as "Indian Fighting."

72 Quoted in Donna Miles, "Rumsfeld Thanks Troops, Likens Them to American Western Legend," October 7, 2003, DoD News, US Department of Defense website, http://archive.defense.gov/news/newsarticle.aspx?id=28364.

73 For my full account of the BP oil crisis and the media blackout, see Anne McClintock, "Slow Violence and the BP Oil Crisis in the Gulf of Mexico: Militarizing Environmental Catastrophe," *e-misférica* 9, nos. 1–2 (Summer 2012), http://hemisphericinstitute.org/hemi/en/e-misferica-91/mcclintock.

74 On militarization and environmental crises, see Jacob Darwin Hamblin, *Arming Mother Nature: The Birth of Catastrophic Environmentalism* (Oxford: Oxford University Press, 2013); Robert P. Marzec, *Militarizing the Environment: Climate Change and the Security State* (Minneapolis: University of Minnesota Press, 2016); and Christian Parenti, *Tropic of Chaos: Climate Change and the New Geography of Violence* (New York: Nation Books, 2013).

75 McClintock, "Slow Violence and the BP Oil Crisis."

76 The CNA Corporation, *National Security and the Threat of Climate Change* (Alexandria, VA: CNA Corporation), 17, https://www.npr.org/documents/2007/apr/security_climate.pdf.

77 Devised by the artist Cannupa Hanska Luger, the mirror shields were inspired by women in the Ukraine holding up mirrors so that riot police could see themselves. On the #NoDAPL movement and settler colonialism, see Whyte, "The Dakota Access Pipeline," 154–69. Nick Estes (Lower Brule Sioux), "'The Supreme Law of the Land': Standing Rock and the Dakota Access Pipeline," January 16, 2017, Indian Country Today, https://indiancountrymedianetwork.com/news/opinions/supreme-law-land-standing-rock-dakota-access-pipeline.

78 For more on the project, see "A Giant Art Installation Targets Predator Drone Operators," https://notabugsplat.com/.

79 Theodor W. Adorno and Max Horkheimer, "On the Theory of Ghosts," in Adorno and Horkheimer, *Dialectic of Enlightenment*, trans. John Cumming (New York: Verso, 1997), 215, 216.

80 Eduardo Galeano, *Open Veins of Latin America: Five Centuries of the Pillage of a Continent* (New York: Monthly Review Press, 1997), 52.

Rachael Z. DeLue

Homer Dodge Martin's Landscape in Reverse

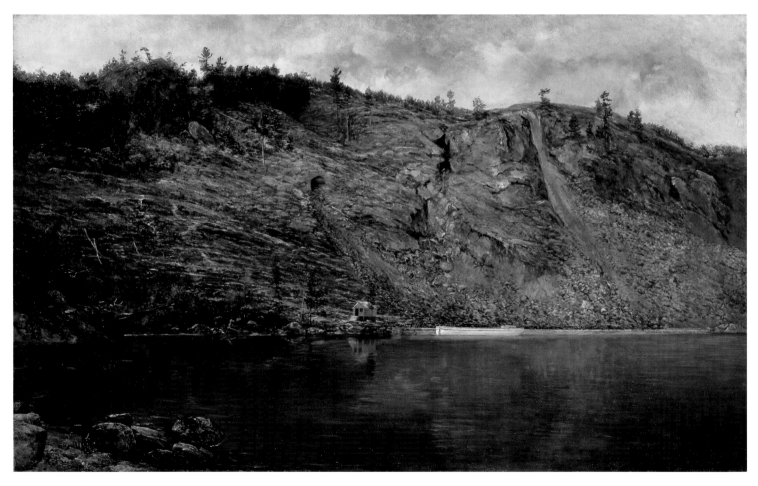

FIGURE 218: Homer Dodge Martin (American, 1836–1897), *The Iron Mine, Port Henry, New York*, ca. 1862. Oil on canvas mounted on fiberboard, 76.5 x 127 cm. Smithsonian American Art Museum. Washington, DC. Gift of William T. Evans (1910.9.11)

I.

In *The City in History*, the American historian and critic Lewis Mumford associated mining with the destruction of the environment and the collapse of communal life. Modern mining, he wrote, degraded the landscape and brutally disordered traditional human culture, engendering by the middle of the nineteenth century "a general loss of form throughout society." Mumford characterized the massive physical and social transformations wrought by mining and its attendant industries, including railroads, timber, and heavy machinery, as "un-building," the unnatural destruction of matter or place absent its replacement or reconstitution. The "immediate product of the mine," said Mumford, "is disorganized and inorganic; and what is once taken out of the quarry or the pithead cannot be replaced." As a rule, Mumford observed, mines "pass quickly from riches to exhaustion, from exhaustion to desertion, often within a few generations." Mining thus presented "the very image of human discontinuity, here today and gone tomorrow, now feverish with gain, now depleted and vacant."[1]

Mumford's critique of development echoes laments from earlier historical periods regarding the fate of the American wilderness in the wake of industrialization and urbanization. In the 1830s Washington Irving wrote nostalgically about the impending and inevitable demise of the rugged wholesomeness of frontier life, and in 1836 the landscape painter Thomas Cole wrote anxiously in his "Essay on American Scenery" of the "low pursuits of avarice," the "iron tramp" of improvement, and the "ravages of the axe," comparing the rise of consumerism to the poisoning of a forest stream.[2] In a report prepared in 1837 for the New York Natural History Survey, undertaken to assay the state's natural resources, the geologist Ebenezer Emmons sounded a similar cautionary note. He lauded the iron-rich terrain of northern New York while advocating for the judicious use of resources to ensure the region's sustainability. Emmons recommended a systematic approach to logging, at the time one of New York State's most lucrative industries. Careful management of the forests, he wrote, was imperative for securing the long-term availability of wood, which fueled the process of extracting iron from ore.[3] Although compelled by the interests of industry—Emmons concluded his report with an analysis of the economic value of iron production in the United States—his advocacy of conservation revealed a proto-ecological understanding of nature's interdependencies and gestured toward the extrahuman temporality or timescale of the natural world, as reflected in his explanation of the prolonged life cycle of a forest:

> To secure a sufficiency of wood for the future, only a given area should be devoted to the axe yearly, and on this enough of the small trees should be left standing to support the soil and prevent its washing.... When steep escarpments have once been stripped of their verdure, it requires a great length of time to reclothe them. To be convinced of this, we may observe the slow progress which nature makes in effecting this work; first, she forms a covering of moss and lichens; then a larger growth of the same; these decaying, form a little spare soil in the cracks and crevices of rocks; in these, larger species of plants fix themselves, which in their turn also die and are decomposed; still larger kinds may now find a footing, when, after many years, a sufficient thickness of soil is formed to support the woody stems. A century may elapse before all these preparations can be completed.[4]

Emmons went on to emphasize the importance of cultivating second-growth forests on cleared land in order to ensure the process of carbonization, the slow transformation of decaying plant matter into coal for use in iron-ore processing and manufacturing. For Emmons, clearly, the longevity of forests and the long-term survival of the mining industry went hand in hand. His remarks point directly to the double bind of progress while sounding a note of caution noticeably absent from much period rhetoric, which ranged from resigned acceptance to exuberance in the face of industry's iron tramp.

II.

By the time Homer Dodge Martin (1836–1897) painted *The Iron Mine, Port Henry, New York* (fig. 218), the mining, timber, and railroad industries had radically transformed much of the terrain described by Emmons in his report, leaving large sections of the Adirondack wilderness looking like the barren hillside in Martin's picture. The lawyer and surveyor Verplanck Colvin wrote of the devastation wrought by logging in the Adirondacks in a published account of his 1870 expedition to the region. Colvin, whose advocacy would be instrumental to the passage of New York's Forest Preserve Act in 1885, lamented the "chopping and burning off of vast tracts of forest in the wilderness" encountered during his

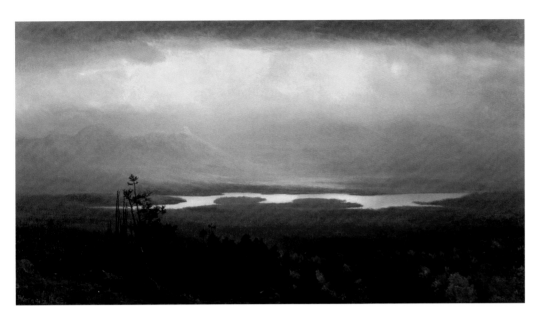

FIGURE 219: Homer Dodge Martin, *Mountain View on the Saranac*, 1868. Oil on canvas, 76.2 ×142.2 cm. The Adirondack Museum, Blue Mountain Lake, New York (1971.46.1)

travels. Following in the footsteps of the early environmentalist George Perkins Marsh, who described the devastating physical, geographical, meteorological, and economic effects of deforestation in his 1864 manifesto *Man and Nature*, Colvin elucidated the widespread consequences of a timber industry run amok, from uncontrolled runoff and barren soil to a dwindling supply of water for the region's rivers and canals.[5] By the 1890s another writer described traveling for miles in the Adirondack region without finding "a tree large enough to make a respectable fish-pole."[6]

The archival record has yet to reveal anything about Martin's own views regarding wilderness conservation. And Martin's life and work, more generally, remain relatively unexplored, for there exists only a small amount of scholarship devoted to his career. The bulk of the scholarly literature appeared within a decade or two after the artist's death, including a short book by the Princeton University art historian and museum director Frank Jewett Mather Jr., published in 1912.[7] Born and raised in Albany, New York, Martin received little formal training as an artist, but by 1857 he exhibited two paintings at the National Academy of Design in New York. He became an associate member of the National Academy in 1867 and a full academician in 1874. It appears that Martin depicted the subject of mining only once. Like many of his contemporaries, he painted mostly wilderness scenes, traveling in the summer months to the

White Mountains, Catskills, and Adirondacks to gather landscape subjects to work up in his New York City studio, his base of operations by 1863.[8] Before taking two extended trips to Europe in 1876 and 1881, Martin regularly visited the Adirondacks in the summer and fall. He joined a growing tourist trade in the area inspired in part by William H. H. Murray's best-selling *Adventures in the Wilderness; or, Camp-Life in the Adirondacks*, a lively travel narrative and guidebook published in 1869. Shortly after the publication of *Adventures in the Wilderness*, the magazine *Every Saturday: A Journal of Choice Reading* commissioned Martin to illustrate a review of Murray's book with images of Adirondacks scenery, and Martin provided views of the Saranac River (fig. 219), canoeing on the Raquette, and camping on Upper Ausable Lake, reproduced as engravings in the magazine.[9]

Echoing Cole's advice to his readers in his "Essay on American Scenery" regarding the physical, mental, and spiritual benefits of encounters with nature, Murray recommended wilderness travel for those "pent up in narrow offices and narrower studies, weary of the city's din" and who "long for a breath of mountain air and the free life by field and flood." According to Murray, the unspoiled wildness of the Adirondacks gave the region its restorative power, in direct contrast to the woods of Maine for which the timber industry had long been, as he put it, the "curse and scourge." For Murray, logging in Maine created logistical

problems for the adventurer—clogged streams and trout pools, rivers blocked with logs, potential campsites littered with trash—as well as aesthetic ones. "Wherever the axe sounds," Murray wrote, "the pride and beauty of the forest disappear. A lumbered district is the most dreary and dismal region the eye of man ever beheld. The mountains are not merely shorn of trees, but from base to summit fires … have swept their sides, leaving the blackened rocks exposed to the eye, and here and there a few unsightly trunks leaning in all directions, from which all the branches and green foliage have been burnt away."[10]

Murray expresses his distaste for logging, not mining, in this passage. But his account of Maine could easily have described numerous spots in the Adirondacks in the 1860s and 1870s cleared to make way for the many mining operations in the region. By 1859 J. P. Lesley's *The Iron Manufacturer's Guide to the Furnaces, Forges, and Rolling Mills of the United States* listed more than a dozen iron mines in Essex and Clinton counties, the northeastern section of the Adirondacks that borders Lake Champlain, as well as numerous blast furnaces and other ore-processing works. Turn-of-the-century chroniclers of the region described iron mining as one of the area's most important industries, reaching its height in the 1860s and 1870s, stimulated in part by the manufacturing demands of the Civil War.[11] So it goes without saying that when Murray described the Adirondacks as never "marred by the presence of men careless of all but gain," he indulged in no small amount of wishful thinking, wholly typical for his historical moment.[12] By the time *Adventures in the Wilderness* hit the shelves, mining, characterized today as "one of the most environmentally destructive activities in which humans participate," had transformed sections of the Adirondacks into denuded terrain: landscapes burnt and stripped bare of trees, riddled with pits and tunnels, and piled high with rubble and debris (fig. 220).[13]

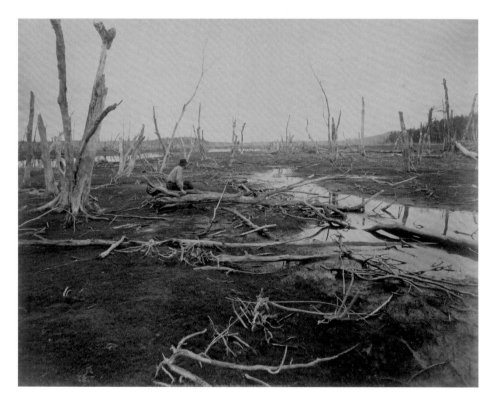

FIGURE 220: Seneca Ray Stoddard (American, 1844–1917), *Drowned Lands of the Lower Raquette, Adirondacks*, ca. 1889. Albumen silver print, 36.7 × 47.6 cm. Library of Congress, Washington, DC. Prints & Photographs Division

Martin's painting presents the viewer with just such a scene (see fig. 218). A steep hillside rises above the western shore of Lake Champlain. The green-blue waters of the lake reflect a cloud-dotted sky, and bright orange tailings, the waste residue of iron ore extraction, streak the barren slope. Boulders in the left foreground suggest a viewpoint from a contiguous shore, at a spot along the natural curve of the harbor. A small wood-frame structure sits on a slight rise, just back from the water, its front door slightly ajar. A retaining wall made of rocks extends from the dwelling toward the right edge of the canvas, and a wooden platform provides mooring for a canal boat, a standard-make vessel around eighty feet long with a small, raised cabin in the stern to house the boat's operators.[14] Several sections of the hillside look blasted, including the shadow-riddled cleft that originates near the top of the slope and intersects

a rock-strewn crater on the descent. A single mine shaft to the left of the crater provides access to deposits below the surface, while rocks and rubble tumble downhill, piling into heaps along the slope and at the shore. Mature trees, most of them evergreens, cluster along the upper ridge of the hill and at its base, but the rest of the slope bears only hints of vegetation, mainly through intimations of fragile new growth, including the thin layer of green that carpets the left side of the hill. A narrow stream of water descends from these corrugated, green-tinged rocks, splashing brightly as it makes its way toward the lake.

Why did Martin, best known for his Barbizon-inspired paintings of nature's poetic aspects and quieter moods, paint an iron mine, a subject that offered very little in the way of the beautiful or the picturesque? It was not unusual in nineteenth-century America for artists and illustrators to

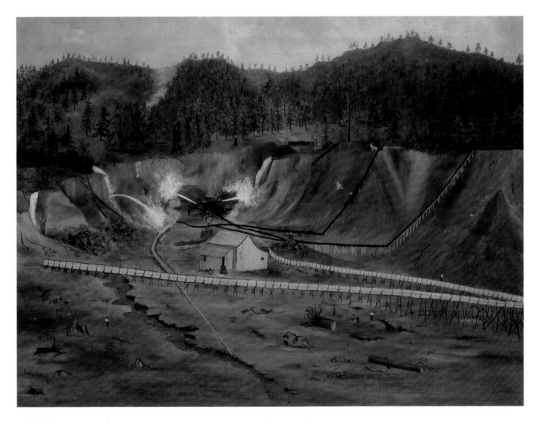

FIGURE 221: Artist unknown, *La Grange Mining Co., Weaverville, Trinity County, California*, ca. 1870. Oil on canvas, 60.5 × 81.3 cm. The Bancroft Library, University of California, Berkeley. Robert B. Honeyman Jr. Collection of Early Californian and Western American Pictorial Material

depict scenes of mining, commissioned or not, and not a few of these images baldly celebrated industry's conquest of nature (figs. 221, 222). Martin's picture, however, in its striking beauty and its resistance to anecdote or incident, diverges from the bulk of such imagery, which tended to focus on the human and mechanical aspects of mining.[15] The historical record suggests that Martin created *The Iron Mine, Port Henry, New York* on request. In the nineteenth century, landscape painters often worked on commission, and captains of industry regularly ordered up views of their holdings, mining operations included. The Pittsburgh investor and abolitionist Charles Avery, for example, commissioned the landscape painter Robert S. Duncanson (1821–1872) to paint a picture of the Cliff Mine (fig. 223), located in Michigan's Upper Peninsula and operated by the Pittsburgh and Boston Mining Company, in which Avery

was a major stakeholder. The commission supported Duncanson's early efforts as an artist while also commemorating the success of America's first significant copper mine and Avery's leading role in the profitable venture.[16]

Martin, too, accepted commissions, a fact noted by Elizabeth Gilbert Martin in her biography of her husband and also in press accounts of his work.[17] In addition to the views of Adirondacks scenery for *Every Saturday*, Martin supplied a lake scene to illustrate William Cullen Bryant's "The Snow-Shower" for the 1871 collection *Winter Poems*. That same year he executed a painting of Duluth, Minnesota, on commission for the wealthy Philadelphia financier Jay Cooke, whom he accompanied on a promotional tour of the Northern Pacific Railway for potential investors that Cooke organized to coincide with a public bond sale run by his firm, Jay Cooke & Company, to raise funds for the

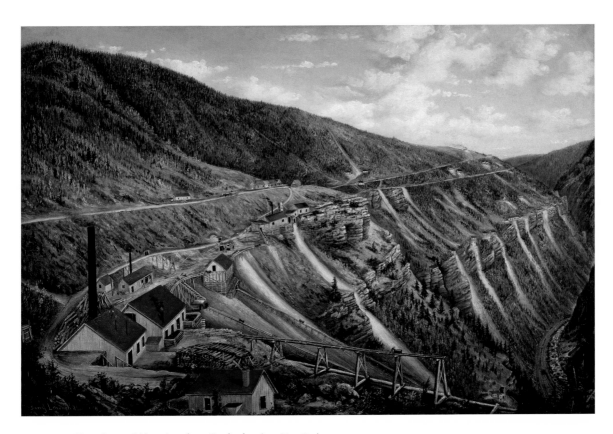

FIGURE 222: Harry Learned (American, born Scotland, active 1880–1890), *Iron Mask Mine, Gilman, Colorado*, 1886. Oil on canvas, 59.7 × 90.3 cm. Denver Art Museum. Museum Exchange (1968.40)

FIGURE 223: Robert S. Duncanson (American, 1821–1872), *Cliff Mine*, 1848. Oil on canvas, 73 × 106.7 cm. Private collection

railroad's construction. A year later, in 1872, Martin accompanied a railroad survey to Cumberland Gap, Kentucky, and traveled afterward to the Smoky Mountains in North Carolina, bringing home a painting used to illustrate the first volume of Bryant's *Picturesque America*.[18] And in 1874 Martin worked on commission for William E. Dodge Jr., a controlling partner in the Phelps Dodge Corporation, at the time one of the largest copper mining companies in the United States. It is worth noting that in the 1890s, the Martins invested in a gold mining venture in Montana, hoping for a "Big Bonanza," and encouraged their close friends, including the art critic William Crary Brownell, to invest along with them. They may have done so with the help of previous contacts in the industry, such as Dodge.[19]

The Iron Mine, Port Henry, New York entered the collection of the National Museum, now the Smithsonian American Art Museum, in 1910, as a gift from the collector William T. Evans, who purchased the picture from M. Knoedler & Company. The painting is currently dated circa 1862, but at the time of the sale the New York artist Edward Gay, an old friend of Martin's, dated the work to around 1873 or 1874.[20]

Knoedler's own record of the sale to Evans, preserved in the M. Knoedler & Co. archives at the Getty Research Institute in Los Angeles, gives the date as "about 1871." Additionally, a thorough examination of the Knoedler archives at the Getty, including stock books from the 1870s, reveals that the Port Henry designation in the painting's title was a late addition; between 1875, when the work was first mentioned in Knoedler's books, and the sale to Evans, the painting was variously titled, including on two occasions by the simple designation "Iron Mine."[21] Martin traveled regularly to the Adirondacks through 1875, up until his departure for Europe, reportedly buying a farm in the area in 1866, and in 1870 the *New York Evening Post* reported that he was hard at work in his studio painting several Adirondack pictures.[22] This likely included *The Iron Mine, Port Henry, New York*.

The style of the Port Henry scene closely aligns with Martin's work in the 1870s and beyond, and with artistic trends in the period after the Civil War more generally (fig. 224). Along with many other American landscape painters in the postbellum period, including Alfred Thompson Bricher, William Stanley Haseltine, Martin Johnson Heade,

and John Frederick Kensett, Martin steered clear of the drama and bombast of much midcentury and earlier landscape art. And like other artists tasked with rendering scenes of mining or other large-scale industrial operations such as logging, Martin did attempt to transform a denuded section of nature into an evocative and pleasing landscape view, a charge likely implicit in the commission, and requisite for maintaining a delicate balance between celebrating the might of American industry and reassuring viewers of that industry's benevolence. Martin rendered portions of the scene with precision, including the carefully painted cabin, boat, and dock, importing the style of his paintings from the 1860s (fig. 225) into this later work to encourage recognition of the scene as an existing mine. Overall, though, he handled his paint loosely and fluidly, rendering solid, weighty forms with lyrical sweeps of color that resist congealing into an accurate delineation of their real-world referents. In the greening slope, lines of white, yellow, brown, and peach pigment tangle at the surface of the canvas, suggesting the desiccated remnants of cleared trees and brush or the heaps of detritus produced by a working mine. In combination with the tailings that sweep down the hill, the rocks tumbling from the tunnel entrance, and the thin stream splashing toward the lake, Martin's fluid, twisting strokes create the effect of the painting as a whole moving and flowing, as if evoking the molten iron produced by a blast furnace, or even the super-heated formation of the planet's crust, abundant with iron. This makes sense, for at its most basic level *The Iron Mine, Port Henry, New York* presents a portrait of Earth's rocky outer layer—namely, the particular geological formations of the Lake Champlain district that came slowly into being over the course of millions of years, ultimately yielding a terrain rich with iron ore. In this way, then, the painting also presents a portrait of *place*, a view of a particular locale, Lake Champlain, marked by physical traits specific to the area that would have been immediately familiar to locals and visitors alike. This of course puts *The Iron Mine, Port Henry, New York* in a category populated by scores of landscape images created in the period by both Martin and his contemporaries that helped cement the sense of place of a given spot or sight, those bits of Adirondacks scenery deemed by artists, travel writers, and tourists to be particularly pleasing and picturesque (fig. 226).

But a mine is an odd sort of place, and an odd sort of landscape—hence Martin's hybrid stylistic approach to the Lake Champlain site, an awkward yet captivating mash-up of lyricism and blunt precision. A mine exists as a location, but by its very nature entails the removal of large portions of the site, a shearing and emptying out that flies in the face of the notion of a continuous identity attached to a constant locale. Mining, one could say, upends any sense of place that depends on the persistence of familiar characteristics or the habitual availability of a recognizable view. Martin's painting foretells such a disassembling, for he depicts a mine in its early years, carved out of a once-familiar landscape that when stripped and pitted swerves toward otherness and, with every rock hacked or blasted from the site, takes one step closer, as with all mines, to its own obsolescence. The darkened hollow of a mineshaft on the hillside signals the absences and voids that counterintuitively constitute this place or, more accurately, ensure that it exists as no place at all. The empty boat, the uninhabited dock, the house with its door slightly ajar: these features, too, configure the scene as simultaneously here and not here, a located and identified place and a terrain in the process of emptying out and becoming null. A tourist may travel to this spot, but the site itself exists in transit, for its features regularly transfigure and its rocky parts persistently set out by boat or rail for other locales.

In picturing a landscape in transition, one in the process of transforming into something other than itself, Martin's painting presciently envisages a key concept of twentieth-century Land Art. In his 1967 essay "A Tour of the Monuments of Passaic, New Jersey," the artist Robert Smithson (1938–1973) posited the idea of "ruins in reverse" to describe the nascent yet already ruinous quality of a construction project not yet begun. He spoke of buildings rising into ruin *before* they are built, which for him served as a figure of absence paradoxically rife with physical blemishes and scars.[23] Following Smithson, Martin's picture of iron mining presents something like a landscape in reverse, for it analogously offers the devastated corpse of a non-thing through its evocation of millions of years of geological place-making in the throes of coming undone. What results is an empty and blank space persistently suffused with and defined by what is no longer there, the essential matter of which will, in turn, be subjected to a kind of geology in reverse. Iron ore first formed in ancient oceans when oxygen released into the water chemically reacted with dissolved iron to produce the minerals hematite and magnetite, which then settled as sediment on the sea floor, over time becoming massive bands of iron-rich rock. The actions of heating, reduction, and separation native to extractive metallurgy, or "smelting," reverse this millennia-long process by removing the pure base metal iron from the chemical and mineral matrix of sedimentary rock, leaving behind incoherent and disembodied piles of slag and reverting terra firma to a quasi-primordial state,

FIGURE 224: Homer Dodge Martin, *Wild Coast, Newport*, 1889. Oil on canvas, 59 × 91.6 cm. Cleveland Museum of Art. Gift of Leonard C. Hanna Jr. (1923.1118)

FIGURE 225: Homer Dodge Martin, *Storm King on the Hudson*, 1862. Oil on canvas, 55.9 × 97.2 cm. Albany Institute of History & Art. Bequest of Mrs. Anna Vandenbergh (1909.19.3)

albeit at the close of a life cycle rather than creation's cusp. Geology served as a lingua franca of landscape in nineteenth-century America, not least because the celebrated and often controversial science had so radically challenged long-held beliefs regarding the history of the physical earth. Geology's popular incarnations saturated contemporaneous culture, from textbooks and collecting kits for the layperson to public lecture series presented by prominent scientists and guided tours of recently discovered subterranean caves. Looking at landscape thus became for artists, tourists, and others of means a matter of seeing and identifying rocks, and knowing a place meant having a sense of its geological past made visible at the surface of the earth. Absent a legible geological profile, a pillaged hillside such as the one in Martin's picture of an iron mine presents the observer with an incomprehensible or alien terrain.[24]

All of this makes a mine an odd subject for a landscape, an aggregating genre bent on celebrating but also *improving* nature through art. Cole lamented the despoiling of the American wilderness at the hands of man, and Murray found Maine lacking both as a travel destination and as a series of views because lumberjacks had made a mess of its forests, even as well-to-do wilderness tourists decorated their parlors with landscape paintings and prints that rendered the sites they visited even more abundant and pleasing to the eye than in real life. Landscape in the nineteenth century was an additive process: it had to exist in excess of the natural world in order to do the work of conveying nature's beauty and plenitude and preserving the myth of its eternal, unchanging presence. Mining thus manifested as a problem for the environment *and* as a problem for representation, for it presented the artist with a *loss* of form, with absence and deprivation, a deficit of material rather than a bounty of things to depict. Nineteenth-century America's prevailing wilderness aesthetic along with its hard-and-fast landscape conventions could not tolerate a terrain transformed and vacated by human use in the midst of transforming into a non-place, so the subject of a mining operation presented a sizable challenge to the landscape genre. *The Iron Mine, Port Henry, New York* reflects such a resistance to being made over into "landscape" in its refusal to sit still, to be fully present before the viewer as solid form or as a sustainable, persistent place or space. In 1913 the art writer Dana H. Carroll ascribed to Martin's picture just such a sense of flux, employing mixed metaphors of transmutation that rendered the mine and its

Whiteface, from Lake Placid.

FIGURE 226: Harry Fenn (American, 1838–1911), *Whiteface, from Lake Placid*, in William Cullen Bryant, ed., *Picturesque America, or, The Land We Live In: A Delineation by Pen and Pencil of the Mountains, Rivers, Lakes, Forests, Water-Falls, Shores, Cañons, Valleys, Cities, and Other Picturesque Features of Our Country*, vol. 2 (New York: D. Appleton and Company, 1874). Princeton University Library. Rare Books and Special Collections

natural setting in his description as if interchangeable. "Its steep side, which contains the mine," Carroll wrote, "is a fascinating study of color—gray and red rocks and brown earth, the light green of gathering mosses, the yellow rust of disintegrating iron in the great laboratory of the earth under the influence of wet and weather."[25] Budding vegetation and the tailings of human labor: in Carroll's account, they are of a piece in a system that dedifferentiates man and nature and posits an equivalency among human labor, industrial processes, and natural phenomena, a network of relationships any landscape painter would struggle to depict.

IV.

Who commissioned Martin to paint this view of a Lake Champlain iron mine? Because iron mining was a booming

industry in the region in the 1860s and 1870s, Martin's patron could have been any number of individuals or companies desirous of promoting a particular mining venture or celebrating big commercial success. This includes William Magear Tweed, the notorious "Boss" of Tammany Hall—the Democratic Party political machine that held sway over politics and patronage in New York City and Albany for much of the nineteenth century—whom the historical record suggests as the probable source of Martin's commission. Possessed of enormous, ill-gotten wealth, Boss Tweed invested in anything that promised a payoff, illicit or otherwise—real estate, hotels, construction, railroads, yachts, printing houses, commodities such as tobacco and whiskey—and at one point he was the third-largest property owner in New York City.[26] In 1870 he put thousands of dollars behind a mining venture, the Champlain Shore Iron Mountain Company, formed in cooperation with a group of Albany men, with Tweed as the president. The company operated an iron mine on the shore of Lake Champlain at Split Rock Mountain, a few miles north of Westport, at a site dubbed "Iron Mountain" by the 1850s and now known as Ore Bed Harbor.[27] While very little historical or archival evidence supports the current Port Henry attribution, evidence for the Split Rock location abounds. Period descriptions of the Split Rock site match the pitted hillside, the single mineshaft opening, the spills of crushed rock, the adjacency of the quarry to the lake, the wooden dock, and the dockside ore piles depicted in Martin's painting, a correspondence further corroborated by period photographs of the Ore Bed Harbor site. Numerous features of Martin's painting also correspond directly with the documented findings of an archaeology survey of the Split Rock harbor, including remnants of the mine located underwater, conducted in 1999 by the Lake Champlain Maritime Museum under the direction of Arthur B. Cohn.[28]

Commissioned by Tweed or not, Martin's painting of an iron mine on Lake Champlain in the postbellum United States incarnates in its intricate interweave of pigment the rich and at times tragic human and natural histories of the region: continents colliding to form mountains, an ancient sea teeming with prehistoric life, Paleo-Indian cultures in the Pleistocene era, European exploration and empire building, two centuries of warfare among the British and French and local Native peoples and the consequent decimation of Indigenous populations, the French and Indian War, the Revolutionary War, the War of 1812, shipbuilding, river travel, steam power, the canal system and interstate commerce, the mining and timber industries, immigrant labor, slavery, the Underground Railroad, and the Civil War. It follows that *The Iron Mine, Port Henry, New York* bears a direct relationship to the complex of politics, industry, and capital that fundamentally shaped the course of the American nation in the aftermath of the Civil War. Martin's painting shoulders the weight of environmental history as well, as powerfully conveyed through its seeming refusal to congeal and cohere as solid, stable form, to be in the end a substantial and materially persistent habitat or place. Such a refusal speaks to the devastating impact of mining and other extractive industries on the environment, then and now, including the destruction of entire ecosystems through the wholesale transmutation of terrain by industry. This pictorial rebuff also speaks to the very nature of existence as a network of ecosystems formed by ongoing and constantly transforming relationships and interactions among all the organisms and the material and phenomenal entities of a locale. The intricate and liquid interweave of pigment in Martin's painting calls to mind just such a landscape of interconnection and transmutation, as does the overall tilt or flow of the scene toward the right edge of the canvas, an effect underscored by the sidelong, hillside sweep of orange tailings, the horizontal stretch of the harbor from arc to straight, and the rightward, clawing motion of the uprooted tree that stretches its leafless and blackened limbs over the water and toward an unseen shore, its sagging reflection in the water the perfect symbol of a failing landscape and an ecosystem on the wane.

The sense in Martin's painting of transmuting terrain, of a landscape always on the move or continually becoming something else—by its own accord or because of what humans have done to it—finds an analogue in Emmons's 1837 account of the reappearance of trees on a site cleared to make way for a mining operation, a process he characterized as a prolonged, multiparty interaction among mosses, low-dwelling plant species, errant soil, rocks, and decay. Emmons's description presents a proto-ecological paradigm in keeping with the idea of the earth as an ongoing collaboration among the totality of its parts, an idea expanded and elaborated by Marsh in his seminal *Man and Nature*. Martin adds to this a sense of the bigness and vastness of existence within which the human constitutes for all intents

and purposes an irrelevancy, merely a blip in cosmic time or a flick of the brush. Yet the painting, a view of the Anthropocene if there ever was one, makes clear that any fervent vision of a state of nature apart from the human, any dream that a pure, prelapsarian wilderness might be made to exist once again in the now, however high-minded or well-intentioned the fantasy may be, rivals in its delusion the plea made by Emmons for benevolent deforestation. The brilliance of Martin's painting lies in its capacity to present a radically human landscape while making manifestly clear that no terrain can ever be solely the domain of any single entity, human or not, and that no landscape can ever delineate with surety and conviction the state of nature in the modern world.

Notes

For generously aiding my research, I extend my thanks to Kenneth D. Ackerman, Elizabeth S. Anderson, Arthur B. Cohn, Barbara J. Mitnick, and Dina Murokh, and to the individuals who assisted me at the American Art and Portrait Gallery Library and the Archives of American Art, Smithsonian Institution, and the Registrar's Office and Curatorial Office at the Smithsonian American Art Museum.

1 Lewis Mumford, *The City in History: Its Origins, Its Transformations, and Its Prospects* (New York: Harcourt, Brace & World, 1961), 450–51. For a discussion of Mumford and, more broadly, the cultural signification of mining in the nineteenth century, particularly in literature, see Rosalind Williams, *Notes on the Underground: An Essay on Technology, Society, and the Imagination*, new ed. (Cambridge, MA: MIT Press, 2008), chaps. 3–6.

2 Lee Clark Mitchell, *Witnesses to a Vanishing America: The Nineteenth-Century Response* (Princeton: Princeton University Press, 1981), 25–28; Thomas Cole, "Essay on American Scenery," *American Monthly Magazine*, n.s., 1 (January 1836): 2, 3, 12.

3 Ebenezer Emmons, "No. 161: First Annual Report of the Second Geological District of the State of New-York," in *Documents of the Assembly of the State of New York, Sixtieth Session, 1837* (Albany: Croswell, 1837), 2:105.

4 Emmons, 2:105.

5 Verplanck Colvin, "Ascent of Mt. Seward and Its Barometrical Measurement," in *Twenty-Fourth Annual Report on the New York State Museum of Natural History, by the Regents of the University of the State of New York* (Albany: Argus Company, 1872), 179–80; George Perkins Marsh, *Man and Nature; or, Physical Geography as Modified by Human Action* (New York: Charles Scribner, 1864), 128–329.

6 Lucius Eugene Chittenden, *Personal Reminiscences, 1840–1890: Including Some Not Hitherto Published of Lincoln and the War* (New York: Richmond, Croscup, & Co., 1893), 162. I am grateful to Arthur B. Cohn, research fellow, William Clements Library, University of Michigan, and cofounder and director emeritus, Lake Champlain Maritime Museum, for directing me to the Chittenden passage.

7 Frank Jewett Mather Jr., *Homer Martin: Poet in a Landscape* (New York: Privately printed by Frederic Fairchild Sherman, 1912); also Elizabeth Gilbert Martin, *Homer Martin: A Reminiscence* (New York: William Macbeth, 1904); Dana H. Carroll, *Fifty-Eight Paintings by Homer D. Martin* (New York: Privately printed by Frederic Fairchild Sherman, 1913); Patricia C. F. Mandel, "Homer Dodge Martin: American Landscape Painter, 1836–1897" (Ph.D. diss., New York University, 1973); Eleanor Jones Harvey, *The Civil War and American Art* (Washington, DC: Smithsonian American Art Museum, 2012), 47. For an early account of Martin's *The Iron Mine, Port Henry, New York*, see "Lost Homer Martin Brings Aid to Widow," *New York Times*, February 1, 1910, 1.

8 Mather, *Homer Martin: Poet in a Landscape*, 11–20; Meg Perlman, "Homer Dodge Martin, 1836–1897," in Natalie Spassky, *American Paintings in the Metropolitan Museum of Art, Volume II: A Catalog of Works by Artists Born between 1816 and 1845* (New York: Metropolitan Museum of Art; Princeton: Princeton University Press, 1985), 420. Mather gave the Princeton University Art Museum a sketchbook of Martin's dating

to 1875–76 that had been given to him by Gertrude Hall Brownell, widow of the art critic William Crary Brownell, who received it as a gift from Martin's son, Ralph. See Mather, "A Sketchbook of 1875 and 1876 by Homer D. Martin," *Record of the Museum of Historic Art, Princeton University* 4, no. 1 (Spring 1945): 5–8.

9 Mather, *Homer Martin: Poet in a Landscape*, 21–25; Perlman, "Homer Dodge Martin," 421; William H. H. Murray, *Adventures in the Wilderness; or, Camp-Life in the Adirondacks* (Boston: Fields, Osgood, and Co., 1869); "In the Adirondacks," *Every Saturday: A Journal of Choice Reading* 1, no. 36 (September 3, 1870): 563.

10 Murray, *Adventures in the Wilderness*, 8, 16.

11 John Peter Lesley, *The Iron Manufacturer's Guide to the Furnaces, Forges, and Rolling Mills of the United States with Discussions of Iron as a Chemical Element, an American Ore, and a Manufactured Article, in Commerce and in History* (New York: John Wiley, 1859), 2, 3, 142, 386–91; Walter Hill Crockett, *A History of Lake Champlain: The Record of Three Centuries, 1609–1909* (Burlington, VT: Hobart J. Shanley & Co., 1909), 322; Frank S. Witherbee, *History of the Iron Industry of Essex County, New York, Prepared for the Essex County Republican* (1906; a pamphlet with no publisher indicated, collection of the Princeton University Library), 4; Morris F. Glenn, *The Story of Three Towns: Westport, Essex, and Willsboro, New York* (Ann Arbor, MI: Braun-Brumfield, 1977), 21–33, 60–73, 265–77; Jane Eblen Keller, *Adirondack Wilderness: A Story of Man and Nature* (Syracuse, NY: Syracuse University Press, 1980), 99–110; Patrick Farrell, *Through the Light Hole: A Saga of Adirondack Mines and Men* (Utica, NY: North Country Books, 1996), 1–69; Jacqueline A. Viestenz and Frank Edgerton Martin, *Moriah and Port Henry in the Adirondacks* (Charleston, SC: Arcadia Publishing, 2013), 11–28; and Anne Kelly Knowles, *Mastering Iron: The Struggle to Modernize an American Industry, 1800–1868* (Chicago: University of Chicago Press, 2013), chap. 5. For the relationship between Martin's painting and the Civil War, see Harvey, *Civil War and American Art*, 47, and Barbara J. Mitnick, "The Civil War and American Art (exhibition review)," *Nineteenth Century* 33, no. 2 (Fall 2013): 42–43.

12 Murray, *Adventures in the Wilderness*, 17.

13 Betsy Taylor and Dave Tilford, "Why Consumption Matters," in *The Consumer Society Reader*, ed. Juliet B. Schor and Douglas B. Holt (New York: New Press, 2000), 472, quoted in Jacob Smith, *Eco-Sonic Media* (Oakland: University of California Press, 2015), 215n22. See also Lucy R. Lippard, *Undermining: A Wild Ride through Land Use, Politics, and Art in the Changing West* (New York: New Press, 2013).

14 My thanks to Arthur B. Cohn, who identified the type of boat depicted in Martin's painting and who discusses period canal boats in detail in his *Lake Champlain's Sailing Canal Boats: An Illustrated Journey from Burlington Bay to the Hudson River* (Basin Harbor, VT: Lake Champlain Maritime Museum, 2003), 36–41.

15 Period imagery frequently featured the heroism and hard work of miners, such as the paintings and prints of Charles Christian Nahl, as well as mining disasters, as in the *Harper's Weekly* coverage of the Avondale Mine disaster, which killed more than one hundred workers at a coal mine near Plymouth, Pennsylvania. See "The Coal Mine Tragedy" and "The Avondale Disaster," *Harper's Weekly*, September 25, 1869, 609–10, 616–18. For examples of paintings from the period that depict mining, see the online Inventory of American Paintings, Smithsonian American Art Museum, http://americanart.si.edu/research/programs/inventory/.

16 Joseph D. Ketner, *The Emergence of the African-American Artist: Robert S. Duncanson, 1821–1872* (Columbia: University of Missouri Press, 1993), 25–28.

17 E. G. Martin, *Homer Martin: A Reminiscence*, 16; "Art Gossip," *The Home Journal*, August 18, 1860, 2, Homer Dodge Martin, Art & Artist Files, Smithsonian American Art Museum/National Portrait Gallery Library, Smithsonian Libraries, Washington, DC (hereafter cited as Martin Files).

18 *Winter Poems by Favorite American Poets* (Boston: Fields, Osgood, & Co., 1871), 44; "Winter Poems," *Every Saturday: A Journal of Choice Reading* 1, no. 52 (December 24, 1870): 834; "Winter Poems. II," *Every Saturday: A Journal of Choice Reading* 1, no. 53 (December 31, 1870): 859; Mather, *Homer Martin: Poet in a Landscape*, 30–31; Christopher P. Munden, "Jay Cooke: Banks, Railroads, and the Panic of 1873," *Pennsylvania Legacies* 11, no. 1 (May 2011): 5; "Personal," *New York Evening Post*, October 28, 1871, 2, Martin Files; "Art at the Century Club," *New York Evening Post*, November 7, 1871, 1, Martin Files; "Art Notes," *New York Evening Post*, June 18, 1873, 2, Martin Files. The "List of Engravings on Steel" at the beginning of volume one of *Picturesque America*, which identifies Martin as the artist of the painting on which Robert Hinshelwood based his engraving of the scene, gives the title as "Smoky Mountains, Eastern Tennessee," but the picture's caption reads "Smoky Mountains, North Carolina." William Cullen Bryant, ed., *Picturesque America, or, The Land We Live In: A Delineation by Pen and Pencil of the Mountains, Rivers, Lakes, Forests, Water-Falls, Shores, Cañons, Valleys, Cities, and Other Picturesque Features of Our Country*, vol. 1 (New York: D. Appleton & Co., 1872), vii, 132.

19 "National Academy of Design," *New York Evening Post*, May 14, 1874, 3, Martin Files; "William E. Dodge Dead," *New York Times*, August 10, 1903, 1; Ralph Martin to Louis Martin, May 20, 1892, Homer Dodge Martin and Elizabeth G. Martin Letters to William Crary Brownell, Box 2, Folder 6, Department of Rare Books and Special Collections, Princeton University Library; Homer Dodge Martin to Thomas B. Clarke, February 21, 1896, Thomas B. Clarke Letters from or about Homer Dodge Martin, 1893–1897, Series 1, Box 1, Folder 4, Archives of American Art, Smithsonian Institution, Washington, DC.

20 "Lost Homer Martin Brings Aid to Widow," 1; Edward Gay to William T. Evans, May 12, 1909, Curatorial file, Curatorial Office, Smithsonian American Art Museum, Washington, DC.

21 Sales book entry, M. Knoedler & Co. records, approximately 1848–1971, Series II. Sales books, 1863–1971, Box 69 Sales book 9, 1907 May–1912 January, p. 200, The Getty Research Institute, Los Angeles, Accession no. 2012.M.54, http://hdl.handle.net/10020/cifa2012m54 (hereafter cited as M. Knoedler records); Series I. Stock books, 1872–1977, Series I.A. Paintings, 1872–1970, Box 2 Painting stock book 2, 1873 April–1878 August, p. 168, and Box 3 Painting stock book 3: 1–4368,

1875 December–1883 December, p. 201, M. Knoedler records; Series III. Commission books, 1879–1973, Commission book 2: C3130–C6024, 1903 April–1927 August, p. 28, M. Knoedler records; Series VII.A. (Photographs) Artist files, approximately 1890–1971, Box 2565, Folder 6: Martin, Homer Dodge, M. Knoedler records; Series VII.C. (Photographs) Paris office photographic files, approximately 1900–1971, Box 3333, Folder 1, Photos: Paris: Carton [LII]: Martin, Homer Dodge, M. Knoedler records. One of the photographs contained in Box 2565 was published as "Iron Mine" in Arthur Hoeber, "Foresight and Hindsight in Art: Pictures That Have Advanced in Value," *Arts & Decoration* 5, no. 1 (November 1914): 18. The Getty's digital finding aid for the two 1875 entries mislabels the title in each, as "Frau Mine" for the entry in Painting stock book 2 and as "Town Mine" for the entry in Painting stock book 3. Examination of the original handwritten entries leaves no doubt that the word in question is "Iron." The current dating of the painting to circa 1862 reflects the research of Patricia C. F. Mandel, who in her 1973 doctoral dissertation identified the site as Craig Harbor, in Port Henry, New York, a possibility suggested to her by Port Henry's town historian; she identified the patron as Benjamin T. Reed, owner of the Bay State Iron Mine, who reportedly commissioned several paintings of his holdings in the late 1850s. Because that particular Reed-owned company ceased regular operations by 1862, Mandel proffered the date as a rough *terminus ante quem* for Martin's picture, eventually prompting the Smithsonian American Art Museum to change the official record from ca. 1865 to ca. 1862. (Patricia C. F. Mandel, "Homer Dodge Martin: American Landscape Painter, 1836–1897" [Ph.D. diss., New York University, 1973], 30–31.) Cataloging records housed at the Smithsonian American Art Museum reflect a revision of the painting's date in 1985, from ca. 1865 to ca. 1862. (Object file, Office of the Registrar, Smithsonian American Art Museum, Washington, DC.) In her biography of Martin, Elizabeth Gilbert Martin noted that her husband rarely titled his paintings unless someone requested that he do so or if a title was needed for a catalogue. E. G. Martin, *Homer Martin: A Reminiscence*, 45.

22 "Art Notes," *New York Evening Post*, August 9, 1875, 1; "Art and Artists," *Boston Daily Evening Transcript*, August 10, 1875, 6; "Addresses of Artists," *The Round Table*, May 19, 1866, 311; "Art Notes," *New York Evening Post*, May 20, 1870, 1, all consulted in Martin files.

23 Robert Smithson, "A Tour of the Monuments of Passaic, New Jersey" (1967), in *Robert Smithson: The Collected Writings*, ed. Jack Flam (Berkeley: University of California Press, 1996), 72.

24 For the popularity of geology, see Rebecca B. Bedell, *The Anatomy of Nature: Geology and American Landscape Painting, 1825–1875* (Princeton: Princeton University Press, 2001); Ralph O'Connor, *The Earth on Show: Fossils and the Poetics of Popular Science, 1802–1856* (Chicago: University of Chicago Press, 2007); Andrew Moore and Nigel Larkin, eds., *Art at the Rockface: The Fascination of Stone* (London: Philip Wilson, 2006); Virginia Zimmerman, *Excavating Victorians* (Albany: State University of New York Press, 2008); and Adelene Buckland, *Novel Science: Fiction and the Invention of Nineteenth-Century Geology* (Chicago: University of Chicago Press, 2013).

25 Carroll, *Fifty-Eight Paintings by Homer D. Martin*, 14.

26 Carroll, 14; Kenneth D. Ackerman, *Boss Tweed: The Corrupt Pol Who Conceived the Soul of Modern New York* (Falls Church, VA: Viral History Press, 2011), 2, 52, 106, 189–90, 198, 348.

27 "One Poor Iron Mine," *Plattsburgh Republican*, May 5, 1883, 1; *Buffalo Express*, March 29, 1871, 2; Adam Kane et al., *Lake Champlain Underwater Cultural Resources Survey, Volume IV: 1999 Results and Volume V: 2000 Results* (Vergennes, VT: Lake Champlain Maritime Museum, 2002), 104, 109; Glenn, *The Story of Three Towns*, 60, 63–64; Champlain Shore Iron Mountain Company stock certificate, October 3, 1870, No. 174, 20 shares, engraving and ink on paper, private collection. Glenn notes that the extent of Tweed's involvement and the exact source—public or private—of the money he put into the venture remain unclear. The *Plattsburgh Republican* reported that although Tweed, Randall, and their partner, one Mr. Bridgeford, knew that the mine would be minimally profitable, they hoped to make money by encouraging investment. See also Seneca Ray Stoddard, *Lake George Illustrated, and Lake Champlain: A Book of Today* (Glen Falls, NY: S. R. Stoddard, 1892), 107, and Witherbee, *History of the Iron Industry of Essex County, New York*, 20, who both report Tweed's ownership of the Split Rock mine.

28 Kane et al., *Lake Champlain Underwater Cultural Resources Survey*, 129–30; "Lewis Ore-beds, Lewis Patent, Lake Champlain, Essex Co., N.Y.," Robert N. Dennis Collection of Stereoscopic Views, The Miriam and Ira D. Wallach Division of Art, Prints and Photographs: Photography Collection, The New York Public Library, Catalog ID (B-number): b11707973; "Iron Ore Pits Split Rock Mountain North of Westport," 1870, Marjorie Lansing Porter Photographic Materials, Series 73.2, Number 570, Special Collections, Feinberg Library, SUNY Plattsburgh, reproduced in Kane et al., *Lake Champlain Underwater Cultural Resources Survey*, 107.

Kimia Shahi

Entanglements of Land and Water: Picturing Contingency in Martin Johnson Heade's *Newburyport Marshes: Approaching Storm*

Wetlands are not conventional wild areas. They do not cater to established, classical concepts of vista, horizon, and landscape.... They force you inward, both upon yourself and upon the nonhuman world. They do not give you grand views; they humble you rather than reinforce your delusions of grandeur.... When you move, you move slowly, tentatively, each step an exploration in its own right.... A wetland is nothing if not a patient environment. It reminds you more of slow, ongoing processes of change than it does of the pinnacles of evolutionary achievement. Its processes are original and ordinary rather than spectacular or catastrophic.

Peter A. Fritzell, "American Wetlands as Cultural Symbol"

Newburyport Marshes: Approaching Storm (fig. 227), by Martin Johnson Heade (1819–1904), is a small painting of the salt marshes of Newburyport, Massachusetts, shown stretching toward a low horizon, below a mix of dark clouds and blue sky punctuated by the hint of a rain shower. Large haystacks line a waterway called Pine Island Creek as it winds through the marshland. In the distance, sunlight illuminates a group of figures at work harvesting salt hay and loading it onto a horse-drawn cart. Nearer to the foreground, a lone fisherman stands at the river's edge with his line extended, the bobber a bright red dot above its mirror image in the water.

Over the course of his career, Heade would paint more than one hundred similar views of marshes along the Eastern Seaboard of the United States, forming a distinctive body of work in the history of American art. An idiosyncratic artist, amateur naturalist, and avid sportsman, Heade returned again and again to the subject of coastal wetlands, and his sustained and probing focus on the salt marsh landscape is evident in his closely woven brushwork and attention to minute detail in *Newburyport Marshes: Approaching Storm*. Examined from

art historical and ecocritical perspectives, Heade's particular view of the salt marsh landscape forms part of the interconnected cultural and ecological histories of New England's coastal wetlands.

When Heade began painting salt marshes in the late 1850s, they were hardly a typical subject. Landscape painting was then the foremost artistic genre in the United States and a powerful vehicle for conveying ideas about the nation's ideals and identity. In his influential 1836 "Essay on American Scenery," Thomas Cole (1801–1848) entreated landscape painters to cultivate the aesthetic taste and moral virtue of their fellow Americans by portraying the picturesque wilderness scenery and sublime natural wonders that he believed distinguished the New World from the Old.[1] Cole's follower Asher B. Durand (1796–1886) amplified these sentiments in the 1850s, emphasizing that the superior painter should pursue an "ideal of Landscape art," meant to reveal "the deep meaning of the real creation around and within us."[2] As evident in his *Landscape* of 1859 (see fig. 57), Durand championed an ordered pictorial structure, offering a clear progression from foreground to background with visual variety and attention to detail—a picture expressing the painter's "loftier stature" in being able to "[comprehend] the capabilities of the material presented in all its relations to human sympathy."[3]

Newburyport Marshes: Approaching Storm diverges from Durand's and Cole's grand endeavors. What the art historian Roberta Smith Favis identifies as Heade's brand of "intense, careful, empirical observation"[4] casts an unbroken gaze across flat lowlands that extend out toward each side of the canvas, emphasizing, as the art historian Barbara Novak has observed, the lateral stretch of both the marshlands and the picture

FIGURE 227: Martin Johnson Heade (American, 1819–1904), *Newburyport Marshes: Approaching Storm*, ca. 1871. Oil on canvas, 38.7 × 76.5 cm. Terra Foundation for American Art, Chicago. Daniel J. Terra Collection (1999.68)

FIGURE 228: Martin Johnson Heade, *Gremlin in the Studio II*, ca. 1871–75. Oil on canvas, 23.5 × 33.1 cm. Wadsworth Atheneum Museum of Art, Hartford, Connecticut. The Dorothy Clark Archibald and Thomas L. Archibald Fund (1997.29.1)

plane itself.[5] The salt marsh offers very little topographical interest, save for the waterway, haystacks, a large rock, and trees. These qualities perhaps help explain why period critics such as James Jackson Jarves described Heade's marsh pictures somewhat disparagingly as "meadows and coast scenes in wearisome horizontal lines and perspective, with a profuse supply of hay-ricks to vary the monotonous flatness."[6] Similarly, more recent scholars have often characterized Heade's marshes as embodying stillness, infinity, reverie, or even meaninglessness.[7] *Newburyport Marshes: Approaching Storm*, however, is also full of meteorological, human, and animal activities that foreground, rather than idealize, the literal "material presented" in the marsh: water, hay, mud, sun, rain, and clouds.

One material, water, is especially central to this painting and the other nine canvases in which Heade depicted the Newburyport marshes under varying combinations of clouds and rainfall.[8] Scholars of history, landscape, and environmental studies such as John Stilgoe, Ann Vileisis, and William Howarth have discussed how salt marshes are a distinctive kind of littoral terrain where land and water meet and converge according to the dynamic cycles of tides, seasons, and weather.[9] Less a fixed boundary between ocean and dry land than a fluid margin, or "marge," defined by contingency and transience, a salt marsh both exceeds and remains peripheral to categories such as landscape, seascape, coast, or shoreline.[10] In these edge-spaces of water and land—which periodically flood with water, continually fill and empty out, and change shape and composition over time—the eye cannot always be trusted; what looks to be solid ground might just as easily give way underfoot.[11] To thrive in a salt marsh, plants and

animals (including humans) have always had to adapt to these challenging, changeable conditions, which are belied by the marshlands' seeming monotony.

Heade humorously took on the challenge of picturing the liquid qualities of the salt marsh in two trompe l'oeil canvases titled *Gremlin in the Studio* (fig. 228) that the artist completed around the same time he painted *Newburyport Marshes: Approaching Storm*.[12] Each *Gremlin* picture shows one of Heade's salt marsh paintings propped up in the artist's darkened studio. A round-faced creature dances below the canvas, which has become so saturated that water leaks out of the bottom edge and drips into a puddle on the floor, a clever analogy between paint and water that constructs an ironic correspondence between the literal edges of Heade's painted canvases and the littoral nature of the salt marsh. By casting doubt on the capacity of Heade's paintings to visually contain the fullness of their watery subject, *Gremlin in the Studio* implies that to paint a salt marsh, some unwieldy liquid matter must be siphoned off or circumscribed so that what is visible will better adhere to the surface. In so doing, says Favis, *Gremlin in the Studio* "draws attention to the constructed nature of the very art of landscape painting"[13] as well as its limitations, while framing the salt marsh as a place in which seeing or representing nature is not equivalent to understanding it.

Something similar might be said of *Newburyport Marshes: Approaching Storm*, even if this picture lacks the overt irony of *Gremlin in the Studio*. Although its tightly balanced composition indicates a fine-tuned awareness of pictorial space and proportion, the painting has a confusing structure. The storm clouds appear to hover directly above the creek, but the water barely registers their reflection, despite the shadow they cast on its grassy banks. The faint rainfall at the painting's center suggests that the storm has already begun, but the unstable correspondence of sky and ground makes it difficult to ascertain where (and when) the rain falls in relation to the path and progress of the clouds. To paint the rain, Heade dragged wet gray pigment from the painted cloud vertically downward across the flat blue sky, an instance of his technical experimentation, which occasionally included painting "wet into wet" rather than waiting for each layer of paint to dry before adding another.[14] Recalling *Gremlin in the Studio*'s water-as-paint conceit, this detail attests to the tensions between the visual and the material that animate marsh and painting alike.

To understand the implications of Heade's painterly engagement with the processes and conditions that define the marsh environment, it is necessary to consider period understandings of salt marshes' place within the natural world. As Heade was painting them, the salt marshes of New England were undergoing a physical transformation and cultural reevaluation that environmental historians such as Vileisis and Kimberly Sebold have shown to be inextricable from changing attitudes about wilderness, land and water use, property, and aesthetic value. In the moralistic worldview of the earliest Anglo-Americans, lowlands and wetlands such as marshes, swamps, and fens had been considered unproductive, even deleterious and disease-ridden wildernesses. However, salt marshes also provided valuable resources such as salt, hay, fish, and habitat for numerous wetland birds and animals. These places had been sites of human enterprise from their earliest days of occupancy: since long before European colonial settlement, people had exploited the littoral properties of tidal ecosystems, and through the nineteenth century, marshlands were utilized for agriculture and subsistence purposes.[15]

Newburyport Marshes: Approaching Storm portrays a fisherman in the foreground and a group of farmers marsh haying, or "marshing," in the background. The latter involved gathering and harvesting nutritious salt grasses native to the marsh and bundling them into massive haystacks to dry, as also shown in the picture. A process contingent on close observation and prediction of tides and weather, marsh haying coaxed productivity out of wetlands that frustrated the operations of more traditional European forms of agriculture. By the mid-nineteenth century, salt hay had become a high-demand commodity, and more farmers began to dike and drain salt marshes to increase production, diminishing their presence along the coast.[16]

Even as they were affected more and more by human alteration, New England's salt marshes were enjoying a cultural renaissance. Ironically, by the 1870s they had acquired a foothold in the literary and artistic imaginary both as regional symbols of unspoiled nature and as remnants of a fading pastoral way of life.[17] As newly built railroads and canals ferried growing numbers of tourists across marshlands, popular writers portrayed these landscapes as nostalgic refuges from industrialization and urbanization.[18] Exemplary of such writings is an 1877 poem, "Inside Plum Island," by Newburyport resident Harriet Prescott Spofford, which emphasizes the silence and

isolation of salt marshes, describing a day "winding down our winding way" through "great sea meadows" and mirrorlike "slumberous waters."[19] Sarah Orne Jewett's 1885 novel *A Marsh Island* tells the story of a young painter from the city who is drawn to the marsh landscape for its "quaint and quiet and secluded beauties," as one reviewer described it.[20] The book celebrates the aesthetic appeal of New England's marshlands and romanticizes the seemingly timeless lives of their farmer residents, perpetually in harmony with their surroundings.

Either of these literary examples might describe aspects of *Newburyport Marshes: Approaching Storm* and its maker. Indeed, Heade's salt marsh paintings have often been considered part of this broad trend toward celebrating the aesthetic and phenomenological experience of that landscape.[21] Even so, *Newburyport Marshes: Approaching Storm* is more than an exercise in pastoralism or regionalist nostalgia. If the painting explores how the marsh's dynamism and contingency challenge visual representation, Heade's portrayal of human activity within the salt marsh ultimately extends these challenges into the realm of resource use and labor. For example, despite every effort to predict them, unexpected storms like the one pictured could prove disastrous for the haying process. The rain's ambiguous approach adds a sense of drama to the scene, heightening the urgency of the farmers' work as it plays out in miniature, muted against the expanse of sky and clouds.[22] Meanwhile, for the fisherman attuned to the invisible marine life below him, the marsh exists as an extension of the water he relies on, rather than as a part of the land.

The presence of both farmers and fisherman here illustrates the breath of activity facilitated by the salt marsh's distinctive littoral status. However, these differing uses of the marsh's lands and waters were not always harmonious during the period in which Heade was painting them. Noticeable near the fisherman is a lone wooden stake in the foreground, which sags precariously at an angle as if about to sink—an apt indicator of the state of private property in undrained marshlands. Those seeking to demarcate stable boundaries often relied on topographical features such as rocks, or drove wooden stakes deep into the marshes in the hope that they would stay put. Even as farmers attempted to clearly establish property lines, they also frequently joined forces—and assets—in the expensive endeavor of draining marshes to shore up dry land. All the same, draining some areas inevitably affected the amount of flooding in others, leading to prolonged disputes over the boundaries between public and private land.[23] From a historical perspective, then, Heade's juxtaposition of two forms of labor echoes the tensions between "dikers" and fishermen as groups of farmers sought "improvement" and others affected adversely by the drainage fought back.[24]

Newburyport Marshes: Approaching Storm constructs an image of the salt marsh that is built upon both the contingency and the interconnectivity of the activities and operations contained within it. Instead of establishing harmony among its constituents, the painting embraces the potential for disunity, even conflict, between its human and nonhuman entities: farmers and livestock, fish and fishermen, water, weather, salt grass, and hay. This is particularly evident in the way the painting draws attention to how the marsh environment challenges an array of endeavors that depend on visual perception and representation: predicting the distance and trajectory of a storm, judging the relative balance of water and dry land, mapping the boundaries of property, and even the act of making a landscape painting. In this way, Heade's project belongs in the context of scientific ideas that had begun to reenvision nature as interconnected and subject to change, and to resituate human beings within, rather than apart from or above, the natural world.

This new view of nature defined by interdependency, competition, and adaptation was most prominently articulated in the work of Charles Darwin (1809–1882), whose follower the naturalist Ernst Haeckel would invent the term "ecology" in 1866. In *On the Origin of Species* (1859), Darwin built on the work of botanists, naturalists, and geologists such as Carolus Linnaeus, Alexander von Humboldt, and Charles Lyell to argue that species evolved progressively over a vast timescale through a process of "natural selection," in relation to their surroundings and to other species.[25] At the close of his book, Darwin paused to observe:

> It is interesting to contemplate an entangled bank, clothed with many plants of many kinds, with birds singing on the bushes, with various insects flitting about, and with worms crawling through the damp earth, and to reflect that these elaborately constructed forms, so different from each other, and dependent on each other in so complex a manner, have all been produced by laws acting around us.[26]

This passage evokes a set of dynamic interrelationships akin to those Heade explores in *Newburyport Marshes: Approaching*

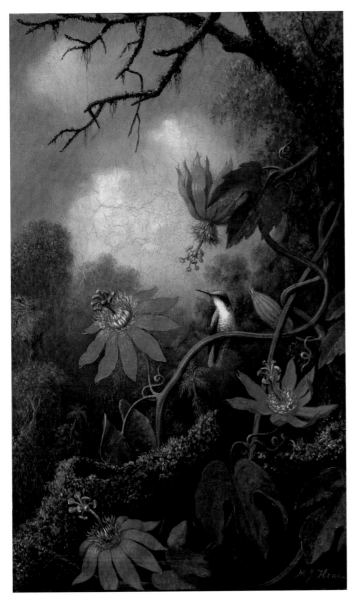

FIGURE 229: Martin Johnson Heade, *Hummingbird and Passionflowers*, ca. 1875–85. Oil on canvas, 50.8 × 30.5 cm. The Metropolitan Museum of Art, New York. Purchase, Gift of Albert Weatherby, 1946 (46.17)

Storm. Although the extent of Heade's knowledge of Darwin is unknown,[27] scholars have drawn parallels between the naturalist and the artist. Such parallels are compelling given the artist's interests in natural history, which he most famously explored in paintings of tropical hummingbirds begun after an 1863 voyage to Brazil (fig. 229). Heade's hummingbird paintings have been called "a perfect illustration of Darwin's theory of natural selection"[28] for their close focus on the tiny birds' unique relationship to floral habitats and dynamic rituals of courtship competition and conflict.[29]

Newburyport Marshes: Approaching Storm arrives at a similarly proto-ecological, Darwinian worldview through the specificity of Heade's formal engagement with the salt marsh. In this way, Heade provides an interesting comparison with his French contemporary Théodore Rousseau (1812–1867), a painter whom the art historian Greg Thomas credits with developing "an ecological visual attitude out of the practice of landscape painting" rather than a fully theorized "ecological consciousness" aligned with nineteenth-century science and philosophy.[30] For his efforts to preserve the Fontainebleau Forest, a key source of artistic inspiration for Barbizon School painting, Rousseau would become known as an early conservationist. Decades later, Heade would also be recognized as an outspoken advocate for the conservation of diminishing bird populations and their wetland habitats thanks to his many published opinion pieces in the journal *Forest and Stream* under the pen name "Didymus."[31] Nevertheless, although New England's salt marshes were increasingly admired by artists and writers in Heade's time, unlike forests they remained relatively peripheral to both the conservation movement and the study of ecology until well into the twentieth century. The full extent of the ecological damage caused by the draining and development of marshlands has only recently been understood, as have the benefits of leaving wetlands unaltered or restoring them to a less developed state, which include sea level and flood mitigation, maintaining water quality, and serving as a habitat for a diverse ecosystem.[32] Heade's *Newburyport Marshes: Approaching Storm* does not predict these developments. Instead, by expanding upon the possibilities of landscape representation, the painting reenvisions the salt marsh as a place of labor and interconnection, in which human endeavor forms part of a contingent web of activities and processes on the margins of land and sea—"an entangled bank" along the shore.

Notes

EPIGRAPH: Peter A. Fritzell, "American Wetlands as Cultural Symbol: Places of Wetlands in American Culture," in *Wetland Functions and Values: The State of Our Understanding; Proceedings of the National Symposium on Wetlands Held in Disneyworld Village, Lake Buena Vista, Florida, November 7–10, 1978* (Washington, DC: American Water Resources Association, 1979), 530–31.

1 Thomas Cole, "Essay on American Scenery," *American Monthly Magazine*, n.s., 1 (January 1836): 1–12.

2 Asher B. Durand, "Letters on Landscape Painting, No. VIII," *The Crayon* 1, no. 23 (June 6, 1855): 354.

3 Asher B. Durand, "Letters on Landscape Painting, No. IX," *Crayon* 2, no. 2 (July 11, 1855): 17.

4 Roberta Smith Favis, *Martin Johnson Heade in Florida* (Gainesville: University Press of Florida, 2003), 35.

5 Barbara Novak, "Luminism: An Alternative Tradition," in *American Painting of the Nineteenth Century: Realism, Idealism, and the American Experience* (New York: Praeger Publishers, 1969), 104–5. Novak notes that Heade's marsh paintings result in "a significant change in the relation to plane" (104), in which spatial definition is "achieved through a series of planes, parallel to the surface, which are never violated but proceed back in orderly, measured steps" (105). See also Novak's chapter on Heade, "Martin Johnson Heade: Haystacks and Light," 125–37.

6 James Jackson Jarves, *The Art-Idea: Sculpture, Painting, and Architecture in America*, 4th ed. (New York: Hurd and Houghton, 1877), 236, quoted in John Baur, "Early Studies in Light and Air by American Landscape Painters," *Brooklyn Museum Bulletin* 9 (Winter 1948): 9.

7 David C. Miller, *Dark Eden: The Swamp in Nineteenth-Century American Culture* (New York: Cambridge University Press, 1989), 225, 237.

8 Theodore E. Stebbins notes that those pictures of the Newburyport marshes constitute "the most celebrated series of Heade's landscapes.... No more than ten of these classic paintings are known." Stebbins, *The Life and Work of Martin Johnson Heade: A Critical Analysis and Catalogue Raisonné* (New Haven: Yale University Press, 2000), 121.

9 John Stilgoe, *Alongshore* (New Haven: Yale University Press, 1994); Ann Vileisis, *Discovering the Unknown Landscape: A History of America's Wetlands* (Washington, DC: Island Press, 1997); and William Howarth, "Imagined Territory: The Writing of Wetlands," *New Literary History* 30, no. 3 (1999): 509–39.

10 Stilgoe notes the insufficiency of terms such as "landscape," "seashore," or "coast" to describe the complex "mix of land and water ... ruled by the whole concept of marge, of coast." Stilgoe, *Alongshore*, 14.

11 John and Mildred Teal, *The Life and Death of the Salt Marsh* (Boston: Little, Brown, 1969), 3: "The ribbon of green marshes, part solid land, part mobile water, has a definite but elusive border, now hidden, now exposed, as the tides of the Atlantic fluctuate." The moisture in the marsh atmosphere can also distort color and light; see Stilgoe, *Alongshore*, 36.

12 Stebbins, *Life and Work*, 256.

13 Favis, *Martin Johnson Heade in Florida*, 30. See also Maggie M. Cao, "Heade's Hummingbirds and the Ungrounding of Landscape," *American Art* 25, no. 3 (Fall 2011): 50. Cao argues that Heade's choice of such a watery, unstable subject as salt marshes was part of the artist's "anxiety about landscape" and efforts "to subvert and reconfigure its long-held but increasingly moribund conventions" by emphasizing its constructedness and undermining its ambitions to convey symbolic or political meaning. In Cao's interpretation, water in Heade's marsh paintings functions primarily as an "aggressive and unstable" force, meant to "unground" landscape painting by repositioning it on leaky, moisture-laden ground.

14 Stebbins, *Life and Work*, 124, 127. See also Elizabeth Leto Fulton, Richard Newman, Jean Woodward, and Jim Wright, "The Methods and Materials of Martin Johnson Heade," *Journal of the American Institute for Conservation* 41, no. 2 (Summer 2002): 155–84; Jim Wright, "The Development of Martin Johnson Heade's Painting Technique," in Theodore E. Stebbins, ed., *Martin Johnson Heade* (Boston: Museum of Fine Arts, 1999), 169–83. My close reading of Heade's composition is informed by T. J. Clark, *The Sight of Death: An Experiment in Art Writing* (New Haven: Yale University Press, 2006).

15 A number of sources outline this history. See Vileisis, *Discovering the Unknown Landscape*; Stilgoe, *Alongshore*; and Kimberly Ruth Sebold, "The Low Green Prairies of the Sea: Economic Usage and Cultural Construction of the Gulf of Maine Salt Marshes" (Ph.D. diss., University of Maine, 1998). On precolonial Indigenous wetland farming and fishing, see Charles Seabrook, *The World of the Salt Marsh: Appreciating and Protecting the Tidal Marshes of the Southeastern Atlantic Coast* (Athens: University of Georgia Press, 2012), 213; and Kathleen J. Bragdon, *Native People of Southern New England, 1500–1650* (Norman: University of Oklahoma Press, 1996), 15, 57–61, 115. I thank Alan Braddock for drawing my attention to Seabrook's and Bragdon's work in this context.

16 Sebold, "The Low Green Prairies of the Sea," 52, 64–65, 106; Stilgoe, *Alongshore*, 111, 113; and Amos Everett Jewett, "The Tidal Marshes of Rowley and Vicinity with an Account of the Old-Time Methods of 'Marshing,'" *Historical Collections of the Essex Institute* 85 (July 1949): 272–91.

17 Sebold, "The Low Green Prairies of the Sea," 181–82. See also Nancy Frazier, "Mute Gospel: The Salt Marshes of Martin Johnson Heade," *Prospects* 23 (October 1998): 193–207. Frazier sees in a painting like *Newburyport Marshes: Approaching Storm* Heade's "painstaking" efforts to document a way of life that was "[dying] under his brush." As Frazier suggests, "Perhaps Heade was trying to arrest time" (204) in order to halt the march of change and preserve the salt marsh landscape, and its constituent inhabitants, as they once had flourished.

18 Vileisis, *Discovering the Unknown Landscape*, 64–65. In *Alongshore*, Stilgoe writes that "by 1860, railroads linked many coastal villages ... building causeways across salt marshes," with their inland embankments sometimes acting as natural dikes (116). Favis notes that Heade included a painting of a railroad trestle in one of his marsh paintings: *Lynn Meadows* of 1863, located at the Yale University Art Gallery; Favis, *Martin Johnson Heade in Florida*, 88.

19 Harriet Prescott Spofford, "Inside Plum Island," *Harper's New Monthly Magazine* 55, no. 327 (August 1877): 415, quoted in Sebold, "The Low Green Prairies of the Sea," 191.

20 "Editor's Literary Record," *Harper's New Monthly Magazine* 71, no. 423 (August 1885): 477.

21 See Stebbins, *Life and Work*; Sebold, "The Low Green Prairies of the Sea"; Frazier, "Mute Gospel"; and Vileisis, *Discovering the Unknown Landscape*.

22 According to Elizabeth T. Holmstead, this vast difference in scale suggests "the relatively small power of humans to alter the landscape … compared with the awesome and dynamic power of meteorological forces." Holmstead, "Neither Land nor Water: Martin Johnson Heade, Frederic Edwin Church, and American Landscape Painting in the Nineteenth Century" (M.A. thesis, American University, 2013), 30.

23 Sebold, "The Low Green Prairies of the Sea," 106–64. See also Stilgoe, *Alongshore*, 108; and David C. Smith, Victor Konrad, Helen Koulouris, Edward Hawes, and Harold W. Borns Jr., "Salt Marshes as a Factor in the Agriculture of Northeastern North America," *Agricultural History* 63, no. 2 (Spring 1989): 270–94.

24 Vileisis, *Discovering the Unknown Landscape*, 90–93.

25 Donald Worster, *Nature's Economy: The Roots of Ecology* (San Francisco: Sierra Club Books, 1977), 132–44.

26 Charles Darwin, *On the Origin of Species by Means of Natural Selection* (London: John Murray, 1859), 489–90.

27 According to Stebbins (*Life and Work*, 63–77): "In the whole of his writings, there are certain words he never uses, including both God and Darwin. Nonetheless, there is a good deal of evidence suggesting that the painter would have been interested in the controversy over *Origin of Species*" (77). Stebbins notes Heade's correspondence and friendships with prominent figures on both sides of the controversy surrounding *Origin of Species*, including noted anti-Darwinist naturalist Louis Agassiz and pro-Darwinists Henry Ward Beecher and Robert Ingersoll.

28 Stebbins, *Life and Work*, 77; see also Jane Munro, "'More Like a Work of Art than of Nature': Darwin, Beauty and Sexual Selection," in *Endless Forms: Charles Darwin, Natural Science and the Visual Arts*, ed. Diana Donald and Jane Munro (New Haven: Yale University Press, 2009), 256–63.

29 The hummingbird paintings' intimate scale and temporal specificity have been contrasted with the monumental work of Heade's friend and fellow artist-naturalist Frederic Edwin Church (1826–1900), whose magnum opus *Heart of the Andes* (1859; see fig. 93) aligned with Alexander von Humboldt's harmonious vision of nature "as one great whole, moved and animated by internal forces," a view increasingly out of fashion with the advent of Darwinism. Humboldt, *Cosmos: A Sketch of a Physical Description of the Universe*, vol. 1, trans. E. C. Otté (London: H. G. Bohn, 1849), ix. See also Annette Blaugrund, "The Tenth Street Studio Building: A Roster, 1857–1895," *American Art Journal* 14, no. 2 (Spring 1982): 64–71; and Stephen Jay Gould, "Church, Humboldt, and Darwin: The Tension and Harmony of Art and Science," in *Frederic Edwin Church*, ed. Franklin Kelly (Washington, DC: National Gallery of Art, 1989), 94–108.

30 Greg M. Thomas, *Art and Ecology in Nineteenth-Century France: The Landscapes of Théodore Rousseau* (Princeton: Princeton University Press, 2000), 1–2.

31 For a summary of his contributions to *Forest and Stream*, see the obituary, "Martin J. Heade," *Forest and Stream* 68, no. 12 (September 17, 1904): 2. See also Stebbins, *Life and Work*, 178.

32 Vileisis, *Discovering the Unknown Landscape*, 2–5.

My father was born in the middle of this genocide, whence my knowledge comes from his lips to my ears.

Wild Horse Island, in Montana's Flathead Lake, has high walls covered in thousands of petroglyphic writings by the ancestors. It's an enigmatic place, leaving us to wonder how they managed on those high, flat, towering walls. I worked on the series *Wild Horse Island* (1983; fig. 234) as if mapping the place. People have seen bears and elk swimming long distances in glacially cold water to get to this island, a mysterious, magical, inexplicable place where no one lives except the animals and those picto-writings left by my ancestors perhaps twenty thousand years ago.

I explored other parts of the reservation through paint and pastel, naming the places as though enumerating limbs on a human body or a tree, the extensions, the necessary connections to complete a place and give it meaning. Another special area is where the buffalo roam at the National Bison Range in Moiese, Montana. The first were driven in from

Canada after the whites killed off all our bison, thinking they could exterminate our families by eliminating our main food source. I go there as often as I can, mainly to park in the middle of a buffalo herd just to listen to their grunts and mews as they pass round me. It's the same thrill as listening to ten powwow drums, smeared in bear grease, going simultaneously at the Gathering of Nations. The sound passes through my body and makes me know I'm alive, or as the Inuit poem says, moves my inward parts with joy.

The *Petroglyph Park* series (1987–89) came about because the lava escarpment that creates the western wall of the city of Albuquerque, and which has thousands of ancient petroglyphs spread over seventeen miles, was under siege by pot hunters and souvenir seekers and needed protection. We artists donated works for an auction and wrote letters to then Representative Bill Richardson (later New Mexico's governor) encouraging him to create a national park. The escarpment was also under threat by real estate developers. I made one large oil painting, *The Courthouse Steps* (1987), after a developer removed a large boulder with petroglyphs and delivered it by truck to the downtown courthouse to protest legal negotiations that were preventing them from destroying these sites to build their developments. Another painting in this series, *Sunset on the Escarpment* (fig. 235), refers to the west side of the city where the sun goes down and where possibly the escarpment could be eliminated like yesterday's trash.

From 1992 to the present I have painted about the environment, racism, immigration, greed, animal rights, the treatment of women, and ideas taken from the news. I always think it will be obsolete in a couple of years, that there will be resolution; then lo and behold, twenty or thirty years later, it's still a relevant story. *The Browning of America* (2000; see fig. 8) borrows for its title a phrase that the brilliant writer Richard Rodriguez has used. I had been painting maps that illustrated political ideas, such as erasing all European presence by erasing all states with European names. My artist friend Amalia Mesa-Bains told me about a legend from Mexico that foretold that the Americas would be brown again. There are similar stories from our tribes in the United States. Anyway, all Europeans come from tribal people, though they usually don't acknowledge that fact. So I added European tribes to this map, giving it additional meaning, particularly since they not only invaded but also committed genocide and stole all the land—fitting for

descendants of the warlike Visigoths, Huns, Mongols, Saxons, and Vandals.

Salish canoes, mountains, and flags have been prominent icons in my art for thirty or more years and can similarly be turned into skewed political conversation. Large paintings of Salish canoes—twelve-, fourteen-, eighteen-feet long—tell stories of their being co-opted by traders who used them as vehicles for genocide, filling them with rotten and dangerous goods to press on Native people. I fill them with piles of war and political images from all eras of art history as well as modern-day corporate images. Some canoes have attachments, such as a row of plastic baskets being offered in trade for elk, grizzlies, and eagles, accompanied by a text that suggests we save endangered loggers and solve our environmental issues by seeking advice from the Wizard of Oz.

Recently I painted a *Trade Canoe* (series begun 1992) titled *Forty Days and Forty Nights* (fig. 233), referring to the book of Genesis. All people throughout the world have a creation story, often referencing a great flood. Possibly we may have a great flood—it seems to be on its way in many parts of the world. Noah-like, I filled this canoe with nature images from my reservation, but there are also images of works by Paul Klee, José Guadalupe Posada, and Keith Haring, and seven Tontos to represent the Seven Generations. There's also a giant Coyote who is Amotken's (my tribal life force) helper in our Salish Creation Story. S/he turned on the lights and was responsible for the welfare of the people. S/he is buffoon and intellect, immoral and beneficent, untrustworthy and honorable. S/he is all of us.

Cherokee humor is called "turning around." It means they turn things upside down and backward. In fact, all our tribal peoples do it, though we may not always have a name for it, other than "NDN" humor. Will it speak to viewers? That's a good question. Years ago, a board member at a museum that had purchased one of my *Trade Canoes* said to me, "I like your painting; I don't like your politics." The comment tells me that my painting caused this man some annoyance. That's okay; it means I provoked a response and that has to be an accomplishment for a silent painting on a wall.

Note

1 T. C. McLuhan, *Touch the Earth: A Self-Portrait of Indian Existence* (New York: Promontory Press, 1971), 25.

FIGURE 234 (OPPOSITE)
Jaune Quick-to-See Smith
Wild Horse Island Series (Untitled), 1983
Pastel, collage on paper
78.7 × 55.9 cm
Collection of the artist

FIGURE 235 (ABOVE)
Jaune Quick-to-See Smith
Sunset on the Escarpment, 1987
Oil on canvas
182.9 × 152.4 cm
Peiper-Riegraf Collection, Berlin

Ecology and
Environmentalism

Alan C. Braddock

Vital Forms: Modernist Biocentrism

When the naturalist Ernst Haeckel (1834–1919) first used "ecology" (*Oecologie*) in 1866 to describe "all those complex interrelations referred to by Darwin as the conditions of the struggle for existence," the term lay dormant for three decades, gaining little traction even in scientific circles in Europe or elsewhere. But then, around the turn of the twentieth century, "ecology" began to circulate more frequently, mainly in botanical research, on both sides of the Atlantic. This uptick in usage resulted, in part, from the work of a Danish scientist named Eugenius Warming (1841–1924), who in 1909 published *Oecology of Plants: An Introduction to the Study of Plant-Communities*, an important investigation of the influence of habitat on patterns of growth. Warming's book had appeared earlier in Danish as *Plantesamfund: Grundtræk af den økologiske Plantegeografi* (1895), but the English edition helped give his study—and the concept of ecology—international currency. Identifying his focus as "oecological plant geography," Warming set his sights on "the manifold and complex relations subsisting between the plants and animals that form one community." As the environmental historian Donald Worster observes, Warming discovered evidence that "each natural assemblage…is a society made up of many species," characterized by not only struggle and conflict but also more cooperative forms of interdependence known as "commensalism," "mutualism," and "symbiosis." According to Worster, "The significance for scientists as well as for philosophers of these ecological linkages was that they proved the organic world is not merely a scene of rampant self-reliant individualism." Ecology thus became a matter of ethics. For example, Peter Kropotkin, a Russian aristocrat and geographer turned anarchist, borrowed Warming's ideas in formulating his theory of "mutual

aid" as an ethical critique of social Darwinism, exemplified by the philosopher Herbert Spencer's dictum about "survival of the fittest."[1]

The research of Warming and other plant geographers circa 1900 also recognized the importance of development and change—evolution—in ecological relationships. Drawing inspiration from Darwin and Warming, the American scientist Frederic Clements (1874–1945) published a formative series of studies about "plant succession" and "plant geography and ecology" during the first two decades of the twentieth century. In *The Development and Structure of Vegetation* (1904), Clements wrote, "Vegetation is essentially dynamic." He echoed aspects of social Darwinism in his insistence on the inevitable upward progress of each plant community toward a culminating "climax" state, but he eventually broadened his thinking to encompass a more complex understanding of multiple species coexisting in a "biotic community." Modern ecological thinking widened further in the 1930s when the Oxford botanist A. G. Tansley introduced the term "ecosystem" to describe a diverse set of relationships encompassing plants, animals, climate, atmosphere, geology, and energy. By this time, says Worster, the ecologist had become "a public figure: at once trusted adviser to a nation reassessing its environmental past and reformer with a controversial program to promote."[2]

The increasingly public discourse about the ecology of communities and systems, together with older ideas concerning wilderness protection and urban reform, provided the foundational stew from which modern environmentalism as an interdisciplinary cultural movement grew in the twentieth century. Other major catalysts included the Dust Bowl, an environmental catastrophe of colossal proportions

that compounded the already disastrous Great Depression of the 1930s, and the publication in 1962 of Rachel Carson's *Silent Spring*, an enormously influential treatise on the negative effects of excessive pesticide use. Artists played an important role within this broad environmental awakening as well, not only by bearing witness to particular ecological problems but also by offering new ethical models for reimagining coexistence and community, with human beings no longer necessarily occupying the center and instead looking more like just one species or agent among many. In a recent study of European and American modernism during the first half of the twentieth century, the art historians Oliver A. I. Botar and Isabel Wünsche have noted a pervasive "biocentrism," which they define as "an active interest in the categories of 'life,' the 'organic,' and even [a concern with] the destruction of the environment." Paralleling contemporary discourse in philosophy and biology, this modernist biocentrism in art embodied an "anti-anthropocentric worldview, and an implied or expressed environmentalism." Few artists actually had read scientific research (although some did), but as ecology became public currency during the twentieth century, many produced creative work that engaged biocentrism and environmentalism in explicit or oblique ways, often with an ethical impulse. By the end of the twentieth century and early in the twenty-first, an artistic genre explicitly addressing matters of environmental justice would materialize. Moreover, as environmental problems such as climate change and species extinction have increasingly fostered global understanding of coexistence and community, parochial conceptions of "American art" and "nature's nation" have lost credibility, prompting a proliferation of creative projects in recent years that look within and across borders with a planetary perspective and ethical sensibility.[3]

Artistic Evolution and Growth

During the late nineteenth and early twentieth centuries, modernist aesthetics transformed the art world in both Europe and America. In contrast to the academic classical tradition, which emphasized humanism, moral narrative, and objective representation of nature, modernism privileged abstract formal properties—color, texture, shape, composition, and pattern—along with their subjective arrangement and appeal to the viewer as the primary focus of art. A key early proponent of these modernist aesthetic principles of

"art for art's sake" was the American expatriate painter James McNeill Whistler (1834–1903), who in one of his many public pronouncements declared, "Art should be independent of all clap-trap—should stand alone and appeal to the artistic sense of ear or eye, without confounding this with emotions entirely foreign to it, as devotion, pity, love, patriotism and the like. All these have no kind of concern with it."[4] In another provocative statement, Whistler had this to say:

> Nature is very rarely right, to such an extent even, that it might almost be said that Nature is usually wrong: that is to say, the condition of things that shall bring about the perfection of harmony worthy a picture is rare, and not common at all. This would seem, to even the most intelligent, a doctrine almost blasphemous.... Still, seldom does Nature succeed in producing a picture.... The desire to see, for the sake of seeing, is, with the mass, alone the one to be gratified, hence the delight in detail.... Nature ... sings her exquisite song to the artist alone, her son and her master.... He does not confine himself to purposeless copying, without thought, each blade of grass.... In all that is dainty and lovable he finds hints for his own combinations, and thus is Nature ever his resource and always at his service.[5]

Whistler's apparent hubris and hostility toward nature as a "resource" that is "usually wrong," aesthetically speaking, brings to mind the French art critic Charles Baudelaire, who expressed similar revulsion about meticulous realism while promoting the artistic imagination as a transcendent power.

And yet modernism unexpectedly encompassed modes of seeing that paralleled and even resonated with aspects of the emerging ethical discourse of ecology and environmentalism. To understand how this is so, let us consider a work of art and a related verbal statement by Alfred Stieglitz (1864–1946), whose modernist sensibility extended and inflected Whistler's aestheticism in the twentieth century. Stieglitz, an accomplished American photographer, gallery owner, and promoter of international modernism, wrote the following description of *The Steerage* (fig. 236), a picture widely considered his greatest artistic achievement, showing working-class passengers observed on one of his many transatlantic voyages:

> The scene fascinated me: A round straw hat; the funnel leaning left, the stairway leaning right; the white

drawbridge, its railings made of chain; white suspenders crossed on the back of a man below; circular iron machinery; a mast that cut into the sky, completing a triangle. I stood spellbound for a while. I saw shapes related to one another—a picture of shapes, and underlying it, a new vision that held me: simple people; the feeling of ship, ocean, sky; a sense of release that I was away from the mob called "rich." Rembrandt came into my mind and I wondered would he have felt as I did.... I had only one plate holder with one unexposed plate. Could I catch what I saw and felt? I released the shutter. If I had captured what I wanted, the photograph would go far beyond any of my previous prints. It would be a picture based on related shapes and deepest human feeling—a step in my own evolution, a spontaneous discovery.[6]

There is much to unpack in this statement, not least concerning Stieglitz's ambivalence about his own elite economic status, which afforded him a commanding view of the human subjects in question even as he disparaged "the mob called 'rich.'" By expressing fascination about ordinary people and banal visual phenomena spread across the pictorial field, Stieglitz called into question classical standards of artistic composition and value, which traditionally stipulated a hierarchical arrangement of thematic elements, wherein one—usually an eminent hero of human history—occupied the focal center, surrounded by various subsidiary figures and forms deemed less important. In making and interpreting *The Steerage*, Stieglitz resisted this classical tradition in two important ways: first, thematically, by placing emphasis on human subjects not historically considered exalted or heroic, and second, formally, by insisting that inanimate things such as a straw hat, railings, suspenders, circular iron machinery, and other "shapes" could leave the viewer "spellbound" by "a new vision." This modernist vision was by no means explicitly ecological in the sense understood by contemporary scientists such as Warming or Clements. Nevertheless, like other modernists at home and abroad, Stieglitz articulated a revisionist theory of value that undid classical hierarchies by democratizing subject matter, decentering aesthetic attention, and asserting the visual interest of mundane beings and things hitherto excluded from the realm of art. Obviously his statement still expressed a lingering humanism, even an element of narcissism, especially in the melodramatic adventure narrative about catching what

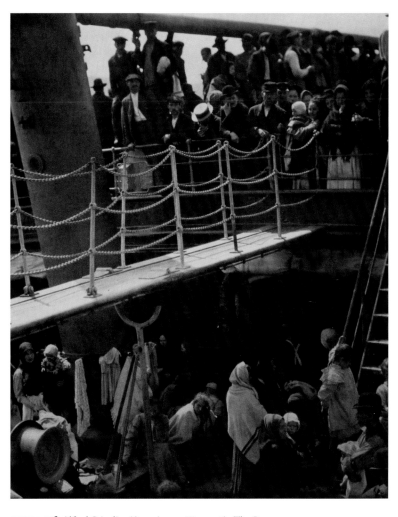

FIGURE 236: Alfred Stieglitz (American, 1864–1946), *The Steerage*, 1907, printed 1911 or later. Photogravure, 33.3 × 26.4 cm. Princeton University Art Museum. Gift of Frank Jewett Mather Jr. (x1949-154)

he "saw and felt" with his last "unexposed plate"—a mini-drama of personal artistic achievement indicating his inability to shed classical habits entirely. But even this evidence of Stieglitz's incomplete break with tradition tells us something important about the evolving nature of art in the twentieth century as modernism realigned conventional ideas and perceptions. Modernism's break with the past, like its relation to ecology, was always complicated and inconsistent yet nonetheless meaningful and difficult to ignore. Accordingly, Stieglitz's reference to *The Steerage* as "a step in my own evolution" reveals this halting, metaphorical relationship with period ecological discourse, for it related his artistic development to evolution, as if aesthetic creativity were a kind of plant subject to environmental conditions of growth.[7]

That Stieglitz really did think of art in such environmental terms can be seen clearly in one of the many letters he wrote to Georgia O'Keeffe (1887–1986). In 1929, after five years of marriage to Stieglitz, amid growing frustration with him and urban life in New York City, O'Keeffe made the first of her many trips to New Mexico without her husband in search of new artistic inspiration and a general change of scenery. Writing from his family's vacation retreat at Lake George in upstate New York, Stieglitz acknowledged the importance of the relocation for her: "You feel yourself strong & happy & free & in the right environment for your growth." Northern New Mexico did indeed provide O'Keeffe with a congenial environment, not only for her own artistic "growth" but also to observe various regionally distinctive forms of nonhuman vitality in nature. One of the most striking outcomes of this newfound sense of creativity appears in *The Lawrence Tree*, painted in Taos in 1929 (fig. 237). The picture offers an extraordinary nocturnal view looking up at a ponderosa pine tree against a starry sky above the property in Taos once occupied by the visiting British writer D. H. Lawrence, whom O'Keeffe and Stieglitz both greatly admired. Although they never met Lawrence in person, they read his books, corresponded with him, and shared a mutual friend in wealthy socialite Mabel Dodge Luhan, who had given her ranch in Taos to the writer in exchange for his manuscript of the book *Sons and Lovers* in 1924. Painted shortly before Lawrence died in 1930, *The Lawrence Tree* paid homage to the author and now serves as a kind of memorial.[8]

In celebrating Lawrence, O'Keeffe's picture also offered a visual analogue to his distinctive brand of vitalist modernism in literature, marked by close attention to generative life forces in nature, both human and nonhuman. Conservative social and cultural authorities vilified Lawrence's writing for what they perceived to be its pornographic vulgarity, but his defenders—including O'Keeffe and Stieglitz—found his exploration of life's procreative energies to be profoundly spiritual, natural, and beautiful. As the art historian Bonnie Grad has observed about O'Keeffe's *The Lawrence Tree*, "Her painting of the author's ponderosa pine was a response to his own poetic images of this tree and to his view of nature as a living presence and the locus of communion and love."[9]

Grad cites a passage in Lawrence's 1926 essay "Pan in America," written while in New Mexico, for its close thematic relation to O'Keeffe's painting and analogous sense of vitalism:

> In the days before man got too much separated off from the universe, he *was* Pan, along with all the rest. As a tree still is. A strong-willed, powerful thing-in-itself, reaching up and reaching down. With a powerful will of its own it thrusts green hands and huge limbs at the light above, and sends huge legs and gripping toes down, down between the earth and rocks, to the earth's middle. Here, on this little ranch under the Rocky Mountains, a big pine-tree rises like a guardian spirit in front of the cabin where we live. Long, long, ago the Indians blazed it. And the lightning, or the storm, has cut off its crest. Yet its column is always there, alive and changeless, alive and changing. The tree has its own aura of life. . . . It is a great tree, under which the house is built. And the tree is still within the allness of Pan. At night, when the lamplight shines out of the window, the great trunk dimly shows, in the near darkness, like an Egyptian column, supporting some powerful mystery in the over-branching darkness. By day, it is just a tree.[10]

We do not know whether O'Keeffe read this particular text by Lawrence, but her painting of his tree provides a remarkable visual gloss on his words, one that is creative and not simply illustrative. Rendering the tree with warm crimson, O'Keeffe depicted its branches like so many arteries, fictively carrying blood from the earth into its "huge limbs" and back again, as if this living entity had "a powerful will of its own," reaching in both directions. By forcefully animating the tree and connecting its orthogonal form in perspective with the act of looking (one can imagine O'Keeffe lying at the base of the trunk, her upturned eyes staring into the canopy of

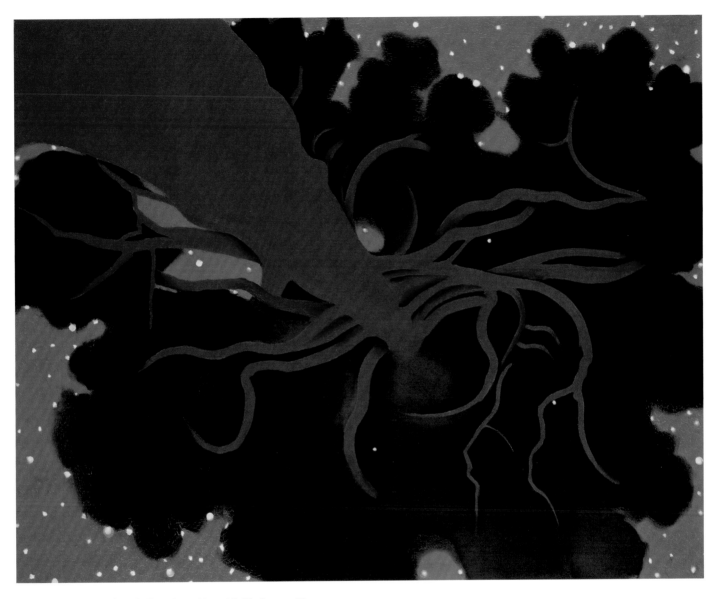

FIGURE 237: Georgia O'Keeffe (American, 1887–1986), *The Lawrence Tree*, 1929.
Oil on canvas, 78.8 × 101.6 cm. Wadsworth Atheneum Museum of Art, Hartford,
Connecticut. The Ella Gallup Sumner and Mary Catlin Sumner Collection Fund
(1981.23)

branches and stars), the artist vividly expressed a Lawrencean sense of connection to nature, "before man got too much separated off from the universe." No wonder Paul Rosenfeld, an art critic friend of Stieglitz and O'Keeffe, called her "one of those persons of the hour, who, like Lawrence … show an insight into the facts of life of an order … intenser than we have known."[11]

O'Keeffe's *The Lawrence Tree* does not illustrate a scientific understanding of arboreal ecology in any strict sense, but it expresses artistic appreciation of the Southwest regional environment in a way that can be regarded as broadly consistent with contemporary research on plant geography by experts such as Warming and Clements. As Stieglitz observed, New Mexico was "the right environment" for her "growth," both artistically and personally. Beyond simply exemplifying modernism's rejection of classical aesthetics, *The Lawrence Tree* decentered humanism by asserting a sense of continuity between the human and nonhuman, in effect reclaiming what Lawrence had called "the allness of Pan." In this respect, O'Keeffe's picture mirrored contemporary cultural and philosophical currents of biocentrism. These found expression not only in the work of Lawrence but also in the writings of European philosophers such as Henri Bergson, whose 1911 book *Creative Evolution* (excerpted by Stieglitz in his photography journal *Camera Work*) articulated the idea of an essential life force, or *élan vital*, flowing through the universe and providing an impetus for change—including in the arts.[12]

Biocentrism in modernist art and philosophy, with its emphasis on the lively agency of more-than-human phenomena, looks dubiously subjective and even mystical to some people today. Yet for the political philosopher Jane Bennett, it anticipated a perspective now much needed and ascendant in an age of environmental crisis, namely a sense of "vital materiality" that refuses to regard matter as inert, passive, or merely inanimate—an object with no agency, aesthetic interest, or ethical significance. Accordingly, Bennett seeks "to awaken what Henri Bergson described as 'a latent belief in the spontaneity of nature'" precisely for ethical and environmental reasons. Just as Stieglitz's "spontaneous discovery" about his own "evolution" toward "a new vision" in *The Steerage* had a timely Bergsonian ring, O'Keeffe's animated ponderosa pine credited non-human life with something more than passive objecthood. For her, Lawrence's tree was very much alive and dynamic.

Moreover, in depicting it, O'Keeffe achieved something through art that most scientists and scholars can only dream about. As one of America's most successful and popular artists, she captured the public's imagination by instilling a sense of wonder about ordinary environmental phenomena, making such things worthy of attention in art and in life. In *The Lawrence Tree* her focus was a ponderosa pine, but a similar energy animates many other entities populating her work, most famously flowers. For example, in *Jimson Weed / White Flower No. 1* (fig. 238), O'Keeffe presented another Southwestern regional plant magnified to monumental

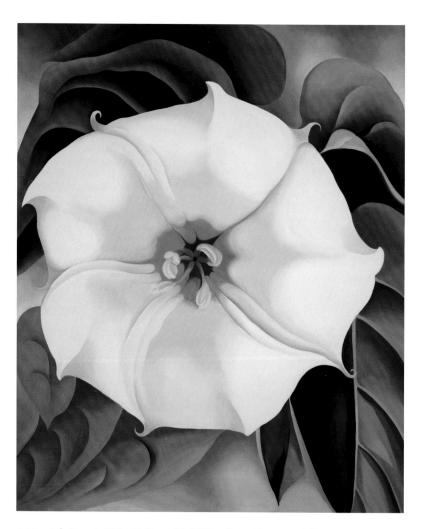

FIGURE 238: Georgia O'Keeffe, *Jimson Weed / White Flower No. 1*, 1932. Oil on canvas, 121.9 × 101.6 cm. Crystal Bridges Museum of American Art, Bentonville, Arkansas (2014.35)

scale and suspended in midair, facing frontally as if behold-
ing the viewer in an uncanny reciprocal gaze. The artist
undoubtedly knew this member of the nightshade family
(*Datura stramonium*) had formidable hallucinogenic and toxic
powers that earned it a variety of colloquial names, includ-
ing "hell's bells," "devil's trumpet," "stinkweed," "devil's
cucumber," and "moon flower."[13]

Land Ethics and Aesthetics

During the 1930s, while O'Keeffe immersed herself in the
rustic vitality and beauty of the Southwestern environment
in New Mexico, artists in the Great Plains confronted the
Dust Bowl—the worst American ecological disaster since the
Civil War. Triggered by a series of severe droughts beginning
in 1930, the Dust Bowl also resulted from destructive settle-
ment and land-use policies over several preceding decades.
Since the 1860s Euro-American homesteaders, land specula-
tors, and mechanized farmers had displaced Indigenous
peoples and vegetation with fields of mono-cropped wheat,
cotton, and corn. These alien plants were unsuited to the
semiarid region. For centuries, native grasses had anchored
Plains ecology, stabilizing the soil while supporting enor-
mous herds of grazing bison and other animals, which in
turn provided sustenance for human communities. Following
the decimation of the bison, systematic plowing and indus-
trial cultivation by white pioneers during the late nineteenth
and early twentieth centuries radically transformed the
Great Plains environment. Worster summarizes the complex
causes of the Dust Bowl in this way:

> It was man's destruction of the grassland that set the dirt
> free to blow. Through such ill-advised practices as plowing
> long straight furrows (often parallel to the wind), leaving
> large fields bare of all vegetation, replacing more diverse
> plant life with a single cash crop, and—most importantly—
> destroying a native sod that was an indispensable buffer
> against wind and drought, the farmers themselves unwit-
> tingly brought about most of the poverty and discourage-
> ment they suffered.[14]

We saw the beginnings of this historic process of ecological
change in John Gast's *American Progress* of 1872 (see fig. 149),
a work that celebrated ranchers, farmers, and railroads
as vanguard agents of Manifest Destiny. These would

soon be followed by modern tractors and other industrial
technologies, facilitating even more intensive commodity
farming in the twentieth century.[15]

By the 1930s, in the absence of rain and native grasses,
the Great Plains experienced catastrophic drought and wind
erosion, converting millions of pounds of topsoil into enor-
mous "black blizzards" of dust, paralyzing entire communi-
ties and even periodically eclipsing the sun. Texas, Oklahoma,
and neighboring states experienced the worst effects, but
the Dust Bowl became a continental emergency when
widespread crop failures forced tens of thousands of people
to abandon their farms in the Plains and migrate elsewhere
in search of work, exacerbating already ruinous economic
impacts of the Great Depression. In a 1935 essay titled
"The Grasslands," published in *Fortune* magazine, the poet
Archibald MacLeish wrote, "For more than three centuries,
men have moved across this continent from east to west. For
some years now, increasingly in the last two or three, dust
has blown back across the land from west to east." Indeed,
dust storms emanating from the Plains reached as far away as
Chicago, New York, and Washington, DC, attracting national
attention and prompting federal action in the form of soil
conservation and economic relief programs created as part
of President Franklin D. Roosevelt's New Deal.[16]

According to the *Oxford English Dictionary*, the term "dust
bowl" originated in the United States and first appeared
in print in a 1936 article in the *Durant Daily Democrat*, an
Oklahoma newspaper, referring to the "panhandle 'dust-
bowl'" with quotation marks, indicating the neologism's
novelty. Actually, a Texas artist named Alexandre Hogue
(1898–1994) had used it earlier as the title for a striking pic-
ture he painted in 1933 (fig. 239). Hogue may not have
invented the term, but the fact that a painter was among the
first to give a name and a look to this national environmen-
tal crisis indicates once again the power of art to imagine
and interpret ecology, often in advance of other discourses.
Hogue's picture adroitly epitomized the Dust Bowl as a
calamity marked by drought, desertification, and economic
devastation. We see an apocalyptic farm landscape reduced to
a sea of sand dunes under a blood-red sky choked with dust,
nearly obscuring the sun. In the foreground, a barbed-wire
fence—symbol of modern agriculture and land ownership—
lies broken and tattered, unable to prevent the flight of
humans or other animals, whose various tracks mingle amid
channels caused by wind erosion. In the face of ecological

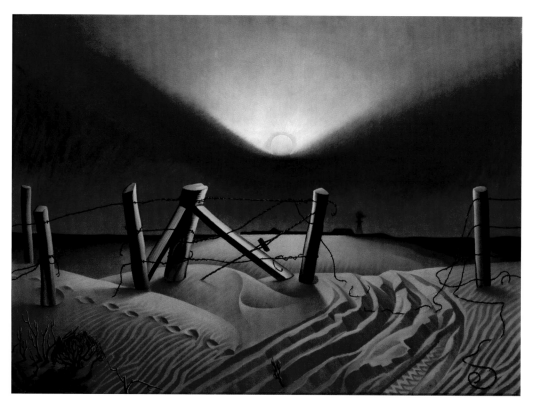

FIGURE 239: Alexandre Hogue (American, 1898–1994), *Dust Bowl*, 1933. Oil on canvas, 61 × 82.8 cm. Smithsonian American Art Museum, Washington, DC. Gift of International Business Machines Corporation (1969.123)

and economic disruption, all inhabitants have abandoned the property. Desiccated plants in the lower left exemplify the utter loss of vitality in this deserted, ruined environment.[17]

Dust Bowl presents a generic, emblematic scene located somewhere on the Great Plains, but Hogue witnessed such conditions firsthand near his home in northern Texas. Born in Missouri and raised in Dallas, he studied art in Minneapolis and worked as an illustrator in New York during the 1920s before returning to Texas. When he made the painting he had been teaching art at Texas State College for Women in Denton for two years. Drought conditions were readily visible there and also around Dalhart, a community in the North Texas panhandle area where his sister owned a fifty-thousand-acre sheep and cattle ranch. Beginning with *Dust Bowl*, Hogue painted a series of related pictures during the next six years he called "Erosions." In 1937 three works in this series, including *Dust Bowl*, were illustrated along with a self-portrait by Hogue in a *Life* magazine article, bringing national attention to both the painter and the crisis. The article referred to Hogue as "the artist of the U.S. Dust Bowl" who had "watched 'suitcase' farmers

[i.e., out-of-state speculators] pour into 'the finest grazing lands,' plow up grass roots where plow had never broken land before, [and] plant wheat and corn for the lucrative boom market." Quoting the artist, the article noted that "old ranchers" had told Hogue, "If you plow up this land, it will blow away." Hogue described his series as a "scathing denunciation of man's persistent mistakes" and his style as "psychoreality" and "superrealism," terms suggesting his awareness and appropriation of international Surrealism for regional American purposes. He also may have known about recent popular and government-sponsored images depicting Dust Bowl conditions, including *The Plow That Broke the Plains*, a 1936 film directed by Pare Lorentz for President Roosevelt's Resettlement Administration, later known as the Farm Security Administration (RA/FSA).[18]

The *Life* article featuring Hogue's paintings also included a number of documentary photographs offering other perspectives on the Dust Bowl. Like Lorentz's film, these photographs were generated by the RA/FSA's Information Division, an agency headed by Roy Stryker and charged with raising public awareness about rural poverty and

promoting federal relief programs. Some of the photographs reproduced by *Life* provided aerial views of dust storms forming over farmland while others depicted drought conditions on the ground and people affected by them. The final, culminating image in the article's pictorial sequence was an eye-catching full-page photograph captioned "Dust Bowl Farmer Is New Pioneer" (fig. 240). Without identifying the photographer, the caption explained:

This man is one of the great army of farmers driven from their land by the dust blight. A Resettlement Administration photographer met him in a battered car on the Oklahoma-California highway, took his picture but not his name. He has joined the pioneers who are seeking new lives on the Pacific Coast, as their fathers trekked west to Oklahoma before them. His courageous philosophy was expressed to the photographer thus: "A man can't make out noways by standin' and watchin' his crops burn up. I heerd [*sic*]

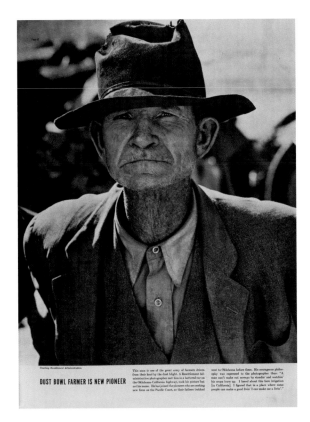

FIGURE 240: Dorothea Lange (American, 1895–1965), "Dust Bowl Farmer Is New Pioneer," published in "The U.S. Dust Bowl," *Life*, June 21, 1937

about this here irrigation [in California]. I figured that in a place where some people can make a good livin' I can make me a livin'."[19]

Not unlike the emblematic landscape in Hogue's *Dust Bowl*, this caption preserved the anonymity of its subject in order to construct a generalized image. Though not a representation of the land per se, the photograph depicted the human figure as an index of ecological and economic conditions, notably dust and wrinkles wrought by wind and wear on both clothing and skin. In contrast to Hogue's apocalyptic vision, this photograph and the accompanying narrative delivered an upbeat flourish, ending the *Life* article on an optimistic note by invoking courage and resilience. Whereas Hogue had offered a "scathing denunciation of man's persistent mistakes," the "Dust Bowl Farmer" searching for a good living was a "new pioneer," words that reclaimed the very tradition of historical settlement that had produced the environmental disaster in the first place. The contradictory tones and modes of address within this *Life* article reveal powerful tensions informing land ethics and aesthetics during the 1930s, as realist artists like Hogue and the RA/FSA photographers grappled with the Dust Bowl and Great Depression. As noted by the historian Lawrence Levine, Stryker acknowledged this very tension in the photographs as one of "dignity versus despair," saying, "Maybe I'm a fool, but I believe that dignity wins out. When it doesn't then we as a people will become extinct." Stryker's reference to extinction here as an end to be avoided through art indicates how thoroughly ecological discourse had saturated the New Deal photographic mission.[20]

The "Dust Bowl Farmer" photograph provides a particularly instructive example when we examine its production and dissemination in greater detail. The vagaries of this image remind us once again about the powerful cultural forces shaping and interpreting nature and ecology, especially in the age of mechanical (and digital) reproduction. Art historians and museum curators know the anonymous *Life* picture as a work of art titled *Ex-Tenant Farmer on Relief Grant in the Imperial Valley, California* by Dorothea Lange (1895–1965), the most famous RA/FSA documentary photographer of all. The Princeton University Art Museum owns a fine, gelatin silver print of this image, bequeathed by the eminent American photographer Minor White (1908–1976), who had invited Lange and others to join him

in teaching at the California School of Fine Arts in San Francisco during the late 1940s. Yet Lange's original version of the photograph—deposited in the official RA/FSA archive at the Library of Congress—included two additional men flanking the central figure (fig. 241). All three men appear to be roughly the same age, wearing hats and rumpled clothing, but only the central figure looks directly at the camera, below a typed caption that reads "Ex-tenant farmer on relief grant." In the blurry background, we can just make out a vehicle and three more figures standing in the distance.[21]

Cropped and focused on a single figure, the *Life* and Princeton versions of Lange's photograph clarified the image for aesthetic, emotional, and rhetorical purposes with a view to public consumption, a fact confirmed by the 1937 magazine caption and by the museum's regular gallery label, which reads:

> Lange documented migrant workers in California, paying particular attention to their emotions and gestures. As a result, her photographs were more narrative and sentimental than those of some of the other FSA photographers. For example, the negative for the photograph shown here originally contained three men, but Lange cropped the image to

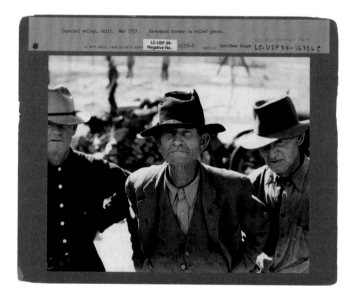

FIGURE 241: Dorothea Lange, *Imperial Valley, Calif. Mar. 1937. Ex-Tenant Farmer on Relief Grant*, 1937. Print from nitrate negative on card, 10.2 × 12.7 cm. Library of Congress, Washington, DC. Prints & Photographs Division

make this man the focus, humanizing his plight and creating a more powerful final image.[22]

Similar to *Migrant Mother* (1936)—Lange's most celebrated and widely disseminated image—her photograph *Ex-Tenant Farmer* distilled the Dust Bowl in an individual human subject, thereby giving a face to complex environmental, economic, and historical forces that resisted comprehension and representation.[23]

Such a process of distillation and dissemination came at a significant cost, though, for it literally erased important contextual information while reifying certain dominant cultural assumptions about the crisis. Lange probably cropped the image herself, but according to the literary scholar Charles Cunningham, "*Life* manipulated the photo and its caption so as to *rid* it of ambiguity," producing a "version of the image [that] excises the insecurity and despair in favor of a paean to the 'pioneer' spirit, a move that suggests that despair was *not* part of the experience of poverty." As a result, viewers were encouraged to feel sympathy without questioning fundamental beliefs about capitalism. Moreover, because the edited photograph was mass-circulated, Cunningham says it emphasized "*white* rural poverty" as a normative public concern in a manner comparable to other prominent Dust Bowl representations of the period by figures such as novelists Erskine Caldwell and John Steinbeck and filmmaker John Ford. When Lange asked Stryker in 1937 whether she should focus her attention mainly on poor white subjects, he replied, "Take both black and white but place the emphasis upon the white tenants, since we know they will receive much wider use." Stryker's strategy of catering to a predominantly white media audience elided African American and other minority victims of the Dust Bowl, even though black subjects appear in six thousand RA/FSA photographs (one-tenth of the entire archive).[24]

Lange sometimes composed photographs with a modernist sense of abstract pattern and design, as in *Tractored Out, Childress County, Texas* (fig. 242). This picture shares aspects of O'Keeffe's rarefied aestheticism, but Lange's attention to repeating linear elements and shapes in damaged land also supported her official government mission to reveal underlying economic patterns, systems, and environmental conditions. The photographer's broader, systemic awareness comes through verbally as well in the subtitle she inscribed on the original archival card for *Tractored Out*: "Power farming

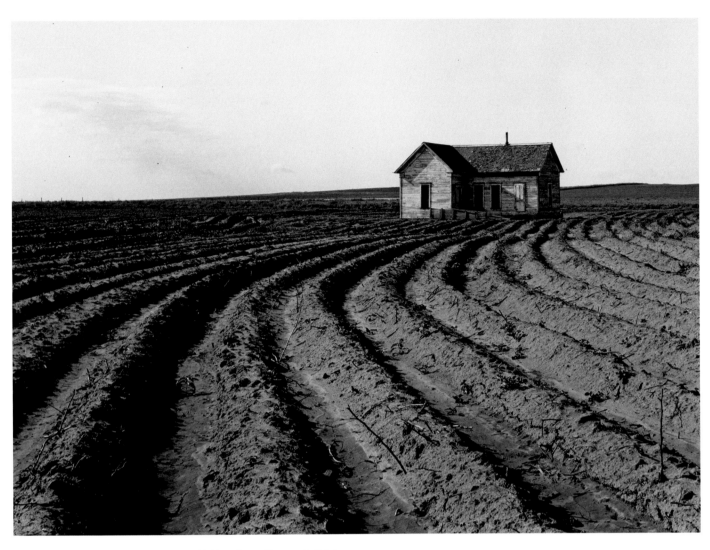

FIGURE 242: Dorothea Lange, *Tractored Out, Childress County, Texas*, 1938. Gelatin silver print, 24.7 × 33.7 cm. George Eastman Museum, Rochester, New York. Museum accession by exchange (1974.0024.0004)

displaces tenants from the land in the western dry cotton area, Childress County, Texas panhandle, June, 1938." We do not literally see tractors here engaged in "power farming," but the effects of such technology stare us in the face. As the historian Linda Gordon observes, "Lange's objective was not only to document poverty but to show also the agricultural *system* from which it grew. She used the rhythm of the plowed ruts and ridges and the rows of plants to increase visually the size of the fields in her shots," while also conveying "the scale of the farms" and "the impersonality of those enterprises where workers never met the boss and did not know many of their co-workers." Accordingly, *Tractored Out* oriented the mechanically tilled trenches of a lifeless

cotton farm roughly in the direction of the viewer's gaze, creating organic lines of perspective that converge at the abandoned dwelling in the middle distance. In contrast to the ashen tones and sculpted dirt of the ground plane, the sky above appears utterly blank, like the bewildered stares of the men excised from Lange's *Ex-Tenant Farmer*.[25]

The desiccated landscape of *Tractored Out* recalls Hogue's *Dust Bowl* and theme of "Erosions," but it also looks forward to *An American Exodus: A Record of Human Erosion*, an illustrated book published collaboratively in 1939 by Lange and her husband, Paul Taylor (1895–1984). Taylor was a progressive agricultural economist and professor at the University of California, Berkeley, known for conducting

fieldwork among migrant laborers and critiquing corporate agribusiness for its profligate consumption of water resources. The historian Finis Dunaway notes that *An American Exodus*, like many other period texts about the Dust Bowl, "linked erosion of soil to the erosion of society" and "revealed the suffering and dislocation caused by machines." Corroborating this point, Gordon observes that Lange, in her pictures, "saw tractors as part of the problem, not the solution," a sentiment also clearly expressed by Taylor in *An American Exodus*

with striking metaphors associating human bodily injury with environmental damage:

Like fresh sores which open by over-irritation of the skin and close under the growth of protective cover, dust bowls form and heal. Dust is not new on the Great Plains, but never ... has it been so pervasive and so destructive. Dried by years of drought and pulverized by machine-drawn gang disk plows, the soil was literally thrown to the winds which

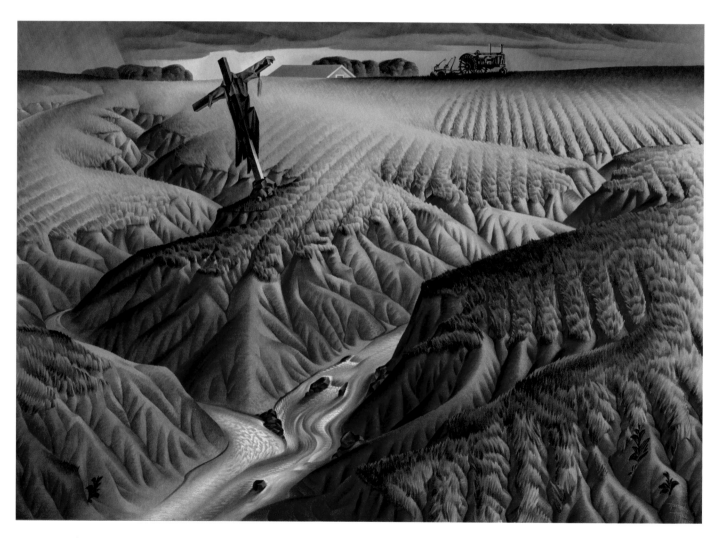

FIGURE 243: Alexandre Hogue, *Crucified Land*, 1939. Oil on canvas, 106 × 152.1 cm. Gilcrease Museum, Tulsa, Oklahoma. Gift of the Thomas Gilcrease Foundation, 1955 (GM 0127.2000)

whipped it in clouds across the country....They loosened the hold of settlers on the land, and like particles of dust drove them rolling down ribbons of highway.[26]

Reading Taylor's text in relation to Lange's *Tractored Out*, one can see with what remarkable visual concision her photograph condensed Taylor's argument into a single image.

A similar environmental ethics informed *Crucified Land*, Hogue's final installment in his "Erosions" series of paintings (fig. 243). Contemporaneous with *An American Exodus*, the picture echoed pervasive rhetoric of Judeo-Christian environmental moralism about the Dust Bowl—discourse most famously expressed in Steinbeck's 1939 novel *The Grapes of Wrath*, with its titular Eucharistic allusions to both the Book of Revelation and "The Battle Hymn of the Republic." For their part, Lange and Taylor adduced the Old Testament book of Exodus to sanctify the displacement and migration of Dust Bowl refugee farmers, but Hogue rendered the land itself as a martyr sacrificed to destructive agricultural practices. In an earlier installment of the "Erosions" series titled *Mother Earth Laid Bare* (1936; Philbrook Museum of Art), Hogue had cast exploited farmland as a female body raped by a phallic plow. This metaphorical approach to ecological embodiment took a decidedly religious turn in *Crucified Land*, perhaps informed by Hogue's upbringing in Texas as the son of a Presbyterian pastor. For the art historian Mark Andrew White, "Hogue's taut forms give the eroded terrain the appearance of jagged, flayed flesh, and his inclusion of the wasted, cruciform scarecrow reinforces the implied comparison in the painting's title between the scourging of the land and the torture of the Passion." As in his earlier Dust Bowl paintings, *Crucified Land* envisioned a generic, emblematic landscape somewhere on the Great Plains, but details in the picture reveal Hogue's awareness of real ecological conditions. For example, we see the "ill-advised" mono-cropping in long straight furrows noted by Worster as a key cause of erosion. Consistent with the contemporary ecological and economic insights of Lange and Taylor, Hogue also depicted a tractor on the distant horizon as a menacing mechanical agent presiding over the factory farm, where industrial efficiency deconstructs itself through desertification and displacement of human labor. Ironically, from our perspective, another series of paintings Hogue produced at this time celebrated the oil industry in Texas for the ostensible cleanliness and order of its automated mechanical

systems of production and distribution. As the artist said in a 1937 interview in the *Dallas Morning News*, "Oil here complements nature. The fields are orderly, and because of the great expanse of the country, the effect of the machinery is not overdone....The shiny tanks, often repeating cylindrical formations in the limestone cliffs, reflect the light very subtly, and the whole effect is one of extraordinary beauty." Whereas Hogue condemned the industrial tractor as an immoral scourge in *Crucified Land*, no such concerns impeded his vision of petroleum's seamless flow.[27]

For African Americans living in the Deep South during these years, martyrdom was more than simply a Christian metaphor. In a landscape defined by Jim Crow racial segregation, violent death was a frighteningly frequent reality. Since the late nineteenth century, white supremacist backlash against black emancipation and civil rights often took the form of lynching, an act of vigilante "justice" in which a white mob murdered an individual, or individuals, of color for alleged but unproven offenses. In 1927, when the African American writer James Weldon Johnson published "The Crucifixion," a poem referring to "black-hearted Judas— / Sneaking through the dark of the Garden— / Leading his crucifying mob," the allusion to contemporary lynching was unmistakable. Lynching typically involved the public torture and hanging of victims from trees, often under cover of night, illuminated only by torches and burning bodies in a spectacle of bloodlust. White onlookers—men, women, and children—often posed triumphantly for grisly photographs with the mangled corpses, spawning a gruesome genre of souvenir imagery that included postcards circulated through the mail, extending the threat of violence. At once deadly and deeply alienating, lynching enacted a particularly egregious form of racial and environmental injustice, for it asserted white prerogatives of social and spatial control as absolute and "natural." According to statistics compiled by the Tuskegee Institute (now Tuskegee University, a historically black educational institution in Alabama), 3,446 blacks and 1,297 whites were lynched in thirty-eight American states between 1882 and 1968, with a noticeable upsurge occurring during the Great Depression of the 1930s. As those statistics demonstrate, African Americans were by far the most frequent targets of such violence, but people of other groups—notably Jews, homosexuals, and civil rights activists regardless of race—died as well. Although lynching was not limited to Southern states, its violence epitomized

Jim Crow segregation and contributed to the Great Migration, a mass exodus of African Americans from the rural South to the urban North during the early decades of the twentieth century.[28]

Responding to the national surge in lynching during the 1930s, progressive artists from diverse backgrounds expressed outrage by producing works in a variety of media for exhibition and publication with the intention of raising public awareness. A notable literary example of this antilynching cultural groundswell was the poem "Strange Fruit," composed and published in 1937 by Abel Meeropol (1903–1986), a Jewish leftist educator in New York who wrote under the pseudonym Lewis Allan. In 1939 Meeropol's words became famous when the African American jazz singer Billie Holiday (1915–1959) interpreted them musically:

> Southern trees bear a strange fruit
> Blood on the leaves and blood at the root
> Black bodies swinging in the southern breeze
> Strange fruit hanging from the poplar trees
>
> Pastoral scene of the gallant south
> The bulging eyes and the twisted mouth
> Scent of magnolias, sweet and fresh
> Then the sudden smell of burning flesh
>
> Here is fruit for the crows to pluck
> For the rain to gather, for the wind to suck
> For the sun to rot, for the trees to drop
> Here is a strange and bitter crop

A foundational statement of social and environmental justice, "Strange Fruit" spoke back to the violence of lynching by exposing the violence underlying the "Pastoral scene of the gallant south."[29]

Five years before Holiday recorded "Strange Fruit," Samuel Joseph Brown (1907–1994) created an equally striking watercolor painting on the same theme titled *The Lynching*, evoking Christ's Crucifixion in a disturbing depiction of racist violence (fig. 244). Born in North Carolina, Brown had moved to Philadelphia and received his master of fine arts degree at the University of Pennsylvania before becoming the first black artist to be employed by the Public Works of Art Project (PWAP), a New Deal agency that hired painters and sculptors to decorate public buildings.

FIGURE 244: Samuel Joseph Brown (American, 1907–1994), *The Lynching*, ca. 1934. Watercolor over graphite on cream wove paper, 77.5 × 52.1 cm. Public Works of Art Project, on long-term loan to the Philadelphia Museum of Art from the Fine Arts Collection, US General Services Administration, 1934

Brown painted *The Lynching* for a 1934 PWAP exhibition in Philadelphia, but he later sent the picture to an antilynching show in New York organized by the National Association for the Advancement of Colored People in 1935. In this very unusual composition, we view the violent scene from above—in a higher place—akin to God's perspective. The bound victim hangs before us in agony, confronting our gaze directly with a terrified visage and screaming mouth while a gawking crowd of spectators watches from a distance below. A white tormenter climbing (or descending) the ladder at right and a group of white youths pulling at the rope at bottom recall art historical iconography of the mocking of Christ, an association vividly underscored by drops of blood trickling down the victim's body. With startling attention to detail, Brown juxtaposed the organic surface patterns and colors of the tree (bark and leaves) with the rectilinear forms of the ladder, in which the meandering wood grain seems imprisoned within an orderly, human-made structure. On the ground below, curving walkways suggest the horrible spectacle unfolds in a picturesque park, their converging paths beneath the victim creating an uncanny illusion of ghostly limbs extending freely in stark contrast to those of his bound body. Brown's violently vertiginous composition here inverts O'Keeffe's exhilarating, heavenward view in *The Lawrence Tree* (see fig. 237). As a result, *The Lynching* starkly challenges pastoral idealism about rural America, even as it binds together man and tree, human and nonhuman. In perhaps the most remarkable detail of all, the mottled colors of Brown's tree and leaves echo the complex tonalities of the victim's skin as well as the variegated complexions of the "white" spectators. By thus revealing nuances of tonality within and across human groups, and by disclosing analogous complexity in the tree, Brown critically exposed the absurdity of racism—and monolithic racial categories in general—as anything but "natural."[30]

The painter Jacob Lawrence (1917–2000) focused much of his artistic attention on the urban environment of his upbringing, but he also acquired considerable knowledge of small-town, pastoral life from his family's oral history. Born in Atlantic City, New Jersey, to working-class parents who had migrated from rural Virginia and South Carolina, Lawrence moved with his mother to New York City at the age of thirteen. Growing up in the city during the Great Depression, he studied in community art studios and the Harlem Art Workshop with the painter Charles Henry

Alston. By the late 1930s Lawrence emerged as a prominent figure in the Harlem Renaissance, a dynamic movement of African American cultural activity in the visual, literary, and performing arts during the first half of the twentieth century. Painting portraits, genre scenes, and historical subjects of African American life, he used a distinctive style of crisply delineated patterns of color and form that he called "dynamic Cubism."[31]

In 1940 Lawrence was awarded a grant from the Rosenwald Foundation to produce a multipart work depicting the mass migration of African Americans from the South to the North during the twentieth century—an appropriate topic in light of his family's history. Consisting of sixty panels painted in tempera, *The Migration Series* met with instant public acclaim when Lawrence exhibited the completed set at the Downtown Gallery in 1941, the first solo exhibition of an African American artist in New York City. Almost immediately, the Museum of Modern Art and the Phillips Collection jointly acquired the series, affirming the artist's reputation as a leading modernist painter.[32]

Lawrence's urban locus of activity and the humanistic theme of *The Migration Series* have tended to obscure the nonhuman environmental dimensions of this masterly meditation on the Southern black diaspora. For example, amid numerous scenes attributing the migration to socio-economic causes such as Southern poverty, segregation, and lynching as well as Northern industrial job opportunities, Lawrence also included three panels—numbers 7, 8, and 9, respectively—with the following descriptive captions: "The migrant, whose life had been rural and nurtured by the earth, was now moving to urban life dependent on industrial machinery."; "Some left because of promises of work in the North. Others left because their farms had been devastated by floods."; and "They left because the boll weevil had ravaged the cotton crop." (fig. 245).[33]

The boll weevil, an invasive insect known to scientists as *Anthonomus grandis*, had migrated from Mexico into Texas during the 1890s. Three decades later it was decimating cotton crops across the American South, exacerbating the Great Depression and accelerating African American movement northward. Named after the cotton bolls, or seed capsules, that it devoured (along with buds and flowers), the weevil in effect was a nonhuman migrant that helped cause human migration. In a recorded interview, Lawrence recalled hearing a popular Depression-era song

FIGURE 245: Jacob Lawrence (American, 1917–2000), *The Migration Series, Panel no. 9: They left because the boll weevil had ravaged the cotton crop.*, 1940–41. Casein tempera on hardboard, 45.7 × 30.5 cm. The Phillips Collection, Washington, DC. Acquired 1942

by the African American blues singer Lead Belly (Huddie Ledbetter) titled "Boll Weevil Blues," which described "the little black bug / Come from a-Mexico they say / Came all the way to Texas / Just a-lookin' for a place to stay / Just a-lookin' for a home." Whereas O'Keeffe had depicted a beautiful but potently poisonous flower in *Jimson Weed* (see fig. 238), Lawrence showed cotton flowers being devastated by bugs. The environmental context and character of each plant clearly informed its artistic interpretation by these modernist painters.[34]

Several panels in Lawrence's *Migration Series* referred to improved living conditions for migrants in the North, but a few acknowledged challenges encountered in their new urban settings. For example, the caption for panel number 55 reads, "The migrants, having moved suddenly into a crowded and unhealthy environment, soon contracted tuberculosis. The death rate rose." (fig. 246). Obviously the problems of urban ecology examined by Jacob Riis in the previous century had not gone away. Lawrence here provided an African American perspective on conditions that disproportionately impacted the urban black community. According to a recent study in the *American Journal of Public Health* on historical disease patterns, African Americans in New York City were more than four times as likely to contract tuberculosis as whites in 1930.[35]

Like Stieglitz, O'Keeffe, and other modernists, Lawrence approached his work with an abstract sense of formal design in which arrangements of shape and color take on a life of their own. For example, the three black triangular mourning figures in panel number 55—each with a black hat, dark brown face, and white glove—correlate with the three flowers left on the bier in the background (see fig. 246). Yet the "background" would almost be impossible to read here were it not for the overlapping of differently colored shapes, since the crispness of the formal pattern tends to foil classical conventions of spatial perspective, mitigating "depth of field" and making everything roughly equal in prominence. Here again, then, despite Lawrence's humanistic theme and traditional tempera medium, modernist aesthetics dispersed visual focus and democratized the pictorial field. An insistence on formal equalization even informed the artist's working method in *The Migration Series* as a whole. Lawrence carried out work on all sixty panels simultaneously after carefully conceiving their compositions in advance. This technique allowed him to apply each individual paint color—black, for

FIGURE 246: Jacob Lawrence, *The Migration Series, Panel no. 55: The migrants, having moved suddenly into a crowded and unhealthy environment, soon contracted tuberculosis. The death rate rose.*, 1940–41. Casein tempera on hardboard, 30.5 × 45.7 cm. The Phillips Collection, Washington, DC. Acquired 1942

example—to the appropriate places in all the panels in one campaign, thereby maintaining tonal consistency throughout the series. Lawrence's comprehensive approach enlivened the entire series as a unit with an internal formal ecology of its own.

In various ways, the artists discussed so far in this essay created works that powerfully correlated human and non-human ecological conditions, often with an ethical aware-ness of environmental history and justice. A recurring theme in their works involved the assertion of metaphorical rela-tionships between bodies and land as comparably fragile entities threatened with abuse and destruction. Nowhere

is this more evident than in Isamu Noguchi's *This Tortured Earth*, a relief sculpture that associates terrain with skin (fig. 247). For Noguchi (1904–1988), a Nisei (Japanese American) artist familiar with the psychological currents of international Surrealism, World War II threatened fundamental conditions on which all life depended. As he explained, "The idea of sculpting the earth followed me through the years, with mostly playground models as meta-phor, but then there were others. *This Tortured Earth* was my concept for a large area to memorialize the tragedy of war. There is injury to the earth itself." With its perforated epidermal surface, the work animates Earth as a vital entity

inviting empathy and identification. Noguchi's abstract relief suggests the war-torn planet is a fragile, damaged mirror of its living inhabitants.[36]

In their respective ways, Hogue, Lange, Brown, Lawrence, and Noguchi were artistic avatars of the "land ethic," a theory of "biotic community" famously articulated by the ecologist Aldo Leopold (1887–1948) in his influential treatise *A Sand County Almanac* (first published in 1949):

> The land ethic simply enlarges the boundaries of the community to include soils, waters, plants, and animals, or collectively: the land.... In short, a land ethic changes the role of *Homo sapiens* from conqueror of the land-community to plain member and citizen of it. It implies respect for his fellow-members, and also for the community as such.... That man is, in fact, only a member of a biotic team is shown by an ecological interpretation of history. Many historical events, hitherto explained solely in terms of human enterprise, were actually biotic interactions between people and land. The characteristics of the land determined the

facts quite as potently as the characteristics of the men who lived on it.... Is history taught in this spirit? It will be, once the concept of land as a community really penetrates our intellectual life.... One basic weakness in a conservation system based wholly on economic motives is that most members of the land community have no economic value. Wildflowers and songbirds are examples.... Yet these creatures are members of the biotic community, and if (as I believe) its stability depends on its integrity, they are entitled to continuance.[37]

"I *am* nature"

The case of Jackson Pollock (1912–1956) provides another illuminating example of how modernist art negotiated changing environmental sensibilities in the twentieth century. Born in Cody, Wyoming, and raised by humble farmers from Iowa who moved the family repeatedly around the West, eventually settling in California, Pollock studied art briefly at the Manual Arts School in Los Angeles before being expelled. Meanwhile he learned about the West and Native American cultures on travels with his father, who worked as a surveyor during the 1920s. In 1930 Pollock followed his older brother, Charles, to New York City, where they studied with the regionalist painter Thomas Hart Benton (1889–1975) at the Art Students League. Pollock disliked Benton, but he absorbed and used elements of his teacher's dynamic approach to composition in early works such as *Going West*, an eerie nocturnal vision of pioneer iconography set in a mountainous landscape (fig. 248). Here the mythic environment of Benton's métier, rooted in a tradition going back to Gast's painting *American Progress*, seems to recede into historical memory as a forgettable cliché or nightmare. Benton had largely abandoned modernist abstraction in favor of a folksy Social Realism celebrating America's past, but his student saw no reason for nostalgia about the West, having grown up there as the child of poor, displaced migrants. For the pupil, modern art could reimagine the frontiers of self and surroundings.[38]

Pollock notoriously struggled with alcoholism and insecurity, even undergoing Jungian psychoanalysis during the late 1930s and early 1940s. After experimenting for more than a decade with mythic archetypes and Surrealist painting techniques, he moved away from New York City

FIGURE 247: Isamu Noguchi (American, 1904-1988), *This Tortured Earth*, 1942-43, cast 1963. Bronze, 7.6 × 71.4 × 73.7 cm. The Isamu Noguchi Foundation and Garden Museum, New York

in 1945 with his wife, the painter Lee Krasner (1908–1984), to a modest rural cottage in the small town of Springs, near East Hampton, Long Island. There, surrounded by trees and open fields, he got sober and embarked on a now-famous series of large works using a drip technique inspired by various artistic precursors, including Diné sand-painting and Surrealist automatism. As noted by the art critic Clement Greenberg (1909–1994), Pollock was particularly influenced by the art of Janet Sobel (1894–1968), a self-taught painter whose "all-over" approach he admired at an exhibition in New York in 1946 (fig. 249). Appropriating and developing the technique, Pollock proceeded to create a series of original works between 1947 and 1950 that are considered landmarks in Abstract Expressionism.[39]

Applying industrial paint rapidly to an unstretched canvas laid horizontally on the floor, Pollock danced around in his

FIGURE 248: Jackson Pollock (American, 1912–1956), *Going West*, ca. 1934–35. Oil on fiberboard, 38.3 × 52.7 cm. Smithsonian American Art Museum, Washington, DC. Gift of Thomas Hart Benton (1973.149.1)

small studio at Springs—or occasionally outdoors—painting in a shaman-like motion, often listening to jazz as he filled the pictorial field with complex material (fig. 250). Contrary to the orthodox modernist claims made by Greenberg, who promoted Pollock's art as the culmination of a historical trajectory toward purification and medium specificity in painting, the artist often produced mixed-media assemblages by incorporating sand, pebbles, matches, buttons, and other detritus into his "paintings." Far from the "purity" or distinctive "competence" in painting that Greenberg imagined, such works engaged and embodied worlds beyond the canvas in a number of important ways. One indication of this wider scope comes from a 1950 statement by Pollock himself:

> Modern art to me is nothing more than the expression of contemporary aims in the age that we're living in.... All cultures have had means and techniques of expressing their immediate aims—the Chinese, the Renaissance, all cultures.... My opinion is that new needs need new techniques. And the modern artists have found new ways and new means of making their statements. It seems to me that the modern painter cannot express this age, the airplane, the atom bomb, the radio, in the old forms of the Renaissance or of any other past culture. Each age finds its own technique.... The modern artist, it seems to me, is working and expressing an inner world—in other words—expressing the energy, the motion, and other inner forces.[40]

Much like his art, Pollock's statement points in multiple directions. He clearly viewed modern art as registering dynamic conditions of both the internal and the external worlds. Moreover, he situated himself as an artist within an expansive horizon of different "cultures." Pollock was no cultural relativist, for he viewed his "new ways and new means" as distinct from the cultural past, embracing modernism's evolutionary sense of artistic progress. In terms of material and conceptual complexity, however, his art far exceeded Greenberg's narrow scheme of strict, formalist "purity."

An especially rich example of Pollock's approach can be found in *Alchemy* of 1947 (fig. 251). Here the artist combined oil, aluminum, and alkyd enamel paint in various colors, throwing them onto the horizontal surface in a network of skeins using sticks or trowels, or pouring directly out of the can. He also incorporated sand, pebbles, fibers, and wood into this mixed-media assemblage. The accumulated

FIGURE 249: Janet Sobel (American, born Ukraine, 1894–1968), *Milky Way*, 1945. Enamel on canvas, 114 × 75.9 cm. The Museum of Modern Art, New York. Gift of the artist's family (1311.1968)

materials sit so thickly on the canvas that they project outward into space like low relief sculpture. Similar heterogeneity and three-dimensionality mark several works by Pollock during these years, including *Number 4* of 1949, produced in a square format using oil, enamel, and aluminum paint with pebbles (fig. 252). Shortly before making this palimpsest, Pollock described a sense of vital, intimate connection to his works-in-progress:

> My painting does not come from the easel.... I prefer to tack the unstretched canvas to the hard wall or the floor. I need the resistance of a hard surface. On the floor I am more at ease. I feel nearer, more a part of the painting, since this way

FIGURE 250: Jackson Pollock, 1950. Photograph by Hans Namuth (American, born Germany, 1915–1990). Courtesy Center for Creative Photography, University of Arizona, Tucson

FIGURE 251: Jackson Pollock, *Alchemy*, 1947. Oil, aluminum, alkyd enamel paint with sand, pebbles, fibers, and wood on commercially printed fabric, 114.6 × 221.3 cm. The Solomon R. Guggenheim Foundation. Peggy Guggenheim Collection, Venice, 1976 (76.2553.150)

FIGURE 252: Jackson Pollock, *Number 4*, 1949. Oil, enamel, and aluminum paint with pebbles on cut canvas, on composition board, 90.2 × 87.3 cm. Yale University Art Gallery. Katharine Ordway Collection (1980.12.6)

I can walk around it, work from the four sides and literally be in the painting.... I continue to get further away from the usual painter's tools such as easel, palette, brushes, etc. I prefer sticks, trowels, knives and dripping fluid paint or a heavy impasto with sand, broken glass or other foreign matter added. When I am in my painting, I'm not aware of what I'm doing. It is only after a sort of "get acquainted" period that I see what I have been about. I have no fears about making changes, destroying the image, etc., because the painting has a life of its own. I try to let it come through.[41]

In addition to embracing "foreign matter," Pollock repeatedly refers here to being "in" the painting, physically and psychologically merging with it to the point of becoming unaware "of what I'm doing." Even more interesting is his statement about the painting having a life of its own, recalling the discourse of modernist biocentrism discussed earlier. Pollock felt a sense of personal continuity with the work of art, which he regarded not as an inanimate

object fashioned solely by him from inert raw materials but rather as a "living" entity with which he collaborated in the process of creation.[42]

Pollock's connection with his art takes on added significance when we consider it in relation to another personal statement, recounted verbatim by Krasner several years later. Sometime in the early 1940s, the painter Hans Hofmann (1880–1966) expressed concern that Pollock's abstraction was becoming too divorced from nature. In response to this criticism, Pollock replied, "I *am* nature." Interpreting this statement as an expression of explicit ecological awareness or environmental activism would be a mistake, but Pollock's retort signals a remarkable realignment of subjectivity, further demonstrating modernism's important break with the classical tradition. For centuries Western classicism had unquestioningly assumed the exceptionalism of human beings and their objective detachment from nature, but Pollock evidently regarded such a position of externality as neither possible nor desirable. In light of this radical reorientation of subject-object relations, the art historian Elizabeth Langhorne describes Pollock's Abstract Expressionism as participating in "the end of an anthropocentric tradition of painting that goes back to the Renaissance, and as an attempt to leave that tradition behind in favor of what can be called a Biocentric approach."[43]

As a way of substantiating this point, Langhorne examines an unfulfilled and largely forgotten proposal put forward in 1949 by the architect Peter Blake (1920–2006), with Pollock's approval, for an "Ideal Museum" (fig. 253) containing several of the artist's recent works, including *Alchemy*. Blake, then curator of architecture at the Museum of Modern Art, envisioned a transparent modernist glass structure, reminiscent of contemporary houses and pavilions by Philip Johnson and Ludwig Mies van der Rohe, to be built in the rural landscape near Pollock's studio at Springs. Though never completed, the museum conceived by Blake would have displayed seven of the artist's signature drip works "suspended between the earth and the sky, and set between mirrored walls so as to extend into infinity." Thus glazed and framed by reflections, Pollock's already massive pictures would have been amplified in scope and scale, demolishing the conventions of classical easel painting. As the artist stated, "My paintings do not have a center, but depend upon the same amount of interest throughout to carry the same intensity to the edges of the canvas." In a

1948 essay on "The Crisis of the Easel Picture," Greenberg noted this decentering, all-over effect in the work of Pollock and a number of his contemporaries, asserting that it "dispenses, apparently, with beginning, middle, end," "comes very close to decoration," and "may answer the feeling that all hierarchical distinctions have been, literally, exhausted and invalidated."[44]

A more positive ecocritical interpretation sees Pollock's technique as contributing to modernism's ongoing democratization of the pictorial field by dispersing visual emphasis and decentering humanism. Such an approach paralleled efforts of twentieth-century ecologists, who increasingly examined subtle relationships among a wide variety of species and phenomena, each considered important within a wider environmental fabric or ecosystem no longer viewed as anthropocentric. To make this claim is not to say that Pollock drew inspiration directly from scientists or sought to illustrate ecology through his art. Rather, as an artist attentive to complexity in the modern "age that we're living in," Pollock arrived at an analogous recognition of the need for a realignment of values in a new political ecology of things.

Later artists frequently took up conceptual strands of Pollock's artistic practice, often highlighting and critically inflecting the environmental implications of his work. For example, in 1953, paying homage to his friend John Cage and responding to Abstract Expressionism, Robert Rauschenberg (1925–2008) created a series of dirt and grass "paintings" that literalized Pollock's idea that a painting had

FIGURE 253: Peter Blake (American, 1920–2006), *"Ideal Museum" for Jackson Pollock's Work,* 1949. Reconstructed model by Patrick Bodden, 1994; 19.7 × 124.5 × 63.5 cm. Pollock-Krasner House and Study Center, East Hampton, New York

FIGURE 255: Eliot Furness Porter (American, 1901–1990), *Pool in a Brook, Pond Brook, New Hampshire, October 4, 1953*, 1953, printed 1984. Dye transfer print, 27.2 × 21.2 cm. Princeton University Art Museum. Gift of the artist (x1984-232)

FIGURE 256: Mark Rothko (American, born Russia, 1903–1970), *Number 61 (Rust and Blue)*, 1953. Oil on canvas, 292.7 × 233.7 cm. Museum of Contemporary Art, Los Angeles (84.9)

FIGURE 257: Eliot Furness Porter, *Dungeon Canyon, Glen Canyon, Utah, August 29, 1961*, 1961, printed 1980. Dye transfer print, 40.6 × 31.3 cm. Princeton University Art Museum. Gift of David H. McAlpin, Class of 1920 (x1982-21.10)

the Hetch Hetchy Valley at Yosemite from damming—an environmental cause célèbre that famously ended in defeat—but no such effort was undertaken by the club to protect Glen Canyon (a fact much regretted by Brower and others). The resulting sense of loss informs the title of Porter's book *The Place No One Knew: Glen Canyon on the Colorado* (1964), the cover of which featured his *Dungeon Canyon, Glen Canyon, Utah, August 29, 1961* (fig. 257). This picture again exemplifies Porter's modernist aesthetic in its startling close-up perspective, rendering the canyon walls as abstract shapes in a formal composition intended to instill a sense of wonder. Though still wedded to the wilderness aesthetic, Porter's intimate abstraction could not be more different from popular artistic representations of the subject, as in Norman Rockwell's *Glen Canyon Dam* (fig. 258). Whereas Porter put the viewer into the canyon at close range—so close that the walls seem almost enveloping and claustrophobic—Rockwell (1894–1978) offered a conventional panoramic spectacle, celebrating the engineering feat for his presumed white viewers as a foil to the depicted family of Diné observers, who seem to gape at the modern technological wonder in speechless astonishment. Rockwell's picture recycled long-standing evolutionary stereotypes about Native backwardness in the face of Euro-American progress, as visualized in earlier pictures such as Henry François Farny's *Morning of a New Day* of 1907, showing traditional Indian nomads on horseback witnessing the "new day" dawning in the form of a modern railroad (fig. 259).[50]

Of course, Porter's commitment to the wilderness aesthetic and Romantic ideas about pristine, untouched nature also prevented him from acknowledging the presence of Native Americans in the region, either historically or in the present. The title of his book, *The Place No One Knew*, falsely implies that no Native American ever saw Glen Canyon. His pictures of the canyon elided living Diné people as well as the many ancient Indigenous petroglyphs that archaeologists were then busily documenting before their submersion. A similar elision of human presence characterizes the paintings and sketches made by Porter's friend O'Keeffe, who accompanied him on two boat excursions through the canyon in 1961 and 1964. Not unlike Porter's photographs, O'Keeffe's pictures of Glen Canyon, including *Canyon Country, White and Brown Cliffs* (fig. 260), treated the rock walls and sky as a pattern of abstract forms, with no signs of human or nonhuman life, except for the geological and aesthetic

FIGURE 258: Norman Rockwell (American, 1894–1978), *Glen Canyon Dam*, 1970. Oil on canvas with gravel, 140.3 × 193.7 cm. Collection of the US Department of the Interior, Bureau of Reclamation (0114052)

FIGURE 259: Henry François Farny (American, born France, 1847–1916), *Morning of a New Day*, 1907. Oil on canvas, 55.9 × 81.3 cm. National Cowboy and Western Heritage Museum, Oklahoma City (1998.072.07)

FIGURE 260: Georgia O'Keeffe, *Canyon Country, White and Brown Cliffs*, ca. 1965.
Oil on canvas, 91.4 × 76.2 cm. Georgia O'Keeffe Museum, Santa Fe, New
Mexico. Gift of the Georgia O'Keeffe Foundation (2006.05.390)

vitality of the stone. Here we see what might be called the Achilles' heel in modernism's political ecology. Although modernist artists democratized art by dispersing visual attention in a more inclusive and egalitarian way that broke from the older academic hierarchies of classicism, their lingering aesthetic commitment to wilderness as a vision of pure, uninhabited nature ultimately failed to become fully ecological. For later artists in the twentieth and twenty-first centuries, ecology demanded a more expansive ethical perspective encompassing Indigenous peoples, people of color, working-class people, and nonhuman beings, whose interests and presence deserve consideration as a planetary matter of environmental justice.

Notes

1 Ernst Haeckel, *Generelle Morphologie der Organismen* (Berlin: Reimer, 1866), 286–87, quoted in Donald Worster, *Nature's Economy: A History of Ecological Ideas*, 2nd ed. (New York: Cambridge University Press, 1994), 192. Eugenius Warming, *Oecology of Plants: An Introduction to the Study of Plant-Communities* (Oxford: Clarendon Press, 1909), quoted in Worster, *Nature's Economy*, 198, 199; Worster, 199, 200. On Kropotkin, see Lee Alan Dugatkin, *The Prince of Evolution: Peter Kropotkin's Adventures in Science and Politics* (self-pub., CreateSpace, 2011).

2 Worster, *Nature's Economy*, 190; on Clements, see Worster, 205–53, Clements quoted 209.

3 Oliver A. I. Botar and Isabel Wünsche, eds., *Biocentrism and Modernism* (Burlington, VT: Ashgate, 2011), 1, 2.

4 James McNeill Whistler, *The Gentle Art of Making Enemies* (London: Heinemann, 1890), quoted in Frances K. Pohl, *Framing America: A Social History of American Art*, 3rd ed. (New York: Thames & Hudson, 2012), 284.

5 James McNeill Whistler, "Mr. Whistler's 'Ten O'Clock'" (lecture) (London: Chatto & Windus, 1885), reprinted in *American Art to 1900: A Documentary History*, ed. Sarah Burns and John Davis (Berkeley: University of California Press, 2009), 804.

6 Alfred Stieglitz, from a 1942 statement, quoted in Katherine Hoffman, *Stieglitz: A Beginning Light* (New Haven: Yale University Press, 2004), 233–34.

7 On organic metaphors in Stieglitz and his circle, see Wanda M. Corn, *The Great American Thing: Modern Art and National Identity, 1915–1935*, rev. ed. (Berkeley: University of California Press, 2001), 1–42.

8 Stieglitz to O'Keeffe, Lake George, New York, July 13, 1929, reproduced in Sarah Greenough, ed., *My Faraway One: Selected Letters of Georgia O'Keeffe and Alfred Stieglitz: Volume One, 1915–1933* (New Haven: Yale University Press, 2011), 475. Bonnie L. Grad, "Georgia O'Keeffe's Lawrencean Vision," *Archives of American Art Journal* 38, nos. 3–4 (1998): 2–19.

9 Grad, "O'Keeffe's Lawrencean Vision," 3.

10 D. H. Lawrence, "Pan in America," *Southwest Review* 2 (January 1926): 105–6.

11 Rosenfeld quoted in Grad, "O'Keeffe's Lawrencean Vision," 4.

12 [Henri Bergson], "An Extract from Bergson," *Camera Work*, no. 36 (1911): 20–21: "The intention of life, the simple movement that runs through the lines, that binds them together and gives them significance ... is just what the artist tries to regain, in placing himself back within the object by a kind of sympathy, in breaking down, by an effort of intuition, the barrier that space puts up between him and his model.... [We] can conceive an inquiry turned in the same direction as art, which would take life in general for its object, just as physical science, in following to the end the direction pointed out by external perception, prolongs the individual facts into general laws."

13 Jane Bennett, *Vibrant Matter: A Political Ecology of Things* (Durham, NC: Duke University Press, 2010), vii–viii; Matt Warnock Turner,

Alan C. Braddock and Karl Kusserow

The Big Picture: American Art and Planetary Ecology

The year 1970 marked a watershed in the public emergence of environmentalism as an international movement, ushering in what the historian Donald Worster has called the "Age of Ecology." US President Richard Nixon, a Republican, created the Environmental Protection Agency in 1970 and signed into law the National Environmental Policy Act, both with strong bipartisan support of Congress. The February issue of *Time* magazine featured the ecologist Barry Commoner on its cover. On April 22 activists led by Senator Gaylord Nelson, a Wisconsin Democrat, organized the first official Earth Day, an event celebrated by twenty million Americans. The immediate inspiration for these actions was a massive offshore oil spill near Santa Barbara, California, in 1969, when a Union Oil drilling rig blew out, leaking three million gallons of crude and killing thousands of sea animals. Many other incidents and factors in the United States and elsewhere during the 1960s played an important galvanizing role as well. In 1962 the publication of Rachel Carson's *Silent Spring* and the Cuban Missile Crisis raised widespread concerns about industrial chemicals and nuclear weapons. Aftereffects of US atomic bomb tests at the Bikini Atoll between 1946 and 1958 spawned international protests and demands for environmental justice in Pacific island communities. Himalayan floods in 1970 prompted popular resistance to unregulated development and deforestation in India, spawning the Chipko movement led by women environmentalists. Growing concerns about various forms of pollution—in air, water, land, and even mother's milk—added to public anxiety around the world. Paul Ehrlich's 1968 book *The Population Bomb* raised the specter of global famine. As the US military waged an unpopular and ecologically destructive war in the "quagmire" of Vietnam, domestic riots and political assassinations indicated a nation in conflagration—an impression menacingly visualized when the oil-soaked Cuyahoga River burst into flames at Cleveland in June of 1969.[1]

The historian Finis Dunaway has examined the "use and abuse of American environmental images" in these years, focusing on various popular media icons such as the Apollo 8 *Earthrise* photograph from space, the "Crying Indian" of the Ad Council's Keep America Beautiful campaign, and Walt Kelly's cartoon figure Pogo with the catchphrase "We have met the enemy and he is us." Arguing that such images helped "make environmental consciousness central to American public culture," Dunaway asserts that many ultimately "impeded efforts to realize—or even imagine—sustainable visions for the future" because they "blamed individual consumers for environmental degradation and thus... deflected attention from corporate and government responsibility." Dunaway also notes the normative homogeneity of mainstream environmental images in their appeal primarily to white, middle-class Americans. Meanwhile, African Americans and other disenfranchised groups faced disproportionate impacts of numerous ecological problems, including urban blight, air pollution, and the siting of industrial facilities in or near neighborhoods of the poor and people of color. In 1967 Dr. Martin Luther King Jr. linked the civil rights movement to economic inequities, ecology, and an emerging sense of global ethics in his "Christmas Sermon on Peace," delivered on Christmas Eve at Atlanta's Ebenezer Baptist Church, declaring: "Yes, as nations and individuals, we are interdependent....It really boils down to this: that all life is interrelated. We are all caught in an inescapable network of mutuality." Yet the problems of poor and minority

Americans received relatively little attention in the popular media, compounding existing social inequalities and catalyzing the movement for environmental justice. The rise of ecofeminism as an insurgent part of the women's movement during the 1970s further galvanized a more politically diverse and activist vision of ecology, notably by relating present disparities to centuries of earlier exploitation—imposed upon women and the earth—by European men colonizing the world in the name of science, religion, and civilization.[2]

In light of the biases and limitations noted by Dunaway in the popular visual culture of environmentalism circa 1970, the art world provides an instructive foil. During this period, avant-garde creative work retained an important degree of distinctness from mainstream imagery, enabling different modes of addressing environmental issues. The aesthetic vanguard certainly had shortcomings as well, including the fact that it attracted relatively little public attention, but greater conceptual and critical freedom often allowed artists in this vein to explore ecology in more complex and provocative ways. This essay examines a selection of these idiosyncratic works. As artists recognized the expansive scope of environmental issues during the late twentieth and early twenty-first centuries, their works became more expansive as well, in sheer size and conceptual scope. Responding to the planetary implications of what would come to be called the Anthropocene, artists increasingly engaged intersectional politics in works that extended across borders of various kinds, illuminating asymmetries between the economically privileged global North and the historically colonized global South. At the same time, they have also revealed analogous asymmetries *within* those somewhat abstract geographical designations, disclosing the limitations of binary logic in the face of environmental realities. More broadly, much environmentally engaged creative work during the last half century has called into question fundamental ideas about nature and nation by revealing them to be culturally contingent and therefore political.

Environmental Art in the Expanded Field

One example of avant-garde art in 1970 that actually did find a large audience was the *Earth Day* poster by Robert Rauschenberg (1925–2008), not only produced as a limited-edition lithograph (fig. 261) but also published in a mass printing of 10,300 by Castelli Graphics and distributed by the American Environment Foundation. Designed as a montage of contemporary media images, it prominently depicts the American bald eagle, then an endangered species, surrounded by pictures of deforestation, urban pollution, junkyards littered with detritus, a contaminated public beach, a stack of empty oil barrels, and an African eastern gorilla. While the eagle's central position emphasizes the US focus of the first Earth Day celebration, the bird's sepia-toned image complicates the work's apparent nationalism. Reminiscent of old newspaper clippings yellowed with age, this rendering of America's avian icon resembles an artifact of the past, connoting its precarious status as a species threatened by the pesticide DDT circa 1970 and potentially slipping into historical memory. Rauschenberg's dimming eagle also suggests the obsolescence of national exceptionalism and progress. Moreover, the problem of endangered species is not exclusively an American story here, for the presence of the African eastern gorilla alerts us to the global dimensions of this environmental issue. *Earth Day* thus broaches an international ecological perspective.[3]

Rauschenberg's jarring appropriation and juxtaposition of heterogeneous real-world images exemplify the eclectic aesthetics of postmodernism. In that respect, the work marks a significant artistic departure from the homogeneous mainstream environmental imagery discussed by Dunaway as well as the modernist wilderness sublimities of Ansel Adams and the pristine abstractions of Eliot Porter (see figs. 255, 257, 294, 295). In an influential 1979 article titled "Sculpture in the Expanded Field," the art historian Rosalind Krauss analyzed postmodernism as a new development in late twentieth-century art, noting how the traditional categories of artistic media—painting, sculpture, architecture, etc.—were breaking down. Artists challenged modernist strictures about medium purity by mixing diverse techniques and materials, often on a large scale. Such heterogeneity was already evident at times in the work of earlier artists, including Jackson Pollock (see figs. 251, 252), but with the generation of Rauschenberg and his contemporaries this eclectic impulse became a dominant trend. Krauss expressed misgivings about the "anything goes" mentality of art in the expanded field, but she grudgingly defended postmodernism by asserting that "this continual relocation of one's energies is entirely logical" even if it "moves continually and erratically." According to Krauss, "within the situation of postmodernism,

FIGURE 261: Robert Rauschenberg (American, 1925–2008), *Earth Day*, 1970. Printed at and published by Gemini G.E.L., Los Angeles. Color lithograph with collage, 132 × 95 cm. Princeton University Art Museum. Gift of the Friends of the Princeton University Art Museum (x1971-21)

FIGURE 262: R. Buckminster Fuller (American, 1895–1983), *Fly's Eye Dome*, 1961, fabricated ca. 1980. Fiberglass-reinforced polyester, 11.6 × 15.2 × 15.2 m. Crystal Bridges Museum of American Art, Bentonville, Arkansas (2015.15)

FIGURE 263: Robert Smithson (American, 1938–1973), *Spiral Jetty*, 1970. Earthwork (black basalt rock, earth), Rozel Point, Great Salt Lake, Utah. Photograph by Gianfranco Gorgoni. Courtesy Dia Art Foundation, New York

practice is not defined in relation to a given medium ... but rather in relation to the logical operations on a set of cultural terms, for which any medium—photography, books, lines on walls, mirrors, or sculpture itself—might be used." As a self-described formalist, Krauss had no interest in political art, but her analysis effectively endorsed creative strategies that have become increasingly useful for addressing the "cultural" concerns of ecology and environmental justice in an era of globalization, mass migration, and gross inequality.[4]

Rauschenberg's use of disparate photographic images in *Earth Day* aptly embodies this mobile, global sensibility. He inherited the technique from an earlier canon of assemblages in twentieth-century art, originating with the Cubist collages of Pablo Picasso (1881–1973) and later overtly politicized in the Dada and Pop photomontages of John Heartfield (1891–1968), Hannah Höch (1889–1978), and other artists. Depicting the word "EARTH" as a disjointed jumble of letters within a collection of visual fragments, Rauschenberg signaled the pervasive sense of planetary disruption then motivating environmentalists to connect the dots and take action. As with other combinatory works by this artist, *Earth Day* brings together heterogeneous elements but leaves the interpretation of meaning somewhat open to individual viewers. Rauschenberg said, "Once the individual has changed, the world can change." Such a statement, in line with Pogo's "We have met the enemy and he is us," places the burden for environmental action on each person.[5]

Postmodern avant-garde artists also helped reveal greater complexity and diversity within ecology itself than was previously understood. As noted by the art historian James Nisbet, the post–World War II period witnessed a significant expansion in the purview of ecological science and thought. Whereas earlier discourse in ecology emphasized economic and biological paradigms, the second half of the twentieth century witnessed extensive discussion about systems, cybernetics, and energy. Nisbet cites Norbert Wiener's *The Human Use of Human Beings: Cybernetics and Society* (1950), R. Buckminster Fuller's *Operating Manual for Spaceship Earth* (1968), and Ludwig von Bertalanffy's *General System Theory: Foundations, Development, Applications* (1968) among the key texts in this regard. According to Nisbet, "from the 1960s onward, all of these fields were integrated as ecologies of information, which emerged as a powerful conception of social dynamics, plant life, and works of art alike." Fuller's planetary research on sustainability and energy

systems—expressed in his various designs for the Geodesic Dome (fig. 262)—is especially relevant here. During the summers of 1948 and 1949, Fuller taught with choreographer Merce Cunningham, composer John Cage, and artists Anni Albers and Joseph Albers at Black Mountain College in North Carolina, an experimental school of art and design modeled on the German Bauhaus and attended by a number of other important postwar artists, including Rauschenberg.[6]

In 1970 Robert Smithson (1938–1973) produced *Spiral Jetty*, a now famous example of Land Art, or Earthworks, and a key specimen used by Krauss to define postmodern art in the expanded field (fig. 263). Built with tons of mud and rock formed into a curving road, it extends fifteen hundred feet into a remote area of Utah's Great Salt Lake currently desiccated by an extended drought, leaving the work now surrounded by dry lakebed. As the art historian Jennifer Roberts has demonstrated, *Spiral Jetty* offers a critical response to historical ideals about progress while marking the location in richly allusive ways. Telescoping form and meaning at multiple scales, the work's involuted shape conjures the molecular structure of salt in the (once) surrounding lake water. Built in a manner similar to a railroad bed, it also gestures to the nearby "Golden Spike" historic site, which commemorates the completion of the transcontinental railroad in Utah a century before. A mile or so down the shore, an abandoned oil exploration jetty disintegrates amid wrecked equipment and the putrid smell of sulfur. Far from celebrating these past enterprises in transportation and energy production, *Spiral Jetty* treats them with darkly comic irony as a recursive road to nowhere, subject to erosion and sedimentation over time. An avid reader of science fiction, physics, and philosophy, the artist here expressed pessimistic fascination with entropy and system failure.[7]

Smithson also critically engaged ecology and environmental history. For one thing, he completed *Spiral Jetty* in April 1970, the same month as the first Earth Day. Yet his work did not celebrate that event either, for the artist took a dim view of popular ecological discourse, disparaging its "one-sided idealism." Instead, Smithson admired Frederick Law Olmsted, designer of New York's Central Park (see fig. 174), as "America's first 'earthwork artist,'" praising the nineteenth-century landscape architect for his realistic willingness to transform and improve terrain without Romantic nostalgia for lost purity. According to Smithson, artists and ecologists who excessively idealize "Mother Earth" fall prey

to a form of "Spiritualism" that "widens the split between man and nature." He felt their timidity about digging into or even touching the land evinces "an Ecological Oedipus Complex" and "wishy-washy transcendentalism."[8] Smithson also expressed his pragmatic view of art and ecology in an untitled statement of 1971:

> The world needs coal and highways, but we do not need the results of strip-mining or highway trusts. Economics, when abstracted from the world, is blind to natural resources. Art can become a resource, that mediates between the ecologist and the industrialist.... Art can help to provide the needed dialectic between them.[9]

This vision of Earthworks informed not only Smithson's *Spiral Jetty* but also an even grander project left unfulfilled after his premature death in a plane crash in 1973. In his proposal for the *Bingham Copper Mining Pit, Utah Reclamation Project*, Smithson conceived an enormous public work of art at the world's oldest open-pit copper mine and largest human excavation ever (fig. 264). More than two and a half miles wide and half a mile deep, the Bingham Canyon Mine in the Oquirrh Mountains near Salt Lake City has been the most productive copper extraction facility on the planet since operations began there in 1906, although the mining of various metals in the region goes back long before. In 1966 the federal government designated the Bingham Canyon

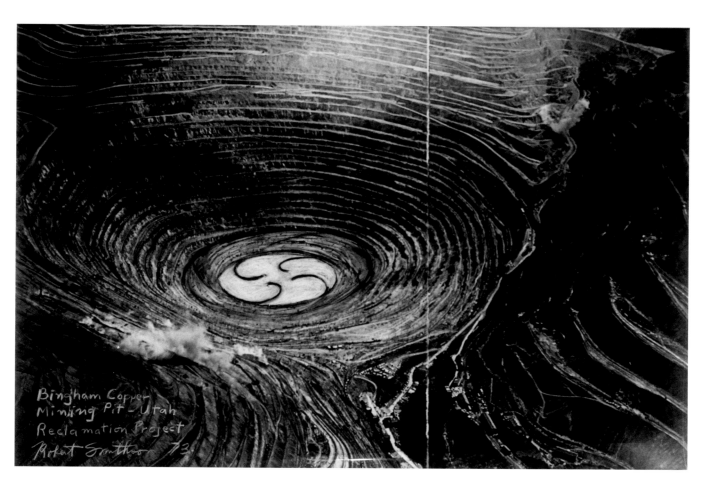

FIGURE 264: Robert Smithson, *Bingham Copper Mining Pit, Utah Reclamation Project*, 1973. Wax pencil and tape on plastic overlay on photograph, 50.8 × 76.2 cm. Seibert Family Collection

Mine a National Historic Landmark in recognition of its importance as an industrial site, one that has been crucial for the production of electrical wiring and other copper materials. Amid growing environmental public consciousness about toxic pollution and erosion caused by mining operations in the early 1970s, Smithson approached the owner of the Bingham facility, Kennecott Copper Corporation, with his artistic reclamation project proposal. Overlaying a Photostat reproduction, he drew four raised crescent earth forms at the bottom of the pit, where water collected after heavy rains. Knowing that such water became bright yellow from toxic acid runoff, called "yellow boy," Smithson imagined the four earthen structures acting as jetties, articulating and channeling the aqueous spectacle of pollution. Building on his own signature series of helical artistic forms—exemplified in *Spiral Jetty* and numerous other works—the artist envisioned a rotating circular platform at the base of the pit, where visitors would have a dynamic 360-degree view of the canyon while standing in place, as in a nineteenth-century cyclorama.[10]

Describing a similar proposal in 1972, Smithson wrote, "The artist, ecologist, and industrialist must develop in relation to each other, rather than continue to work and produce in isolation." For Smithson, isolation was destructive—ecologically, economically, aesthetically, and philosophically. "The artist," he said, "must come out of the isolation of galleries and museums and provide a concrete consciousness for the present as it really exists." In a bid for the necessary financial support to realize such projects, Smithson declared, "Art on this scale should be supported directly by industry, not only private art sponsorship. Art would then become a necessary resource, and not an isolated luxury." During the same year, Smithson articulated these ideas more generally by calling for "art and ecology viewed in terms of social rather than esthetic problems.... Changing views of nature. Nature as a physical dialectic rather than a representational condition. The end of landscape painting and the limits of idealism." In many ways, Smithson's art and writings anticipated the influential ecocritical perspectives of scholars today such as William Cronon, Timothy Morton, Steven Vogel, and others who have similarly called into question the legacy of Romantic idealism about nature. As the writer Andrew Menard observes, "Smithson set out to destroy the sort of historical idealism that signified both a nostalgic attachment to the nineteenth century and a lingering belief in American exceptionalism.... At a time when many others looked to an outmoded or non-existent environment to define the nature and future of the nation, Smithson avoided this wistful, insulated historicism by thinking truly environmentally."[11]

Smithson's bracing statements, together with the remoteness and conceptual obscurity of projects such as *Spiral Jetty* and the unrealized *Bingham Copper Mining Pit, Utah Reclamation Project*, made his work challenging and inaccessible to many. Some critics disliked what they perceived to be the destructiveness of Earthworks in general as damaging to the land in a manner akin to the violence of warfare. For example, in 1972 the artist Alan Gussow disparaged "earth works artists who cut and gouge the land like Army engineers." For other critics, such violence conjured centuries of earlier masculine aggression against women and the land, rooted in long-standing Western attitudes about controlling nature through science. In *The Death of Nature* (1980), the historian Carolyn Merchant examined the role of early modern European science in transforming environmental perceptions beginning in the Renaissance. According to Merchant, an ancient "organic theory" identifying nature with "a nurturing mother: a kindly beneficent female who provided for the needs of mankind in an ordered, planned universe" competed with "another opposing image of nature as female ... wild and uncontrollable nature that could render violence, storms, droughts, and general chaos." As a result of shifting beliefs, epistemologies, and power structures in the 1600s, says Merchant, "the metaphor of the earth as a nurturing mother was gradually to vanish as a dominant image as the Scientific Revolution proceeded to mechanize and to rationalize the world view," calling forth "an important modern idea, that of power over nature." A growing number of writers and cultural figures embraced this critical-historical perspective during the "Age of Ecology" after World War II. Carson, before deciding to call her book *Silent Spring*, had considered using the title *The Control of Nature* as an ironic statement about the hubris and failure of modern science in an era of industrial chemicals. Instead, she concluded her influential study with this statement: "The 'control of nature' is a phrase conceived in arrogance, born of the Neanderthal age of biology and philosophy, when it was supposed that nature exists for the convenience of man."[12]

Ecofeminist artists responded to the ongoing environmental legacy of modern Western science and violence in a

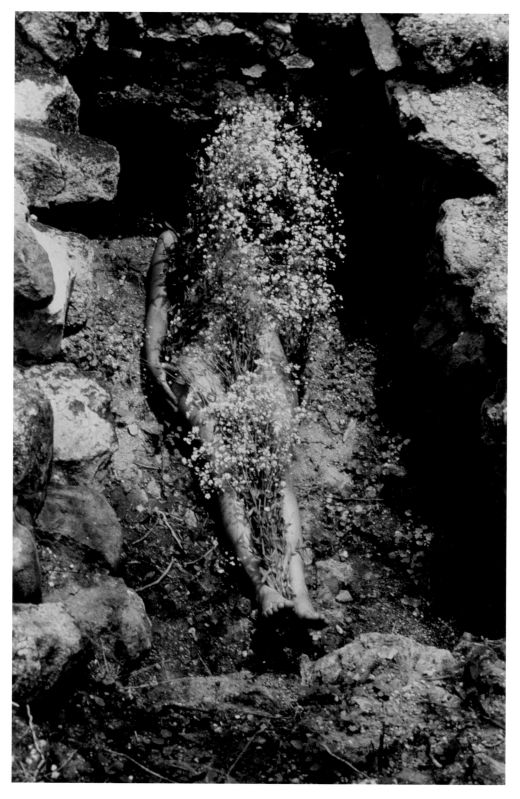

FIGURE 265: Ana Mendieta (American, born Cuba, 1948–1985), *Untitled, Silueta Series, Mexico*, 1973, from *Silueta Works in Mexico*, 1973–77, Estate print 1991. One from a suite of twelve chromogenic prints, 48.9 × 32.7 cm. Galerie Lelong, New York

number of ways, often by creatively incorporating their own bodies into performances that celebrated women's relationships with land and labor. In a startling series of outdoor "earth/body" performances in Iowa and Central America, documented in photographs and videos during the 1970s and early 1980s, Ana Mendieta (1948–1985) repetitively enacted a corporeal encounter with the earth, which she perceived as a nurturing maternal entity. In her *Silueta* series, for instance, the artist lay on (or in) the land, sometimes almost disappearing into plant growth attached to her body (fig. 265). At other times, Mendieta removed herself, leaving a ghostly, silhouette-shaped concavity in the soil. On one level, these corporeal gestures expressed her personal sense of dislocation as an immigrant refugee from the Cuban Revolution, sent away from her homeland in 1961 and raised by American foster parents as part of a controversial program known as Operation Peter Pan conducted by the US Central Intelligence Agency. At the same time, Mendieta's far-reaching work also celebrated ancient Indigenous animist traditions and the syncretic Caribbean religion of Santería while raising broader ecofeminist concerns about environmental alienation associated with the objectifying, male-dominated impulses of modern Western science and colonialism. As the artist observed in 1981, "I have been carrying out a dialogue between the landscape and the female body (based on my own silhouette). I believe this has been a direct result of my having been torn from my homeland (Cuba) during my adolescence. I am overwhelmed by the feeling of having been cast from the womb (nature). My art is the way I re-establish the bonds that unite me to the universe. It is a return to the maternal source. Through my earth/body sculptures I become one with the earth."[13]

In contrast to Mendieta's transnational ecofeminism, the art of Mierle Laderman Ukeles (born 1939) largely focuses on creative engagements with urban ecology and the environmental ethics of labor in the United States. Beginning with her "Manifesto for Maintenance Art!" (1969), Ukeles has tirelessly raised awareness of and appreciation for the efforts of sanitation workers, whom she recognizes as nurturing agents of great value to the public on a metropolitan scale, analogous to her own private household labor as a mother. In 1977 she became the unpaid artist in residence of the New York City Department of Sanitation, a position providing a platform for numerous maintenance-related performances, installations, and other projects. In addition

FIGURE 266: Mierle Laderman Ukeles (American, born 1939), "May 15, 1980, Sweep 10, Queens 14," image from *Touch Sanitation Performance*, July 24, 1979–June 26, 1980. Citywide performance with 8,500 Sanitation workers across all fifty-nine New York City Sanitation districts. Photograph by Vincent Russo. Private collection; courtesy of the artist and Ronald Feldman Gallery, New York

to acknowledging and praising the department's workforce, her activities have educated urban residents about the life-sustaining labor and systems that manage the millions of tons of waste they generate every year. Ukeles's most ambitious and visible project was *Touch Sanitation* (1979–80), a yearlong performance in which she met and shook hands with more than 8,500 city sanitation workers (fig. 266). While documenting her meetings and conversations in photographs and texts, the artist thanked each employee "for keeping New York City alive." Through this systematic gesture of appreciation, Ukeles drew attention to a crucial yet neglected group of laborers and brought the art world into direct contact with urban ecology. Unafraid to "touch sanitation" and make it visible, she affirmed the importance and dignity of these vital custodians, who process the endless stream of materials that the rest of us throw "away."[14]

Art and Environmental Justice

As suggested by the outdoor performances of Mendieta and Ukeles, ecofeminist art helped draw attention to something missing from many Earthworks and other forays in the expanded field of postmodernism: the politics of

environmental justice. Since 1970 the enormous scale and scope of ecological concerns have made it clear that the American context coexists and unfolds within a larger, planetary ethics. No nation—not even one as powerful and influential as the United States—exists as an island unto itself, shut off from the world in an exceptional state of being. There is no such thing as "Nature's Nation," nor is it possible to "decolonize nature," as some scholars and activists imagine. Critical ecological thinking demands recognition of an intractably compromised, contingent, and politically complex condition of mutual implication, in which environmental and economic asymmetries produce both injustice and entanglement. As Smithson, Cronon, Morton, Vogel, and others have recognized, human beings have altered the earth so significantly that there is no returning to Eden. All of Earth's inhabitants, including nonhumans, must share and make the best of a changing planet with no pristine oasis or external metaperspective.[15]

Vivid proof of this inextricable state of planetary imbrication appears in the deluge of recent scientific reports about global warming. In 2014 the United Nations Intergovernmental Panel on Climate Change (IPCC) confirmed that the effects of anthropogenic global warming are now visible on every continent. The IPCC's *Fifth Assessment Report* cataloged and quantified a daunting array of internationally observed evidence concerning melting polar ice, rising sea levels, acidifying water, intensifying heat waves, pervasive flooding, dislocation of human and nonhuman species, rising extinction rates, growing risks to food supplies, and increasing socioeconomic inequalities. Such conditions will worsen during the coming century, according to the IPCC, even if humans take immediate radical steps to curb carbon dioxide emissions—an unlikely scenario now that President Donald Trump has withdrawn the United States from the 2015 Paris Agreement, which created a framework for international cooperation to counteract global warming. According to a joint 2017 report of the US National Aeronautics and Space Administration (NASA) and the National Oceanic and Atmospheric Administration (NOAA), "Earth's 2016 surface temperatures were the warmest since modern recordkeeping began in 1880 … with 16 of the 17 warmest years on record occurring since 2001." Clearly, the United States is not exempt from this global trend.[16]

Earth's inhabitants have left behind the Holocene era and entered the Anthropocene, an unprecedented historical condition defined by the pervasive impacts of anthropogenic warming, pollution, and other human-dominated vectors. As a result, classical distinctions between culture and nature, human history and natural history, have begun to collapse, merging ecology and art history in a global ethical struggle to curate survival—a struggle that demands art history take into consideration the politics of environmental justice. A watershed in the crystallization of such a concept occurred with the First National People of Color Environmental Leadership Summit, held in Washington, DC, in 1991, an event resulting in the declaration of seventeen "principles of environmental justice." By the mid-1990s a wave of academic research and government actions—including numerous books by Robert Bullard, an eminent scholar of urban planning and policy, and a 1994 executive order by President Bill Clinton—further established "environmental justice" as a key term in American public discourse.[17]

Since the 1990s cultural scholarship on environmental justice has blossomed. For example, in the book *Slow Violence and the Environmentalism of the Poor* (2011), the literature scholar Rob Nixon critiques the growing inequities between wealthy elites of the global North and impoverished communities of the global South, who already bear the brunt of climate change and other environmental impacts. For Nixon, art and literature must reveal the slow, "attritional" violence inflicted upon the latter communities by the former. Preferring "representational power" over what he calls the scholarly "fetishism of form" in the humanities, Nixon argues that "any interest in form must be bound to questions of affiliation, including affiliation between writers and movements for environmental justice."[18]

Timothy Morton articulates a different view of formal concerns in the following passage from his book *The Ecological Thought* (2010):

A truly ecological reading practice would think the environment beyond rigid conceptual categories—it would include as much as possible of the radical openness of the ecological thought.…[A]ll art—not just explicitly ecological art—hardwires the environment into its form. Ecological art, and the ecological-ness of all art, isn't just about something (trees, mountains, animals, pollution, and so forth). Ecological art is something, or maybe it does something. Art is ecological insofar as it is made from materials and exists in the world.…[A]ll texts—all artworks,

indeed—have an irreducibly ecological form. Ecology permeates all forms.[19]

Both arguments have merit and provide important interpretive models for ecocritical art history moving forward. Representation is indeed a powerful artistic tool for engaging ethical issues of environmental justice, but there is also a "radical openness" about ecological thought and an inescapable ecological dimension to every artwork both formally and thematically. Matters of representation *and* form underlie the consideration that follows of numerous American artworks created since the middle of the twentieth century. Produced by diverse artists in various media, they address issues of environmental justice in an increasingly broad geographical context.

Five African American Perspectives

In 1934 Aaron Douglas (1899–1979) painted a monumental mural series titled *Aspects of Negro Life* for the 135th Street Branch (now Countee Cullen Branch) of the New York Public Library in Manhattan. A key figure in the Harlem Renaissance, Douglas had grown up in Kansas, earned a bachelor of fine arts degree at the University of Nebraska, and by 1925 found his way to New York, where he continued artistic study with the German immigrant painter Winold Reiss while designing illustrations for important African American magazines, including the *Crisis* and *Opportunity*. After traveling around the United States during the late 1920s and then studying abroad for a year in Paris, in 1931, Douglas returned to New York. With support from the Public Works Administration, he created *Aspects of Negro Life*, a large, four-panel work offering a composite visual narrative of struggle from Africa to the urban American metropolis. Now a centerpiece of the library's Schomburg Center for Research in Black Culture, the murals display Douglas's signature style of silhouetted figures inspired by West African sculpture in scenes that blend realism with modernist abstraction. Tracing black American history through slavery, Emancipation, Reconstruction, and Jim Crow into the twentieth century, Douglas situated human social relations within a complex environmental context at each stage. In 1966, the year he retired after more than two decades of teaching art at Fisk University in Nashville, Douglas reprised the final panel of the famous Depression-era series (fig. 267).

It shows an African American saxophone player standing triumphantly at the center, in New York City, surrounded by skyscrapers and a view of the Statue of Liberty in the distance. Circles of light radiate from the figure's musical instrument, connoting artistic power and freedom. Yet troubling signs appear in the lower foreground, where two other men struggle, one rising at right and the other falling at left, on either side of a symbolic wheel of modern progress. Meanwhile pollution belches from smokestacks as greenish-white fumes waft through the air and ghostly, menacing hands clutch at the figures. The eerie form of a cotton plant intrudes at the lower right, introducing a disturbing reminder of the plantation South, from which nearly two million African Americans had migrated northward in search of better lives during the early decades of the twentieth century. With brilliant dialectical subtlety, Douglas tells us that although this first Great Migration to northern industrial centers allowed some African Americans to advance, many obstacles remained, including environmental forms of injustice associated with racial discrimination and disproportionate levels of pollution in minority neighborhoods. By revisiting such imagery in the 1960s, Douglas recognized enduring inequities that had originated in slavery and persisted through the Jim Crow era into the present.[20]

Only a few years before, in about 1960, Hughie Lee-Smith (1915–1999) painted a striking picture titled *Slum Lad*, showing a young black man facing the viewer and standing before the ruins of an urban building (fig. 268). Born in Florida and raised in Cleveland by his mother and her relatives, Lee-Smith had moved north with his family as part of the Great Migration. Settling in Detroit in 1940, he drew inspiration from European Renaissance art and twentieth-century Surrealism in developing a distinctive urban iconography, representing lonely city dwellers struggling with psychological alienation amid midcentury blight and decay. As he later told an interviewer, "In my case, aloneness, I think, has stemmed from the fact that I'm black. Unconsciously, it has a lot to do with alienation. The condition of the artist is already one of aloneness.... And in all blacks there is awareness of their isolation from the mainstream of society." Like many of his paintings, *Slum Lad* powerfully expresses such feelings in relation to urban decay, resulting from the fact that white, middle-class people had flown to the suburbs, taking with them valuable economic resources that previously helped maintain the vitality of

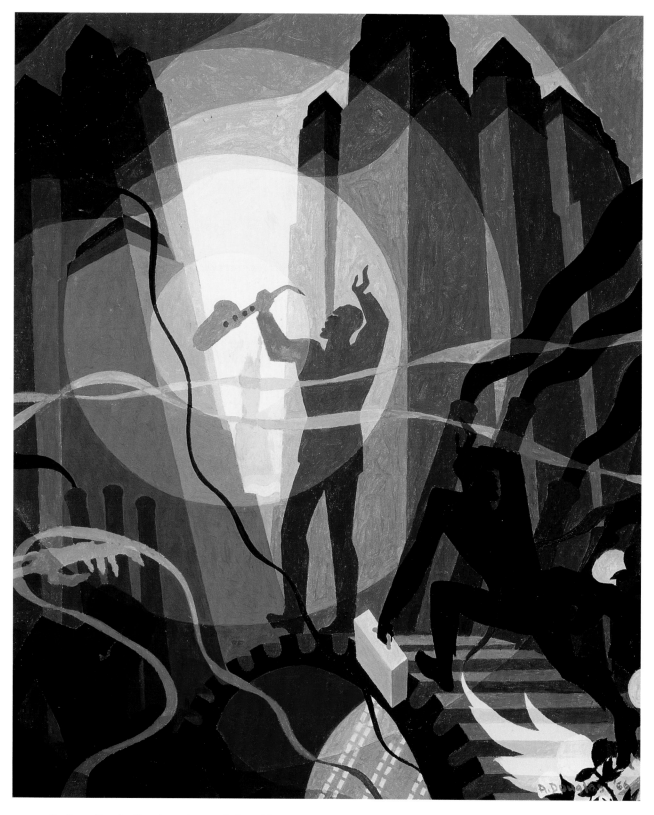

FIGURE 267: Aaron Douglas (American, 1899–1979), *Song of the Towers*, 1966.
Oil and tempera on canvas, 76.2 × 63.5 cm. Milwaukee Art Museum.
Lent by State of Wisconsin, Executive Residence, Madison (L1.2006)

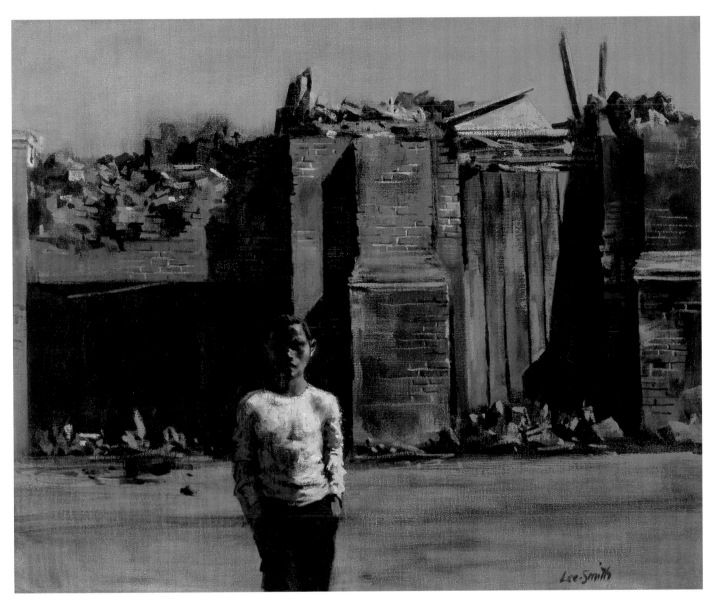

FIGURE 268: Hughie Lee-Smith (American, 1915–1999), *Slum Lad*, ca. 1960.
Oil on canvas, 66 × 81.3 cm. Flint Institute of Arts, Michigan. Courtesy the
Isabel Foundation, Inlander Collection (L2003.80)

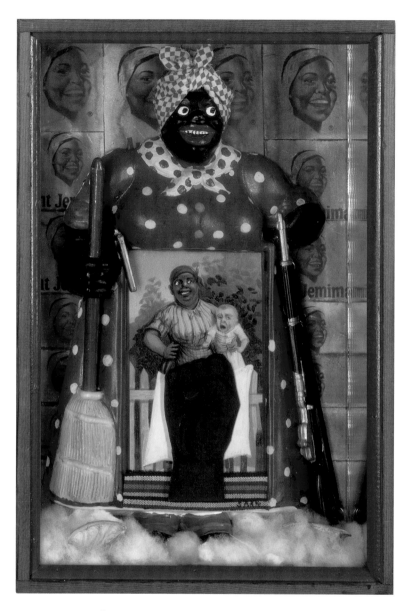

FIGURE 269: Betye Saar (American, born 1926), *The Liberation of Aunt Jemima*, 1972. Mixed media, 29.9 × 20.3 × 7 cm. Berkeley Art Museum and Pacific Film Archive, California. Purchased with the aid of funds from the National Endowment for the Arts (selected by the Committee for the Acquisition of Afro-American Art)

cities. Combining meticulous academic formal techniques with Surrealist psychological effects, Lee-Smith's painting vividly depicts social and environmental inequity.[21]

Slum Lad does more than simply represent such conditions; the painting also registers them through its provenance as a work now in the collection of the Flint Institute of Arts in Michigan. This municipal museum resides in a city devastated by a lead-tainted public water crisis that began in 2014 and continues to worry residents years later. The crisis resulted from bad decisions made by city and state officials who, in an effort to reduce Flint's budget deficit (owing to downsizing by General Motors Corporation), opted to use the polluted Flint River as a water source instead of continuing to purchase relatively clean water from nearby Detroit. On multiple levels, *Slum Lad* represents Nixon's "slow violence" while exemplifying Morton's assertion that "ecology permeates all forms."[22]

In 1972 Betye Saar (born 1926) created *The Liberation of Aunt Jemima*, a signature expression of black feminism and a critique of racial stereotypes, composed of found objects recycled into a mixed-media assemblage box (fig. 269). In the center of the work, we see an African American "mammy" figurine designed to hold a notepad and pencil. Her caricatured smiling face, checkered headscarf, floral dress, and broom are all racist clichés of black servility rooted in the Jim Crow culture of segregation. In place of the pencil originally held in the figurine's left hand, Saar has inserted a rifle. A pistol and hand grenade appear in the other hand, along with the broom. Where a notepad once rested, the artist substituted a picture of another smiling "mammy" figure holding a crying white infant. The baby reacts in fear to the dark clenched fist in the foreground, symbolizing the Black Power movement. Meanwhile, images of Aunt Jemima from commercial pancake boxes and syrup bottles decorate the back wall, their garish sameness recalling Pop art but also addressing the repetitive quality of racial stereotypes. The entire composition occupies a fictive heavenly realm, set above clouds made of cotton, another symbolic material, evoking the history of African American slavery and debt peonage (see fig. 165). Standing above in a space of empowerment and critical appropriation, Aunt Jemima/Mammy thus achieves "liberation."

Born in Los Angeles, Saar studied art at UCLA and other southern California schools during the 1950s, drawing inspiration from the Surrealist assemblages of Joseph Cornell and

Simon Rodia's Watts Towers before emerging as a leading figure in the Black Arts movement. Saar's fascination with heterogeneous source materials in art mirrors her own sense of complex identity as a woman of African, Irish, and Native American ancestry. She has often referred to her artistic technique as a form of "recycling," a process she interprets in a global perspective. In a statement published in the catalogue of a 2006 solo exhibition titled *Migrations/Transformations*, Saar observed, "My travels have taken me to every continent (except the Arctic and Antarctic)....Remnants of journeys—tangible and intangible—are stored. When I begin to select materials to create an art object, my stream-of-consciousness is activated....With hand, head and heart, I manipulate them until they are recycled and reborn into Art." In another statement, she addressed the political dimensions of her work, saying, "I made Aunt Jemima into a revolutionary figure....I was recycling the imagery, in a way, from negative to positive, using the negative power against itself....Discarded materials have been recycled, so they're born anew, because the artist has the power to do that."[23]

Saar created *The Liberation of Aunt Jemima* just two years after a University of Southern California student named Gary Anderson designed the now-famous recycling logo, featuring three curved arrows forming an endless loop. Influenced by Möbius strips popularized in the work of the twentieth-century Dutch artist M. C. Escher, Anderson's logo presented what Dunaway has called "a new aesthetic of environmental hope" that appealed to mainstream consumers for its promise of technocratic solutions without sacrifice, lifestyle change, or political debate. Meanwhile, radical environmental activist organizations such as Black Survival in Saint Louis and the Berkeley-based Ecology Action contested this kind of green consumerism. Working creatively in parallel with such activism, Saar's art politicized contemporary environmental discourse about recycling by reusing found materials to critique the history of racism. *The Liberation of Aunt Jemima* also discloses and contests the lingering environmental injustice of an American consumer landscape still polluted with racially demeaning images of the past.[24]

In 1992 Kerry James Marshall (born 1955) painted a large picture titled *The Land That Time Forgot*, an allegory about the racist Apartheid regime in South Africa (fig. 270). The work prominently features a springbok—a southern African gazelle that was a national symbol of the country under white minority rule—pierced with arrows and surrounded by imported European emblems: Christian crucifixes, tulips, and a portrait of Jan van Riebeeck, the Dutch colonial founder of Cape Town in 1652. Marshall's picture also alludes to the gold, uranium, and diamond mining industries that propped up Apartheid. At the time, Riebeeck and the springbok still appeared on South Africa's gold coins, but the nation had begun to dismantle its system of racial segregation. By 1994 Nelson Mandela would become the first black president. Marshall, born in Birmingham, Alabama, and raised in South Central Los Angeles, now lives in Chicago. He is best known for large-scale paintings of African Americans in everyday urban US settings, rendered with jet-black skin and savvy self-confidence. His oeuvre manifests a critical awareness of history, including Western canons of art history, which he strategically appropriates and reconfigures. *The Land That Time Forgot* expands beyond Marshall's familiar repertoire by examining international racism in relation to colonial resource extraction and exploitation. Although the picture's South African theme is not strictly "American," Marshall here broaches global issues of social, economic, and environmental injustice that relate to problems familiar to him as an African American.[25]

Another Chicago-based artist, Theaster Gates (born 1973), creatively reuses found or discarded objects and materials to create vital new structures for fostering community in low-income African American neighborhoods. He has referred to his practice as a form of "critique through collaboration," since he often includes groups of people in performances and actions with the reclaimed materials. Like the other artists discussed here, Gates develops these contemporary projects with a keen awareness about historical forces of discrimination and social resilience going back decades, if not centuries. Although the artist does not explicitly articulate his motives in environmentalist terms, he has said that for someone growing up "poor on the West Side of Chicago, environmental justice was just making sure you didn't eat lead paint. The way I understand environmental justice is, how can we be good to each other?" Gates's use of humble materials to create social capital provides a model of engagement that recalls the etymological origins of "ecology" in "economy" and the ancient Greek *oikos*, or household. His art reminds us that ecology is always already social and political.[26]

Mantle with Hose III (2011) is one in a series of works by Gates titled *In the Event of a Race Riot*, composed of

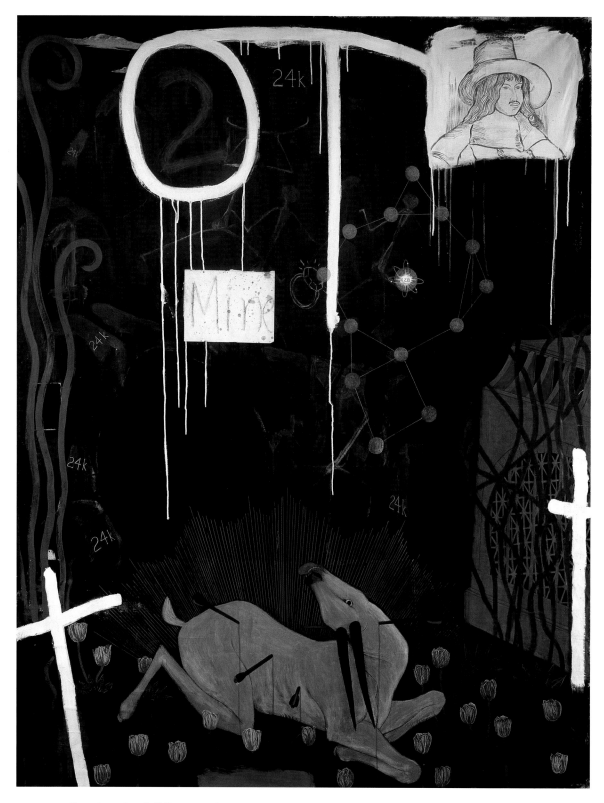

FIGURE 270: Kerry James Marshall (American, born 1955), *The Land That Time Forgot*, 1992. Acrylic and collage on canvas, 246.4 × 190.5 cm. Columbus Museum of Art, Ohio. Museum Purchase, The Shirle and William King Westwater Fund and Derby Fund (2005.004)

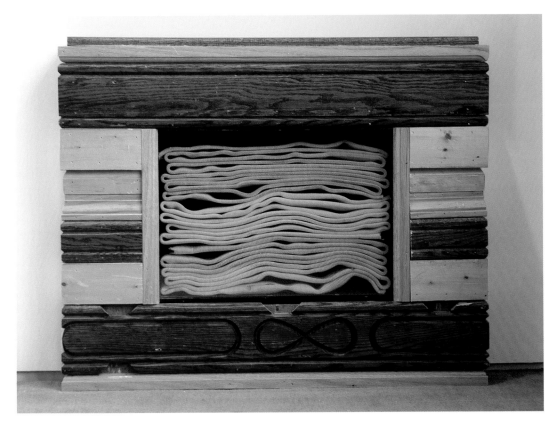

FIGURE 271: Theaster Gates (American, born 1973), *Mantle with Hose III*, 2011. Wood, fire hose, glass, 73.7 × 94 × 14 cm. Kolodny Family Collection

decommissioned fire hoses encased in wood-and-glass boxes (fig. 271). Like other examples in the series, this one refers to historical conflicts over civil rights, notoriously exemplified by the violent use of high-pressure water hoses by Birmingham police officers against peaceful African Americans protesting discrimination in May 1963. Although Gates's careful folding and enclosure of the hose evokes preservation of an artifact from the past, it retains an uncanny presence and readiness, suggesting that the attainment of equality remains unresolved—akin to a smoldering flame under the mantel of a fireplace—while subtly reminding us of the political ecology that makes objects like fire hoses mean diffferent things in different environments. Indeed, Gates recognizes that the pursuit of civil rights is an ongoing *global* struggle, a fact that helps explain why he has participated in projects in a wide variety of international contexts.[27]

Imaging Other Animals and the Sixth Extinction

After the prodigious Peale family, active in Philadelphia during the early years of US national history, perhaps the most renowned artistic dynasty in American art is that of the Wyeth family, centered for three generations around the Brandywine Valley community of nearby Chadds Ford, Pennsylvania. Its patriarch, Newell Convers (N. C.) Wyeth (1882–1945), settled there in 1907 following training with the illustrator Howard Pyle, who had founded a school of art in Wilmington, Delaware. N. C. established the Wyeth family tradition of evocative realism, passed on to the three of his five children who became artists, notably the youngest, Andrew (1917–2009), whose son Jamie (born 1946) in turn became a painter. Collectively, the Wyeths have promulgated a variety of skilled, often psychologically inflected naturalism that has enjoyed enormous popular and, more recently,

FIGURE 272: N. C. Wyeth (American, 1882–1945), *Roping Horses in the Corral*, 1904. Oil on canvas, 55.9 × 81.3 cm. Private collection

critical success. The predominantly rural character of their art has entailed the frequent portrayal of animals, represented in ways that, over more than a century of artistic production, varies considerably. Indeed, viewed across the generations, the Wyeths' treatment of nonhuman beings evinces a broader periodization of human attitudes toward other species—from utilitarian anthropocentrism to sympathetic sentimentalization to empathetic identification—that both reflects and transcends the chronological confines of their respective careers.

In 1904, to mark the completion of his studies with Pyle, N. C. Wyeth traveled west to produce a series of paintings depicting cowboy life for prospective use by *Scribner's Magazine*, a fashionable monthly distinguished by its high-quality illustrations. The artist worked as a cowpuncher for several weeks at Gill Ranch in Limon, Colorado, playing at

cowboy in the romanticized manner popularized by other educated easterners, including Theodore Roosevelt (who was elected to his first full term as US President during Wyeth's trip). In a hotel room in Denver following his adventure, Wyeth completed four paintings, only one of which, *Roping Horses in the Corral* (fig. 272), survives. It shows a rugged contest of man against animal played out in the confines of a dusty enclosure, with the unbroken horses marshaled between fence and wranglers, whose alternately animated and stolid poses leave little doubt as to which will prevail. Animals are imagined here as essentially undifferentiated, wild-eyed, brute forces in the process of being subdued for human ends. Such a relationship evokes centuries of anthropocentric thinking in which their often violent subjugation desirably reified animals' distinction from humans at times

when the realities of existence placed people in close proximity and states of mutual dependence with them. Aristotle (384–322 BCE) offered an early articulation of human exceptionalism and the resulting rationale for the exploitation of animals, noting, "When there is such a difference as that between soul and body, or between men and animals ... the lower sort are by nature slaves, and it is better for them as for all inferiors that they should be under the rule of a master." Sovereignty over animals offered a means to bolster humans' self-definition as rulers of a world in significant ways beyond their comprehension and control. The Aristotelian conception was complemented over the centuries by the biblical injunction to "have dominion ... over every living thing that moveth upon the earth" and in related ways by religious and secular philosophers from Saint Augustine (354–430) and Saint Thomas Aquinas (1225–1274) through René Descartes (1596–1650), Martin Heidegger (1889–1976), and beyond. In 1984 Pope John Paul II declared, "It is certain that animals are intended for human use."[28]

And yet, beginning in the eighteenth century, as urbanization, industrialization, and technological advance increasingly separated humans from other animals, the need to distance the one from the other diminished, even as an increase in disposable income enabled the rise of pet keeping and its attendant culture of sentimentalization. Companion animals, especially dogs, have been known for millennia, but it was not until the nineteenth century that the practice became widespread—the first commercial dog food, for example, was not available in the United States until the early twentieth century. In part as a result of the growing experience of pets, advocates for the ethical treatment and conservation of other domesticated as well as wild animals emerged, and the practice of vegetarianism enjoyed increased adherence. The first animal cruelty legislation was passed in England in 1824, and a century later the conservationist William Hornaday, motivated by the near extinction of the bison in the American West, published *The Minds and Manners of Wild Animals*, which included a chapter on "The Rights of Animals." Now the treatment of animals did not reflect the desire to differentiate humans from them but instead was understood to positively express progressive and enlightened values in their "humane" use and handling—a congratulatory term that belies the self-referentiality still underlying such attitudes.[29]

Andrew Wyeth's depiction of animals revolved around pets and farms. In contrast to his father's rendering of the rough and ongoing process of "breaking" horses, Andrew's sympathetic portrayals of domesticated animals underscore the twentieth-century perception of human success in subduing nature. The artist's first tempera painting (a favored method employing usually egg instead of oil to bind pigment), completed in 1936, is a sensitive portrait of his pet Boston terrier, *Lupe* (fig. 273). Its affectionate but objectified quality, with the closely observed subject shown looking blankly away from the viewer, sets the pattern for Wyeth's images of numerous other pets over decades, most of which are also consummately rendered representations of passive—often sleeping or lying—animals devoid of much inherent interest. Among Wyeth's best-known images of dogs is *Ides of March* (1974; private collection), depicting his yellow Labrador retriever, Nell Gwyn, lying inertly beside an

FIGURE 273: Andrew Wyeth (American, 1917–2009), *Lupe*, 1936. Tempera on panel, 25.4 × 20.1 cm. Private collection

FIGURE 274: Andrew Wyeth, *My Hound*, 1962. Watercolor and drybrush on paper, 58.7 × 41.6 cm. Private collection

ancient, ember-filled hearth, opposite antique kitchen implements rendered at least as carefully as she is. Though undoubtedly beloved, Wyeth's pet was the namesake, apparently in jest, of a seventeenth-century English actor and mistress of King Charles II who died at thirty-seven of syphilis. Describing the painting long after its completion, Wyeth confused Nell with another pet of the same breed, Rattler, who lived years before *Ides of March* was undertaken. It is likely Rattler who appears in an earlier watercolor, *My Hound* (fig. 274), a portrait of an animal again rendered sympathetically but without differentiation—evidently even in the artist's mind—from others of the same species with whom he lived for years. The work's title, at once possessive and generic, further suggests Wyeth's essentially objectifying approach to depicting nonhuman animals—a stark contrast to his frequently penetrating images of people.[30]

If Andrew Wyeth's animals embody ideals of benign anthropocentrism, those of his son Jamie reflect the late twentieth century's accelerating challenge to presumed categorical boundaries between humans and animals. The first work in his mature style, an evocative portrait of a formidable ewe encountered by the artist on the small, treeless island of Manana off the coast of Maine (fig. 275), offers a telling comparison to his father's inaugural tempera (see fig. 273). Jamie's *Portrait of Lady, Study #1* gestures emphatically to emerging conceptions of nonhuman animals as worthy not just of sympathetic consideration but of empathetic identification. In Wyeth's study Lady is afforded a concern for individualization and interiority usually reserved for human subjects—an impression bolstered by the sensitive pencil sketch of her face appearing to the right of the central image. Her piercing gaze meets the viewer's in an assertion of her agency and a respectful apprehension of her status as a fellow being.[31]

FIGURE 275: Jamie Wyeth (American, born 1946), *Portrait of Lady, Study #1*, 1968. Watercolor, 35.6 × 55.9 cm. Private collection

FIGURE 280: Patrick Nagatani (American, 1945–2017), *Golden Eagle, United Nuclear Corporation Uranium Mill and Tailings, Churchrock, New Mexico*, 1990. Dye destruction print, 43.3 × 56.1 cm. Princeton University Art Museum. Gift of Dr. Donald Lappé, Class of 1968, and Mrs. Alice Lappé (2001-231)

quadruped ears while another has the head of a fox. An ivory-billed woodpecker steadies itself with an unusual striped phallic appendage. A grasshopper erupts from the breast of a green parakeet and the long tail of a bird of paradise merges with that of a night heron, creating a hybrid species. The head of an oversized American bald eagle with griffin-like feathers peers down menacingly from above. Several other creatures exhibit even more fantastic characteristics. Rockman's unsettling image suggests evolution gone awry, probably as the result of human interference, leaving the "tree of life" altered and increasingly unrecognizable.[42]

A New York–based artist, Rockman studied at the Rhode Island School of Design and the School of Visual Arts in Manhattan in the early 1980s. Since then he has creatively synthesized scientific research, science fiction, international travel, and meticulously surreal painting techniques in exploring themes of evolution, genetic engineering, climate change, and species extinction. Knowledgeable about both

natural history and art history, he frequently collaborates with scientists and supports environmentalist causes while using his art to critique idealistic beliefs about nationalism and ecology. In words that recall those of Smithson, Rockman has stated, "I am attracted to the unofficial version of history: where the failures, the losers, and the mutations that fell through the cracks reside." Unlike Smithson, however, Rockman acknowledges the positive impact of mainstream environmentalism and the influence of "the first wave of eco-consciousness from the 1960s," including books such as Carson's *Silent Spring* and Ehrlich's *The Population Bomb*. Recounting his participation in a 1998 expedition to study the effects of deforestation in the Amazon rainforest, sponsored by the Smithsonian Institution and Brazil's government, Rockman said, "My role was to describe what was happening and make people care."[43]

Many recognize endangered species and extinction as pressing environmental issues, but some artists and activists

now regard industrial agriculture—especially meat production—as an ethical and ecological problem affecting both humans and nonhumans. Sue Coe (born 1951) has addressed these related concerns for nearly half a century. Raised in Staffordshire, England, near an industrial slaughterhouse, Coe studied at the Royal College of Art in London and moved to the United States in 1972. She has subsequently produced an enormous body of politically engaged paintings and prints, often selling her work to benefit animal rights

organizations and other causes. In a 1991 lithograph titled *Feed Lot,* Coe critically examined the stark realities of modern factory "farming" in confined animal feeding operations, or CAFOs, which process more than fifty billion animals (not including fish) globally for meat every year (fig. 283). Coe's composition renders the abstracting forces of industrial agriculture with poetic concision. Animals destined for systematic slaughter crowd the pictorial field, extending to the horizon. Watched over by an anonymous human worker, the cattle lose individuality as they diminish into the distance, morphing into repetitive patterns of units symbolizing their economic status as commodities. In this way, Coe relates artistic "perspective" to the emotional distancing and ethical limits of human vision that enable the mass killing of sentient beings. The dark sky and somber monochromatic tonality of the print allude to the environmental pollution associated with industrial agriculture, which produces not only meat but also enormous amounts of greenhouse gas emissions, nitrogen runoff, aquatic dead zones, antibiotic resistance, and other negative ecological effects, not to mention unimaginable suffering for nonhuman animals as well as human workers and nearby residents. Coe's subtle artistic reinterpretation of Christian traditions about stewardship and hope—with the worker recalling a Christ-like shepherd and the distant factory perverting the Kingdom of Heaven—creatively indicts the CAFO model of agriculture as corrupting historically accepted moral values.[44]

In an effort to address the enormous complexity and scale of global environmental problems more comprehensively, artists have expanded the field of postmodernism even further recently by developing elaborate works of multimedia data-visualization that present large amounts of information, either online or through spectacular public displays or both. One of the most prominent examples is Maya Lin's *What Is Missing?,* an ongoing online interactive "memorial to the planet" highlighting extinct and endangered species around the world (fig. 284). Lin (born 1959) began the project in 2009; it contains crowd-sourced texts, images, sounds, and videos, which the artist calls "memories," along with eyewitness historical accounts and testimony about current threats posed by climate change, pollution, overhunting, and habitat loss. Like earlier bricks-and-mortar memorials by the artist, such as the *Vietnam Veterans Memorial* (1982; Washington, DC), *What Is Missing?* projects a mood of somber seriousness and even melancholy in many of its

FIGURE 281: Andō Hiroshige (Japanese, 1797–1858), Edo Period, 1615–1868, *Fukagawa Susaki and Jūmantsubo,* no. 107 from *One Hundred Famous Views of Edo,* 5th month of 1857. Woodblock print (*ōban yoko-e* format); ink and color on paper, 34 × 22.2 cm. Brooklyn Museum. Gift of Anna Ferris (30.1478.107)

FIGURE 282: Alexis Rockman (American, born 1962), *Aviary*, 1992.
Oil on wood, 203.2 × 172.7 cm. Private collection

FIGURE 283: Sue Coe (British, active in the United States, born 1951), *Feed Lot*, 1991. Lithograph on white heavyweight Rives paper, 46.6 × 35.9 cm. Galerie St. Etienne, New York

FIGURE 284: Maya Lin (American, born 1959), *What Is Missing?*, 2009–present. Website (whatismissing.net) and multimedia installations. Courtesy of the artist

Speaking back to the classical Western tradition of peripatetic learning where it originated, Postcommodity reclaimed this technology of oppression by using it to give voice to various disenfranchised and dislocated people. The vast conceptual scope of *The Ears Between Worlds Are Always Speaking*, a work encompassing global histories and cultural geographies, exemplifies creative engagement in the age of the hyperobject and the Anthropocene.[54]

In that respect, the approach of Postcommodity differs from more localized activist work. For example, *The Mirror Shield Project* (2016), created by Cannupa Hanska Luger (Mandan/Hidatsa/Arikara/Lakota, born 1979), consisted of Masonite boards with Mylar surfaces that enabled the same Indigenous Water Protectors at the Oceti Sakowin Camp, near the artist's home community of Standing Rock, to reflect images of state police and federal authorities back at them during protests (fig. 288). A sense of global awareness informed Luger's project, for he has observed that it "was inspired by images of women holding mirrors up to riot police in the Ukraine, so that the police could see themselves." Yet the immediate political impulse of his activist intervention gave it a more specifically circumscribed focus than Postcommodity's expansive critical response to Western peripatetic philosophy at its source.[55]

Like a growing number of artworks addressing matters of environmental justice in a global perspective, the works discussed here have insistently brought art, history, philosophy, and politics into conversation with ecological ethics in a variety of American contexts. The increasingly ambitious scope of such works embodies art in the expanded field of postmodernism while it also responds to the planetary implications and inequities of the Anthropocene. In the face of daunting environmental challenges in a rapidly changing world, artists are critically reframing the meaning of nature and nation, revealing these contingent concepts to be up for renegotiation by a broad range of stakeholders.

FIGURE 288: Cannupa Hanska Luger (Mandan/Hidatsa/Arikara/Lakota, born 1979), Image still from drone footage of *Mirror Shield Project*, Oceti Sakowin Water Protector camp, near Standing Rock, North Dakota, 2016. Each *Mirror Shield*: Masonite board, Mylar adhesive paper, rope, 121.9 × 40.6 cm. Courtesy of the artist

Notes

1 On events in the United States circa 1970, see Adam Rome, *The Genius of Earth Day: How a 1970 Teach-In Unexpectedly Made the First Green Generation* (New York: Hill & Wang, 2014); and Donald Worster, *Nature's Economy: A History of Ecological Ideas*, 2nd ed. (New York: Cambridge University Press, 1994), 356–58. Regarding the Bikini Atoll tests and their aftermath, see Timothy J. Jorgensen, *Strange Glow: The Story of Radiation* (Princeton: Princeton University Press, 2017); Connie Goldsmith, *Bombs over Bikini: The World's First Nuclear Disaster* (Minneapolis: Twenty-First Century Books, 2014); and Chris Hamilton, "Survivors of Nuke Testing Seek Justice: Marshall Islanders on Maui Rally to Share Nation's Story," *Maui News*, March 23, 2012. About the Chipko movement, see Ramachandra Guha, *The Unquiet Woods: Ecological Change and Peasant Resistance in the Himalaya* (Berkeley: University of California Press, 2000); and Vandana Shiva, *Water Wars: Privatization, Pollution, and Profit* (London: Pluto Press, 2002), 3. On the Vietnam War, see David Zierler, *The Invention of Ecocide: Agent Orange, Vietnam and the Scientists Who Changed the Way We Think about the Environment* (Athens: University of Georgia Press, 2011); and David Halberstam, *The Making of a Quagmire: America and Vietnam during the Kennedy Era* (New York: Random House, 1965).

2 Finis Dunaway, *Seeing Green: The Use and Abuse of American Environmental Images* (Chicago: University of Chicago Press, 2015), 35–95, quoted 1, 2, book jacket; Robert D. Bullard, ed., *The Quest for Environmental Justice: Human Rights and the Politics of Pollution* (Berkeley: Counterpoint Press, 2005). Dr. King's 1967 sermon is available on YouTube: https://www.youtube.com/watch?v=1jeyIAH3bUI; see also Drew Dellinger, "Dr. King's Interconnected World," *New York Times*, December 22, 2017. Maria Mies and Vandana Shiva, *Ecofeminism*, 2nd ed. (London: Zed Books, 2014).

3 Robert Mattison, "Robert Rauschenberg's Environmental Activism," in *Last Turn, Your Turn: Robert Rauschenberg and the Environmental Crisis* (New York: Jacobson Howard Gallery, 2008), 3–19; see also "Earth Day," Robert Rauschenberg Foundation website, https://www.rauschenbergfoundation.org/art/art-in-context/earth-day.

4 Rosalind Krauss, "Sculpture in the Expanded Field," *October* 8 (Spring 1979): 30–44, quoted 42.

5 On photographic montage, see David King and Ernst Volland, eds., *John Heartfield: Laughter Is a Devastating Weapon* (London: Tate Modern, 2015); and Peter Boswell and Maria Makela, eds., *The Photomontages of Hannah Höch* (Minneapolis: Walker Art Center, 1996). Rauschenberg quoted in Mattison, "Robert Rauschenberg's Environmental Activism," 4.

6 James Nisbet, *Ecologies, Environments, and Energy Systems in Art of the 1960s and 1970s* (Cambridge, MA: MIT Press, 2014), 3. Helen Molesworth, *Leap Before You Look: Black Mountain College 1933–1957* (Boston: Institute of Contemporary Art, 2015).

7 Jennifer Roberts, *Mirror-Travels: Robert Smithson and History* (New Haven: Yale University Press, 2004), 114–39.

8 Robert Smithson, "Frederick Law Olmsted and the Dialectical Landscape" (1973), in *Robert Smithson: The Collected Writings*, ed. Jack Flam (Berkeley: University of California Press, 1996), 159, 163, 164.

9 Smithson, untitled statement (1971), in *Collected Writings*, 376.

10 On Smithson's Bingham Copper Mine proposal, see Ron Graziani, *Robert Smithson and the American Landscape* (New York: Cambridge University Press, 2004), 155–56. For information about the mine, see Leonard J. Arrington and Gary B. Hansen, *The Richest Hole on Earth: A History of the Bingham Copper Mine* (Logan: Utah State University Press, 1963).

11 Smithson, "Letter to John Dixon" (1972) and "Proposal," in *Collected Writings*, 377, 379, 380. William Cronon, "The Trouble with Wilderness; or, Getting Back to the Wrong Nature," in *Uncommon Ground: Rethinking the Human Place in Nature*, ed. William Cronon (New York: W. W. Norton, 1996), 69–90; Timothy Morton, *Ecology without Nature: Rethinking Environmental Aesthetics* (Cambridge, MA: Harvard University Press, 2009); Steven Vogel, *Thinking Like a Mall: Environmental Philosophy after the End of Nature* (Cambridge, MA: MIT Press, 2015). Andrew Menard, "Robert Smithson's Environmental History," *Oxford Art Journal* 37, no. 3 (2014): 304.

12 Alan Gussow, *A Sense of Place: The Artist and the American Land* (San Francisco: Friends of the Earth, 1972), cited in Smithson, "Frederick Law Olmsted," 163. For a discussion of Earthworks and contemporary violence, including the Vietnam War, see Suzaan Boettger, *Earthworks: Art and the Landscape of the Sixties* (Berkeley: University of California Press, 2002), 18–20, 31, 80, 84, 88, 108, 110, 136, 140–41, 146, 181, 187, 221–23. Carolyn Merchant, *The Death of Nature: Women, Ecology, and the Scientific Revolution* (San Francisco: Harper & Row, 1980), 2. On ecofeminist critiques of warfare, see also Jessica M. Frazier, *Women's Antiwar Diplomacy during the Vietnam War Era* (Chapel Hill: University of North Carolina Press, 2017), 48. Rachel Carson, *Silent Spring* (Boston: Houghton Mifflin, 1962), 297; on the title, see Michael B. Smith, "'Silence, Miss Carson!' Science, Gender, and the Reception of *Silent Spring*," *Feminist Studies* 27, no. 3 (Autumn 2001): 733–52.

13 Mendieta quoted in Petra Barreras del Rio and John Perreault, *Ana Mendieta: A Retrospective* (New York: New Museum of Contemporary Art, 1988), 10; see also Anne Raine, "Embodied Geographies: Subjectivity and Materiality in the Work of Ana Mendieta," in *Generations and Geographies in the Visual Arts: Feminist Readings*, ed. Griselda Pollock (New York: Routledge: 1996), 228–47; Jade Wildy, "The Artistic Progressions of Ecofeminism: The Changing Focus of Women in Environmental Art," *International Journal of the Arts in Society* 6, no. 1 (2012): 53–65; and Noël Sturgeon, *Ecofeminist Natures: Race, Gender, Feminist Theory and Political Action* (New York: Routledge, 1997).

14 Patricia C. Phillips, *Mierle Laderman Ukeles: Maintenance Art* (New York: Queens Museum, 2016); Michelle Grabner, "One World," *X-tra: Contemporary Art Quarterly* 20, no. 1 (Fall 2017): 112–29.

15 Morton, *Ecology without Nature*; Walter Mignolo, *The Darker Side of Western Modernity: Global Futures, Decolonial Options* (Durham, NC: Duke University Press, 2011), 11; Vogel, *Thinking Like a Mall*; T. J. Demos, *Decolonizing Nature: Contemporary Art and the Politics of Ecology* (Berlin: Sternberg Press, 2016).

16 Christopher B. Field, Vicente R. Barros et al., *Climate Change 2014: Impacts, Adaptation, and Vulnerability; Summaries, Frequently Asked Questions, and Cross-Chapter Boxes; A Working Group II Contribution to the Fifth*

Assessment Report of the Intergovernmental Panel on Climate Change (Geneva: Intergovernmental Panel on Climate Change, 2014); Michael D. Shear, "Trump Will Withdraw U.S. from Paris Climate Agreement," *New York Times*, June 2, 2017; "NASA, NOAA Data Show 2016 Warmest Year on Record Globally," National Aeronautics and Space Administration (NASA) press release, January 18, 2017, https://www.nasa.gov/press-release/nasa-noaa-data-show-2016-warmest-year-on-record-globally; "2017 Was 3rd Warmest Year on Record for U.S.," National Oceanic and Atmospheric Administration (NOAA) website, January 8, 2018, http://www.noaa.gov/news/2017-was-3rd-warmest-year-on-record-for-us.

17 Elizabeth Ammons and Modhumita Roy, eds., *Sharing the Earth: An International Environmental Justice Reader* (Athens: University of Georgia Press, 2015), 279; Robert D. Bullard, ed., *Unequal Protection: Environmental Justice and Communities of Color* (San Francisco: Sierra Club Books, 1994).

18 Rob Nixon, *Slow Violence and the Environmentalism of the Poor* (Cambridge, MA: Harvard University Press, 2011), 31, 32.

19 Timothy Morton, *The Ecological Thought* (Cambridge, MA: Harvard University Press, 2010), 11.

20 Romare Bearden and Harry Henderson, *A History of African-American Artists: From 1792 to the Present* (New York: Pantheon, 1993), 127–35; Jeffrey Myers, "Pastoral and Anti-Pastoral in Aaron Douglas's *Aspects of Negro Life*," in *A Keener Perception: Ecocritical Studies in American Art History*, ed. Alan C. Braddock and Christoph Irmscher (Tuscaloosa: University of Alabama Press, 2009), 151–67; Isabel Wilkerson, *The Warmth of Other Suns: The Epic Story of America's Great Migration* (New York: Random House, 2010).

21 Bearden and Henderson, *A History of African-American Artists*, 328–36, Lee-Smith quoted 332–33.

22 "Flint Water Crisis Fast Facts," CNN Library, CNN.com, November 28, 2017, http://www.cnn.com/2016/03/04/us/flint-water-crisis-fast-facts/index.html.

23 Betye Saar, artist's statement, in *Betye Saar: Migrations/Transformations* (New York: Michael Rosenfeld Gallery, 2006); Betye Saar, "Influences: Betye Saar" [as told to Jonathan Griffin], Frieze.com, September 27, 2016, https://frieze.com/article/influences-betye-saar. Also see Mario Mainetti, ed., *Betye Saar: Uneasy Dancer* (Milan: Fondazione Prada, 2016).

24 Dunaway, *Seeing Green*, 98–103, quoted 101.

25 *The Land That Time Forgot*, exhibition wall label, *Kerry James Marshall: Mastry*, Metropolitan Museum of Art, New York, October 25, 2016–January 29, 2017.

26 Theaster Gates, conversation with Karl Kusserow, May 11, 2017.

27 Honey Luard, ed., *Theaster Gates: My Labor Is My Protest* (London: White Cube, 2013); Mark Brown, "US Artist Theaster Gates to Help Bristol Hear Itself in First UK Public Project," *Guardian*, July 19, 2015.

28 Géné E. Harris, *N. C. Wyeth's Wild West* (Chadds Ford, PA: Brandywine River Museum, 1990); Adrian Franklin, *Animals and Modern Cultures: A Sociology of Human-Animal Relations in Modernity* (London:

Sage Publications, 1999), 11; Keith Tester, *Animals and Society: The Humanity of Animal Rights* (London: Routledge, 1992), 51; Aristotle, *Politics* (350 BCE), quoted in Sue Donaldson and Will Kymlicka, "Animals in Political Theory," in *The Oxford Handbook of Animal Studies*, ed. Linda Kalof (New York: Oxford University Press, 2017), 44. For the entrenchment over time of Aristotelian approaches to animals, see Margo DeMello, *Animals and Society: An Introduction to Human-Animal Studies* (New York: Columbia University Press, 2012), 36–41. The biblical passage is from Genesis 1:28. John Paul II quoted in DeMello, *Animals and Society*, 38.

29 Stephen F. Eisenman, *The Cry of Nature: Art and the Making of Animal Rights* (London: Reaktion Books, 2013); Keith Thomas, *Man and the Natural World: Changing Attitudes in England, 1500–1800* (London: Allen Lane, 1983); DeMello, *Animals and Society*, 152; Franklin, *Animals and Modern Cultures*, 12–14; William T. Hornaday, *The Minds and Manners of Wild Animals: A Book of Personal Observations* (New York: Charles Scribner's Sons, 1923).

30 Virginia O'Hara, *Andrew Wyeth's "Ides of March": The Making of a Masterpiece* (Chadds Ford, PA: Brandywine River Museum, 2013), 14. Eleanor "Nell" Gwyn (1650–1687), called "the Protestant whore," was a popular figure during her lifetime, known for her colorful behavior. For a discussion of pet portraiture in an earlier American realist context, see Alan C. Braddock, "'Our Yard Looks Something Like a Zoological Garden': Thomas Eakins, Philadelphia, and Domestic Animality," in *A Greene Country Towne: Philadelphia's Ecology in the Cultural Imagination*, ed. Alan C. Braddock and Laura Turner Igoe (University Park: Pennsylvania State University Press, 2016), 118–40.

31 Lincoln Kirstein, "James Wyeth," in *An American Vision: Three Generations of Wyeth Art* (Boston: Little, Brown, 1987), 158.

32 Peter Singer, *Animal Liberation: A New Ethics for Our Treatment of Animals* (New York: New York Review, 1975). On cognitive ethology, see Donald R. Griffin, *Animal Minds: Beyond Cognition to Consciousness* (Chicago: University of Chicago Press, 1992). For an overview of human-animal relations during modernity and the effects of the transition to postmodernity, see Franklin, *Animals and Modern Cultures*, 9–61.

33 Franklin, *Animals and Modern Cultures*, 2.

34 Cary Wolfe, ed., *Zootologies: The Question of the Animal* (Minneapolis: University of Minnesota Press, 2003), xi–xii, book jacket; Charles Darwin, *The Descent of Man, and Selection in Relation to Sex* (1871; New York: Appleton, 1896), 65.

35 Steve Baker, *The Postmodern Animal* (London: Reaktion, 2000), 16; emphasis in original. See also Elizabeth Kolbert, *The Sixth Extinction: An Unnatural History* (New York: Holt, 2014).

36 Mark Rosenthal, *Joseph Beuys: Actions, Vitrines, Environments* (Houston: Menil Collection, 2005), 33; Caroline Tisdall, *Joseph Beuys: Coyote* (Munich: Schirmer-Mosel, 1980), Beuys quoted 28–30.

37 Steve Baker, "Sloughing the Human," in Wolfe, *Zootologies*, 151, 153.

38 Nick Clark, "A Vanishing World, According to Andy Warhol: How the Artist Highlighted the Plight of Endangered Animals," *Independent*,

March 1, 2013; Anthony E. Grudin, "Warhol's Animal Life," *Criticism* 56, no. 3 (Summer 2014): 593–622.

39 Kurt Benirschke and Andy Warhol, *Vanishing Animals* (New York: Springer-Verlag, 1986). In a 2011 phone conversation with Alan C. Braddock, Warhol associate Vincent Fremont testified unequivocally to the artist's love of nonhuman animals. On art and the feather trade, see Carolyn Merchant, *Spare the Birds! George Bird Grinnell and the First Audubon Society* (New Haven: Yale University Press, 2016); Alan C. Braddock, "Home of the Hummingbird: Thaxter, Hassam, and the Aesthetics of Nature Conservation," in *The Artist's Garden: American Impressionism and the Garden Movement*, ed. Anna O. Marley (Philadelphia: Pennsylvania Academy of the Fine Arts in association with University of Pennsylvania Press, 2014), 43–60; and Robin W. Doughty, *Feather Fashions and Bird Preservation: A Study in Nature Protection* (Berkeley: University of California Press, 1974).

40 Patrick Nagatani, *Nuclear Enchantment*, artist's website, https://www.patricknagatani.com/pages/nucenchant/205_NE.html; Valerie L. Kuletz, *The Tainted Desert: Environmental and Social Ruin in the American West* (New York: Routledge, 1998), 19–37; Doug Brugge, Timothy Benally, and Esther Yazzie-Lewis, eds., *The Navajo People and Uranium Mining* (Albuquerque: University of New Mexico Press, 2006); Judy Pasternak, *Yellow Dirt: An American Story of a Poisoned Land and a People Betrayed* (New York: Free Press, 2010); Doug Brugge, Jamie L. deLemos, and Cat Bui, "The Sequoyah Corporation Fuels Release and the Church Rock Spill: Unpublicized Nuclear Releases in American Indian Communities," *American Journal of Public Health* 97, no. 9 (September 2007): 1595–1600.

41 *Nuclear Enchantment: Photographs by Patrick Nagatani*, essay by Eugenia Parry Janis (Albuquerque: University of New Mexico Press, 1991).

42 Joanna Marsh, *Alexis Rockman: A Fable for Tomorrow* (Washington, DC: Smithsonian American Art Museum, 2010), 29.

43 Rockman quoted in Marsh, *Alexis Rockman* (New York: Monacelli Press, 2003), 30, 108, 181.

44 Daniel Imhoff, ed., *The CAFO Reader: The Tragedy of Industrial Animal Factories* (Healdsburg, CA: Watershed Media, 2010); Stephen F. Eisenman, *The Ghosts of Our Meat: Sue Coe* (Carlisle, PA: Trout Gallery, Dickinson College, 2013).

45 *What Is Missing?*, online interactive global memorial, https://whatismissing.net/; Diane Toomey, "Maya Lin's Memorial to Vanishing Nature," Yale Environment 360, June 25, 2012, http://e360.yale.edu/features/maya_lin_a_memorial_to_a_vanishing_natural_world.

46 Timothy Morton, *Hyperobjects: Philosophy and Ecology after the End of the World* (Minneapolis: University of Minnesota Press, 2013), book jacket; Martin Heidegger, *The Fundamental Concepts of Metaphysics: World, Finitude, Solitude*, trans. William McNeill and Nicholas Walker (Bloomington: Indiana University Press, 1995), 193.

47 Xavier Cortada, *Astrid*, artist's website, http://www.cortada.com/2007/ice-paintings/astrid, and *Antarctic Ice Paintings*, http://www.xaviercortada.com/?page=AntIP_index. See also Barbara C. Matilsky,

Vanishing Ice: Alpine and Polar Landscapes in Art, 1775–2012 (Bellingham, WA: Whatcom Museum, 2013), 112–13.

48 Xavier Cortada, "Artist's Statement," artist's website, http://cortada.com/statement, and "Biography," http://cortada.com/about/. Rignot quoted in Justin Gillis and Kenneth Chang, "Scientists Warn of Rising Oceans from Polar Melt," *New York Times*, May 12, 2014.

49 Xavier Cortada, email message to Alan C. Braddock, June 3, 2014. "Antarctic Ice Is Melting Faster. Coastal Cities Need to Prepare—Now," editorial, *Washington Post*, June 22, 2018, referencing a study by an international team of scientists identified by the acronym IMBIE (ice sheet mass balance intercomparison exercise) titled "Mass Balance of the Antarctic Ice Sheet from 1992 to 2017," *Nature*, June 14, 2018, 219–22.

50 "China Overtakes U.S. in Greenhouse Gas Emissions," *New York Times*, June 20, 2007; Will Steffen, Jacques Grinevald, Paul Crutzen, and John McNeill, "The Anthropocene: Conceptual and Historical Perspectives," *Philosophical Transactions of the Royal Society A* 369 (2011): 842–67, esp. 845, 849–55, 862.

51 First commissioned by the Fondation Cartier pour l'art contemporain, Paris, *Exit* was presented there November 21, 2008–March 15, 2009; the revised installation was on view at the Palais de Tokyo, Paris, November 24, 2015–January 10, 2016; Diller Scofidio + Renfro, https://dsrny.com/project/exit?index=false§ion=projects&search=Exit. COP21 is shorthand for the twenty-first Conference of the Parties to the 1992 United Nations Framework Convention on Climate Change.

52 For a critique of environmental data visualization as a spectacular "garden of data delights," see Heather Houser, "The Aesthetics of Environmental Visualizations: More Than Information Ecstasy?," *Public Culture* 26, no. 2 (2014): 319–37.

53 Postcommodity, *The Ears Between Worlds Are Always Speaking*, Postcommodity website, http://postcommodity.com/TheEarsBetweenWorlds.html.

54 Louise Erdrich, "Sonic Spirituality: Louise Erdrich on Postcommodity's Ceremonial Transformation of LRAD," *Sightlines* (Walker Art Center, Minneapolis), April 18, 2017, https://walkerart.org/magazine/lrad-louise-erdrich-postcommodity-at-documenta-14-nodapl.

55 Cannupa Hanska Luger, *Mirror Shield Project*, artist's website, http://www.cannupahanska.com/mniwiconi/. Luger has discussed his project in terms that resonate with Rob Nixon's notion of "slow violence," or environmental injustice that fails to attract mainstream media attention unless it takes spectacular forms; see Carolina A. Miranda, "The Artist Who Made Protesters' Mirrored Shields Says the 'Struggle Porn' Media Miss Point of Standing Rock," *Los Angeles Times*, January 12, 2017; Nixon, *Slow Violence*.

Robin Kelsey

Photography and the Ecological Imagination

Discussions of photography and ecology tend to be one-sided. They tend to focus on the photography of ecology—photographic imagery with an ecological cast, such as the quiet woodland scenes of Eliot Porter (1901–1990) or the disturbing aerial views of Edward Burtynsky (born 1955) (fig. 289). They are likely to neglect the ecology of photography, the material effects that photography has on the biosphere. Photographs, including those representing ecological beauty or degradation, require industrial chemicals and processes to produce. Photography offers such a captivating illusion of transparency and immediacy that these material dimensions can readily fall from view. In our search for the ecological, we habitually look *through* photography rather than *at* it.[1]

The problem is not simply that we may look at one half of the equation (the photograph as representation) and not the other (the photograph as industrial product). The problem is deeper and more intractable. The problem is that photographs, as matters of habit, commerce, and pleasure, are structured by a wish to disregard the material apparatus that produced them.

My aim here is to resist and analyze this wish, which requires dragging photography through the mud of its material basis. The intent is not to denigrate the technology but to develop a more honest relationship with its marvelous way of depicting the world. If we are ever going to have a truly ecological photography—that is, a photography that contributes in the fullness of its circulations and effects to planetary health—we will need such a reckoning.

Prior to the digital era, most photographs began in the labor of silver miners. Film photography relied principally on silver halides and their propensity to darken in proportion to light exposure. Although photography has entailed the use of other metals, such as copper for daguerreotype plates, copper and zinc for the brass fittings of cameras, and gold for toning, silver has always been at the heart of the business. The making of images through a combination of silver and light gave early photography an alchemical cast. Although silver had long been a material source for decorative objects (see pages 146–53), photography made it an agent of pictorial art.

The emergence of silvery images in the darkrooms of photography has therefore always had a grim counterpart in the extraction of silver underground. This haunting double has made photographs of mines particularly interesting. Although most photographs keep the material history of photography away from the camera, photographs of mines direct the medium toward its metallurgical origins.[2] Some early photographers, including Carleton E. Watkins (1829–1916), finessed the problem by staying above ground and representing mines as if they were harmonious additions to the landscape (see fig. 171). Others, such as Watkins's contemporary Timothy H. O'Sullivan (1840–1882), more explicitly acknowledged the ties of photography to subterranean sweat. In a photograph that O'Sullivan made in the Comstock Lode, a miner works the surface of a silver mine, while behind him the photographer works the surface of his silvered photographic plate (fig. 290). To illuminate the rocky surface, the miner uses a candle; to illuminate the scene, the photographer uses a magnesium flash, two sparks of which have left trails on the left side of the image. As a photographer with an Irish-American status akin to that of many miners of his day, O'Sullivan produced a picture underscoring the affinity between his work and theirs.[3] The reflexive structure of his photograph acknowledges both the social and the metallic materiality of his craft.

The ecological effects of photography have extended far beyond the extraction of metals. As photography grew into an industry, the chemical by-products of large photographic supply and processing companies polluted waterways, the atmosphere, and surrounding communities. Kodak, for example, over its long history has used massive quantities of toxic chemicals, from formaldehyde to the carcinogen dichloromethane, to manufacture and process photographic film. For many years Kodak appeared regularly on lists of the top corporate polluters in the United States. According to one study, zip code 14652 in Rochester, New York, due almost wholly to the presence of Kodak, led all US zip codes for emissions of cancer-causing chemicals between 1987 and 2000.[4] Even at very low concentrations, the silver thiosulfate of photo-processing solutions is highly toxic to aquatic organisms, and elevated pancreatic cancer rates have been reported in areas abutting Kodak Park.[5]

Large photographic supply and processing companies have tended to extol photography as a chemical marvel while suppressing its role as a toxic industry. Polaroid, which grew into one of Kodak's great competitors in the decades following World War II, was ingenious in this respect. With the introduction of its SX-70 camera in 1972, Polaroid enabled amateur photographers to watch their color pictures emerge on film in minutes, turning the chemistry of development into a private spectacle. SX-70 film contained the negative, positive, and developers in a single seventeen-layer unit, which reacted in stages after the shutter was clicked and the film ejected. Watching the picture develop was a wondrous experience of chemistry, but also a fantasy of containment. Even as the thin chemical packets at the base of each SX-70 film unit ensured hermetic neatness for the consumer, chemicals were leaking from Polaroid plants.[6]

FIGURE 289: Edward Burtynsky (Canadian, born 1955), *Oil Spill #10, Oil Slick, Gulf of Mexico, June 24, 2010*, 2010. Chromogenic print, 99.1 × 132.1 cm. Courtesy Howard Greenberg Gallery, New York

The arrival of digital processes changed the economy of photographic images, and writers have hailed the shift as a greening of photography. But such claims are more complicated than enthusiasts often acknowledge. Digital cameras, smartphones, and tablets, as well as laptop and desktop computers, contain rare-earth metals and many other products of mining, from aluminum to zinc. In 2016 global e-waste generation was around 44.7 million metric tons, or the equivalent of 4,500 Eiffel Towers, only 20 percent of which is documented to have been collected and properly recycled.[7] By one estimate, the 500 million personal computers discarded in the United States between 1997 and 2007 contained 6.32 billion pounds of plastics, 1.58 billion pounds of lead, 3 million pounds of cadmium, 1.9 million pounds of chromium, and 632,000 pounds of mercury.[8] There is no statistical way to isolate the amount of e-waste attributable to our desire for photography, but the proportion is substantial. In addition to the waste, there is the energy that our photographic desires consume. The massive servers that handle our image-dense internet usage run on electricity, the leading global source of which is coal. Even in the age of screen and "cloud," mining and discharge continue to stand behind the fairy wonders of photography.

FIGURE 290: Timothy H. O'Sullivan (American, 1840–1882), *Gould Curry Mine. Comstock Lode Mine Works, Virginia City, Nevada*, 1868. Albumen silver print, 17.7 × 21.9 cm. George Eastman Museum, Rochester, New York. Gift of Harvard University (1981.1887.0017)

All this takes on special significance in a moment of growing concern about climate change. Painful though the fact may be, photography has historically been part and parcel of the economic regimes and habits driving climate change and not simply a means of commentary upon them.

To be sure, such a charge of complicity can be leveled at almost everything we use or consume, and no modern means of communication (including those standing behind this essay) is free from ecological fault. But the environmental effects of photographic production and circulation deserve special scrutiny, because photography has systematically suppressed its industrial entanglements while playing a celebrated role in communicating ecological concerns. As Richard Maxwell and Toby Miller have observed about our media technologies, "It is difficult to comprehend the scale of environmental destruction when technology is depicted in popular and professional quarters as a vital source of plenitude and pleasure, the very negation of scarcity and dross."[9] What is true of media technology generally is especially true of photography. Photography delivers plenitude and pleasure, including the congenial formal properties of landscapes and other environmental subjects, via images that seem to float free from material constraint or consequence.

Much of the ecological conundrum of photography has arisen through framing. By that I mean the channeling of our attention to the subject of the photograph and away from the material circumstances of both subject and image. Framing can be a relatively simple act of pointing a camera in one direction and not another, toward the mountains, say, and away from the paved lot where the photographer has parked. But it can also be a subtler habit of upholding the apparent transparency or immediacy of photography and thus tamping down awareness of its material substrates. One of the great pleasures of photography is the fantasy of having access to the world proffered by the image. Whereas the surface of a painting is *worked*, even if for some painters the aim of that work is the erasure of brush marks, the surface of a typical photograph seems simply *given*. The metals and chemicals of most photographs do not look like metals and chemicals; they look like a moment revealed as if through a window or telescope. They efface themselves to make a hole in the here and now, showing us a world apart.

The role of framing in representing the environment is not limited to photography. Certain nineteenth-century painters found ingenious ways to use framing to comment

FIGURE 291: Lee Friedlander (American, born 1934), *Mount Rushmore, South Dakota*, 1969, printed 1980s. Gelatin silver print, 20.3 × 30.5 cm. Courtesy Fraenkel Gallery, San Francisco

on the relationship between human economy and natural surroundings. For example, as Alan Wallach has noted, Thomas Cole (1801–1848) used expectations for framing to introduce moral ambiguity into his 1843 picture *River in the Catskills* (see fig. 83). Although the view of the river and the distant train abides by a classical taste for serenity and loveliness, the conventions of landscape would require a tree at one edge of the picture to serve as a repoussoir, an internal framing device accentuating the illusion of spatial progression into the distance. Cole undercut this convention by representing instead a figure with an axe next to a stump and pieces of the felled tree. A traditional contrivance for framing the scene has fallen victim to economic desire. With this tweaking of the classical formula, Cole questioned whether modernization is compatible with the values of landscape.[10]

Photography has historically isolated and emphasized the act of framing in distinctive ways. The camera cuts out a piece of the visual field, taking the contents of its rectangular selection wholesale.[11] To be sure, practitioners can work around this tendency. They can pursue a directorial mode, assembling and composing things to be photographed.[12] And there are techniques, from photomontage to Photoshop, that enable a photographer to add or withdraw elements of a picture after it has been taken. In a 1990 work from his series *Nuclear Enchantment*,

Patrick Nagatani (1945–2017) used montage to put a graphic eagle above a uranium mill and tailing site (see fig. 280). But our recent fascination with these exceptions should not lead us to neglect the historical rule. Framing is arguably *the* elemental photographic act. In much photography, framing is not, as it is in most drawing, a way of giving bounds to a composition, but rather the means of composing itself.

A push and pull on framing has done much to define the history of landscape photography in the twentieth century. The paradigmatic landscape photographer Ansel Adams (1902–1984) worked assiduously to frame views that conveyed an ideal of wilderness, leaving any trash bins and restrooms in the national parks out of the picture. In the 1960s and 1970s, practitioners of a subsequent generation, such as Robert Adams (born 1937), Lee Friedlander (born 1934), and Joel Sternfeld (born 1944), responded by puckishly including such tasteless banalities in their exquisite prints. Friedlander was particularly thoughtful in his acknowledgment of the complicity of photography in the spectacular commercialization of nature. In his famous photograph at Mount Rushmore, the reflection of the photographer in the plate glass of the visitor center pictorially mingles his scopophilic practice with that of the tourists who face him (fig. 291). His photograph reminds us that the cultural habit of making nature over into an image

FIGURE 292: Kenneth Josephson (American, born 1932), *Wyoming*, 1971. Gelatin silver print, 22.9 × 20.2 cm. Cleveland Museum of Art. Severence and Greta Millikin Purchase Fund (2010.269)

experience to the framing of a picture.[13] Friedlander and other artists had already taken this inquiry into photography, questioning conventional perspectives by framing things differently. Kenneth Josephson (born 1932), for example, included postcards and rulers in photographs to put the very act and habit of framing, and its determination of scale and representation, into view (fig. 292).

When modernist photographers of landscape in the 1960s and 1970s began leaving traces of production within the frame, they renewed a practice dating back to the nineteenth-century work of O'Sullivan. In his photography of the American West, O'Sullivan not only abided traces of his magnesium flashes but also selected views that included his footprints, equipment, and wagon-cum-darkroom (fig. 293). By leaving signs of his work in his photographs, O'Sullivan called attention to his exploits in the field and to the government survey operation of which he was a part. He made it clear that the landscape was a social project and site of labor.[14] A century later, leading artists, photographers, and critics lauded O'Sullivan's work for its structural reflexivity. In 1982 Robert Adams called O'Sullivan "our Cézanne."[15]

A more radical alternative to keeping signs of production within the frame is to flout the frame and cut and combine photographs into a montage of images. Artists associated with the Russian Revolution pursued photomontage to subject photography to a kind of radical labor, to empower both the maker and the receiver of the montage to escape the passivity of ordinary photography and construct meaning anew. Photomontage enabled the complex fragmentation and material relations of modern life to emerge into a dynamic visual field. In recent decades, many artists have taken up montage to grapple with social ills. Although Nagatani hewed to the rectangular frame in his *Nuclear Enchantment* series, his use of montage marked both the land and his art with signs of politics and displacement. His cutout images remind us of what a material process both selects and leaves behind.

Despite the determination of certain postwar practitioners to make photographic production visible, the convention of keeping it out of the frame has largely prevailed. Even today O'Sullivan, Josephson, Friedlander, and Nagatani remain outliers in the history of landscape or topographic photography. The choice to avoid telltale signs of production is understandable. Subhankar Banerjee (born 1967) presumably wants to keep viewers focused on the majestic movement of

of our desires has shaped not only the Black Hills and the conventions of tourism but also Friedlander's art.

In the 1960s and 1970s, Friedlander and his photographer peers were not alone in their concern for framing. Many thinkers of the day employed the concept to grapple with the constricted imagination and ideological blinders of a Cold War culture. Erving Goffman, in his influential 1974 book *Frame Analysis: An Essay on the Organization of Experience*, argued that framing should be a fundamental concept of sociology. According to Goffman, insights into society can be gleaned by comparing the framing of social

caribou herds across the threatened Arctic National Wildlife Refuge rather than distracting them with the shadow of the aircraft that bore him aloft (see fig. 13). Chris Jordan (born 1963) presumably wants viewers to feast their eyes on the plastic flotsam swallowed by a baby albatross without the feet of his tripod drawing their attention away (see fig. 300). But such decisions exact a cumulative cost. They suppress awareness of photography's participation in our profligate economy and enable the myth of the camera as a mere witness to persist.

Distracting us from the reality of production is, of course, what capitalism does. The market sorts goods in a manner that allows us to enjoy our commodities without experiencing the uncomfortable facts of their material history. The suppressive framing that conventional photography entails likewise separates pleasurable consumption from the unpleasantness of its material basis. The invisible hand of the market, one might say, has an accomplice in the invisible hand of photography.[16]

Recognition of the ecology of photography can enrich and complicate our understanding of the photography of ecological subjects. It can remind us that the pursuit of a more ecological society entails tradeoffs between the material effects of photographic production on the environment and the salutary provocations of trenchant pictures. The aim of this essay is not to undercut particular photographic practices. We can recognize the carbon cost of the

FIGURE 293: Timothy H. O'Sullivan, *Steamboat Springs, Washoe, Nevada*, 1867. Albumen silver print, 19.7 × 26.8 cm. George Eastman Museum, Rochester, New York. Gift of Harvard University (1981.1886.0030)

FIGURE 294: Eliot Furness Porter (American, 1901–1990), *Maple and Birch Trunks and Oak Leaves, Passaconaway Road, New Hampshire, October 7, 1956*, 1956. Dye transfer print, 27.4 × 21.1 cm. Princeton University Art Museum. Gift of the artist (x1984-239)

airplane flights that photographers take to produce aerial views of migrations or mines without dismissing the production of those views as sheer hypocrisy. But the very recognition of these external costs moves us beyond the troublesome habit of taking photographs as pure images rather than as industrial products. It shakes us out of our habitual emphasis on the intentions and agenda of the photographer to consider the material systems that photography willy-nilly perpetuates.[17]

The implications of this recognition are significant. To tease them out, we might revisit the role of photography in American environmentalism. In the late 1950s and early 1960s, David Brower, then executive director of the Sierra

Club, recognized that photographs could sell the cause of environmental conservation. He looked to Ansel Adams and other photographers to help give the mission of the Club a national scope. Brower put particular stock in his Exhibit Format series of books, which promoted the poetic and spiritual value of natural scenery via finely reproduced photographs. The first book in the series, the 1960 volume *This Is the American Earth*, featured photographs by Adams and a portentous accompanying text by curator Nancy Newhall. Both title and text made the cause of conservation patriotic, as though natural splendors defined American identity and its global significance.[18]

The Exhibit Format books were highly popular and became an engine for Club membership. According to Edgar Wayburn, a five-term president of the Club, the enthusiastic reception of *This Is the American Earth* changed Brower's "whole way of looking at the conservation movement."[19] The fourth book in the series, *"In Wildness Is the Preservation of the World,"* which dovetailed color photographs by Eliot Porter (fig. 294) with selected passages by Henry David Thoreau, was also a huge success.[20] Whereas Adams preferred the stark morphology and magnificent expanses of Yosemite (fig. 295), Porter was inclined to the seasonal rhythms of the eastern forest, rendered in quiet details and exquisitely harmonized colors. Although *This Is the American Earth* contained moralizing photographs of insensitive land use as well as beautiful landscapes, the bread and butter of the Sierra Club became idealized scenes of natural harmony.[21] The aesthetic paradigms that Adams and Porter developed for such scenes together underwrote a stream of imagery that filled books and calendars and still abounds in stores and on the internet today.

The brilliance of the Club's pictorial campaign was widely noted and admired. One commentator wrote in 1963: "The Sierra Club's peculiar effectiveness in this new climate is largely traceable to a series of publications through which it has successively celebrated America's natural and scenic resources with unparalleled beauty. Fresh from the perusal of Club books like Ansel Adams' photographs of American parklands or Eliot Porter's record of the changing seasons, almost any responsible citizen can be looked upon as a potential vigilante in the protection of the American wilderness."[22] This effect is precisely what Brower had in mind.

Means, however, have a way of shaping ends. Over time, photography became for the Sierra Club not only a way to

FIGURE 295: Ansel Adams (American, 1902–1984), *Monolith, the Face of Half Dome*, 1927, printed 1960. Published by the Sierra Club, San Francisco. Gelatin silver print, 27.9 × 20.8 cm. Princeton University Art Museum. Gift of David H. McAlpin, Class of 1920 (x1971-564.1)

FIGURE 296: *Earthrise*, 1968. Courtesy of NASA

FIGURE 297: *Blue Marble—Image of the Earth from Apollo 17, 1972.* Courtesy of NASA

drum up support for conservation but also a measure of natural value. The basic formula was simple: the better a landscape looked in a photograph, the worthier of preservation it was likely to be deemed. The Club essentially acknowledged this precept in its 1951 statement of purpose: "to explore, enjoy, and preserve the Sierra Nevada and other scenic resources of the United States." The phrase "scenic resources" clarified that land was to be conserved primarily on the basis of its visual appeal. Photographs served exceedingly well as tokens for the land, because the land was often being valued as a photograph. The most important thing to conserve was the pleasurable view.

The norms of Sierra Club photography have become so familiar that their peculiarity is easy to overlook. The photographs that Brower and his staff chose for posters and calendars regularly framed the landscape to exclude signs of people or history. Not only are there no malls or gas stations in these pictures, there are no ancient burial mounds or mining settlements, no parking lots or roads. One would look in vain through most Sierra Club calendars to find even a trace of a trail. Fantasies of a welcoming Eden systematically elide the role in America of environmental history, from the genocidal displacement of Indigenous peoples to the frontier ideology of outdoor recreation. The iconic Sierra Club photograph proffers a pristine, ready-to-occupy world, outfitted with trees and plants, rocks and earth, water and sky. It is this *here for you alone* quality that has made such beckoning landscapes so susceptible to hijacking by commercial enterprises. Car companies, for example, essentially reproduce the Club aesthetic in many advertisements, with the promoted vehicle featured in an otherwise untouched landscape.

In the Sierra Club calendar photographs, nature seems eager to expose its timeless delights to our gaze. Distant mountains and nearby branches arrange themselves to provide an ideal prospect. Stillness prevails: although a soft blurring of waterfalls is permitted, wind-blurred branches are not, and pouring rain or turbulent skies are rare. However transient the effects of light, and however perfectly yellowed the leaves, the moment seems eternal. In these several ways, the typical photograph of the Sierra Club calendar opposes the calendar itself. It surmounts the linear, irreversible passage from day to day, with its temporal demands and material limitations. It establishes scenic beauty as an antidote to ordinary life.

The success of the Sierra Club in establishing an environmental aesthetic of beguiling purity doubtless informed the swooning reception of the "whole earth" images produced by the National Aeronautics and Space Administration (NASA). The two most famous of these, *Earthrise* and *Blue Marble*, were taken as part of the Apollo space program in 1968 and 1972 respectively (figs. 296, 297). Environmentalists seized upon them as revelatory of a precious and fragile earth, a small fertile orb in the cold darkness of space. Peaceniks heralded them as reminders of human commonality and of the artificiality of territorial boundaries and strife. Ever since, various organizations have used these images to deliver sentimental messages along one or more of these lines.

Distance was crucial to the symbolic charge of these photographs. Securing the look of Eden in the production of calendar landscapes had required careful framing to keep roads and buildings out of view, but distance did the trick for NASA. The vast expanse between the Apollo spacecraft and the earth rendered humanity invisible. The cities, roads, and factories of the world remained hidden. Paradoxically, these photographs represented our common home in the darkness of space by erasing all signs of human existence. From this great distance, the unpopulated Eden promised by every calendar landscape encompassed the entire planet. These views from space abided by an aesthetic principle of much twentieth-century landscape, namely that nature's beauty and wholeness required the negation of human presence.[23] The whole earth lies before our gaze, untouched and unclaimed. In this photographic moment, the fantasy of environmental conservation fell into a telling coincidence with the fantasy of imperial exploration. Bent on planting an American flag on the moon to claim the farthest reach of national empire, NASA looked back on the earth as though it, too, were uninhabited and wholly available.[24]

Suppressing the circumstances of production was essential to the symbolism of the whole earth photographs. Although celebrated as signs of universal humanity and ecological fragility, they emerged from a Cold War rivalry between military powers and an environmentally profligate space program. The Apollo missions' Saturn V rockets burned fifteen tons of kerosene per second in their initial stage of ascent, and afterward they shed orbiting junk.[25] To the extent that writers implicitly acknowledged this irony, they glossed it with a note of redemption. At the apex of technological ambition and imperial rivalry, the human

race had encountered a humbling reminder of the shared miracle of its natural habitat. Or so the story was spun.

The power of picturing the earth as Eden has been undeniable. From the photographs NASA took from space to the Sierra Club publication machine, American environmentalism in the middle decades of the twentieth century ran on the appeal of untainted nature. As the Sierra Club churned out photographs by Adams and Porter and their followers, it saw its membership swell from seven thousand in the early 1950s to fifty-five thousand in 1967.[26] These photographs established celebrated styles of landscape that inspire nature lovers and fuel environmental campaigns even today.

Some critics, however, have questioned the reliance of conservation on photographic allure.[27] New scientific understandings of ecology have made the emphasis on "scenic resources" seem outdated. Growing threats to biodiversity or the alarming accumulation of carbon in the atmosphere are not, first and foremost, matters of scenic impairment. This tension has come to a head when ways to improve ecological health have come under attack for their visual effects. When a plan emerged to install 130 wind turbines in ocean waters between Cape Cod and Nantucket, opposition quickly mounted, and the organization spearheading the resistance stated its case in scenic terms: "the Cape Wind project would be highly visible both day and night from Cape Cod and from the islands of Nantucket and Martha's Vineyard. The plant would dramatically alter the natural landscape."[28] According to the logic of this lament, our responsibility as Americans is less to reduce our dependence on fossil fuels and more to look after our views. This logic bears the imprint of the Sierra Club and its photographic aesthetic.

One possible antidote to the pristine "here for you" representation of nature celebrated by the Sierra Club is a photography that exposes us to the politics of landscape or the environmental degradations of industry, a photography of tailing ponds and cooling towers, of border agents and poisoned animals. Such a photography promises to undo parts of the calendar landscape formula. A photograph of a housing development can remind us of the violent territoriality and dehumanizing commerce that have authorized the parceling out of the country into lots and parks. A photograph of a rusty pipeline harmoniously articulating the seam between pea-green water and scraggly swampland can pry apart the equation of ecological health and visual pleasure (see fig. 216).

But turning attention to the ecology of photography reframes the problem of the Sierra Club aesthetic in an interesting way. From a materialist perspective, the principal problem with that aesthetic is less the innocence it imputes to the landscape than the innocence it imputes to photography. And this latter innocence is one that much photography invoking geopolitics and ecological degradation shares.

In other words, Friedlander's photograph at Mount Rushmore may be a more potent antidote to the Eden-like calendar scene than an aerial shot of a housing development. The Friedlander photograph brings traces of the material basis of photography into the image. In its very structure, the photograph acknowledges the long history of obscuring the processes by which land becomes landscape. It calls on us to recognize the conscription of our desires in indifferent systems of expenditure and exchange whenever we pick up a camera. If we are to write a history of some future ecological photography, we might do well to begin with efforts, stretching back to O'Sullivan, to bring notice of this conscription within the frame.

Turning photography toward its social and material basis has an ecological value. As long as photography systematically suppresses that basis, it will sacrifice the world in favor of the image. The use of photographic tokens to signify the value of nature inevitably shifts that value toward photography itself. This in turn leaves nature prone to substitution by other sources of visual delight and spectacular fascination. The image world becomes the only world we know. Photography that offers fantasies of mere witnessing may have done valuable work in the twentieth century, but it seems structurally unprepared to meet the ecological needs of the twenty-first. Photography cannot reckon with the world's ecology honestly until it acknowledges its own.

Notes

1 My notion of an ecology of photography bears kinship to the "ecology of images" for which Andrew Ross has called; see Andrew Ross, "The Ecology of Images," in *The Chicago Gangster Theory of Life: Nature's Debt to Society* (New York: Verso, 1994).

2 It is interesting that Allan Sekula honed his extraordinary critique of writing on photography while attending to photographs of mines and mining; see Allan Sekula, "Reading an Archive: Photography between Labor and Capital," in *Mining Photographs and Other Pictures, 1948–1968: A Selection from the Negative Archives of Sheddon Studio, Glace Bay, Cape Breton*, ed. Benjamin H. D. Buchloh and Robert Wilkie (Halifax: Press of the Nova Scotia College of Art and Design, 1983), 193–271.

3 For more on O'Sullivan's photography of mines, see Robin Kelsey, "Materiality," *Art Bulletin* 95 (March 2013): 21–23; and Kelsey, *Archive Style: Photographs and Illustrations for U.S. Surveys, 1850–1890* (Berkeley: University of California Press, 2007), 117–31.

4 Tony Dutzik, Jeremiah Baumann, and Meghan Purvis, *Toxic Releases and Health: A Review of Pollution Data and Current Knowledge on the Health Effects of Toxic Chemicals* (Washington, DC: US Public Interest Research Group Education Fund, 2003), 12.

5 Benoit Delaveau, "The Environmental Impact of the Retail Photoprocessing Industry in Santa Clara County: 1996 vs. 2006" (M.A. thesis, San Jose State University, 2011).

6 The United States Environmental Protection Agency has linked Polaroid to Superfund sites. See, for example, *Schnapf Environmental Journal*, March/April/May 2005, 17: "EPA entered into a settlement agreement with Reorganized Polaroid Corp. where the agency received an allowed general unsecured claim in the amount of $11 million for the Peterson/Puritan, Inc. Superfund Site, located in the towns of Cumberland and Lincoln, Rhode Island."

7 C. P. Baldé, V. Forti, V. Gray, R. Kuehr, and P. Stegmann, *The Global E-waste Monitor 2017* (Bonn, Geneva, Vienna: United Nations University, International Telecommunication Union, and International Solid Waste Association, 2017), 38–39.

8 Richard Maxwell and Toby Miller, *Greening the Media* (New York: Oxford University Press, 2012), 3.

9 Maxwell and Miller, 4.

10 See Alan Wallach, "Thomas Cole's *River in the Catskills* as Antipastoral," *Art Bulletin* 84, no. 2 (June 2002): 334–50.

11 See Rosalind Krauss, "Stieglitz/Equivalents," *October* 11 (Winter 1979): 129–40.

12 On the directorial mode, see A. D. Coleman, "The Directorial Mode: Notes Toward a Definition," *Artforum* 15, no. 1 (September 1976): 55–61.

13 Erving Goffman, *Frame Analysis: An Essay on the Organization of Experience* (Cambridge, MA: Harvard University Press, 1974).

14 In the history of landscape photography, O'Sullivan is a curious case. Ansel Adams brought him to the attention of the museum world in the late 1930s and early 1940s as a precursor to his own grand landscapes, but

because O'Sullivan left traces in his pictures that betrayed the constructedness of his views, he was an equally compelling antecedent for a subsequent generation of photographers, including Friedlander and Josephson.

15 Robert Adams, "Introduction," in *The American Space: Meaning in Nineteenth-Century Landscape Photography*, ed. Daniel Wolf (Middletown, CT: Wesleyan University Press, 1983), 8. The critic Ann-Sargent Wooster has similarly compared "O'Sullivan's mountains" to Cézanne's paintings of Mont Sainte-Victoire; Wooster, review of *American Frontiers: The Photographs of Timothy H. O'Sullivan, 1867–1874*, by Joel Snyder, *Afterimage* 9, no. 8 (1982): 8.

16 It may be unfair to lay this formula entirely at the feet of capitalism. The desire to detach objects from the material circumstances of their making, to give them their own life, to make them seem spontaneously given or fashioned by powers greater than human agency, seems to have run strong in some economies predating or outside the ambit of capitalism. Much of the magic or transcendental power of art stems from a social practice of obscuring or transmuting material origins. But capitalism distinctively pursues a destabilizing double interest, suppressing any signs of industry while aggressively amplifying its power.

17 As Peter Haff has argued, a key to understanding the Anthropocene is to recognize those "aspects of system behavior that are independent of human intentionality, and thus, when applied to individuals, suggest the extent to which human actions are influenced by purposes that lie beyond their own intentions." P. K. Haff, "Purpose in the Anthropocene: Dynamical Role and Physical Basis, *Anthropocene* 16 (2016): 54.

18 Ansel Adams and Nancy Newhall, *This Is the American Earth* (San Francisco: Sierra Club, 1960).

19 Edgar Wayburn, "Sierra Club Statesman, Leader of the Parks and Wilderness Movement: Gaining Protection for Alaska, the Redwoods, and Golden Gate Parklands," an oral history conducted 1976–81 by Ann Lage and Susan Schrepfer, Regional Oral History Office, Bancroft Library, University of California at Berkeley, 1985, 192.

20 Eliot Porter, *"In Wildness Is the Preservation of the World," from Henry David Thoreau: Selections & Photographs by Eliot Porter* (San Francisco: Sierra Club, 1962).

21 For more on *This Is the American Earth*, see Cécile Whiting, "The Sublime and the Banal in Postwar Photography of the American West," *American Art* 27, no. 2 (Summer 2013): 44–67.

22 Preprint from *Collector's Quarterly Report*, 1963, Sierra Club records, carton 304, Bancroft Library, University of California, Berkeley.

23 For more on this contradiction within the environmentalist imagination, see Robin Kelsey, "Landscape as Not Belonging," in *Landscape Theory*, ed. James Elkins and Rachael Ziady DeLue (New York: Routledge, 2008), 203–13. On the whole earth photographs and Sierra Club–style landscapes, see James Nesbit, *Ecologies, Environments, and Energy Systems in Art of the 1960s and 1970s* (Cambridge, MA: MIT Press, 2014), 80.

24 See Denis Cosgrove, "Contested Global Visions: One-World, Whole-Earth, and the Apollo Space Photographs," *Annals of the Association of American Geographers* 84 (1994): 270–94; Robin Kelsey, "Reverse Shot: *Earthrise* and *Blue Marble*," *New Geographies* 4 (2011): 10–16.

25 On the fuel burning rate, see Paul Eisenstein, "Saturn V Is the Biggest Engine Ever Built," *Popular Mechanics* 180, no. 3 (April 2003): 84–85.

26 Wayburn, "Sierra Club Statesman," 194–95.

27 See, for example, Rebecca Solnit, "The Nature of Gender: Uplift and Separate; The Aesthetics of Nature Calendars" in *As Eve Said to the Serpent: On Landscape, Gender, and Art* (Athens: University of Georgia Press, 2001); and Finis Dunaway, *Natural Visions: The Power of Images in American Environmental Reform* (Chicago: University of Chicago Press, 2005). See also William Cronon, "The Trouble with Wilderness; or, Getting Back to the Wrong Nature," in *Uncommon Ground: Rethinking the Human Place in Nature*, ed. William Cronon (New York: W. W. Norton, 1995), 69–90.

28 Martin J. Pasqualetti, "Opposing Wind Energy Landscapes: A Search for Common Cause," *Annals of the Association of American Geographers* 101, no. 4 (July 2011): 909. The objections to Cape Wind went beyond its visual effects, but there is little question that the impairment of the landscape view was the primary driver of resistance. On wind farms and resistance based on visual effects, see Timothy Morton, *The Ecological Thought* (Cambridge, MA: Harvard University Press, 2010), 9.

Rob Nixon

Three Islands:
An Environmental Justice Archipelago

Environmental injustice thrives on distance and the dissociations that distance enables. Life-threatening or life-shortening environmental harms fall disproportionately on communities remote from centers of power. Island communities are particularly vulnerable for this reason: they can be dismissed as offshore, as politically and imaginatively discontinuous with mainland society. Often islands get bracketed as outside modernity itself, as backward, disposable places, whose inhabitants can be casually dispossessed, their lifeways and landscapes reduced to sacrifice zones.

Islands furthermore have long served as repositories for fantasies of some absolute elsewhere, hovering above and apart from reality, across the entire dystopian-utopian spectrum.[1] Actual islanders have often struggled to exhume themselves from beneath the symbolic freight of an otherworldliness imposed from afar by forces for whom such inhabitants lack the full dignity of being.

Vulnerable islands have assumed an outsize role during the Great Acceleration, the post–World War II era that has seen an upsurge in humanity's enduring transformations of Earth's biology, chemistry, and geology. A signal feature of the Great Acceleration is our deepening awareness of the global interconnectedness of everything from microbial life to geopolitical power. Oceanic circuits of trash and toxins, intercontinental military sprawl, and the ripple effects of climate change all attest to the fact that, whatever else they are, islands are not insular.

Ralston Crawford's *Bikini, Tour of Inspection* (1946), Jennifer Allora and Guillermo Calzadilla's *Land Mark (Foot Prints)* (2001–2), and Chris Jordan's *Midway: Message from the Gyre* (2009–present) all unsettle assumptions about island insularity. These works grapple with the unequal fallout of

a globalized violence in an age of ever-widening human impacts. If islands often serve as places of heightened risk and diminished responsibility, in what ways are island communities disproportionately burdened with exposure to environmental hazards? Although working in very different mediums, Crawford, Allora and Calzadilla, and Jordan have all created art that illuminates the illusions—and attendant injustices—that can stem from the island effect. Collectively, their work throws into relief questions of island ecology and equity in places of apparently remote concern.

The Detonation of Representation

1946. The date of Crawford's painting comes layered with significance. Conventionally, that year signals the beginning of the postwar era, a new world order that ushered in peace and democracy, clearing a path for decolonization. But 1946 also represents this: the onset of oceanic nuclear colonialism, inaugurated by the Americans, with the French to follow. In retrospect, 1946 acquires a third global significance: it marks, for many, the tipping point where the Anthropocene becomes the Great Acceleration, as humanity's enduring transformations of Earth's geochemical and biological character gather speed. As evidence of the Great Acceleration's beginning, scholars routinely cite the advent of unprecedented isotopes that will remain legible in the planet's fossil record for hundreds of millions of years. These novel isotopes entered planetary history in 1945 with the Trinity test in the New Mexico desert, the bombing of Hiroshima and Nagasaki, and shortly thereafter the nuclear assault on Bikini Atoll that occasioned Crawford's painting.

Marshall Islanders—who include Bikini's erstwhile inhabitants—stand alone among the world's nations in having been

FIGURE 298: Ralston Crawford (American, 1906–1978), *Bikini, Tour of Inspection*, 1946. Oil on canvas, 61 × 86.4 cm. The Vilcek Foundation, New York (VF2015.01.01)

thrust into exile as a result first of the nuclear bomb, then of the climate bomb, the greatest planetary threats of the twentieth and twenty-first centuries, respectively. These two global threats pose very different challenges, aesthetically and politically. The nuclear bombs that targeted Bikini were spectacular in their devastation, while the climate bomb is slow ticking and attritional, rendering, inch by rising inch, the low-lying archipelago uninhabitable and futureless. Yet together, the nuclear and climatic devastation of the islands underscores the injustice of talking about the Great Acceleration as a set of big-*H* Human impacts without adequately acknowledging the vast disparities between modernity's beneficiaries and casualties. For ultimately, the Great Acceleration is inseparable from the Great Divide between the cushioned rich and the discarded communities that include atomic refugees and climate refugees among their number.

A crucial principle driving environmental justice thought and activism is the need to recognize—and redress—the highly concentrated suffering that pervades environmental sacrifice zones. In a plutocratic age, islands of outrageous wealth depend on such sacrifice zones, which include many actual islands. The nuclear history of Bikini Atoll demonstrates this point dramatically.

In February 1946, Commodore Ben H. Wyatt led an American delegation to Bikini and asked the residents whether they would leave their atoll—for a short time only—so that America could test atomic bombs "for the good of mankind and to end all world wars."[2] Thus were the Bikinians dispatched on the first forced removal among the many they would endure. And thus "for the good of mankind" (selectively defined) the human and ecological communities of those islands suffered traumatic displacement and toxic devastation.

Later that year, a second, far larger delegation arrived at Bikini: 242 US Navy ships; 156 aircraft; thousands of military and civilian personnel bearing 25,000 radiation detection devices; 5,400 Navy-supplied rats, goats, and pigs for experimenting on; and 124 journalists. This eclectic gathering was brought together by Operation Crossroads, the first of the 67 atomic and thermonuclear bomb tests that would rock the Marshall Islands between 1946 and 1958.

Included in this delegation was a solitary artist named Ralston Crawford (1906–1978). Crawford had built a reputation not just as a wartime painter, but as a painter of war. In 1942, aged thirty-six, he had accepted a position with the august title of Chief of the Visual Presentation Unit of the Weather Division at the Army Air Force Headquarters in Washington, DC.[3] Crawford was the only serviceman the army employed for the specific purpose of interpretive painting. His experience in this role had led to earlier iconoclastic work such as *Air War* (1944; Harvard Art Museums), with its abstracted yet material sense of metal wreckage, the jagged lines severing planes of color above a bomb-cratered landmass.

But Crawford came to Bikini in a different capacity. *Fortune* magazine had commissioned him to paint the two nuclear explosions—Test Able and Test Baker—that would constitute Operation Crossroads. What *Fortune* expected in return for their investment is anybody's guess, but one can safely hazard that *Bikini, Tour of Inspection* was not it (fig. 298). The ironic title, like the painting's aesthetic, suggests Crawford's refusal—or inability—to imaginatively subordinate the chaos he witnessed to the cold, calculating rationality of military order. The disturbed spirit of the painting is closer to the exclamation by exiled Bikinian Kilon Bauno that "we really didn't know what was going on … when they dropped the bomb on my island" than it is to the sanguine insistence of the Crossroads commander, Vice Admiral William H. P. Blandy, that his operation would be a controlled experiment. "The bomb will not start a chain reaction in the water," Vice Admiral Blandy declared. But a chain reaction did start; it was chaotic, and through intergenerational genetic mutation across human and ecological communities, that chain reaction remains ongoing.[4] Bikini Atoll is still uninhabitable for humans: in 2012 United Nations special rapporteur Călin Georgescu described the atoll as afflicted by "near-irreversible environmental contamination."[5]

Crawford couldn't have foreseen the blast's scrambling of DNA. But he did recognize on Bikini Atoll a denaturing of reality that standard-issue realism could not begin to adequately represent. Crawford was already associated with Precisionism and modernist abstraction; he'd expressed an affinity for Cézanne and Matisse in particular. But the series from which *Bikini, Tour of Inspection* is drawn represented a heightening of a style and a motif that had begun to emerge in *Air War*. Of his Bikini paintings Crawford observed:

> Destruction is one of the dominant characteristics of our time. These pictures constitute a comment on destruction.… They refer in paint symbols to the blinding light of the blast, to its color, and mostly to its devastating character as I saw it in Bikini Lagoon.[6]

What Crawford witnessed was simultaneously blinding and illuminating in ways that demanded the detonation of representation. He responded to what he saw—and to what was impossible to see—with jagged lines, geometrical incoherence, and a two-dimensional world of flattened planes. Foreground and background collapse into each other as the artist refuses the familiar consolations, the humanizing handrails, that depth of field provides.

Crawford's chaos of colliding forms is both exact and indecipherable. If it's a vision bereft of orientation, it's also a Pacific painting bereft of blues. Blacks, browns, yellows, and reds are all there, but the defining color of any Pacific lagoon has been blown out of the water. From here on out, this is no longer the ocean as we thought we knew it. *Bikini, Tour of Inspection* conveys the atomic era's disfiguration of the force fields of perception. Crawford's "tour" is not a controlled, rational enterprise, susceptible to detached military scrutiny. As Hiroshima, Nagasaki, and now Bikini Atoll all testified, science can be a fickle, conditional, and sometimes catastrophic ally, not an intrinsically benign guarantor of collective progress for the species.

If, as the geographer Nigel Clark suggests, the Great Acceleration links "earthly volatility to that of bodily vulnerability," we can read *Bikini, Tour of Inspection* as a great Anthropocene painting *avant la lettre*, long before the Anthropocene, atomic refugees, and climate refugees were on anybody's tongue.[7] The flattened-out vitality of Crawford's painting suggests both a volatile and a vulnerable world, one in which, to invoke the science writer Peter Brannen, humans—primarily the wealthiest among us—have thrown into jeopardy "the thin glaze of life-supporting chemistry that coats the earth."[8]

Bikini, Tour of Inspection, like many powerful acts of witnessing, doubles as an uncanny foreshadowing. Crawford's subject, while very specific, also conveys the aura of a planetary tipping point, an as yet unimaginable shift in Earth's geochemical history. This shift is marked by an apparently remote, apparently circumscribed Pacific island encounter. Some powerful strangers arrive on your doorstep and demand that you abandon your ancestral home, "for the good of mankind and to end all world wars." And you've no choice but to comply. These strangers aren't just any strangers, but the type who arrogate to themselves the freedom to blow up other people's worlds.

Boots on the Ground

In 1940 the Puerto Rican island of Vieques boasted a population of thirty thousand. But by 2001–2, when Jennifer Allora (American, born 1974) and Guillermo Calzadilla (Cuban, born 1971) created *Land Mark (Foot Prints)* (fig. 299), the number of inhabitants had shrunk to eight thousand.[9] What triggered the exodus? In 1941—five years before a joint US Army/Navy task force began detonating nuclear bombs at Bikini Atoll—the navy expropriated two-thirds of Vieques as a bombing range. Over the next six decades, the navy dropped an average of five million pounds of ordnance on the island annually.[10] The dispossession and exodus during the 1940s were followed by economic collapse, above all, of the island's rich fishing traditions that relied on the teeming marine life harbored by Vieques's fragile coral reefs. The people who remained on Vieques suffered military "tests" and "practice runs" as life-threatening realities, toxic to human communities and to the ecologies that sustained them. Unlike Bikini, Vieques never became the target of serial nuclear attacks, but the US Navy did drop depleted uranium munitions on the island that pose perturbing health risks. The radioactive half-life of depleted uranium (U-238) is 4.468 billion years.

In the late 1970s local fishermen led the resistance to the navy's usurpation of Vieques as a live bombing range and ammunition depot. Thereafter, protests waxed and waned until 1999, when an errant bomb killed David Sanes, a civilian security guard. Sanes quickly assumed martyr status. His killing provided the protesters with an international symbol of abrupt violence—and a memorial site—that the slow violence associated with the diffuse poisoning of the island's people, aquifers, bays, and marshlands had not afforded. Sanes's death reignited the resistance, firing up protesters who descended on the island from the rest of Puerto Rico, the United States, Europe, and Latin America, giving the protests, in the name of anticolonialism, human rights, public health, and environmental justice, an unprecedented global visibility.

Allora and Calzadilla's *Land Mark (Foot Prints)* series took shape in the months after Sanes's killing and bears witness to a historical tipping point, breathing new life into the dead metaphor of the landmark event. The work is a testament to—and an emanation of—the cascading resistance that forced the navy to leave the island altogether in 2003.

To create *Land Mark (Foot Prints)* the artists devised customized shoe soles, using silicone castings from a Plexiglas

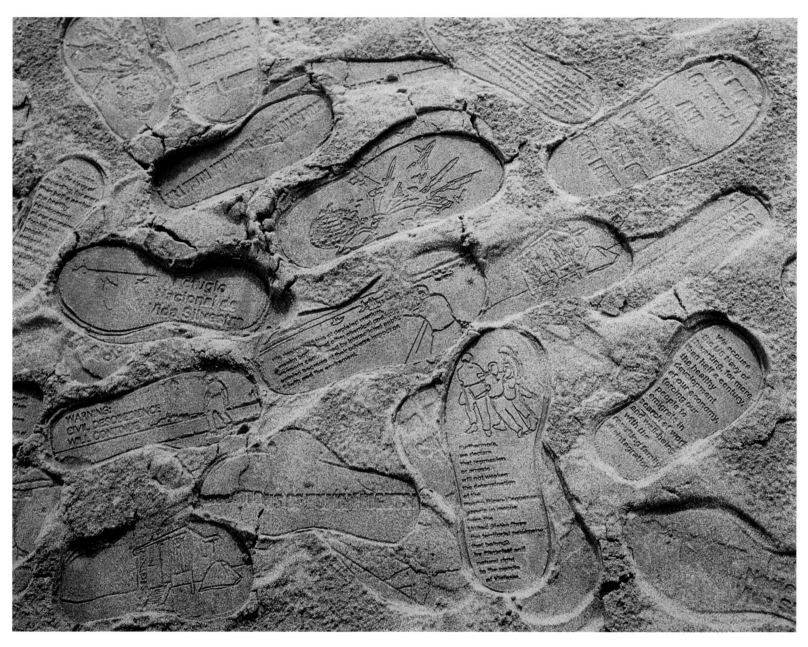

FIGURE 299: Allora & Calzadilla (working together from 1995), Print from the series *Land Marks (Foot Prints)*, 2001–2. Chromogenic print from a digital file, 46 × 60.5 cm. Princeton University Art Museum. Fowler McCormick, Class of 1921, Fund (2009-147 b)

template. Protesters wearing these embossed shoes stamped into the sand slogans, images, commemorative eulogies, and manifestos as these artist-activists joined a mass trespass—or, more accurately, countertrespass—onto a US Navy practice range. The protesters' insurgency became an act of historic reclamation performed through the medium of insurrectionary walking.

Each walking body leaves behind an individual mark, bearing down on the ground with a personal force and weight and tilt. But when footprints appear en masse, as in *Land Mark (Foot Prints)*, they assume a different symbolic resonance, connecting the unique body to a broader body politic. Collective footprints have a long history in the conflict between the commons and enclosure—the often-violent contests that every society has experienced, contests that pit public access against appropriation and enclosure. The crisscrossing patterns left behind after bodies have moved across terrain become integral to the political dance between land theft and land reclamation, between eviction and return. For the activists who crossed a Vieques beach at the turn of the millennium, to walk was to partake of a larger act of repossession, at once symbolic and restorative.

In *Land Mark (Foot Prints)*, Land Art doubles as civil disobedience. Allora and Calzadilla draw on the imprint's figurative power: from Daniel Defoe's footprint in the sand to the carbon footprint, the impact of the departed foot connotes both presence and absence. The footprint is empirically decisive—somebody passed by here—yet elusively nonspecific. Who? When? How? All questions that give footprints an urgent vitality in narratives of trespass and legal access. Each impression leaves telltale signs: a person's weight, age, gender, direction of travel, speed of movement. Thus, in detective novels—and detective art—the footprint becomes subject to a layered scrutiny.

In Allora and Calzadilla's series the medium is the message, or at least a large part of it. The beach sand in the photographs is firm with water—not too soggy, not too dry, just moist enough to maintain an impression for the time being. The work depends for its effect on a dynamic friction between two types of print: the photographic prints and the prints that linger on the sand. The photographic prints uphold, in perpetuity, the words, images, and impressions that rhythmically rising and falling feet have left behind. But *Land Mark (Foot Prints)* also summons to mind a very different set of rhythms: the work is alive to tidal ebbs and

flows, so that in the great tradition of Land Art, vast natural forces—tides, waves, wind, sun—become active partners in shaping the artwork's uncertain life span. At some point the physical footprints will recede, then vanish, whether inundated by rushing water or dried out and scattered by the wind's attritional energies. Here the footprints are in their element. In their environmentally responsive, built-in brevity, the ephemeral dents in the sand draw attention to the natural rhythms that long precede and will outlast a militarized humanity's shallow occupation.

But a third type of print is also active here, one unseen, yet an agitating presence. What genetic imprint have sixty-plus years of bombing left on the cellular structures of the island's human and nonhuman life? For the protests were fueled not only by a demand for sovereignty and access but also by an angry anxiety over the bombings' fallout for public health. Cancer clusters, malformed fish: fearful legacies of uncertainty.

After the bombing ceased in 2003, the protests shifted focus to the navy's unmet responsibility for decontamination and remediation. In what some saw as a sleight of hand, the Pentagon transferred 3,100 acres of navy land to the US Fish and Wildlife Service, creating the Vieques National Wildlife Refuge. This constituted, at best, an ambiguous return of territory to the people of Vieques, because the sanctuary remained off-limits, given the risks posed by unexploded munitions lingering in the mangrove forests and wetlands. Critically, this was a cost-effective move for the Pentagon, one it has deployed widely when decommissioning contaminated military land from Hawaii to Nevada. Yes, protesters forced the navy to exit the island and, yes, they pressured the Environmental Protection Agency to designate Vieques a Superfund site in 2005. But decontamination efforts remain underfunded, dilatory, and half-hearted. The need to clean up land dedicated to wildlife rather than humans can be rationalized as less urgent, in ways that suppress the long-term slow violence that permeates the ecosystems—and public health—of the island at large.

This Brief Multitude

Where does environmental justice begin and end? Not simply in space and time, but biologically? If unequal exposure to harms and unequal access to resources stand at the heart of environmental justice politics, can we extend such concerns to injustices inflicted on nonhuman communities?

How do we reckon with the environmental burdens imposed on other species by the accelerating fallout from Anthropocene humanity's outsize powers?

In his series *Midway: Message from the Gyre*, Chris Jordan (born 1963) grounds such questions, giving them a material gravity (fig. 300). Throughout his career, Jordan has sought to translate inert data into visually vital forms. How, his work asks, in a world sated with statistics, can the artist give numbing numbers a sensory reality? Given Jordan's fascination with making vastness visceral, he was drawn to the idea of photographing the Great Pacific Garbage Patch, otherwise known as the Pacific Trash Vortex. The ocean currents of the North Pacific Gyre have trapped a volume of discarded and degraded plastic into a vortex that, by some measures, is twice the size of Texas. Jordan determined to fly over the gyre in an effort to convey its full scale, in the hopes of bringing into focus the dimensions of our throwaway culture in all its enormity.

Yet when Jordan's plane passed over the gyre, his dream of rendering visible this geographically remote atrocity evaporated. Although the garbage patch is vast and material, it remains elusive to the photographic eye. Jordan found that it was impossible from the air to see the totality of the gyre, indeed to see very much at all. The Great Pacific Garbage Patch may be dubbed, by some, the eighth continent, yet its constitutive parts are barely visible except close-up. Unlike other great planetary structures—the Great Wall of China, the Great Barrier Reef, the Grand Canyon—the Great Pacific Garbage Patch is indiscernible from outer space or even from a plane.

Much of the plastic detritus in the vortex has degraded into tiny bits and is suspended just below the surface. And much of it was never accessible to the human eye in the first place, having entered the ocean as minute micropellets. To compound this relative invisibility, algae and other biota have colonized and coated the plastic flotsam and jetsam.

When Jordan expressed exasperation at the garbage patch's visual elusiveness, someone urged him to travel to Midway Atoll to get an angle on the crisis from there. Midway might seem an odd vantage point: it is one of the most physically remote places on the earth, twenty-four hundred miles from the nearest continent. Today, apart from some thirty or forty research scientists, Midway remains uninhabited, depending on how one defines inhabitants. For the island possesses the world's largest breeding colonies of Laysan and black-footed albatross.[11] The island air rings with the cries of hundreds of thousands of them hovering above their rudimentary nests.

But what Jordan found complicated this dynamic, life-affirming din. The air may be dense with birds, but albatross corpses litter the ground. What is causing this mortuary effect?

Albatross are unusual for the immense distances they travel: for most of the year they remain airborne and during the brief breeding season they venture far in pursuit of food for their offspring. This quest takes the adult birds into the heart of the Great Pacific Garbage Patch, some areas of which have been found to have a concentration of plastics seven times greater than the concentration of zooplankton. Here the wanderings of peripatetic plastics and pelagic birds converge with disastrous consequences. The parent birds ingest plastic, both accidentally, because the parts are tiny, and deliberately, drawn by the fish-like colors of plastic shards. Albatross are particularly vulnerable to plastic ingestion, as they depend on their acute sense of smell for finding food. Ocean-degraded plastic emits plumes of dimethyl sulfide that the birds interpret as signals of food—false food in this case—on the horizon.[12]

Thus, an adult albatross seeking to nourish its chicks via regurgitation often ends up siphoning plastic from the garbage patch into its fledgling's gut. This deathly parent-to-offspring transmission lies at the heart of Jordan's *Midway* series, which delivers a visceral impact that is at once aesthetic, ethical, and physiological. Jordan's work is, in every sense, a blow to the gut. Here deep-seated biological impulses—toward nourishment and procreation—become fatal inversions of themselves, as the life-sustaining parental vomit morphs into its opposite, the lethal upchuck of the throwaway society. Jordan's art, by linking regurgitation and failed recycling, toggles between the global and the granular, mapping onto the entrails of a single bird the cumulative consequences of humanity's casually catastrophic everyday acts.

Jordan operates surgically, dissecting each dead bird and photographing the innards, before tweezering the plastic contents into Ziploc bags. He then dispatches the bags to a scientist at the National Museum of Natural History who is researching plastic pollution's impact on ocean fauna. This collaboration affords Jordan a more granular understanding of the ingested detritus. The artist's *Midway* series becomes, in a double sense, anatomical. Each dissected baby albatross delivers insights into the feeding practices of the adult birds, but the photographs also serve to anatomize the

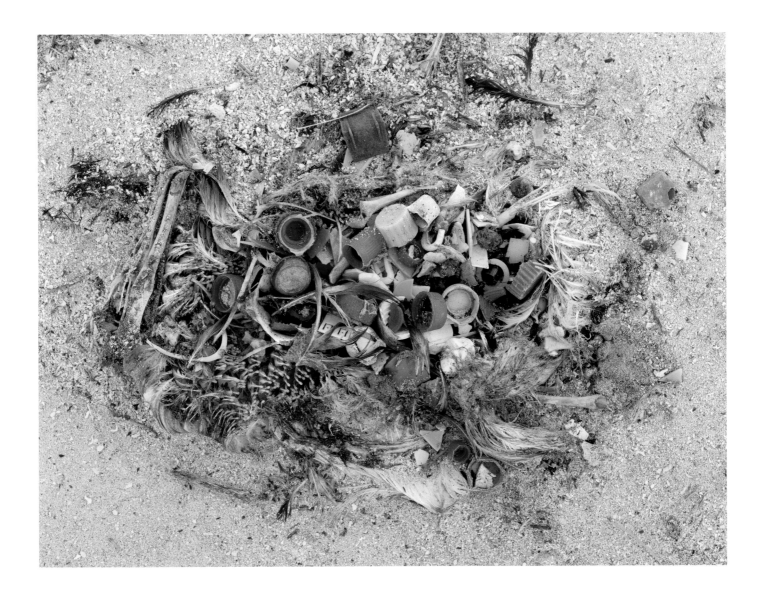

inner life of a globalized consumer culture. Against the vast transnational abstraction of that culture, Jordan places specific objects extracted from fledgling viscera: a gray plastic cigarette lighter; an entire yellow toothbrush; a nail polish bottle (pink). Slicing open one albatross, he discovers that it has devoured a tiny plastic Buddha. Yet another bird has swallowed whole, but failed to draw nourishment from, a discombobulated plastic polar bear that has washed up in the tropical Pacific. Jordan turns to the next bird, exhuming an indigestible white plastic fork tossed aside after some human's presumably more successful meal. From a single albatross stomach, he removes twenty-two bottle caps, of variable antiquity. He peers in closely at one of the newer bottle tops that bears the still legible instructions: "push down and turn to close." [13]

FIGURE 300: Chris Jordan (American, born 1963), *CF000668*, from the series *Midway: Message from the Gyre*, 2009. Ultrachrome inkjet print, 66 × 78.7 cm. Nevada Museum of Art. The Altered Landscape, Gift of the artist (2012.01.01)

FIGURE 301: Kelly Jazvac (Canadian, born 1980), One of a series of plasti-glomerates collected with geologist Patricia Corcoran in 2013. Subrounded fragment containing basalt clasts, molten plastic, yellow rope, and green and red netting, 16.5 × 18.4 × 7.6 cm. Courtesy of the artist

But this is art that offers no closure. What it offers instead is a counterintuitive encounter with assumptions about resilience and plasticity. The Great Acceleration in plastic use after World War II became emblematic of a culture of convenience: plastic goods became valuable by being virtually valueless. Even for the poor, to enter into the realm of "throwaway living" was a visible marker of being modern. Yet, as it turns out, plastics are neither as malleable as advertised nor as uncostly.

In 2012 the Canadian geologist Patricia Corcoran and her team identified a type of stone, unprecedented in Earth's geological history, that they named plastiglomerates.[14] These geological novelties are composed of hardened molten plastic, natural sediments, and sundry detritus. Corcoran contends that plastiglomerates may serve as future fossils, potential markers of our Anthropocene cultural practices. Viewed through the rearview mirror of some far-off future, plastiglomerates may offer a vital clue to how a once-upon-a-time species called *Homo sapiens* transformed Earth's biochemistry.

The Canadian sculptor Kelly Jazvac (born 1980) has collaborated with Corcoran to collect a series of plastiglomerate

samples that could provide an illuminating complement to Jordan's *Midway* series (fig. 301). Together Jazvac and Jordan engage the politics of disposability, the deep duration of the apparently short-lived, and the lasting legacy of plastic's lack of plasticity.

If plastics shorten the lives of individual albatross, might they also truncate the lives of entire species? The din above Midway Atoll suggests otherwise, as albatross throng the air. Yet what the environmental philosopher Thom van Dooren calls "the dull edge of extinction" can advance imperceptibly.[15] Incremental decline may be particularly difficult to perceive in the case of colonial species such as albatross and passenger pigeons, which breed in immense congregations. Officially, the passenger pigeon passed into extinction when the last bird, called Martha, expired at the Cincinnati Zoological Garden on September 1, 1914. But imaginatively, the species was already long gone, had predeceased her individual death. For surely a bird known to darken the sky—even blot out the sun—exists only nominally when the great aggregates have disappeared.

Is it easier to take such communal species for granted, to fail to hear, beneath the rush of wings and voices, some underlying note alerting us to an incremental vanishing? Can concentrated plenitude induce a particular kind of complacency that doesn't occur with more solitary species? Do birds such as albatross, which gather in great raucous crowds, communicate the illusion of an everlasting plenitude? And are we heading toward a time when routine collective nouns—such as flock and shoal and herd—have less and less to gather in?

For now, the black-footed and Laysan albatross that Jordan photographed are classified as "near-threatened," not "endangered." Yet some ornithologists argue that albatross constitute the single most vulnerable family of birds on Earth. Albatross face compound threats not just from plastic pollution but from industrial fishing and climate change too. They get impaled and drown on the long lines of vast fishing factory vessels that can trail hooks for sixty miles. Other birds starve, or fail to breed, because oceans warmed by climate change are becoming nutrient deficient.

We talk idly about global flows. About junk food. About human-nonhuman entanglements. About the mesh of life. Jordan's art infuses a visceral immediacy into the dulling distance that such dead metaphors provide. In one photograph, the artist painstakingly disentangles some hooks and nylon

netting that have lashed together, in near-fatal intimacy, a parent albatross and its hungry fledgling. The mesh of life indeed.

In the industrial age, humans took canaries into coal mines for advance warning of imminent threats. Are albatross the canaries of the twenty-first century, barometers of oceanic—and by extension—planetary health? These nomads wander so widely that no national frame could possibly define their survival or disappearance. They depend on our oceans' interconnected ecological viability. In their vitality and their mortality, albatross are sentinel species whose dissected bodies can alert us to perturbing planetary processes. Jordan's *Midway* series allows us to enter the Great Pacific Garbage Patch via the clogged viscera of a baby albatross. There, if we listen carefully, we can hear almost inaudible vanishings that, in their remote silence, implicate us all.

All Our Relations

Shortly before her assassination in 2016, Berta Cáceres, the Honduran environmental activist, insisted that "Earth—this militarized, fenced-in, poisoned place where basic rights are violated—demands that we take action."[16] Cáceres viewed environmental justice as inseparable from a social justice rooted in a cosmology of interconnection. She saw the violent dispossession of vulnerable communities as symptomatic not just of a breakdown in kinship between the wealthy and the impoverished but also of a breakdown between humans and their more-than-human kin. Pope Francis similarly implores us to heed "the cry of the earth and the cry of the poor," insisting that environmental ills—pollution, militarization, runaway consumerism, and climate change—rob both the poorest people of our age and future generations of planetary life.[17]

Art can help us surmount destructive forms of severance by bearing witness to all our relations with bodies that might otherwise be seen as foreign and distant others. A jagged atomic blast, footprints on an occupied beach, the entrails of an albatross can render the far-off intimate, refusing the island effect. Crawford, Allora and Calzadilla, and Jordan respectively use their circumscribed small islands as portals into immense planetary processes, deepening our kinship with the human and more-than-human inhabitants of our global sacrifice zones.

Notes

1 Helen Kapstein, *Postcolonial Nations, Islands, and Tourism: Reading Real and Imagined Spaces* (London: Rowman & Littlefield, 2017).

2 Jack Niedenthal, *For the Good of Mankind: A History of the People of Bikini and Their Islands* (New York: Micronitor, 2002), 15.

3 Sarah Elizabeth Adams et al., *Selective Visions: The Art of Ralston Crawford* (Carlisle, PA: Trout Gallery, Dickinson College, 2001), 24.

4 Niedenthal, *For the Good of Mankind*, 7.

5 Cited in Barbara Rose Johnston, "Nuclear Betrayal in the Marshall Islands," *CounterPunch*, September 17, 2012, https://www.counterpunch.org/2012/09/17/nuclear-betrayal-in-the-marshall-islands/.

6 William Agee, *Ralston Crawford* (Pasadena: Twelve Trees Press, 1983), 27.

7 Nigel Clark, *Inhuman Nature: Sociable Life on a Dynamic Planet* (London: Sage, 2011), 23.

8 Peter Brannen, "Headstone for an Apocalypse," *New York Times*, August 16, 2013.

9 Katherine T. McCaffrey and Sherrie L. Baver, "Ni Una Bomba Mas: Reframing the Vieques Struggle," in *Beyond Sun and Sand: Caribbean Environmentalisms*, ed. Sherrie L. Baver and Barbara Deutsch Lynch (New Brunswick, NJ: Rutgers University Press, 2006), 109.

10 Kelly Baum, "Supplement: Reading *Land Mark (Foot Prints)*," in *Nobody's Property: Art, Land, Space, 2000–2010*, ed. Kelly Baum (Princeton: Princeton University Art Museum, 2012), 85.

11 Thom van Dooren, *Flight Ways: Life and Loss at the Edge of Extinction* (New York: Columbia University Press, 2014), 30.

12 Adam Nicolson, *The Seabird's Cry: The Lives and Loves of Puffins, Gannets and Other Ocean Voyagers* (London: William Collins, 2017), 231.

13 Chris Jordan, "Midway Journey," https://www.youtube.com/watch?v=MjK0cvbm20M.

14 Andy Chen, "Rocks Made of Plastic Found on Hawaiian Beach," *Science*, June 4, 2014, http://www.sciencemag.org/news/2014/06/rocks-made-plastic-found-hawaiian-beach.

15 Van Dooren, *Flight Ways*, 45.

16 "Honduran Environmental Activist Murdered," http://www.loe.org/shows/segments.html?programID=16-P13-00011&segmentID=1.

17 Pope Francis, *Encyclical Letter Laudato Si' of the Holy Father Francis on Care for Our Common Home* (Rome: Vatican Press, 2015), 67.

Fonna Forman and Teddy Cruz

Citizenship Culture and the Transnational Environmental Commons

We live and work at the US–Mexico border in the largest binational urban region in the world: the metropolis of San Diego/Tijuana. Over the last decades this border zone has been our laboratory to engage the central challenges of urbanization today: deepening social and economic inequality, dramatic migratory shifts, urban informality, environmental degradation, climate change, the thickening of border walls, and the decline of public thinking. Blurring conventional boundaries between theory and practice, and situated at the intersection of architecture, art, and civic engagement, our practice has been committed to exploring the invisible transborder flows and circulations that define the territory and have shaped the transgressive hybrid identities of everyday life in this part of the world. We think of the border less as a militarized jurisdictional line, or as a political artifice, and more as a region defined by interdependence. Our work reimagines the border zone as a transnational environmental commons, an eco-region that demands cross-border collaboration for the benefit of all. We are activating this vision through a robust collaboration with agencies and universities on both sides of the border that are eager to pursue a new era of partnership to protect shared environmental assets and tackle climate change, the mother of all public problems. A key dimension of this research is to rethink citizenship itself—opposing conventional jurisdictional or identitarian ideas that divide communities and nation-states with a more practical idea focused on the shared social norms, everyday practices, interests, and aspirations that typically flow across boundaries.[1]

The fortress mentality that once characterized the political fringe has gone mainstream in the United States and across the world, legitimizing bigotry and the urgency to build walls that are higher and stronger and to protect national resources from an endless flow of dangerous interlopers. In our zone of conflict and increasing militarization, we seek to draw on regional flows, convergences, and interdependencies to construct a more speculative imaginary of regional citizenship, one that provokes young people to aspire beyond the political realities of border enclosure to imagine possible futures. In the midst of calls for wall-building, we should call even more loudly for interdependence and transgressive experiments in "unwalling" that allow people to see each other anew and cultivate cross-border public commitment toward a more inclusive, democratic, and environmentally progressive binational region.

The Political Equator

Over the last decade we have been linking border regions around the globe to investigate their differences and similarities, and what those regions can learn from each other about civic and environmental interdependence and tactics of transgression. *The Political Equator* (2005–present) is a visualization project that traces an imaginary line along the US–Mexico continental border and extends it directly across a world atlas, forming a corridor of global conflict between thirty and thirty-eight degrees north latitude (fig. 302). Along this imaginary boundary lie some of the world's most contested thresholds, including the US–Mexico border at San Diego/Tijuana, the most trafficked international border checkpoint in the world and the primary migration route from Latin America into the United States; the Strait of Gibraltar and the Mediterranean, the main funnel of migration from North Africa into Europe through which waves

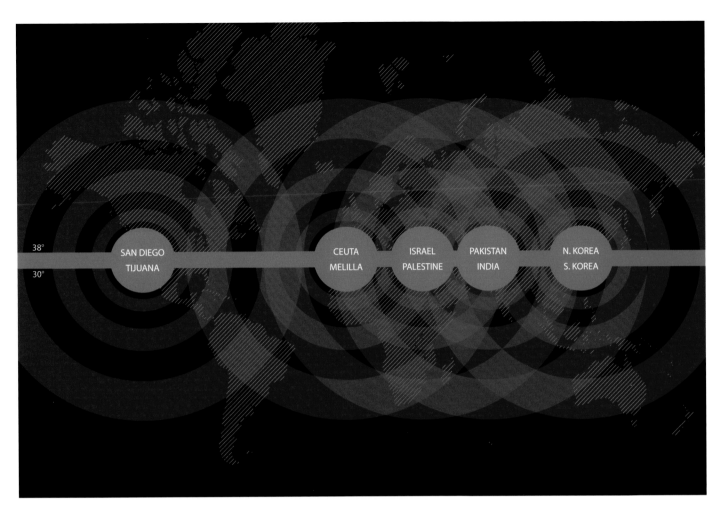

FIGURE 302
Estudio Teddy Cruz + Fonna Forman
The Political Equator, 2005–present

of migrants and refugees from North Africa and Syria flow across "Fortress Europe," recently thickened to contain the flow of refugees from Lampedusa into Italy and from Lesbos into Greece; the Israeli–Palestinian border that divides the Middle East, emblematized by Israel's fifty-year military occupation of the West Bank and the Gaza Strip; India/Kashmir, a site of intense and ongoing territorial conflict between Pakistan and India since the British partition of India in 1947; and the border between North and South Korea, which represents decades of intractable conflict, carrying Cold War tensions forward to the present day. Of course, the real political equator extends beyond this flat line, since border conditions are distributed across the globe. Although we tend to think of border walls as physical fortresses, borders are reproduced in peripheral neighborhoods everywhere, where public divestment, racism, and inequality divide communities and institutions.

Communities most affected by political marginalization likewise often bear the brunt of the accelerating impact of climate change. The collision of geopolitical borders, environmental crisis, and human displacement is the great crisis of our age.[2] This convergence of environmental and social injustice is evident in the experience of African American residents of New Orleans in the aftermath of Hurricane Katrina; more generally in the conditions of the poorest and most vulnerable across the globe, who tend to settle along lagoons and low-lying coastal zones at the front lines of sea-level rise; and with particular urgency in the Syrian refugee crisis, which arguably began decades ago with a thirty-year drought that drove rural Syrians to cities politically unprepared to integrate

them and evolved into one of the most horrific political and human catastrophes of the last century.[3]

Unfortunately, the political rhetoric of hatred and border closures across the world today further marginalizes the most vulnerable among us, criminalizing their movement and dehumanizing their condition. But anti-immigrant sentiment has been met with irruptions of civic and political resistance, frequently in border regions where the collision is most immediately experienced, demanding new and more inclusive imaginaries of coexistence and sanctuary. How can we, as cultural producers, disrupt the mythologies that have been perpetuated by xenophobic, often racially motivated fears about the other and produce a new conversation? Can we advance new ideas of citizenship that transcend borders, ones based on practical urgencies rather than identitarian categories? Can environmental urgency and climate change become tools for new cross-border thinking?

Perhaps no one has posed the issue of climate justice more eloquently and powerfully than Pope Francis in his 2015 encyclical, *Laudato Si'*. Pope Francis has become a great ally in the simultaneous fight against poverty, the fight for tolerance and human dignity, and the fight against climate change. He wrote: "Today . . . we have to realize that a true ecological approach *always* becomes a social approach; it must integrate questions of justice in debates on the environment, so as to hear *both the cry of the earth and the cry of the poor*."[4]

Localizing Action

Effective strategies to promote social inclusion and environmental justice together require widespread and pervasive cultural shifts in attitude and behavior.[5] Policy and planning are essential but not enough without genuine buy-in from the bottom up, at all scales—from the vast canvas of public opinion to collective and individual attitudes and behavior at neighborhood or village scales, where the rubber hits the road, so to speak.

This is particularly true of disadvantaged neighborhoods plagued by poverty, violence, failing schools, and failing infrastructure, where environmental concerns can seem remote from the acute challenges of everyday life. Proximity matters. Research shows that disadvantaged urban populations, for example, are more likely to become engaged in climate action when they understand the linkages between climate and poverty in their own neighborhoods, and when local opportunities for participatory action with neighborhood-scale impact are made available to them.[6] When the negative effects of climate change are made tangible and present for people, rather than something far-off like melting icecaps and polar bears—when they understand, for instance, precisely how sea-level rise will affect one's city or neighborhood—individuals are more likely to be receptive to the concept of global climate change generally and supportive of climate-friendly public policy.

All this research is confirmed by powerful examples across the world. In our practice we have been inspired by Latin American cities that have been particularly successful in recent decades at transforming local attitudes and behavior around environment and climate while producing more equitable outcomes in the city. A long lineage of climate-forward mayors across the region committed their administrations to bold environmental agendas that were combined with participatory strategies designed to promote dignity and agency among the poor, and ultimately to produce greener, more equitable cities.[7]

When the philosopher Antanas Mockus (fig. 303) became mayor of Bogotá, Colombia, in 1995, the city was in a free fall of violence, poverty, infrastructural failure, and choking air quality, the worst anywhere on the continent. At that time it was often referred to as "the most dangerous city on the planet." Rejecting the conventional law-and-order response to urban violence, Mockus came up with a very different idea, one based on transforming societal norms—changing the hearts and minds of citizens—to repair patterns of public trust and social cooperation. Provoking architects and urbanists, Mockus asserted that before improving the city physically, it was first necessary to intervene into the belief systems that perpetuate an acceptance of poverty and dramatic inequality. He focused not only on those with resources and |power but also, more essentially, on the marginalized and the poor, with the goal of restoring urban dignity, reclaiming neighborhoods, and fostering collective agency. He became legendary for the distinctive ways he intervened into the behavioral dysfunction of urban Bogotá, using arts and culture and sometimes outrageous performative interventions to dramatically reduce violence and lawlessness, reconnect citizens with their government and with each other, increase tax collection, reduce water consumption, reduce vehicle emissions, and ultimately improve

quality of life for the poor. His use of street mimes, games, and theatrical street disruptions has inspired civic actors, urbanists, and artists across Latin America and the world to think more creatively about upsetting civic dysfunction and transforming urban norms and behavior.

Shifting social norms and renewing public trust paved the way in Bogotá for succeeding mayor Enrique Peñalosa's renowned multinodal and egalitarian transportation agenda, consisting of a network of bus rapid transit, bicycle hubs, cyclovias, and dedicated walking paths that literally stitched that troubled city together and revolutionized public transportation in Latin America.[8] In other words, shifting social norms came first; the environmental interventions followed. As Peñalosa stated in 2013, "An advanced city is not one where even the poor use cars, but rather one where even the rich use public transport."[9]

Mockus and Peñalosa emerged from a long tradition of participatory urbanization across Latin America, stewarded by environmentally forward mayors who were inspired by the Brazilian educator and philosopher Paulo Freire and his "critical pedagogy" for reclaiming the humanity of the colonized.[10] These mayors committed to robust agendas of civic engagement, from the Workers' Party mayors in Porto Alegre, Brazil, who experimented with participatory budgeting in the 1970s, to the mayor of Curitiba in Brazil, Jaime Lerner, who pioneered bus rapid transit and dozens of green interventions in the 1980s, to the "social urbanism" of Sergio Fajardo when he was mayor of Medellín, Colombia, in the early 2000s that transformed public spaces and green infrastructure into sites of education and citizenship-building, elevating Medellín into a global model of urban social justice (fig. 304).[11] This tradition still thrives in cities across the continent, from La Paz in Bolivia to Quito in Ecuador to Mexico City, and carries important lessons for equitable green urbanization in cities across the world today.

Cross-Border Community Stations: Cultural Platforms for Participatory Climate Action

Inspired by our research in Bogotá and Medellín, where citizenship was mobilized through cultural action in public space, we founded the UCSD Cross-Border Community Stations at the University of California, San Diego. They are field-based hubs in underserved neighborhoods on both sides of the San Diego–Tijuana border, where experiential learning,

research, and teaching are conducted with community-based nonprofits, advancing a new model of community-university partnership and reciprocal knowledge production.[12] Social and environmental justice today not only is about redistributing resources and technologies but also depends on redistributing knowledges and capabilities. The UCSD Cross-Border Community Stations employ innovative models of environmental education at community scale to transform hearts and

FIGURE 303
Antanas Mockus in Tijuana, 2015
Courtesy of Teddy Cruz and
Fonna Forman

FIGURE 304
Centro de Desarrollo Cultural
de Moravia, Medellín, Colombia
Courtesy of Teddy Cruz and
Fonna Forman

minds about climate change and environmental health and to foster participatory, bottom-up responses.

We do this by converting vacant and neglected sites and spaces into active civic classrooms—spaces of knowledge, cultural production, small-scale participatory design and construction projects, environmental research, and display that are curated collaboratively between community and university, and where environmental literacy can stimulate climate action and political agency in marginalized neighborhoods. Access to arts education and cultural production has been compromised everywhere in recent years, particularly in marginalized contexts, by significant reduction in public spending and the budget cuts faced by local community-based nonprofits. Retraction in cultural activity can produce apathy among residents and a lack of neighborhood participation in the planning of the community's future. In the UCSD Cross-Border Community Stations, arts and culture programs become summoners, instruments for civic participation, as well as engines to incentivize new neighborhood-based economies to improve the quality of life across these underserved, demographically diverse immigrant neighborhoods.

In recent years we have built strong relationships with two communities adjacent to the border wall and cultivated long-term partnerships with the most rooted and active nonprofit organizations based there. The UCSD/Divina Community Station (fig. 305)—one of two stations in operation[13]—is located in the informal settlement of Los Laureles Canyon on the western periphery of Tijuana, in partnership with the nonprofit Los Colonos de Divina Providencia. Los Laureles is geographically the last slum of Latin America, literally crashing against the border wall and home to eighty-five thousand people. The Laureles station is focused on environmental education (fig. 306), participatory climate action, cross-border environmental and urban policy, and informal urbanization, with an emphasis on the intersection of water management, dust management, and cross-border citizenship.

Our Cross-Border Community Station in Los Laureles Canyon is unique because it is directly adjacent to the Tijuana River National Estuarine Research Reserve on the US side, the tip end of our binational watershed system, which has been impacted by the flow of wastewater and trash from the slum, exacerbated by the truncation of the canyon systems as the border wall has been fortified in the last decade. Preventing the further degradation of this essential binational environmental asset has been among

the chief priorities of our work in the canyon. We are cultivating cross-border, cross-sector relationships to mobilize shared water management capabilities between the canyon and the estuary (fig. 307). Simultaneously we have developed a "distributed system" of small public spaces that radiate from the UCSD/Divina Community Station and function as water management infrastructures as well as contexts for pedagogical-cultural experiments. In other words, this unique network of microbasins operates not only as functional waste management infrastructure, to prevent pollution from reaching the estuary, but also as pedagogic and cultural spaces that teach children about food harvesting, nutrition, waste, soil, and water.

Here, classrooms become nomadic cultural stages and conduits for itinerant community planning workshops. We have long argued that public spaces cannot remain as mono-use physical amenities, but must be curated *with* support systems for community engagement, promoting social participation for cultural action. In collaboration with our nonprofit partners, we develop visualization tools that enable comprehension of complex cross-border issues and the policies necessary to protect binational social and environmental assets. Our community workshops involve speculative cartography and mapping, in the form of videography experiments conducted by community residents and students to interpret everyday practices and aspirations and to advance fictional scenarios of spatial and urban transformation. In this way, art becomes a cognitive tool to enable the visualization and recognition of regional ecologies beyond walls. These exercises help to expose the missing information that often disrupts the organic relationship a community has to its immediate environment.

We believe that raising awareness about unrecognized environmental and social assets helps to recuperate a community's agency for political action, and in our region ultimately helps to construct a more grounded, cross-border sense of belonging. Sometimes these nomadic actions are "agonistic interventions" through which we summon institutions and agencies that are at odds with one another—whether border patrol and activists or maquiladoras (NAFTA factories) and NGOs—to enter into dialogue and debate about the implications of their actions and agendas, as well as the potential for mutual recognition and collaboration. One example, discussed below, is a border-drain crossing organized with US Homeland Security and our community partners.

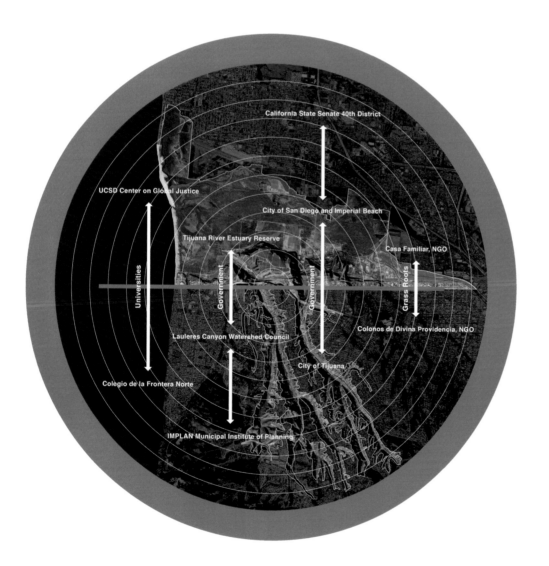

FIGURE 305 (TOP LEFT)
Estudio Teddy Cruz + Fonna Forman
Rendering of the UCSD/Divina
Community Station, Tijuana, Baja
California, Mexico, 2016

FIGURE 306 (TOP RIGHT)
Children in the garden at Los Colonos
de Divina Providencia, 2017
Courtesy Estudio Teddy Cruz +
Fonna Forman

FIGURE 307 (LEFT)
Estudio Teddy Cruz + Fonna Forman
Diagram of the coalition of binational
partners, 2018

We also cocurate participatory design workshops and hands-on small-scale environmental and agricultural interventions to stimulate both community awareness of urban challenges that can seem remote or secondary to communities living in conditions of scarcity and a sense of completion and community capacity. One ongoing participatory design project is our *Mecalux Retrofit* begun in 2013. For many years we have been documenting how informal environments such as Los

Laureles Canyon grow incrementally as people build their own housing by recycling the urban waste of Southern California. We have been studying the relation of these informal processes to the dynamics of cheap labor, as multinational maquiladoras typically settle at the edges of these slums.

In the first period of research we began to engage these issues, proposing a model of "reciprocal urban development" whereby factory-made systems could help stabilize

FIGURES 308 a, b
Estudio Teddy Cruz + Fonna Forman
Mecalux Retrofit, multiple uses, 2014

FIGURE 309 (OPPOSITE)
Estudio Teddy Cruz + Fonna Forman
Map and panorama of the border-drain crossing, 2011

the temporal evolution of precarious housing in the slums. The project evolved into the *Mecalux Retrofit*, a social housing research collaboration with Mecalux, a Spanish maquiladora in Tijuana that produces lightweight metal pallet rack systems for global export and employs many of its workers from adjacent informal neighborhoods. We began negotiating with this factory to adapt and retrofit its prefab shelving systems into new microinfrastructures to support informal housing and waste recycling practices in the slums of Tijuana, suggesting an act of reciprocity between factories and marginalized communities surrounding them.[14]

These maquiladora "parts" become the material of our community design workshops in the UCSD/Divina Community Station, where we and our students work closely with community members to stitch these pieces together with existing structures to design and construct small and large infrastructures alike (figs. 308 a, b). For example, we worked with community members to design and build a bus stop from Mecalux parts, to shelter maquiladora workers from the sun as they await erratic shuttles to factory sites. At a larger scale, we are also designing a mixed-use housing project that will surround an economic incubator, as well as a new UCSD/Divina Community Station that will integrate spaces for environmental research and education, sport, arts and culture production and display (including a blackbox theater), and the first "prepa" (middle and high school) in Los Laureles Canyon.

A Transnational Environmental Commons

In recent years the activities of US Homeland Security and the installation of more invasive infrastructures of surveillance and control have had a devastating impact on the sensitive environmental systems that flank the border wall as it descends into the Pacific Ocean. New border wall infrastructure post–9/11 has truncated the many canyons that travel north and south as part of the binational watershed between Tijuana and San Diego. Los Laureles sits in one of these canyons, at an elevation higher than the estuary. The carving of concrete dams and drains into the new border wall has accelerated the northbound flow of waste from the slum into the estuary, siphoning tons of trash and sediment with each rainy season and contaminating one of the most important environmental zones, the "lungs" of the bioregion.

A major project of the UCSD Cross-Border Community Stations is the development of an environmental commons, a transnational land conservancy to encompass the San Diego estuary and the Tijuana informal settlement in a continuous cross-border political, social, and environmental system. The project began in 2011, when we curated a cross-border public action through a sewage drain underneath a section of the border wall recently built by Homeland Security, located at the precise point where the informal settlement in Mexico collides with the estuary on the US side (fig. 309). We negotiated a permit with US Homeland Security to transform a drain under the wall into an official port of entry for twenty-four hours. They agreed, as long as Mexican immigration officials were waiting on the other side to stamp our passports. As participants moved southbound under the wall against the natural northbound flow of slum wastewater headed toward the estuary, we reached Mexican immigration officers who had pitched an improvisational tent on the south side of the drain, inside Mexican territory (fig. 310). The strange juxtaposition of pollution seeping into the environmental zone, the stamping of passports inside this liminal space, and the passage from pristine estuary to slum under a militarized culvert amplified the region's most profound contradictions and interdependencies.

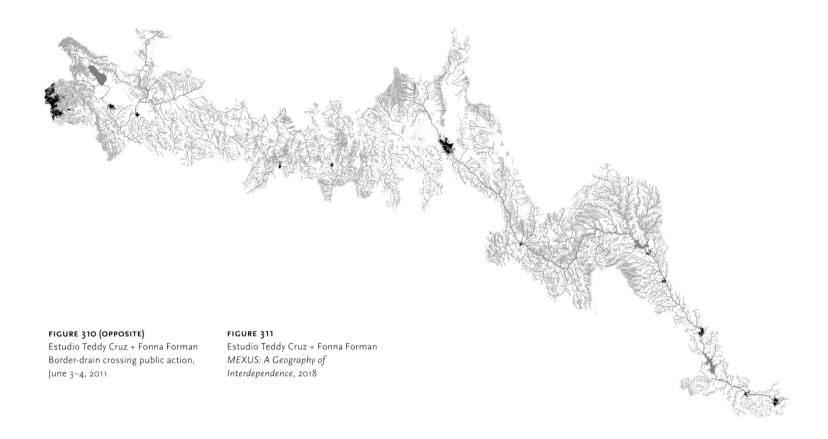

FIGURE 310 (OPPOSITE)
Estudio Teddy Cruz + Fonna Forman
Border-drain crossing public action,
June 3–4, 2011

FIGURE 311
Estudio Teddy Cruz + Fonna Forman
*MEXUS: A Geography of
Interdependence*, 2018

Although the border wall is regularly presented to the American public as a structure of national security, it is a self-inflicted environmental wound, violently bisecting and damaging regional resources. The wall undermines vital regional ecosystems that are essential to the survival of the communities on both sides. Can a more just cross-border public be mobilized to steward the shared environmental interests between two divided cities? As the development economist Amartya Sen argues, global justice requires a "cross-border public framework" that includes not only voices within our own jurisdictional and territorial boundaries but also the voices of those beyond our borders whom we impact through our decisions and actions.[15] Can border regions with shared environmental assets become laboratories to reimagine citizenship beyond the nation-state?

Anticipating the vaster social and environmental damages that will be inflicted by the new proposed border wall—whose prototypes have already been constructed a few miles east of San Diego[16]—we embarked in 2017 on a new phase of our cross-border citizenship agenda with a project called *MEXUS: A Geography of Interdependence*.[17] While the Mexico–US border has been publicly maligned, again, as a site of violence and crime, division and fear, *MEXUS*

presents the national threshold as a site of urban and political creativity and experimentation, characterized by grassroots dynamics and the invisible cross-border flows that our practice has been documenting.

MEXUS is a visualization of the continental border region without the line, presented instead as a transnational environmental zone composed of eight watershed systems shared by Mexico and the United States (fig. 311). By unwalling this thickened system of interdependencies, *MEXUS* provokes a more inclusive idea of citizenship based on coexistence, shared assets, and cooperative opportunities between divided communities. *MEXUS* visualizes those things that a physical barrier wall along the political border cannot contain: watersheds, Indigenous lands, ecological corridors, and migratory patterns. The drama of this unrecognized geography of interdependence is that it invites the viewer to imagine the disruption that a jurisdictional border inflicts on the continental environmental commons.

MEXUS gets particular at the Tijuana River Watershed, our region—the westernmost tip of *MEXUS*, at the precise juncture between the informal settlement of Los Laureles Canyon and the Tijuana River estuary, bisected by the wall. There, the project has inspired an ambitious coalition of

state and municipal governments, communities, and universities to steward a cross-border environmental commons (fig. 312), a land conservancy that identifies slivers of land in the Mexican slum, bundles them, and connects them with the American estuary to form a continuous political, social, and ecological zone that transgresses the line. *MEXUS* visualizes "Nature's Nation" in the US–Mexico border region and challenges the legitimacy of a jurisdictional wall that truncates the social and environmental systems that bridge divided nations.

In the 1970s the renowned urbanists Donald Appleyard and Kevin Lynch drafted a vision plan for San Diego called *Temporary Paradise?*[18] The title is punctuated by a question mark, as if to prefigure a warning: that the future of San Diego depends on the future of Tijuana, that the destinies of these two border cities are intertwined. Appleyard and Lynch proposed that the binational system of canyons should be the armature for regional planning in the future, and urged

collaboration to reimagine the border wall as a shared infrastructure with civic projects along its trajectory.

Fifty years later we remain inspired by this ecological vision for our binational region. US policy toward the border has always prioritized physical security over environmental security, and is presently regurgitating uniquely ugly rhetorics of fear, division, and national identity to justify its mandates. This moment has triggered a great uptick of artistic and cultural interventions by local artists to mobilize public protest at the wall. While we are inspired by these important and often hugely creative gestures of cultural resistance right now, they tend to be ephemeral in their impact. Drawing on the very practical impulses of Appleyard and Lynch, we have been focusing our efforts instead on cultivating cross-border partnerships to mobilize longer-term spatial, environmental, and cultural interventions that can deepen public knowledge and sustain meaningful cross-border citizenship culture over time.

The Trans-National Environmental Commons

A Social-Ecological Script for Co-Existence

FIGURE 312
Estudio Teddy Cruz + Fonna Forman
Diagram of the transnational
environmental commons, 2018

Notes

Our great thanks to Alan Braddock and Karl Kusserow for including our work in *Nature's Nation*. We would like to thank our partners on the transnational environmental commons: Delia Castellanos Armendariz, Ana Eguiarte, Rebeca Ramirez, Kyle Haines, and Kristen Goodrich. Our gratitude to Mimi Zeiger, Ann Lok Lui, and Niall Atkinson, the curatorial team for *Dimensions of Citizenship* in the United States pavilion at the 2018 Venice Architecture Biennale, for inviting our work, and to Cliff Curry and Delight Stone for generously supporting this stage of our research. Endless thanks to our *MEXUS* project team: Jonathan Maier, Marcello Maltagliati, Benjamin Notkin, and Juan Pablo Ponce de Leon. Finally, the UCSD Cross-Border Community Stations presented here would have been impossible without the support of Richard C. Blum and the Andrew W. Mellon Foundation.

1 We explore this subject in our forthcoming monograph *The Political Equator: Unwalling Citizenship* (London: Verso).

2 See Fonna Forman and Veerabhadran Ramanathan, "Climate Change, Mass Migration, and Sustainability: A Probabilistic Case for Urgent Action," in *Humanitarianism and Mass Migration: Confronting the World Crisis*, ed. Marcelo M. Suárez-Orozco (Berkeley: University of California Press, forthcoming).

3 Colin P. Kelley, Shahrzad Mohtadi, Mark A. Cane, Richard Seager, and Yochanan Kushnir, "Climate Change in the Fertile Crescent and Implications of the Recent Syrian Drought," *Proceedings of the National Academy of Sciences* 112, no. 11 (March 17, 2015): 3241–46, www.pnas.org/cgi/doi/10.1073/pnas.1421533112.

4 Pope Francis, *Laudato Si'*, encyclical letter, Vatican website, May 24, 2015, http://w2.vatican.va/content/francesco/en/encyclicals/documents/papa-francesco_20150524_enciclica-laudato-si.html, chap. 1, sec. V (emphasis in the original).

5 See Fonna Forman, Gina Solomon, Rachel Morello-Frosch, and Keith Pezzoli, "Bending the Curve and Closing the Gap: Climate Justice and Public Health," *Collabra* 2, no. 1:22 (December 12, 2016), http://doi.org/10.1525/collabra.67.

6 Forman et al., "Bending the Curve."

7 For a summary, see Fonna Forman and Teddy Cruz, "Latin America and a New Political Leadership: Experimental Acts of Co-Existence," in *Public Servants: Art and the Crisis of the Common Good*, ed. Johanna Burton, Shannon Jackson, and Dominic Willsdon (Boston: MIT Press, 2016), 71–90. See also Justin McGuirk, *Radical Cities: Across Latin America in Search of a New Architecture* (London: Verso, 2014).

8 Fonna Forman, "Social Norms and the Cross-Border Citizen: From Adam Smith to Antanas Mockus," in *Cultural Agents Reloaded: The Legacy of Antanas Mockus*, ed. Carlo Tognato (Cambridge, MA: Harvard University Press, 2017), 335–58.

9 Enrique Peñalosa, "Why Buses Represent Democracy in Action," TED talk, September 2013, https://www.ted.com/talks/enrique_penalosa_why_buses_represent_democracy_in_action.

10 See, notably, Paulo Freire, *Pedagogy of the Oppressed* (New York: Continuum, 1970).

11 On Medellín, see Fonna Forman and Teddy Cruz, "Global Justice at the Municipal Scale: The Case of Medellín, Colombia," in *Institutional Cosmopolitanism*, ed. Luis Cabrera (New York: Oxford University Press, forthcoming). See also *The Medellín Diagram*, a project by Teddy Cruz, Fonna Forman, Alejandro Echeverri, and Matthias Görlich, commissioned by the Medellín Museum of Modern Art for the 2014 World Urban Forum and additionally presented at the Santa Monica Museum of Art in September 2014, the 2016 Shenzhen Biennale of Urbanism/Architecture, and the Yerba Buena Center for the Arts, San Francisco, March 2017.

12 Teddy Cruz and Fonna Forman, "The Cross-Border Community Stations: Eight Notes on Redistributing Knowledge Beyond Walls," in *Back to the Sandbox: Art and Radical Pedagogy*, ed. Jaroslav Anděl (Cambridge, MA: MIT Press, forthcoming).

13 The second, the UCSD/Casa Community Station, is located in the border neighborhood of San Ysidro, California, in partnership with the nonprofit Casa Familiar. San Ysidro is the first immigrant neighborhood into the United States, after the checkpoint. This station focuses on immigration, public space, affordable housing, and equitable urban development.

14 We built the first prototypes as part of *Wohnungsfrage*, a major international exhibition on the global housing crisis presented at the Haus der Kulturen der Welt (HKW) in Berlin in 2015. The project highlights the role of architects in engaging institutions, and negotiating the redistribution of resources and knowledges to reorient surplus value toward social and public priorities.

15 Amartya Sen, *The Idea of Justice* (Cambridge, MA: Harvard University Press, 2009).

16 For further discussion, see Teddy Cruz and Fonna Forman, "The Wall: The San Diego–Tijuana Border," *Artforum* 54, no. 10 (Summer 2016): 370–75; and Cruz and Forman, "Un-walling Citizenship," *Avery Review: Critical Essays on Architecture*, no. 21 (Winter 2017): 98–109, http://www.averyreview.com/issues/21/unwalling-citizenship.

17 *MEXUS*, by Estudio Teddy Cruz + Fonna Forman, was presented for the first time at the 2018 Venice Architecture Biennale, commissioned by the United States pavilion for the exhibition *Dimensions of Citizenship*.

18 Donald Appleyard and Kevin Lynch, *Temporary Paradise? A Look at the Special Landscape of the San Diego Region: A Report to the City of San Diego* (Cambridge, MA: Department of Urban Studies and Planning, Massachusetts Institute of Technology, 1974).

Kornhauser, Elizabeth Mankin, and Tim Barringer. *Thomas Cole's Journey: Atlantic Crossings*. New York: Metropolitan Museum of Art, 2018.

Krech, Shepard. *The Ecological Indian: Myth and History*. New York: Norton, 2000.

Kuletz, Valerie L. *The Tainted Desert: Environmental and Social Ruin in the American West*. New York: Routledge, 1998.

Kusserow, Karl. "Memory, Metaphor, and Meaning in Daniel Huntington's *Atlantic Cable Projectors*." In *Picturing Power: Portraiture and Its Uses in the New York Chamber of Commerce*, edited by Karl Kusserow, 319–75. New York: Columbia University Press, 2013.

———. "Selfhood and Surroundings in Early American Portraiture: An Ecocritical Approach." In *New England/New Spain: Portraiture in the Colonial Americas, 1492–1850*, edited by Donna Pierce, 59–80. Denver: Denver Art Museum, 2016.

LaDuke, Winona. *The Militarization of Indian Country*. Makwa Enewed, American Indian Studies Series. East Lansing: Michigan State University Press, 2013.

Lange, Dorothea, and Paul Schuster Taylor. *An American Exodus: A Record of Human Erosion*. New York: Reynal & Hitchcock, 1939.

Leivick, Joel. *Carrara: The Marble Quarries of Tuscany*. Stanford, CA: Stanford University Press, 1999.

Leopold, Aldo. *A Sand County Almanac: With Essays on Conservation from Round River*. 1949. Reprint, New York: Ballantine, 1966.

Lewis, G. Malcolm. "Maps, Mapmaking, and Map Use by Native North Americans." In *Cartography in the Traditional African, American, Arctic, Australian, and Pacific Societies*, edited by David Woodward and G. Malcolm Lewis, 51–182. Vol. 2, bk. 3 of *The History of Cartography*. Chicago: University of Chicago Press, 1998.

Lewis, Michael, ed. *American Wilderness: A New History*. New York: Oxford University Press, 2007.

Lidchi, Henrietta, and Hulleah J. Tsinhnahjinnie, eds. *Visual Currencies: Reflections on Native Photography*. Edinburgh: National Museums Scotland, 2009.

Linnaeus, Carolus. *Systema naturae*. Leiden: Johannes Wilhelm de Groot, 1735.

Lippard, Lucy R. *Undermining: A Wild Ride through Land Use, Politics, and Art in the Changing West*. New York: New Press, 2013.

Longmuir, Marilyn V. *Oil in Burma: The Extraction of "Earth Oil" to 1914*. Bangkok: White Lotus Press, 2001.

Lovejoy, Arthur O. *The Great Chain of Being: A Study of the History of an Idea*. Cambridge, MA: Harvard University Press, 1936.

Lowenthal, David. *George Perkins Marsh: Prophet of Conservation*. Seattle: University of Washington Press, 2000.

Lyman, Christopher M. *The Vanishing Race and Other Illusions*. New York: Pantheon, 1982.

Lyons, Maura. "An Embodied Landscape: *Wounded Trees at Gettysburg*." *American Art* 26, no. 3 (Fall 2012): 44–65.

———. "Nature Defamiliarized: Picturing New Relationships between Humans and Nonhuman Nature in Northern Landscapes from the American Civil War." *Panorama* 1, no. 1 (Winter 2015). http://journalpanorama.org/nature-defamiliarized-picturing-new-relationships-between-humans-and-nonhuman-nature-in-northern-landscapes-from-the-american-civil-war/.

Manthorne, Katherine Emma. *Tropical Renaissance: North American Artists Exploring Latin America, 1839–1879*. Washington, DC: Smithsonian Institution Press, 1989.

Marsh, George Perkins. *Man and Nature; or, Physical Geography as Modified by Human Action*. Edited by David Lowenthal. 1864. Reprint, Cambridge, MA: Harvard University Press, 1965.

Marsh, Joanna. *Alexis Rockman*. New York: Monacelli Press, 2003.

———. *Alexis Rockman: A Fable for Tomorrow*. Washington, DC: Smithsonian American Art Museum, 2010.

Marzec, Robert P. *Militarizing the Environment: Climate Change and the Security State*. Minneapolis: University of Minnesota Press, 2016.

Mattison, Robert. "Robert Rauschenberg's Environmental Activism." In *Last Turn, Your Turn: Robert Rauschenberg and the Environmental Crisis*. New York: Jacobson Howard Gallery, 2008.

Maxwell, Richard, and Toby Miller. *Greening the Media*. New York: Oxford University Press, 2012.

Mayer, Lance, and Gay Myers. *American Painters on Technique: The Colonial Period to 1860*. Los Angeles: J. Paul Getty Museum, 2011.

———. *American Painters on Technique: 1860–1945*. Los Angeles: J. Paul Getty Museum, 2013.

McClintock, Anne. "Imperial Ghosting and National Tragedy: Revenants from Hiroshima and Indian Country in the War on Terror." *Publications of the Modern Languages Association (PMLA)* 129, no. 4 (October 2014): 819–29.

———. *Imperial Leather: Race, Gender and Sexuality in the Colonial Contest*. New York: Routledge, 1995.

———. "Slow Violence and the BP Oil Crisis in the Gulf of Mexico: Militarizing Environmental Catastrophe." *e-misférica* 9, nos. 1–2 (Summer 2012). http://hemisphericinstitute.org/hemi/en/e-misferica-91/mcclintock.

McGuirk, Justin. *Radical Cities: Across Latin America in Search of a New Architecture*. London: Verso, 2014.

McKibben, Bill. *The End of Nature*. New York: Anchor Books, 1989.

McLuhan, T. C. *Touch the Earth: A Self-Portrait of Indian Existence*. New York: Promontory Press, 1971.

McNeur, Catherine. *Taming Manhattan: Environmental Battles in the Antebellum City*. Cambridge, MA: Harvard University Press, 2014.

Meier, Kathryn Shively. *Nature's Civil War: Common Soldiers and the Environment in 1862 Virginia*. Chapel Hill: University of North Carolina Press, 2013.

Menard, Andrew. "Robert Smithson's Environmental History." *Oxford Art Journal* 37, no. 3 (2014): 285–304.

Merchant, Carolyn. *American Environmental History: An Introduction*. New York: Columbia University Press, 2007.

———. *The Death of Nature: Women, Ecology, and the Scientific Revolution*. New York: Harper & Row, 1980.

———, ed. *Major Problems in American Environmental History: Documents and Essays*. Boston: Wadsworth, 2012.

———. *Spare the Birds! George Bird Grinnell and the First Audubon Society*. New Haven: Yale University Press, 2016.

Mies, Maria, and Vandana Shiva. *Ecofeminism*. 2nd ed. London: Zed Books, 2014.

Mignolo, Walter. *The Darker Side of Western Modernity: Global Futures, Decolonial Options*. Durham, NC: Duke University Press, 2011.

Miller, Angela L. *The Empire of the Eye: Landscape Representation and American Cultural Politics, 1825–1875*. Ithaca, NY: Cornell University Press, 1993.

Miller, David C. *Dark Eden: The Swamp in Nineteenth-Century American Culture*. New York: Cambridge University Press, 1989.

Miller, Lillian B., ed. *The Peale Family: Creation of a Legacy, 1770–1870*. New York: Abbeville Press in association with the Trust for Museum Exhibitions and the National Portrait Gallery, Smithsonian Institution, 1996.

Miller, Lillian B., and David C. Ward, eds. *New Perspectives on Charles Willson Peale: A 250th Anniversary Celebration*. Pittsburgh: University of Pittsburgh Press, 1991.

Miller, Perry. *Nature's Nation*. Cambridge, MA: Belknap Press of Harvard University Press, 1967.

Milroy, Elizabeth. *The Grid and the River: Philadelphia's Green Places, 1682–1876*. University Park: Pennsylvania State University Press, 2016.

Mirzoeff, Nicholas. "Visualizing the Anthropocene." *Public Culture* 26, no. 2 (2014): 220–26.

Mitchell, Lee Clark. *Witnesses to a Vanishing America: The Nineteenth-Century Response*. Princeton: Princeton University Press, 1981.

Mitchell, Timothy. *Carbon Democracy: Political Power in the Age of Oil*. New York: Verso, 2011.

Mitchell, W. J. T., ed. *Landscape and Power*. Chicago: University of Chicago Press, 1994.

Mithlo, Nancy Marie, ed. *For a Love of His People: The Photography of Horace Poolaw*. New Haven: Yale University Press, 2014.

Moffitt, John F. "Painters 'Born Under Saturn': The Physiological Explanation." *Art History* 11, no. 2 (June 1988): 195–216.

Moore, Kathleen Dean, Kurt Peters, Ted Jojola, and Amber Lacy, eds. *How It Is: The Native American Philosophy of V. F. Cordova*. Tucson: University of Arizona Press, 2007.

Morton, Timothy. *Dark Ecology: For a Logic of Future Coexistence*. New York: Columbia University Press, 2016.

———. *The Ecological Thought*. Cambridge, MA: Harvard University Press, 2010.

———. *Ecology without Nature: Rethinking Environmental Aesthetics*. Cambridge, MA: Harvard University Press, 2007.

———. *Humankind: Solidarity with Nonhuman People*. London: Verso, 2017.

———. *Hyperobjects: Philosophy and Ecology after the End of the World*. Minneapolis: University of Minnesota Press, 2013.

Muir, John. *Our National Parks*. Boston: Houghton Mifflin, 1903.

Nash, Roderick Frazier. *Wilderness and the American Mind*. 5th ed. New Haven: Yale University Press, 2014.

Natanson, Nicholas. *The Black Image in the New Deal: The Politics of FSA Photography*. Knoxville: University of Tennessee Press, 1992.

Nelson, E. Charles, and David J. Elliott, eds. *The Curious Mister Catesby: A "Truly Ingenious" Naturalist Explores New Worlds*. Athens: University of Georgia Press, 2015.

Nemerov, Alexander. *The Body of Raphaelle Peale: Still Life and Selfhood, 1812–1824*. Berkeley: University of California Press, 2001.

Newell, Jennifer, Libby Robin, and Kirsten Wehner, eds. *Curating the Future: Museums, Communities, and Climate Change*. New York: Routledge, 2017.

Nickel, Douglas R. *Carleton Watkins: The Art of Perception*. New York: Abrams, 1999.

Nisbet, James. *Ecologies, Environments, and Energy Systems in Art of the 1960s and 1970s*. Cambridge, MA: MIT Press, 2014.

Nixon, Rob. *Slow Violence and the Environmentalism of the Poor*. Cambridge, MA: Harvard University Press, 2011.

Novak, Barbara. *American Painting of the Nineteenth Century: Realism, Idealism, and the American Experience*. New York: Oxford University Press, 1980.

———. *Nature and Culture: American Landscape and Painting, 1825–1875*. New York: Oxford University Press, 1980.

Nuclear Enchantment: Photographs by Patrick Nagatani. With an essay by Eugenia Parry Janis. Albuquerque: University of New Mexico Press, 1991.

Nygren, Edward J., ed. *Views and Visions: American Landscape before 1830*. With Bruce Robertson. Washington, DC: Corcoran Gallery of Art, 1986.

O'Connor, Ralph. *The Earth on Show: Fossils and the Poetics of Popular Science, 1802–1856*. Chicago: University of Chicago Press, 2007.

Olmsted, Frederick Law. *Writings on Landscape, Culture, and Society*. Edited by Charles E. Beveridge. New York: Library of America, 2015.

Paden, Roger. "Picturesque Landscape Painting and Environmental Aesthetics." *Journal of Aesthetic Education* 49, no. 2 (Summer 2015): 39–61.

Parenti, Christian. *Tropic of Chaos: Climate Change and the New Geography of Violence*. New York: Nation Books, 2013.

Pasternak, Judy. *Yellow Dirt: An American Story of a Poisoned Land and a People Betrayed*. New York: Free Press, 2010.

Patterson, Daniel. "Audubon's Conservation Ethic Reconsidered." In *The Missouri River Journals of John James Audubon*, edited by Daniel Patterson, 211–304. Lincoln: University of Nebraska Press, 2016.

Payne, Carol, and Jeffrey Thomas. "Aboriginal Interventions into the Photographic Archives." *Visual Resources* 18, no. 2 (2002): 109–25.

Phillips, Patricia C. *Mierle Laderman Ukeles: Maintenance Art*. New York: Queens Museum, 2016.

Porter, Eliot. *"In Wildness Is the Preservation of the World," from Henry David Thoreau: Selections & Photographs by Eliot Porter*. San Francisco: Sierra Club, 1962.

Porter, Joy. *Native American Environmentalism: Land, Spirit, and the Idea of Wilderness*. Lincoln: University of Nebraska Press, 2014.

Purdy, Jedediah. *After Nature: A Politics for the Anthropocene*. Cambridge, MA: Harvard University Press, 2015.

Raab, Jennifer. *Frederic Church: The Art and Science of Detail*. New Haven: Yale University Press, 2015.

Rader, Dean. *Engaged Resistance: American Indian Art, Literature, and Film from Alcatraz to the NMAI*. Austin: University of Texas Press, 2011.

Raine, Anne. "Embodied Geographies: Subjectivity and Materiality in the Work of Ana Mendieta." In *Generations and Geographies in the Visual Arts: Feminist Readings*, edited by Griselda Pollock, 228–47. New York: Routledge, 1996.

Rainhorn, Judith. "The Banning of White Lead: French and American Experiences in a Comparative Perspective." *European Review of History/Revue européenne d'histoire* 20, no. 2 (April 2013): 197–216.

Reynolds, Joshua. *Discourses*. New York: Penguin, 1992.

Richards, John F. *The Unending Frontier: An Environmental History of the Early Modern World*. Berkeley: University of California Press, 2003.

Riis, Jacob. *How the Other Half Lives: Studies among the Tenements of New York*. New York: Charles Scribner's Sons, 1890.

Rio, Petra Barreras del, and John Perreault. *Ana Mendieta: A Retrospective*. New York: New Museum of Contemporary Art, 1988.

Roark, Elisabeth L. "Justus Engelhardt Kühn (?–1717), Portrait Painter to a Colonial Aristocracy." In *Artists of Colonial America*, 73–90. Westport, CT: Greenwood Press, 2003.

Roberts, Jennifer L. *Transporting Visions: The Movement of Images in Early America*. Berkeley: University of California Press, 2014.

Robins, Nicholas A. *Mercury, Mining, and Empire: The Human and Ecological Cost of Colonial Silver Mining in the Andes*. Bloomington: Indiana University Press, 2011.

Rohrbach, John, and Rebecca Solnit. *Eliot Porter: The Color of Wildness*. New York: Aperture in association with Amon Carter Museum, 2001.

Rome, Adam. *The Genius of Earth Day: How a 1970 Teach-In Unexpectedly Made the First Green Generation*. New York: Hill & Wang, 2014.

Rosenheim, Jeff L. *Photography and the American Civil War*. New York: Metropolitan Museum of Art, 2013.

Rosenzweig, Roy, and Elizabeth Blackmar. *The Park and the People: A History of Central Park*. Ithaca, NY: Cornell University Press, 1992.

Rosler, Martha, Caroline Walker Bynum, Natasha Eaton, Michael Ann Holly, Amelia Jones, Michael Kelly, Robin Kelsey et al. "Notes from the Field: Materiality." *Art Bulletin* 95, no. 1 (March 2013): 10–37.

Ross, Andrew. *The Chicago Gangster Theory of Life: Nature's Debt to Society*. New York: Verso, 1994.

Rushing, W. Jackson. *Native American Art and the New York Avant-Garde*. Austin: University of Texas Press, 1995.

Rybczynski, Witold. *A Clearing in the Distance: Frederick Law Olmsted and America in the Nineteenth Century*. New York: Scribner, 1999.

Sachs, Aaron. *Arcadian America: The Death and Life of an Environmental Tradition*. New Haven: Yale University Press, 2013.

——. *The Humboldt Current: Nineteenth-Century Exploration and the Roots of American Environmentalism*. New York: Viking Penguin, 2006.

Sackman, Douglas Cazaux, ed. *A Companion to American Environmental History*. Chichester, UK: Wiley Blackwell, 2014.

Sandweiss, Martha A. *Print the Legend: Photography and the American West*. New Haven: Yale University Press, 2002.

Savage, Kirk. *Standing Soldiers, Kneeling Slaves: Race, War, and Monument in Nineteenth-Century America*. Princeton: Princeton University Press, 1999.

Sayers, Daniel O. *A Desolate Place for a Defiant People: The Archaeology of Maroons, Indigenous Americans, and Enslaved Laborers in the Great Dismal Swamp*. Gainesville: University Press of Florida, 2016.

Schama, Simon. *Landscape and Memory*. New York: Vintage Books, 1995.

Schenker, Heath Massey. *Melodramatic Landscapes: Urban Parks in the Nineteenth Century*. Charlottesville: University of Virginia Press, 2009.

Schoen, Brian. *The Fragile Fabric of Union: Cotton, Federal Politics, and the Global Origins of the Civil War*. Baltimore: Johns Hopkins University, 2009.

Schuyler, David. *The New Urban Landscape: The Redefinition of City Form in Nineteenth-Century America*. Baltimore: Johns Hopkins University Press, 1986.

Schwarz, Astrid, and Kurt Jax, eds. *Ecology Revisited: Reflecting on Concepts, Advancing Science*. New York: Springer, 2011.

Scigliano, Eric. *Michelangelo's Mountain: The Quest for Perfection in the Marble Quarries of Carrara*. New York: Free Press, 2005.

Scott, Emily Eliza, and Kirsten Swenson, eds. *Critical Landscapes: Art, Space, Politics*. Oakland: University of California Press, 2015.

Sen, Amartya. *The Idea of Justice*. Cambridge, MA: Harvard University Press, 2009.

Sheikh, Fazal. *Erasure Trilogy*. New York: Steidl, 2015.

Simpson, Marc. *Winslow Homer: Paintings of the Civil War*. San Francisco: Fine Arts Museums of San Francisco, 1988.

Smith, Kimberly K. *African American Environmental Thought: Foundations*. Lawrence: University Press of Kansas, 2007.

Smith, Laura E. *Horace Poolaw: Photographer of American Indian Modernity*. Lincoln: University of Nebraska Press, 2016.

Smith, Paul Chaat. *Everything You Know about Indians Is Wrong*. Minneapolis: University of Minnesota Press, 2009.

Smithson, Robert. *Robert Smithson: The Collected Writings*. Edited by Jack Flam. Berkeley: University of California Press, 1996.

Snyder, Robert W., and Rebecca Zurier. *Metropolitan Lives: The Ashcan Artists and Their New York*. Washington, DC: National Museum of American Art, 1995.

Solnit, Rebecca. "The Nature of Gender: Uplift and Separate; The Aesthetics of Nature Calendars." In *As Eve Said to the Serpent: On Landscape, Gender, and Art*, 200–204. Athens: University of Georgia Press, 2001.

Spence, Mark David. *Dispossessing the Wilderness: Indian Removal and the Making of the National Parks*. New York: Oxford University Press, 1999.

Stebbins, Theodore E. *The Life and Work of Martin Johnson Heade: A Critical Analysis and Catalogue Raisonné*. New Haven: Yale University Press, 2000.

Steffen, Will, Jacques Grinevald, Paul Crutzen, and John McNeill. "The Anthropocene: Conceptual and Historical Perspectives." *Philosophical Transactions of the Royal Society A* 369, no. 1938 (2011): 842–67.

Steinberg, Ted. *Down to Earth: Nature's Role in American History*. 3rd ed. New York: Oxford University Press, 2013.

Stilgoe, John. *Alongshore*. New Haven: Yale University Press, 1994.

Stowe, Harriet Beecher. *Dred: A Tale of the Great Dismal Swamp*. Leipzig: Bernhard Tauchnitz, 1856.

——. *Uncle Tom's Cabin; or, Life among the Lowly*. Boston: Jewett, 1852.

Stuart, Tristram. *The Bloodless Revolution: A Cultural History of Vegetarianism from 1600 to Modern Times*. New York: W. W. Norton, 2007.

Sturgeon, Noël. *Ecofeminist Natures: Race, Gender, Feminist Theory and Political Action*. New York: Routledge, 1997.

Tarbell, Ida M. *The History of the Standard Oil Company*. New York: McClure, Phillips, 1904.

Taylor, Dorceta E. *The Environment and the People in American Cities, 1600s–1900s: Disorder, Inequality, and Social Change*. Durham, NC: Duke University Press, 2009.

——. *The Rise of the American Conservation Movement: Power, Privilege, and Environmental Protection*. Durham, NC: Duke University Press, 2016.

Teal, John, and Mildred Teal. *The Life and Death of the Salt Marsh.* Boston: Little, Brown, 1969.

Thielemans, Veerle. "Beyond Visuality: Review on Materiality and Affect." *Perspective* 2 (2015). http://journals.openedition.org /perspective/5993.

Thomas, Greg M. *Art and Ecology in Nineteenth-Century France: The Landscapes of Théodore Rousseau.* Princeton: Princeton University Press, 2000.

Thomas, Keith. *Man and the Natural World: Changing Attitudes in England, 1500–1800.* London: Penguin Books, 1984.

Thoreau, Henry David. *Walden; or, Life in the Woods.* Boston: Ticknor and Fields, 1854.

———. "Walking." *Atlantic Monthly* 9, no. 56 (June 1862): 657–74.

Tisdall, Caroline. *Joseph Beuys: Coyote.* Munich: Schirmer-Mosel, 1980.

Truettner, William H., ed. *The West as America: Reinterpreting Images of the Frontier.* Washington, DC: Smithsonian Institution Press, 1991.

Truettner, William H., and Alan Wallach, eds. *Thomas Cole: Landscape into History.* New Haven: Yale University Press, 1994.

Turner, Elizabeth Hutton, ed. *Jacob Lawrence: The Migration Series.* Washington, DC: Phillips Collection, 1993.

Turner, Frederick Jackson. "The Significance of the Frontier in American History." In *Annual Report of the American Historical Association for the Year 1893*, 197–228. Washington, DC: Government Printing Office, 1894.

Upright, Diane. *Morris Louis: The Complete Paintings; A Catalogue Raisonné.* New York: Abrams, 1985.

Van Dooren, Thom. *Flight Ways: Life and Loss at the Edge of Extinction.* New York: Columbia University Press, 2014.

Varnedoe, Kirk, and Pepe Karmel. *Jackson Pollock.* New York: Museum of Modern Art, 1999.

Vileisis, Ann. *Discovering the Unknown Landscape: A History of America's Wetlands.* Washington, DC: Island Press, 1997.

Vlach, John Michael. *The Planter's Prospect: Privilege and Slavery in Plantation Paintings.* Chapel Hill: University of North Carolina Press, 2002.

Vogel, Steven. *Thinking Like a Mall: Environmental Philosophy after the End of Nature.* Cambridge, MA: MIT Press, 2015.

Wallach, Alan. "Thomas Cole and the Aristocracy." In *Reading American Art*, edited by Marianne Doezema and Elizabeth Milroy, 79–108. New Haven: Yale University Press, 1998.

———. "Thomas Cole's *River in the Catskills* as Antipastoral." *Art Bulletin* 84, no. 2 (June 2002): 334–50.

Walls, Laura Dassow. *The Passage to Cosmos: Alexander von Humboldt and the Shaping of America.* Chicago: University of Chicago Press, 2009.

Ward, David C. *Charles Willson Peale: Art and Selfhood in the Early Republic.* Berkeley: University of California Press, 2004.

Warhus, Mark. *Another America: Native American Maps and the History of Our Land.* New York: St. Martin's Press, 1997.

Warming, Eugenius. *Oecology of Plants: An Introduction to the Study of Plant-Communities.* Oxford: Clarendon Press, 1909.

Warren, Christian. *Brush with Death: A Social History of Lead Poisoning.* Baltimore: Johns Hopkins University Press, 2000.

Warren, Louis S., ed. *American Environmental History.* Malden, MA: Blackwell, 2003.

Watts, David. *The West Indies: Patterns of Development, Culture, and Environmental Change Since 1492.* New York: Cambridge University Press, 1987.

Weizman, Eyal, and Fazal Sheikh. *The Conflict Shoreline: Colonization as Climate Change in the Negev Desert.* New York: Steidl, 2015.

Wexler, Laura. *Tender Violence: Domestic Visions in an Age of U.S. Imperialism.* Chapel Hill: North Carolina Press, 2000.

Whiting, Cécile. "The Sublime and the Banal in Postwar Photography of the American West." *American Art* 27, no. 2 (Summer 2013): 44–67.

Whyte, Kevin Powys. "The Dakota Access Pipeline, Environmental Injustice, and U.S. Colonialism." *Red Ink* 19, no. 1 (Spring 2017): 154–69.

Wildy, Jade. "The Artistic Progressions of Ecofeminism: The Changing Focus of Women in Environmental Art." *International Journal of the Arts in Society* 6, no. 1 (2012): 53–65.

Williams, Raymond. "Ideas of Nature." In *Problems in Materialism and Culture: Selected Essays*, 67–85. London: Verso, 1980.

Williams, Rosalind. *Notes on the Underground: An Essay on Technology, Society, and the Imagination.* New ed. Cambridge, MA: MIT Press, 2008.

Wilmerding, John, ed. *American Light: The Luminist Movement, 1850–1875; Paintings, Drawings, Photographs.* Washington, DC: National Gallery of Art, 1980.

Wilton, Andrew, and Tim Barringer. *American Sublime: Landscape Painting in the United States, 1820–1880.* Princeton: Princeton University Press, 2003.

Wolf, Bryan. "Revolution in the Landscape: John Trumbull and Picturesque Painting." In *John Trumbull: The Hand and Spirit of a Painter*, edited by Helen A. Cooper, 206–15. New Haven: Yale University Art Gallery, 1982.

Wolfe, Cary, ed. *Zoontologies: The Question of the Animal.* Minneapolis: University of Minnesota Press, 2003.

Worster, Donald. *Nature's Economy: A History of Ecological Ideas.* 2nd ed. New York: Cambridge University Press, 1994.

Wulf, Andrea. *The Invention of Nature: Alexander von Humboldt's New World.* New York: Alfred A. Knopf, 2015.

Yochelson, Bonnie, and Daniel Czitrom. *Rediscovering Jacob Riis: Exposure Journalism and Photography in Turn-of-the-Century New York.* New York: New Press, 2007.

Zapf, Hubert, ed. *Handbook of Ecocriticism and Cultural Ecology.* Berlin: De Gruyter, 2016.

Zierler, David. *The Invention of Ecocide: Agent Orange, Vietnam and the Scientists Who Changed the Way We Think about the Environment.* Athens: University of Georgia Press, 2011.

Lenders to the Exhibition

Arader Galleries, Philadelphia
Autry Museum of the American West, Los Angeles
Brooklyn Museum, New York
Crocker Art Museum, Sacramento
de Young Museum, Fine Arts Museums of San Francisco
Denver Art Museum
Detroit Public Library
Diller Scofidio + Renfro, New York
Estudio Teddy Cruz + Fonna Forman, San Diego
Fenimore Art Museum, Cooperstown, New York
Flint Institute of Arts, Michigan
Fondation Cartier pour l'art contemporain, Paris
Galerie Lelong, New York
Galerie St. Etienne, New York
George Eastman Museum, Rochester, New York
Gilcrease Museum, Tulsa
Harry Ransom Center, University of Texas at Austin
Harun Farocki GbR, Berlin
Howard Greenberg Gallery, New York
Kolodny Family Collection, Princeton
Lannan Foundation, Santa Fe
Los Angeles County Museum of Art
Cannupa Hanska Luger, Glorieta, New Mexico
Maryland Historical Society, Baltimore
Maya Lin Studio, New York
The Metropolitan Museum of Art, New York
Alan Michelson, New York
Milwaukee Art Museum
Missouri Botanical Garden, Peter H. Raven Library, Saint Louis
Munson-Williams-Proctor Arts Institute, Utica, New York
Museum of the City of New York
National Gallery of Art, Washington, DC
National Museum of American History, Washington, DC
Nevada Museum of Art, Reno
New York City Department of Records and Information Services
New-York Historical Society, New York
New York Public Library, New York
Noguchi Museum, Long Island City, New York
North Carolina Museum of Art, Raleigh
Paul Kasmin Gallery, New York
Peabody Essex Museum, Salem, Massachusetts
Peabody Institute Library, Peabody, Massachusetts
Pennsylvania Academy of the Fine Arts, Philadelphia
Philadelphia Museum of Art
Philbrook Museum of Art, Tulsa
Pollock-Krasner House and Study Center, East Hampton, New York
Princeton University
Princeton University Art Museum
Princeton University Library, Rare Books and Special Collections

Private collection, Bridgeton, New Jersey
Private collection, Greenville, Delaware
Private collection, Greenwich, Connecticut
Private collection, Irvington, New York
Private collection, Mountain Brook, Alabama
Private collection, New York
Reynolda House Museum of American Art, Winston-Salem, North Carolina
Richard Misrach Photography, Emeryville, California
Ronald Feldman Fine Arts, New York
R. W. Norton Art Gallery, Shreveport, Louisiana
Seibert Family Collection, Bernardsville, New Jersey
Smithsonian American Art Museum, Washington, DC
Terra Foundation for American Art, Chicago
University of Pennsylvania Museum of Archaeology and Anthropology, Philadelphia
US Department of the Interior and Southern Plains Indian Museum, Anadarko, Oklahoma
Vilcek Foundation, New York
Wadsworth Atheneum Museum of Art, Hartford, Connecticut
The Westmoreland Museum of American Art, Greensburg, Pennsylvania
Winterthur Museum, Garden & Library, Wilmington, Delaware
Yale University Art Gallery, New Haven

Index

Photography Credits

Courtesy the Adirondack Museum: fig. 219

Courtesy A. J. Kollar Fine Paintings, LLC, Seattle, Washington: fig. 84

Courtesy American Philosophical Society: fig. 22

© 2018 The Andy Warhol Foundation for the Visual Arts, Inc. / Licensed by Artists Rights Society (ARS), New York: fig. 278

The Art Institute of Chicago / Art Resource, NY: fig. 77

© 2018 Artists Rights Society (ARS), New York / VG Bild-Kunst, Bonn: fig. 277

Photo by Gavin Ashworth: fig. 45

Courtesy the Bancroft Library, UC Berkeley, BANC PIC 1,963.002:1379-FR: fig. 221

© Subhankar Banerjee: fig. 13, cover

Courtesy Miranda Belarde-Lewis: figs. 137–39, 140 (taken by Clarissa Rizal with a self-timer)

© Bernisches Historisches Museum, Bern. Photo by Stefan Rebsamen: fig. 191

© Luc Boegly; courtesy Diller Scofidio + Renfro: fig. 286

Bridgeman Images: figs. 26, 41, 92; photo © Paul Maeyaert: fig. 111

© Edward Burtynsky; courtesy Howard Greenberg Gallery and Bryce Wolkowitz Gallery, New York: fig. 289

© Edward Burtynsky; courtesy Metivier Gallery, Toronto: fig. 122

Photo © Christie's Images / Bridgeman Images: fig. 133

Photography © The Cleveland Museum of Art: fig. 224; art © Kenneth Josephson: fig. 292

© 1991 Sue Coe; courtesy Galerie St. Etienne, New York: fig. 283

Collections of the Museum of the City of New York: figs. 182, 185, 187

© Xavier Cortada: fig. 285

Crystal Bridges Museum of American Art, Bentonville, Arkansas. Photography by the Metropolitan Museum of Art: fig. 58

Crystal Bridges Museum of American Art, Bentonville, Arkansas. Photo by Dwight Primiano: fig. 101

Crystal Bridges Museum of American Art, Bentonville, Arkansas. Photography by Edward C. Robison III: fig. 43; © 2018 Georgia O'Keeffe Museum / Artists Rights Society (ARS), New York: fig. 238

Crystal Bridges Museum of American Art, Bentonville, Arkansas. Photo by Dero Sanford: fig. 262

Photography courtesy Denver Art Museum: figs. 37, 222; © Kent Monkman: fig. 203

Courtesy Department of Rare Books and Special Collections, Princeton University Library: figs. 16, 29/detail p. 42, 30, 31, 113, 178, 186, 192, 207, 210, 226

© Mark Dion; courtesy the artist and Tanya Bonakar, New York and Los Angeles: figs. 144–47; photo by Craig T. Mathew: fig. 148

© The Estate of Ana Mendieta Collection, LLC; courtesy Galerie Lelong, New York: fig. 265

© Estate of Alexandre Hogue: figs. 239, 243/detail p. 242

© Estate of Horace Poolaw; images courtesy University of Science and Arts of Oklahoma, Chickasha: figs. 211, 213

© Estate of Hughie Lee-Smith / Licensed by VAGA, New York, NY: fig. 268

Art © Estate of Ralston Crawford / Licensed by VAGA, New York, NY: fig. 298

© Estudio Teddy Cruz + Fonna Forman: figs. 302, 305, 307, 308, 309, 311, 312

© Harun Farocki GbR: fig. 112

By permission of the Folger Shakespeare Library, Washington, DC: fig. 33

Courtesy the Folk Pottery Museum of Northeast Georgia; photo by David Greear: fig. 161

© Walton Ford; courtesy the artist and Paul Kasmin Gallery: fig. 32

© Lee Friedlander; courtesy Fraenkel Gallery, San Francisco: fig. 291

© Theaster Gates; courtesy the artist and Kavi Gupta: fig. 271

Courtesy George Eastman Museum: figs. 154, 242, 290, 293

Georgia O'Keeffe Museum, Santa Fe / Art Resource, NY. © 2018 Georgia O'Keeffe Museum / Artists Rights Society (ARS), New York: fig. 260

© 1991 Hans Namuth Estate; courtesy Center for Creative Photography: fig. 250

Courtesy Hargrett Rare Book and Manuscript Library, University of Georgia Libraries: fig. 36/detail p. 71

© Valerie Hegarty; image courtesy the Brooklyn Museum: fig. 9, jacket front

© Heirs of Aaron Douglas / Licensed by VAGA, New York, NY. Photo by John R. Glembin Art: fig. 267

Art © Holt-Smithson Foundation / Licensed by VAGA, New York, NY: fig. 264; photo © Gianfranco Gorgoni, courtesy Dia Art Foundation, New York: fig. 263

Image courtesy Lily Hope and the Portland Art Museum, Oregon: fig. 141

Photo by Jeremy Horner / Alamy Stock Photo: fig. 91

© The Isamu Noguchi Foundation and Garden Museum, New York / ARS. Photo by Bill Taylor: fig. 247

© 2018 The Jacob and Gwendolyn Knight Lawrence Foundation, Seattle / Artists Rights Society (ARS), New York: figs. 245, 246

© Kelly Jazvac: fig. 301

Courtesy the John Carter Brown Library at Brown University: fig. 114

© Chris Jordan: fig. 300

© Cannupa Hanska Luger: fig. 288

Collection W. Bruce and Delaney H. Lundberg: fig. 74

© Kerry James Marshall; courtesy the artist and Jack Shainman Gallery, New York: fig. 270/detail p. 356

Courtesy Maryland Historical Society: figs. 24, 34, 47, 50

© Anne McClintock: fig. 215

Memorial Art Gallery of the University of Rochester, New York. This photograph may not be reproduced except for nonprofit publicity without written permission: fig. 103

Photographs by Peter Metcalfe: figs. 142, 143

© The Metropolitan Museum of Art. Image source: Art Resource, NY: figs. 70, 71, 157, 205

Image copyright © The Metropolitan Museum of Art. Image source: Art Resource, NY. © 2018 Delaware Art Museum / Artists Rights Society (ARS), New York: fig. 188

Reproduced with permission of MiBACT. Further reproduction by any means is prohibited: fig. 17

© Alan Michelson: fig. 80

© Richard Misrach; courtesy Fraenkel Gallery, San Francisco: fig. 216

Munson-Williams-Proctor Arts Institute / Art Resource, NY: fig. 128

Museo Nacional Thyssen-Bornemisza / Scala / Art Resource, NY: fig. 99

Image © 2018 Museum Associates / LACMA. Licensed by Art Resource, NY: fig. 165

Photography © 2018 Museum of Fine Arts, Boston: fig. 83

Digital Image © The Museum of Modern Art / Licensed by Scala / Art Resource, NY: fig. 249

NASA: figs. 296, 297

Courtesy National Gallery of Art, Washington: figs. 40, 73, 75

National Gallery of Canada, Ottawa: fig. 28

Photography © New-York Historical Society: figs. 35, 76, 177; digital image created by Oppenheimer Editions: figs. 79, 89/detail p. 102

The New York Public Library: fig. 173

Courtesy NYC Municipal Archives: figs. 174, 176